D1229142

Feb 1987

Views and Visions

Views and Visions
American Landscape before 1830

EDWARD J. NYGREN

with

BRUCE ROBERTSON

and contributions by

AMY R. W. MEYERS

THERESE O'MALLEY

ELLWOOD C. PARRY III

JOHN R. STILGOE

THE CORCORAN GALLERY OF ART

WASHINGTON, D.C.

1986

WADSWORTH ATHENEUM
Hartford, Connecticut
September 21 –November 30, 1986

THE CORCORAN GALLERY OF ART
Washington, D.C.
January 17–March 29, 1987

VIEWS AND VISIONS is made possible by generous grants
from the Luce Fund for Scholarship in American Art, a
program of the Henry Luce Foundation, Inc. and the
National Endowment for the Arts.

This catalogue is also supported by the Kathrine Dulin
Folger Publications Fund.

VIEWS AND VISIONS
Copyright ©1986 THE CORCORAN GALLERY OF ART, Washington, D.C.

All rights reserved.

LIBRARY OF CONGRESS CATALOGUING -IN - PUBLICATION DATA

Nygren, Edward J.
 Views and visions.

 Bibliographies.
 Includes indexes.
 1. Art, American — Exhibitions. 2. Landscape in art —
Exhibitions. 3. Art, British — Exhibitions. 4. Art,
Modern — 17th–18th centuries — United States — Exhibitions.
5. Art, Modern — 19th century — United States — Exhibitions.
6. Landscape gardening — United States — History — 18th
century — Exhibitions. 7. Landscape gardening — United
States — History — 19th century — Exhibitions. I. Title.
N8214.5.U6N9 1986 758'.1'09730740153 86–18064
ISBN 0–88675–022–9

COVER: William Guy Wall, *Cauterskill Falls on the Catskill Mountains,
Taken from under the Cavern,* 1826–1827, Honolulu Academy of Arts (see
Plates 65 and 128).

Edited by Diana Menkes, Praia da Luz, Portugal
Designed by Gerard A. Valerio, Annapolis, Maryland
Typeset by General Typographers, Washington, D.C.
Printed by Balding + Mansell, Wisbech, Cambs., England

Contents

Foreword

ATTENTION TO AMERICAN ART has been a hallmark of the last thirty years. Within that seemingly ever-growing appreciation of our artistic heritage, landscape occupies the most prominent place. "The Hudson River School" has become a common oversimplification for a large segment of nineteenth-century landscape painting, and names like Church, Cole or Doughty are part of an increasingly well known group of popularized names. But there is much yet to be discovered and savored in American landscape painting. *Views and Visions* is another chapter in that exploration.

Indeed, this exhibition examines the moment before the Hudson River School, a period from the 1780s to the 1820s characterized by exploration and identification of the American terrain at a time when it was a study in contrast between wilderness and domestication. Towns lay on the edge of the uncultivated open spaces; travel was difficult; and America remained under the spell of English taste and conventions, if not English rule. The artists who encountered America's nearly virgin territory created a body of work steeped in English expectation yet drawn inevitably to the boundless promise of the American landscape. It is this conjunction that makes up *Views and Visions*.

Many of the subjects confirm this conjunction. We have "views," we also have "prospects," and other terms drawn from the vocabulary of English landscape. The English aesthetic of the picturesque casts its light on scenes of villages, brooks, valleys, and hills. But within this sensibility a distinct sense of place emerges. The ideal landscape is replaced by a desire to specify unique and identifiable locations: Niagara, Kaaterskill, and Passaic Falls, New York, Philadelphia, Baltimore, each striving to replace some of the quality of the picturesque with a definable sense of place.

For research support of this project, which presents, for the first time, a collective picture of the Anglo-American tradition in American landscape, I want to thank the Luce Fund for Scholarship in American Art, a program of the Henry Luce Foundation, Inc. For the past four years this funding has underwritten the basic research that bears fruit in this exhibition.

We are grateful to the National Endowment for the Arts for support of the exhibition and catalogue. We also extend appreciation to the Kathrine Dulin Folger Publications Fund, which has supported this catalogue as well as many other Corcoran books. No exhibition of this scope would be possible without the generous cooperation of the lenders. We thank them for sharing with all of us. We are grateful as well to our colleagues at the Wadsworth Atheneum, whose enthusiasm and support for the project helped make it happen. Finally, we recognize the enormous contribution made by Edward Nygren. Not only does his research constitute an important chapter in the development of American art history, but in this wonderful exhibition and the catalogue that accompanies it, he carries forward the glorious Corcoran tradition of celebrating the American genius, a tradition stretching back to the Gallery's founding in 1869.

MICHAEL BOTWINICK
Director
The Corcoran Gallery of Art

Preface and Acknowledgements

Most studies of American art have tended to stress the seminal position of Thomas Cole and the Hudson River School in the history of landscape painting in the United States. While Cole's role, and that of his followers, was unquestionably critical to the growth of a vital landscape tradition in America, there were many artists who preceded Cole, laying the foundation for his achievements. The purpose of this exhibition is to examine this area of American art.

Although artistic response to America began with the first European settlers, the focus of this study is the closing two decades of the eighteenth century and the opening three of the nineteenth. It begins essentially with the end of the Revolution and ends with Cole's departure for Europe after a meteoric rise to prominence. In that half-century, landscape became a significant form of artistic expression in America and, it should be noted, in Europe as well. In that half-century, a new country was expanded and consolidated. In that half-century, Americans moving west turned a wilderness into a garden and banished the Indian to undesirable lands beyond the Mississippi.

Although paintings of wilderness are commonly associated with early American landscape, the genre, particularly before 1825, is in fact dominated by scenes of cultivated land. Wilderness images are just part of the iconography of American landscape, and a rather late development. Today, pictures extolling man's role in shaping his world seem less American than those glorifying nature. But at a time when much of America was wilderness, artists stressed human control and use of natural resources in their representations of the young republic. Obviously such images and the need to portray them reflect the attitudes and values of the society that produced them. They are, in effect, just as American as a painting of a primeval forested mountain; conversely, a picture that portrays the natural sublime is just as European in its aesthetic perception as a depiction of a beautiful rolling countryside.

A few recent exhibitions have looked at the cultivated landscape. Notable are Jay Cantor's "Landscape of Change" and Roger Stein's "Susquehanna." In a recent article on American landscape painting between 1730 and 1845 in the *American Art Journal*, William Gerdts has provided an overview that inevitably covers some of the same points and uses many of the same sources as I do here. There have also been new approaches to American landscape and painting, for example John Stilgoe's *Common Landscape of America, 1580 to 1845* and Bryan Wolf's *Romantic Re-Vision*. Recent studies of individual artists such as Allston, Peale, and Trumbull have brought reevaluations of their landscapes.

The desire to explore conceptions of American landscape within a larger context is apparent in the breadth of subject matter covered by the essays in this catalogue. I wish to take this opportunity to thank the contributors: Amy Meyers, Therese O'Malley, Ellwood C. Parry III, and John Stilgoe. Special acknowledgment is due

Bruce Robertson, whose collaboration and assistance over the past several years has been critical. I also want to thank my graduate students at George Washington University for their help in writing the commentaries on the artists. Diana Menkes has given consistency a good name by providing the essential editorial glue for this joint effort.

Work on this project began early in 1982 when I was a fellow at the Henry Francis du Pont Winterthur Museum under a program funded by the National Endowment for the Humanities. A grant from the Henry Luce Foundation insured that the research begun at Winterthur could continue and that planning for an exhibition could be undertaken. Support from the National Endowment for the Arts has made the exhibition and catalogue a reality.

No exhibition is possible without the help of countless people. My colleagues at the Corcoran have been untiring. I particularly wish to thank Starr Figura and Nancy Huvendick for their assistance. A special word of gratitude is due Barbara Moore, Curator of Education, for coordination of this catalogue and other aspects of the project. Conservation of several paintings and works on paper was undertaken by Dare Hartwell and the Conservation Department.

Obviously the success of an exhibition depends on the objects in it. The lenders, who are listed elsewhere, have been extremely generous and cooperative. I want to single out the Wadsworth Atheneum, which is both a major lender to the show and a participant. Like the Corcoran, the Wadsworth Atheneum is recognized for its outstanding nineteenth-century American collection. Its participation in this undertaking gives special meaning to the occasion.

EJN

Views and Visions

EDWARD J. NYGREN

From View to Vision

ROM THE SEVENTEENTH THROUGH THE EARLY NINETEENTH CENTURY, landscapes
in art were divided between topographical representations and imaginary
creations, between views (Plate 1) and visions (Plate 2). In accordance with
academic theory this polarity served to differentiate an imitative, and therefore in-
ferior, art form from a poetic, elevated one. In practice the distinction broke down. The
eighteenth century saw the emergence of a poetic view that combined lyricism with
literalism (Plate 3). It is the poetic view that became the dominant form in American
landscape of the nineteenth century.

Geographically and culturally isolated throughout much of its early period,
America provides an unusual opportunity to explore how depictions of real and ideal
landscapes reflected changing attitudes toward nature and became symbols of social
concepts. By studying these landscapes it is possible to chart the emergence of artistic
conventions and to analyze their meaning. The transformation of the landscape from
colonial record to cultural myth is the American experience.

Documentary Views

Today, wilderness areas provide a welcome refuge from the pressure of contemporary
life. Such was not always the case. Five hundred years ago, when Europeans first made
forays into the unknown, their limited knowledge of the world fueled apprehension
and their analogical minds drew parallels between unfettered nature and human sin-
fulness.[1] The wilderness — whether found in nearby forests or in remote parts of the
globe—was fraught with danger. Impenetrable woods harbored wild animals and evil
spirits; the physical condition of the New World and the moral state of its ungodly
natives were considered by some a case in point. Puritans such as William Bradford
and Michael Wigglesworth judged the wilderness in biblical terms as a hideous and
desolate waste; it was their mission to dominate and improve the land.[2] Even those
who viewed America more as an Edenic garden than a howling desert equated the
cultivation of land with civilization and frequently with godliness. God had, after all,
fashioned the original garden out of which Adam and Eve were driven into a wilder-
ness.[3]

An important activity of early visitors to America was recording, verbally and
visually, the natural world they found. Exploration of unknown regions from the

3

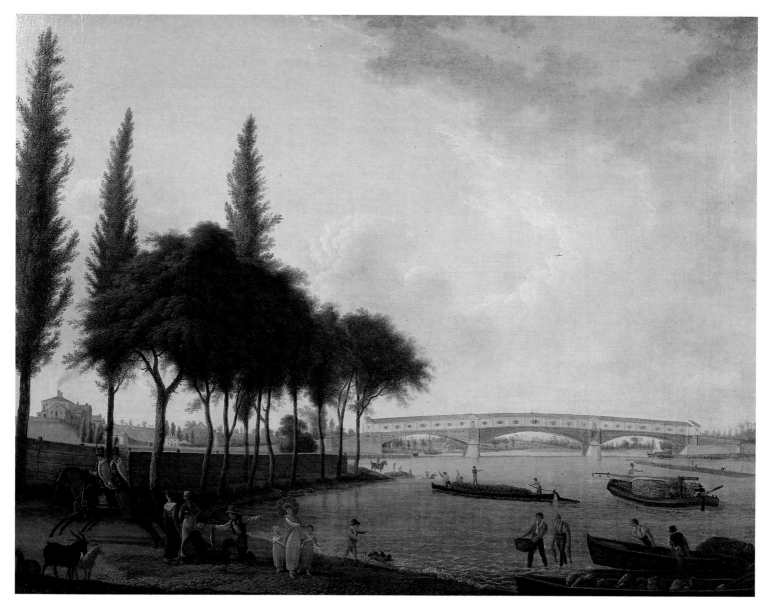

PLATE 1. JOHN JAMES BARRALET, *Bridge over the Schuylkill (Market Street Bridge)*, c. 1810.

fifteenth century on put western man in contact with the strange and exotic. Illustrated travel accounts and natural histories, common from the seventeenth century through the nineteenth, brought this information to a wide audience. Such books document the spread of European culture to all parts of the world and underscore the imperial aspirations of rival nations. The observations of these travelers were inevitably colored by their experiences at home; they judged what they found in America and elsewhere in terms of what they knew.

The explorer artist was essential to any expedition. Among the first to record his impressions of America and its native peoples was John White, who in 1585 was sent to the Roanoke Colony by Sir Walter Raleigh. His watercolors, many of which are in the British Museum, illustrated a book on the colony (Plate 4).[4] Although there is a particularization of setting, White's compositions focus on people. Idealized in proportion and stylized in gesture, native American Indians are presented as specimens in their natural environment.

The purchase of the Louisiana Territory in 1803 led to several expeditions which included artists such as Titian Ramsay Peale, who sketched the terrain and wildlife (see Plate 114) of the regions they visited. British military artists such as Robert Hood and George Back accompanied similar expeditions that charted the vast areas of Canada (Plates 5, 6).

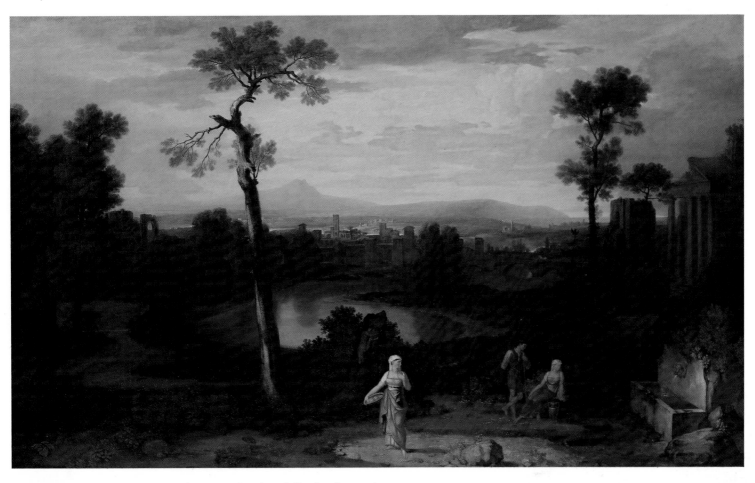

PLATE 2. WASHINGTON ALLSTON, *Italian Landscape*, 1814.

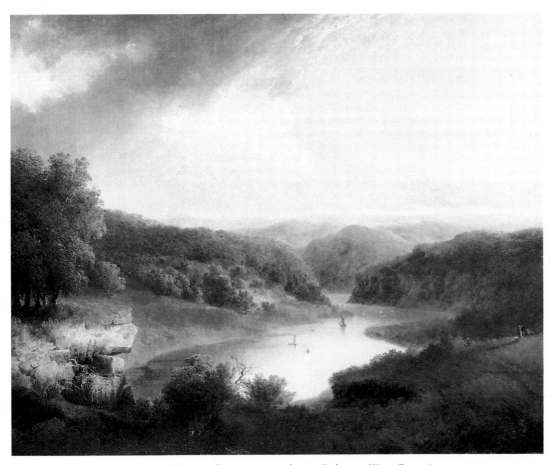

PLATE 3. THOMAS DOUGHTY, *Landscape: Delaware Water Gap*, 1826.

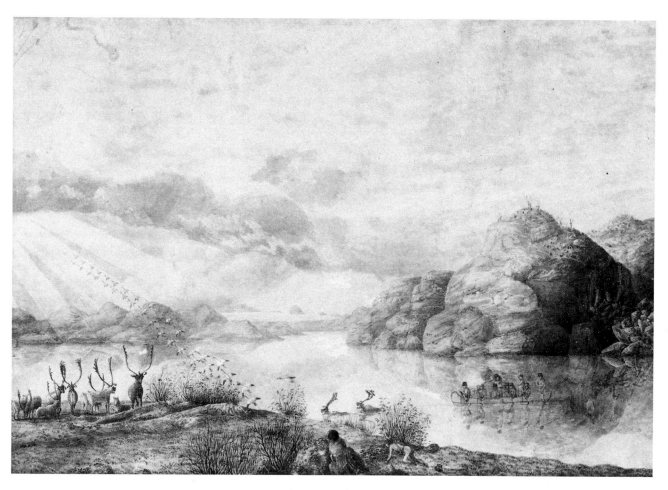

PLATE 5. ROBERT HOOD, *A Canoe on the Northern Land Expedition Chasing Reindeer in Little Marten Lake, Northwest Territories, 1820.*

Concern for accuracy in the rendering of a natural history subject had an impact on the landscapes portrayed. This is particularly true of the compositions of John James Audubon (see Fig. 27), but the concern is evident in Titian Peale's drawings as well. The background becomes integral to the presentation; the landscape assumes a prominence and importance almost equal to that of the animal depicted.

Topographical drawings created by military officers and civil servants represent another kind of visual documentation. From the beginning of military history, information on terrain to be defended or attacked had been a necessity, and by the eighteenth century training in drawing was a part of a British officer's education. Such practical representations of the countryside would have ranked low in the academic hierarchy of landscape art, but these views frequently exhibit current artistic conventions. In *View of the Lines at Lake George, 1759* (Plate 7), Thomas Davies frames his prospect with trees just like any other eighteenth-century English follower of Claude Lorrain, the seventeenth-century artist whose work was a major influence on British and, by extension, American landscape.[5]

The conflicts between France and Britain, and then Britain and America in the eighteenth and early nineteenth centuries required the topographical skills of military artists. Officers such as Davies, however, did not employ their talents only for military purposes, and Hood and Back accompanied expeditions. Nor were all draftsmen in the army or navy. Civil servants in colonial government, such as George Heriot, also frequently exercised artistic talents (Plate 8). In Canada, because of its long colonial status, the tradition of the bureaucrat cum amateur topographical artist lingered well into the nineteenth century (Plate 9).

British representatives in America, civilian or military, transcribed their reactions to the New World and took these visual mementos home. Other travelers, foreign and

PLATE 4. THEODOR DE BRY after JOHN WHITE, *Incolarum Virginiae piscandiratio*, from Thomas Harriot's *Admiranda narratio fida tamen*, 1590.

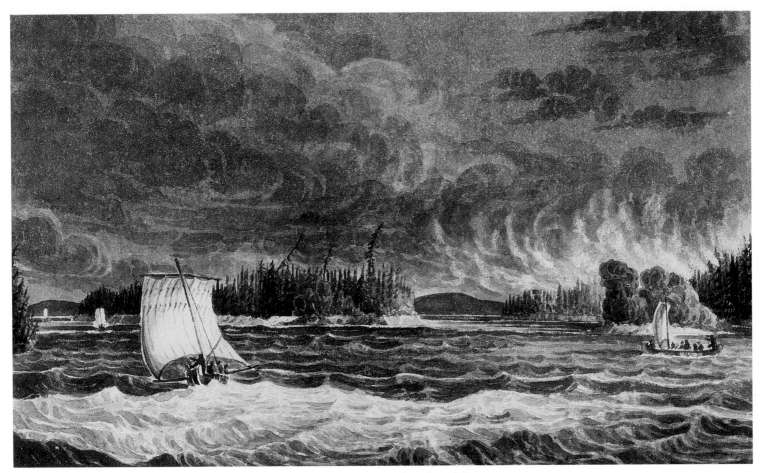

PLATE 6. GEORGE BACK, *Upper Part of the McKenzie River, Woods on Fire*, 1825.

PLATE 7. THOMAS DAVIES, *View of the Lines at Lake George, 1759*, c. 1774.

native, did the same. Governor Thomas Pownall had his views translated into prints on his return to England; Heriot illustrated an account of his travels through Canada. Because attractions such as Passaic Falls, Hudson Palisades, Genesee Falls, and Montmorency Falls were easily reached, depictions of them were frequent and formulaic. Their standardized formats attest to the popularity of the sites and to the general use of artistic conventions. As in English compositions, human beings are often introduced to provide scale and focus. These figures also give a sense of the psychological impact of the scene portrayed, their gestures indicating whether the site elicited delight or fear.

With its natural wonders and cultivated landscape, America became a rich subject for the pen and pencil of European and American artists and travelers. Although far less accessible than the British countryside or European locales, and seemingly far more dangerous, still America attracted the adventuresome professional traveler whose illustrated books provided vicarious thrills (and at times misinformation) to those at home. Like Pownall's views, these works were aimed at a British market and reflected current aesthetic concepts.

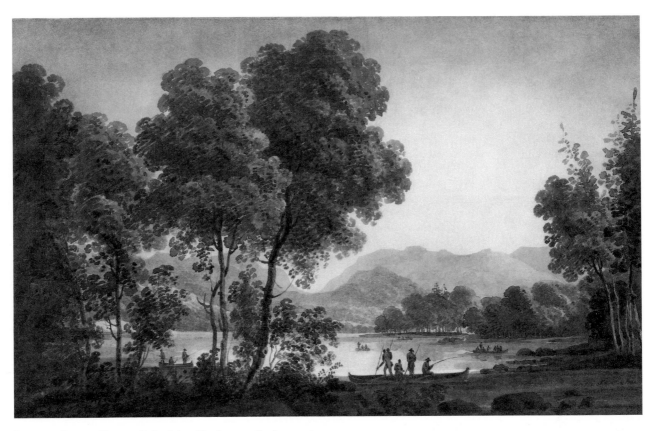

PLATE 8. GEORGE HERIOT, *Lake Saint Charles near Quebec*, c. 1800.

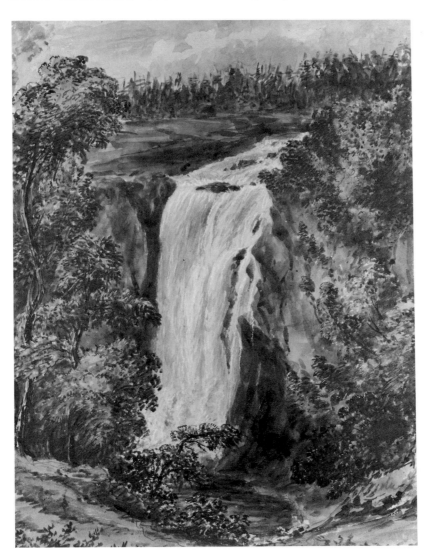

PLATE 9. JAMES COCKBURN, *Montmorency Falls*, 1827.

9

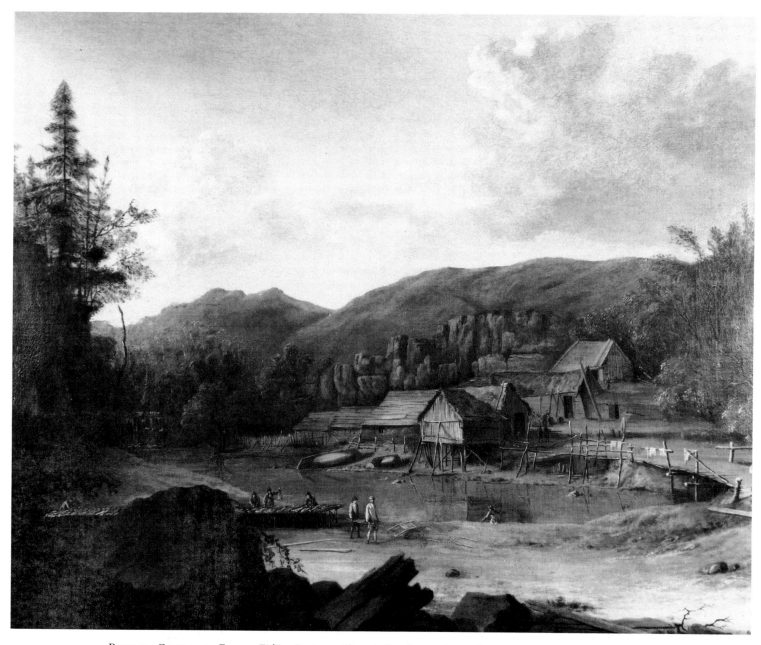

PLATE 10. GERARD VAN EDEMA, *Fishing Station on Placentia Bay,* late seventeenth century.

From the beginning, America's promise was exploited in art and literature. Colonists may have come to the New World for a variety of reasons, but the colonies themselves were vast tracts of uncultivated land requiring settlers to establish their economic viability, as is evident from Gerard van Edema's *Fishing Station on Placentia Bay* (Plate 10). Although recalling in its handling of form and space the work of his Dutch seventeenth-century contemporaries, van Edema's painting captures the isolation of this fishing village in what was then remote Newfoundland.

Starting in the mid-1600s, when engraved views were ubiquitous in Europe, panoramic scenes (Fig.1) provided evidence of a colony's prosperity and development. The American panoramas, some of which appeared as book illustrations, undoubtedly were conceived in part as inducements to would-be colonists as well as documents of a community's state of development. *View of Savannah* of 1734 (Plate 11) is an early example of such a prospect. The image may accurately describe the way in which Savannah was carved out of the wilderness, but it also conveys a sense of man-made order amidst nature's confusion. It portrays a world being transformed, controlled, and tamed by European civilization. It also shows a world being destroyed and implies

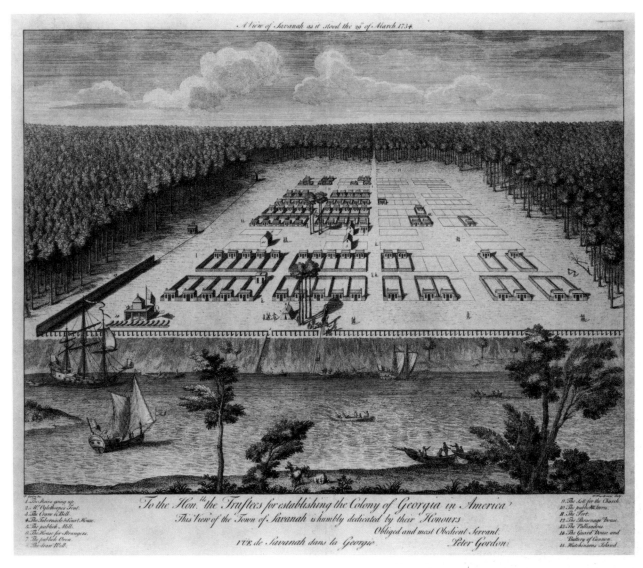

PLATE 11. PIERRE FOURDRINIER after PETER GORDON, *A View of Savannah as It Stood the 29th of March, 1734*.

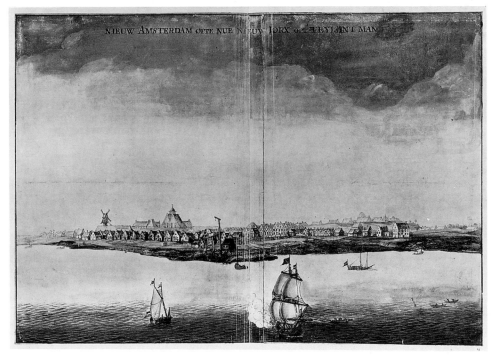

FIG. 1. Probably VINCKEBOONS, *New Amsterdam now New York on the Island of Manhattan View Taken from the East River, 1650–1653*. Watercolor. Algemeen Rijksarchief, The Hague.

an underlying disregard for unimproved nature. Nevertheless, the lush landscape extending beyond the borders of the village hints at the area's unlimited agricultural potential just as the location of the settlement on the water suggests ease of transportation and access to the homeland.

Painted and printed views of cities (see Plate 104) from the mid-eighteenth century emphasize how urban, commercial, and civilized New York, Boston, Philadelphia, and Charleston were. How much like home! Such views would have struck a responsive chord in those familiar with comparable panoramas of cities in Britain.[6] While the introduction of an emblematic Indian occasionally adds an exotic element (see Plate 105), such compositions generally present familiar activities and imply comfortable social relations. Business ventures in themselves, these printed views promoted the stability of the colonies to potential colonists and investors.

The Landscape Tradition

In the first two centuries after settlements were founded in the New World, travelers, naturalists, and officials — French, Dutch, and English — produced views of this land of promise. These were frequently published as prints or as illustrations in books. Panoramas of bustling seaports promoted the image of prosperous colonies. Portrayals of America's towns paralleled depictions of European cities.

After Canada became part of the British empire in 1763, aesthetic influences and artistic models were almost exclusively British. English landscape art throughout the seventeenth century had been predominantly topographical. Only in the next century did easel landscape painting, modelled on Italian and Dutch prototypes, establish itself in Britain as a discrete art form. By mid-century the aesthetic concepts of the beautiful and the sublime as defined by Edmund Burke in his influential *Philosophical Enquiry into the Origins of Our Ideas of the Sublime and Beautiful* (1757) were affecting how the educated person saw the natural world and evaluated representations of it. Simply put, rugged wild scenery tended to be classified as sublime; rolling cultivated land, as beautiful.

Richard Wilson and Thomas Gainsborough were among the late-eighteenth-century painters who made landscape an accepted mode of high artistic expression in England. By the turn of the century the subject matter was a fixture in British art. "We live in an age when landscape painting has obtained the highest degree of excellence," one artist remarked in 1812.[7] The early nineteenth century saw cities such as Bristol and Norwich develop distinct landscape schools. The emergence of landscape painting in America at about the same time is part of this development. Boston, New York, and Philadelphia — although major cities in an independent country on the other side of the Atlantic — were, culturally speaking, provincial centers like Bristol and Norwich and thus responsive to artistic stimuli from London.

The eighteenth century was a time when British writers and artists discovered the pleasures of nature in its wild, uncultivated state. Mountains, long considered aesthetically unappealing and viewed primarily as obstacles to travel, became major attractions for tourist and artist.[8] Gardens took on an informal appearance. By mid-century people were traveling just to see natural wonders, and they looked at them as pictorial compositions through special optical devices. In this climate America's vast natural resources took on new meaning. William Byrd was among the first to delight in the American wilderness and to admire mountains.[9] In 1743 John Bartram, the Philadelphia naturalist, wrote of fine mountain prospects and noble woods while still dreading "the dismal wilderness," by which he meant uninhabited country.[10] Governor Pownall's portrayal of some of America's grand sites (see Plate 85), published in

PLATE 13. UNKNOWN ARTIST, *Overmantel from the Perez Walker House,* last quarter of the eighteenth century.

London in 1761, were in essence colonial equivalents to views of the Lake District and other English areas, whose picturesque and romantic scenery was just beginning to be appreciated.

Decorative Views and Visions

In the first half of the eighteenth century, landscape views, topographical and imaginative, began to appear as decorations in American houses over fireplace mantels and on paneling. An early example from the Clark-Frankland House in Boston (Plate 12) is attributed to John Gibbs. The landscape is clearly imaginary, perhaps based on a print source.[11] Comparable paintings were produced in England and are middle-class imitations of elaborate murals in royal and aristocratic houses.[12] Although many of

PLATE 12. JOHN GIBBS, *Panel from the Clark-Frankland House*, c. 1712.

the artists remain anonymous (Plate 13), works by Benjamin West (Plate 14), Winthrop Chandler (Plate 15), Ralph Earl, and Jonathan Fisher (see Plates 154, 155), created between the mid-eighteenth and early nineteenth centuries in Pennsylvania, Connecticut, Massachusetts, and Maine, attest to the continuing and widespread popularity of this kind of decoration. There were also easel paintings, but with the exception of Smibert's *View of Boston* (see Plate 105) few have survived. [13]

Landscapes also appear as backgrounds in portraits, where changes in treatment suggest shifts in attitude toward nature. Portraits from the early 1700s by Justus Engelhardt Kühn (Fig. 2) silhouette the sitter against the type of formal garden popular in Europe at the time. Whether real or contrived, such settings reflect not only social pretensions but imply, like the contemporary *View of Savannah*, man's mastery of nature. By contrast, in Charles Willson Peale's portrait of John Dickinson of 1770 (Fig. 3), the falls of the Schuylkill add a picturesque note as well as an identifying association with the sitter. The background was introduced at the request of Edmund Jenings, a Marylander living in London, who was obviously familiar with current aesthetic theories and pictorial conceits. [14]

PLATE 14. BENJAMIN WEST, *Landscape with Cow,* c. 1752–1753.

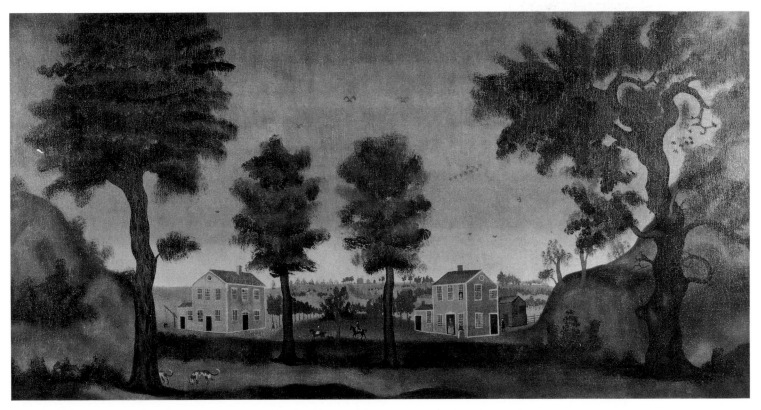

PLATE 15. WINTHROP CHANDLER, *Homestead of Timothy Ruggles,* late eighteenth century.

15

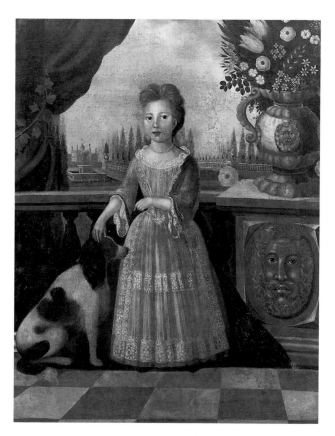

FIG. 2. JUSTUS ENGELHARDT KÜHN, *Eleanor Darnall (Mrs. Daniel Carroll I of Upper Marlboro)*, c. 1710. Oil on canvas. The Maryland Historical Society.

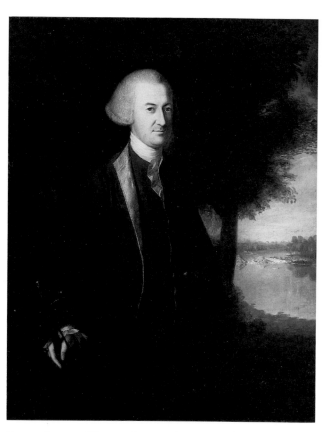

FIG. 3. CHARLES WILLSON PEALE, *John Dickinson*, 1770. Oil on canvas. The Historical Society of Pennsylvania.

FIG. 4. CHARLES WILLSON PEALE, *Mrs. David Forman and Child*, 1784. Oil on canvas. The Brooklyn Museum; Carll H. de Silver and Museum Collection Fund.

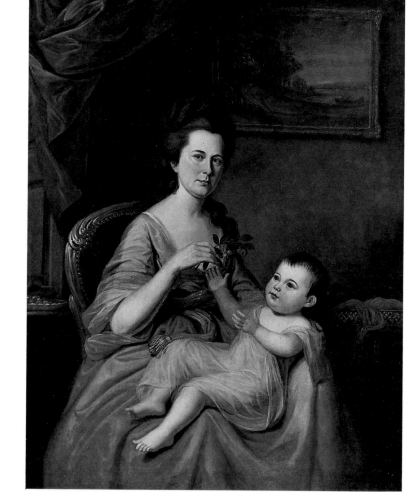

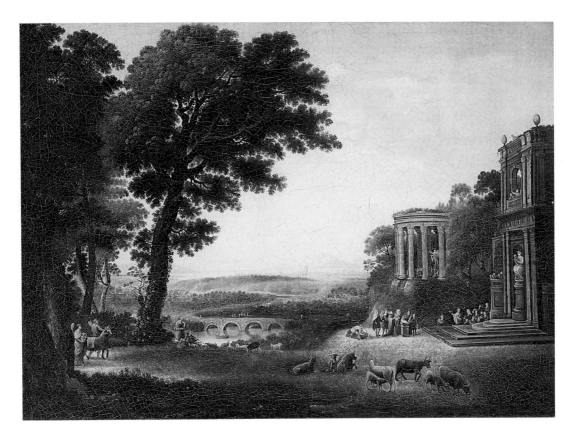

FIG. 5. JOHN BEALE BORDLEY, *The Temple of Apollo*, 1776. Oil on canvas. Philadelphia Museum of Art; gift of Mr. and Mrs. William F. Machold.

A few of Peale's portraits also show in the background landscape paintings hanging on the walls of American houses (Fig. 4), presumably paintings owned by the sitters. Such a poetic scene alludes to the taste and gentility of the person portrayed, but also demonstrates awareness of high-style landscape art, as does John Beale Bordley's *Temple of Apollo*, a 1776 copy after Claude (Fig. 5). The Peale and Bordley paintings document the influence of the European landscape vision on American sensibilities. The extent to which European paintings, or prints made after them, were available in America before the end of the century is difficult to determine, but it can be reasonably assumed that Peale's sitters and patrons were not unique in their admiration for landscapes and Old Masters.[15]

Picturesque America

Landscape emerged as an important artistic and intellectual concern in the young United States shortly after the colonies won their independence of England. It was then that the quality of American life and scenery assumed nationalistic overtones. The improved landscape not only provided evidence of the country's progress but displayed its integrity and wholesomeness. As Crèvecoeur wrote in his *Letters of an American Farmer* (1782): "Here we have in some measure regained the ancient dignity of our species; our laws are simple and just, we are a race of cultivators, our cultivation is unrestrained, and therefore everything is prosperous and flourishing."[16]

Invariably travel accounts of America and Canada — usually written by visitors for the British market — compared the New World with the Old. Colored by national prejudice, comments were frequently critical of the people. The landscape was another matter. Found wanting in certain respects, such as the absence of ruins, by Americans as well as Europeans, it was generally admired and viewed as a reflection of the nation's egalitarian society and republican government.

PLATE 16. ARCHIBALD ROBERTSON, *On the Art of Sketching,* c. 1800.

The travel accounts also reveal the English enthusiasm for the picturesque, promoted from 1782 on by the Reverend William Gilpin in numerous volumes describing his journeys around Britain. Judging a real landscape according to standards derived from compositions by Claude Lorrain, Gaspard Dughet, Salvator Rosa, Claude-Joseph Vernet, and other seventeenth- and eighteenth-century artists was integral to the aesthetic as defined by Gilpin. Although the concept would take on additional significance, the picturesque at first simply meant something suitable for representation in a picture.[17] He made a distinction between the appreciation of real scenery and its pictorial potential. A landscape in nature could be beautiful or sublime, but rarely would it be suitable for depiction as found. Nature needed to be manipulated by the artist, to be organized into a satisfactory composition.

For Gilpin, the perfect landscape in nature combined the rough with the smooth, the untamed with the cultivated. Not surprisingly, his model of perfection was British scenery. He praised its variety, its "intermixture of wood and cultivation, which is found oftener in English landscape, than in the landscape of other Countries."[18] Published during a period of international turmoil, his opinions are arguably chauvinistic. Unlike revolutionary France, Gilpin's England was a world in balance, visually and politically. Productive and sunlit fields epitomized the moral values and simple pleasures of rural life; they projected a sense of social stability. Woods provided a protective boundary for this pastoral ideal, while shrouded mountains became transcendent guardians. Together they provided visual, psychological, and spiritual contrast to civilized nature. Americans embraced this conceit and read feelings of national potential into their agrarian society and evolving landscape with its mixture of the wild and the cultivated.[19]

The wilderness, according to Gilpin, was not suitable for pictorial representation. "The idea of a wild country, in a natural state, however picturesque, is to the generality of people but an unpleasing one," he remarked, perhaps thinking of America. He added, "There are few, who do not prefer the busy scenes of cultivation to the grandest of nature's rough productions."[20] For him, "vast, wild, and unfinished" country was a "shapeless waste"; and rugged hills, "wild and barren."[21] Except for views of natural wonders, American artists seem to have shared Gilpin's point of view more than their

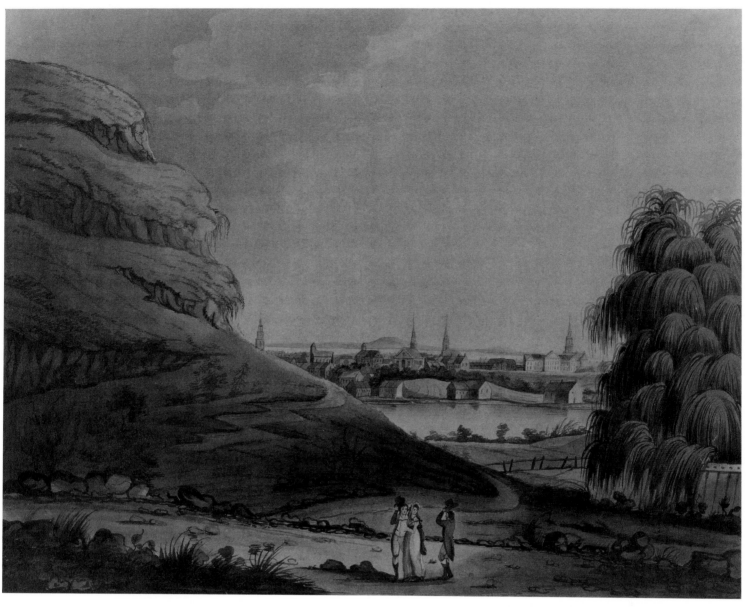

PLATE 17. ARCHIBALD ROBERTSON, *Collect Pond*, 1798.

British counterparts, who were exploring the wilder manifestations of nature at home and abroad.

The Gothic ruin held a central place in Gilpin's pantheon of picturesque motifs. Imbued with poetic and transcendent significance, crumbling abbeys and castles surrounded by encroaching nature were greatly admired for their pictorial and associational qualities. The absence of such romantic remnants in the United States, save for the occasional damaged industrial site or military blockhouse, gave educated Americans a case of aesthetic inferiority.[22] Blasted or decaying trees in primeval forests became America's antiquities. Here Gilpin provided the justification: the ruin of a noble tree was a sublime symbol of "wildness and desolation."[23] Pictorial precedent lay in seventeenth-century Dutch and Italian painting.

Gilpin's ideas were widely disseminated in America during the last decade of the century. Excerpted in magazines, sold in shops, and available through libraries, his books were also promoted by British landscape artists and drawing masters who emigrated to America in the 1790s. Among these were Alexander and Archibald Robertson, who came to New York from Scotland. Gilpin's precepts inform their compositions (Plates 16, 17) and teachings at the Columbian Academy of Painting.

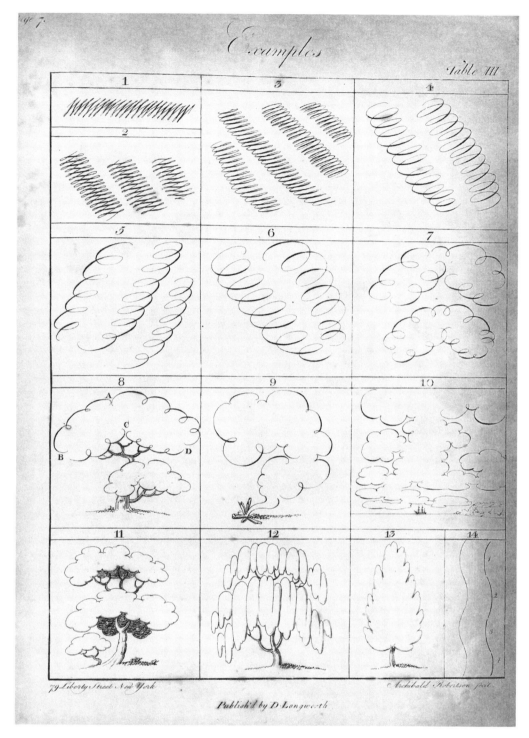

PLATE 18. ARCHIBALD ROBERTSON, *Elements of the Graphic Arts*, 1802.

Their approach is outlined in *Elements of the Graphic Arts* (Plate 18). Published in New York in 1802, it argues, like Gilpin, that what is admirable in nature may not be suitable for a picture; it also recommends to the reader Gilpin's various books.[24]

The close observation of nature practiced by naturalists was contrary to the generalization of nature championed by Gilpin, which was based on the concept of nature as imperfect, a result of man's fall from grace. In reproducing nature's diversity, the artist focused on its imperfections. The painter's function, however, was to generalize nature, not imitate its deviations from the norm; to extract the essence of a landscape, not depict its details. By the late eighteenth century, artistic attitudes changed, as the multiplicity of nature, its plenitude and variety, came to be viewed as evidence of divine power.[25] The particular replaced the general as an aesthetic preference.

Both published in 1791, Gilpin's *Remarks on Forest Scenery* and the *Travels* of the naturalist William Bartram, the son of John Bartram, present entirely different views of nature, views based not only on their understanding of aesthetics but also on their experiences in Britain and America respectively. The former looks back to Italian and Dutch seventeenth-century painting and the Enlightenment; the latter looks forward to transcendental thought and Romanticism. Bartram accepts nature as he finds it; Gilpin tries to improve on it. The naturalist sees order in nature's details and diversity; the aesthetician sees confusion before artistic simplification and generalization.

Bartram, who describes a journey through the Carolinas, Georgia, Florida, and the Indian country, found himself "almost insensible" of the charming objects around him as he contemplated the magnificent varied and boundless landscape. He reveled in a "sublimely awful scene of power and magnificence, a world of mountains piled upon mountains" that Gilpin would have found pictorially unfit. Bartram saw the world in all its variety and majesty, "a glorious apartment of the boundless palace of the Sovereign Creator. . . ."[26] His *Travels,* written in the mid-1770s, did not see publication until 1791. They had an impact on English Romantic writers, especially Coleridge and Wordsworth, who in turn influenced American thought.[27]

Bartram's views may also have influenced Timothy Dwight, the future president of Yale, who beginning in the late 1790s made excursions through New York and New England. His enthusiastic response to mountains and wilderness, published many years later in 1821, shows a keen awareness of the Burkean sublime. Dwight felt the grandeur of nature offered inspiration to poet and painter; still he looked ahead to when the sublime wilderness would be replaced by farms "enlivened with all the beauties of civilization."[28]

Foreign travelers were also responsive to America's natural beauties, commenting on its "romantic situations."[29] The Englishman Isaac Weld in *Travels through the States of North America* (1799) judged the scenery along Lake George "extremely grand and picturesque." Undoubtedly taking a cue from Jefferson's *Notes on Virginia*, he praised Natural Bridge (see Plate 149) while taking issue with the statesman's high opinion of the confluence of the Potomac and Shenandoah rivers. Weld felt, and others concurred, that grand scenery was lost on most Americans, who preferred "the sight of a wheat field or a cabbage garden" over "the most romantic woodland views." Like his fellow countryman Gilpin, he took pleasure in the intermixture of extensive fields and forested hills that created a "variety of pleasing landscapes."[30]

Another English visitor, William Strickland, applauded the "neat mansions of comfort and independence" he found in the Connecticut valley as evidence of America's egalitarian society.[31] Sensitive to the sublimity of its waterfalls and mountains, he, too, praised the diversity of a landscape modified through cultivation at the same time that he condemned the "barbarous backwoodsman" for the wanton destruction of trees and his "utter abhorrence for the works of creation" (see Plate 153). This disregard for nature made Strickland conclude, like Weld, that sublime scenes were unnoticed and unappreciated by the frontiersman.[32] Only later did the woodsman emerge as a symbol of the advance of civilization.[33]

Landscape as Subject

Post-Revolutionary rural America was the embodiment of the pastoral ideal that figured so prominently in English art and literature of the eighteenth century.[34] To observers like Strickland, rural America retained traces of the savage wilderness and showed the effects of cultivation. Paintings and images created in the closing years of the century presented America as a place where the intermixture of the wild and culti-

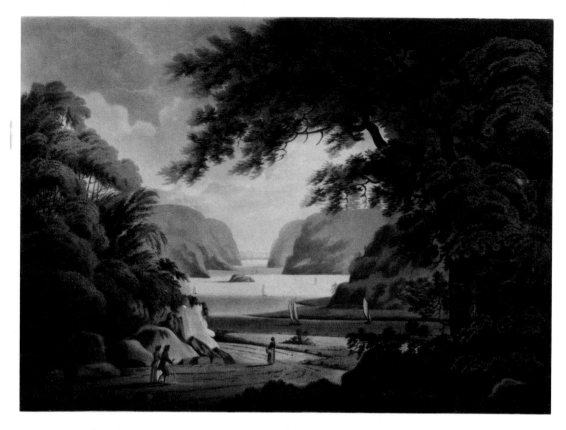

PLATE 19. FRANCIS JUKES after ALEXANDER ROBERTSON, *Hudsons River from Chambers Creek,* 1802.

vated had come about naturally and was not, as in the case of English estates, the artful product of man. This is particularly evident in the work of the British artists who came to America in the closing years of the eighteenth century: Barralet, Beck, the Birches, Groombridge, Guy, Parkyns, the Robertsons, Winstanley. With the exception of attractions such as Niagara and Natural Bridge or sites associated with historical events and personages such as West Point or Mount Vernon, the landscapes painted by these artists were generally the inhabited scenes familiar to them at home. However, these scenes also displayed the progress of America.

Almost all of the artists who came planned series of landscapes. Serial views had long been a part of the European artistic tradition and a number had been produced recently in England, including the Pownall/Sandby compositions of American scenery. William Birch and George I. Parkyns had engaged in similar ventures before coming to America. Parkyns in 1795 advertised twenty-four views, of which only a few were published presumably because of lack of interest (see Plate 124). Alexander Robertson at the turn of the century executed a group issued in London by Francis Jukes, Gilpin's publisher (Plate 19). George Beck depicted several sublime waterfalls such as Niagara and the Great Falls of the Potomac as well as city prospects (Plate 20). William Winstanley proposed a series in 1801, which never was executed.[35]

Two of the more ambitious undertakings were William Birch's *The City of Philadelphia in the State of Pennsylvania as It Appeared in 1800,* engraved from designs made by his son Thomas, and *The Country Seats of the United States of North America* (1808). The volume on Philadelphia promoted America's cultural and former political capital through its handsome architecture. As Birch noted in his introduction, the city stood on ground that less than a century before had been in "a state of wild nature." With the volume's publication, Birch intended to convey to Europe "an idea of the early improvements of the country . . . to promote and encourage settlers to the establishment of trade and commerce. . . ."[36] Comparable views of British cities, including London and Dublin, had only recently been issued.[37] *Country Seats* emphasized the quality of

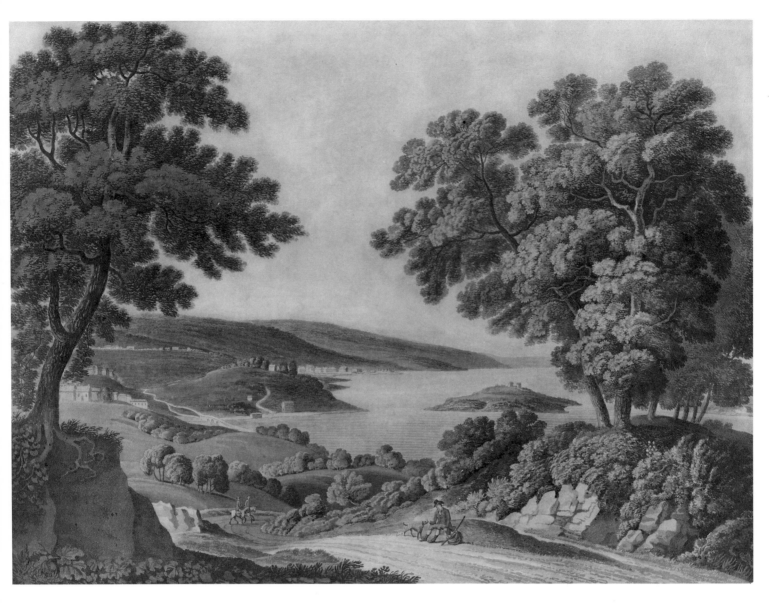

PLATE 20. T. CARTWRIGHT after GEORGE BECK, *Georgetown and Federal City, or City of Washington*, 1801.

life in America (Plate 21). Birch's prospects glorified "the riches of the richest state" (Pennsylvania) as they presented its "chequered country with her merchants seats" and the "bustle of agriculture."[38] By taking as his model British publications dealing with the country estates of landed gentry and nobility,[39] Birch invited comparison between Britain and America (Fig. 6).

Although the land adjoining an American country seat was modest in comparison with the park surrounding a great English house, the American idea was essentially borrowed. Like its English prototypes, *Country Seats* contains an occasional view of neighboring wild scenery (Plate 22). As Birch observed in his opening remarks: "Such scenes which decorate the grounds, and form the choicest Pictures of themselves, and which cannot be brought into the same Place with the Villa, will be given separately, as highly necessary to form a full and correct idea of the American Country Residence."

In England, the untamed look in landscape gardening was then being championed by Uvedale Price, Humphrey Repton, and Richard Payne Knight. Price attempted to establish the picturesque as a distinct aesthetic category comparable to the beautiful and sublime. Qualities in nature such as roughness and wildness were integral to his definition. Works by Price and Knight were available in America shortly after they were published.[40] Their ideas may well be reflected in Birch's introduction

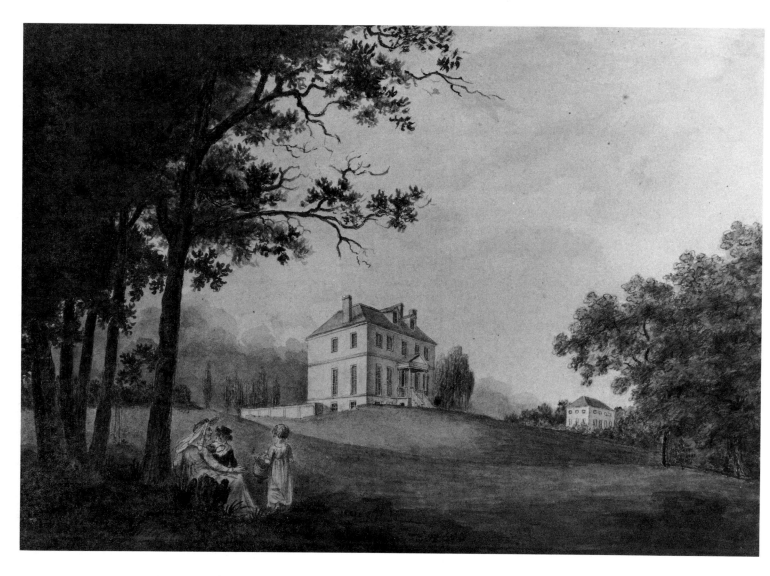

PLATE 21. WILLIAM RUSSELL BIRCH, *Sweetbriar,* c. 1808.

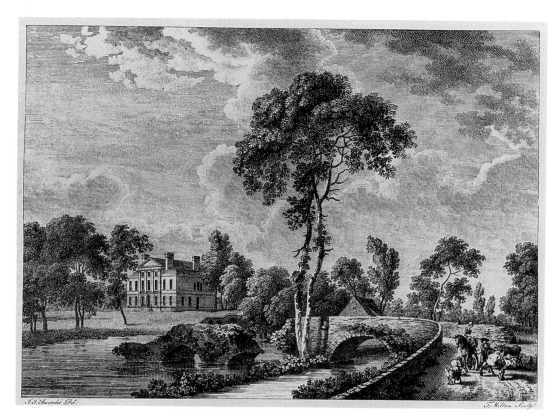

FIG. 6. THOMAS MILTON after JOHN
JAMES BARRALET, *Lucan House in
the County of Dublin*. Engraving
from *Seats and Demesnes of the
Nobility and Gentry of Ireland*, 1773.

PLATE 22. WILLIAM RUSSELL BIRCH, *Sun Reflecting on the Dew, a Garden Scene, Echo*, c. 1808.

to *Country Seats*, where he observed that nature had blessed America so that such features did not have to be created, as in "countries less favoured."

William Birch's nationalistic sentiments were echoed in *The Port Folio* at the end of the War of 1812. An anonymous writer, defending American responsiveness to nature, stated:

> *It may, however, be remarked that this beauty of natural scenery can be fully relished only in a populous and long settled country whose face is marked with accumulated operations of art; but in embellishing on country seats in the United States, where the features of nature have as yet undergone but little change, an appearance of human labour and skills, and even of formality, produces the agreeable effect of variety, and awakens the pleasing ideas of progressive civilization and improvement.*[41]

Thomas Birch, William Groombridge, Francis Guy, and Archibald Robertson convey comparable messages about the progress of America and its refined taste in their portrayals of estates in Pennsylvania, Maryland, and New Jersey (Plates 23-26). Frequently placed on elevated sites, the villas overlooked the lands of their owners. With their rolling lawns and natural settings, these estates of free men in a free society spoke to the success of the American experiment: commodious and tasteful, they were, by English standards, modest in scale as befitted the citizenry of a temperate republic.

Other images of prosperous America projected a vision of a harmonious society with infinite opportunities and little poverty, the biblical land of promise, flowing with milk and honey.[42] In a very tangible way, they visualize the fulfillment of a dream:

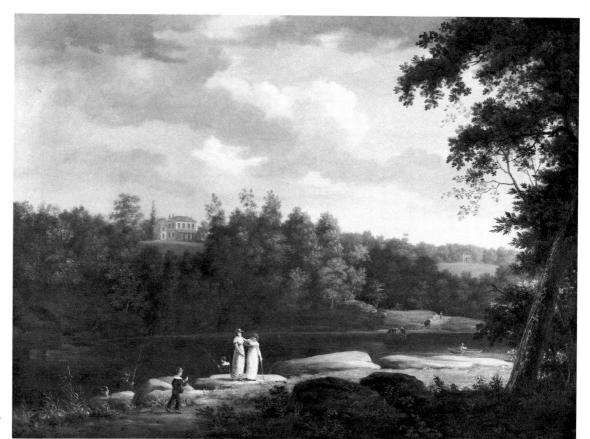

PLATE 23. THOMAS BIRCH,
Eaglesfield, 1808.

PLATE 24. WILLIAM GROOMBRIDGE,
Fairmount on the Schuylkill River,
1800.

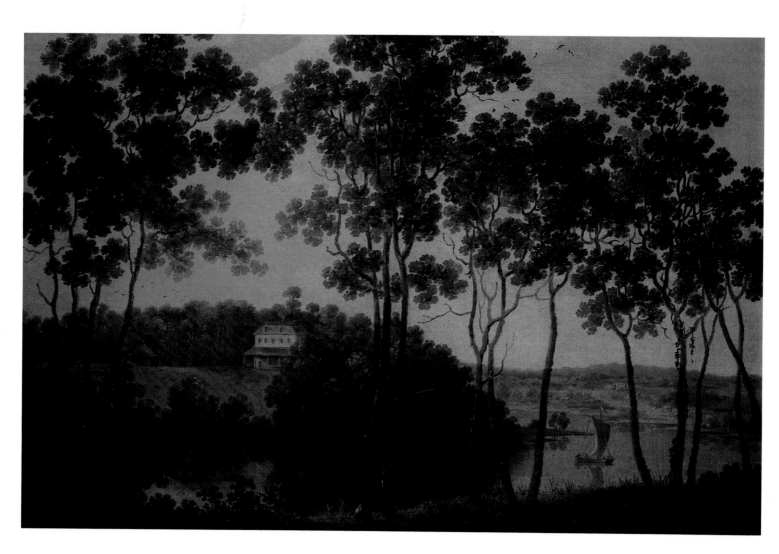

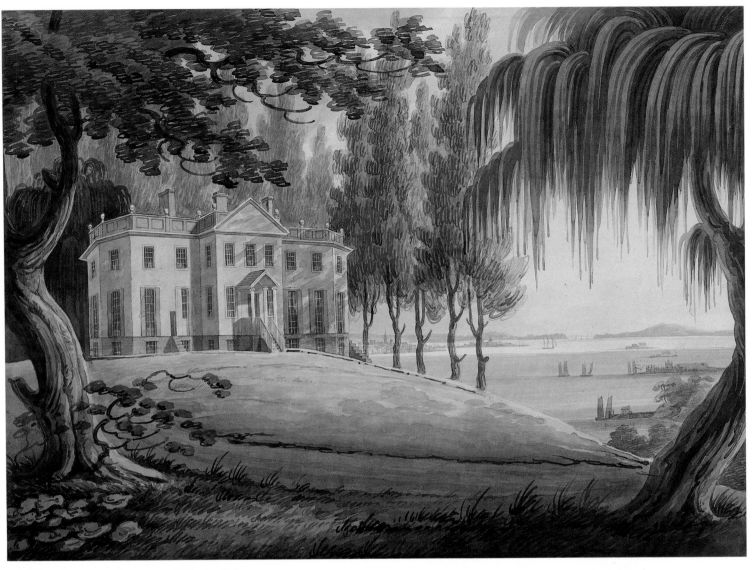

PLATE 26. ARCHIBALD ROBERTSON, *Hobuck*, 1808.

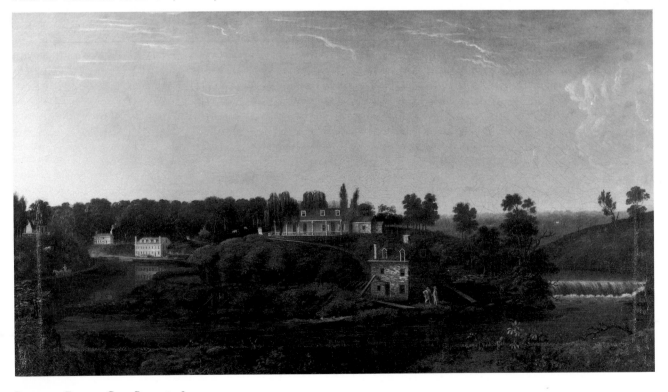

PLATE 25. FRANCIS GUY, *Prospect*, 1805.

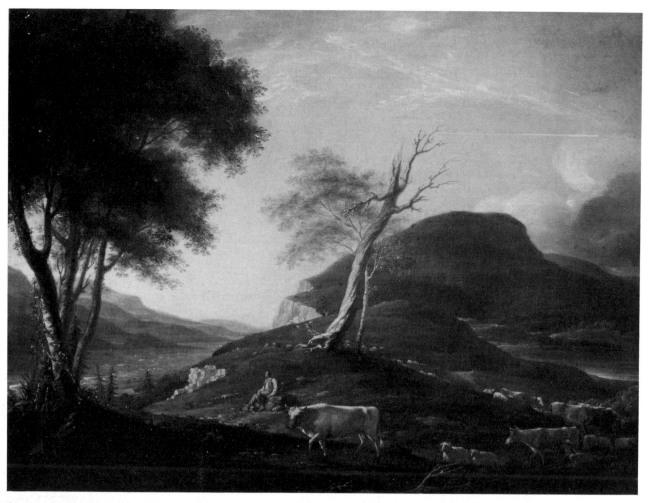

PLATE 27. JOHN TRUMBULL, *View on the West Mountain near Hartford*, c. 1791.

Trumbull's *View on the West Mountain near Hartford* (Plate 27), Cornè's *Derby Farm* (Plate 28), Woodside's *A Pennsylvania Country Fair* (Plate 29), Peale's *Meadow and Road* (Plate 30) present Virgilian landscapes analogous to Pownall's imaginary conception of the progress of an American settlement or farm (see Plate 87). Similar sentiments inform the bountiful panoramas of Ralph Earl and Jonathan Fisher.

Views eulogizing America's natural attractions exhibit another form of national pride: the country had beautiful and sublime scenery comparabe to any in England. Winstanley's *Morning* and *Evening*, created for George Washington (Figs. 7, 8), are derived thematically and compositionally from Claude by way of Claude-Joseph Vernet and Richard Wilson. Paired scenes dealing with times of day were not uncommon in British and continental art of the period. The canvases supposedly depict the Hudson, but they are not topographical; rather they project an Edenic vision of America. Their soft tones, muted light, and gently receding planes epitomize the beautiful.

The more sublime aspects of American scenery were represented in Washington's collection by a view of the *Falls of the Genesee* by Winstanley (Plate 31) and two views of the Potomac by George Beck: one of Great Falls, the other of the passage of the Potomac through the Blue Ridge Mountains.[43] Plate 32 is another version of Beck's view of the falls. The sublime was also the aesthetic response sought by Roberts in his rendering of the awe-inspiring Natural Bridge of Virginia (Plate 33) towering over the insignificant visitors, and in his depiction of the dramatic confluence of the Potomac and Shenandoah at Harpers Ferry (see Plate 147). Jefferson owned paintings by Roberts of these two sites, which he had enthusiastically described in *Notes on Virginia*, first published in 1784.[44] These compositions attest to Washington's and Jefferson's familiarity with Burke's concept of the sublime and beautiful.[45]

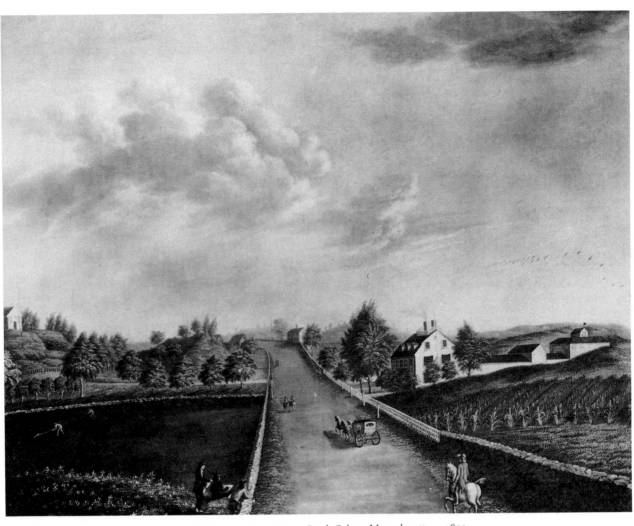

PLATE 28. MICHELE FELICE CORNÈ, *Ezekiel Hersey Derby Farm, South Salem, Massachusetts*, c. 1800.

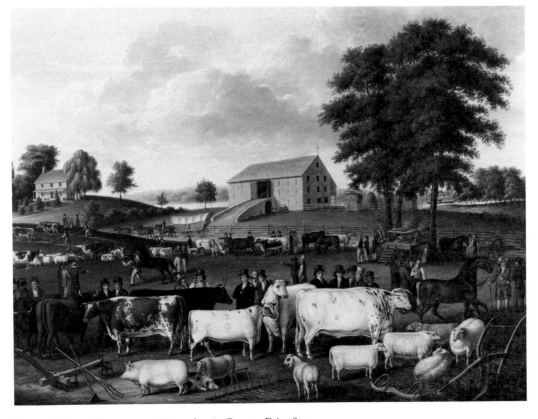

PLATE 29. JOHN WOODSIDE, *A Pennsylvania Country Fair*, 1824.

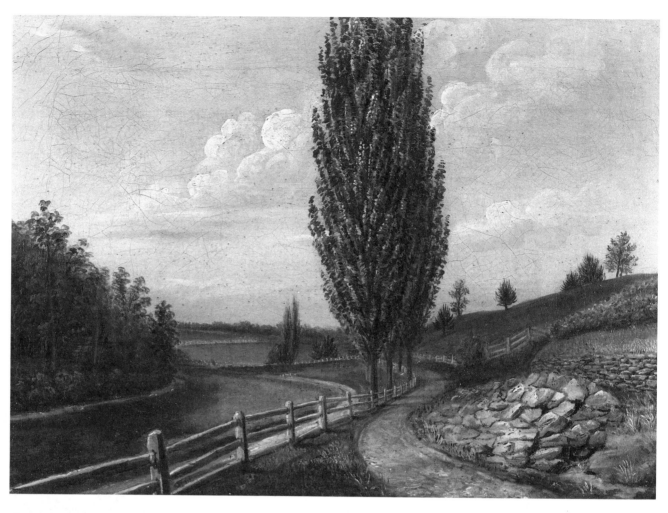

PLATE 30. CHARLES WILLSON PEALE, *Meadow and Road in Germantown (Country Lane)*, 1815–1820.

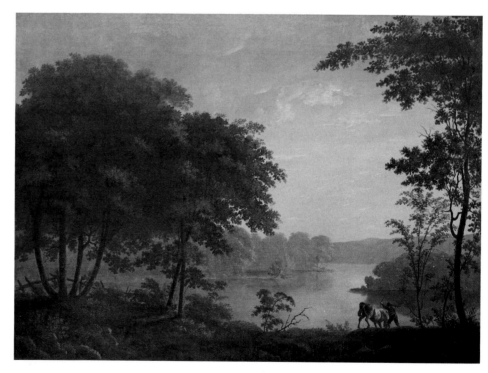

FIG. 7. WILLIAM WINSTANLEY, *Morning*, 1793. Oil on canvas. Mount Vernon Ladies Association.

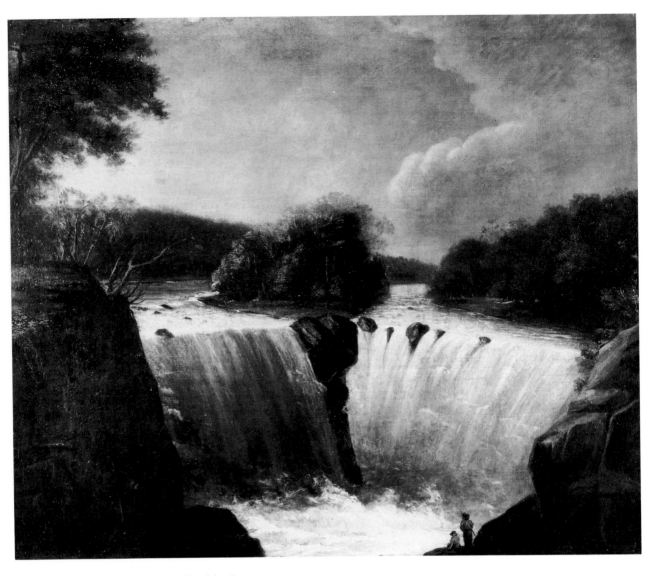

PLATE 31. WILLIAM WINSTANLEY, *Falls of the Genesee*, 1793–1794.

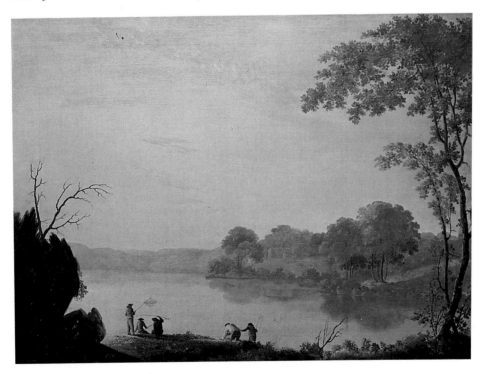

FIG. 8. WILLIAM WINSTANLEY, *Evening*, 1793. Oil on canvas. Mount Vernon Ladies Association.

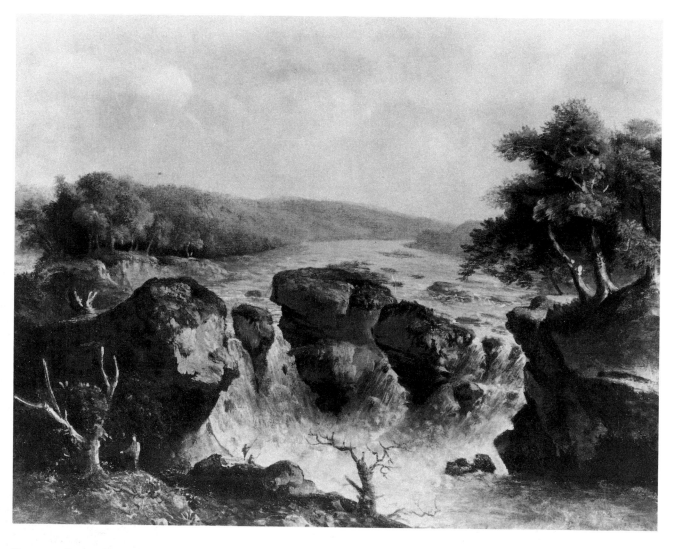

PLATE 32. GEORGE BECK, *The Falls of the Potomac*, 1797–1801.

Few artists depicted the wilder aspects of American scenery. Groombridge in *Autumn Landscape* (Plate 34) captured the country's renowned fall foliage, considered far superior to that of Europe, in a wilderness setting; Trumbull in *Norwich Falls* (Plate 35) conveyed a sense of romantic solitude.[46] Many attempted to express the sublime grandeur of Niagara in compositions that ranged from miniatures, watercolors, and prints (Plates 36-38) to ambitious, almost theatrical presentations (Plate 39).[47] Generally, sites treated by artists were well known and close to civilization. Wilderness areas, which would appeal to the next generation, attracted little attention, despite contemporary portrayals of wild scenery in British and continental art.

There is a fundamental difference between wilderness and wild scenery. Britain had its wild scenery, but little wilderness, except in the stark Scottish highlands and rugged Welsh mountains. Even then, it was possible in Britain to make excursions to these wonders by horse or carriage under relatively comfortable conditions, for by the end of the eighteenth century roads and inns had improved significantly. Furthermore, a village or a farm was seldom more than a half-day's walk or ride. While the traveler might experience hostility from local inhabitants, he need not fear for his life. In America at that time a vast unsettled wilderness with real and imagined dangers covered thousands of square miles. It was a concept that artists transplanted from England, or bred in the cultivated East and schooled in the European tradition, were incapable of comprehending in aesthetic terms.

Limitless and therefore unpaintable, the American wilderness held little attraction; it was not picturesque in Gilpin's meaning of the word. What was sought and

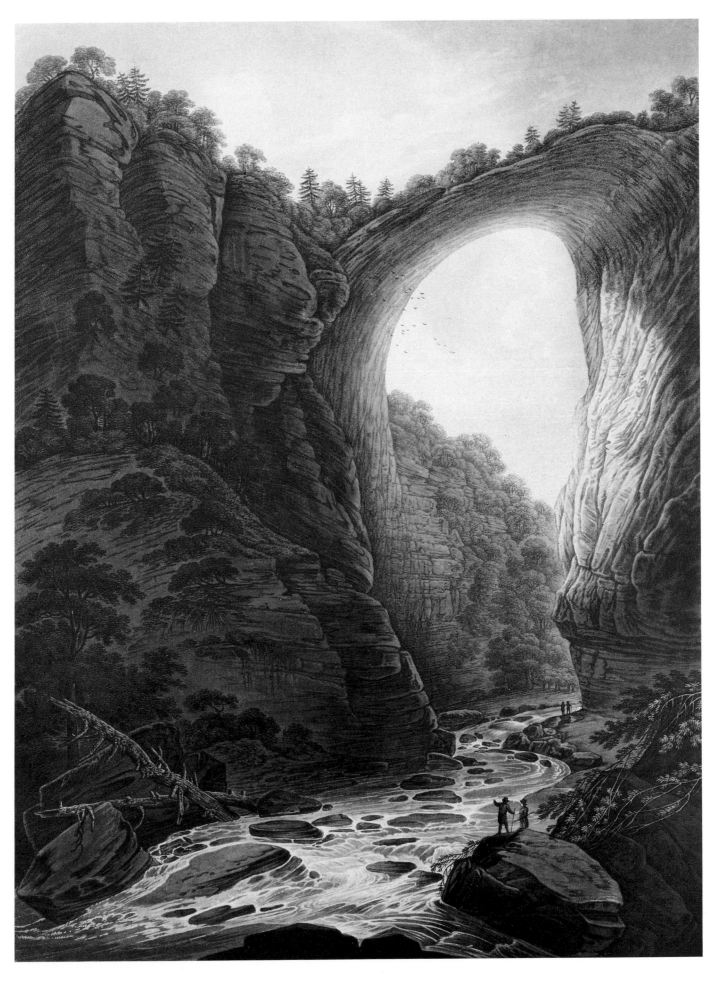

PLATE 33. WILLIAM ROBERTS, *Natural Bridge*, 1808.

PLATE 35. JOHN TRUMBULL, *Norwich Falls*, 1806.

PLATE 34. WILLIAM GROOMBRIDGE, *Autumn Landscape*, 1802.

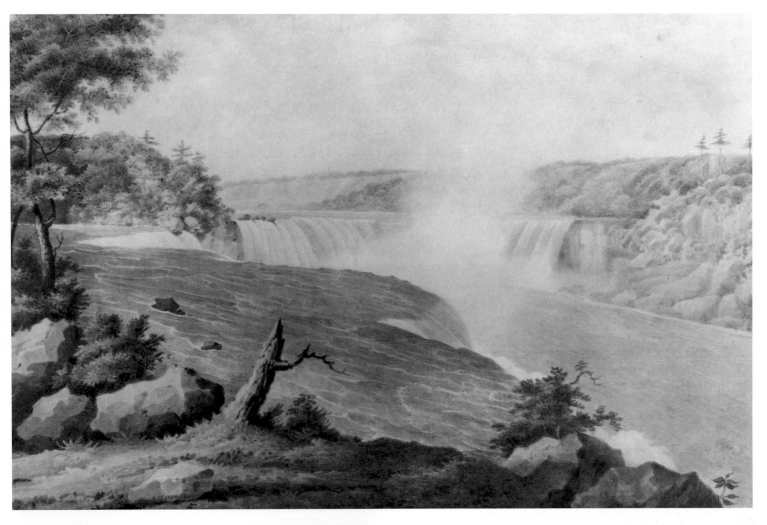

PLATE 36. CHARLES FRASER, *View of Niagara with Spray Rising*, 1820.

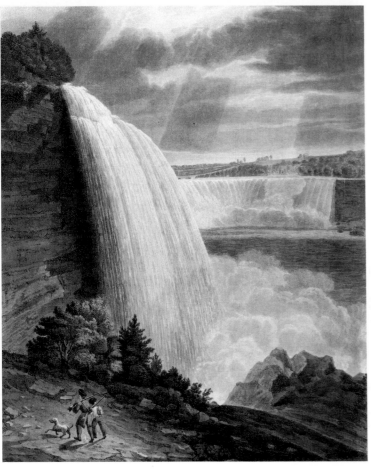

PLATE 37. JOHN HILL after WILLIAM JAMES BENNETT, *Niagara Falls, Part of the American Fall from the Foot of the Stair Case*, 1829.

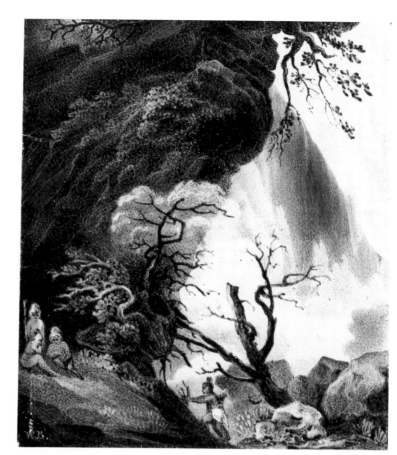

PLATE 38. WILLIAM RUSSELL BIRCH, *Falls of Niagara,* c. 1808.

PLATE 39. GEORGE B. WILLIS, *Niagara,* 1816.

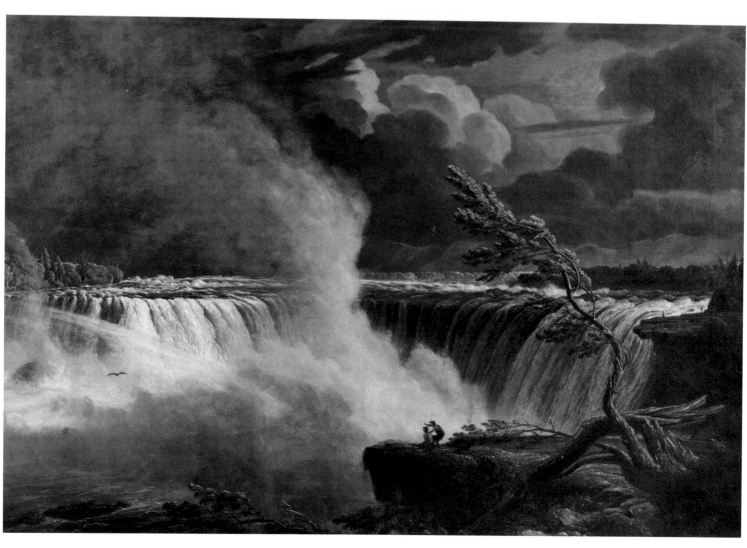

admired in America as well as in England was the varied prospect, the mixture of wild and improved nature which gave the promise of progress and bore the trace of civilization. Such landscapes were close at hand. The English tourist Strickland, traveling in 1794, rhapsodized about an area not far from Dobbs Ferry in New York:

> . . . our ride was extended by some miles through a country abounding with the most picturesk scenery, representing a succession of lawns and parks, which art attempts to imitate in old countries, but which nature here has executed, and which the destructive waste of the occupier and his axe, improves, rather than injures by breaking the woods and diversifying the surface of the country. . . .

The more sublime scenes "unknown to the civilized man, unnoticed by the settlers of the present times, undoubtedly wait to gratify the eye of the inquisitive traveller, or ornament in future times the residence of the more cultivated owner, into whose possession they may chance to fall. All in its present state," he added somberly, "is solitude and waste."[48]

Although Gilpin recognized that a landscape could be beautiful or sublime, inhabited or desolate, cultivated or rugged, his less than enthusiastic response to the wilder aspects of scenery may well have influenced the selection of landscape subjects in America. Faced with a real landscape beyond the scope of their experience, the artists who came to America in the early 1790s naturally gravitated toward subjects which struck familiar aesthetic and visual chords. Visitors commented on the similarities between American and provincial English cities, and these similarities extended to the rolling cultivated countryside within an easy ride of the metropolis. And it was in the rural areas that art patrons built country seats and had other property. Small wonder that artists did not venture beyond civilization in search of subjects at a time when the wilderness was seen as an obstacle to be overcome if there was to be progress.

Changing Scene

By the time of the Louisiana Purchase of 1803, which more than doubled the size of America, a growing population was moving south and west, turning, as a contemporary put it, "a wilderness to a cultivated garden."[49] Westward expansion is an artistic theme of the third quarter of the century, but Thomas Birch's *Conestoga Wagon on the Pennsylvania Turnpike* of 1816 (Plate 40) expresses the mobility of American society in the early nineteenth century even if it does not convey a sense of a population on the move. The rapidity with which America was physically changing elicited concern. One observer remarked in 1805: "The woods are full of new settlers. Axes were resounding and the trees literally were falling about us as we passed."[50] Another, who had gone to upstate New York in 1796 and again in 1810, wrote on the latter occasion: "The Genesee was at that time [1796] almost a wilderness, and I was not tempted to go further westward than the mouth of the river. It is now a very populous and well cultivated country. . . ."[51] Two decades later the transformation of upstate New York at the end of the century was the subject of James Fenimore Cooper's *The Pioneers* (1823) and John James Audubon was condemning the destruction of the forests in the Ohio valley.[52]

Published and private accounts chart the progress of civilization and reveal new attitudes toward the wilderness. In 1794 Strickland wrote home that he went "about 50 miles beyond Albany, just sufficiently near the verge of barbarism to give me an idea of the country in a state of nature which having once seen I feel not the least inclination to revisit. . . ."[53] Three years later, a writer who clearly had his information secondhand, observed in the *New York Magazine* that "the *Kaats Kill Mountains*, make a majestic appearance, and, it is said, furnish many things for the gratification of the curious."[54]

Shortly thereafter, Timothy Dwight rhapsodized about the same area with Burkean delight: "All was grandeur, gloom and solitude."[55]

In 1809–1810, Alexander Wilson published in *The Port Folio* his long poem *The Forester*, which recounted his pedestrian journey in 1803 with friends through the wilderness from Philadelphia to Niagara. In an opening reminiscent of James Thomson's enormously popular *The Seasons*, Wilson invited his readers to : "Come roam with me Columbia's forests through / where scenes sublime shall meet your wondering view. . . ."[56] In 1810, about the time that William Constable sketched Genesee Falls (Plate 41), another tourist on his way to Niagara made a detour to the site and wrote ecstatically that the river and the woods "form altogether a scene of grandeur and of beauty unrivalled."[57] In 1820 Washington Irving declared in *The Sketch Book*: "never need an American look beyond his own country for the sublime and beautiful of natural scenery."[58] In 1821 a tourist accommodation was built on Mount Holyoke, Massachusetts. Two years later, the first shelter was erected by the Catskills Mountain Association. In 1828 *The Atlantic Souvenir* exhorted Americans not to "leave their native land for enjoyment, when you can view the rugged wildness of her mountains, [and] admire the beauty of her cultured plains."[59]

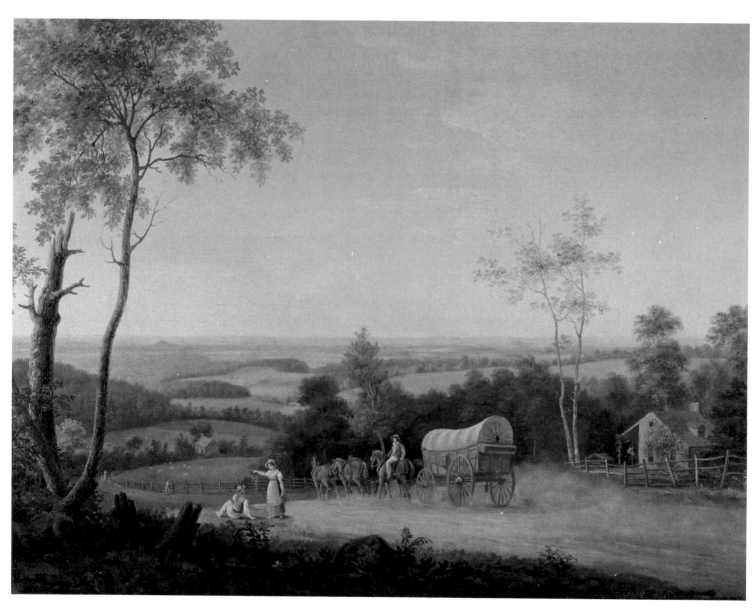

PLATE 40. THOMAS BIRCH, *Conestoga Wagon on the Pennsylvania Turnpike*, 1816.

FROM VIEW TO VISION

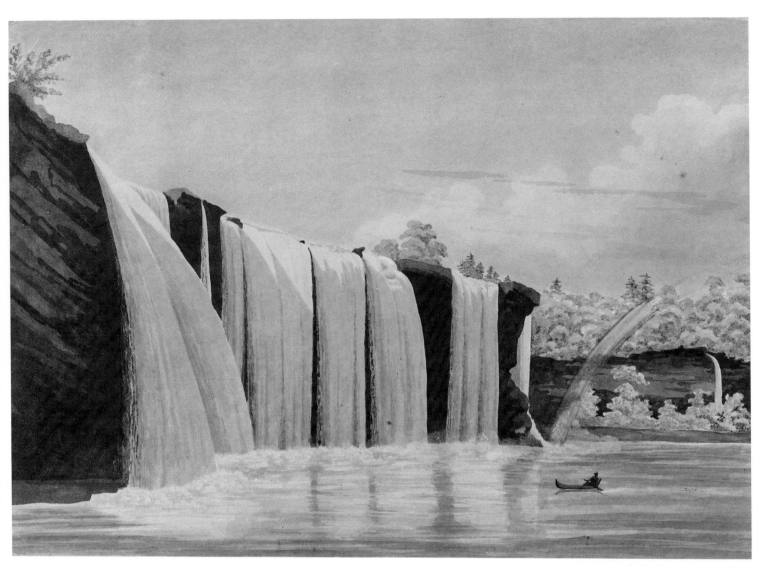

PLATE 41. WILLIAM CONSTABLE, *The Great Falls of the Genesee*, 1806.

Travelers at the end of the eighteenth century were aware of the dangers of the wilderness, but a decade later these had diminished sufficiently so that the wilderness was a source of pleasure for the naturalist poet. Shortly thereafter, natural attractions in rugged areas began to be visited by ordinary tourists, and Americans were encouraged to see America first. Yet in 1825, three years before the article was published in *The Atlantic Souvenir*, the last buffalo reported east of the Mississippi had been shot in western Virginia. By that time, Cooper in *The Pioneers* (1823) had expressed doubts about civilization's treatment of nature. And in *The Prairie* (1827) the aged Hawkeye laments: "How much has the beauty of the wilderness been deformed in two short lives!" Later in the novel, in words that ironically recall the Puritan view of wilderness, the old hunter remarks: "Settlements, boy! It is long sin' I took my leave of the waste and wickedness of the settlements and the villages."[60]

The wilderness clearly had been subdued. No longer a source of loathing or fear, it was a place for reflection and meditation. Its sublimity, in effect, became picturesque, something to be enjoyed and admired by genteel tourists. Following that change, it emerged as a subject for art. In February 1809, *The Port Folio* announced (p. 101): "It is our intention to devote a plate in each number of the *Port Folio* to the description of American Scenery. To the pencil our country affords an inexhaustible abundance, which for picturesque effect, cannot be surpassed in any part of the old world." The statement accompanied a view of *Buttermilk Falls* by George Murray (Plate 42). While

PLATE 42. GEORGE MURRAY, *Buttermilk Falls Creek, Luzerne County, Pennsylvania*, 1809.

the magazine did not live up to its promise of a plate an issue, such scenes appeared regularly. Aimed at a general audience, the views in *The Port Folio* imply a broad appeal for depictions of the American wilderness, albeit one not far from civilization. Accompanying descriptions as well as articles on travel and art were frequently laced with fashionable adjectives such as *sublime, beautiful, picturesque, romantic, savage, grand, magnificent.*

George Murray's address to the Society of Artists of Philadelphia in 1810 extolled American landscape:

> *Chains of mountains of immense height, gradually rising from the sea, extending through the country in nearly a parallel direction with the coast, and intersected as they are in many places by beautiful and magnificent rivers, form a vast variety of the most sublime and picturesque scenery in the world.* [61]

Similar sentiments were voiced by the jurist Joseph Hopkinson to the Pennsylvania Academy of the Fine Arts in the same year:

> *Do not our vast rivers, vast beyond the conception of the European, rolling over immeasurable space, with the hills and mountains, the bleak wastes and luxuriant meadows through which they force their way, afford the most sublime and beautiful objects for the pencil of the landscape?* [62]

This defense of native scenery was part of the so-called paper war of the early nineteenth century in which Americans reacted to unfavorable criticism in British travel accounts. Irving, for example, decried the prejudicial accounts of America by English travelers, and James Kirke Pauling published a book critical of England and artistic exaggeration of British scenery. [63] It came at a time of international tension, when the

United States was anxious to maintain its political and assert its cultural independence. It also came at a time when the arts were taking on a national character.

The Art Scene

The American Academy of Fine Arts had been established in New York in 1802; the Pennsylvania Academy of the Fine Arts, in Philadelphia in 1805. While these institutions, organized and supported mainly by businessmen and amateurs, frequently were the focus of artistic discontent rather than the source of encouragement, they did nevertheless indicate a growth in art interest and support. Fashioned after the Royal Academy in London, they were part of an Anglo-American development that saw comparable organizations open about the same time in Bath, Bristol, Edinburgh, Liverpool, and Norwich.[64] Almost from the beginning, exhibitions were part of the artistic activities at the academies in New York and Philadelphia just as they were at the Royal Academy.

Exhibitions began to be a significant feature of the Pennsylvania Academy in the early 1810s and of the American Academy a few years later. The late 1820s saw annual exhibitions at the new National Academy of Design in New York and at the Boston Athenaeum. Landscapes had been shown at the short-lived Columbianum in Philadelphia in 1794; however, the first exhibition at the Pennsylvania Academy in 1811 established the artistic importance of the genre. For the rest of the century, enthusiasm for landscape never waned.

The early exhibitions included landscapes by contemporary European and American artists as well as dubious Old Masters. Contemporary artists tended to be British: George Barrett, Thomas and Benjamin Barker of Bath, Alexander Nasmythe, Philip de Loutherbourg, Richard Wilson. Among the Old Masters shown were paintings by or after many of the major figures in the history of landscape — Poussin, Gaspard Dughet, Claude, Ruysdael, Rosa, Rubens, Wynants, Pynacker, Berchem, Breughel, Brill. Engraved works by these and other artists were also available in America at the time,[65] and artists were encouraged to make copies as a way to learn technique and composition. Rembrandt Peale's copy after Claude-Joseph Vernet (Fig. 9) is an exam-

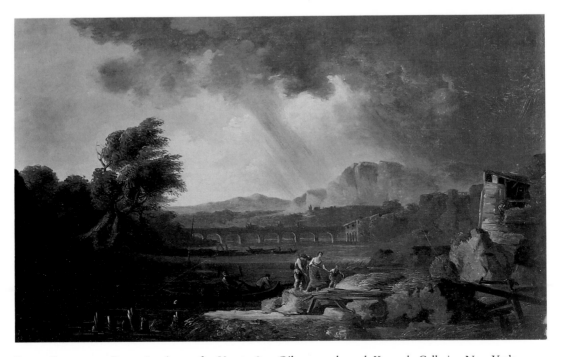

FIG. 9. REMBRANDT PEALE, *Landscape after Vernet*, 1809. Oil on wood panel. Kennedy Galleries, New York.

41

ple. Copies were acquired by patrons and admired for their own sake; artists even exhibited them.[66]

Major collectors also lent works to exhibitions, making them accessible to artists. Robert Gilmor, Jr., of Baltimore, Thomas Perkins of Boston, Luman Reed and Philip Hone of New York, and Daniel Wadsworth of Hartford all collected landscapes and shared their collections with the public.[67] Selections from the collection of Joseph Bonaparte, brother of Napoleon, were shown at the Pennsylvania and American academies. Bonaparte had come to America in 1815, settling in Bordentown, New Jersey. His large collection was seen by many artists, including Thomas Birch (see Plate 120), and Charles Lawrence (Plate 43), who painted his residence, Point Breeze. Artists, too, such as William Birch, had holdings by other artists which they put on view or sold.[68]

Among the early exhibitors at the academies were Barralet, Beck, the Birches, Groombridge, Guy, the Peales, the Robertsons, and Trumbull. Younger artists such as Allston, Doughty, Alvan Fisher, and Lawrence also showed in the first decade. By the late 1820s, when annual exhibitions were taking place at the National Academy and the Boston Athenaeum, the ranks of landscape artists had grown significantly and included Thomas Cole, Charles Codman, Henry Cheever Pratt, Joshua Shaw, William Guy Wall. Some of the artists, unidentified then, are today only known through tantalizing references to their works in the press.[69]

Periodicals helped expand public awareness of landscape painting. In *The Port Folio*, which carried articles on Old Masters, Salvator Rosa was described as an artist who "delighted to contemplate nature in her most awful forms — the dark and gloomy recesses of a forest infested with banditti — the frowning precipice — the landscape blasted by lightning. . . ." Titian was proclaimed "almost the father of landscape painting"; Domenichino, "illustrious in landscape."[70] Biographies of a number of other artists including Rubens, Van Dyck, and West also appeared. Although not all were discussed for their contributions to landscape, art in its various forms was being promoted in these popular accounts.

Drawing books and artist manuals dealing exclusively with landscape became available in America.[71] Artistic aids had been sold for much of the eighteenth century; but books, limited to special topics and primarily directed at the amateur, began to be published in England in greater numbers at the turn of the century. Some were imported; others had American editions. Even when the scenes illustrated were not English, which was rare, the ideas were derived from British sources. Fielding Lucas' *Progressive Drawing Book*, published in Baltimore in 1827, was the first artist's manual issued in America with native landscapes (Plate 44), but the text quotes extensively from *A Treatise on the Principles of Landscape Design* by John Varley, one of the leading British watercolorists of the day, whose book on perspective had been published by Lucas a few years earlier.

The dissemination of interest in landscape can be seen as well in the watercolors of amateurs (Plate 45), in decoration on furniture (Fig. 10) and motifs on ceramics (Fig. 11). In most cases, domesticated scenery or famous sites were represented. Nevertheless, such views document the spread of landscape imagery and the pervasiveness of the aesthetic of the picturesque.

Picturesque Views

The first decades of the nineteenth century saw an increase in travelers, American and European, visiting the wilderness. America's natural beauties were lauded by writers such as Alexander Wilson and Washington Irving. Improved transportation opened many areas to tourists, and easily accessible spots were accorded special attention. Travel accounts resonate with picturesque phrases and religious reflections. Robert

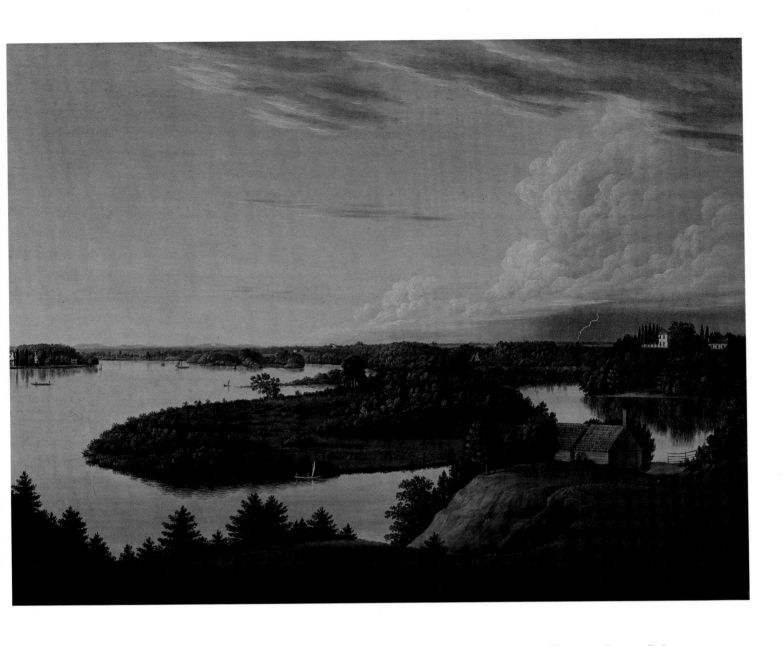

PLATE 43. CHARLES B. LAWRENCE,
Point Breeze, c. 1817–1820.

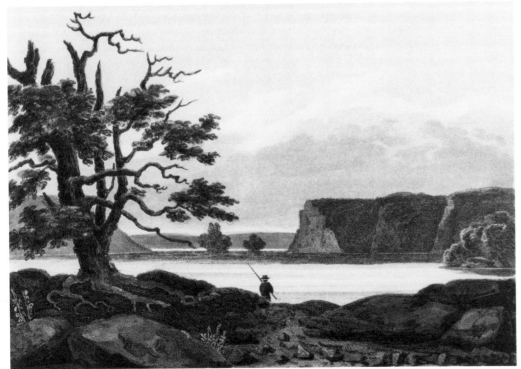

PLATE 44. FIELDING LUCAS, JR., *Lucas'
Progressive Drawing Book*, 1827–1828.

PLATE 45. UNKNOWN ARTIST, *Townscape, Stonington, Connecticut*, c. 1800–1825.

Vaux, a Quaker going through central and northeastern Pennsylvania, wrote glowingly back home to Philadelphia in 1807:

> The country we have road [sic] through is the most picturesque & grand that thee can imagine, the lofty Hills, the peaceful vales, alternately changing — the creeks & Rivers (more particularly) peeping occasionally through the trees at a distance, or rolling majestically by, as we ride on its margin, dispose the minds to read in the great folio of nature — & conduct our thoughts with pleasing irresistibility towards the Great being *whose omnipotence & omniscience spreads an unbounded canopy of greatness over all his works —*[72]

Although derived from the aesthetic of the sublime, particularly as it relates to grand natural scenery such as Niagara, Vaux's comments also suggest that he may have been aware of associationism, an aesthetic concept that emphasized the importance of the viewer's association of ideas or past experiences in his emotional reaction to situations, nature, or art. The theory, promulgated by the Scottish aesthetician Archibald Alison, was first published in *Essays on the Nature and Principles of Taste* (1790). Reissued in an enlarged version in 1811, the work influenced American response to landscape in the early decades of the nineteenth century.[73]

A number of American travel accounts appeared in the 1820s: Thomas Nuttall issued a journal of his trip to the Arkansas Territory; Henry Schoolcraft and Thomas McKenney both published observations on journeys to the Great Lakes; Timothy

FIG. 10. Side chair, 1815–1825. Henry Francis du Pont Winterthur Museum.

FIG. 11. *Upper Ferry Bridge over the Schuylkill,* platter, English Staffordshire. Courtesy of the New-York Historical Society, New York City.

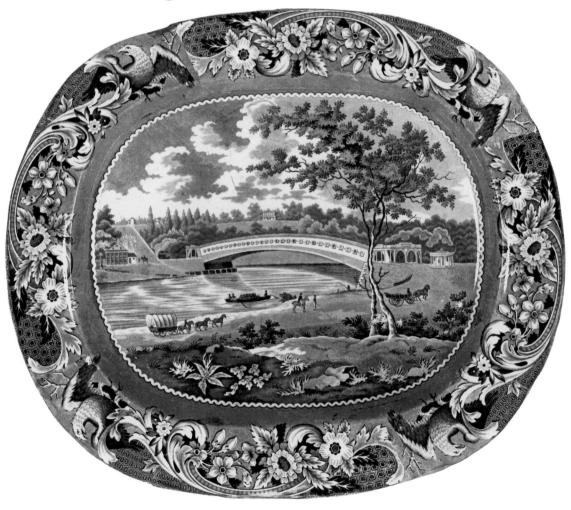

Dwight belatedly put in print remarks on a tour through New England and New York, while his brother Theodore Dwight issued several editions of his sketches on American scenery and manners; Philip Stansbury gave an account of his walk through 2,300 miles of North America; Benjamin Silliman reported on his travels in New England. Publications such as Henry Gilpin's *A Northern Tour* and Joshua Shaw's *U.S. Directory*, advising people where to stay and what to see, were directed at travelers "in search of the picturesque," a phrase borrowed perhaps from the satirical English poem dealing with the tours of the fictional Dr. Syntax (i.e., Rev. William Gilpin).[74]

In the early 1820s two major series of American views were published that focused on the wilder aspects of the country's landscape: Joshua Shaw's *Picturesque Views of American Scenery* (1820-1821) and William Guy Wall's *Hudson River Portfolio* (1821-1825). The Shaw and Wall portfolios were artistic counterparts to travel books glorifying the American landscape. Both were done by recently arrived British artists in cooperation with a fellow countryman, John Hill, a master engraver and aquatinter who had also just emigrated. Serialized, they were created over several years and were projected to be somewhat larger.

The introduction to *Picturesque Views* voices sentiments reminiscent of those uttered a decade earlier by George Murray and Joseph Hopkinson:

> *In no quarter of the globe are the majesty and loveliness of nature more strikingly conspicuous than in America. The vast regions which are comprised in or subjected to the republic present to the eye every variety of the beautiful and the sublime. Our lofty mountains and almost boundless prairies, our broad and magnificent rivers, the unexampled magnitude of our cataracts, the wild grandeur of our western forests, and the rich and variegated tints of our autumnal landscapes, are unsurpassed by any of the boasted scenery of other countries.*

The author goes on to explain the reason for the project, saying that the striking natural features of the United States had rarely been treated pictorially. "Europe abounds with picturesque views of its scenery," he observed:

> *From the mountains of Switzerland to the tame level of the English landscape, every spot that is at all capable of exciting interest is familiar to admirers of nature, while America only, of all the countries of civilized man, is unsung and undescribed. To exhibit correct delineations of some of the most prominent beauties of natural scenery in the United States is the object of the work. . . .*

English precedents for Shaw's *Picturesque Views* are numerous. Publications with beautiful aquatints had been issued in Britain in the late eighteenth and early nineteenth centuries. Particularly applicable to America were depictions of the rugged and wild scenery of Wales, Scotland, and Ireland. An American edition of John Nattes' *Picturesque Views in Scotland* was published in Philadelphia in 1804. Among the series that would have been known to Shaw and Hill was Philip de Loutherbourg's *The Romantic and Picturesque Scenery of England and Wales* (1805). De Loutherbourg was one of the major landscape painters of the day. Shaw, who undoubtedly saw his work in London, knew enough about the artist to explain his color practices to a fellow Philadelphian, John Neagle, and Hill had engraved some of his works in England.[75] *Romantic and Picturesque Scenery* explored dramatic and sublime subjects from windswept mountains to thunderous waterfalls, from decaying castles to infernal industrial sites. Shaw's *Burning of Savannah* (Plate 46) may owe its dramatic treatment of fire to *Iron Works, Colebrook Dale* (Fig. 12), although other English artists such as Joseph Wright of Derby had painted similar scenes of conflagration.

Shaw brought a highly developed romantic strain of landscape to America. In oil paintings executed in the United States, poetic remembrances of Britain recur (Plates 47, 48). Even ostensibly American compositions, such as *Night Scene* (Plate 49), with

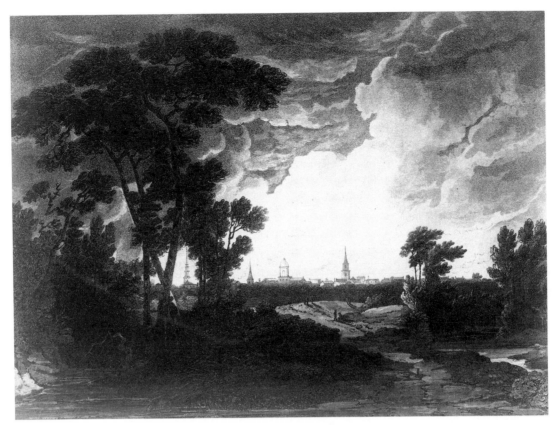

PLATE 46. JOHN HILL after JOSHUA SHAW, *Burning of Savannah*, from *Picturesque Views of American Scenery*,. 1820–1821.

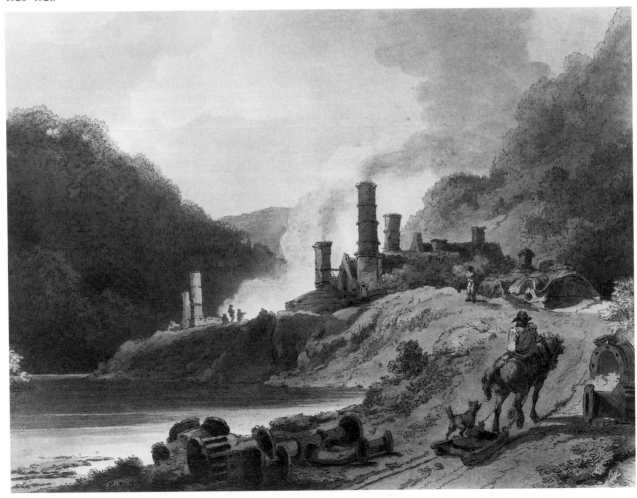

FIG. 12. After PHILIP DE LOUTHERBOURG, *Iron Works, Colebrook Dale*. Colored aquatint from *Picturesque Scenery of Great Britain*, 1801.

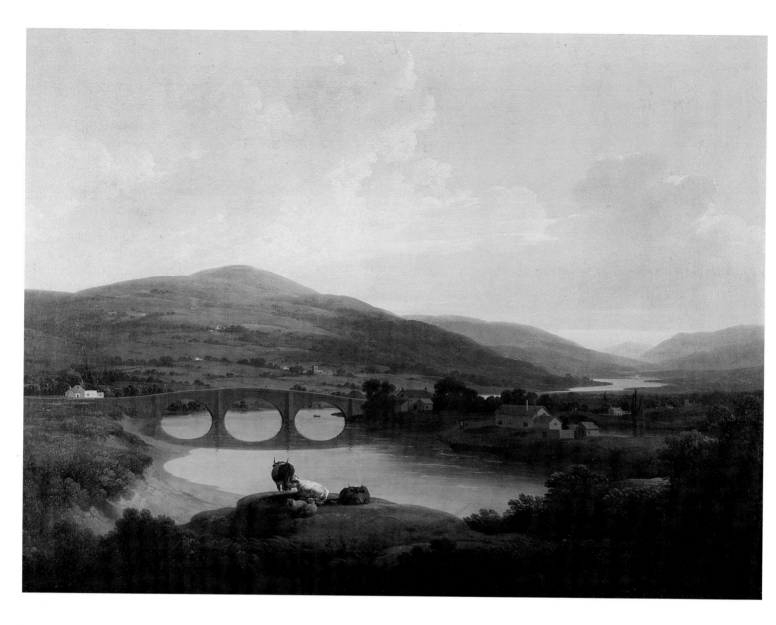

PLATE 47. JOSHUA SHAW, *Landscape with Cattle,* 1818.

PLATE 48. JOSHUA SHAW, *Stormy Landscape,* 1818.

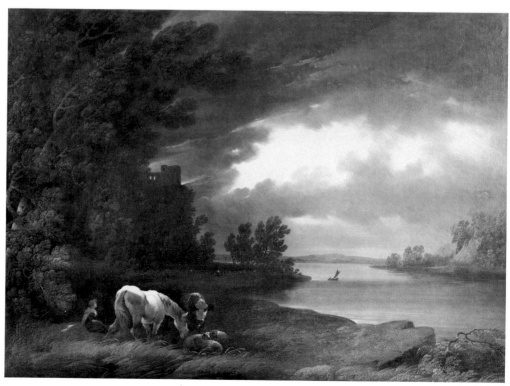

its obvious debt to the moonlight subjects of Aert van der Neer, and *View in the Pennsylvania Countryside* (Plate 50), reminiscent of compositions by Richard Wilson, are clearly landscapes of mood rather than portraits of place.[76] This aesthetic underlies both subject and presentation of *Picturesque Views*. Shaw's *View near the Falls of the Schuylkill* (Plate 51) with a solitary figure descending a lonely road projects an air of melancholy and a sense of isolation, recalling works by Gilpin (Fig. 13) and Wilson.[77] In his description of the plate, Shaw observed: "The banks of the Schuylkill are uncommonly romantic and picturesque." The actual spot, even if known, probably would not have been recognized by his audience. The ambiguity adds to the scene's romantic character, expressed through dramatic handling of light and composition.

In describing *On the North River* from the series, Shaw observed that "the scenery of the North River [the Hudson] possesses great variety and is among the most remarkable in the United States. . . . it affords abundant materials for picturesque delineation." The Hudson was generally admired. The pictorial merits of the valley were recognized by early Dutch settlers, and in Shaw's time Washington Irving among other writers praised the river's landscape.[78] Many artists had sketched it: Thomas Davies had depicted it as a military artist (Plate 52); Winstanley had caught its morning and evening moods in the 1790s for Washington (Figs. 7-8); Charles Willson Peale created a panorama of the river as he progressed northward from the city in 1801 (Plate 53); Charles Fraser in 1818 recorded its charms in a delicate style derived from his

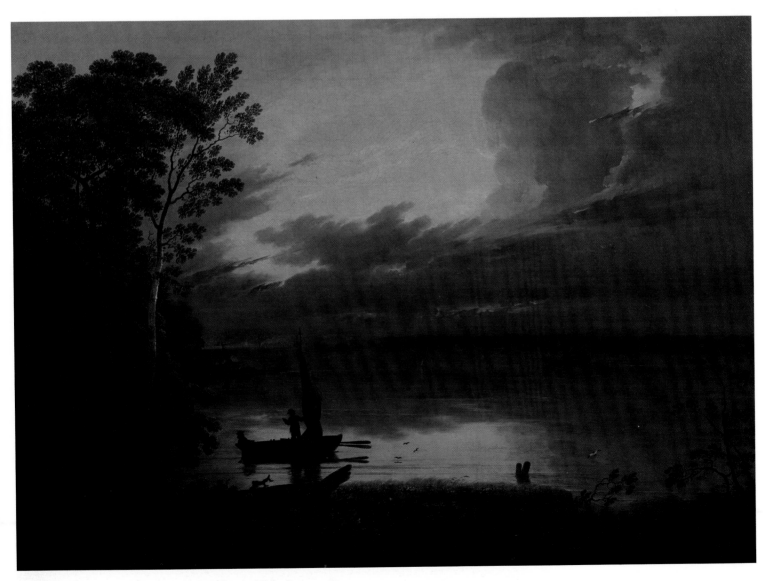

PLATE 49. JOSHUA SHAW, *Night Scene*, c. 1819.

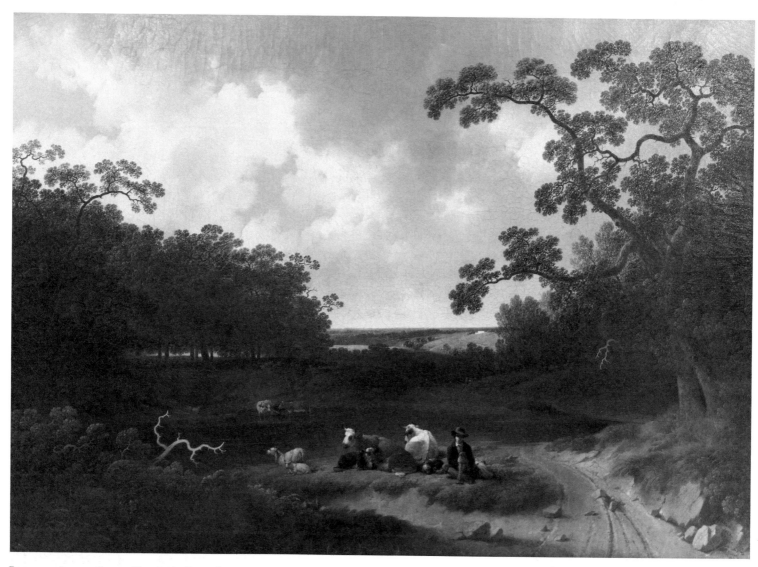

PLATE 50. JOSHUA SHAW, *View in the Pennsylvania Countryside,* 1823.

FIG. 13. WILLIAM GILPIN, aquatint from *The Last Work,* 1810, Plate 22. Henry Francis du Pont Winterthur Museum Library, Collection of Printed Books.

PLATE 51. JOHN HILL after JOSHUA SHAW, *View near the Falls of the Schuylkill*, from *Picturesque Views of American Scenery*, 1820–1821.

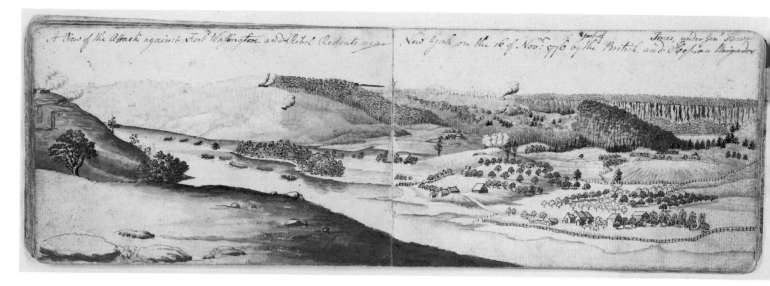

PLATE 52. THOMAS DAVIES, *Sketchbook*, c. 1773–1797.

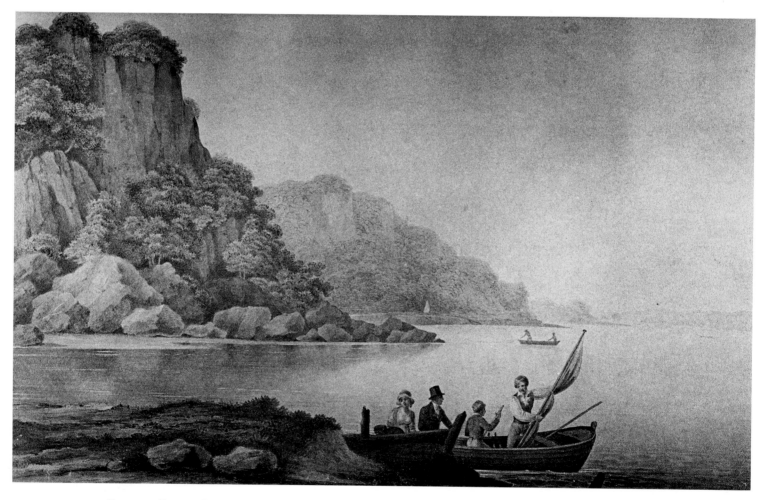

PLATE 54. CHARLES FRASER, *View on the Hudson River*, 1818.

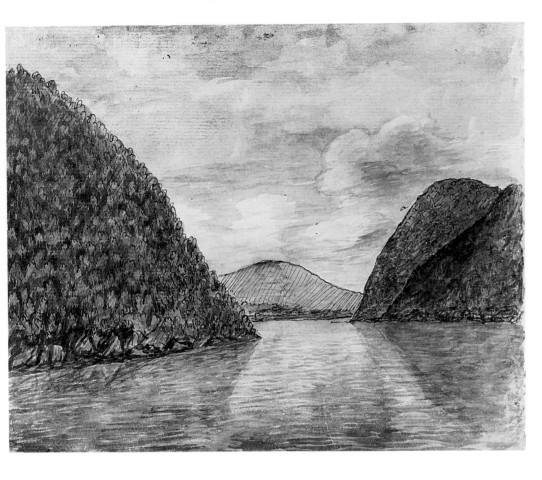

PLATE 53. CHARLES WILLSON PEALE,
Sketchbook of the Hudson, 1801.

PLATE 55. PAVEL PETROVICH SVININ,
*The Sailing Packet Mohawk of Albany
Passing the Palisades of the Hudson
River*, early nineteenth century.

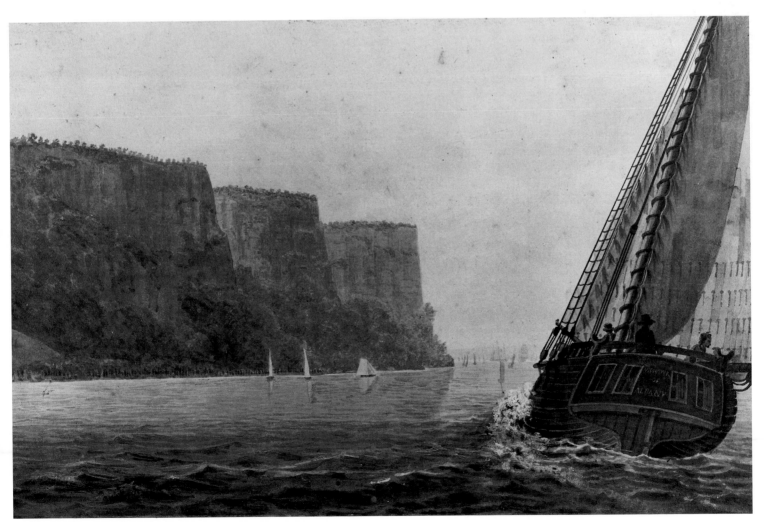

miniature paintings (Plate 54); and Pavel Svinin, a Russian artist, captured the excitement of sailing on the ample river (Plate 55). Shaw promised "to gratify the public with a series of views of this stream," but the series was never executed. However, about the time *Picturesque Views* was published, another artist, William Guy Wall, undertook a similar project.

The Hudson River Portfolio was serially published between 1821 and 1825 from watercolors executed by Wall as a result of a tour of the river in the summer of 1820. Originally, it was to contain twenty-four views, but only twenty were issued. John Rubens Smith, who subsequently claimed to have taught Wall proper watercolor technique,[79] was announced in the prospectus as the engraver. Although Smith worked on four plates, the rest were executed by John Hill. The twenty views are an astounding artistic achievement, which could not have been realized without an engraver of Hill's technical skills. Dedicated to the "American Rhine," the portfolio charts the passage of this great avenue of transportation and commerce, made even more important with the opening the Erie Canal in 1825, from Luzerne to Governor's Island, two hundred miles down river.

Rivers had long been recognized for their aesthetic appeal and historic importance. William Gilpin in his book on the Lake District proclaimed a river winding through a country "one of the most beautiful objects in nature." He encouraged those looking for "pleasing and picturesque views" to follow the course of a river.[80] Rivers were also arteries along which civilizations flourished and commerce flowed. The historic as well as pictorial potential of rivers, their role in the progress of civilization, made them frequent subjects for artists, American as well as European, in the eighteenth and nineteenth centuries.

As if in response to Gilpin's remarks, a group of prints chronicling the Thames from its source to its mouth began to be published in 1794. Issued serially from 1794 to 1796 and reprinted over the next two decades, *A History of the River Thames* contained aquatints by Joseph Stadler after drawings by Joseph Farington. This undertaking traced in seventy scenes the Thames from its source to Gravesend.[81] William Havell's *A Series of Picturesque Views of the River Thames* in twelve prints appeared in 1811 and was reissued in 1818, the year that saw the publication of W. B. and G. Cooke's *Thames Scenery*. Similar volumes dealing with the Thames and other rivers in Britain were published by Samuel Ireland in the late 1790s.

With its mountains, waterfalls, mills, Indians, and frontier villages, Hudson scenery is grander and wilder than the rolling countryside with elegant villas and neat towns lining the Thames, but the concept of the Wall portfolio, if not the images themselves, was undoubtedly inspired by English publications. Like its prototypes, *The Hudson River Portfolio* contains verbal descriptions of the sites, including allusions to historical events. In describing the area, the words and images capture the mood and stimulate associations with the particular site or general area. Although in *Meeting of the Hudson and Sacandaga*, the scene portrayed is actually the cultivated land near the river, the surrounding area is described in the text as of "a wild, ferocious, and solitary sublimity." The time of day is morning "when dark *strata* of clouds, relieving themselves in intermitting showers, give a gloomy tone to the landscape. . . ."

One of the most spectacular and romantic views in the series is *Hadley's Falls* (Plate 56), reportedly rarely visited by people who lived in the vicinity because of the difficulty in getting there. The composition recalls depictions of Welsh waterfalls (Fig. 14). By introducing well-dressed figures, Wall emphasizes the attraction of the falls to dedicated tourists in pursuit of the picturesque. *View near Hudson* (Plate 57), on the other hand, treats a countryside "pleasingly diversified by gentle and frequent undulations" and "animatd by numerous and neat residences which are scattered throughout at short intervals."

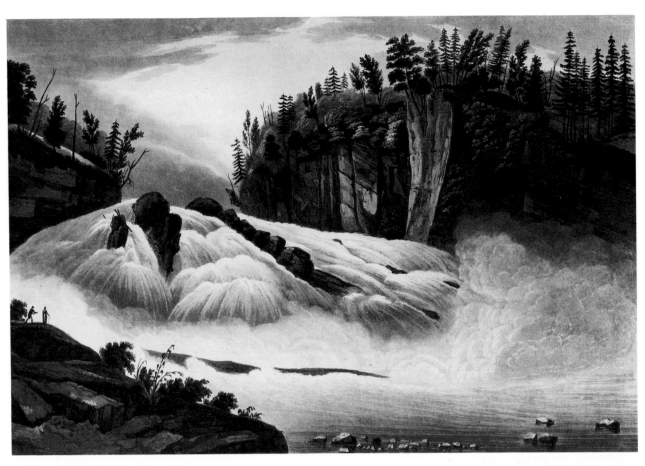

PLATE 56. WILLIAM GUY WALL, *Hadley's Falls*, from *Hudson River Portfolio*, 1828 edition.

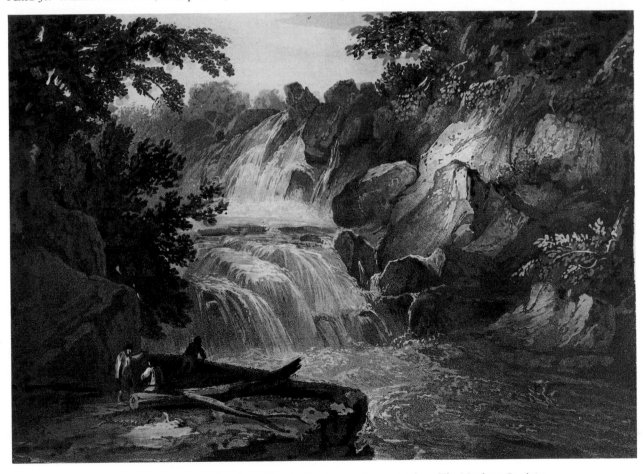

FIG. 14. T. FIELDING after F. NICHOLSON, *Rhaiadyr y Wennol*. Hand-colored aquatint from *The Northern Cambrian Mountains* by T. Compton, 1820, Plate 31. Yale Center for British Art, Paul Mellon Collection.

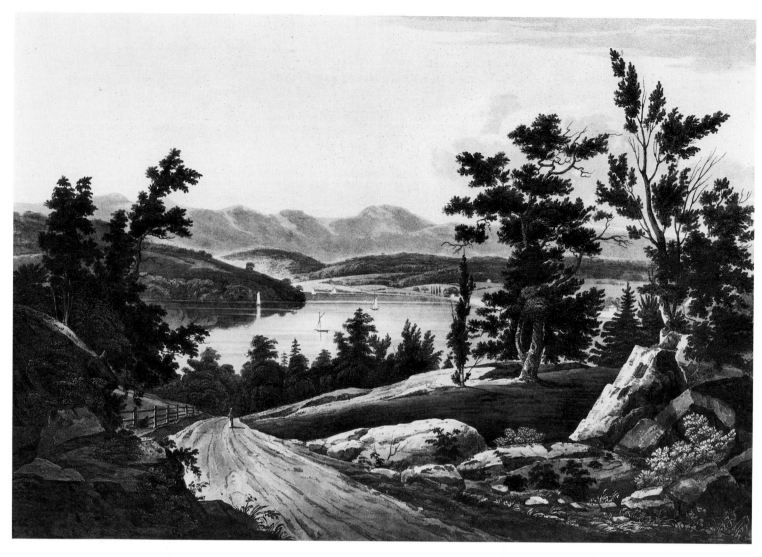

PLATE 57. WILLIAM GUY WALL, *View near Hudson*, from *Hudson River Portfolio*, 1828 edition.

Both the text and imagery of the portfolio make frequent allusions to divine providence and God's blessings on America. In *View from Fishkill Looking to West Point* (Plate 58) heavenly light radiates on "some of the finest scenery of the Highlands, combining beauty and sublimity. . . ." The transcendent power of this magnificent scene, supported in the text by biblical references, was, according to the author, John Agg, lost on the common folk:

> *Here the rough husbandman pursues his daily labor, heedless of the striking attractions with which the bounty of nature has surrounded him; and the herdsman traverses with thoughtless step paths in which painting and poetry would delight to sojourn, and to lose the recollections of the cares and tumults of a busier world.*

As Carole Fabricant has observed, a society that envisioned a Great Chain of Being extending unbroken from the lowest living creature to the heavenly hosts also conceived of a hierarchic chain of seeing and nonseeing.[82] As their dress indicates, the people in Charles Fraser's *Trenton Falls* (Plate 59) and those in Wall's *Hadley's Falls* are clearly refined. Like Weld and Strickland before him, the author of the *Portfolio*'s text, and presumably the artist, believed the uneducated frontiersman was insensitive to nature. Although hundreds of copies of each plate were sold, the Wall-Hill portfolio with its social attitudes and aesthetic allusions was directed at an educated elite.

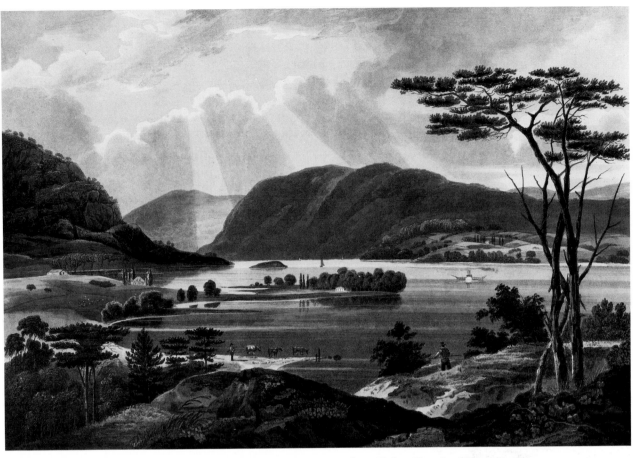

PLATE 58. WILLIAM GUY WALL, *View from Fishkill Looking to West Point*, from *Hudson River Portfolio*, 1828 edition.

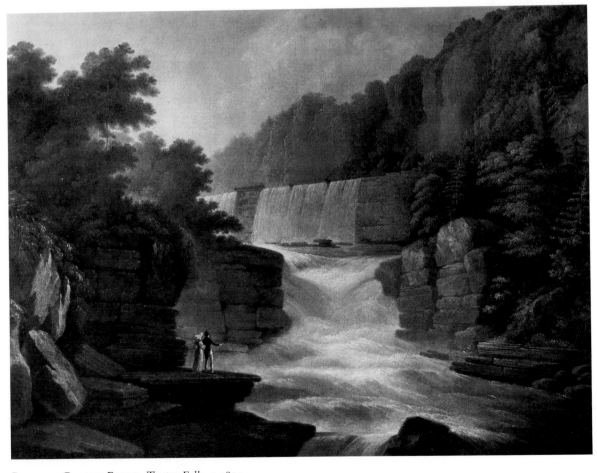

PLATE 59. CHARLES FRASER, *Trenton Falls*, c. 1830

The Artist in Nature

Going to nature was considered morally uplifting: the more sublime the scenery, the more man dwelt on God. In his view of Natural Bridge (Plate 60) Edward Hicks, a Quaker preacher as well as artist, draws the parallel between natural wonders and divine providence. Based on Roberts' view (Plate 33), the composition seems to define in its complex iconography America's past, present, and future: its purchase from the Indians, its present youth, and its millennial future. Few compositions have the symbolic overtones of Hicks'. Usually the spiritual benefits to be derived from nature were merely suggested. For example, Charles Codman's *Footbridge in the Wilderness* (Plate 61) implies both the need to go to the wilderness and the ability to get there, made possible by the civilizing presence of a man-made bridge. It does not specify the lesson to be learned. The artist lays out the book of nature to man. Dramatic presentations such as Fraser's *Trenton Falls* or Wall's *Hadley's Falls* helped the viewer to experience vicariously the sublimity of the actual site. Although depictions of nature could not compare with the original, the created image was, in one respect, better: designed to stimulate specific responses, it could be repeatedly viewed to the same end.

Making summer excursions, which was a regular artistic practice in England during the second half of the eighteenth century, was adopted in America at the turn of the century. The pursuit of sublime and picturesque subjects, not to mention hope for financial return, sent Shaw up and down the east coast and Wall on his tour of the Hudson. As the nineteenth century progressed, other artists took to the country each summer: Thomas Sully and Thomas Doughty went sketching together in the 1820s, as did Thomas Cole and Henry Pratt. Professionals and amateurs alike filled sketchbooks with notations of their travels.

The image of the artist sketching in a landscape was a common theme in European art throughout much of the eighteenth century. After appearing in Anglo-American art around mid-century,[83] it remains a recurring motif through the early 1800s (Plate 62). The subject visualizes the conceit that nature is the artist's first school. In publications, manuals, and criticism, artists were encouraged to go to nature for inspiration. In America, with its limited artistic tradition, the idea took on new meaning. One writer remarked in *The Port Folio* in 1812: "our artists, instead of servilely imitating the works of European masters, will boldly pursue the same course as the ancient Grecians, who had nature only for their model, and genius for their guide."[84] America's artistic deficiency would prove to be an artistic stimulus by making the artist learn from nature rather than from other artists.

By the early nineteenth century American writers were keenly aware of the rapidity with which the country was changing. Some expressed concern about the fate of the wilderness and viewed civilization as a destructive force. In 1809, for example, Irving was "lamenting the melancholy progress of improvement" and the "savage hand of cultivation."[85] Artists shared these concerns. Although the portrayal of an artist in the act of sketching from nature is the embodiment of the picturesque aesthetic, it also implies a temporal relationship to the landscape: the artist portrays himself or another at a moment in time, recording a transient scene. Intermediary between nature and man, as well as student at nature's knee, the artist becomes the preserver cum recorder of nature's glories.

In the seventeenth and eighteenth centuries the Indian often served in art as an emblem of America. In the nineteenth century his disappearance from the real landscape came to symbolize the disappearance of the wilderness. Irving in *A History of New York* (1809) and later in *The Sketch Book* (1820) criticized the colonists' unflattering opinion and harsh treatment of native Americans.[86] In the same year Alexander Wilson in *The Forester* saw the destruction of the wilderness through Indian eyes:

PLATE 60. EDWARD HICKS, *Peaceable Kingdom of the Branch*, c. 1825.

PLATE 61. CHARLES CODMAN, *Footbridge in the Wilderness*, 1830.

PLATE 62. JOHN RUBENS SMITH, *Falls on the Sawkill*, c. 1820.

Oh happy days! for ever, ever gone
When these deep woods to white men were unknown;
. . .

Now all is lost! and sacrilege is spread!
Cursed ploughs profane the mansions of the dead. . . .[87]

The anonymous writer of "The Indian," a poem published in *The Port Folio* in 1810, ironically observed that "Art is fleeting, and produces / Pleasures that she soon destroys."[88] Cooper explored the subject extensively in his Leatherstocking novels over several decades, beginning in 1823 with *The Pioneers*, in which the decrepit remnant of a once glorious race is proof of the corrupting influence of white civilization. In 1830 President Jackson signed the Removal Act which gave him authority to deport all tribes east of the Mississippi to the "desert" west of it. And he may well have been voicing the sentiments of the majority of Americans when he remarked in his second annual message:

> *What good man would prefer a country covered with forests and ranged by a few thousand savages to our extensive Republic studded with cities, towns, and prosperous farms, embelished with all the improvements which art can devise or industry execute, occupied by more than 12,000,000 happy people and filled with all the blessings of liberty, civilization, and religion.*[89]

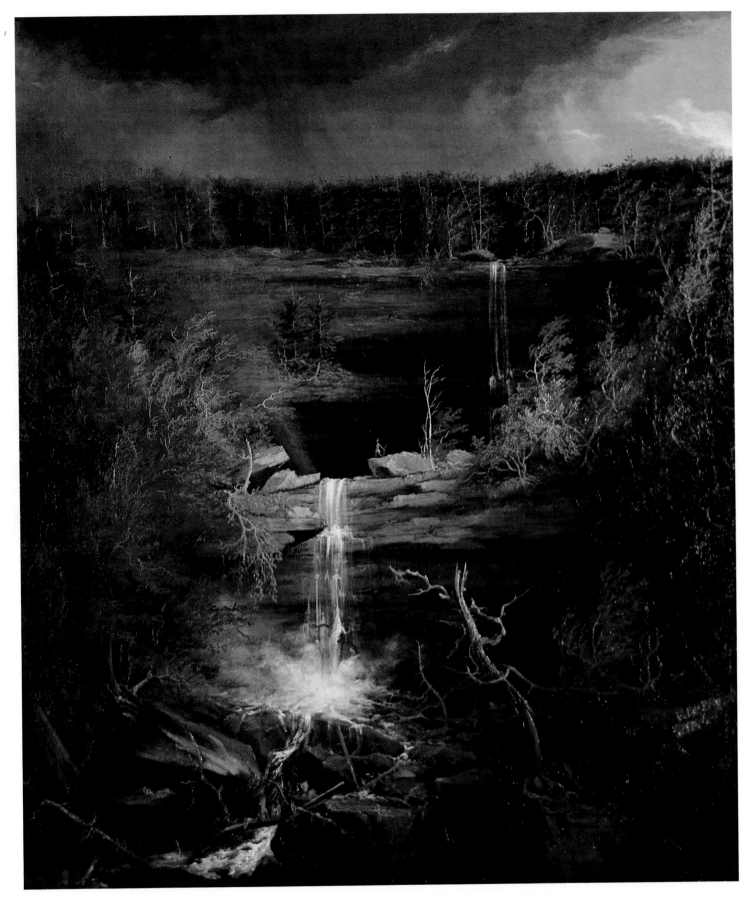

PLATE 63. THOMAS COLE, *Kaaterskill Falls*, 1826.

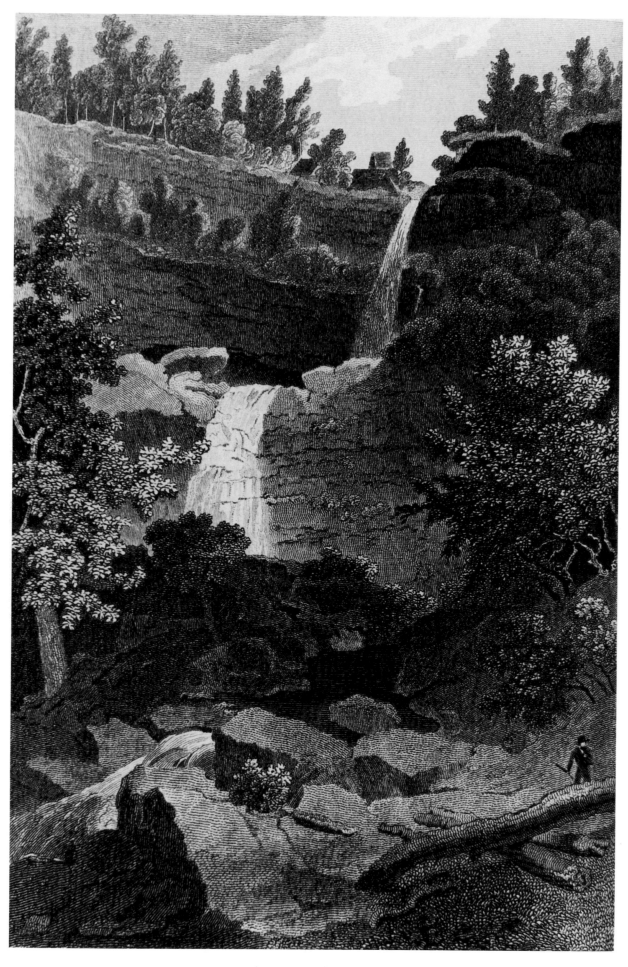

PLATE 64. THOMAS DOUGHTY, *Catskill Falls*, from *The Northern Traveller*, 1828.

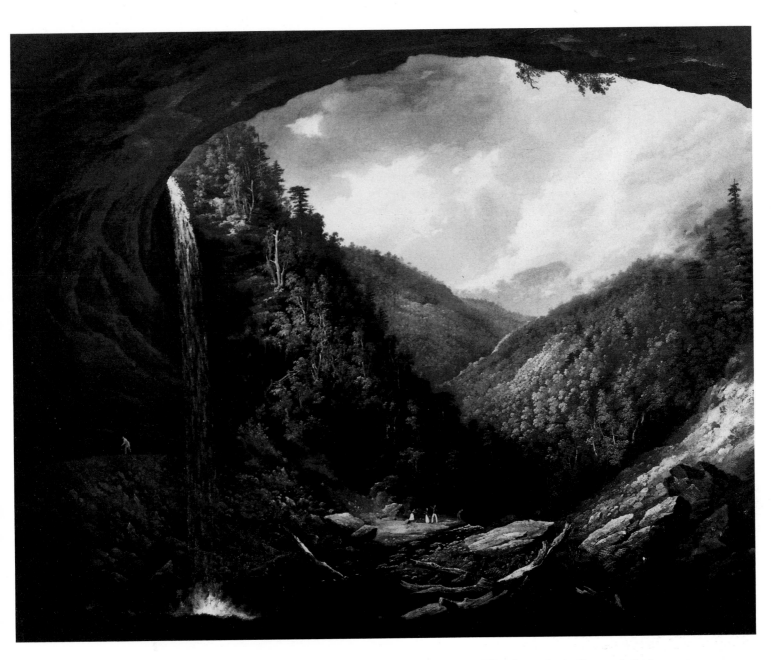

PLATE 65. WILLIAM GUY WALL, *Cauterskill Falls on the Catskill Mountains, Taken from under the Cavern*, 1826–1827.

With the Indian effectively removed from the East, what remained were areas of tamed wild scenery and memories of a savage wilderness. The noble savage, prominent as an emblem of the new continent in Smibert's view of Boston, reappears in Cole's *Kaaterskill Falls* of 1826 as a Romantic symbol of a vanished world (Plate 63). Cole eliminated the physical evidence of civilization then present at the site (Plate 64). Unlike Wall, who populated his painting of the same area with genteel men and women on an outing (Plate 65), Cole introduced a solitary Indian. Placed high above the cascading falls in an autumnal landscape suggestive of the end of a way of life, the native surveys a scene unspoiled by civilization.[90]

Wall emphasized the picturesqueness of the site; Cole captured the essence of American wilderness. It is Cole's remarkable ability to imbue an actual landscape with poetic overtones that places him in the forefront of artists who were inspired by and gave new meaning to the wilder aspects of American scenery. He is pivotal in the development of American landscape after 1825. But his coming was, in part, made possible by the growth in interest in native scenery and the accomplishments of artists such as William Guy Wall and Joshua Shaw.

Enthusiasm for landscape, pictorial and real, grew significantly in the period immediately before and after the War of 1812. The war had not been very popular, nor was it distinguished by military successes; nevertheless, America had defended itself against a powerful England once again, and survival as an independent nation seemed assured. This alone was cause for national pride, particularly to a generation of Americans who had reached maturity with no personal knowledge of the country's colonial past.

Throughout the 1810s and 1820s landscape took on nationalistic overtones. Artists and writers came together in informal groups, such as the Bread and Cheese Club in New York, to discuss issues of mutual interest. Painters went on sketching trips. The Shaw and Wall portfolios were issued. The public, too, responded: collections of contemporary American artists were formed; native literature was encouraged; excursions were made to natural attractions.

The number of artists painting landscapes increased significantly. Alvan Fisher around 1815 shifted from portraiture to scenes of rural life (Plate 66), probably inspired by engraved works by British painters such as George Morland. Commenting on the change, he remarked to William Dunlap, the early biographer of American artists: "this species of painting being novel in this part of the country [Massachusetts], I found it a more lucrative, pleasant and distinguishing branch of art than portrait painting."[91] In a few years Fisher was painting fresh interpretations of New England scenery (Plate 67) that captured the quality of light peculiar to America[92] and projected a sense of its pastoral character. Later he explored the drama of the American wilderness (Plate 68) and the migration of the Indian.

Even artists not normally associated with landscape became interested in the subject. Thomas Sully, for example, painted landscape studies in oil and watercolors, some

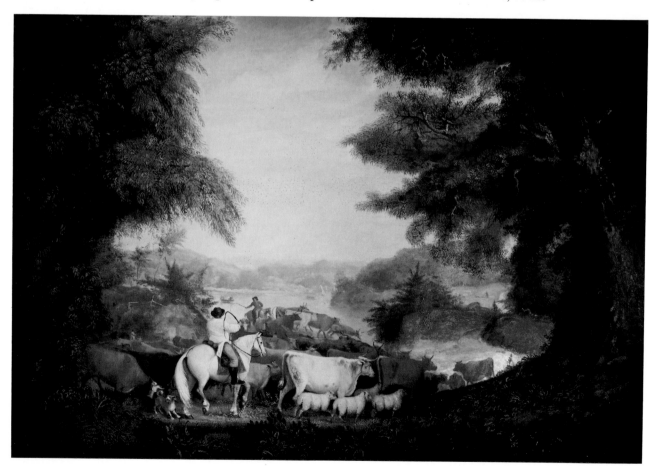

Plate 66. Alvan Fisher, *Landscape with Cows*, 1815.

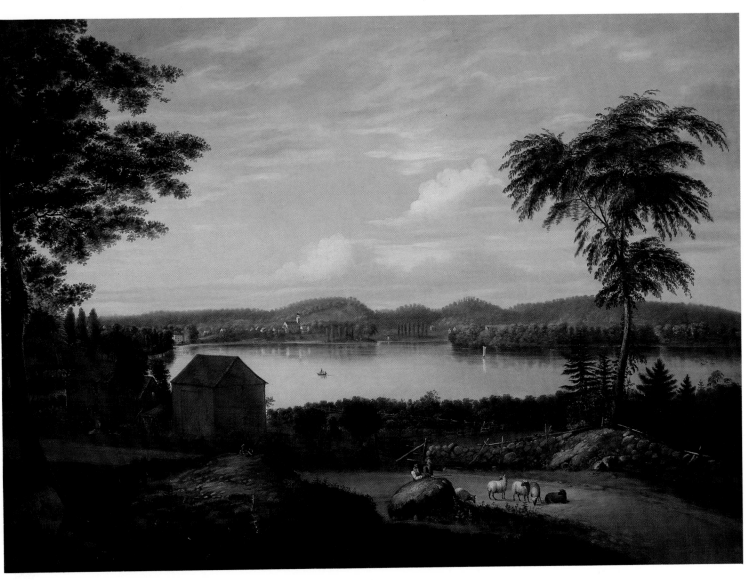

PLATE 67. ALVAN FISHER, *View near Springfield along the Connecticut River*, 1819.

of which consciously imitate English masters (Plate 69) while others (Plate 70) exhibit a spontaneity that seems unusually contemporary in its direct response to nature. Sully shared his knowledge with other artists, including his son-in-law John Neagle, who copied some of his compositions (Plate 71). But it is Neagle's *View of Peter's Island on the Schuylkill* (Plate 72) that expresses both the artist's and society's concept of America. With its charming child frolicking in a rolling countryside dotted with modest houses, the view epitomizes the American pastoral ideal and draws visual parallels between the simple landscape and the wholesome innocence of its people. The young country is enlivened and symbolized by a child, who speaks for a contented land.

Neagle's real landscape tempered by a poetic vision is symptomatic of a shift from factual to interpretive landscapes in the pivotal decade of the 1820s. Thomas Doughty executed a view of Baltimore in 1821 for his patron Robert Gilmor, Jr., of Baltimore (Plate 73) which demonstrates his early topographical style. Within a few years, however, he was creating landscapes (Plate 74) that, although suggestive of native scenery, are not portraits of particular places but eulogies to nature's and to America's innocence. The country folk in Doughty's *On the Beach* (Plate 75), seemingly oblivious to the scene around them, imbibe its essence. In a setting visually suggestive of religious landscapes by Claude or Rosa, the figures are sanctified by the

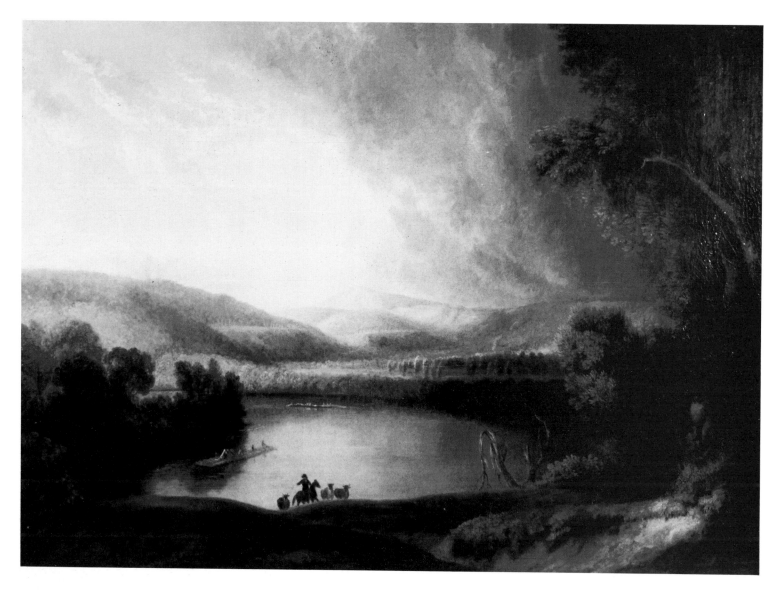

PLATE 68. ALVAN FISHER, *A Storm in the Valley*, 1830.

pure light that bathes the scene and purified in the clean river from which they drink. This spiritually charged composition is the artistic and moral precursor of Doughty's *In Nature's Wonderland* (Detroit Institute of Arts) of 1835 in which a solitary figure — a hunter, not a genteel tourist — stands in awe of the majesty before him. The hunter and the Indian in Cole's *Kaaterskill Falls* are counterparts to Cooper's Hawkeye and Chingachgook, who morally benefit from their close association with nature. In a period of growing democratic sentiments, such figures are visual refutations of the belief that the common man was insensitive to nature.

Doughty's shift from topographical views to poetic visions was criticized by his patron Gilmor. In 1826, while voicing to Cole his preference for real American scenes, he complained about Doughty's moving away from his earlier manner.[93] Gilmor's preference for truthful but artistic transcriptions of real scenes was at odds with the academic position that placed imaginary landscapes on a higher plane than depictions of actual places. In his opposition to fanciful scenes, he was not alone. John Neal, an early art critic, noted with regret in 1829:

> *Painting is poetry now. People have done with nature — life is insipid, prose flat. The standard for landscape is no longer what we see outstretched before us, and on every side of us, with such amazing prodigality of shape and color. We have done with the trees of the forest and the wilderness.*[94]

PLATE 69. THOMAS SULLY, *Castle on a Cliff, Sea at Base – Imitation of Turner,* 1814.

PLATE 70. THOMAS SULLY, *Fort Putnam from across the River,* 1814.

PLATE 71. JOHN NEAGLE, *From Sully's Imitation of Turner,* c. 1825–1830.

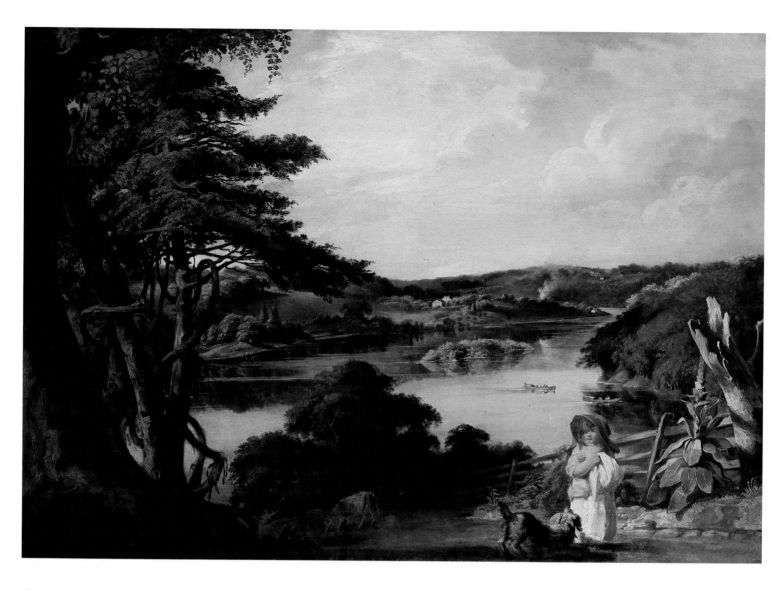

PLATE 72. JOHN NEAGLE, *View of Peter's Island on the Schuylkill, 1827.*

PLATE 73. THOMAS DOUGHTY, *View of Baltimore from Beach Hill, The Seat of Robert Gilmor, Jr., 1821.*

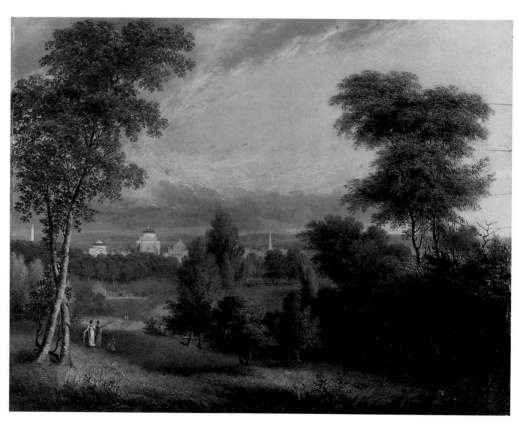

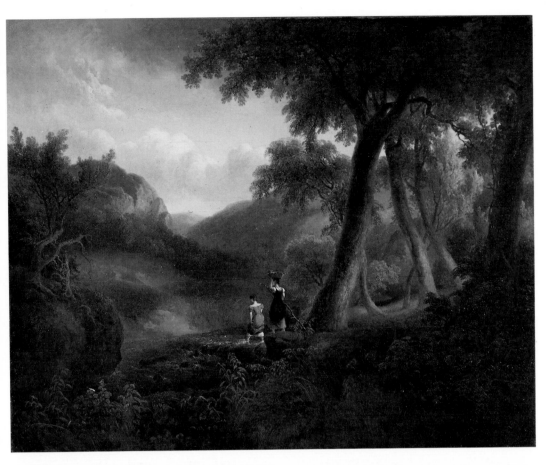

PLATE 74. THOMAS DOUGHTY, *Girls Crossing the Brook*, 1829.

PLATE 75. THOMAS DOUGHTY, *On the Beach*, 1827–1828.

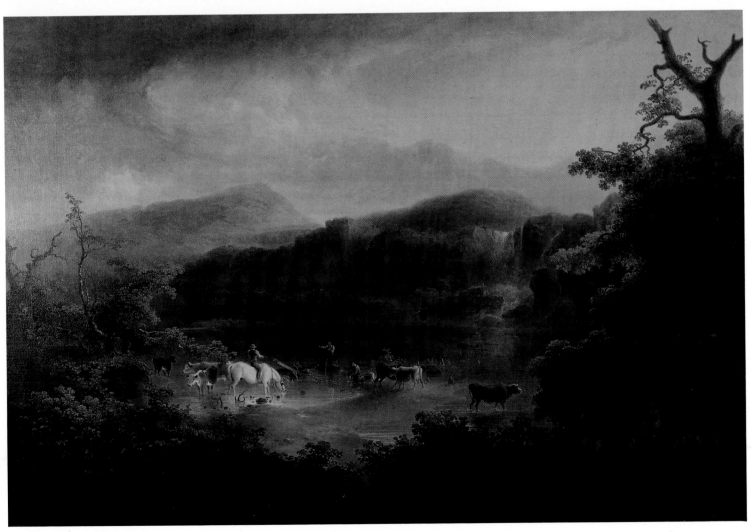

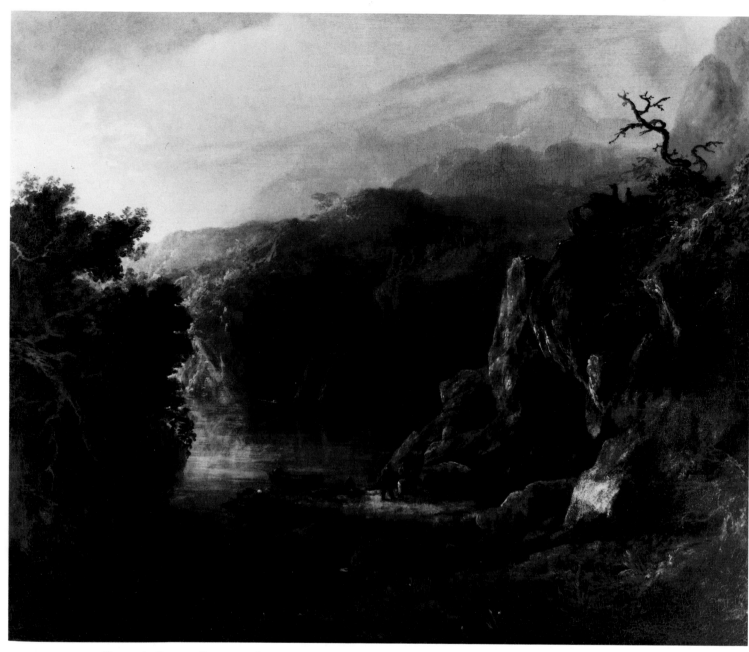

PLATE 76. CHARLES CODMAN, *The Pirate's Retreat*, 1830.

And yet artists such as Charles Codman, whom Neal admired, consistently explored romantic subject matter in his work (Plate 76). In essence, Gilmor and Neal were in favor of poetic views that combined truthfulness to nature with artistic imagination; and it was, in fact, this type of landscape that Doughty, Cole, and other major artists were creating. It was the limitation to creativity imposed by Gilmor on the artist that Cole resisted.[95] For Cole, landscape painting should not be an imitative art; the reproduction of mundane topographical details could not reveal the poetry of nature. Precisely because they were products of his imagination and not imitations of nature, paintings such as Cole's *Landscape Composition, Saint John in the Wilderness* (see Plate 130) were more satisfying to the artist than the more factual *View of the White Mountains* (see Plate 133), but the latter is no slavish treatment of the site. With its dramatic handling of the atmosphere, the figure juxtaposed against the towering mountains, the composition glorified the grandeur of American scenery. As moralizing landscapes, the historical works were in the great tradition to which the artist aspired. This tradition dominated Cole's artistic production following his first trip to Europe in 1829.

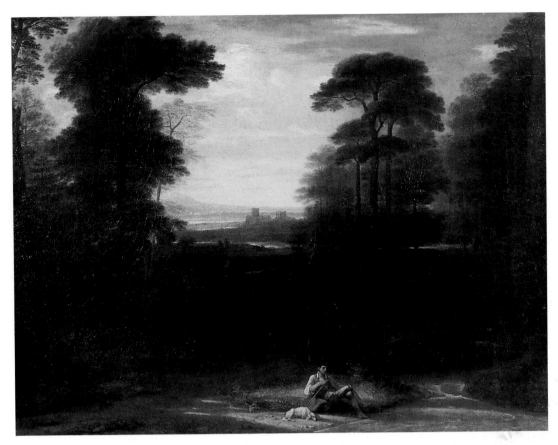

PLATE 77. WASHINGTON ALLSTON, *Landscape, Evening (Classical Landscape)*, 1821.

The most important practitioner before Cole of the poetic landscape in American art was Washington Allston, whose works were greatly admired by his contemporaries. His work is closely tied to the art of Claude and Gaspard, to the German classicists Joseph Anton Koch and Gottlieb Schick,[96] to the British Wilson and Turner. As champion of an international style, he became a model for American painters striving to rival the art of Europe, present as well as past.

Unlike Doughty, Cole, or the other members of the Hudson River School, Allston never depicted specific sites, European or American; his landscapes project a sense of mood and reverie. Suffused with the glow of a setting sun (Plate 77), or bathed in moonlight, they seem remembrances of things past — of dreams, of visions, of art. His compositions achieve a timelessness: the pastoral figures are generic; the architecture, antique. With their evocations of a classical past (Plate 78) and allusions to the spiritual fountainhead of art (Plate 2) they are totally removed from the American experience, and yet his art is essentially an outgrowth of the pastoral European ideal which shaped perceptions of America.

Early evidence of the poetic vision in America exists in Winstanley's lyrical views of the Hudson (Figs. 7, 8); in Groombridge's paean to autumn (Plate 34); in Cornè's Italianate decorations (Plate 79). But it was Joshua Shaw who, in the 1820s, provided one of the strongest and most direct links to this tradition (Plates 47-50). The extent to which Shaw influenced his younger contemporaries Cole, Doughty, and Neagle has not been determined, but that they were aware of his work and benefited from his knowledge is certain.[97] Like Allston, Shaw created landscapes of mood; but unlike Allston, he frequently alluded to specific locales. More modest in intent than the historical compositions of Cole or of Pratt (Plate 80) Shaw's landscapes are in fact not so much poetic visions as poetic views that combine a subjective interpretation of nature with a degree of literalism. It is this marriage of the poetic and topographical, the imaginary and the real, that is at the core of American landscape art before mid-century.[98]

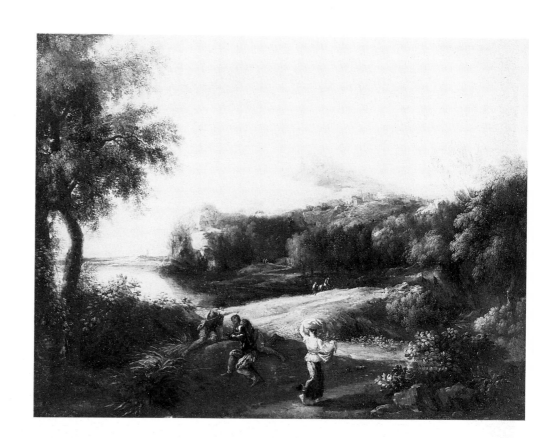

PLATE 78. WASHINGTON ALLSTON,
Romantic Landscape, c. 1803.

PLATE 79. MICHELE FELICE CORNÈ, *Classical Landscape,* 1804.

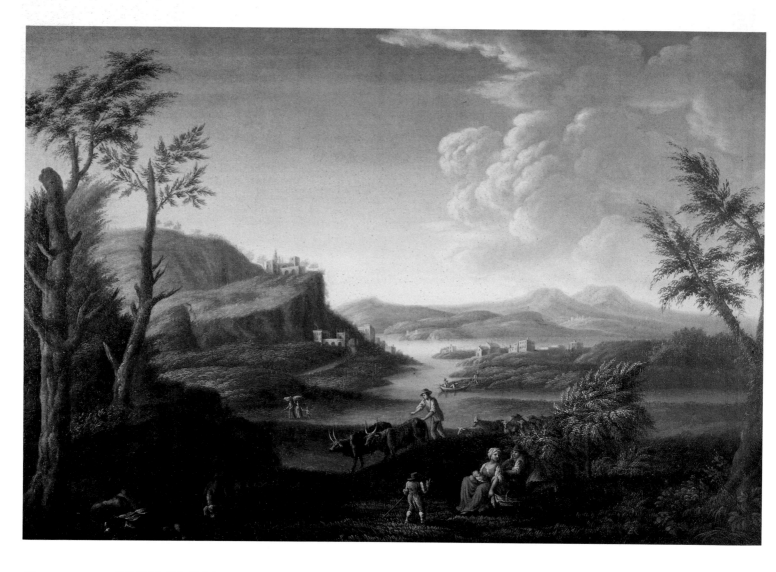

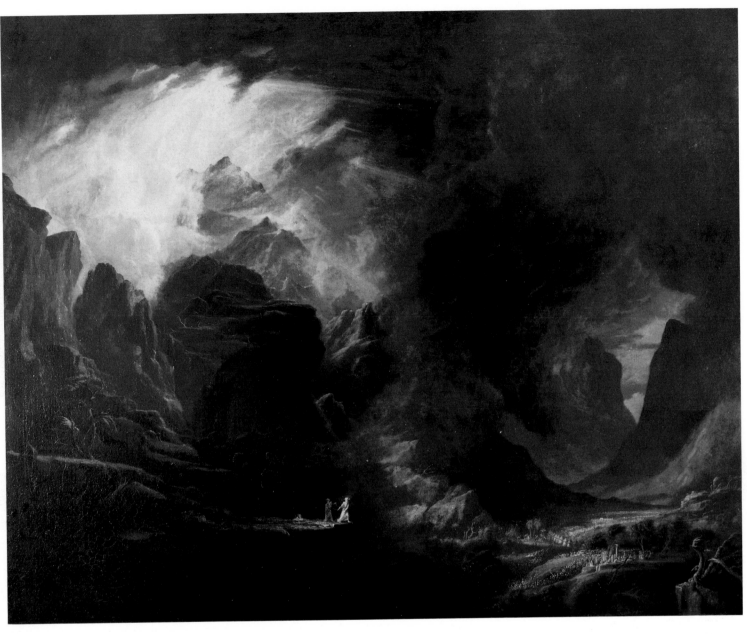

PLATE 80. HENRY CHEEVER PRATT, *Moses on the Mount*, 1828–1829.

Summary

The representation of landscape in America was conservative in comparison with contemporary treatment in England. Throughout much of the eighteenth century British painting focused on improved scenery where man's mark had made itself felt, and this tradition was also well established in America by the end of the century. But when English painting turned to nature's wilder manifestations, American art was not quick to follow; it remained committed to the varied landscape, taking pride in the mixture of the wild and cultivated which projected a national ideal based on the European concept of the pastoral. The images painted by American artists reinforced in composition and iconography America's ties to European civilization rather than proclaimed its uniqueness.

It was only in the second decade of the nineteenth century that the American wilderness began to emerge as a cultural concern and artistic subject. By 1830 the wilderness as an expression of the American temperament was established. Two landscapes by James Peale, separated by forty years, dramatize the shift: *Pleasure Party by a*

73

PLATE 81. JAMES PEALE, *Pleasure Party by a Mill*, c. 1790.

Mill of 1790 (Plate 81) exudes a sense of rural gentility, of man at ease in an environment of his making; *Landscape near Philadelphia* of 1830 (Plate 82) speaks for the sublimity of nature where man is a mute observer of forces beyond his control. The wilderness is not so much a place (Peale's wild scene is supposedly near Philadelphia) as a state of mind, offering solitude and contemplation. This inner landscape with its heightened emotional response to nature is far removed from the pastoral vision of the earlier work.

American appreciation of the wilderness shared certain similarities with the European. Initially an upper-middle-class manifestation, interest in rugged scenery was, as in England, urban in its origins. It was concentrated in the population centers of the American Northeast with the writers and artists who treated the theme. The South, despite its wilderness landscape, produced few significant works (Plate 83).

There were also differences in points of view. With much of America still wilderness, there was ambivalence toward nature. Americans were torn between wanting the refinements of civilization and cherishing the primeval landscape.[99] Traces of original forests still survived not far from the major eastern cities in the hills and mountains of New York and New England. America's uniqueness among western nations in this regard nurtured artistic pride in this resource. As Thomas Cole in his 1835 essay on American scenery remarked: "It is the most distinctive because in civilized Europe the primitive features of scenery have long since been destroyed or modified — the extensive forests that once overshadowed a great part of it have been felled . . . the once tangled wood is now a grassy lawn." The unimproved "scenes of solitude from which

the hand of nature has never been lifted, affect the mind with a more deep toned emotion than aught which the hand of man has touched."[100]

It was generally believed in the late eighteenth and early nineteenth centuries that only cultivated man could enjoy uncultivated nature, that "natural scenery can be fully relished only in a populous and long settled country whose face is marked with accumulated operations of art."[101] The idea is expressed by the Englishmen Weld and Strickland, the American Agg, and the French observor De Tocqueville. The pleasurable response to wilderness was not considered by these authors to be either natural or intuitive but rather a matter of education and taste. By the 1840s appreciation of wilderness imagery was one of the hallmarks of a man of breeding.[102] But true wilderness had been experienced by only a few of the people who saw such images. The emotions aroused on viewing a picture were therefore triggered by associations with an aesthetic ideal, not with a particular place. It was assumed that those less educated who lived close to nature could not enjoy the forest for the trees.

As Romanticism took a strong hold on the American mind and as Jacksonian democracy added to the national sense of moral superiority vis-à-vis decadent, aristocratic Europe, the attitude that the common man was insensitive to nature was ques-

PLATE 82. JAMES PEALE, *Landscape near Philadelphia,* 1830.

tioned. If anything, he came to be regarded as having a special relationship with nature that made him responsive to its moral lesson. William Cullen Bryant, one of the first American poets to write feelingly of nature, was central to this development along with his friends Cole, Cooper, and Irving. His view of the forest as God's first temple was echoed by Cooper's hero Deerslayer: "a man of strong, native, poetical feeling . . . [who] loved the woods for their freshness, their sublime solitude, their vastness, and the impress that they everywhere bore of the divine hand of the creator."[103]

In his prospectus for *The American Landscape* of 1830 Bryant addressed the issue of American appreciation of landscape:

> *The perception of her [nature's] charms is not less quick and vivid among our countrymen, nor will we believe that there is wanting either taste to appreciate the truth and effect with which the features are copied, or willingness to reward those who executed the task with success. . . .*[104]

The projected series of picturesque American views which involved the leading landscape painters of the day reportedly was not a financial success because of the inferiority of the engravings. Nevertheless, *The American Landscape* appeared at a time when no one — at least no one in America — would dispute the claim that the New World offered beautiful and sublime scenery comparable if not superior to that of the Old.

Although the pastoral vision of America and the glorification of its rural delights continued, landscape painting focusing on the wilder aspects of nature came to the fore in the 1820s. Artists like Cole were "overwhelmed with an emotion of the sublime" on confronting the rugged scenery of their native land whose silent energy "stirred the soul to its inmost depths."[105] The irony, of course, was that the artistic response to the wilderness, which represented another kind of control over the landscape, came at a time when the primeval setting was rapidly disappearing. The eulogies to the wilderness were in effect elegies by an urban elite for a mythic connection between man and his natural environment.[106]

Cole and Doughty, Codman and Fisher, Shaw and Wall were sensitive to the loss of the wilderness that made America special. And yet it probably was the loss of at least the most fearful aspects of the wild that made it possible for these artists to exploit the subject. Acutely felt because so recent, the loss gave rise to nostalgia. It is this nostalgia, tinged with regret as well as awe, that informs American landscape art after 1825. It is this view that becomes a vision.

PLATE 83. RALPH E. W. EARL, *Cumberland River*, 1823.

NOTES

1. This idea is central to Roderick Nash's *Wilderness and the American Mind* (New Haven: Yale University Press, 1967). Keith Thomas, *Man and the Natural World* (New York: Pantheon, 1983), examines English attitudes, including Puritan ones, toward forests and wilderness between 1500 and 1800.

2. Nash, *Wilderness,* pp. 23–43. Cecelia Tichi, *New World, New Earth* (New Haven: Yale University Press, 1979), discusses the improvement of the American landscape from the Puritans through mid-nineteenth century. Leo Marx, *The Machine in the Garden* (1964; reprint, London: Oxford University Press, 1976), explores the pastoral ideal in America.

3. Henry Nash Smith, *Virgin Land* (1950; reprint, Cambridge, Mass.: Harvard University Press, 1975), examines the idea of the garden as a southern myth

(Chapter 13). Marx (*Machine in the Garden*) and Tichi (*New World*) both deal with the New England (Puritan) view of the inhospitable wilderness and the southern concept of the New World as an Edenic garden.

4. Paul Hulton, *America 1585: The Complete Drawings of John White* (Chapel Hill: University of North Carolina Press and British Museum Publications, 1984).

5. The influence of Claude and other seventeenth-century Italian artists on British art is discussed at length in Elizabeth Wheeler Manwaring, *Italian Landscape in Eighteenth Century England* (1925; reprint, New York: Russell & Russell, 1965). A modern study touching on the same subject is Peter Bicknell, *Beauty, Horror and Immensity: Picturesque Landscape in*

Britain, 1750–1850 (Cambridge: Cambridge University Press, 1981). Although Claude's influence on certain American artists such as Thomas Cole is well known, there is no general study of his impact on American landscape painting.

6. For a recent study of panoramic views, see Ralph Hyde, *Gilded Scenes and Shining Prospects: Panoramic Views of British Towns 1575–1900* (New Haven: Yale Center for British Art, 1985).

7. W. H. Pyne, *Rudiments of Landscape Drawing in a Series of Easy Examples* (London: R. Ackermann, 1812), p. 9.

8. The seminal study on the shift in attitude toward mountainous landscape is Marjorie Hope Nicolson, *Mountain Gloom and Mountain Glory* (1959; reprint, New York: W. W. Norton, 1963).

9. Nash, *Wilderness*, pp. 51–53. William Byrd made his observations when he was surveying the dividing line between Virginia and North Carolina in 1728–1729.

10. John Bartram, *Observations on the Inhabitants, Climate, Soil, Rivers, Productions, Animals . . . made by Mr. John Bartram in his Travels from Pensilvania to Onondago, Oswego, and the Lake Ontario in Canada* (London: J. Whitson and B. White, 1751), pp. 39, 66.

11. Another panel from the same house is also in the collection of the Society for the Preservation of New England Antiquities. For a discussion of American wall decoration, see Nina Fletcher Little, *American Decorative Wall Painting 1700–1850* (Sturbridge, Mass.: Old Sturbridge Village in cooperation with Studio Publications, New York, 1952).

12. For a study of British murals, see Edward Croft-Murray, *Decorative Painting in England, 1537–1837*, 2 vols. (London: Country Life, 1962).

13. J. Hall Pleasants, *Four Late Eighteenth Century Anglo-American Landscape Painters* (Worcester: American Antiquarian Society, 1943), p. 4. Pleasants refers to possible landscapes by Justus Englehardt Kühn (d. 1717) and Nathaniel Emmons (d. 1740), as well as to the thirteen landscapes left in John Smibert's studio in Boston on his death in 1751.

14. Edgar P. Richardson, Brooke Hindle, Lillian B. Miller, *Charles Willson Peale and His World* (New York: Abrams, 1982), p. 46. Also, Charles Coleman Sellers, *Charles Willson Peale* (New York: Scribner's, 1969), pp. 81–82.

15. In 1771 John Cadwalader bought landscapes in England for his house when Peale did not complete a commission to paint some scenes; see Richardson et al., *Peale and His World*, pp. 89–90. Also see Frances Ann Miner, "Landscape in Eighteenth Century America and Its European Sources," M.A. Thesis, University of Delaware, 1969, p. 22.

16. J. Hector St. John Crèvecoeur, *Letters from an American Farmer* (1782; reprint, New York: A. & C. Boni, 1925), p. 9.

17. William Gilpin, *Three Essays* (London: R. Blamire, 1791), [p. 3]. There were many editions of this work. Marquis de Chastellux, *Travels in North America*, trans. by Howard C. Rice, Jr., 2 vols. (Chapel Hill: University of North Carolina Press, 1963) occasionally alludes to American scenery in terms of European painters; e.g., see Vol. I, pp. 84, 172, 226. *Travels* was first published in French in 1786; an English translation followed in the next year. The basic study of the picturesque remains Christopher

Hussey, *The Picturesque: Studies in a Point of View* (1927; reprint, London: Archon Books, 1967). Also see Walter John Hipple, Jr., *The Beautiful, The Sublime and The Picturesque* (Carbondale: Southern Illinois University Press, 1957).

18. William Gilpin, *Observations . . . on Several Parts of England, Particularly the Mountains, and Lakes of Cumberland, and Westmoreland*, 2 vols. (London: R. Blamire, 1792), Vol. I, p. 7.

19. Tichi, *New World*, pp. 84, 108, 156. For a contemporary account of French and English reactions to America, see "America by French Pens," *Port Folio* 4 (August 1814): 188–201. See also Leo Marx, *The American Revolution and the American Landscape* (Washington, D.C.: American Enterprise Institute for Public Policy Research, 1974), for a discussion of the influence of landscape on American political and social attitudes, especially at the time of the Revolution.

20. William Gilpin, *Remarks on Forest Scenery*, 2 vols. (London: R. Blamire, 1791), Vol. II, p. 166.

21. William Gilpin, *Observations on the River Wye* (London: R. Blamire, 1792), pp. 75, 76, 99.

22. Gilpin, *Three Essays*, p. 46. For an American reaction see Washington Irving, "The Sketch Book of Geoffrey Crayon, Gent." (1820), in *Washington Irving* (New York: Library of America, 1983), p. 744. See Chastellux, *Travels*, p. 118, for mention of a picturesque industrial ruin.

23. Gilpin, *Forest Scenery*, Vol. I, pp. 8–9, 14.

24. Archibald Robertson, *Elements of the Graphic Arts* (New York: Longworth, 1802), pp. 5, 10.

25. A study of this development is Arthur O. Lovejoy, *The Great Chain of Being* (1936; reprint, Cambridge, Mass.: Harvard University Press, 1964); see in particular pp. 288–314.

26. William Bartram, *Travels through North and South Carolina, Georgia, East and West Florida . . .* (Philadelphia: James and Johnson, 1791), Intro., pp. 13, 212, 229.

27. Hans Huth, *Nature and the American: Three Centuries of Changing Attitudes* (Berkeley: University of California Press, 1957), pp. 21, 31. For the influence of Bartram's *Travels* on Coleridge, e.g. on *Kubla Khan*, see J. L. Lowes, *Road to Xanadu* (1927; reprint, Princeton: Princeton University Press, 1986).

28. Timothy Dwight, *Travels in New-England and New-York*, 4 vols. (1821; reprint, Cambridge, Mass.: Harvard University Press, 1969), Vol. I, pp. 77, 94.

29. Two examples are Jacques Pierre Brissot, *New Travels in the United States of America* (London: J. S. Jordan, 1794), p. 70; and Thomas Cooper, *Some Information Respecting America* (London: J. Johnson, 1795), p. 104.

30. Isaac Weld, *Travels through the States of North America and the Provinces of Upper and Lower Canada*, 2 vols. (1807; reprint, of 4th ed., New York: Johnson Reprint Co., 1968), Vol. I, pp. 39, 224, 231, 301. Thomas Jefferson, *The Life and Selected Writings*, ed. with Intro. by Adrienne Koch and William Peden (1944; reprint, New York: Random House, 1972), pp. 192–193, 196–197.

31. William Strickland, *Journal of a Tour of the United States (1794–1795)*, ed. J. E. Strickland (New York: New-York Historical Society, 1971), p. 197.

32. *Ibid.*, p. 33.

33. For discussions of this image in American art,

see Barbara Novak, "The Double-Edged Axe," *Art in America* 76 (January–February 1976): 44–50; and Nicolai Cikovsky, Jr., "The Ravages of the Axe: The Meaning of the Tree Stump in Nineteenth Century American Art," *The Art Bulletin* 61 (December 1979): 611–26. Also see Barbara Novak, *Nature and Culture* (New York: Oxford University Press, 1980), pp. 157–165.

34. For a discussion of the pastoral ideal in America and its relationship to English literature, see Marx, *Machine in the Garden,* pp. 73–144. The concept of the farmer in the foundation of the American way of life is discussed in Loren Baritz, *City on a Hill: A History of Ideas and Myths in America* (New York: Wiley, 1964), pp. 100–103.

35. William Dunlap, *History of the Rise and Progress of the Arts of Design in the United States,* 3 vols. (1834; reprint, New York: Benjamin Blom, 1965), Vol. II, p. 78.

36. William Birch, "The Life of William Russell Birch, Enamel Painter, Written by Himself," typescript, New York Public Library, p. 48.

37. See, e.g., James Malton, *A Picturesque and Descriptive View of the City of Dublin* issued in six parts between 1792 and 1799, and published as a set in London, 1799. Also see the work by his brother, Thomas Malton, Jr., *A Picturesque Tour through the Cities of London and Westminster* (London, 1792).

38. William Birch, *The Country Seats of the United States of North America* (Springland, Pa.: W. Birch, 1808), unpaged, sheet 4 on "Belmont."

39. See, e.g., William Watts, *The Seats of the Nobility and Gentry,* issued serially between 1779 and 1786; William Angus, *The Seats of the Nobility and Gentry in Great Britain and Wales,* between 1787 and 1797; and Thomas Milton, *Seats and Desmenes of the Nobility and Gentry of Ireland,* between 1783 and 1793. The work of John James Barralet, who had immigrated to Philadelphia about the same time as Birch, is represented in the Milton volume.

40. For the availability of works by Price, Knight, and Repton, see Janice G. Schimmelman, "A Checklist of European Treatises on Art and Essays on Aesthetics Available in America through 1825," *Proceedings of the American Antiquarian Society* 93 (1983): 137, 148. Price's work was also recommended to readers of Robertson's *Elements* (p. 10).

41. "Thoughts of a Hermit . . . ," *Port Folio* 6 (July 1815): 85.

42. John Filson, *The Discovery, Settlement and Present State of Kentucke* (1784), quoted in Smith, *Virgin Land,* p. 129; for similar sentiments, see Tichi, *New World,* p. 83.

43. The views by Beck are at Mount Vernon. Washington also owned a number of landscape prints by European artists, see Miner, "Landscape," pp. 128–132. For discussion of the Winstanleys and Becks owned by Washington, see William Barrow Floyd, "The Portraits and Paintings at Mount Vernon from 1754 to 1799, Part II," *Antiques* 100 (December 1971): 894–899. Also see James Thomas Flexner, "George Washington as an Art Collector," *American Art Journal* 4 (September 1972): 24–25.

44. See note 30 above. Jefferson possessed oils by Roberts of these two sites and was owner of the land on which Natural Bridge stood. See Barbara C. Batson, "Virginia Landscapes by William Roberts," *The Journal of Early Southern Decorative Arts* 10 (November 1984): 34–49.

45. Jefferson in 1771 remarked that Burke's *Philosophical Enquiry into the Origins of Our Ideas of the Sublime and Beautiful* (1757) should be in a gentleman's library (Schimmelman, "Checklist of European Treatises," p. 101); also see pp. 112–120, for availability of the work in America.

46. For a discussion of Trumbull as a landscape painter and mention of this work, see Bryan Wolf, "Revolution in the Landscape: John Trumbull and Picturesque Painting," in *John Trumbull,* ed. Helen Cooper (New Haven: Yale University Art Gallery, 1982), pp. 212–214.

47. Among those who painted Niagara before 1830 are John Vanderlyn, Ralph Earl, John Trumbull, and Alvan Fisher. For a discussion of Niagara as a subject in art and as a national symbol, see Jeremy Elwell Adamson, "Nature's Grandest Scene in Art" and Elizabeth McKinsey, "An American Icon" in *Niagara: Two Centuries of Changing Attitudes, 1697–1901* (Washington, D.C.: Corcoran Gallery of Art, 1985). Also see Elizabeth McKinsey, *Niagara Falls: Icon of the American Sublime* (Cambridge and New York: Cambridge University Press, 1985).

48. Strickland, *Journal of a Tour,* pp. 94, 185.

49. William Darby, *A Tour from the City of New York to Detroit* (1819; reprint, Chicago: Quadrangle Books, 1962), p. v.

50. Timothy Bigelow, *Journal of a Tour to Niagara Falls in 1805* (1805; reprint, Boston: J. Wilson, 1876), p. 45.

51. T. C., "A Ride to Niagara," *Port Folio* 4 (July 1810): 53.

52. John James Audubon, "The Ohio," *Delineations of American Scenery and Character* (1826; reprint, New York: Arno, 1920), p. 4; also Nash, *Wilderness,* p. 97 and Tichi, *New World,* p. 154.

53. Strickland, *Journal of a Tour,* p. 234.

54. "Description of the Plate," *New York Magazine* 2 N.S. (September 1797): 449.

55. Dwight, *Travels,* Vol. IV, p. 177. Darkness and solitude — as found in a gloomy forest, for instance — were an aspect of Burke's category of the sublime.

56. Alexander Wilson, "The Forester," *Port Folio* 1 (June 1809): 538. For a study of Thomson's important poem *The Seasons,* first published in England in its entirety in 1730, see Ralph Cohen, *The Art of Discrimination* (Berkeley: University of California Press, 1964).

57. T. C., "A Ride to Niagara," *Port Folio* 4 (August 1810): 164.

58. Irving, "The Sketch Book," p. 744. In the same breath, Irving, who had just left for Europe, explained that his reason for going was to see the masterpieces of art and enjoy the refinement of society not available in America. He remained abroad a number of years.

59. Quoted in Huth, *Nature and the American,* p. 78.

60. James Fenimore Cooper, *The Prairie* (1827; reprint, New York: New American Library, 1980), pp. 260, 384.

61. George Murray, "Progress of the Fine Arts: Address Delivered before the Society of Artists of the United States, on the first of August, 1810," *Port Folio* 4 (September 1810): 261.

62. Joseph Hopkinson, "Annual Discourse," *Port Folio* 4, No. 6 (December 1810): Supplement, 33. Hopkinson had earlier (1798) written the words for *Hail, Columbia*.

63. The subject is treated in H. Lloyd Flewelling, "Literary Warfare: Literary Criticism in American Magazines 1783–1820," Ph.D. dissertation, University of Michigan,1931, pp. 179–221. See Irving, "English Writers in America" in "The Sketch Book" (pp. 786–794); and James Kirke Paulding, *A Sketch of Old England by a New-England Man,* 2 vols. (New York: Wiley, 1822).

64. For a study of developments in the provinces, see Trevor Fawcett, *The Rise of English Provincial Art: Artists, Patrons, and Institutions outside London 1800–1830* (Oxford: Clarendon Press, 1974).

65. See Miner, "Landscape," pp. 128–132. Paulding, *A Sketch of Old England,* mentions availability of English landscape prints; Vol. I, p. 60.

66. See, e.g., the advice given to Charles Lawrence: G. M. [George Murray?], "Review of the Second Annual Exhibition," *Port Folio* 8 (July 1812): 28. Among artists who exhibited copies after landscapes by old masters were John Wesley Jarvis (American Academy, 1818); Samuel Scarlett (Pennsylvania Academy, 1825); Joshua Shaw (Pennsylvania Academy, 1818); Thomas Doughty (Pennsylvania Academy, 1829). See Frank H. Goodyear, Jr. *Thomas Doughty* (Philadelphia: Pennsylvania Academy of the Fine Arts, 1973), p. 13, for mention of the role copying Old Masters played in Doughty's development as an artist.

67. The basic study is Lillian B. Miller, *Patrons and Patriotism: The Encouragement of the Fine Arts in the United States 1790–1860* (Chicago and London: University of Chicago Press, 1966). Also see Neil Harris, *The Artist in American Society: The Formative Years 1790–1860* (1966; reprint, Chicago and London: University of Chicago Press, 1982), esp. pp. 98–107. Additional information on owners and lenders can be found in the published records of the Boston Athenaeum, American Academy, National Academy of Design, and Pennsylvania Academy.

68. A listing of Birch's extensive collection as well as notations on purchasers appear in his unpublished autobiography (see note 36 above), pp. 30–36, 45–46.

69. See, e.g., praise for an anonymous woman painter from Virginia: M. [George Murray?], "Review," *Port Folio* 2 (August 1813): 131; 4 (July 1814): 99.

70. "The Fine Arts," *Port Folio* 7 (May 1812): 464; 8 (August 1812): 156; 8 (September 1812): 284.

71. Among works published in America were Johnson and Warner, *A Drawing Book of Landscapes* (1810); William Charles, *A Drawing Book of Rural Scenery* (1814); Fielding Lucas, *The Art of Colouring and Painting Landscape in Water Colours* (1815), and *Progressive Drawing Book* (1827–1828); John Varley, *A Practical Treatise on Perspective* (c. 1819); *The Art of Drawing Landscapes by an Amateur* (1820); John Hill, *Drawing Book of Landscape Scenery* (1821). Peter Marzio in *The Art Crusade* (Washington, D.C.: Smithsonian Institution Press, 1976) analyzes American drawing manuals between 1820 and 1860. English books were also available.

72. Robert Vaux to James Pemberton Parke, July 18, 1807, Vaux Papers, Historical Society of Pennsylvania, Philadelphia.

73. Allusions to associationism appear in print in America as early as 1809; see, e.g., Analyticus, "Sympathy," *Port Folio* 2 (December 1809): 537. Specific references to landscape occur in *Port Folio* 2 (November 1809): 419; *Analectic Magazine* 3 (May 1814): 356; *Port Folio* 5 (May 1811): 449. See Shimmelman, "Checklist of European Treatises," pp. 107–111, for the availability of Alison's work in America. Historical associations are integral to the images and text of *The Hudson River Portfolio*. William Cullen Bryant in *Lectures on Poetry* (1825) reveals his familiarity with the principles. Also see Ralph N. Miller, "Thomas Cole and Alison's *Essays on Taste*," *New York History* 37 (1956): 281–299.

74. Joshua Shaw, *U.S. Directory for the Use of Travellers and Merchants* (Philadelphia: J. Maxwell, 1822), p. 142. William Combe's *The Tour of Dr. Syntax in Search of the Picturesque* with illustrations by Thomas Rowlandson was published serially in London between 1809 and 1811. It appeared as a separate volume in 1812 and was issued in Philadelphia around 1817–1819.

75. John Neagle, "Receipts," MS, American Philosophical Society [p. 57], mentions Shaw's discussion of de Loutherbourg's use of orange orpiment in his sunny effects and in his fire. In 1808, Hill reengraved de Loutherbourg's *Picturesque Scenery of Great Britain,* first issued in 1801.

76. Although *Night Scene* is believed to be a view of the Delaware River near Philadelphia, Shaw exhibited at the Pennsylvania Academy in 1819 *View of the Isle of Wight, by Moonlight,* which this conceivably could be. *View in the Pennsylvania Countryside* is presumed to be a Pennsylvania landscape because of the inscription "Philada"; however, this could mean simply that the work was executed there. In any case, the scene as well as the distant estate is as suggestive of England as of America.

77. In this case Wilson's *The White Monk,* of which there are over twenty versions; see David Solkin, *Richard Wilson* (London: Tate Gallery, 1982), pp. 214, 215.

78. Raymond J. O'Brien, *American Sublime: Landscape Scenery of the Lower Hudson Valley* (New York: Columbia University Press, 1981), p. 71; Irving, "A History of New York," p. 625 and "The Sketch Book," p. 774.

79. The following notation appears on the bottom of a watercolor by Wall, *View of New York from Brooklyn* (Philadelphia Print Shop): "Wall's style of painting before he came to me, in a year after I got him engaged to Megary — to paint the subjects of the Hudson River Portfolio — in return he gratefully tried to ruin me in Business — Ingratitude JRS." The work is mistakenly annotated "1825–28," presumably by Smith. The date must be wrong in view of Wall's painting trip up the Hudson in 1820, the commencement of the publication in 1821, and the elimination of Smith as the aquatinter around the same time. Presumably Wall and Smith, and perhaps Megary the publisher, had a falling out.

80. W. Gilpin, *Observations . . . Cumberland and Westmoreland,* Vol. I, p. 69; Vol. II, p. 100.

81. The project was initially conceived as a multivolumed "History of the Principal Rivers of Great

[see above]

Britain," but only the book on the Thames was published with six unrelated views.

82. Carole Fabricant, "The Aesthetics and Politics of Landscape in the Eighteenth Century," *Studies in Eighteenth-Century British Art and Aesthetics,"* ed. Ralph Cohen (Berkeley: University of California Press, 1985), p. 70.

83. One of the earliest depictions of the artist sketching in a landscape is *A South View of the Great Falls of the Genesee River on Lake Ontario* (1761) by Thomas Davies. The work was engraved as part of *Six Views of North American Waterfalls* (c. 1768).

84. G. M., *Port Folio* (July 1812): 19.

85. Irving, "A History of New York," p. 489.

86. *Ibid.*, pp. 412–419; and "The Sketch Book," pp. 1002–1012.

87. Wilson, *Port Folio* 2 (November 1809): 457.

88. "The Indian," *Port Folio* 4 (November 1810): 517.

89. Quoted in Arthur A. Ekirch, Jr., *Man and Nature in America* (1963; reprint, Lincoln: University of Nebraska Press, 1973), p. 24.

90. In *The Pioneers,* Cooper describes this landscape at a time when "not a dozen white men have ever laid eyes on it" (p. 281).

91. Dunlap, *History*, Vol. III, p. 32.

92. In 1794 Strickland comments on the peculiar light of "the American sky"; *Journal of a Tour,* p. 39.

93. Barbara Novak, *American Paintnig of the Nineteenth Century* (New York: Praeger, 1969), p. 66.

94. Harold Edward Dickson, ed., "Observations on American Art: Selections from the Writings of John Neal (1793–1876)," *Pennsylvania State College Bulletin* 37 (February 5, 1943): 46.

95. Novak, *American Painting of the Nineteenth Century,* pp. 66–67.

96. William H. Gerdts, "Washington Allston and the German Romantic Classicists in Rome," *Art Quarterly* 32 (Summer 1969): 166–196.

97. See note 75. Doughty, who lived near Shaw in Philadelphia, was in artists' organizations with both Neagle and Shaw and exhibited at the Pennsylvania Academy with them. Cole would have seen the work of Shaw when he was in Philadelphia in the early 1820s. Shaw also contributed articles on artists' materials to the *Journal of the Franklin Institute* in 1827 and 1832.

98. Novak explores at length the synthesis of the real-ideal dichotomy in *American Painting of the Nineteenth Century.*

99. This conflict is implicit in Irving's explanation for his going to Europe despite his admiration for American scenery, "The Sketch Book," pp. 743–744.

100. Thomas Cole, "Essay on American Scenery" (1835), quoted in John W. McCoubrey, *American Art 1700–1960: Sources and Documents* (Englewood Cliffs, N.J.: Prentice-Hall, 1965), p. 102.

101. "Thoughts of a Hermit . . . ," *Port Folio* 6 (July 1815): 85.

102. Nash, *Wilderness,* p. 60.

103. William Cullen Bryant, "A Forest Hymn" (1825), in Tremaine McDowell, *William Cullen Bryant: Representative Selections, with Introduction, Bibliography, and Notes* (New York: American Book Co., 1935), p. 49; James Fenimore Cooper, *The Deerslayer* (1841; reprint, New York: New American Library, 1980), p. 267.

104. Quoted in John Durand, *The Life and Times of A. B. Durand* (1894; reprint, New York: Kennedy Graphics, 1970), p. 73.

105. Cole, "American Scenery," p. 104.

106. Carl G. Jung, et al., *Man and His Symbols* (1964; reprint, New York: Dell, 1981), p. 85. In "Approaching the Unconscious," Jung explores, among other things, the symbolic connection between man and nature, a connection which seems to have relevance to the American experience in the early nineteenth century.

BRUCE ROBERTSON

Venit, Vidit, Depinxit
The Military Artist in America

AFTER THE DISCOVERY OF THE NEW WORLD by Europeans, those who stayed at home were treated to reports of the curiosities to be found there — the plants, the animals, the people. But not for over two centuries were they able to visualize America's greatest wonder, the landscape itself. With few exceptions the first landscape views of North America were engravings made after sketches by British military officers. Throughout the second half of the eighteenth century, British officers were the primary sources of visual information, and they continued to be important as long as the British military presence lasted, which in Canada was 1867. The views these men rendered were often the first to identify major topographical features and to establish many of the important themes in American landscape painting. They had an enduring influence, not only on the way Europeans perceived America, but also on the development of the American landscape tradition.

The Context of Military Draftsmanship

The ability to sketch was not unusual among military men in the eighteenth century, for drawing was an accomplishment required of all military cadets. It was part of the curriculum of the Royal Military Academy at Woolwich, founded in 1743, which principally trained officers for the Royal Corps of Engineers and the Royal Artillery Corps, and also of the Naval Academy at Portsmouth, founded in 1733. The two branches of the military seem to have had different expectations. Navy officers were encouraged to develop the skill in order to draw coastal outlines for navigation purposes. Drawing was less regularly practiced in the army, and then was used to locate defensive and offensive positions, describe fortifications, and record battles. Draftsmen were specialized within the Engineers and the Artillery, under the aegis of the Board of Ordnance and hardly part of the regular army.[1] The Ordnance also ran its own Drawing Room at its headquarters in the Tower of London, as well as hired civilian draftsmen for much of its work.

The majority of drawings produced by military artists was exceedingly uniform and crude. The official work required was of the most limited kind: maps and surveys of fortifications, with only an occasional perspective view of a building or landmark. Based on French models established by 1700, the style of this official work remained nearly constant during the late eighteenth and early nineteenth centuries.[2] Pen and ink

outlines, with either monochrome washes or a few schematized tints, set out a pan-oramic vista from an elevated viewpoint. The foreground was usually decorated with lounging soldiers; the fortifications were in the middle distance with a vista beyond them. A great body of this material survives in the Public Record Office, London, and in the Map Room of the British Library. Of great historical interest, it is of limited aesthetic power. However, a significant number of military artists drew American views for their own pleasure or for their patrons back in England. Some, sensing the commercial possibilities, published their views for a wider audience, and it is this group which is of central concern.

Military artists did not restrict themselves to military subjects. Any officer with artistic pretensions beyond the limited scope of the curriculum of his academy would have hired a private drawing master for additional lessons. These private masters were apt to be changed from year to year until the student found one he liked, developed his own style, or lost interest.[3] Drawings of the best military artists reflect the styles currently popular and are indistinguishable from those of other amateurs and profes-sionals of the time. The well-trained officers who came to the New World for over a hundred years found time to record the landscapes around them, often the wildest and least explored terrain. The unifying thread in their work is the experience of the wil-derness, an experience essentially American.

The French and Indian War

Numerous military views exist from the French and Indian War of 1755 to 1763 in North America, which was just one aspect of the worldwide conflict between France and Great Britain. Although French and British troops had previously engaged each other three times in this arena, in this war both nations committed their forces mas-sively to the New World for the first time. Moreover, for over a decade Britain had been building up and modernizing her military establishment, and thus for the first time a large number of trained landscape draftsmen were active in America.

The victory of General James Wolfe at Quebec in 1759 was greeted with wild enthusiasm in England, prompting several artists and publishers to capitalize on pub-lic interest with views of battlefields and landmarks. The taste for landscape engrav-ings had increased significantly in the previous decade and a half, and there were a number of professional engravers in London able to undertake the work. This fortu-nate convergence of opportunity and talent produced engravings that were widely circulated in both Europe and America for over fifty years.

The first publishing venture was a set of *Six Elegant Views of the Most Remarkable Places in the River and Gulph of St. Lawrence* after Captain Hervey Smyth, published on November 5, 1760. *Six Remarkable Views in the Provinces of New-York, New-Jersey, and Pensylvania,* after Thomas Pownall, followed on May 20, 1761. Seven years later, these twelve and sixteen others (nearly all by officers) were bound together and issued as *Scenographia Americana.* Over the next twenty years *Scenographia* was augmented until it included more than seventy views of varying size and quality. The original, however, was an expensive folio volume of high quality, featuring views of cities, harbors, naval battles, West Indian scenes,[4] and a number of landscapes. The views after Smyth and Pownall are the most impressive and were copied into the nineteenth century.[5]

The only information on Hervey Smyth appears in the legend of the engravings: he was an aide-de-camp to General Wolfe. On the other hand, a great deal is known about Pownall. A colonial governor and military commander, he wrote tracts on ad-ministration and topography. Smyth's views, in keeping with his military duties, depict naval operations on the Saint Lawrence. Pownall's present scenic attractions

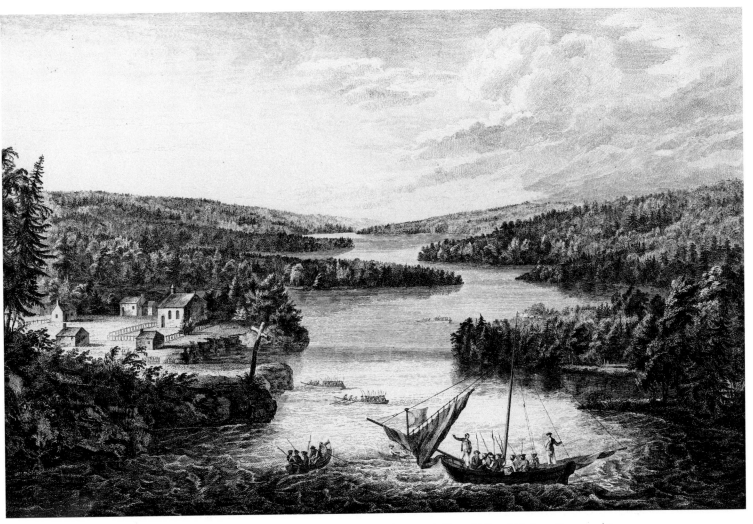

PLATE 84. PAUL SANDBY and P. BENAZECH after HERVEY SMYTH, *A View of Miramichi,* from *Scenographia Americana,* 1768.

along the East Coast. Both, however, emphasize the wildness and the vastness of the landscape. In Smyth's ostensibly military views, ships and men are dwarfed by the panoramas. Giant waterfalls and rocks break the face of heavily wooded cliffs. In *View of Miramichi* (Plate 84), the elevated viewpoint underscores the width of the river, the breadth of the sky, the stretch of coniferous wilderness. Pownall's views are generally less expansive, concentrating on a central subject—a waterfall (Plate 85) or settlement. But in his, too, the human element looks insignificant set amidst American nature.

Until these engravings appeared, depictions of actual wilderness were almost nonexistent in European art. The natural scenery of the English Lake District, Wales, and Scotland, as well as the Alps, was only just beginning to be appreciated. Although engraved imaginary landscapes of Gaspard Dughet and Claude-Joseph Vernet depicted nature in a wild state, topographical views of rugged scenery were usually confined to domesticated landscapes. For example, the waterfalls and rocky outcroppings of Derbyshire estates portrayed in Thomas Smith of Derby's engravings of the 1740s paled before the vaster sublimity of America.

Precedents for panoramic compositions can be found in European scenes, but in American views the landscape looms larger, the figures become smaller. This change in proportion would have struck the eighteenth-century eye forcefully. In his description of America published at the time of the Revolution, Pownall mentions several times the difficulties of getting the scale correct. He found some scenes "so astonishingly great, that none but those who have made the Trial know how difficult it is to bring up the Scale of the ordinary Objects to this, which is (as it were) beyond the

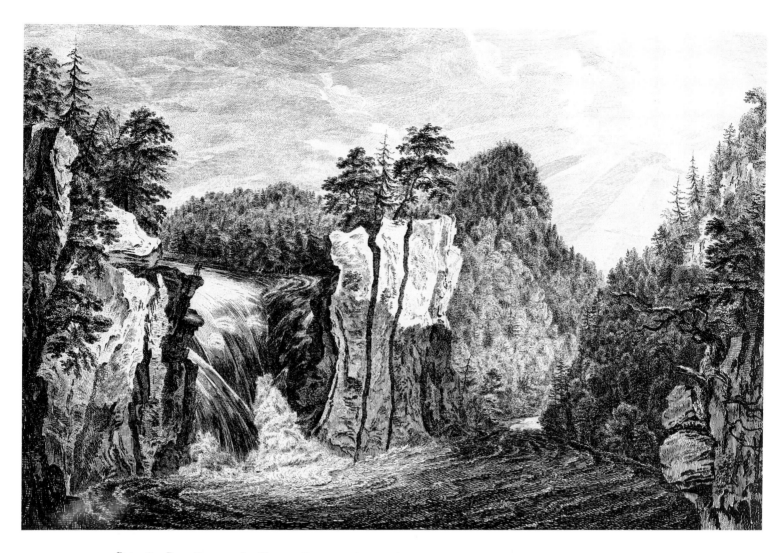

PLATE 85. PAUL SANDBY after THOMAS POWNALL, *A View of the Falls on the Passaick*, 1761.

Garb of Nature."[6] It can be argued that the new scale found in the engravings after Smyth and Pownall in turn influenced the development of European landscape painting. Like so much else about the European discovery of the New World, what had been merely imagined in the Old — true freedom, true wilderness — was discovered to exist in the New, in undreamed-of magnitude.

The engravings in the *Scenographia* were also important for the attention they gave to specific sites, many of which remained tourist attractions for over a century, until commercial exploitation destroyed them and the opening of the Far West substituted new wonders. The two great American rivers for the British in the eighteenth century were the Saint Lawrence and the Hudson. They were in Anglo-American territory and were accessible. Although occasionally depicted by French artists, the Mississippi did not offer the picturesque variety of the two eastern rivers. Tourism was naturally focused on scenic features located along major routes: Pownall and Smyth provided the first views of the Catskills (Plate 86), Cohoes Falls on the Mohawk (a tributary of the Hudson), Montmorency Falls on the Saint Lawrence. Pownall also published a view of the only major waterfall close to New York City, within reach of all visitors — Passaic Falls in New Jersey.

The engravings established a number of motifs and themes explored repeatedly in American landscapes. Waterfalls assumed an importance for topographical landscape which they had not had before, particularly Niagara, which came to symbolize the American continent. More important was the emphasis given to wilderness. Smyth's views convey a sense of the expanse of the American landscape and man's

PLATE 86. PAUL SANDBY after THOMAS POWNALL, *A View in Hudson's River of Pakepsey and the Catts-Kill Mountains,* 1761.

isolation within it. In *A View of Miramichi,* for example, the Acadian settlement is swallowed up by the wilderness around it. Even the wooden cross which marks the village is rough; like the trees, it tilts out across the water, away from the houses. For an English audience this cross in the wilderness would have been a reference to the Jesuit presence in the French colonies. Yet its harmony with its surroundings might also have suggested one way of approaching the wilderness — the French way of sinking into it, working in accord with the Indians and the forest.

Pownall's imaginary *An American Settlement or Farm* (Plate 87) suggests the potential of America. On the left bank of the river is a rude log cabin overshadowed by pine trees; on the right, in sunlit fields and orchards, is a prosperous farm. Pownall writes that although traveling on rivers "through Parts not yet settled" was astonishingly picturesque, "with what an overflowing Joy does the Heart melt, while one views the Banks where rising Farms, new Fields, or flowering Orchards begin to illuminate this Face of Nature; nothing can be more delightful to the Eye, nothing go with more penetrating Sensation to the Heart." He makes a similar point when describing the Moravian community at Bethlehem, Pennsylvania: "The Place itself makes a delightfull landskip but found, & thus seen in the center of a wilderness, derives unusual beauty from the contrast & surprise with which it presents itself."[7] *Settlement* visualizes the colonists' relationship to the land: the settler transforms the wilderness into a landscape of pastoral contentment. Pownall's image may well be the first pictorial expression of this common theme in American culture.[8]

Thomas Davies

No original drawings by Smyth or Pownall have been discovered, so it is impossible to discuss the quality of their designs, which may have been substantially altered by the

PLATE 87. JAMES PEAKE after THOMAS POWNALL and PAUL SANDBY, *A Design to Represent the Beginning and Completion of an American Settlement or Farm,* 1761.

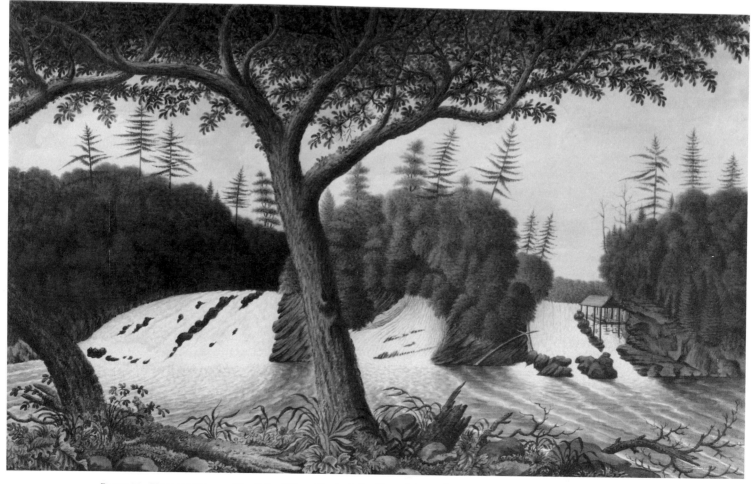

PLATE 88. THOMAS DAVIES, *The Falls of Otter Creek, Lake Champlain, with a Saw Mill,* 1766.

professional artists who produced the engravings. A number of drawings do exist by officers in the French and Indian War, but they are generally crude renderings of fortifications done by Ordnance draftsmen. One notable exception is the work of Thomas Davies.[9] Davies entered the Royal Military Academy in 1755 and was commissioned in the Artillery Corps in 1756, serving in North America from 1757 until 1790, with several extended periods in England. In style and technique his early work is military in the use of strong outlines and schematic color, but his later drawings are close to the decorative, linear touch of William Pars, or even Francis Towne, watercolor artists who were Davies' contemporaries in Britain.[10] Davies' compositions are important and distinctive for the way in which he distorts and mythologizes the American landscape.

Davies' earliest watercolors date from 1757. Around 1763 a set of engravings of waterfalls, dedicated to his patron Lord Amherst, commander in chief of the British forces in North America, was printed and probably circulated privately at first (Plate 88).[11] Davies also exhibited several paintings in the early 1770s at the Royal Academy, most notably a view of Fort Ticonderoga in 1774 (see Plate 7).

The prints, probably inspired by Pownall's, are rather crudely engraved. Davies had neither the money nor the commercial backing that Smyth and Pownall enjoyed. One of his strengths, however, was his interest in accuracy: his views of Cohoes Falls (the sketch is in the Library of Congress) and Passaic Falls (Fig. 15) corrected Pownall's distortions. Davies was recognized for his scientific interests by election to the Royal Society in 1781. His artistic sensibility is evident in dramatic compositions and romantic motifs. *Niagara Falls from Above* (Fig. 16) is paradigmatic: the river twists away in a strong arc; above it floats an eagle, presented head-on like the dove appearing to Moses after the Flood. The successful compositional solution to the problem of representing both the Horseshoe Falls and American Falls simultaneously and dramatically from the upper banks, represented in the engraving of the same subject, was employed by later artists.[12] Davies' other dramatic solutions to topographical dilemmas were also influential. The views of Passaic Falls were copied by Benjamin Latrobe in 1799 and the engraving of *The Lower Cataract on the Casconchiagon* (the lower falls of the Gene-

FIG. 15. THOMAS DAVIES, *South View of Passaic Falls, New Jersey,* 1766. Watercolor. Royal Ontario Museum, Toronto.

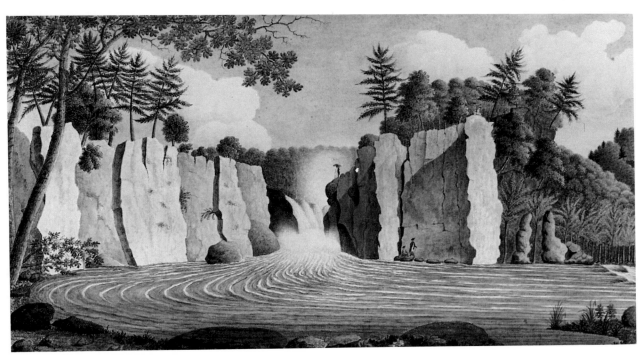

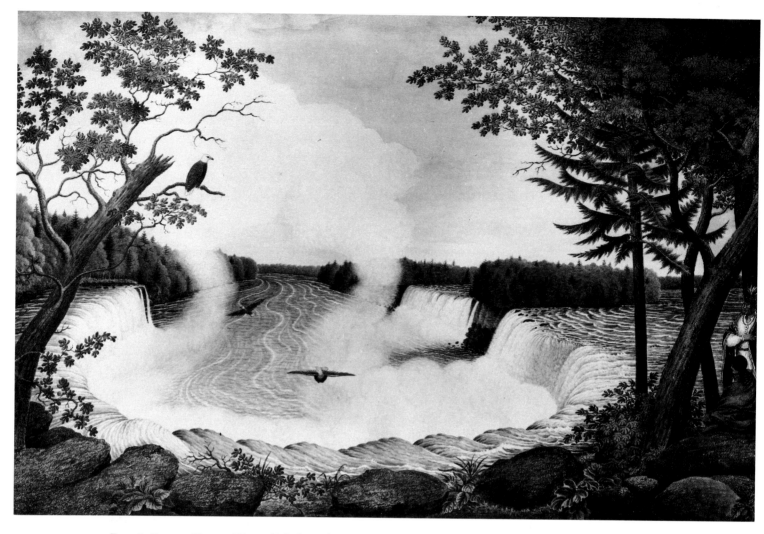

Fig. 16. Thomas Davies, *Niagara Falls from Above*, c. 1766. Watercolor. The New-York Historical Society.

see at Rochester, New York) may be the model for Thomas Cole's and William Guy Wall's scenes of the Kaaterskill Falls (see Plates 63 and 65).

Davies also introduces mythologizing elements — American birds, animals, and Indians — that reinforce the meaning of the composition. His sources can be found in the cartouches of decorated maps, where emblematic Indians stand beside beavers and eagles. Davies was not the only military artist to employ these motifs, but he animates the device by setting the figures naturally within the landscape.[13] Hunting, fishing, or quietly conversing, his Indians populate an Arcadian landscape.

The work of only a few military artists reached the public through engravings and exhibitions at the Society of Artists and the Royal Academy; the rest was quickly interred in official archives. A few officers, however, were able to make their work known in military, artistic, and scientific circles. Captain Thomas Howdell (active 1747–d.1771), contributor of two views of New York to the *Scenographia,* was an "Enthusiast of the Arts." So close were his friendships with artists that on his departure from London in 1766, Thomas Jones (a student of the leading British landscape painter Richard Wilson) and his friends formed the Howdalian Society in his honor, with the painter John Hamilton Mortimer as president.[14] Sir Joshua Reynolds, president of the Royal Academy, owned a drawing of the Saint Lawrence by Davies, which was probably given to him by Davies' patron, Lord Amherst, to use in the background of the general's portrait. Davies himself seems to have supplied two drawings of Passaic Falls to the Reverend Andrew Burnaby for the third edition of Burnaby's *Travels through the Middle Settlements in North America,* published in 1798.[15] Within six

months Latrobe was viewing Passaic Falls through the prism of Davies' drawings. Latrobe's revisions bring Davies up to date — no Indians, different trees in the foreground — but do not significantly alter the compositions. Davies probably influenced fellow military artists directly. It is possible to detect his influence in the work of James Erskine, Thomas Anburey, James Hunter, Edward Hern, and Ralph Gore.[16]

Smyth, Pownall, and Davies were the best military artists from the French and Indian War. During the following decade the number of landscapes slowed to a trickle as the British garrison was reduced. The next large body of views was produced during the American Revolution.

The American Revolution

In the work done between 1775 and 1783 one might reasonably expect to see the influence of **Paul Sandby**, Chief Drawing Master at the Royal Military Academy since 1768. He was one of the most influential watercolor artists in England and one of the most prominent drawing masters in London in the 1760s and 1770s. Sandby rendered Pownall's drawings into paintings and etched several of the prints, as well as one of Smyth's. His influence on the work of military artists in North America is invariably emphasized by historians of the subject,[17] but it is actually curiously weak. For one reason, very few officers who actively sketched were trained at the Royal Military Academy; the majority of the artillery officers and engineers whose training is known received it in the Drawing Office of the Board of Ordnance in the Tower of London. Since records are not complete, evidence of influence must be based on style as much as documents. For example, the use of etched outline, one of Sandby's favorite teaching tools, was employed by a few officers: Archibald Robertson, James Peachey, and Joseph F. W. DesBarres.[18] None of these artists, however, could have studied with Sandby, although they would certainly have been familiar with his work and might well have been acquainted with him. The number of Sandby's known students increases in the 1780s and early 1790s. But the careers of the most prominent — George Heriot and James Pattison Cockburn — illustrate the general truth that any cadet with artistic talent and ambition studied with private drawing masters; very few of Sandby's military students retained much allegiance to their official drawing master.

The style of military artists during the American Revolution is slightly more sophisticated than it was earlier, as exemplified by Peachey, who worked as a surveyor for the provincial government of Quebec. His carefully constructed landscapes, less inventive than Davies', are populated by elegantly disposed figures (Plate 89). But few landscape engravings were produced during the Revolutionary period. British audiences were more interested in who the rebels were than where they fought. The major publishing venture was an official one: the *Atlantic Neptune,* supported by the Admiralty, was issued to British captains who had to ply North American waters during the war. Of no set size, it included over two hundred charts and coastal profiles, as well as about seventeen landscape views, in four volumes. The engineer responsible was Joseph F. W. DesBarres. After the French and Indian War he was active as a surveyor in the Canadian territories, and these surveys were the basis for the *Atlantic Neptune.*

Although landscapes were an incidental part of the *Atlantic Neptune,* and not included with every copy, they are nonetheless striking additions to the corpus of American views. Perhaps their most significant feature is the medium. Originally published in etched outline, they were enhanced by the addition of aquatint washes beginning late in 1778 or 1779, becoming the first aquatints of American subjects. Aquatint had been commercially viable for only three years, through the efforts of Paul

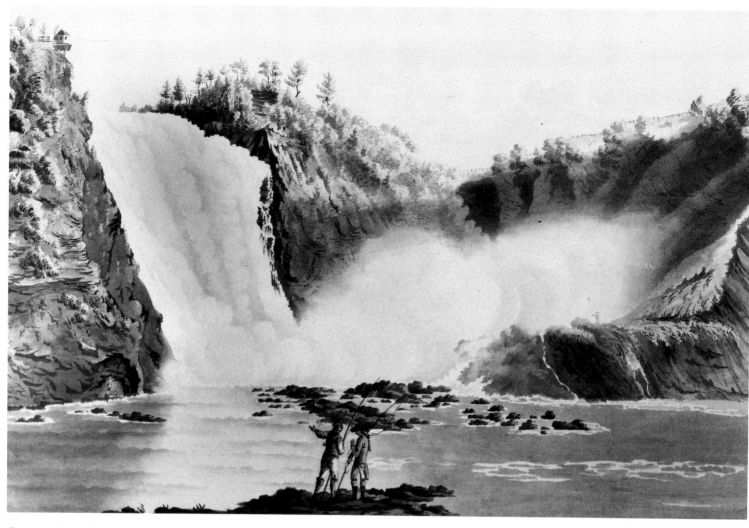

PLATE 89. JAMES PEACHEY, *A View of the Falls of Montmorency*, 1783.

PLATE 90. JOSEPH F. W.
DESBARRES, *A View of the
Entrance of Port Hood*, from
The Atlantic Neptune, 1773.

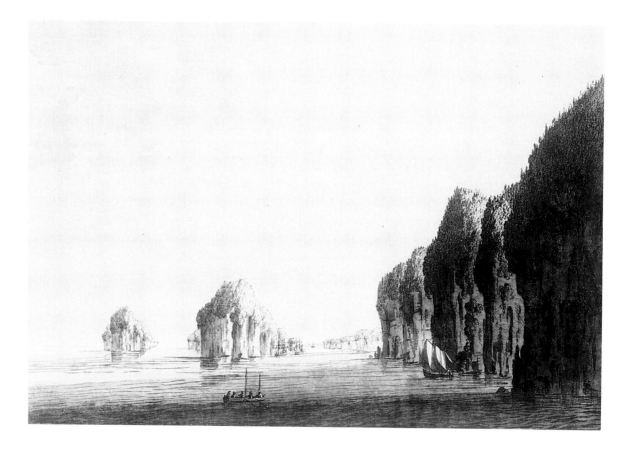

Sandby, and less than half a dozen artists used the technique. The early date of Des-Barres' aquatints speaks strongly of Sandby's influence, as does the way the washes are used, though in other respects the works show little of Sandby's manner. The landscapes are empty, the cliffs and trees distant, the sites almost barren. The best have a stark power which is reminiscent of Smyth's views, set as they are in the same region and emphasizing the same elements of wilderness (Plate 90).

The *Atlantic Neptune* also included the work of DesBarres' contemporaries. Several of the harbor scenes closely resemble Robertson's work. The most interesting of the contributors is Lieutenant William Pierie, active in the Royal Artillery from 1759 to 1777. His work for DesBarres consists of several small views of Boston. The originals in the British Library indicate that he was a careful and sensitive draftsman, not so heavy-handed as Davies could be, but much less imaginative.[19] Pierie's significance lies in the fact that Richard Wilson painted an oil version of a view of Niagara Falls by Pierie "taken on the spot in 1768." The Wilson painting was engraved in 1774; by July it was advertised for sale in the *New York Gazetteer*, documenting the close ties between the English and American print markets.

During the Revolution there were few active American military artists. Although British surveys in the previous decade had employed a number of American drafts-

FIG. 17. PIERRE CHARLES L'ENFANT, *West Point, New York,* 1780s. Watercolor. Library of Congress.

men, none seem to have had significant artistic interests.[20] However, artists did accompany the French forces who aided America.[21] The most interesting of these was Pierre Charles L'Enfant, later the designer of the city of Washington. His unfinished panorama of West Point, delicate and sensitive in its suggestion of atmosphere, captures the vast sweep of space from the heights above the Hudson (Fig. 17). Conventional in composition and motifs (resting soldiers in the foreground; fortifications in the distant middle-ground below them; river and hills winding into the far distance), the drawing comes to life because of L'Enfant's skill in handling the conventions. In comparison, earlier drawings by military artists in America are crudely handled and awkwardly composed. Even Davies' watercolors, despite their inventiveness and originality, are stiff and naive. But L'Enfant's sophisiticated drawing is an anomaly, important for the light it throws by contrast on the general quality of training and ability of military artists during the Revolution.

Amateur Artists

Relations between America and Britain were cool for a decade after the war, until the mid-1790s. By that time landscape painting in both countries had become more popular with artists and viewers alike. The quality and quantity of the work produced by officers reflect this improvement. Of this generation of military artists the most innovative are George Bulteel Fisher and George Heriot, as influential in different ways as any of their predecessors.

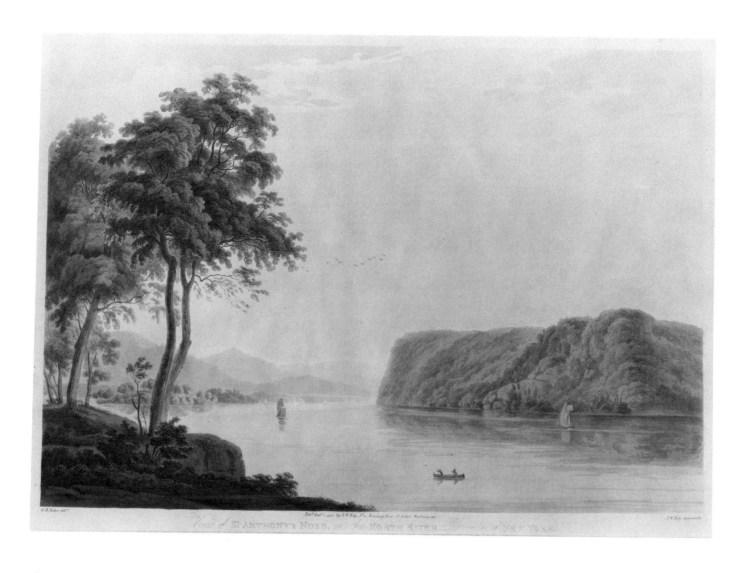

PLATE 91. JOHN WILLIAM EDY after GEORGE BULTEEL FISHER, *View of Saint Anthony's Nose, on the North River of New York*, c. 1790–1795.

PLATE 92. GEORGE HERIOT, frontispiece from *Travels through the Canadas*, 1807.

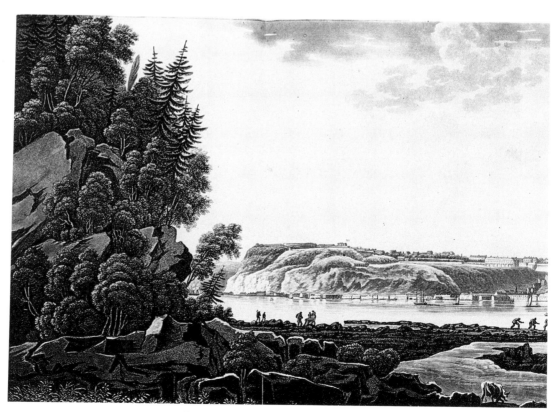

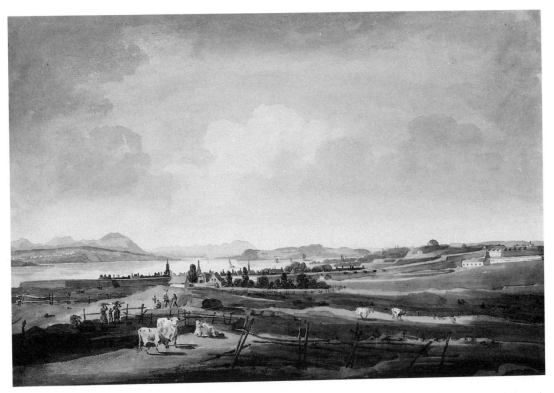

PLATE 93. GEORGE HERIOT, *Quebec Seen from Outside the Walls near Saint Louis Gate*, c. 1800.

General George Bulteel Fisher was responsible for the finest set of aquatint views of America before William Guy Wall and Joshua Shaw. Trained in the Drawing Room of the Board of Ordnance in the Tower of London, he toured Canada with the Royal Artillery from 1791 to 1794. He was most familiar with Quebec, but also visited New York, traveling down the Hudson. As a prolific amateur artist, he seems to have been influenced most by Joseph Farington, a student of Richard Wilson's, employing clear pale blue and green washes over faint pencil outlines.

His six views of North America, "from Original Drawings, Made on the Spot," were aquatinted and published by J. W. Edy in 1795, along with a view of Niagara in the same folio format. The aquatints faithfully reproduce the watercolors (Plate 91). The compositions are generally classical and calm, with large trees framing a distant vista. Their serenity is underlined by the pale monochrome tints which achieve a luminosity that may have influenced Wall. Fisher's views were the first successful attempts to marry the unique qualities of the American landscape—its scale, light, and wildness—to classical landscape conventions. They provided a model for artists interested in developing a picturesque response to the American scene. The foremost among these is George Heriot, a civil servant who belongs with other military artists by virtue of his training. Although he had artistic ambitions, he followed a career in Ordnance and in 1799 was appointed deputy postmaster general of British North America, a post he held until 1816, when he returned to England. While he was in Canada he drew constantly: small topographical sketches, picturesque inventions, large watercolors. Few of these reached the public, except as plates for his book *Travels through the Canadas* published in 1807 (Plate 92).

Heriot is one of the few military artists trained by Paul Sandby who show his influence; in Heriot's case it is in his strictly topographical work.[22] Heriot is most remarkable for applying to the American landscape the full range of picturesque conventions, which he did quite self-consciously. For example, when depicting a sublime scene, he uses a dark wash, abraded paper, and a closed composition. *Quebec Seen from Outside the Walls near Saint Louis Gate* (Plate 93) is a panoramic prospect, and every-

FIG. 18. GEORGE HERIOT, *West Point Looking Down the River 18 July* (18a); *Looking up the River 18 July* (18b). Watercolor. From *Sketchbook*, 1815. The New-York Historical Society.

thing is correspondingly lighter. Much of his work resembles the slight sketches of William Gilpin, the most prominent spokesman for the picturesque.

Because of his extensive travels as postmaster, Heriot's sketches record a great number of sites along the Saint Lawrence and eastern seaboard. However, in his more picturesque studies it is often difficult to recognize the places as American. His persistent attempt to match the American landscape with European picturesque conventions recalls the efforts of his fellow tourists to describe American scenes by comparison to equivalent English landscapes.

Perhaps the most interesting documents from Heriot's travels are his two sketchbooks which record a trip to Washington from Quebec in 1815. On his return up the Hudson he tried to capture the various pictures into which the banks of the river composed themselves as he glided past. West Point, one of the most famous sites on the Hudson for its scenic grandeur and associations, he sketched repeatedly. The gap between the continuous flow of perception and the picturesque artist's desire to frame the landscape into a composition is nowhere more perfectly seen (Fig. 18). Heriot struggles to sketch each different picture as it presents itself, while the citadel recedes relentlessly behind him.[23] The differences between William Gilpin's experience of the British river Wye, the model for such artistic tours, and Heriot's experience of the Hudson are underscored. The Wye is so small that picturesque views vanish the moment after they appear and must be sketched by the artist from memory (as Gilpin in fact advises); whereas the Hudson is so spacious that the scene may be recorded "on the spot." Nature seems to present permanent pictures to the artist, ones which are immanent, not mediated by recollection. The regret felt as the view disappears around the bend is that much greater. And yet always another slightly better prospect presents

itself, defeating the quest for the perfect scene, one improved by the artist in memory.[24] Prodigal America, as always, overwhelms European-bred expectation.

After 1800 the number of military artists, most of them stationed in Canada, increased markedly. A short hiatus due to the War of 1812 was followed by a flood of tourists, many of them navy officers on extended shore leave. The war itself seems to have had little impact. A few views, nearly all of naval battles, were produced in America and Britain, but for the British the conflict was a side show to the continental war with Napoleon, and one ultimately inglorious for all participants. The styles employed by these officers are varied, reflecting the popularization and professionalization of watercolor painting in England. Older modes continued along with the current and fashionable. A few examples may characterize the range of work.

Charles Ramus Forrest, commissioned in the Infantry in 1802, was in Canada from 1821 to 1823. His work — its scale and monochromatic palette reminiscent of Fisher — has an impressive presence (Plate 94). Often panoramic in format, the designs and execution are crisply stylized.

Robert Hood, a member of Sir John Franklin's Arctic expedition in 1819, reflects a more advanced style, with more fluid handling of the layers of wash. His work mirrors the contemporaneous development of J. M. W. Turner's watercolor techniques. Hood's drawings portrayed regions new to the public, in a less picturesque, more dynamic mode (Plate 95). The work of George Back, who also traveled with Franklin, is similar (Plate 96).

PLATE 94. CHARLES RAMUS FORREST, *Cape Diamond and the Saint Lawrence River from the Seignory of Lauzon*, 1822.

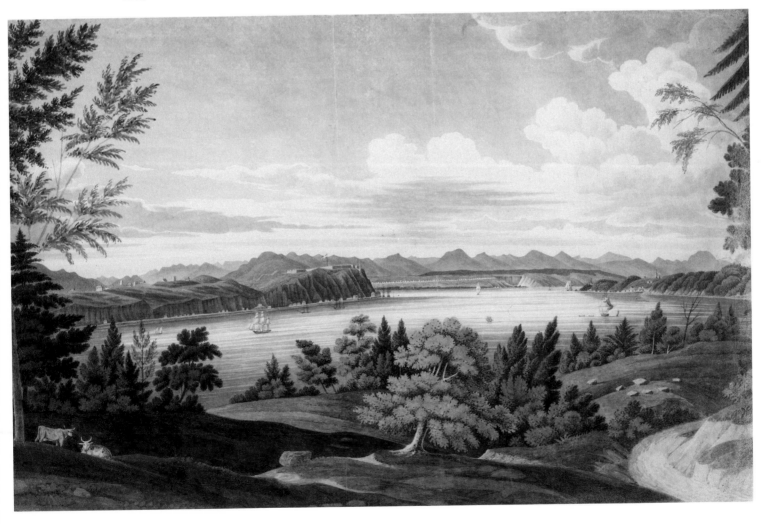

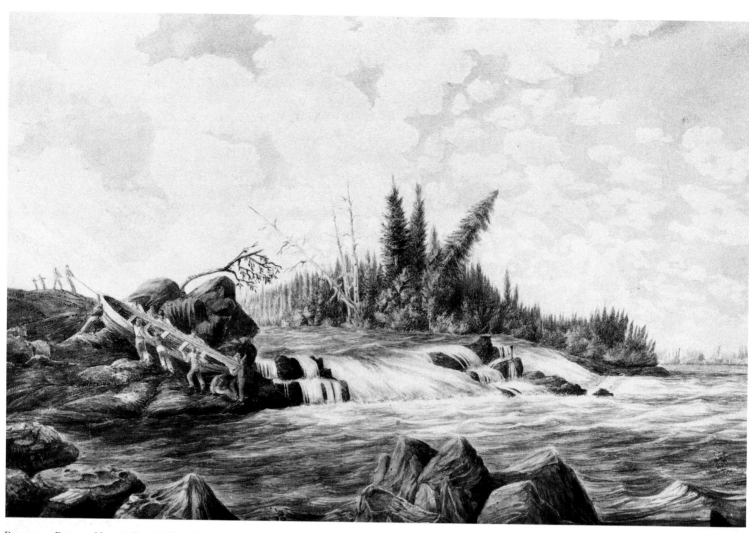

PLATE 95. ROBERT HOOD, *Trout Fall and Portage on the Trout River, Northwest Territories,* 1819.

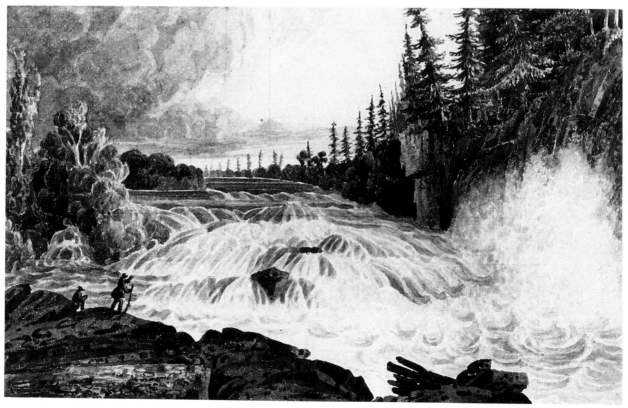

PLATE 96. GEORGE BACK, *A-wak-au-e-paw-etek or Slave Falls,* 1825.

PLATE 97. JAMES COCKBURN, *The Winter Cone of Montmorency*, 1827.

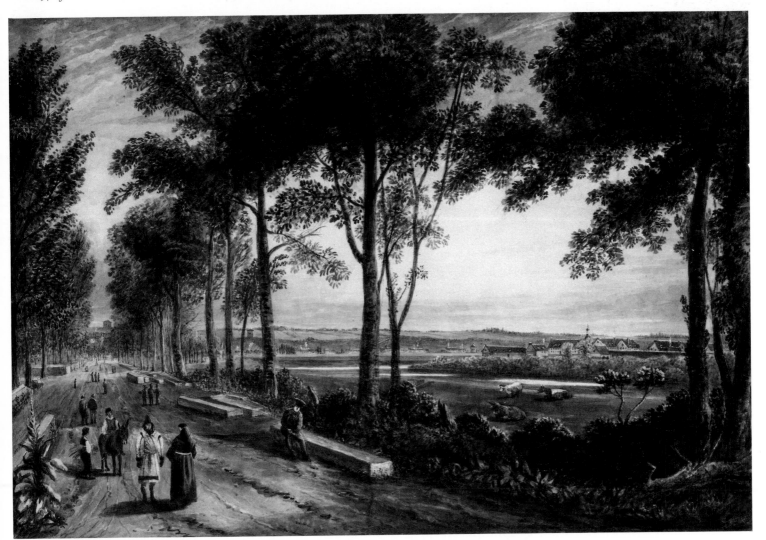

PLATE 98. JAMES COCKBURN, *General Hospital, Quebec*, 1830.

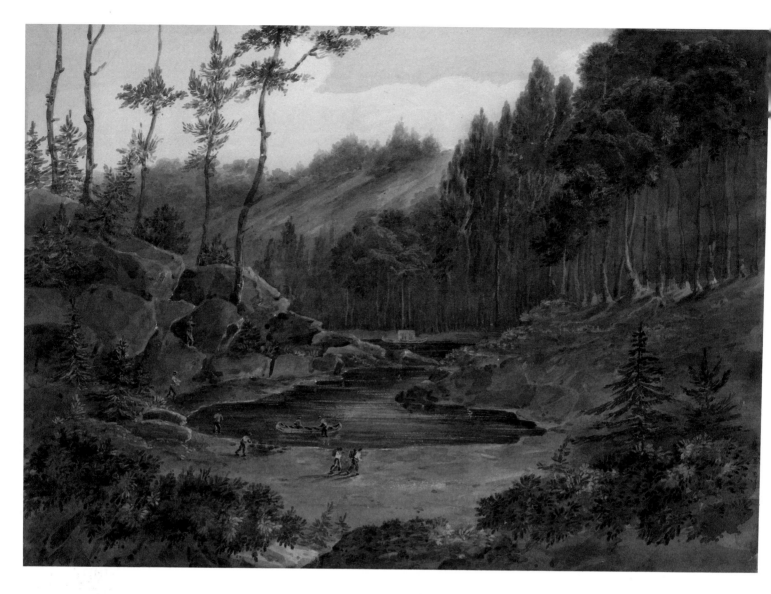

PLATE 99. JOHN ELLIOTT WOOLFORD, *Head of a River, Runs into Lake Nipissing*, 1821.

James Pattison Cockburn is perhaps the most representative. Although trained by Sandby at the Royal Military Academy, his work reflects several fashionable styles. The palette and the scraping in *The Winter Cone of Montmorency* (Plate 97) resemble Turner, while other watercolors, like *General Hospital, Quebec* (Plate 98), are reminiscent of those produced by members of the Old Watercolour Society in London; his sketches resemble work by such artists as J. C. Ibbetson. Cockburn's landscapes are completely domesticated. Despite their titles and backdrops, they are always park scenes, usually filled with couples — ladies squired by soldiers. The work of J. E. Woolford, a Royal Engineer, is equally conventional (Plate 99).

Ralph Gore, Basil Hall, and Joshua Rowley Watson, on the other hand, represent a continuing British military tradition in America.[25] Watson's work is particularly straightforward and delicate (Plate 100).[26] Gore's and Hall's drawings (Plate 101) show them in the guise of tourists, a far cry from the earlier role of the military artist.

The first military artists in America were pioneers, astounded by the wilderness, struggling to come to terms with its scale and its undeveloped quality. By 1830 military artists in North America were part of a distinguished tradition. They and their fellow officers traveled throughout the world as scions of Britain's emerging empire. Many of them published views in a rising tide of books which included volumes on Aus-

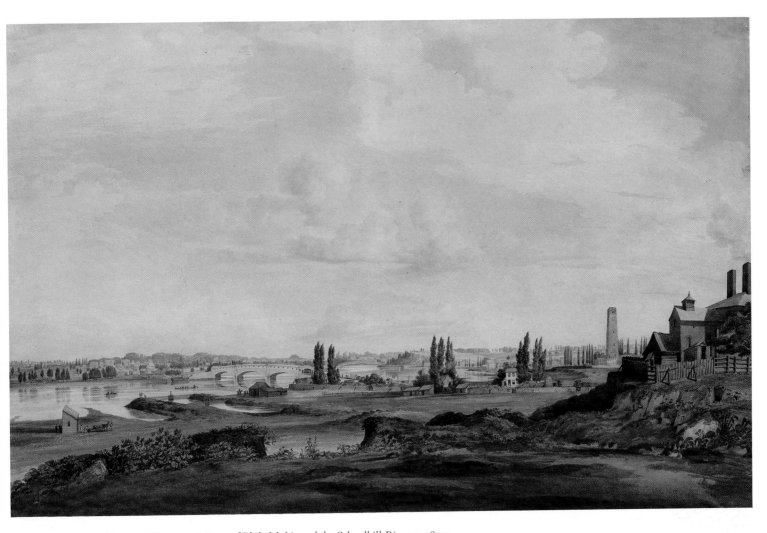

PLATE 100. JOSHUA ROWLEY WATSON, *A View of Philadelphia and the Schuylkill River*, c. 1827.

PLATE 101. BASIL HALL, *Wooding Station on the Mississippi*, from *Forty Sketches Made with the Camera Lucida in North America*, 1829.

tralia, Africa, India, and China; few were either very influential or distinguished. The painting of landscape had so matured within seventy-five years that artists had an appropriate response to every condition, one reached without strain. But if they could see so clearly and easily what had taken their grandfathers so much effort, it was because they relied on the vision given to Europeans in the 1760s by that first generation of military artists.

NOTES

1. The drawing curriculum for the army academy is known only in its broadest outline; see *Records of the Royal Military Academy 1741–1892* (Woolwich, 1892), pp. 33, 45.

2. For this background, read J. B. Harley, et al., *Mapping the American Revolution* (Chicago: University of Chicago Press, 1978).

3. I am indebted to Kim Sloan for clarifying this point. See also "Drawing — A 'Polite Recreation' in Eighteenth-Century England," *Studies in Eighteenth Century Culture* 11 (1982): 217–240.

4. Although this exhibition concentrates on the area of the northeastern United States, it should be remembered that the West Indies were extremely important to British mercantile interests. Even after the Revolution, the Caribbean remained part of the tour of duty for most British officers in the New World and was part of most visual records produced.

5. E.g., in the Royal Ontario Museum there is a copy after Smyth by J. Hay, 1813, and one after Pownall by T. S. Cochrane, 1812. Mary Allodi, *Canadian Watercolours and Drawings in the Royal Ontario Museum* (Toronto: Royal Ontario Museum, 1974).

6. Thomas Pownall, *A Topographical Description of the Dominions of the United States of America* (1776; reprint, ed. Lois Mulkearn, Pittsburgh: University of Pittsburgh Press, 1949), pp. 31, 36.

7. *Ibid.*, pp. 31, 102.

8. See, among many others, J. Hector St. John Crèvecoeur, *Letters from an American Farmer* (1782; reprint, New York: A & C Boni, 1925), pp. 59–61.

9. Works by other artists which should be noted include several loose watercolor views by an unknown artist in the British Library Map Library dated 1765 (KTOP.CXXI.523, 527, 536, 548), and views of Quebec and Halifax painted by Dominic Serres after a naval officer, Richard Short, engraved by Boydell in 1761 but not included in the *Scenographia*.

10. Although there is no documentary evidence of his having known their work, Davies was certainly cognizant of the artistic community in London through his participation in public art exhibitions.

11. The engravings are not dated, indicating that they were not publicly available. Davies was back in London in 1763 and again in 1768; he might have arranged for publication at either time. The later date has generally been favored because of the 1766 date on several watercolors of the same scenes as the engravings. However, this group of drawings seems to be an elaboration of ideas in the prints, not preparatory studies. One drawing, dated 1762, is clearly preparatory and also clearly less sophisticated in handling than those from the 1766 group.

12. Jeremy Adamson, *Niagara: Two Centuries of Changing Attitudes, 1697–1901* (Washington: Corcoran Gallery of Art, 1985), p. 20.

13. Exactly contemporary is *A Draught of the Isthmus which Joins Nova Scotia to the Continent. . .* by W. Tonge, 1755, which uses the same symbols. British Library Map Library, KTOP.CXIX.64. Davies' motifs quickly become increasingly expressive. For example, in the 1763 engraving of the view above the Horseshoe Falls at Niagara, *An East View of the Great Cataract of Niagara*, two Indians stand and stiffly point; in the 1766 watercolor of the same scene in the New-York Historical Society, *Niagara Falls from Above* (Fig. 16), an Indian couple quietly contemplate the eagle. Similarly, in the 1763 engraving *The Great Cataract on the Casconshiagon* (the upper falls on the Genesee), the only figure is a sketching artist with his back to us; in the 1766 watercolor of the same scene in the National Gallery of Canada, *Great "Seneca" Falls*, he is replaced by an Indian family. In Davies' later watercolors great numbers of Indians, birds, and beasts appear. See the reproductions in R. H. Hubbard, *Thomas Davies* (Ottawa: National Gallery of Canada, 1972). The Indian family in G. B. Fisher's aquatint view *Falls of Niagara* (1796), are their descendants.

14. Thomas Jones, "Memoirs," *Walpole Society Journal* 32 (1946–1948): 11.

15. The views were re-engraved for John Pinkerton, *A General Collection of . . . Voyages and Travels* (London, 1812), Vol. XIII.

16. For examples of their work see Allodi, *Canadian Watercolours.*

17. See, among many others: J. Russell Harper, *Painting in Canada: A History* (Toronto: University of Toronto Press, 1978), p. 48; Michael Bell, *Painters in a New Land* (Toronto: McClelland and Stewart, 1973), p. 11; Allodi, *Canadian Watercolours*, No. 1482.

18. The work of Archibald Robertson, an engineer in active service from 1759 to 1786, is reminiscent of Sandby's Italianate work of the 1760s, with fantastically gaunt trees and classically garbed foreground figures imposed on the topographical view (presaging G. B. Fisher's work in the 1790s). See *Archibald Robertson, Lieutenant-General Royal Engineers, His Diaries and Sketches in America, 1762–1780*, ed. Harry Miller (Lydenbeg, N.Y.: New York Public Library, 1930). It is probable that he knew Sandby, given the fact that his cousin was Robert Adam, the architect, a good friend of the Sandbys.

19. British Library Map Library KTOP.CXX.34. Reproduced in *The American War of Independence 1775–1783* (London: British Library, 1975). The Li-

brary of Congress has copies, perhaps by Pierie, of several of these watercolors. Donald H. Cresswell, *The American Revolution in Drawings and Prints: A Checklist of 1765–1790 Graphics in the Library of Congress* (Washington, D.C.: GPO, 1975), Nos. 489, 490, 495, 500, 503.

20. For further information on engineers and draftsmen, read Harley et al., *Mapping the American Revolution;* Douglas W. Marshall, "The British Engineers in America: 1755–1783," *Journal of the Society for Army Research* 51 (Autumn 1973): 149–162; Lester Jesse Cappon, "Geographers and Map-makers, British and American, from about 1750 to 1789," *Proceedings of the American Antiquarian Society* 81, Part 2 (1972): 243–271.

21. *The French in America 1520–1880* (Detroit: Detroit Institute of Arts, 1951). Pierre Ozanne is the most proficient of the naval draftsmen; his work may be found in the Library of Congress.

22. Gerald Finley, *George Heriot* (Toronto: University of Toronto Press, 1983), pp. 21–24.

23. Henry Dilwood Gilpin provides a verbal description of these unfolding scenes in *A Northern Tour: Being a Guide to Saratoga, Lake George, Niagara, Canada, Boston, etc.* (Philadelphia, 1825), pp. 24–25: "After turning this point, the river has a direct course about nine miles to West Point. . . . Looking back, the scene is closed by the mountains we have passed: and looking forward, the same high chains, stretching along on either hand appear to unite in the distance. As we approach West Point, the scene increases more and more in picturesque grandeur — the banks on each side rise in rugged majesty, and present a uniform covering of wood, except where interrupted by projecting rocks, which assume every hue as the sun shines upon them, and reflect an ever-changing picture on the placid mirror at their feet."

24. William Gilpin instructs the "picturesque traveller": "The first source of amusement . . . is . . . the expectation of new scenes continually opening, and arising to his view." "New objects, and new combinations of them, are continually adding something to our fund [of artistic ideas]." Gilpin, "On Picturesque Travel," *Three Essays* (London, 1792), pp. 47, 50. The point is echoed by an anonymous author in *Port Folio* 4 (August 8, 1807): 83: "In viewing objects from a distance, a pleasing anticipation accompanies us as we gradually approximate to them. Those gained, new ones are constantly rising, as we change our horizon: so that we are always in the pleasing state of actual fruition and delightful anticipation." Gilpin advises the traveler to deal with this flux: "There may be more pleasure in recollecting, and recording, from a few transient lines, the scenes we have admired, than in the present enjoyment of them . . . in general, tho [memory] may be a calmer species of pleasure, it is more uniform, and uninterrupted." *Three Essays,* pp. 51–52.

25. Despite the fact that drawing was taught at West Point, few examples of American military topographical art are known.

26. Also see *Album of Scenes in the United States of America,* New-York Historical Society, the record of a tour in the summer of 1816.

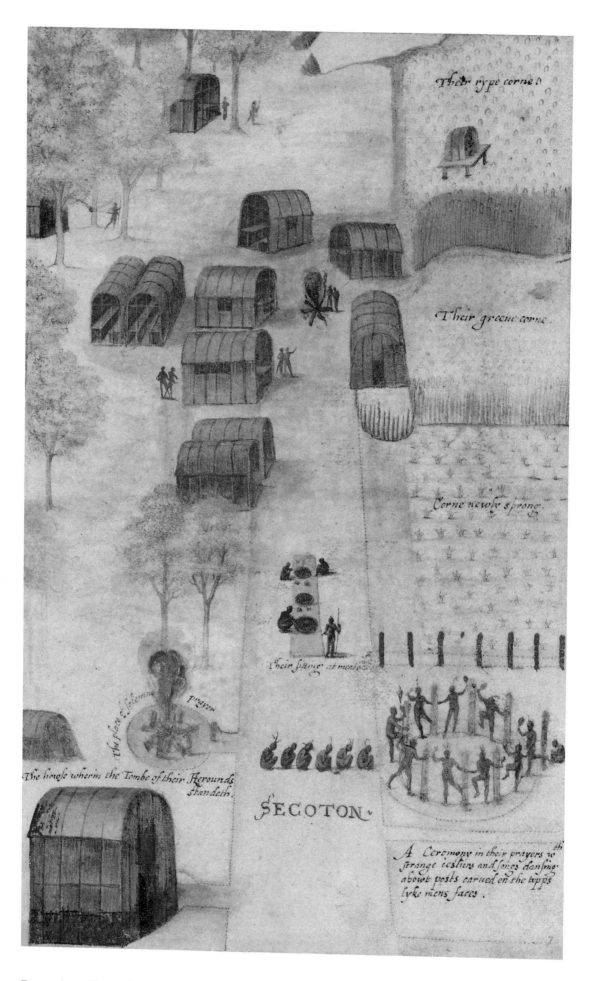

Their rype corne

Their greene corne.

Corne newly sprong.

Their sitting at meate

The place of Solemne prayer

The house wherin the Tombe of their Herounds standeth

SECOTON

A Ceremony in their prayers w[th]
strange iestures and songes dansing
abowt posts carued on the topps
lyke mens faces.

7

FIG. 19. JOHN WHITE, *Secoton*, c. 1585. Pen, ink, and watercolor. The British Museum, London.

Amy R. W. Meyers

Imposing Order on the Wilderness
Natural History Illustration and Landscape Portrayal

IN CONTRAST TO THE EUROPEAN LANDSCAPE, much of the physical environment that greeted seventeenth- and eighteenth-century settlers of the British colonies of North America seemed a vast wilderness, unmodified by human settlement. Yet British and American artists rarely chose to depict the American terrain devoid of human activity and settlement. This pictorial neglect of wilderness resulted not from a lack of interest in the physical environment of the New World but from a vested interest in representing that environment as structured rather than chaotic.[1] In both landscape scenes and natural history illustrations, artists made use of traditional ordering systems to depict the physical environment of North America as an extension of the structure of the known world.

The imposition of a familiar order upon the landscape and the natural forms within it is evident in the earliest-known British drawings of the New World. These were produced by the artist John White, who took part in Sir Walter Raleigh's ventures to found the first settlement in the British colony of Virginia, from 1584 through 1590. Although most of White's extant drawings illustrate single specimens of flora and fauna or portray individual members of Indian tribes, several of his works depict larger scenes. These more fully developed drawings include elements from several of White's simpler compositions.[2] They illustrate either Indian settlements or Indians engaged in characteristic activities within landscape settings. Each drawing presents a close-range aerial view of an environment that is carefully controlled by its human inhabitants.

In his 1585 drawing of the Indian village of Secoton (Fig. 19), for example, White presents a highly ordered settlement, organized along the central axis of a broad, straight avenue. Branching off from this avenue are places designated for religious devotion, habitation, and cultivation. The physical terrain appears only as a flat plain upon which Indian life is neatly structured. Since the edge of the paper interrupts both the road along which the settlement is organized and the fields of corn stretching off to the right, the drawing implies that the order of Indian life continues indefinitely. Only a semi-circle of woodland in the upper left-hand corner intervenes in this controlled environment, and even this poses little threat to the structure of the Indian settlement. Houses appear comfortably nestled among the pale, feathery trees, and Indians gracefully stride from the woods toward the clearing.

White's drawing of the village of Secoton is only one of several of his works in which native Americans are shown to control the physical world in which they live. This theme is also developed in his drawing of Indians fishing, probably from the

same year (Fig. 20). In this image, a neat perspectival grid organizes the landscape. The horizon, the shoreline, the fish in the water, and the two canoes establish a horizontal pattern against which the strong diagonal line of the fishtrap seems to move forever into the distance. In this way White presents the open face of the sea as structured — and even contained—by the men who fish in it. The surface of the water ripples gently in the foreground but spreads toward the horizon as a calm plane, receptive to human action. The symmetrically positioned and evenly spaced Indians successfully harvest these waters abundant with fish.

White's drawings of productive environments, carefully controlled by their Indian inhabitants, seem to argue for an attractive existence in the New World. White may well have hoped that his pictures would entice an English audience eager to test the possibilities of life across the Atlantic. Indeed, his interest in the success of Raleigh's settlement ventures may help to support such a reading of his work. White probably produced his two images between 1585 and 1586, on Raleigh's second expedition to the Island of Roanoke, in the Outer Banks of what are now the Carolinas. According to the title page of Thomas Harriot's *A Brief and True Report of the New Found Land of Virginia*, printed by Theodor de Bry in 1590, a group of pictures were "Diligentlye collected and draowne by Ihon White who was sent thiter speciallye and for the same purpose by the said Sir Walter Ralegh the year abouesaid 1585."[3] As Raleigh's first attempt to establish a colonial settlement on the North American continent, this expedition followed an exploratory mission in 1584, which had produced enthusiastic reports on the region's rich potential for settlement.

Captain Arthur Barlowe's report to Raleigh as printed in Richard Hakluyt's *The Principall Navigations, Voiages & Discoveries of the English Nation* (London, 1589) stresses the unequalled natural abundance of the Outer Banks. In describing Hatarask Island, the first land explored by the expedition, Barlowe writes:

> *Wee viewed the lande aboute us, . . . so full of grapes, as the very beating, and surge of the Sea overflowed them, of which we founde such plentie, . . . that I thinke in all the world the like aboundance is not to be founde; and my selfe having seene those partes of Europe that most abound, finde such difference, as were incredible to be written.*
>
> *This Island had many goodly woods, full of Deere, conies, hares, and Fowle, even in the middest of Summer, in incredible aboundance. The woodes are not such as you finde in Bohemia, Moscovia, or Hyrcania, barren and fruitlesse, but the highest, and reddest Cedars of the world. . . .*[4]

Barlowe also discusses the kindness and generosity shown by the Indians toward their English visitors. In all, he paints a picture of a comfortable world in which physical needs are easily satisfied:

> *We were entertained with all love, and kindnes, and with as much bountie, after their manner, as they could possibly devise. Wee found the people most gentle, loving, and faithfull, void of all guile, and treason, and such as lived after the manner of the golden age. The earth bringeth foorth all things in aboundance, as in the first creation, without toile or labour. The people onely care to defend them selves from the cold, in their short winter, and to feede themselves with such meate as the soile affoordeth. . . .*[5]

Implicit in Barlowe's picture of the luxuriant natural environment of Raleigh's Virginia, and the idyllic existence of the native inhabitants, is the idea that an Englishman might also find a profitable and good life here. Certainly Barlowe's report contributed to the enthusiasm of Raleigh and his backers for a colonizing venture the following year. His descriptions conjure up a world as rich as that before the biblical fall of man, inhabited by uncorrupted peoples ready to embrace the British settler.

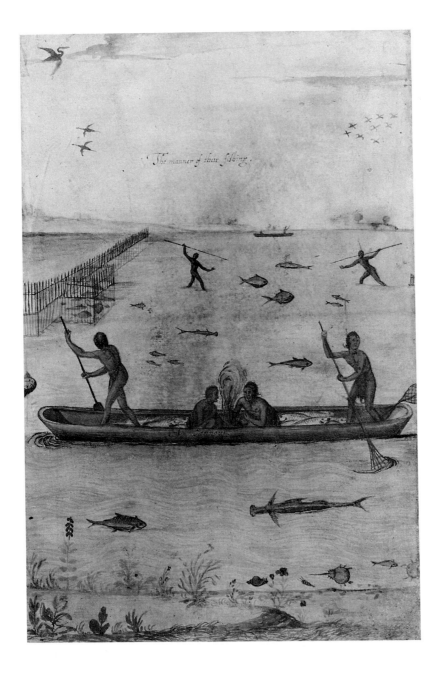

The manner of their fishing.

FIG. 20. JOHN WHITE, *Indians Fishing*, c. 1585. Pen, ink, and watercolor. The British Museum, London.

White's drawings from the 1585 expedition also emphasize the bountiful, well-ordered life afforded by the New World, and suggest the accessibility of that life to the British settler. Although the native inhabitants of White's landscapes are shown in control of their physical world, the British viewer of these images is given an elevated position of dominance over both the terrain and the Indians who shape it. There is something diagrammatic about these works with their neat italic labels. Even the most unfamiliar aspects of Indian life appear fully analyzed and categorized — and so completely comprehensible to the viewer. In this way the life of the native American comes under the intellectual control of the Englishman, and its comforts and productivity appear as if they might easily be appropriated by him.

White's pictorial approach to the New World is not surprising in light of his personal commitment to Raleigh's colonizing venture. Before joining the Roanoke expedition as official artist, it is probable that White had already traveled to the New World in the same capacity on Martin Frobisher's second voyage to Baffin Bay, in 1577.[6] It is also likely that he accompanied Raleigh's exploratory venture to Roanoke in 1584. The seriousness of his belief in the colonizing endeavor is illustrated by the fact that even after the 1585 venture had to be abandoned the following year, White re-

turned to Roanoke as governor in 1587 and again in 1590. His rise in status from expedition artist to governor indicates Raleigh's regard for him as the proper man to oversee the first British colonial settlement in America.

The concept of British control over the physical environment of the New World is conveyed not only through White's larger views of the village of Secoton and Indians fishing, but also through his illustrations of individual plants, animals, and people. White worked in 1585 with the naturalist and mathematician Thomas Harriot, who had prepared the navigational instructions for the voyage and who sailed with the expedition to see them carried out. Together White and Harriot created a visual and verbal description of the unusual forms they observed, first in the Caribbean and then on their extensive surveys of the Outer Banks.

White and Harriot had probably been given orders similar to those received by Sir Humphrey Gilbert's artist Thomas Bavin and an accompanying observer on a 1582 expedition to the region of North America now known as southern New England.[7] Bavin's instructions stress that he is to record forms of life that differ from those of Britain. He is asked to "drawe to lief one of each kinde of thing that is strange to us in England . . . all strange birdes beastes fishes plantes hearbes Trees and fruictes . . . also the figures & shapes of men and woemen in their apparell as also their manner of wepons in every place as you shall finde them differing."[8] This emphasis on things foreign suggests that the British, after a century of active global exploration, expected natural forms to differ widely from one region to the next. It also implies the desire to assimilate exotic forms into a familiar structure for ordering Creation.

In many of his drawings White isolated a specimen of each "kinde of thing" from its natural habitat and showed it against a blank white sheet. This compositional approach for portraying flora and fauna followed traditional European conventions derived from medieval pattern books, herbals, bestiaries, and, in the fifteenth and sixteenth centuries, printed botanical and zoological tracts (Fig. 21). By choosing a familiar pattern to depict the unfamiliar, White comfortably assimilated the strange forms of a New World into a structure of understanding long established for the forms of the Old. His pictures are essentially specimen drawings which define organisms according to their characteristic visual traits.[9]

In White's drawing of three fireflies and a gadfly, for example (Fig. 22), the insects do not interact as living organisms but as geometric forms that create a well-balanced pattern. The legs, wings, and antennae of each insect are arranged symmetrically and flattened rigidly against the sheet. The fireflies are shown in different stages of wing-spread, illustrating various states of the insect's appearance to the viewer. The drawing succeeds in categorizing the insects primarily by their visible traits and secondarily according to their behavior as it is described in words. The physical relation of these insects to the external world is not considered a factor that might help to define these organisms meaningfully for the viewer. Indeed, the fact that behavior toward other organisms is reduced to abstraction through the written word, and is not shown pictorially, illustrates the importance of stripping away the idiosyncracies of environmental interaction in defining a specimen type.

By creating images that neatly divide organisms one from another and then type them according to their own visual attributes, White begins to order the confusing forms of a New World. In using the commonly accepted visual language of the specimen drawing, he imposes a familiar structure over a part of Creation which, until that time, had not fallen under the intellectual control of a British audience. As we have already seen, even when White integrates individual specimens into larger views, he stresses British dominion over the terrain and all the elements within it. Through both his specimen drawings and his landscapes, White creates a vision of the New World under the power of the British viewer.

Fig. 21. *Water Lily,* from *The Grete Herball,* London, 1529, sig. R3 verso. The Folger Shakespeare Library, Washington, D.C.

Fig. 22. JOHN WHITE, *Fireflies and Gadfly,* c. 1585. Pen, ink, and watercolor. The British Museum, London.

A flye which in the night semeth a flame of fyer.

A dangerous byting flye.

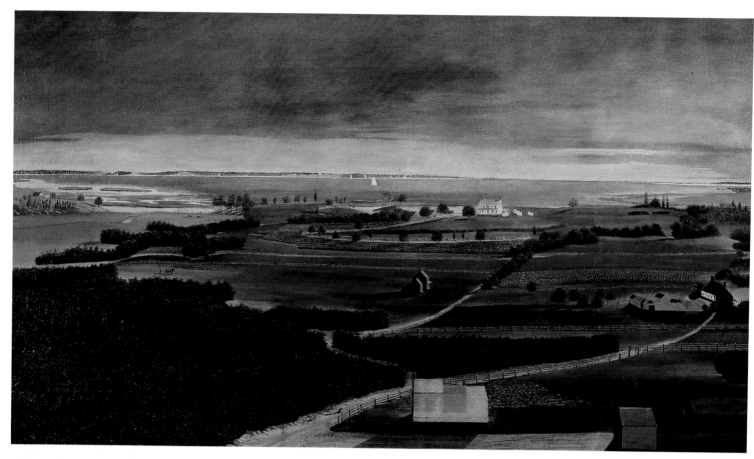

PLATE 102. JONATHAN FISHER, *View of Bluehill, Maine*, c. 1824.

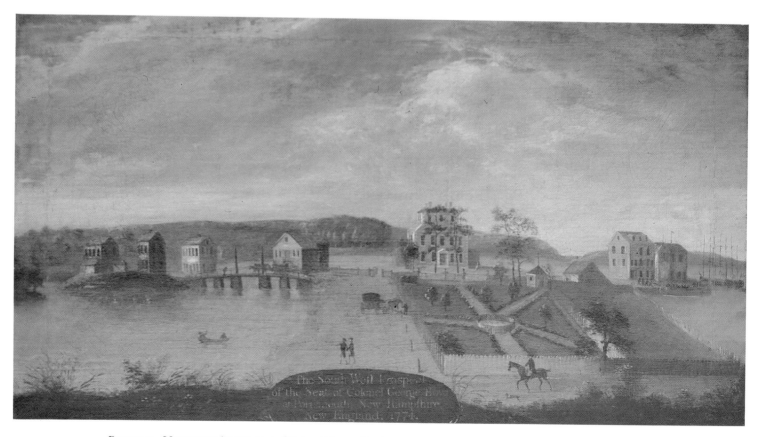

PLATE 103. UNKNOWN ARTIST, *Seat of Colonel George Boyd*, 1774.

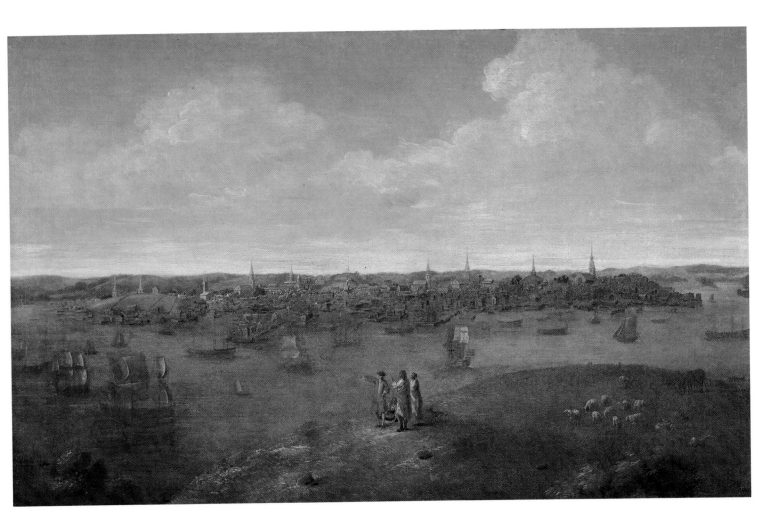

PLATE 105. JOHN SMIBERT, *A View of Boston*, 1738.

It is probable that a related impetus that moved White to describe and order American flora and fauna rose from the urge to contribute more generally to the quickly growing compendium of European knowledge about the physical universe as a whole. During the Renaissance a new faith in empirical observation emerged as the means by which a complete picture of the cosmos might be drawn. The structure of Creation was generally understood as a hierarchical chain of being in which each link played an essential role. Man was thought to stand at the head of this chain; however, to use his position of privilege to his own advantage, he had to discover and order correctly all of the links that followed. The emergence of this desire for complete knowledge of the structure of the physical world was accompanied by energetic exploration of the globe. Men of learning who accompanied expeditions into the unknown were led by their interest in empirical science to describe and catalogue the new life forms they discovered on their travels. The impulse to understand and control the whole of Creation for intellectual as well as practical ends moved explorers like White and Harriot to focus their attention on organisms that differed from those already known. They attempted to define these new organisms, not in terms of the particular environments in which they were discovered, but in terms of their proper place in the Great Chain of Being. Explorers who drew thus tended to isolate individual forms from their environments. Their specimen drawings were used to classify the strange forms of a New World according to the familiar order of the Old.

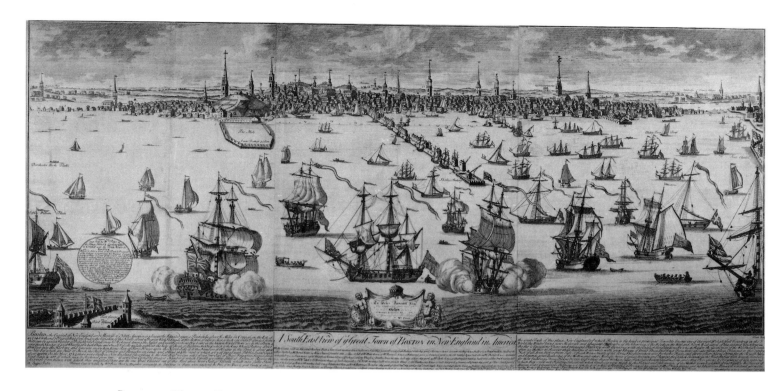

PLATE 104. WILLIAM BURGIS, *A South East View of Ye Great Town of Boston in New England in America*, c. 1722.

Structuring the Landscape

For British explorers who depicted the North American continent, the practical and philosophical necessity to present the landscape and the organisms within it as structured by both human settlement and divine plan persisted from the early colonial period through the first decades of the republic. Although pictorial styles changed to some extent from the topographical view to the picturesque description, artists who represented the American environment imposed on their subjects the same physical and intellectual order found in the drawings of John White.

Through the end of the eighteenth century, artists who portrayed landscape generally adopted British topographical conventions for depicting cities, towns, and country seats from an elevated perspective (Plates 102, 103). Characteristically these views illustrate man's power to shape the physical world by stressing the dominance of architectural form over the natural landscape. The imposition of manmade structures on the natural terrain is clearly seen in William Burgis' view of Boston, first engraved in 1725 (Plate 104), and in a painting of the same city by John Smibert (Plate 105) from 1738, based in part on Burgis' work.[10] Both images stress the way in which land and sea have been transformed into thriving city and harbor. In Burgis' panorama, the viewer overlooks a major part of the city of Boston and its harbor. The image is densely packed with a wide variety of ships and buildings. The sides and bottom edges of the print cut off these manmade forms, implying that they continue beyond the spectator's range of vision. As in White's drawing of Indians fishing from almost 150 years before (Fig. 20), the water is perfectly calm, serving as an excellent ground against which to show off the ships that crowd its surface. Only a thin line of waves jostles the water's surface in the immediate foreground.

The land in Burgis' view is even more crowded by manmade forms than is the water. Almost no open space is visible between the buildings in Boston, except for Beacon Hill, which is stripped bare and neatly fenced into rectangular sections. Echoing the masts of the large ships in the foreground, exaggerated church spires press up into the open sky, towering over the horizon line of rolling hills. The centermost hill is

capped by a spire of its own, suggesting that tall churches dominate the landscape beyond the city as well. On the harbor side, the city moves out into the water along the wharves. Long Wharf, exaggerated in length, seems to serve a purpose similar to the fishtrap in White's image, dividing the open water into containable areas that serve human needs.

The dominance of the city's architecture over the physical terrain and the bustling activity of its port proclaim the success of the "Great Town of Boston" in structuring the American landscape for the needs of civilized British society. The enormous flags that fly from the fort and the ships proudly claim for Britain the highly ordered environment that appears to lie beyond.

Smibert's view of the same subject is presented from the northeast, from Noddles Island in Boston Harbor.[11] The structures in Smibert's picture are more realistically proportioned than those in Burgis' view. This is particularly true of the church towers and Long Wharf. However, Smibert's work continues to stress the impressive size and density of Boston and its harbor. The hills beyond the city appear just slightly above the tops of the buildings, and the church towers continue to dominate the skyline. The strong presence of the hand that shapes the landscape is embodied in the figure of a gentleman who stands with a group of Indians in the cleared sheep pasture of Camp Hill. He faces the Indian with whom he speaks and the viewer of the work, with his left hand placed securely on his hip and his right outstretched possessively over the harbor. Like Burgis' print, Smibert's painting emphasizes the physical supremacy of the British colonist over the North American landscape.

The imposition of architectural form on physical terrain persisted in landscape portrayal well into the nineteenth century. Works by John James Barralet (Plate 106), Thomas Birch (Plate 107), and William Birch (Plate 108), which stress the domination of colonial and early republican cities over the natural landscape, are particularly char-

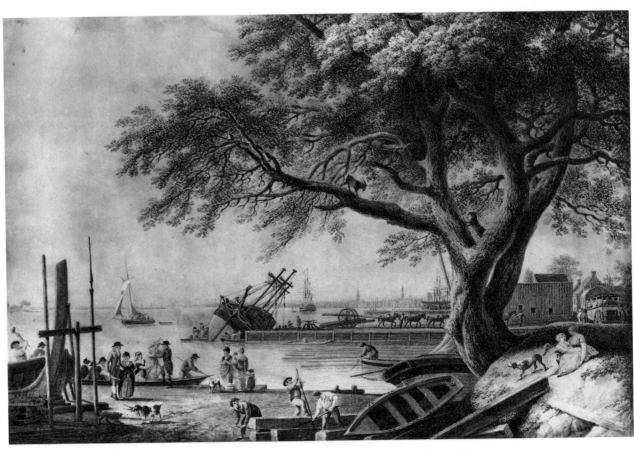

PLATE 106. JOHN JAMES BARRALET, *View of Philadelphia from the Great Elm Tree in Kensington*, 1796.

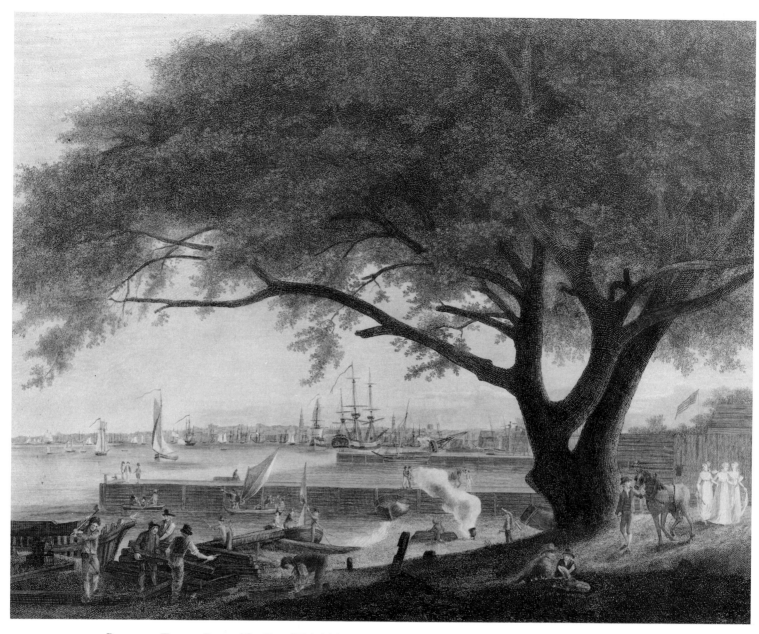

acteristic of this trend. Paintings of gentlemen's estates which became popular in the eighteenth and early nineteenth centuries also emphasize the ordering of the landscape through architecture (Plate 109). Indeed, even depictions of more rural scenes, such as George Parkyns' *Falls of the Schuylkill,* of 1800 (Plate 110), seem to argue for the control of the American landscape by human settlement.

Ordering Natural Forms

Just as American landscape artists presented the North American environment in terms of conventional pictorial systems for ordering and controlling landscape, so American naturalists depicted the individual organisms of the North American environment in terms of conventional systems for ordering and controlling Creation. During the seventeenth and eighteenth centuries, the desire to amass a complete body of knowledge about the physical world continued to grow, and naturalists, following in the steps of White, set out to name and describe the unknown forms of the New World. These men were inspired by the writings of the seventeenth-century English

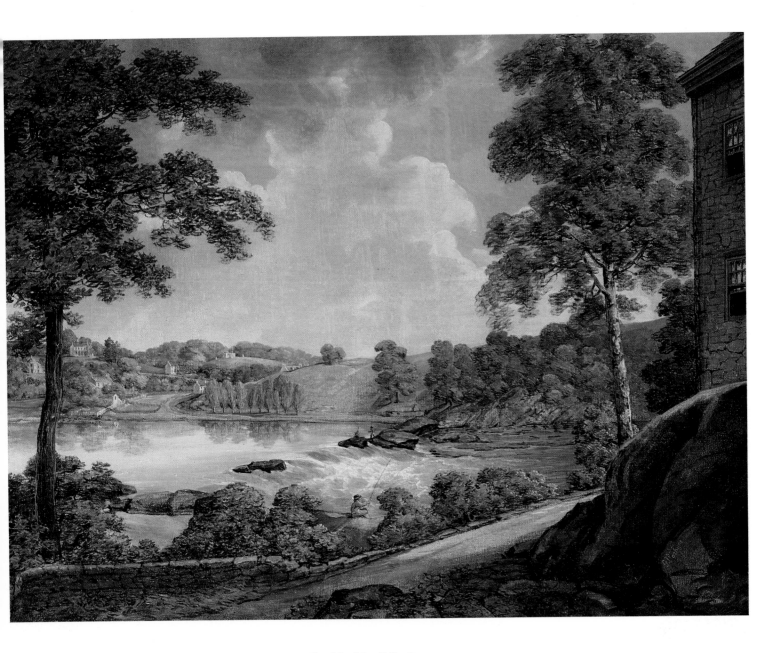

PLATE 110. GEORGE ISHAM PARKYNS, *Falls of the Schuylkill, 1800.*

empiricist Sir Francis Bacon, who, in his *Novum organum,* calls on man to examine nature directly in order to comprehend the mechanism which orders and animates the cosmos. Bacon expresses the belief that human power is grounded in man's empirical understanding of the physical world: "Human knowledge and human power meet in one; for when the cause is not known the effect cannot be produced."[12] Bacon planned the third part of his unfinished masterwork, the *Great Instauration,* as an all-encompassing natural history — a thorough description of "the Phenomena of the Universe."[13] Although this monumental scheme was never completed, English naturalists began to adopt the inductive means of investigation that Bacon championed, pursuing great natural histories of their own, and ushering in the age of modern science.

Although British naturalists who worked in America made frequent use of verbal texts to describe the new forms they discovered, as empirical thinkers they came to believe that carefully rendered drawings might best communicate to distant colleagues their firsthand observations of the natural world. The conventions of the specimen drawing, employed by White in the sixteenth century, continued to be used by these men, whose primary concern remained the ordering of life forms and physical phenomena according to the Great Chain of Being. These conventions were utilized by

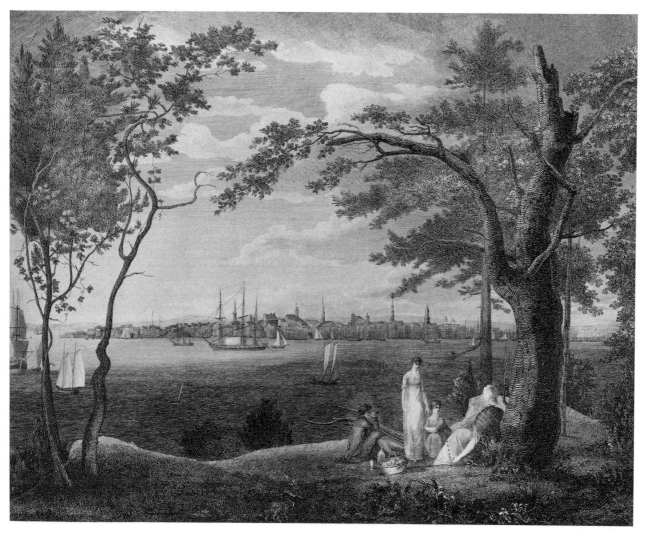

PLATE 108. WILLIAM RUSSELL BIRCH, *The City of New York in the State of New York North America*, 1803.

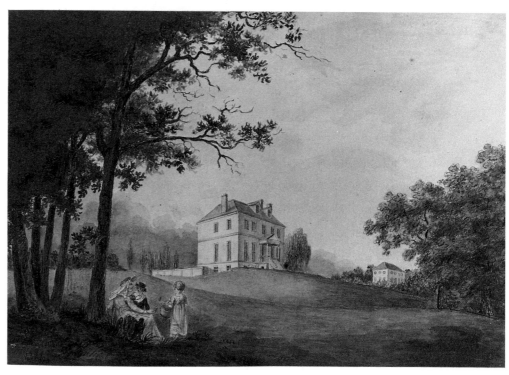

PLATE 109. WILLIAM RUSSELL BIRCH, *Sweetbriar*, c. 1808.

John Banister, the first trained naturalist to reside permanently in the British colonies of North America. Although Banister was untutored in the delineation of natural forms when he arrived in Virginia, in 1678, he quickly found the need to draw. Banister learned from his British correspondents that verbal descriptions and dried specimens rarely conveyed an accurate idea of the organisms they were meant to portray, and so he came to rely upon drawings to represent the flora and fauna that he discovered on his travels through the colony.[14] His pictures are perfect specimen drawings, isolating individual forms from their natural habitats and flattening them slightly against a blank sheet. These images are accompanied only by Latin titles and numeric scales, moving them further out of the integrated physical world and into the realm of abstract analysis. Each portrayal becomes an ideal type, representing in full the characteristics of its kind. Indeed, the visual classification of life forms is the primary focus of these works.

In his picture of a plant labelled *Chrysanthemum Pentapetalon villoso caule,* for example, Banister shows the plant in its entirety, as well as several stages of the flower's development (Fig. 23). The two mature blossoms on the right turn fully toward the viewer so that he may study their internal structure. In contrast, four buds at the top of the uppermost branches stand in full profile, each at a different point of growth. The three youngest nestle between small, paired leaves, while the one that approaches blossoming shoots up on a stem away from the foliage. This image would serve the viewer as a tool for identifying a *Chrysanthemum* at any stage of flowering. The picture defines the species visually, distinguishing it definitively from all other types.

FIG. 23. JOHN BANISTER, *Chrysanthemum Pentapetalon villoso caule,* 1680–1692. Pen and ink. Sloan MS 4002, fol. 83. By permission of the British Library, London.

Banister's interest in pictorially categorizing specific types complemented his desire to produce a natural history of Virginia. He was well aware of the active interest taken by his British colleagues in discovering the true system by which organic Creation is ordered, and he discussed the problem in outlining his projected work. Although in his own natural history Banister decided to divide Creation into the traditional categories of fire, air, earth, and water, he determined to categorize the plants that he himself had identified for the first time according to the revolutionary plant-classification system developed by his friend John Ray, founded on the empirical method.[15]

Renowned for his empirical approach to the classification of flora and fauna, Ray drew the plant kingdom into two major groups: the dicotyledons (plants with two seed leaves) and the monocotyledons (plants with only one). He then categorized plants in terms of whether they are trees, shrubs, or herbs, and continued to subdivide these groups according to criteria similar to those used by scientists today to determine so-called natural families.[16] Like Banister, Ray strongly believed in using pictures to define the foral and faunal types that he was attempting to order according to their visual characteristics. After many failed attempts to solicit funds for copper-plate engravings to supplement the third volume of his *Historia plantarum* (1704), Ray despaired, "But it is still a blind work, not illustrated by any figures, and so useless to any but great proficients in botanics."[17]

Although Banister was never able to complete his natural history of Virginia, he was not the last to produce specimen drawings to define and order the natural forms of the British colonies of North America. Interest in explicating the systems of nature accelerated over the course of the eighteenth century, and American naturalists strove hard to categorize their discoveries of indigenous animals and plants according to the new classification systems that developed in their day. Like most of their European colleagues, American naturalists were strongly influenced by the empirically based system developed by the Swedish naturalist Carl Linnaeus. Inspired by his seventeenth-century predecessors, Linnaeus conceived the grandest scheme by which the living world might be understood as rationally and coherently ordered. Through his empirical studies of plants discovered on his own explorations of Lapland, Öland, and Gotland, and his examination of the specimens he received through a network of naturalists surveying every corner of the globe, Linnaeus concluded that all flora might be ordered by their sexual characteristics, mainly on the basis of the number of stamens and pistils in the flower. He first described this idea in *Systema naturae* (1735) and then used it to order his future botanical works.

In a sense, Linnaeus sidestepped seventeenth-century objectives in proposing his sexual system of classification. The method is actually artificial in that it groups plants according to only one or more easily observable traits, thus tending to bind organisms together arbitrarily. There were other systems considered more natural which grouped organisms by as many common characteristics as possible; however, these characteristics were extremely difficult to discern in Linnaeus' day. Although Linnaeus believed that the most desirable method of classification would reflect the divine plan for Creation, he also recognized that the complexity of nature itself made the discovery and employment of such a system problematic.[18] In the end, it is actually not easy to demarcate where systems of classification become artificial — and, indeed, Linnaeus' system often groups together plants quite naturally.[19]

Not only did Linnaeus discover a consistent means by which to categorize plants, he also formulated a systematic way to name and classify the rest of organic Creation. Until his time no coherent method for naming and ordering animals and plants had been developed and accepted universally. Numerous systems existed for naming and describing species; but as the discovery of new organisms increased, these varied sys-

FIG. 24. JANE COLDEN, *Parts of the Saracena and Other Plants,* mid-eighteenth century. Pen and ink. Courtesy of the British Museum (Natural History), London.

tems of nomenclature became unwieldy. In an age of active scientific exploration and discovery, names became longer and longer as an ever-increasing number of newly found organisms had to be distinguished from known species. Linnaeus created a system of binomial nomenclature for flora and fauna so that each species would have two names — one to label it simply and another to describe it in more precise detail. In both cases the generic name would be the same. The simple name itself was known as a binomial, since it consisted of the generic name and usually one other word (the *nomen triviale*) which together formed a label easy to remember for everyday use. Linnaeus applied this system of binomial nomenclature to approximately 5,900 species of the vegetable kingdom in his *Species plantarum* (1753) and to almost the entire known animal kingdom in the tenth edition of his *Systema naturae* (1758-1759). Binomial nomenclature remains the method by which organisms are named and classified today.

Americans and Classification

From the appearance of Linnaeus' works in the mid-eighteenth century through the early nineteenth, American naturalists based their understanding of the structure of Creation largely upon his system of classification. One of the earliest American-born naturalists to master Linnaean classification in the mid-eighteenth century and to utilize the system to name and order American plants was Jane Colden, daughter of Cadwallader Colden, surveyor-general of New York.[20] Jane Colden relied upon simple — almost crude — line drawings to define each plant for her European colleagues (Fig. 24). Her specimen drawings, based on Linnaeus' sexual system, illustrate the reproductive organs of the plants they portray as the distinguishing traits of each species. These drawings were prized by her correspondents and held up as models to William

Fig, 25. William Bartram, *Sarracenia Purpurea L.,* c. 1803. Pen and ink. Frontispiece for Benjamin Smith
Barton, *Elements of Botany,* Philadelphia, 1803. American Philosophical Society, Philadelphia.

Bartram, a young Philadelphia naturalist who began sending illustrations of American
flora and fauna to British naturalists in the mid-1750s.[21]

Bartram employed the Linnaean system in many of his drawings for British
patrons and in his illustrations for the first American botanical text, *Elements of Botany*
(1803), by Benjamin Smith Barton (Fig. 25). It is important to point out, however, that
Bartram's drawings are not simply the reflections of a classifying mind. Indeed, many
of his works pointedly undermine the conventions of the specimen drawing. In these
revolutionary images, organisms are not isolated from their environments but are
compositionally united with them. In his map of the Alachua Savanna (Plate 111), for
example, Bartram not only illustrates animals and plants within their natural environ-

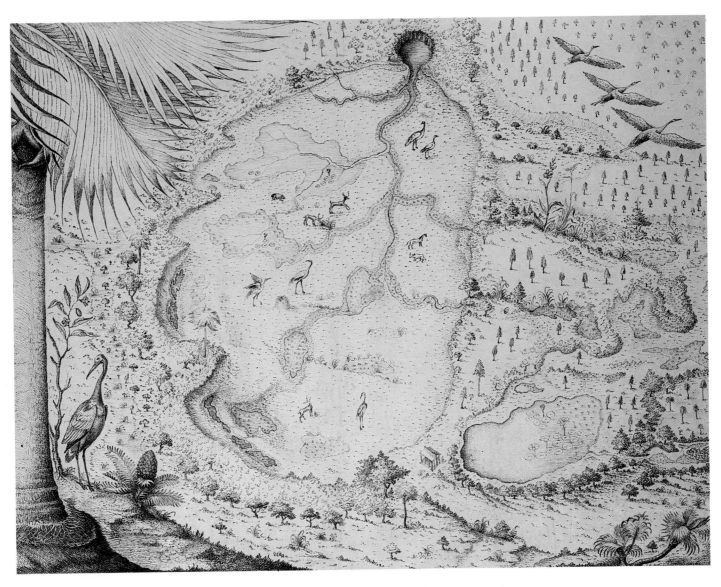

PLATE III. WILLIAM BARTRAM, *The Great Alachua-Savanna in East Florida,* c. 1774.

ments but he links them through reflections of form. The same undulating lines that trace the geographic outlines of the savanna are repeated in the forms of the plants and animals that thrive upon it. Bartram's concept of a wholly integrated cosmos in which clear distinctions between organic types become problematic was part of a subcurrent in American natural history illustration, beginning with Mark Catesby's *The Natural History of Carolina, Florida and the Bahama Islands* (Fig. 26), produced between 1731 and 1748, and continuing through the works of John James Audubon (Fig. 27). This subcurrent countered the general trend toward systematic classification.[22]

Despite Bartram's radical notion of environmental unity, most American naturalists of the late eighteenth and early nineteenth centuries devoted themselves to the strict categorization of organic and inorganic forms according to contemporary classification systems. Bartram's own protégé, Alexander Wilson, worked hard to master Linnaeus' system for his *American Ornithology* (1809-1814), the first book printed in America devoted entirely to American birds. Although the engravers of Wilson's plates placed a number of his representations of individual birds against simple landscape settings, few compositional associations or reflections of form tie the landscapes and the birds together. This is true even in a print such as the *Great-Footed Hawk* (Fig. 28), in which the landscape is more fully developed than in most other plates from *American Ornithology.* In this print the bird is portrayed in great detail. It stands on a bit

FIG. 26. MARK CATESBY, *Viper Fusca. Arum & c.* Hand-colored etching from Catesby's *The Natural History of Carolina, Florida and the Bahama Islands,* London, 1731–1748, Vol. II, Plate 45. Dumbarton Oaks, Trustees for Harvard University, Washington, D.C.

FIG. 27. Attributed to JOHN JAMES AUDUBON, *Red-Shouldered Hawk with Bullfrog,* c. 1827–1830. Oil on canvas. Collection of the Newark Museum.

FIG. 28. ALEXANDER WILSON, *Great-Footed Hawk*. Hand-colored engraving by Alexander Lawson, in Alexander Wilson, *American Ornithology*, Philadelphia, 1808–1814, Vol. IX, Plate 120. The Library Company, Philadelphia.

of marshy turf, profiled against a pine forest in the distance and a brooding, cloud-filled sky. The hawk dominates the landscape entirely. Even the rushes bending to the left seem to cower before its form. And yet, there is no real sense of environmental interaction in this image, since the bird is not seen to act within the scene. Its body is completely static and its talons fail to sink into the grass on which it stands. The hawk floats on the surface of the page, separated from the landscape that recedes behind it. Essentially the plate remains the specimen drawings that Wilson originally designed.

In early-nineteenth-century America, the placement of specimens against landscape backgrounds became prevalent both in natural history illustration and in museum display. For his innovative Philadelphia Museum, the artist-naturalist Charles Willson Peale designed the first American museum cases to display zoological specimens against painted landscape backgrounds intended to simulate their natural environments.[23] Peale's cases were not meant to shift the emphasis of illustration away from the traditional categorization of life forms toward a view of the natural world as a more integrated system. Rather, the attributes of Peale's landscape settings were intended to help define the organisms more precisely than ever before and to aid the viewer in distinguishing one organism from another.

Installed in his museum, Peale's displays of animals and plants were arranged according to the Linnaean system of classification, as well as the more natural systems of contemporary French naturalists, such as Buffon and Cuvier.[24] As Peale had formed

his museum's collections it had been his objective "to bring into one view a world in miniature."[25] In his "great school of nature," Peale displayed his floral and faunal specimens "classed and arranged according to their several species."[26] As Brooke Hindle has pointed out, it was Peale's highest aim in science "to classify all the varieties and species, genera and orders of nature, that came within his purview."[27] Framed catalogues hung near the exhibition cases naming specimens in Latin, French, and English and arranging them in terms of order and class.[28] Peale discussed the purpose of a "classically arranged" collection when he projected his vision of a successful museum in his *Discourse Introductory to a Course on the Science of Nature,* delivered at the University of Pennsylvania, on November 8, 1800:

> *First let us suppose that we have before us a spacious building . . . in which are arranged specimens of all the various animals of this vast continent, and of all other countries; . . . Let us suppose them classically arranged, so that the mind may not be confused and distracted in viewing such a multitude of objects.*
>
> *Whether we begin at the first or last link of the chain is of little consequence; . . . provided we proceed step by step, to trace the beauties which we shall find that each possesses, in its relative situation to other beings. . . .*[29]

The "classical arrangement" of Peale's museum would allow the visitor to perceive the inherent order of nature without being confused by its great diversity. One specimen type of each organic and inorganic production of nature would be shown so that the viewer might be able to distinguish the most minute differences in kind. In Peale's ideal museum, natural forms would be seen in terms of the traditional hierarchical chain of being.

In arranging his collections in taxonomic order, Peale was able to integrate American natural productions with those of Europe and other regions of the globe. When seen as indispensable links in the universal chain of being, the vast array of new productions brought back from the undeveloped regions of the continent could not be mistaken for the arbitrary creations of a chaotic wilderness. Peale allied the order of the New World with the order of the Old by insisting upon the arrangement of America's natural forms according to the principles of European classification.

The desire to control the productions of the American wilderness in traditional terms is not only suggested by Peale's museum cases but also by the drawings of his son Titian. Of Peale's many children, Titian Ramsay Peale expressed a special interest in the art of natural history illustration. His early scientific education took place largely in his father's museum, where he first served as assistant to his brother Rubens in 1816. There he learned to catalogue organic and inorganic specimens according to the major taxonomic systems of his day.

Titian Peale was at heart a categorical thinker who sought through his drawings to order the natural world in familiar terms that would render it accessible to the American viewer. Working according to the pattern established by his father, he was inclined to portray organisms not only by their physical attributes but also by their habitats. By blending the full-fledged landscape with the specimen drawing, Peale defines the organism more specifically. In his images landscape depiction is pressed into the service of systematic classification.

Titian Peale's interest in representing Creation as systematically ordered is clearly reflected in the illustrations he drew as assistant naturalist on a western expedition led by Major Stephen H. Long of the United States Topographical Engineers, from 1819 to 1820. Major Long was in charge of a scientific contingent which formed one arm of a venture known as the Yellowstone Expedition — a much larger military undertaking under the command of Colonel Henry Atkinson, which had as its objective the planting of posts along the upper Missouri River, near the mouth of the Yellowstone. As

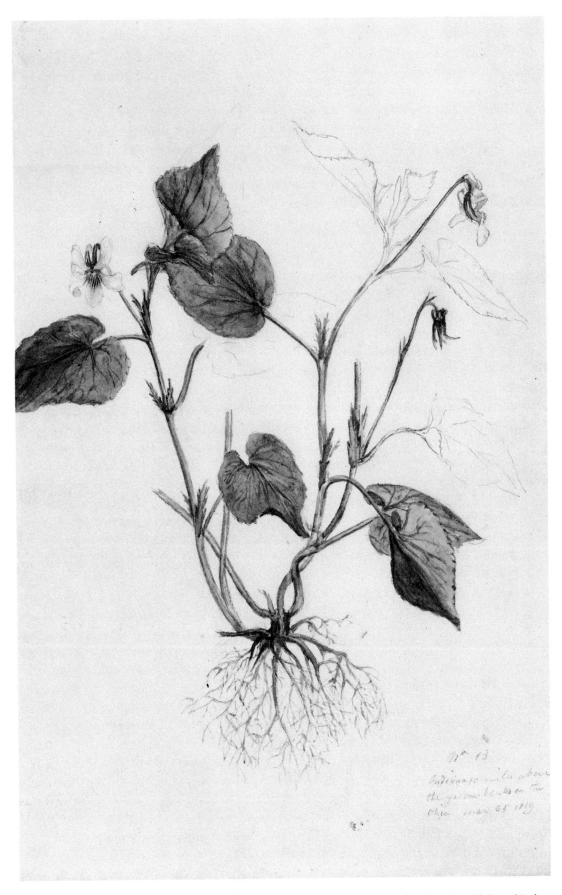

FIG. 29. TITIAN RAMSAY PEALE, *White Violet,* May 25, 1819. Graphite and watercolor. American Philosophical Society, Philadelphia.

early as the Lewis and Clark Expedition in 1803, federal surveys of the West had been ordered to collect scientific data as they pursued broader national objectives. The Yellowstone Expedition, however, was the first major reconnaissance to include its own scientific corps under separate command. When the military expedition failed at Council Bluffs in the winter of 1819, the scientific survey went on alone, making it the first federal expedition to be conducted by a group of naturalists and topographers.[30]

On the Long expedition Peale produced many images of isolated flora and fauna according to the traditional conventions of the specimen drawing (Fig. 29); he also created works in which a specimen is incorporated into the foreground of a highly particularized landscape. These are essentially elaborate specimen drawings in which the attributes of the subject's physical setting help define the subject as unique. In one of Peale's pencil and watercolor depictions of a magpie (Fig. 30), four birds are shown in various positions within a stark landscape setting. Peale constructed a hierarchical work in which the large, close-up image of the bird first defines the species, and the smaller subordinated landscape then describes the place where the species can be found. In the foreground Peale shows how the magpie as a scavenger consumes deer flesh, holding the end of the strand with its feet and tearing at the center with its beak. This silhouetted figure also shows the bird's characteristic markings when its wings are closed. Directly above flies another magpie, its body tilted toward the viewer so that its shape and markings in flight can be seen. Two more magpies perch on the branches of a dead tree, demonstrating typical poses from front and side. By defining the typical physical attributes and activities of the magpie, the image serves as a specimen drawing. It functions in the long-established tradition of White's sixteenth-century depiction of fireflies (Fig. 22), in which several organisms of the same species are shown in a number of characteristic poses.

In Peale's image, however, the birds are actors in a landscape that can also be defined as unique by its highly particularized features. Here a flat, barren foreground, bearing only tufts of grass and broken trees, leads toward a curved river bank. Across the river lies a village of tepees and low forest, backed by distant hills. The image visually defines not only a species of bird, but also the place where this species can be found. To make this dual purpose clear, Peale notes the name of the bird on the drawing, and on the mount he writes the place and date on which the drawing was made ("Engineering Cantonment Mo. Dec. 1819"). It is the environment in which the magpie can be found that helps to distinguish this species from any other.

Peale employs a similar compositional format many times over in his pictures of western fauna. In his drawing of the muskrat (Plate 112), for example, he chooses to show a pair of animals in the foreground of a detailed plains landscape. One animal is in full profile, illustrating the characteristic color and form of the species, while another is engaged in the typical act of swimming across a river. Form and habit as well as place define the unique character of the species depicted in this work.

The emphasis on place in Peale's studies from the Long expedition reveals an interest not only in the classification of species but in their geographical distribution as well. By defining the range of one animal as distinct from that of another, Peale could draw a clearer line between species than ever before and so contribute to the neat categorization of all life forms. Even with the inclusion of landscape backgrounds, Peale's images fundamentally remain specimen drawings which help to order the new species of the western environment according to accepted systems of categorization.

Peale's compositional approach to the landscape within these drawings complements the notion of an ordered and accessible West. In drawing his landscapes Peale adopted the conventions of the picturesque that had become popular in late-eighteenth-century and early-nineteenth-century British and American landscape portrayal. Although less schematic than topographical views, picturesque landscapes con-

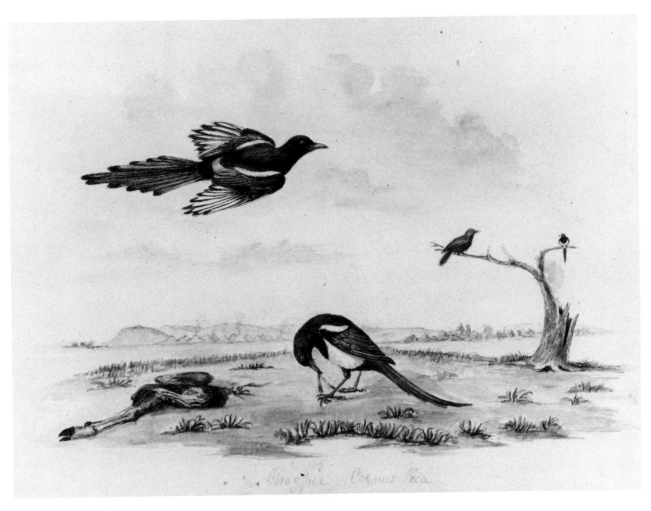

FIG. 30. TITIAN RAMSAY PEALE, *Magpie. Corvus Pica*. June 29, 1820. Graphite and watercolor. American Philosophical Society, Philadelphia.

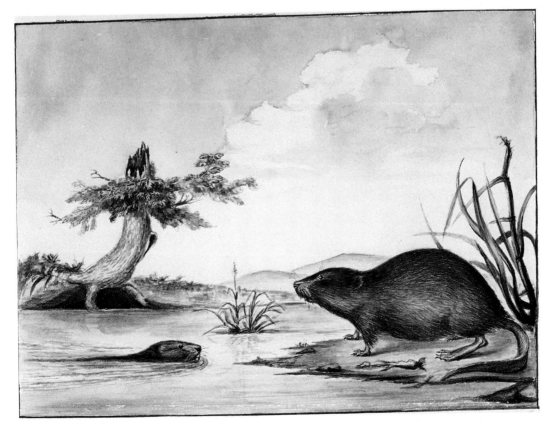

PLATE 112. TITIAN RAMSAY PEALE, *Muskrats*, C. 1820.

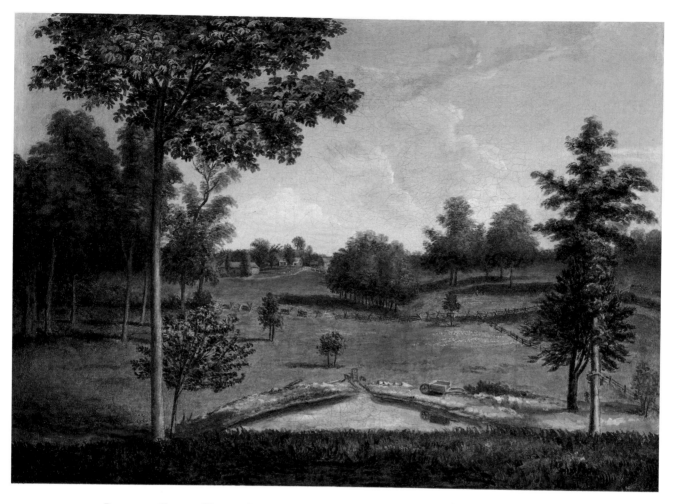

PLATE 113. CHARLES WILLSON PEALE, *Landscape Looking toward Seller's Hall from Mill Bank*, c. 1818.

tinued to order the terrain so that it would be wholly comprehensible to the British and American viewer[31]; making the New World resemble the familiar landscape of Britain rendered it even more accessible.[32] The traditional compositional approach, which had evolved from Claude Lorrain's seventeenth-century pastoral landscapes, is based on a series of wedges that press toward the center of the picture, rhythmically alternating from side to side, and gently moving the viewer's eye back into an illusionistic space. Often a body of water snakes through the middle distance complementing this gradual movement into the scene. Aerial perspective aids in creating a sense of depth and in harmonizing the varied elements of the landscape. In using the pastoral tradition as modified by picturesque convention, landscape painters made the North American continent appear to be a comfortable environment that encourages the entry of the spectator and accommodates him with ease.

Titian Peale became familiar with the conventions of the picturesque both through his knowledge of prints by British and continental landscapists and through his exposure to landscapes by his father (Plate 113) and his uncle, James Peale (see Plate 82). He also saw picturesque landscapes by a number of artists who exhibited at the Pennsylvania Academy of the Fine Arts, such as William and Thomas Birch, George Beck, William Groombridge, and Francis Guy. Peale's strong background in composing picturesque views led him to impose a conventional order on his western landscapes (Plate 114) that complements the neat compartmentalization of western organ-

isms in his specimen drawings. In Peale's pictures both the forms within the landscape and the landscape itself fall under the power of the viewer.

Peale's image of the sandhill crane clearly demonstrates his use of picturesque convention to place the western landscape in the viewer's control (Fig. 31). In essence, Peale dramatically compresses the conventional landscape to portray the crane's flat habitat. Two birds take the place of trees that would normally edge the picturesque view. Their legs and bodies tightly frame the progression of the major topographical features into the background. Peale appears to have calculated quite carefully the effect of the cranes' positions on the scene. In his first sketch of the birds alone, he faces the two standing cranes in the same direction, fitting them closely together; but here he turns the bending crane around to create a frame for the landscape.

Directly beyond the open foreground space, a slender wedge of grassland presses across the image from the left. A thin strip of river arcs up above this wedge, winding back toward the horizon. The river is intersected first on the left by a point of land covered by low trees and then by an even thinner point of land pressing in from the right. Within the space of several inches on the page, these alternating sections diminish drastically, indicating to the viewer that his eye has traveled far back into a flat landscape. The horizon is finally marked by a line of thin blue hills which barely rise above the plain. Although the topographical elements that draw the eye back into the scene are contained between the bodies of the cranes, the full extent of the landscape continues to stretch to either side beyond the birds. The horizontal band of open sky that lies below the clouds helps to emphasize this movement in paralleling the horizon and pushing the eye to the left and right. Indeed, the edges of the scene fade off, implying that the landscape moves on infinitely in all directions. While Peale uses the picturesque landscape format to illustrate the openness of the plains, he also allows his image to spill over the conventional bounds to portray the unusual expansiveness of this hitherto-undescribed terrain. In doing so, he adopts what he can from the accepted traditions, making only those changes necessary to exaggerate the notion of the land's accessibility to man.

In truth, the experience of the Long expedition on the plains ran counter to the notion of accessibility expressed in Peale's picturesque landscapes. The initial leg of the expedition up the Missouri to Council Bluffs, and the ensuing winter's camp at the Engineer Cantonment, were accomplished with ease relative to the later trek through

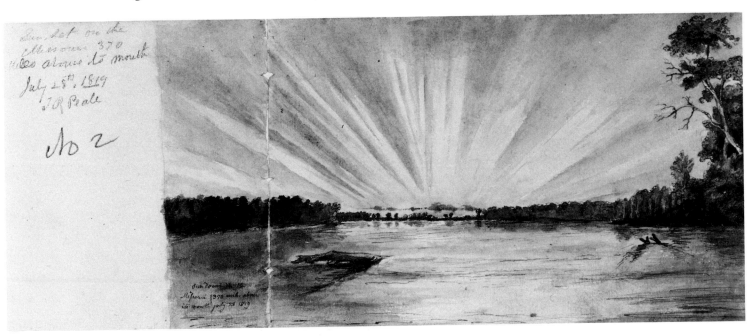

PLATE 114. TITIAN RAMSAY PEALE, *Sundown on the Missouri*, c. 1820.

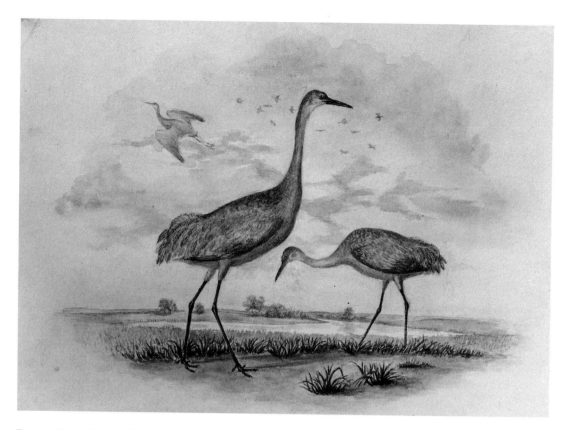

Fig. 31. TITIAN RAMSAY PEALE, *Ardea Canadensis*, March, 1820. Graphite and watercolor. American Philosophical Society, Philadelphia.

the Rocky Mountains and the trip back across the plains. Many of Peale's colleagues, including Major Long, corroborated the opinion formed by Lieutenant Zebulon Pike on his 1806 expedition, that the plains were a Great American Desert that would permanently deter westward expansion.[33] However, while Long and other members of the party did not pursue the notion of a prairie road west, it is evident from his pictures that Titian Peale did. His portrayal of the plains as open and accessible came much closer to the popular spirit of expansionism than Long's practical assessment of the prairie as inhospitable.

Peale's interpretation of the prairie as structurally familiar and inviting accorded with his assessment of nature as clearly ordered and intellectually accessible. When he catalogued the new animals and plants of the West, he entered them in their neatly ordered positions on the scale of being and rendered them fully comprehensible. Similarly, when he portrayed the unusual features of the western environment in terms of the well-known conventions of the picturesque landscape, he made even the most hostile terrain easy to penetrate. His drawings reflect an optimism about America's possession of the West that was not only currently popular but had been instilled in him by his father many years before. Implicit in Charles Willson Peale's constant acquisition and ordering of materials from around the globe was the Baconian idea that through knowledge man gains both intellectual and physical control over the natural world. The elder Peale's passionate interest in the objects brought back from the western reaches of the continent may well have involved the nationalistic urge to possess and control the territory from which these objects came. Titian Peale seems to have been directed by similar motivations in his activities as an artist and naturalist. By utilizing the conventional forms of the specimen drawing and the picturesque landscape to describe the West, Peale took hold of the region intellectually. This act of possession corresponded closely to the popular drive that over the course of the century moved the nation to claim the West for settlement.

NOTES

1. English settlers' attempts to structure the American wilderness and describe it verbally as such have been discussed by many authors, including Perry Miller, Henry Nash Smith, Charles Sanford, Leo Marx, Roderick Nash, John Stilgoe, Annette Kolodny, and John Seelye. Cecelia Tichi has written of the American settler's "driving aspiration to reform the New World environment cojointly with reform of the spiritual and political life of the nation," as this is expressed in literary sources, from the Puritans through the Revolutionary period. See Cecelia Tichi, *New World, New Earth: Environmental Reform in American Literature from the Puritans through Whitman* (New Haven: Yale University Press, 1979).

2. Paul Hulton, *America 1585: The Complete Drawings of John White* (Chapel Hill: University of North Carolina Press, 1984), p. 9.

3. Quoted in *ibid.*, p. 7.

4. Quoted in W. P. Cumming, R. A. Skelton, and D. B. Quinn, *The Discovery of North America* (New York: American Heritage Press, 1971), pp. 193-194.

5. *Ibid.*, p. 200.

6. See Hulton, *America 1585*, p. 8, for a detailed discussion of White's participation in expeditions to the New World.

7. *Ibid.*, p. 9.

8. Quoted in *ibid.*, p. 9, from British Library, Department of Manuscripts, Add. MS 38823, fols. 1–8.

9. White employed the same approach to depict indigenous American peoples. It would seem fruitful to do a comparative study of the way the flora and fauna and the indigenous peoples of the New World were represented.

10. Peter Benes, *New England Prospect. A Loan Exhibition of Maps at the Currier Gallery of Art* (Dublin, N.H.: Dublin Seminar for New England Folk Life, 1981), p. 105.

11. *Ibid.*

12. *Francis Bacon*, Arthur Johnston, ed. (New York: Schocken Books, 1965), p. 79.

13. *Ibid.*, p. 146.

14. Joseph and Nesta Ewan, *John Banister and His Natural History of Virginia, 1678-1692* (Urbana: University of Illinois Press, 1970), pp. 74-75.

15. Raymond Phineas Stearns, *Science and the British Colonies of North America* (Urbana: University of Illinois Press, 1970), pp. 207-208.

16. F. D. and J. F. M. Hoeniger, *The Growth of Natural History in Stuart England from Gerard to the Royal Society* (Charlottesville: University Press of Virginia, 1969), pp. 54-55.

17. Quoted in Ewan, *John Banister*, p. 152.

18. William T. Stearn, "Linnean Classification, Nomenclature and Method," in Wilfrid Blunt, *The Complete Naturalist* (New York: Viking, 1971), p. 244.

19. *Ibid.*, p. 243.

20. Jane Colden, *Botanic Manuscript*, H. W. Rickett, ed. (New York: Chanticleer Press, 1963), p. 23.

21. "To John Bartram," January 20, 1756, *Memorials of John Bartram and Humphrey Marshall*, William Darlington, ed. (1849; reprint, New York: Hafner, 1967), p. 202.

22. This subcurrent came to be of major importance to the ultimate direction of the life sciences in the nineteenth century, and is the subject of my dissertation, "Sketches from the Wilderness: Changing Conceptions of Nature in American Natural History Illustration, 1680–1880" (Yale University, 1985).

23. Brooke Hindle, "Charles Willson Peale's Science and Technology," in *Charles Willson Peale and His World*, by Edgar P. Richardson, Brooke Hindle, and Lillian B. Miller (New York: Abrams, 1982), p. 114.

24. Charles Coleman Sellers, *Charles Willson Peale* (New York: Scribner's, 1969), p. 331.

25. Quoted in *ibid.*, p. 212.

26. Advertisement for the Philadelphia Museum, *Pennsylvania Packet* (July 18, 1786).

27. Hindle, "Peale's Science and Technology," p. 110.

28. Sellers, *Peale*, p. 337.

29. Charles Willson Peale, *Discourse Introductory to a Course on the Science of Nature, Delivered at the University of Pennsylvania, November 8, 1800* (Philadelphia, 1800).

30. Seven soldiers and several interpreters and guides also escorted the party, bringing its number to twenty-two. See Howard Lamar, *Account of an Expedition from Pittsburgh to the Rocky Mountains under the Command of Major Stephen H. Long*, by Edwin James (Barre, Mass.: Imprint Society, 1972), p. xxii.

31. Bryan Wolf, "Revolution in the Landscape, John Trumbull and Picturesque Painting," in *John Trumbull: The Hand and the Spirit of a Painter* (New Haven: Yale University Press, 1982), pp. 207-212.

32. I. S. MacLaren, "The Limits of the Picturesque in British North America," *Journal of Garden History* 1 (December 1978): 97-111.

33. See *The Expedition of Zebulon Montgomery Pike*, Elliot Coues, ed. (New York: Francis P. Harper, 1895), Vol. II, p. 525, and Edwin James, *Account of an Expedition from Pittsburgh to the Rocky Mountain, Performed in the Years 1819 and '20 by the Order of the Hon. J.C. Calhoun, Sec'y of War Under the Command of Major Stephen H. Long* (Philadelphia: H. C. Carey and I. Lea, 1823), Vol. II, p. 361.

FIG. 32. B. COLE, *Perspective View of the Chelsea Physick Garden*. Engraving in Philip Miller, *The Gardeners Dictionary*, London, 1735. Dumbarton Oaks, Trustees for Harvard University, Washington, D.C.

THERESE O'MALLEY

Landscape Gardening in the Early National Period

IN THE YEARS FOLLOWING AMERICAN INDEPENDENCE, landscape gardeners celebrated the creation of a new republic and the uniqueness of its natural setting with the design of a variety of parks, gardens, and townscapes. The purposes served by these gardens ranged from private to public, academic to commercial, and aesthetic to scientific. The history of American landscape design during the late eighteenth and early nineteenth centuries is the study of the integration of European garden styles with the physical conditions of the unspoiled natural environment of the New World.

Landscape styles imported from England and France were the predominant models for gardens in America. Communicated through literature and by gardeners trained abroad, landscape theory was often reinterpreted for implementation on the American continent. Several of the most noted practitioners of the art of landscape design, such as Thomas Jefferson, William Hamilton, and Benjamin Henry Latrobe, visited the great European gardens and through their designs in the United States provided examples of styles that were current abroad. There was also a community of botanists, landscape designers, and nurserymen who carried on an exchange of plant materials between the Old and New Worlds through which concepts of natural philosophy and aesthetics were shared. This in turn helped to form an American landscape movement. It is the interaction of botanical science and the art of landscape gardening as exemplified in several gardens built between 1776 and 1830 which is the subject of this essay.

The natural sciences of the late eighteenth and early nineteenth centuries were characterized by an approach to nature which was basically ecological in their concern with the interrelatedness of environments and organisms.[1] Botanists were encouraged to leave the herbaria and laboratories to study plants *in situ*.[2] Garden designers subscribed to greater naturalism in landscaping as a result of influence by botanists who appreciated the peculiarities of a site, particularly when dealing with New World topography and flora. The response in landscape design was in general a movement from abstraction and artifice toward increased naturalism — from formal, geometric plans to increased irregularity and asymmetry.[3]

The varying approaches to landscape which existed concurrently in the Old and New Worlds are illustrated by the comparison of two gardens in London and Philadelphia. The Chelsea Physick Garden (Fig. 32) outside London was laid out in a formal, geometrical plan with different plants separated into beds, or parterres.[4] The image illustrated is the frontispiece of *The Gardeners Dictionary*, written in 1735 by

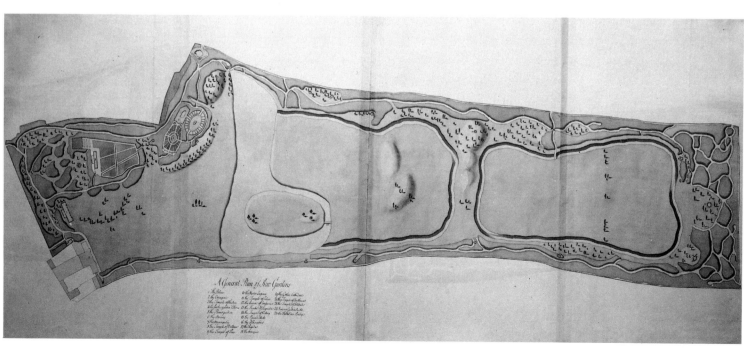

FIG. 33. JOHN or WILLIAM BARTRAM, *A Draught of John Bartram's House and Garden as it Appears from the River,* 1758. Graphite and ink. Library of the Earl of Derby's Estate, Knowsley, Prescot, Lancashire, England; Peter Collinson Collection.

FIG. 34. WILLIAM CHAMBERS, *Plan of Kew Gardens.* Watercolor, pen, and pencil. For Chambers' *Plans, Elevations, Sections, and Perspective Views of the Gardens and Buildings at Kew in Surrey. . . ,* London, 1763. The Metropolitan Museum of Art; Harris Brisbane Dick Fund. The Royal Gardens at Kew were laid out with belts of trees separating garden scenes ornamented with a Chinese pagoda and several other exotic architectural features.

Philip Miller, the director of the Physick Garden. It shows an arrangement of beds according to the sections detailed in his book: "the Kitchen, Fruit and Flower Garden and also the Physick Garden, Wilderness, Conservatory and Vineyard." Many of the plants which appeared under the category "Wilderness" were sent to Miller by John Bartram, a Quaker botanist who lived outside Philadelphia. Because it contained information about so many native plants, *The Dictionary* became the most important resource for gardeners and botanists in America for the next one hundred years.[5]

John Bartram's own garden in Philadelphia is depicted in a sketch made in 1758 (Fig. 33) as a rustic version of a terraced garden with three long avenues of trees leading down to the banks of the Schuylkill River. The drawing does not show the full extent of his garden, which included a plantation of two to three hundred acres outside this enclosed area. It was there that he created habitats, or ecological niches, as nearly identical as possible to those in which his plants had been collected. Bartram and several of his contemporaries created a new form of garden in the wilderness. Dr. Alexander Garden of South Carolina observed that Bartram substituted natural elements for traditional artificial garden features: "He disdains to have a garden less than Pennsylvania, every den is an arbour, every run of water, a canal, and every small level spot, a *parterre*."[6]

In scientific gardening as well as pleasure gardening, the trend toward a more ecological and naturalistic landscape was seen in the next generation of gardens after Chelsea and Bartram's. The Royal Gardens at Kew outside London (Fig. 34), and several American gardens which will be discussed below, carried on the overriding botanical interest which characterized the period while integrating the aesthetic ideal of the naturalistic landscape. The abstract formality of Chelsea was replaced at Kew by an irregular layout of winding paths and informal beds. The wilderness of Bartram's plantation was tempered by the ideal of a cultivated pastoral garden with plants arranged scientifically[7] in order to make botanical observation possible as well as pleasurable.

Landscape Gardening Theory as Practiced in America

George Washington was disappointed when he saw the famous garden of the botanist John Bartram: "It was not laid off with much taste nor was it large."[8] The general, in the process of landscaping his own plantation, did not appreciate Bartram's rustic approach to gardening. Bartram had sent Washington a great deal of plant material, but in terms of stylistic preferences the general was influenced by *The Gardeners Dictionary* and Batty Langley's *New Principles of Gardening*, written in 1728.[9] Both Miller's and Langley's publications represent what has been called the earliest phase of the English landscape movement, which is also associated with the poet and garden designer Alexander Pope and the architect-designer William Kent. It is a style which emphasized formal features of the garden while attempting to break away from the strict geometry which dominated seventeenth-century gardens. This type of garden appeared as early as 1740 in America[10] and is well represented by Mount Vernon (Fig. 35), which became the model for many plantations in the South.

Mount Vernon was a perfectly kept, well-cultivated estate, planned in what was referred to by contemporary visitors as the "English style": "The general had never left America; but when one sees his house and his home and his garden it seems as if he had copied the best samples of the grand old homesteads of England."[11] Mount Vernon contained all the usual features of a mid-eighteenth-century English estate: a deer park, mounts, two wildernesses, two groves, shrubberies, serpentine drives, a bowling green, symmetrical vegetable and flower gardens, a "botanick" garden, a parterre (Fig.

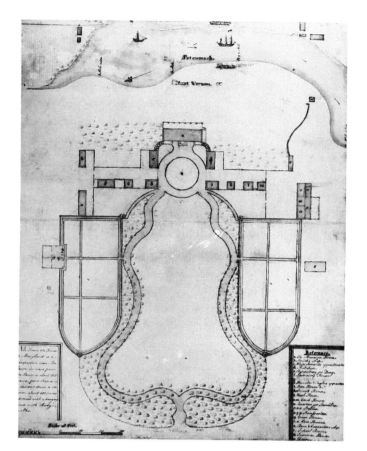

FIG. 35. SAMUEL VAUGHAN, *Gardens of Mount Vernon*, 1787. Pen and ink wash. Mount Vernon Ladies Association.

FIG. 36. Fleur-de-lis at Mount Vernon, 1954. Mount Vernon Ladies Association. This box-hedged parterre is a modern replanting of the original design. Beds of geometrical shapes remained popular in North America long after they went out of fashion abroad.

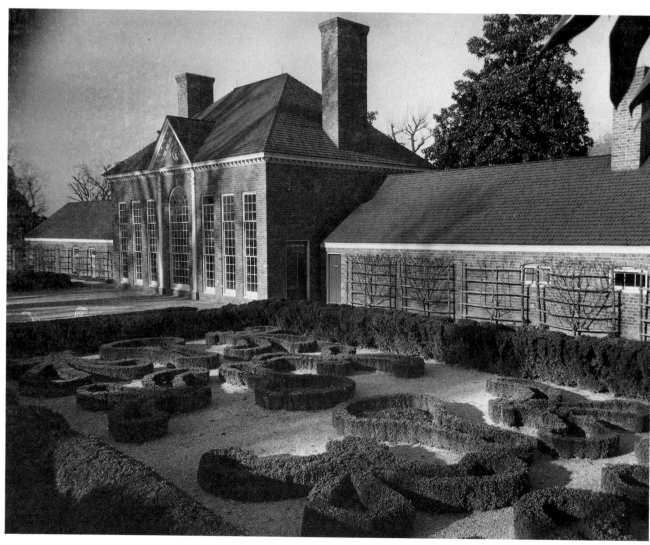

36), and a ha-ha, or sunken hedge.[12] Mount Vernon exemplified the *ferme ornée,* literally ornamented farm,[13] which contained fields, kitchen garden, orchards, and a pasture very near the purely decorative parterre and walks bordered by shrubbery. A garden type first described by Stephen Switzer in 1715–1718 in his *Iconographia rustica,*[14] the *ferme ornée* permitted the integration of "the pleasurable and profitable parts of a country life," or as Thomas Jefferson said of Monticello, here "the attributes of a garden are interspersed among the articles of husbandry."[15]

Although the ornamented farm continued to appeal to Americans well into the nineteenth century, the English by mid-century began to lose their taste for artifice tempered by agriculture. As Thomas Whately, author of *Observations on Modern Gardening,* commented in 1770: "Fields profusely ornamented do not retain the appearance of a farm; and an apparent attention to produce, obliterates the idea of a garden."[16] Instead there began to be a preoccupation with "picturesque" garden making as an art related to landscape painting more than to agriculture. The major influence in this second phase of the picturesque movement was Lancelot ("Capability") Brown, whose undulating landscapes dominated gardening theory until his death in 1783 and the English countryside long afterward. During the 1760s Brown cleared slopes, planted isolated clumps of trees, made perimeter belts of woodland, and dammed streams in order to create the uninterrupted landscapes which have come to be known as English parks. Brown's methods found little following in America for very simple reasons. He did away with the flower garden, which was essential in America where interest in new plants was intense.[17] In addition, Brown's ability to create the appearance of unspoiled countryside was unappreciated in the New World where this condition prevailed anyway. Thomas Jefferson summed up the fundamental difference between English and American planting at this time in a letter entitled "Objects of attention for an American": "Gardens, [are] peculiarly worthy of the attention of an American, because it is the country of all others where the noblest gardens can be made without expense. We have only to cut out the superabundant plants."[18] Americans sought the middle ground, the effect of nature cultivated by art.

It is not surprising that by 1796, when the English architect Benjamin Henry Latrobe, recently immigrated to America, visited Mount Vernon he found it representative of a *retarditare* taste: "For the first time again since I left Germany, I saw here a parterre, chipped and trimmed with infinite care into the form of a richly flourished Fleur de lis: the expiring groans I hope of our Grandfather's pedantry."[19] In England Latrobe had been exposed to the most recent debates concerning the picturesque, the beautiful, and the sublime in landscape theory. In 1794 the letters of Uvedale Price and Richard Payne Knight were published, and they in particular disapproved of the mid-century landscapes of Capability Brown.[20] The aristocratic landscaping of Brown was seen as reflecting the political ideals of the Whigs: it promulgated taste over feeling and status quo over change. The Brownians, claimed their critics, had applied a formula to every landscape regardless of its location or peculiarities. "Smooth round forms, gradual deviations, serpentine lines, clear margins, and the elimination of nature's 'false Accidents' were beautiful but not picturesque."[21] The new movement turned away from the Brownian landscape, which embodied the concept of stabilized beauty, toward the new Romanticism, which promoted the individual and creative imagination. In gardening this meant the recognition of the peculiar character of each site and the unique quality of each specimen.

Unlike Brown, who had taken the park right up to the architectural edge of the house, Humphrey Repton, working in the late eighteenth century in England, was concerned with the line of separation between building and landscape. The house was under the management of art while the landscape park was nature's province. Repton's solution was to establish a pleasure ground or flower garden of "embellished nature"

PLATE 115a. BENJAMIN HENRY LATROBE, *Taste Anno 1620,* from "An Essay on Landscape," 1798–1799.

which would act as a transition space, whose "decoration should be as much those of art as of nature." For the flower garden Repton encouraged "rare plants of every description," revealing the enthusiasm for the newly imported exotics that characterized the period. "Beds of bog-earth should be prepared for the American plants . . . the aquatic plants . . . should grow on the surface or near the edges of water. The numerous class of rock plants should have beds of rugged stone. . . ."[22] With an approach that was similar to Bartram's, Repton was providing the appropriate environment for his plantings.

In America in the late eighteenth century Latrobe, expressing his own rejection of standardized beauty, wrote: "there are in nature perhaps no two Trees exactly of the same form. Even among individuals of those species that assume the most regular shapes, an infinite variety may be observed."[23] Latrobe's thoughts on landscape theory and design can be found in "An Essay on Landscape Painting" which he wrote in 1798–1799 for the benefit of his student Susan Catherine Spotswood. In this rich compendium of intellectual history, Latrobe addresses many related topics including natural philosophy, the Great Chain of Being, and geology.[24]

Latrobe's discussion of landscape design begins with the seventeenth and early eighteenth centuries, when it was the "fashion . . . to admit nature in every shape but her own." With a sketch of men and women in a formal garden (Plate 115a) Latrobe illustrates the predilection for topiary and trimmed plantings:

> *In an age, in which the elegant forms of the Ladies were cooped up in Whalebones stays, and fenced in by the vast circumference of a hoop, when the Men were confined by ten dozen buttons, and smothered by enormous wigs; it would be unreasonable in the trees to have complained of being cut into Cones and Pyramids, twisted into spires, and clipped into Lions and Elephants.*[25]

Latrobe both subscribed to naturalism in landscaping and appreciated New World flora and topography. His philosophy descends from the developments in natural history which John Bartram had expressed. Latrobe, as an amateur botanist and illustrator, shared Bartram's ecological concerns, which came to characterize the scientific and philosophical thought of this period. In keeping with this tradition, Latrobe believed the new environment demanded new treatment:

PLATE 115b. BENJAMIN HENRY LATROBE, *Studies of Trees,* from "An Essay on Landscape," 1798–1799.

In America we have been, in our taste in Gardening, a little behind our scale of improvement in other respects. Till very lately we still loved straight unshaded Walks, and called them a Garden, and the few Trees about our dwellings which escaped the axe, we robbed of their best property — that of shading us from the scorching sun. The rage of trimming our trees still subsists. . . . The sketches on the page [Plate 115b] show the contrast of the benevolence of nature, and the ingenuity of Man. Under the spreading oak on the left every hour of the day is shady and cool, to the right may be easily recognized the old arrangement of a Virginian plantation. [26]

Thomas Jefferson sympathized with Latrobe's desire for landscaping which was suited to the requirements of the environment and not only represented the latest British taste. In a letter to another gardener he contrasted garden design in England and the American South:

. . . their sunless climate has permitted them to adopt what is certainly a beauty of the very first order in landscape. Their canvas is of open ground, variegated with clumps of trees distributed with taste. They need not more of wood than will serve to embrace a lawn or a glade. But under our beaming, constant and almost vertical sun of Virginia, shade is our Elysium. In the absence of this no beauty of the eye can be enjoyed. [27]

American Private Gardens

While Latrobe viewed American gardening as somewhat lagging, and Jefferson cautioned against unthinking adoption of British styles, American gardeners were actually more sophisticated than this implies — or than is usually assumed. They were not only aware of a variety of landscape styles but they employed them with virtuosity, as is exemplified in three drawings, dating from around 1795, for the grounds of the Elias Hasket Derby house in Salem, Massachusetts. [28] In all three, the ring walk around the house and the carriage entry path is gently curving and slightly irregular in shape. The

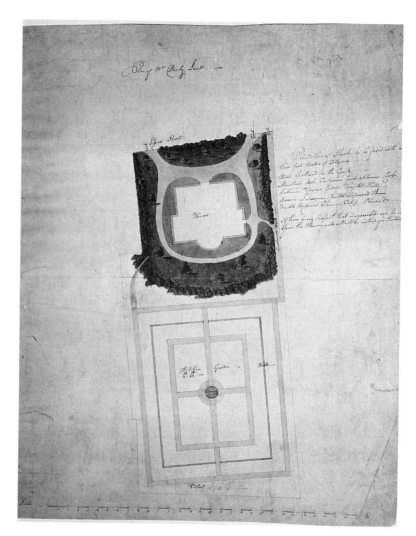

Fig. 37–38a, b.
Three drawings for the layout of the grounds for the Elias Hasket Derby house, Salem, Massachusetts. c. 1800. Derby Papers, Essex Institute, Salem, Massachusetts.

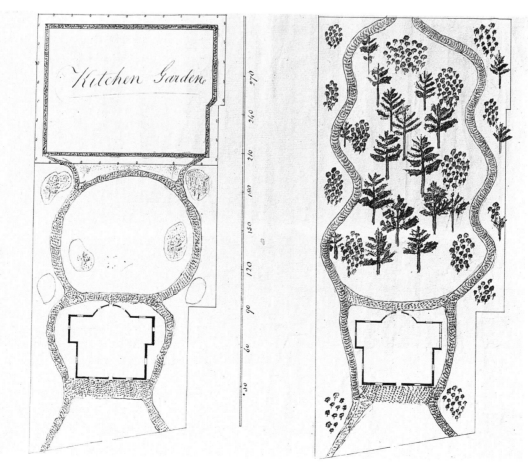

first drawing (Fig. 37) shows the rear garden to have a symmetrical plan with a center rectangle divided into quadrants and finished with a centralized fountain. Surrounding the house is a walk with smaller paths breaking off tangentially at irregular points. This is the most formal of the plans. The other two views display increasingly naturalistic approaches. The second (Fig. 38a) shows isolated beds or mounds breaking up the lawn; beyond the back circuit, a rectangular kitchen garden looks as if it might have been kept from view by fencing or trees. The third design (Fig. 38b) is the most naturalistic. A single extensive serpentine path encircling the length of the grounds behind the house is filled with large randomly placed trees, creating a wilderness right outside the door. The designer used a Brownian formula which brings the park right up to the edge of the house. This display of versatility is a good indication of the range and sophistication of American landscape taste in the late eighteenth century.

A garden in New Hampshire, seen in Plate 116, was similar to the first design (Fig. 37). The enclosed garden depicted in these images was not unusual in New England in the mid- to late eighteenth century. The broad allée on axis with the main house leads to a pool or fountain which serves as the central point for asymmetrically radiating paths. The walkways are lined with small plantings, and trees are randomly placed about the lawn. In the fanciful painting, Plate 117, a Greek Revival house is set in a naturalistic informal landscape. Just outside the main door a winding path diverges in two directions, one to a ruined arch in the background, the other, curving down a few steps to the foreground, leads to a tree-lined allée. Although scale and perspective are distorted in this depiction, the garden elements are recognizably those appropriate to a natural garden treatment.

The style developed by Humphrey Repton was the garden type used at several of the most famous landscape gardens during this period. The Woodlands, the country estate of William Hamilton, was considered by many to be the prime example of the

PLATE 116. UNKNOWN ARTIST, *Seat of Colonel George Boyd*, 1774.

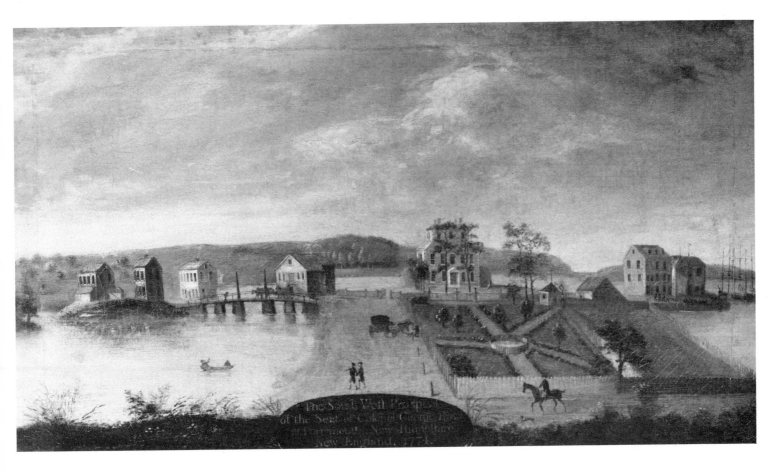

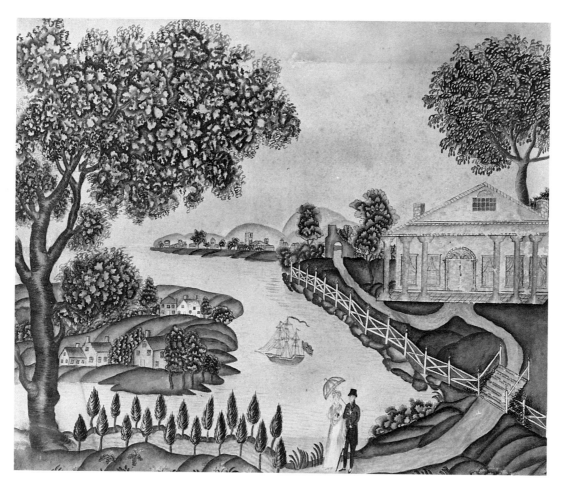

PLATE 117. UKNOWN ARTIST, *Townscape, Stonington, Connecticut,* c. 1800–1825.

Reptonian style outside of England.[29] A wealthy botanist and landscape gardener, Hamilton during 1779-1789 enlarged the family home which dated from 1740. With Frederick Pursh, his full-time gardener, he created "a magnificent garden" on ten acres of "hill'n dale" on the banks of the Schuylkill River.[30] The intention was to create a small English park of winding paths for a pleasure garden with a greenhouse, hothouse, and exotic yard for his botanizing. After the Revolution, Hamilton spent several years in England, where he clearly was influenced by the latest landscape fashions and acquired the taste which Jefferson claimed made The Woodlands the only rival in America to what could be seen in England.[31] It was during the period when Jefferson was secretary of state, beginning in the 1790s, that he and Hamilton began their long friendship and correspondence. Later, as president, Jefferson so admired Hamilton's abilities as a botanist and landscape gardener that he entrusted him with the "botanic fruits" of the Lewis and Clark Expedition.[32]

The Reverend Manasseh Cutler, whom we rely upon for many descriptions of gardens, gives us an account of his visit to The Woodlands:

> . . . we then walked over the pleasure grounds, in front, and a little in back of the house. It is formed into walks, in every direction, with borders of flowering shrubs and trees. Between are lawns of green grass, frequently mowed, and at different distances numerous copse of native trees, interspersed with artificial groves, which are of trees collected from all parts of the world. . . . We then took a turn to the garden and green houses. . . . the garden . . . [is] ornamented with almost all the flowers and vegetables the earth affords. . . . The green houses which occupy a large space of ground, I cannot pretend to describe. Every part was crowded with trees and plants, from the hot climates, and such as I had never seen. . . . He assured us, there was not a rare plant in Europe, Asia, Africa, from China and the islands in the South Sea, of which he had any account, which he had not procured.[33]

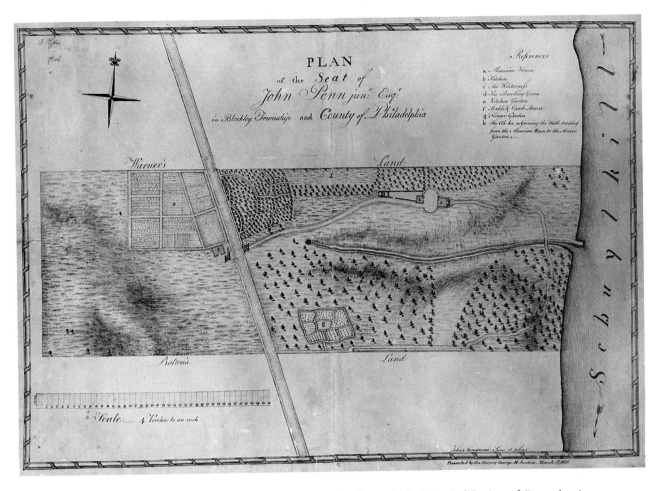

FIG. 39. JOHN NANCARROW, *Plan of the Seat of John Penn. . . ,* c. 1784. Pen and ink. Historical Society of Pennsylvania. This plan of the estate Solitude is one of the few extant contemporary American landscape plans. The legend reads: "a. Mansion House; b. Kitchen; c. The Wilderness; d. The Bowling Green; e. Kitchen Garden; f. Stable & Coach Houses; g. Flower Garden; h. The Ah-ha adjoining the walk leading from the Mansion House to the Flower Garden."

Up the river from Woodlands, John Penn built an estate during 1785–1798 called Solitude (Plate 118), which William Birch included in his series *Country Seats of the United States* of 1808. The grounds were landscaped in a Reptonian manner, which meant that "formality was not wholly banished from the neighborhood of the house."[34] A circular-ended forecourt connected the main house with the kitchen behind it. In Birch's view, taken from below near the Schuylkill, only the park-like grounds encompassing the house are visible. Other garden features indicated on the plan drawn by John Nancarrow (Fig. 39) included a wilderness, bowling green, kitchen and flower gardens, and a ha-ha. The walk leading from the house to the flower garden is quite circuitous in order to provide varying views along the way. The ha-ha was built on the border of the grounds to hide any fences or separation and give the effect of continuous property.

Sweetbriar (Plate 119) was a Federal-style country house built in 1797 on the Schuylkill for Samuel Breck, a prominent local politician and member of Congress.[35] The situation of the house provided excellent vistas while creating a picturesque scene for travelers on the river. The view, drawn by William Birch's son Thomas, illustrates a typical Reptonian landscape with a raised terrace separating the house from the surrounding landscape park of "hill n' dale." The painting *Point Breeze on the Delaware* (Plate 120), also by Thomas Birch, shows the view from the house out across the terrace, dominated by a marble statue. The terrace, which has been treated in a far more architectonic manner than the park beyond, displays a combination of artifice and plant materials, and thus makes the transition from the house to the park. Individual flower beds and pots contain exotics or curiosities set apart from the larger land-

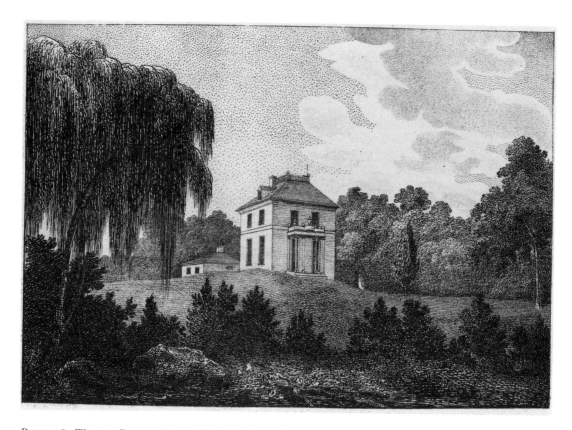

PLATE 118. WILLIAM RUSSELL BIRCH, *Solitude in Pennsylvania belonging to Mr. Penn*, from *The Country Seats of the United States of North America*, 1808.

scape. The artist has gone to some effort to depict recognizable species of flowers in the foreground, which is in contrast to his generalized treatment of trees in the landscape park. Birch's method reflects the practice of the garden designer who selected trees and shrubs for the park on the basis of compositional qualities of color and texture, while preparing flower beds or specimen planting for closer botanical scrutiny.

Simultaneously, landscape designers were practicing older, more formal styles of design along the Schuylkill River. Belmont Mansion in Philadelphia had gardens with clipped evergreen hedges, topiary, a labyrinth, wilderness, and "a most perfect sample of the old taste of parterres." The owner, Judge Richard Peters, preferred the formal rather than the more "modern" fashion.[36] Judge Peters became known not only for his aesthetic sense but also for his scientific acumen. He was the founder of the Philadelphia Society for the Promotion of Agriculture and author of a treatise on farming.

South along the Schuylkill was Lemon Hill (Plate 121), or Pratt's Garden, which was famous for its horticultural marvels. According to a record of 1795, it had a large and elegant greenhouse (shown in the center) filled with citrus trees, which figured prominently in the many popular views of the estate. Lemon Hill was decorated by bowers, rustic retreats, fountains, fishponds, and an artificial cascade. The summerhouses of bark and thatch were embellished with marble statues of Roman gods.[37] In 1837 Andrew Jackson Downing described this estate as being the finest example of the formal or "ancient" style. However, a visitor in 1829 described the garden more accurately as one which was designed in the early picturesque mode, that is a garden featuring both formal and naturalistic elements in the style of William Kent and Alexander Pope. There are in fact some elements which imitate Pope's garden at Twickenham rather closely. For example, at Lemon Hill, "The grotto is dug in a bank [and] is of a circular form, the side built up of rock and arched over head, and a number of shells. A dog of natural size carved out of marble sits just within the entrance, the guardian of the place."[38] This comment reminds one of Pope's shell-encrusted grotto

on the banks of the Thames, which remains to this day guarded by a stone replica of his loyal dog.

American Public Gardens

The private gardens just discussed were clearly products of families of great wealth, education, and international connections. But what about the common citizen of this new democracy? In England it was said that the egalitarian system would discourage the making of magnificent gardens on the scale of European estates. However, it was precisely because of the democratic political ideal that public parks and gardens would be the great expression of landscape art in America. John Claudius Loudon, English horticulturalist, landscape architect, and author, discussed the state of American gardening in his *Encyclopedia of Gardening*: "The only splendid examples of park and hot house gardening that, we trust, will ever be found in the United States, and ultimately every country are such that will be formed by towns, villages, or other communities, for the joint use and enjoyment of all inhabitants or members."[39]

Although the great age of public parks in America did not begin until after the mid-nineteenth century, there were several early examples of the ornamentation of common space and the dedication of open ground to the recreation and edification of the populace. It is not surprising that Philadelphia, birthplace of the new republic, with its tradition of horticultural achievements, would be the site of some of the earliest public gardens and parks. In 1732 the City Assembly first discussed levelling the area behind the State House, the colonial seat of the Pennsylvania colony, and enclosing it "in order that Walks may be laid out, and Trees planted to render the same more beautiful and commodious."[40] In 1784 a garden (Fig. 40) was designed for the State

Drawn & Engraved by W. Birch & Son . Published by R.Campbell &C.º Nº 30 Chesnut Street Philadª 1798.

FIG. 40. WILLIAM and THOMAS BIRCH, *State-House Garden, Philadelphia,* 1798. Engraving. Philadelphia Free Library.

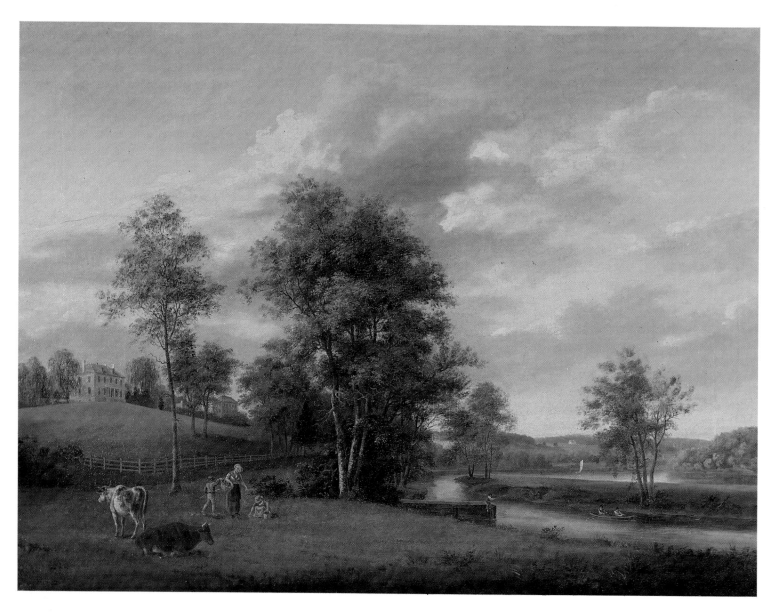

PLATE 119. THOMAS BIRCH, *View of Sweetbriar*, 1811.

PLATE 120. THOMAS BIRCH, *Point Breeze*, 1818.

House yard by Samuel Vaughan, a Jamaican planter and friend of Benjamin Franklin, who became a wealthy industrialist and active member of the American Philosophical Society.[41] Vaughan planned two circulation systems for the square. First, a wide gravel walk led from the tower door of Independence Hall to the gate on Walnut Street. Second, the perimeter of the square was bordered by a serpentine walk. Vaughan had originally proposed using specimens of trees representing all the states, but records show that the square was instead planted with one hundred elm trees. Manasseh Cutler described the State House yard three years after its execution:

> As you enter the Mall through the State House, which is the only avenue to it, it appears to be nothing more than a large inner court-yard to the State House ornamented with trees and walks. But here is a fine display of rural fancy and elegance. It was so lately laid out in its present form that is has not assumed that air of grandeur which time will give it. The trees are yet small but judiciously arranged. The artificial mounds of earth and depressions, and small groves in the squares have a most delightful effect. The numerous walks are well gravelled and rolled hard; they are all in a serpentine direction, which heightens the beauty, and affords constant variety. That painful sameness, commonly to be met with in garden-alleys, and other works of this kind, is happily avoided here, for there are no two parts of the mall that are alike. Hogarth's "Line of Beauty" is here completely verified.[42]

Eventually the high brick walls that had been surrounding the State House yard for several decades were removed, so that by admitting a freer circulation of air it

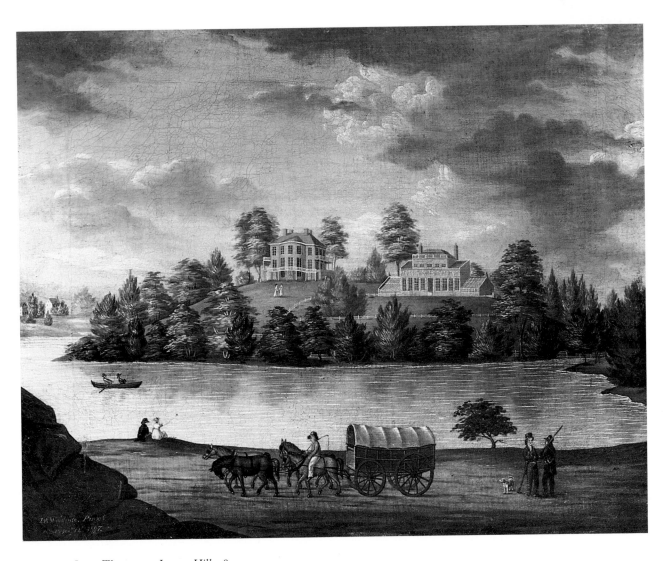

PLATE 121. JOHN WOODSIDE, *Lemon Hill*, 1807.

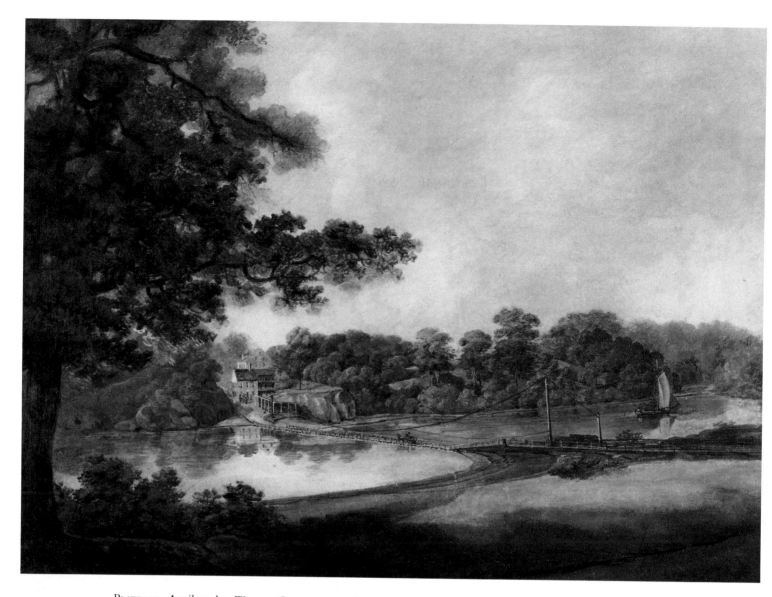

PLATE 122. Attributed to WILLIAM GROOMBRIDGE, *Gray's Ferry Bridge on the Schuylkill*, c. 1800.

would "conduce to the health of the citizens."[43] It was also fashionable to reject the enclosure which had been a feature of late-seventeenth-century garden design in favor of the open, distant views endorsed by the modern styles.

Gray's Garden (Plate 122), along the banks of the Schuylkill River, was another early public garden designed by Samuel Vaughan. This was a very popular pleasure garden admired by many famous Americans. The garden was designed to have a number of separate sections varying in size and shape, "each of which was formed in a different taste." Cutler visited Gray's Garden in 1787 and wrote:

> *The alleys were none of them straight, nor were there any two alike. At every end there were summer houses, arbors covered with vines, or flowers or shady bowers encircled with trees and flowering shrubs. . . . There is every variety that imagination can conceive, but the whole improved and embellished by art, and yet the art so blended with nature as hardly to be distinguished, and seems to be only a handmaid to her operations.* [44]

In 1815 five acres surrounding the Fairmount Waterworks in Philadelphia were landscaped and opened as a public garden (Plate 123 and Fig. 41). This was the beginning of Fairmount Park, which is today one of the largest municipal park systems in the world. The design of the Waterworks by Frederick Graff consisted of stuccoed pavilions with Doric tetrastyle porticoes, recalling both the engineering achievements

of ancient civilization and the romantic picturesque garden planning with plaster antique temples and ruins in the landscape. The combination of the political symbolism of the classical architecture, the engineering feat, and the context of the beautiful landscape combined to make the Waterworks an enormously popular scene for contemporary artists. As G. C. Childs wrote in his *Views of Philadelphia* in 1827–1830: "The situation of Fairmount is exceedingly picturesque, and the works themselves are constructed with great neatness. It is a favorite resort of the citizens, and the view of it is highly interesting, blending as is does the beauty of nature with the ornaments of useful art, and the gaiety of animation of groups of well dressed people."[45]

The gardens were laid out with walks and decorated with gazebos and sculpture. One gazebo was placed half-way up the rocky mount behind the Waterworks, thus providing a view along the river. William Rush's *Nymph and Bittern* fountain as well as other pieces by him were moved there from the Centre Square waterworks. In 1825 a visitor to the park wrote:

> *The superb dam — the beautiful though small expanse of water above it and the fine lively stream below, with its handsome bridges, combined with the delightful gardens, shaded seats, wooded hills rising here and there from the brink of the water by the side of the smooth lawns — present in the* tout ensemble, *a paradise, where the lover of nature could almost delight to dwell, even as a stranger. . . .* [46]

Soon after the Revolution the ornamentation of public spaces such as town centers and commons became very popular. During this period every town in New England, as well as every college and university center, started a civic improvement program.[47] The Green in New Haven (Fig. 42) benefited from a public subscription begun in 1787 which sponsored the planting of elm trees, valued for the "Gothic arches" they produced when fully grown. The straight rows of elms along the New

FIG. 41. J. T. BOWEN, *A View of the Fairmount Waterworks,* c. 1838. Lithograph. The Library Company of Philadelphia.

PLATE 123. THOMAS BIRCH, *Fairmount Waterworks*, 1821.

Haven Green are seen in the drawing for the master plan of Yale College made by John Trumbull in 1792. The somewhat simplistic formal outlining of the common area and streets contrasts with the irregular naturalistic planting of the campus, which was hidden from the street. The private campus demanded less formal treatment than the public city streets. Just as gardens of the period were often ornamented by temples and garden follies, the most densely planted areas in Trumbull's plan concealed privies, which he referred to as the Temples of Cloacina.[48]

The Capital City

Undoubtedly the greatest landscape undertaking by the new federal government was the planning of a capital city. From the earliest designs for Washington, D.C. by Thomas Jefferson and Pierre Charles L'Enfant, public gardens or reservations formed the ceremonial center for the city. In the map of the city made in 1792 after L'Enfant's design, Fig. 43, the L-shaped area of open space was one of several versions of the scheme for a Mall or grand avenue which would connect the president's house with the Capitol. This plan represents the "rectified" version of L'Enfant's original design. Andrew Ellicott, the surveyor, believing that the Frenchman had extravagantly added too many public squares, removed these "errors" in the engraved map.[49] Nevertheless, the plan does indicate the large proportions of ground given over for public reservation. L'Enfant's appreciation of the setting of the city amidst hills and irregular water-

line must not be overlooked. Drawing on the French tradition of Baroque planning, as well as the Romantic movement of his day, L'Enfant created a perfect blend of monumentality and picturesque variety. Both the large Mall and the intersection of radial and grid street plans which created irregularly shaped plazas and squares throughout Washington provided relief from the grandiosity which might be expected when looking at L'Enfant's design. He planned a city in which the classical architecture would recede into the picturesque scenery of the harbor and countryside. The view by George Isham Parkyns (Plate 124) is from the heights of Georgetown looking southeast toward the city. Although it is a romanticized depiction, it is actually a good indication of the lush, rolling, and unspoiled landscape which L'Enfant chose to be the site of the new capital. L'Enfant's abstract design must be seen in relationship to this topography in order to appreciate his sophistication as a landscape planner.

Although L'Enfant delimited the borders of the Mall, very little was done until the mid-nineteenth century to build the Mall's gardens and parks in any unified manner. There were however three separate areas of early gardening activity which should be mentioned. In 1803 Thomas Jefferson chose the erect formal Lombardy poplar tree, which William Hamilton had introduced at Woodlands, to line Pennsylvania Avenue. Jefferson preferred it to the popular elm because it grew quickly, which was important in this new town. In addition, because it was erect and tall rather than full and curving, it would not block the view of the White House or Capitol on either end of the wide boulevard. It would, on the other hand, screen the slipshod development that was taking place along unpaved Pennsylvania Avenue and thus would give the street the sense of dignity which it otherwise lacked. In a letter to Thomas Munroe, superintendent of public buildings, Jefferson sketched a plan for placing Lombardy poplars four deep along the avenue. Munroe replied with a finished drawing of Jefferson's scheme (Fig. 44) plus two alternative designs by William Thornton, architect of the Capitol, and Nicholas King.[50]

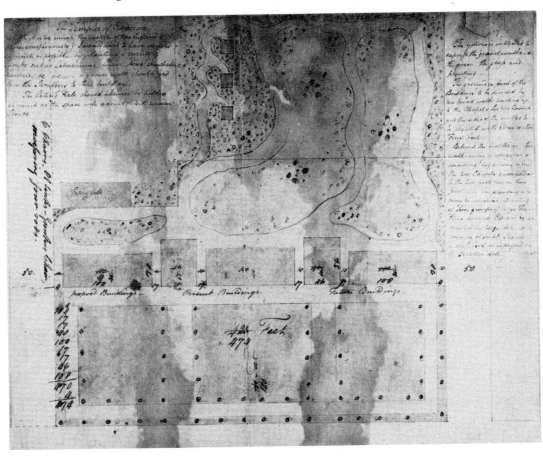

FIG. 42. JOHN TRUMBULL, master plan for Yale College, 1792. Ink and watercolor. Yale University Library.

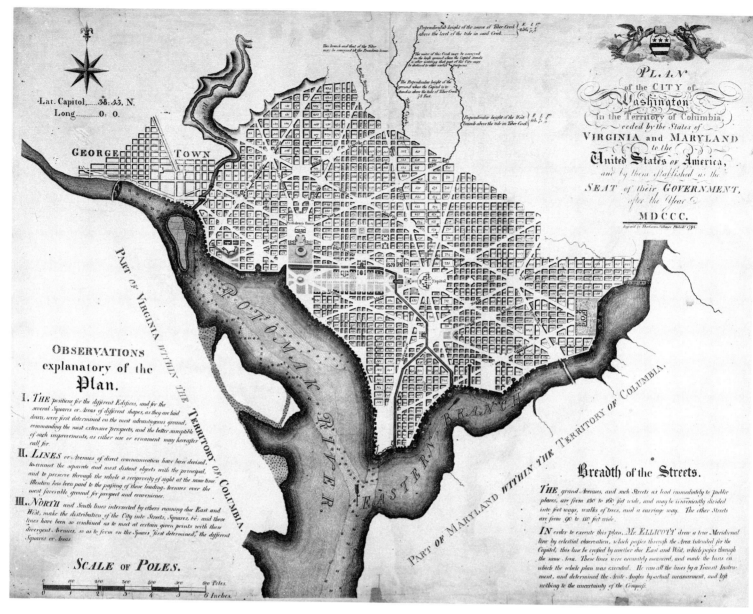

FIG. 43. ANDREW ELLICOTT, *Plan of the City of Washington in the Territory of Columbia.* . . . Engraving by Thackara and Vallance, Philadelphia, 1792. Stokes Collection, Prints Division, the New York Public Library, Astor, Lenox, and Tilden Foundations.

A second area of activity was at the foot of Capitol Hill. Here a series of gardens were started in 1820 by the Columbia Institute for the Promotion of Arts and Sciences. Latrobe was one of the founding members of this society, which had as its goal the creation of a showplace for native plants.[51] In the bottom left of Fig. 45 part of the gardens can be seen. The view also shows the allée of poplars screening the unsightly area along Pennsylvania Avenue.

John Quincy Adams was not the first but was surely the most ambitious gardener to inhabit the White House. As president he encouraged the planting of gardens for ornament, experiment, and for the preservation of natural resources. He extended the flower beds at the White House to 10,000 square feet and planted literally hundreds of trees and shrubs with his own hands. The grounds were levelled and graded and in time "began to assume a park-like appearance." In the watercolor by Anthony St. John Baker (Fig. 46) part of Adams' arboretum is visible. It contained hundreds of trees which formed what he claimed was the foundation of an oak and walnut forest around the White House, "which a century hence may be my successor." Adams was an ardent conservationist, and his chief goals as a gardener were to preserve the country's hard-

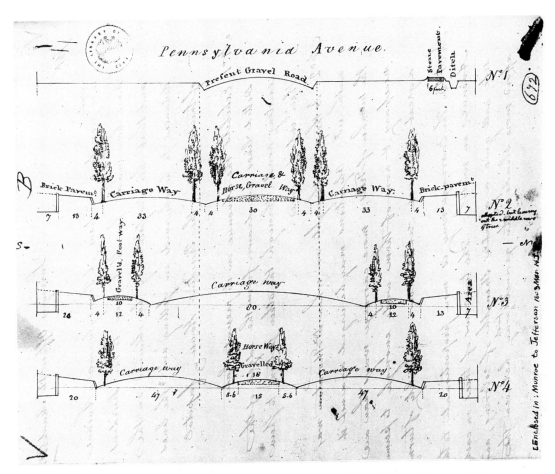

FIG. 44. Planting Sketch for Pennsylvania Avenue. Enclosed in letter from Thomas Munroe to Thomas Jefferson, 1803. Library of Congress, Manuscripts Division.

FIG. 45. J. R. SMITH, *View from the Capitol to the White House along Pennsylvania Avenue in 1834.* Engraving by J. B. Neagle, from Conrad Malte-Brun, *A System of Universal Geography,* 1834. Library of Congress, Prints and Photographs Division.

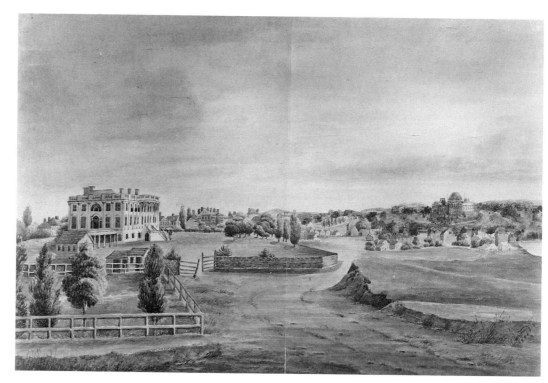

FIG. 46. ANTHONY ST. JOHN BAKER, *The White House,* 1826. Drawing from the artist's *Mémoires d'un Voyageur qui se Repose,* in the collection of the Henry C. Huntington Library and Art Gallery. This southwest view of the White House shows part of the arboretum planted by John Quincy Adams. Just right of center is Lombardy-lined Pennsylvania Avenue, which leads to the Capitol seen on the right.

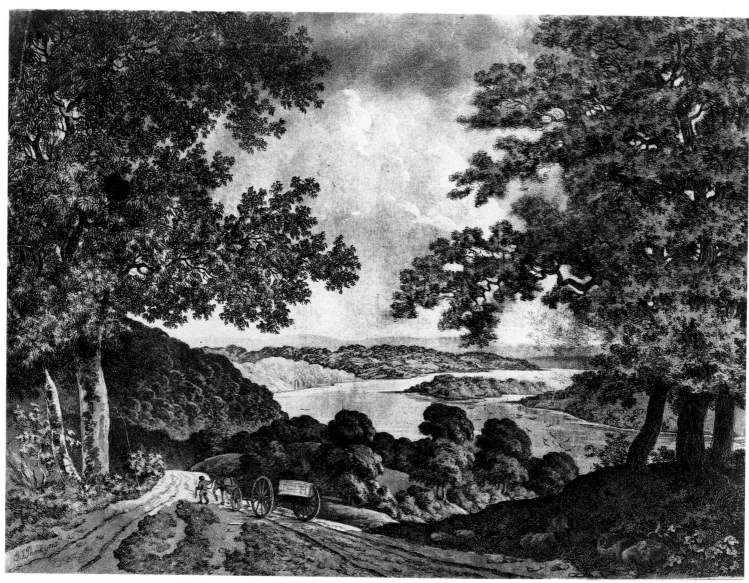

PLATE 124. GEORGE ISHAM PARKYNS, *Washington,* C. 1800.

wood forests for use in naval shipbuilding, to identify and save endangered trees, and to introduce foreign species which might be naturalized.[52]

American Botanic Gardens

The early nineteenth century witnessed the establishment of several great botanic gardens designed for both scientific and aesthetic purposes. The gardens of Harvard, Yale, Princeton, the University of South Carolina, and the University of Pennsylvania were started within the first two decades. In addition to the obvious educational function, the naturalization and cultivation of useful plants taking place in these gardens was significant at this time, because the political economy of the new nation was still based on the belief in an agrarian democratic society. The last three early American gardens to be discussed were all arranged in a systematic fashion for botanical study. They are notable also because they displayed their scientific character with artistic designs of the highest quality. Each garden—one public, one private, and the last commercial—were established by influential figures in the history of landscape gardening and the natural sciences.

The Elgin Gardens on Manhattan Island were founded in 1801 by Dr. David Hosack, a faculty member of Columbia College and one of the first Americans to be elected to the Royal Horticultural Society of England.[53] When he announced its opening, Hosack attributed great social importance to the American botanic garden: "we have every reason to expect that the establishment of a botanic garden . . . will . . . in a short time meet with the general design of protecting useful knowledge, and those arts which are most essentially connected with human happiness."[54] Located on twenty acres on Fifth Avenue and 47th Street, now the site of Rockefeller Center, the gardens were celebrated for their scientific pursuits as well as for their beautifully landscaped grounds. In the watercolor shown in Plate 125 the main greenhouse and hothouses are surrounded by scattered trees and shrubs, the grounds traversed by a curving pathway. In *Old New York* of 1807 it was reported that the gardens were "a resort for the admirers of Natural Vegetable Wonders and the student of her mysteries." Dr. Hosack was in close communication with the great figures of the day, including Bartram, Jefferson, and André Michaux, who would meet there to discuss botanical issues. In 1810 the Elgin Gardens were taken over by the state and their name changed to the Botanic Gardens of the State of New York.[55]

In 1810 Charles Willson Peale retired to his farm, Belfield, which he transformed into a private botanic garden for what he called "rational amusements."[56] Peale's practice of scientific agriculture as well as artistic landscaping made Belfield famous. He painted over fifteen views of his farm and the surrounding countryside. In Fig. 47 the artist/gardener has given prominence to pots of unusual plants in the foreground, lest the spectator forget the botanical function of this pretty place. On either side of the growing fields are a temple, a pond with a fountain, flower beds, and various garden ornaments. Not included in this scene were an obelisk, summerhouse, and pedestal inscribed with moral messages addressed to the numerous visitors to Belfield.[57]

In the 1820s André Parmentier moved to the United States from Belgium in order to practice landscape gardening, and within a few years he had established his Horticultural and Botanical Gardens in Brooklyn. Parmentier was able to provide total landscaping services, from surveying property and providing a design to furnishing the plants and trees from his nursery. Andrew Jackson Downing wrote that Parmentier, whose work spread from upper Canada down through the South, had "effected, directly far more for landscape gardening in America, than . . . any other individual whatever."[58] Parmentier published a periodical catalogue of his nursery, which con-

FIG. 47. CHARLES WILLSON PEALE, *View of Garden at Belfield*, 1816. Oil on canvas. Private collection.

tained a plan of his garden (Fig. 48). The grounds were laid out naturalistically with a scientific arrangement of plants.

During his short career Parmentier also wrote the essay "Landscapes and Picturesque Gardens," concerned with the rules of what he called "the modern style." This may simply be defined as that irregular, naturalistic, deliberately assymetrical kind of planting that descended from Repton and Loudon and would be continued by Downing into the mid-nineteenth century. With principles that we recognize as consistent throughout the period, Parmentier claimed "the good taste of our age . . . [will] reinstate Nature in the possession of those rights from which she has too long been banished by an undue regard for symmetry."[59] The career of André Parmentier marked the beginning of a new age of professionalism for landscape gardeners in this country. He combined aesthetic theory with the practice of gardeners and the science of botanists. Most important, he disseminated his skill and knowledge to a public who had a growing interest in gardening.

The evidence of private, public, and botanic gardening presented here is only a part of a very rich history that resulted from the efforts of Americans to establish gardens that reflected their familiarity with European models while retaining a distinctly nationalistic flavor. The increased effort to build gardens after the Revolution was motivated by the patriotic desire to ornament the new republic, as well as a belief in the intellectual and moral precepts embodied in the art of landscape design.

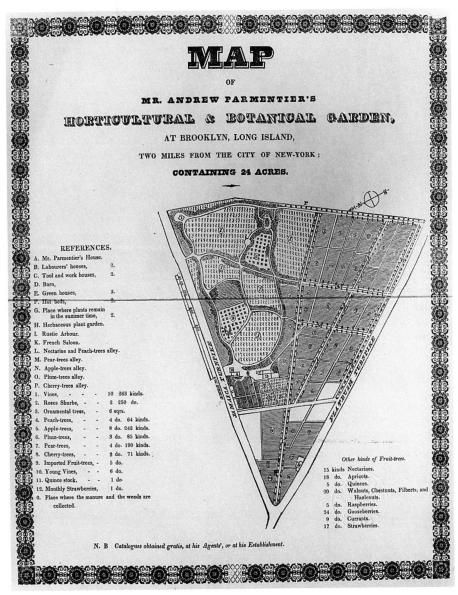

REFERENCES.

A. Mr. Parmentier's House.
B. Labourers' houses, 2.
C. Tool and work houses, 2.
D. Barn,
E. Green houses, 3.
F. Hot beds, 2.
G. Place where plants remain
 in the summer time, 2.
H. Herbaceous plant garden.
I. Rustic Arbour.
K. French Saloon.
L. Nectarine and Peach-trees alley.
M. Pear-trees alley.
N. Apple-trees alley.
O. Plum-trees alley.
P. Cherry-trees alley.
1. Vines, - - 10 263 kinds.
2. Roses Shurbs, - - 2 250 do.
3. Ornamental trees, - 6 sqrs.
4. Peach-trees, - - 4 do. 64 kinds.
5. Apple-trees, - - 8 do. 242 kinds.
6. Plum-trees, - - 3 do. 85 do.
7. Pear-trees, - - 4 do. 190 kinds.
8. Cherry-trees, - - 3 do. 71 kinds.
9. Imported Fruit-trees, - 5 do.
10. Young Vines, - - 6 do.
11. Quince stock, - - 1 do.
12. Monthly Strawberries, 1 do.
0. Place where the manure and the weeds are
 collected.

Other kinds of Fruit-trees.

15 kinds Nectarines.
18 do. Apricots.
5 do. Quinces.
20 do. Walnuts, Chestnuts, Filberts, and
 Hazlenuts.
5 do. Raspberries.
24 do. Gooseberries.
9 do. Currants.
17 do. Strawberries.

N. B *Catalogues obtained gratis, at his Agents', or at his Establishment.*

PLATE 125. HUGH REINAGLE,
*View of Elgin Garden on
Fifth Avenue,* c. 1811.

FIG. 48. Plan of
Parmentier's Horticultural
and Botanic Garden, c. 1828.
From a broadside in the
collection of the Brooklyn
Historical Society.

157

1. Donald Worster, *Nature's Economy, A History of Ecological Ideas* (Cambridge: Cambridge University Press, 1977), p. 5.

2. Dr. Waterhouse, *The Botanist* (Boston, 1811).

3. The definition of what was more or less natural and what was more or less artificial was relative. Capability Brown, the English landscape designer who will be discussed later in the essay, created the appearance of great naturalness in country estates, when in fact massive construction was required to gain that effect. On the other hand, J. C. Loudon's "Gardenesque" style in the early nineteenth century was concerned with the true characteristics of plants. "True qualities of nature" were celebrated in an extremely artificial bedding out of plants. In botany the "natural" system of classifying plants according to behavioral characteristic by the early nineteenth century had replaced the Linnaean sexual system of classification, which was very abstract.

4. The word *parterre*, "first used in France in 1549 and in England in 1639, denotes any level garden area containing ornamental flower beds of any shape and size. The *parterre* was developed initially in Italy. . . ." Anthony Huxley, *An Illustrated History of Gardening* (New York and London: Paddington Press, 1978), p. 59.

5. William Howard Adams II, ed., *The Eye of Thomas Jefferson* (1976; reprint, Charlottesville: University Press of Virginia, 1981), p. 323.

6. Edmund Berkeley and Dorothy Smith Berkeley, *The Life and Travels of John Bartram from Lake Ontario to the River St. John* (Tallahassee: University Presses of Florida, 1982), pp. 115-116. Horace Walpole's oft-repeated statement about the architect and landscape designer William Kent could have been applied to Bartram as well: "he leaped the fence, and saw that all nature was a garden." Although Kent's concerns were aesthetic and Bartram's scientific, their lack of interest in the artifice of the walled-in, geometric garden led them toward the same end, "the living landscape."

7. To be arranged scientifically meant according to a systematic classification system whether it be Linnaeus' sexual system or one of the newer natural systems that were just being introduced. These gardens were often labeled with both botanical and popular names with the intention of interesting those spectators who were unschooled.

8. Quoted in Ann Leighton, *American Gardens in the Eighteenth Century: For Use or for Delight* (Boston: Houghton Mifflin, 1976), p. 264.

9. George B. Tatum, "The Gardens They Made," in *American Garden Legacy: A Taste for Pleasure,* George H. M. Lawrence, ed. (Philadelphia: Pennsylvania Horticultural Society, 1978), p. 79.

10. James D. Kornwolf, "The Picturesque in the American Garden and Landscape before 1800," *Eighteenth Century Life* 8 (January 1983): 94.

11. Quoted in Leighton, *American Gardens*, p. 269.

12. *Ibid.*, pp. 250–269. The ha-ha, or sunken fence, was named because "it surprizes the eye upon coming near, and makes one say Ah! Ah!" John James, *Theory and Practice of Gardening* (1712), quoted in Huxley, *Illustrated History of Gardening*, pp. 95-98.

13. It is not untypical in this period to find the English using a French phrase, *ferme ornée*, for a gardening concept.

14. William A. Brogden, "The *Ferme Ornée* and Changing Attitudes to Agricultural Improvement," *Eighteenth Century Life* 8 (January 1983): 39-40. The rediscovery in the eighteenth century of literary texts by Virgil and the Younger Pliny on husbandry, villas, and plantations inspired the association of Roman virtue with agriculture. Early American landowners were influenced by this association as they established a new republic which tried to emulate the classical world.

15. William L. Beiswanger, "The Temple in the Garden: Thomas Jefferson's Vision of the Monticello Landscape," *Eighteenth Century Life* 8 (January 1983): 131.

16. Brogden, "The *Ferme Ornée*," p. 43.

17. Tatum, "The Gardens They Made," p. 79.

18. Jefferson to John Rutledge and Thomas Lee Shippen. Quoted in Fiske Kimball, "Beginnings of Landscape Architecture in America," *Landscape Architecture* 42 (July 1917): 184.

19. *The Virginia Journals of Benjamin Henry Latrobe, 1795–1798*, Edward C. Carter II, ed. (New Haven: Yale University Press, 1977), Vol. I, p. 165.

20. Laurance Fleming and Alan Gore, *The English Garden* (London: Michael Joseph, 1979), p. 157. Mavis Batey, "The High Phase of English Landscape Gardening," *Eighteenth Century Life* 8 (January 1983): 46-47.

21. Batey, "The High Phase," p. 45.

22. Humphrey Repton, *Observations on the Theory and Practice of Landscape Gardening* (London: T. Bersley for J. Taylor, 1803), pp. 101–102.

23. *The Virginia Journals of Latrobe*, Vol. II, p. 499.

24. *Ibid.*, pp. 457-531.

25. *Ibd.*, p. 500.

26. *Ibid*.

27. Letter from Jefferson to William Hamilton, quoted in Beiswanger, "The Temple in the Garden," p. 182. Edwin Morris Betts, *Thomas Jefferson's Garden Book, 1766-1824* (Philadelphia: American Philosophical Society, 1944), pp. 323-324.

28. Alice B. Lockwood, in *Gardens of Colony and State*, 2 vols. (New York: Scribner's, 1931), Vol. I, p. 67, says that Samuel McIntire prepared all three drawings. Although they are found in the McIntire papers, it is doubtful that he drew all of them.

29. Frederick Doveton Nicholas and Ralph E. Griswold, *Thomas Jefferson Landscape Architect* (Charlottesville: University Press of Virginia, 1981), p. 129.

30. Elizabeth McLean, "Town and Country Gardens in Eighteenth Century Philadelphia," *Eighteenth Century Life* 8 (January 1983): 142-144; Kornwolf, "The Picturesque in the American Garden," p. 100.

31. Adams, *Eye of Jefferson*, p. 328; Betts, *Jefferson's Garden Book*, p. 323.

32. Betts, *Jefferson's Garden Book*, p. 344.

33. W. P. and J. P. Cutler, *Life, Journal, and Correspondence of Rev. Manasseh Cutler* (Cincinnati, 1888), quoted in McLean, "Town and Country Gardens," p. 144.

34. Lockwood, *Gardens*, pp. 345-346. McLean, "Town and Country Gardens," p. 42, misquotes Birch by writing "formality was banished from the house. . . ." The omission of the word "not" misses the point that artifice was appropriate near the house in a Reptonian garden.

35. Richard Webster, *Philadelphia Preserved* (Philadelphia: Temple University Press, 1976), p. 241.

36. Robert Wheelwright, "Gardens and Places of Colonial Philadelphia," *Colonial Gardens: The Landscape Architecture of George Washington's Time* (Washington, D.C. : United States George Washington Bicentennial Commission, 1982), p. 27. Adams, *Eye of Jefferson*, p. 328.

37. McLean, "Town and Country Gardens," p. 141.

38. *Philadelphia: Three Centuries of American Art* (Philadelphia: Philadelphia Museum of Art, 1976), p. 186.

39. Rudy Favretti and Joy Putnam Favretti, *Landscapes and Gardens for Historic Buildings* (Nashville: American Association for State and Local History. 1978), p. 35. Joseph Ewan, "Philadelphia Heritage: Plants and People," *American Garden Legacy: A Taste for Pleasure*, George H. M. Lawrence, ed. (Philadelphia: Pennsylvania Historical Society, 1978), pp. 10-11. The term *public garden* had another meaning, as described in *American Gardener's Magazine* (July 1835): 241: "There is another class of gardens in Philadelphia, called public gardens which combine in addition to a flower garden, greenhouses, hot houses &c., a bar-room or tavern. This later addition we are far from believing useful or needful." For the purposes of this essay *public garden* refers to those common spaces that have been dedicated to the recreation and edification of all citizens.

40. Edward Riley, "The Independence Hall Group," *Historic Philadelphia: Transactions of the American Philosophical Society* 43, Part 1 (1953): 7-8.

41. Pennsylvania Horticultural Society, *From Seed to Flower: Philadelphia, 1681-1876* (Philadelphia: Pennsylvania Horticultural Society, 1976), p. 17.

42. Riley, "Independence Hall Group," pp. 7-9. In this last line, Cutler is referring to William Hogarth's formula for achieving elegance and grace in composition — the serpentine line. This principle was put forth in his treatise *The Analysis of Beauty* (1753), which has been called the first work on aesthetics based on formal analysis. In it Hogarth rejects symmetry and frontality in favor of asymmetrical movement along lines and surfaces. It had great influence on landscape design, particularly because the concept of movement and changing perspectives could be exploited three-dimensionally as movement through space. By 1794 an English visitor to the State House found that the yard "was the pleasantest walk at Philadelphia" and "was something like Kensington gardens but not so large" (*ibid.*,p. 21). It was probably the serpentine gravelled walkways and trees that re-

minded him of Kensington Gardens in London, which had been laid out around 1730 by Henry Wise and Charles Bridgman. Edward Hyams, *A History of Gardens and Gardening* (New York: Praeger, 1971), p. 236.

43. Riley, "Independence Hall Group," p. 9, n. 22.

44. McLean, "Town and Country Gardens," p. 142.

45. *Philadelphia: Three Centuries*, p. 299.

46. *Ibid.*, p. 272.

47. Rudy Favretti "The Ornamentation of New England Towns: 1750–1850," *Journal of Garden History* (October-November 1983): 325-342.

48. Paul Venable Turner, *Campus: An American Planning Tradition* (New York: MIT Press, 1984), Fig. 37. *Cloaca* is the Latin word for sewer; Cloaca Maxima was the main sewer in ancient Rome.

49. J. L. Sibley Jennings Jr., "Artistry as Design: L'Enfant's Extraordinary City," *Quarterly Journal of the Library of Congress* 36 (Summer 1979): 245.

50. Nichols and Griswold, *Thomas Jefferson Landscape Architect*, pp. 67-69. Also discussed in Frederick Gutheim and Wilcomb Washburn, *The Federal City: Plans and Realities* (Washington, D.C: Smithsonian Institution Press, 1976), pp. 116,141,142. The Lombardy poplar was introduced into this country in 1784 by William Hamilton at Woodlands. By the time Jefferson wanted them for Washington they were available for purchase at Mount Vernon.

51. Richard Rathburn, "The Columbian Institute for the Promotion of Arts and Sciences," *Smithsonian Institution, United States National Museum Bulletin* 101(1917): 1-77.

52. Jack Shepherd, "Seeds of the Presidency: The Capitol Schemes of John Quincy Adams," *Horticulture* (January 1983): 38-47.

53. *From Seed to Flower*, p.110.

54. David Hosack, *Introduction to Medical Education* (New York, 1801).

55. In 1824 Dr. Hosack, in a lecture for the New York Horticultural Society, outlined principles for an ideal botanic garden. They included the employment of a drawing professor, instruction in horticulture, and the requirement that the grounds exemplify the principles of ornamental planting or landscape gardening. Lockwood, *Gardens*, pp. 268-269. John J. Kouwenhaven, *The Columbia Historical Portrait of New York* (New York: Harper & Row, 1972), p. 102.

56. Edgar P. Richardson, Brooke Hindle, Lillian B. Miller, *Charles Willson Peale and His World* (New York: Abrams, 1983), p. 96.

57. *Ibid.*, pp. 225-229.

58. Andrew Jackson Downing, *Treatise on the Theory and Practice of Landscape Gardening* (New York, 1841), p. 24.

59. Essay published in Thomas Fessenden, *New American Gardener* (1828), pp. 184-185. Parmentier died at the age of fifty in 1830.

159

Fig. 49. THOMAS COLE, *Moonlit Landscape with Two Figures*, 1824. Charcoal and white chalk on colored paper. Private collection.

ELLWOOD C. PARRY III

Thomas Cole's Early Career: 1818-1829

We can delight in the discovery of young genius without believing it necessary immediately to deify it; and we can rejoice to see its progress to perfection, without proclaiming it to have all at once arrived at the end of its journey. . . . He is neither Claude, nor Poussin, nor Salvator Rosa; but he is a man of real genius, and the works under consideration are evidence of great improvement since the last exhibition. Mr. Cole's excellence consists in a fine feeling for the picturesque, and good management of chiaro oscuro; he has a fertile invention, and grand conception. . . .

— Unsigned review of the Second Annual Exhibition of the National Academy of Design, *United States Review and Literary Gazette* 2 (July 1827): 249–250.

THOMAS COLE (1801 –1848) WAS FAR FROM THE FIRST PERSON IN AMERICA to make landscape painting a specialty. Nevertheless, he still deserves to be remembered as a founder of the Hudson River School, primarily because the Romantic images of natural or imaginary scenery he produced from 1825 onward were consistently more powerful, more compelling, and more lastingly enjoyable than any of his contemporaries'. In short, because Cole did so much to establish landscape as a viable and immensely popular alternative to portrait or figure painting on this side of the Atlantic in the early nineteenth century, his early career merits biographical treatment here. This essay, dealing just with the first eleven years of Cole's life and work in the United States, is divided into chronological sections corresponding to his early years as apprentice, itinerant portraitist, and art student (1818–1825); his initial success at the time of the opening of the Erie Canal and his rapidly increasing fame thereafter (1825–1827); and finally his growing ambition to produce larger and more complex historical landscape compositions just before leaving on an aesthetic pilgrimage to Europe (1828–1829). A closer look at these three stages of Cole's development will reveal not only that he was a product of a particular moment in American cultural history but also that he struggled to transcend the older, limited, eighteenth-century expectations of what the beautiful and the sublime should look like in landscape form.

Earliest Biographies

Since so few examples of Cole's artistic output before 1825 have survived, modern students of his work are fortunate that the first biographical account of his early years, based on notes supplied by the painter himself, was published during his lifetime. In

addition, a full-scale treatment of his entire career was published just five years after his untimely death in 1848 at age forty-seven. Both major biographies were written by close friends, yet both contain enough factual errors to make one wonder about their overall reliability with respect to Cole's first experiences in America. For this reason the story of how the first prose depiction of his early life got into print is worth retelling, however briefly, before turning to the few available images.

At the end of July 1834 Thomas Cole and Thomas Seir Cummings called on their elderly friend and fellow member of the National Academy of Design William Dunlap at his home on Sixth Avenue in New York City. Dunlap, then in the process of completing his extensive history of American art, recorded this social visit in his journal, along with the notation that Cole had "left some sheets of biography."[1] The tale grows more complicated because just four weeks later Dunlap sent a follow-up letter to "My good young friend" in Catskill, New York. While admitting that "Your memoir is one of the most interesting and instructive that I know, & in my attempt to manage the story I have succeeded to my satisfaction," Dunlap pleaded with Cole to send him more information about the present state of the arts in England and Italy.[2] Unfortunately for his subsequent peace of mind, Cole complied with this request in writing. Then, to Cole's intense chagrin, the predominantly negative opinions he voiced about contemporary artists and schools abroad appeared almost verbatim, together with his more innocent autobiographical lines, in Chapter 25 of Dunlap's *The History of the Rise and Progress of the Arts of Design in the United States,* which was published before the end of 1834.

How Cole atttempted to limit the political damage of his offhand remarks by writing apologetic letters to American artists abroad, such as Charles Robert Leslie in London, belongs to another chapter of his life. For the purposes of this essay, however, it is intriguing to learn that Cole's personal copy of Dunlap's *History,* filled with marginalia to Chapter 25, has come to light in a private collection. In his longest gloss on what Dunlap printed, Cole blamed himself for not sticking to simple facts which would have avoided the appearance of egotism or the creation of false impressions. On the other hand, opposite many sections of Dunlap's text dealing with his career up to 1825, Cole simply wrote "true" or "true in the main."[3] And next to a basic factual paragraph near the beginning of Dunlap's narrative, Cole surprisingly made only one correction where he might have made several:

> *His family, consisting of his parents, three sisters, and himself the youngest child* [Cole noted: *"Youngest but one. My sister Sarah is younger"*], *and only son, resided at one time in Philadelphia, afterwards in Pittsburg, and then in Steubenville, Ohio. In this last place, in 1818, his father established a paper-hanging manufactory, and Thomas was early engaged in drawing patterns and combining pigments for colours. This was his first step on that ladder, whose summit he has attained.*[4]

Consistent with his desire to "manage" the instructive story of Cole's life as an editor and commentator, Dunlap dramatized the facts by making Thomas the youngest child, by simplifying the family's westward movements into a more linear progression, by pushing back the implied date of their arrival, and by leaving out the several part-time jobs Cole had taken before reaching Steubenville. For a more detailed account of Cole's early years one must turn, inevitably, to the biography compiled by the Reverend Louis Legrand Noble, first published in 1853 and again in 1854, *The Course of Empire, Voyage of Life, and Other Pictures of Thomas Cole, N.A., with Selections from his Letters and Miscellaneous Writings: Illustrative of his Life.* This cumbersome title was not shortened to *The Life and Works of Thomas Cole* until 1856; and a new edition of this text, edited by Elliot S. Vesell and issued by Harvard University Press in 1964, has

remained the standard reference work for the last twenty years. Nevertheless, in spite of Noble's friendship with the artist and his widow, Maria, who gave him unlimited access to sketchbooks, notebooks, correspondence, family papers, and the like, his literary description of Cole's early life on this side of the Atlantic is not totally trustworthy either. A rather glaring error occurs, for example, in the opening lines of the second chapter. According to Noble, "It was in the spring of 1819 that Mr. Cole sailed with his family for America. After a prosperous voyage, he arrived, on the 3rd of July, at Philadelphia."[5] We now know from a copy of the ship's manifest in the National Archives that the Cole family sailed from Liverpool aboard the American ship *Andrew,* which docked in Philadelphia on July 3, 1818, not 1819. There were seven people in the party, traveling steerage: James and Mary Cole, age fifty-five; Thomas, seventeen; his three sisters, Ann, Mary, and Sarah; and Lydia Hooloway, presumably an aunt who lived with them. The worldly goods they brought from Bolton-le-Moors, Lancashire, included "13 Boxes or Chests and one cask containing Wearing apparel, old Books, Glass, China, and an old Clock — 1 Liquor Case, Beds & Bedding & Fowling piece, all of which have been used and are intended for the sole use of James Cole and Family."[6]

Humble Beginnings in Pennsylvania and Ohio

By methodically comparing Noble's biography with Dunlap's, and by cross-checking statements of fact with surviving bits of documentation and correspondence, one can reconstruct a detailed and fairly reliable chronology of Thomas Cole's initial activities in the New World. What emerges is not just a sense of restless movement from place to place — as if to take advantage of whatever financial opportunity might present itself in America — but also a glimpse of the astounding variety of artistic endeavors and art-related tasks which Cole was willing to try his hand at. Even in a highly condensed survey it is easy to see that drawing and painting landscapes constituted a very minor aspect of his production as he approached maturity.

After arriving in Philadelphia the young Cole was first employed as a wood engraver, creating what must have been a fairly typical neoclassical mourning picture with "Grief leaning against a monument beneath a weeping willow."[7] When his family set off for Steubenville by way of Pittsburgh in late September 1818, Cole stayed behind, boarding with Quakers, ostensibly to work on illustrations for a new edition of John Bunyan's *A True Relation of the Holy War, Made by King Shaddai upon Diabolus, for the Regaining of the Metropolis of the World.*[8] With his roommate, a law student whose poor health required a trip to a warmer climate, Cole sailed from Philadelphia in January 1819 for Saint Eustatius, one of the Leeward Islands in the West Indies. Before returning to Philadelphia in May, Cole thoroughly explored this volcanic island, which later provided the dramatic tropical setting for his short story "Emma Moreton, A West Indian Tale," published in the *Saturday Evening Post.*[9] In addition, if Noble is to be believed, he also drew some heads in crayon besides copying a view of the island for a gentleman.[10] But the most significant outcome of this exotic trip has to have been Cole's lifelong fascination with the sublimity of volcanos, both real and imaginary.

In the autumn of 1819, after traveling on foot from Philadelphia, Cole joined his family in Steubenville, where his father had started the Steubenville Paper Hanging Manufactory and his older sisters, Ann and Mary, had established a Seminary for Young Ladies, all in one commodious rented house on Third Street. Besides mixing colors, designing wallpaper patterns, and cutting the woodblocks to print them with, he also advertised in the *Western Herald and Steubenville Gazette* as early as January 1820, immediately following an announcement for the seminary: "THOMAS COLE, Will

instruct a class of males or females, in Painting and Drawing, three times a week between 6 and 8 o'clock in the evening, at the above price per quarter." This meant the same fee charged by his sisters, namely five dollars for three months, exclusive of implements, colors, and stationery, which cost one dollar and fifty cents extra.[11]

How well Cole fared as a nineteen-year-old teacher is unknown, but two surviving landscapes in monochromatic watercolor, which may date from this period, suggest by their crudity of composition and handling that his instruction could not have been much more than rudimentary. He confessed that working as an assistant to his father was somewhat to his taste, "but there was too little art and too much manual labour for one of an imaginative mind."[12] Even after the family had to move when the lease on one house ran out, James Cole continued to promote his wares in the local newspaper in a way that indicates both the marginal nature of his business and his awareness of the need to appeal to nationalistic feelings five years after the end of the War of 1812:

> STEUBENVILLE/Paper Hanging Manufactory/James Cole, Respectfully informs the public, that he has on hand, of his own Manufacture, a quantity of PAPER HANGINGS, Of Various Patterns, Which can be had, on application at the Manufactory in Fourth Street, Steubenville, opposite Porter's Tavern. Shopkeepers will find it in their interest to deal with him, instead of importing paper from abroad, as he will sell his paper on very reasonable terms. Orders from the country punctually attended to. He relies with confidence, on the liberality and patriotism of the public, to encourage this new establishment.[13]

Sometime in 1820 Thomas Cole learned the rudiments of working with oil paints from an itinerant portrait painter he later identified to William Dunlap as "Mr. Stein." Since a John Stein was active in Pittsburgh during the early 1820s, when he kindly explained his working methods to another young artist, James Reid Lambdin, this may be the same person who acted as Cole's mentor for a short time.[14] Fired with ambition, Cole began to paint in his spare moments, making his own brushes and getting colors from a chairmaker who employed him briefly to do ornamental work. As Cole later admitted to Dunlap, even though he had never drawn from nature, he tried his hand at several landscapes, and one of these happened to come to the attention of Judge Benjamin Tappan of Steubenville, later a U.S. Senator from Ohio, who invited the young artist to his home to see a copy he himself had painted after a portrait by Gilbert Stuart.[15]

Considering the importance of portraiture, which had remained the dominant artistic form in the United States since colonial times, it is far from surprising that Cole should suddenly have thrown himself into this enterprise. Given the fact that Stuart in Boston, John Wesley Jarvis in New York, and Thomas Sully in Philadelphia were probably the most famous artists living in America in the early 1820s, turning to portraiture must have seemed like the surest route to financial success and independence from his father's faltering wallpaper business. At the same time, knowing that money was scarce in Ohio and elsewhere and realizing that many well-trained portrait painters were forced to live an itinerant existence in order to find enough commissions to live on, one can easily see why Cole decided to travel at this particular moment and also why he failed.

Shortly after his twenty-first birthday in February 1822, Cole left Steubenville on foot for Saint Clairsville, Ohio, thirty miles away. But a German painter, named Des Combes, had preceded him through the area. Lured on by the possibility of finding more than just a few scraps of patronage, Cole moved on to Zanesville, about sixty miles still farther west, in the late spring, but again Des Combes had arrived first. Nevertheless, Cole was able to do a few portraits. He also took a room in which to offer drawing instruction, but only two pupils came. Similar problems confronted him in

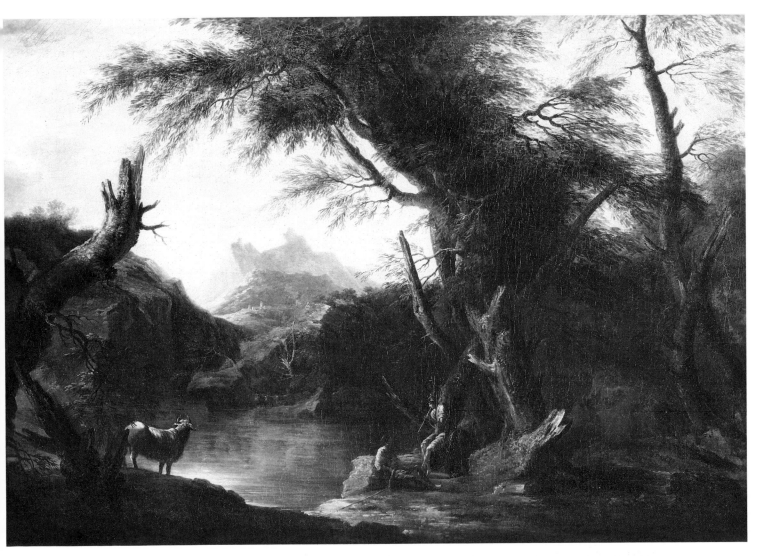

FIG. 50. Follower of Salvator Rosa, *Landscape with Mercury Deceiving Argus,* seventeenth century or later. Oil on canvas. Pennsylvania Academy of the Fine Arts, Philadelphia; gift of Joseph Allan Smith, 1812.

Chillicothe: after traveling seventy-five miles on foot in two and half days of summer heat, he found but a few townspeople willing to sit for their portraits and a similarly limited number to take drawing lessons. Again he made little or no profit. And any thought he had had of going south to Tennessee was swept aside by news that his parents were planning to move back over the mountains and wished to see him before they departed. In the end a lack of money forced James Cole to settle his family in Pittsburgh, but his son spent the winter of 1822–1823 in Steubenville, doing a few portraits on commission and painting scenery for a local thespian society.[16]

All told, in the year since setting off on his own, Thomas Cole had produced, in addition to portraits, a drinking scene for a barroom in Saint Clairsville (to pay his debt to the innkeeper); a landscape from nature in Zanesville (as a collaborative effort with William A. Adams, a law student friend who was to become important in Cole's career again in the 1830s); a picture of George Washington, copied from a print in Chillicothe, which gained him twenty-five dollars through a raffle; a feudal scene by moonlight, executed during a days' stopover in Zanesville on his return home; and perhaps a silhouette or two in Steubenville, besides painted stage scenery and two biblical subjects, *Ruth Gleaning in the Field of Boaz* and *Belshazzar's Feast.*[17] Regrettably, these two attempts at history painting were destroyed by young vandals, but it is difficult to imagine that they were very accomplished performances in the first place.

In the spring of 1823 Cole rejoined his family in Pittsburgh, where he assisted his father in a new commercial venture, a floor-cloth manufactory. He also placed the following ad in the *Pittsburgh Gazette:* "THOMAS COLE, Engraver & Portrait Painter, Respectfully informs the inhabitants of Pittsburgh and its vicinity, that he intends opening a DRAWING SCHOOL. For terms apply to him in Ross Street, at the end of Third Street, where specimens may be seen."[18] It seems unlikely that this drawing school ever got started, since Cole never mentioned it to either of his biographers. But his own earliest dated drawings from nature, done early in the mornings along the banks of the Monongahela River, were executed in May and June of 1823. We also know that he painted a few landscapes and portraits, including an oil copy of a likeness of Andrew Jackson,[19] before deciding late in the fall—apparently against his father's wishes —to return to Philadelphia in the hope of becoming a professional artist.

At first Cole made little progress toward a new career. An illness lasting several weeks from December 1823 into the new year forced him to sell some items in order to obtain a stove and fuel for his unfurnished and unheated room in Philadelphia. Noble later characterized this period as the artist's winter of discontent because of the sharp contrast between his miserable living conditions and the genre scenes he produced, when his health allowed, of a "mostly comic nature" for sale in barrooms, barber shops, and oyster houses. The commission for a couple of landscapes for a gentleman's parlor offered partial relief from a state of poverty.[20]

More important, from James Thackara, keeper at the Pennsylvania Academy of the Fine Arts, Cole got permission to draw from the collection of casts. Of the major paintings in the academy's collection, he could have studied Johann Karl Loth's *Adam and Eve* and *Death of Abel,* Thomas Sully's *George Frederick Cooke as Richard III,* and Washington Allston's *Dead Man Restored to Life by Touching the Bones of the Prophet Elisha.* At the annual exhibitions, no doubt, he was also able to examine closely the productions of other leading artists. In fact, according to Dunlap, Cole's heart sank "as he felt his deficiencies in art, when standing before the landscapes of Birch and Doughty."[21]

Exactly how much Thomas Cole, at age twenty-three, wanted to emulate the styles of Thomas Birch or Thomas Doughty, who were eight to twenty-two years older, is open to question. A direct influence might have been evident in some of Cole's drawings from nature, but no such sheets survive from this period. On the other hand, the one drawing that can be securely dated as a Philadelphia work of 1824 (Fig. 49) is clearly a studio production inspired by the large *Landscape with Mercury Deceiving Argus* (Fig. 50), which Joseph Allan Smith had given to the Pennsylvania Academy as an original Salvator Rosa in 1812. Much has been made of Cole's later debt to Rosa, but this particular drawing offers the earliest proof that he had absorbed the lesson of how to inject a sense of mystery and grandeur into a landscape composition by deliberate alternations of light and dark patterns as well as by massive, intertwined, or blasted tree trunks dominating the immediate foreground.[22]

The important issue of early influences on Cole would be easier to resolve if only it were possible to identify the one work he submitted to the Pennsylvania Academy's 1824 exhibition, where it was shown as No. 89, *Landscape.* One can only guess that it might have looked something like his modest-sized *Landscape with Figures and a Mill* (Fig. 51). This image shares a number of compositional features with Cole's *Moonlight Landscape* drawing of 1824, including a prostrate tree across the foreground and a dramatic mound of earth in the middle ground from which three trees reach out in different directions, but the canvas is clearly signed and dated "T. Cole 1825."

Precisely when Cole painted the *Landscape with Figures and a Mill* seems as debatable as its subject matter. We know that he had other major commitments during 1824–1825. For example, he worked for a japanner, creating decorative designs on a

variety of ornamental objects, before that employer commissioned him, for a small price, to paint a large canvas of *King Louis XVI Parting from His Family* —which Cole probably copied from the 1795 engraving after Mather Brown's painting of that subject. Near the end of September 1824, when General Lafayette visited Philadelphia as the nation's guest, a temporary triumphal arch was erected as part of the lavish reception festivities, and large transparencies on paper (to be lit from behind) were needed for it as well. According to Dunlap, Cole got some of this work to do under the direction of Bass Otis. Late in 1824 the young artist's parents and sisters passed through Philadelphia on their way to New York City, hoping to take advantage of better business opportunities there.[23] Perhaps it was the memory of their former life together in Ohio or, more likely, western Pennsylvania that inspired *Landscape with Figures and a Mill,* which seems far too mountainous to represent a scene along either the Delaware River or the Schuylkill. How little training Cole had received in composition shows up here in the odd sense that this one canvas contains two separate views awkwardly stitched together. From a slightly elevated vantage point the viewer can see, deep in the right foreground, a man holding his dog, but there are two cows in the middle distance very near his head. Simultaneously, on the left-hand side, the viewer is made to look down a rapidly descending land toward a mill. The woodchopper in the foreground (Fig. 52) is actually suspended several feet in the air as he chops away at the obstruction, while a figure on horseback is about to disappear from view just above his upraised ax.

This *Landscape* may very well have been painted during the first months of 1825, although Cole's major project at that time was an exhibition picture of *Christ Crowned with Thorns and Mocked* ("after Mingardi"), which was shown at the Pennsylvania Academy in 1825 and again in 1827 and 1828 as an *Ecce Homo.*[24] Having a print source may have helped, but given the crudity of Cole's man with an ax, it is hard to believe that his latest attempt at a biblical subject drew any crowds of admirers. And it seems doubtful that the artist himself stayed in Philadelphia long enough to see his own figure painting on public display.

1825–1827: Initial Success in New York

In a fresh notebook, now in the Detroit Institute of Arts, Cole wrote "Came to New York in April 1825" at the head of a list of pictures he completed there over the next twelve months or so.[25] This list is invaluable in sorting out problems of chronology, because it establishes a numerical order for his productions, as well as providing the names of purchasers and the prices paid. What is perplexing about this list, however, is the fact the first five works Cole produced were all from his imagination—"Composition," "Composition, A Storm," "Composition," "A Tree," and "A Battle-Piece"— and all five may have been relatively small as a result of the cramped space of his studio in the narrow, ill-lit garret of his father's house in Greenwich Street. In any event, among the artist's first patrons were George Dixey, who ran a carving and gilding business where the pictures were displayed, and George W. Bruen, a merchant interested in the arts. Between them Bruen and Dixey purchased four works for thirty-one dollars, and it was Bruen who offered the financial aid that allowed Cole to make an extended sketching trip up the Hudson River in late summer of 1825, not long before the official opening of the Erie Canal.[26]

Many other artists, not to mention tourists, had covered the same terrain before Cole visited the Hudson Highlands, the confluence of the Mohawk and Hudson rivers north of Albany, and finally the new Catskill Mountain House, Kaaterskill Falls, and the village of Catskill on the way home. William Guy Wall, for instance, had already

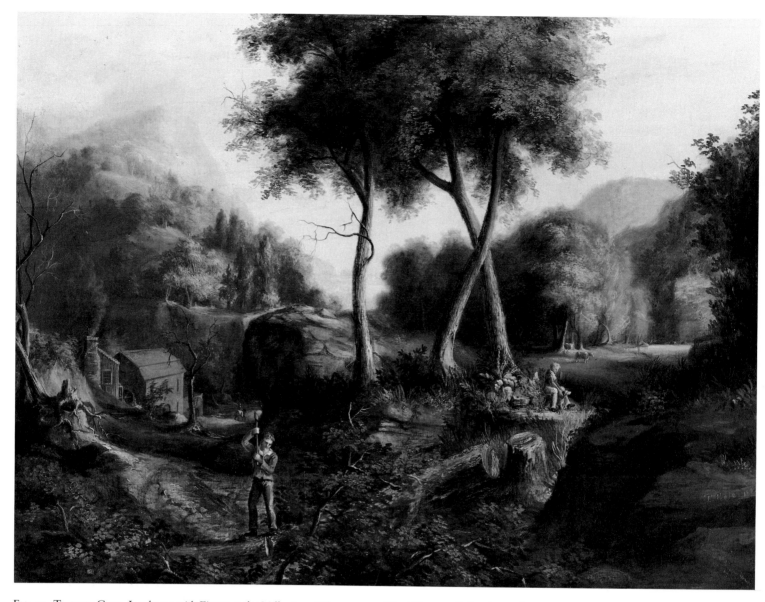

FIG. 51. THOMAS COLE, *Landscape with Figures and a Mill*, 1825. Oil on canvas. The Minneapolis Institute of Arts; bequest of Mrs. Kate Dunwoody.

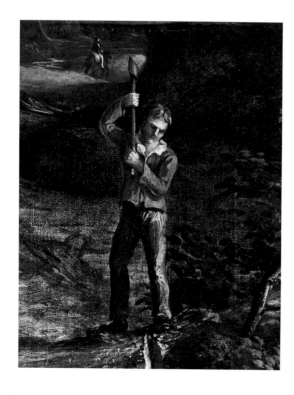

FIG. 52. Detail of Fig. 51.

THOMAS COLE

mapped out the route, so to speak, in the plates of his *Hudson River Portfolio* (Plate 126). But Cole brought to the same scenery a passion for the sublime that was far less encumbered by knowledge of the topographical tradition. Hence his trip up the North River, just before the opening of the last leg of the Erie Canal, offers a more convincing starting date for the Hudson River School in general than Wall's earlier excursions.

After Cole's return to New York, the first five paintings to result from this journey—probably completed by late October 1825—were placed on sale for twenty-five dollars each in the shop of William Colman, a book and picture dealer. Two *Views of Coldspring* (unlocated) were purchased by Mr. A. Seton, who lent them to the American Academy of Fine Arts annual exhibition in 1826. Although overlooked at first by other customers during the period of the Great Canal Celebration, the three remaining landscapes were soon "discovered" by Colonel John Trumbull, who immediately bought the *View of Kaaterskill Falls* (unlocated) with the proceeds due him from the sale at Colman's of some of his own works. Then, as if re-enacting the tale of the artist Cimabue discovering Giotto as a shepherd boy drawing on a rock in the Italian landscape, the much older Trumbull quickly called the remaining two pictures to the attention of three other New York artists. William Dunlap purchased the *Lake with Dead Trees* (Oberlin College), while Asher B. Durand acquired the *View of Fort Putnam* (unlocated). As Cole's instant fame began to spread, Dunlap actually sold his picture to Philip Hone for double the price without sharing any part of the fifty dollars with Cole, but he assuaged his conscience by publishing a long article, full of praise, in the *New-York Evening Post*.[27] Subsequently the *New-York Literary Gazette* picked up

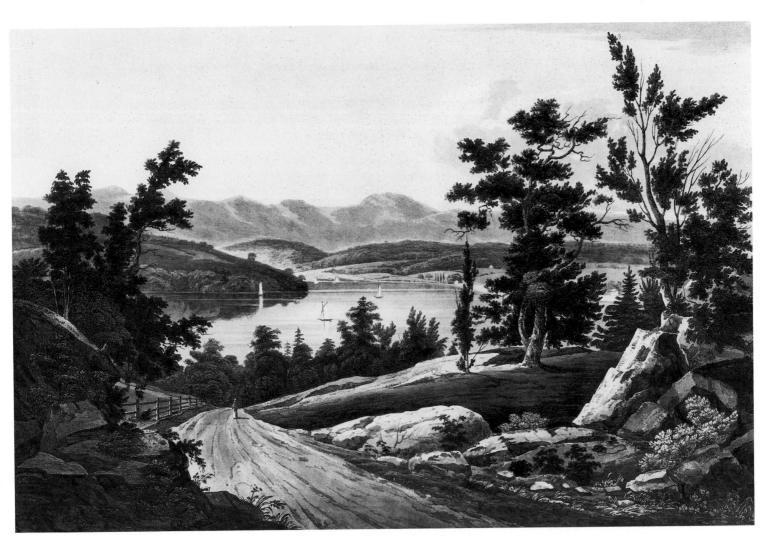

PLATE 126. WILLIAM GUY WALL, *View near Hudson,* from *Hudson River Portfolio,* 1828 edition.

the story with its heavy stress on Americanness, youth , and self-reliance. By the time their own condensed version of Cole's discovery appeared in December, all three of the paintings in question had been added to the current show at the American Academy of Fine Arts in the New York Institution building behind City Hall:

> Another American Genius — *Six or seven weeks ago, Mr. Cole, a young man from Philadelphia, came to this city, and placed three landscapes in the hands of a picture dealer for sale. They remained for some time unnoticed, until Col. Trumbull calling at the dealer's room on business, cast his eye upon one of them, and immediately inquired "Whence came this ?" He was told in reply, that it was the work of an untaught and unknown young man. He immediately purchased the picture, and expressed the warmest admiration of the genius that executed it. The Col. mentioned his purchase to another artist, who upon the first glance at the picture was equally delighted, and forthwith purchased one of those that remained. This he carried to Col. Trumbull's rooms, where two of our eminent artists were with the Col. These gentlemen also were instantly struck with admiration of the pictures, and one of them purchased the third. The four left their cards for Mr. Cole, who with the modesty generally attendant on genius in its first efforts, had not sought a personal acquaintance with any of our distinguished artists or amateurs.*
>
> *Thus we have one more name to add to the illustrious list (for such it is) of American painters. The frank and cordial manner in which Col. T. and his associates welcomed this stranger, confirms an opinion that we have long held, that in their profession there is a generous and manly emulation which "noble ends by noble means obtains," and which is so free from envy and selfishness, that rivals in other professions should blush for the insincerity, the coldness and the ill-will which they indulge towards one another.* [28]

This report, like the original one by Dunlap, was clearly meant to stir chauvinistic passions at a time of growing national pride. But given the fact that open hostilities had just erupted between Colonel Trumbull, as president of the American Academy, and the group of younger artists who had met in November 1825 to form the New-York Drawing Association, the closing paragraph seems badly out of touch with the realities of art politics at that particular moment in New York. As a relative newcomer, however, and one who had at last decided to specialize in landscapes rather than portraiture or figure painting, Cole was able to remain apart from the organizational battles then brewing. And this aloofness may have helped to keep the first mature stage of his career "free from envy and selfishness" on the part of rivals.

As evidence of Cole's unique position one can point to the fact that Trumbull was promoting his name, not just by hanging his pictures "with the works of the first European masters" at the American Academy, but by writing to Robert Gilmor of Baltimore: "a young man of the name of T. Cole has just made his appearance here from the interior of Pennsylvania, who has surprised us with landscapes of the most uncommon merit."[29] Trumbull no doubt was also responsible for showing his *Kaaterskill Falls* to his nephew-in-law, Daniel Wadsworth of Hartford, who quickly commissioned Cole to paint a replica of the same view. Meanwhile Cole was treated kindly by the younger generation as well. The records of the New-York Drawing Association show that on the evening of November 16, 1825, "Mr. Coles was proposed by the President [Samuel F. B. Morse] as a candidate for membership." Subsequently, when that association was transformed under Morse's leadership into the National Academy of Design in mid-January, Thomas Cole was out of town. Nevertheless, when the first ten professional artists, forming the nucleus of the new academy, voted again in January for a slate of ten more members on one ticket and five additional names on separate tickets, Cole's was the twelfth elected, despite the fact that his work had been known to his colleagues for only two months.[30]

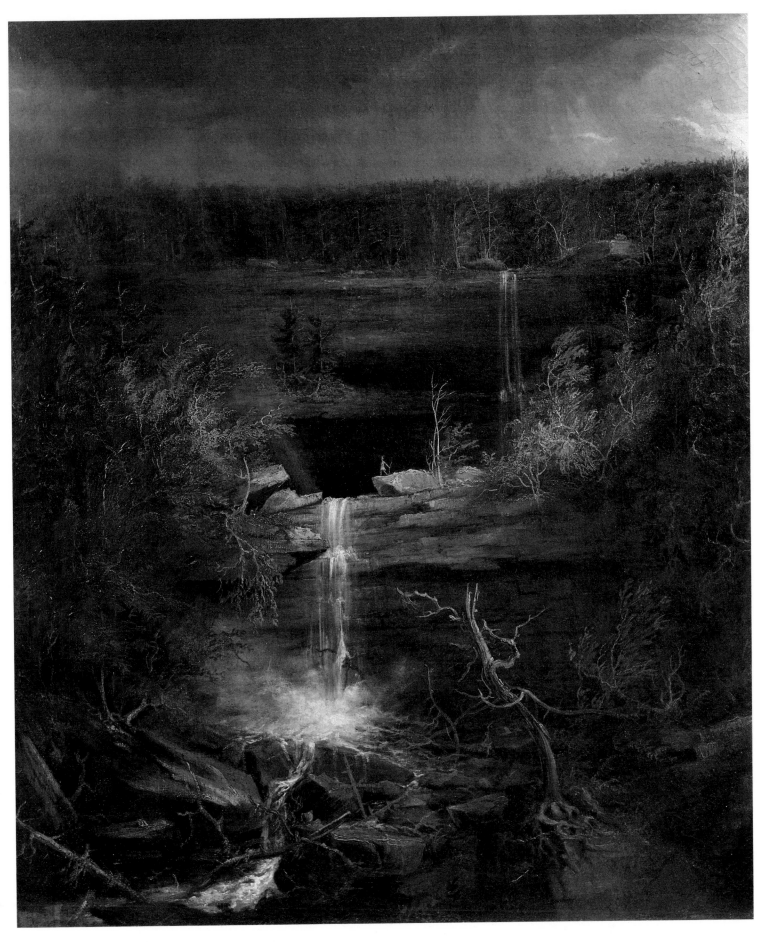

PLATE 127. THOMAS COLE, *Kaaterskill Falls*, 1826.

During the winter season of 1826 Cole was extremely busy at his easel set up in a painting room provided by George William Featherstonhaugh (pronounced Fanshaw) on his estate at Duanesburg, New York, overlooking the Schoharie River southwest of Albany. In addition to turning out at least four different views of Featherston Park for the patron's promotional purposes, plus three topographical views of the nearby town of Esperance on the Schoharie (one with snow and a wolf on a foreground ledge), Cole also produced there his most memorable rendering of Kaaterskill Falls in the Catskill Mountains (Plate 127). This vertical canvas, executed for William Gracie for fifty dollars, was clearly composed in terms of a dramatic X-pattern, with a tiny Indian figure placed at the exact intersection of the corner-to-corner diagonals to heighten the viewer's sense of the sublime double plunge of the falls. As the artist confessed in a long letter he sent to Colonel Trumbull from Duanesburg in February 1826, he was doing his best to turn out good pictures, but scenery along the Schoharie, albeit "fine" and "extensive," was too soft for his taste; he preferred landscapes with more "character."[31] This comment makes it clear why Gracie's *Kaaterskill Falls* has so much spirit, but the same lines also hint at another truth for Cole's early career — he could fall in and out of love with the places he visited and captured in his sketches. After a while, as his best sketches were turned into paintings, his enthusiasm for a particular site would begin to wane, in which case commissions to paint replicas of earlier pictures became sheer drudgery.

While Cole was out of town for the first three months of 1826, several interesting cultural events took place in New York. James Fenimore Cooper's new novel *The Last of the Mohicans* was an instant bestseller. In fact, the *New-York Review and Atheneum Magazine* admitted in March that "the excitement cannot be controlled, or lulled, by which we are borne through strange and fearful, and even agonizing scenes of doubt, surprise, danger, and sudden deliverance."[32] In its April issue the magazine heralded "an auspicious era for the Fine Arts in our city" and called attention to the forthcoming exhibition of the American Academy of Fine Arts to be held in the same gallery leased during the winter first to William Dunlap for the showing of his large *Death on a Pale Horse*, "and since to some French gentleman, for the purpose of exhibiting the great picture of the coronation of Bonaparte, by the celebrated painter, David, who has recently died in exile."[33]

When the American Academy's Twelfth Exhibition opened in May 1826, Cole was extremely well represented with seven landscapes, including two sent downriver by Featherstonhaugh and the *Kaaterskill Falls* belonging to William Gracie. At the same time Cole was deeply involved with the National Academy of Design as a member of the "Committee of Selection and Disposition of paintings and other works of the fine arts," which arranged to rent a room on the second floor of a house at Reade Street and Broadway for the first annual exhibition of this rival organization. In this show, which opened to the public on May 14, 1826, Cole had only three landscapes, listed without owner's names; but at least two of them may have been sold during the run of the exhibition to New York collectors. And out-of-town visitors, including Robert Gilmor of Baltimore, Daniel Wadsworth of Hartford, Henry Pickering from Salem, and Samuel Griswold Goodrich from Boston must have visited Cole's studio and either purchased or commissioned works from him.

The steady sale of his pictures and the demand for more, despite the increase in his prices up to fifty, sixty, and even seventy-five dollars apiece, apparently allowed Cole to leave the city on an extended trip perhaps as early as late May 1826. He first visited the area of Lake George, including Fort Ticonderoga, a site made newly famous and intriguing by Cooper's *The Last of the Mohicans*. For the balance of the summer he stayed at Mr. Bellamy's in the village of Catskill, and from there during July he wrote to each of his new patrons in turn, conveying news of his travels and making much the same excuses for not having finished the paintings they had ordered.

Unfortunately for students of his work, Cole's way of dealing with incoming requests or commissions was rather haphazard. After that initial list of 1825-1826 he kept no master file in one place. Instead, scattered throughout his surviving papers — on single sheets, on separate pages in the middle of sketchbooks, or sometimes on the inside cover of a handy notebook — he jotted down occasional listings of pictures ordered with notations added when the works were completed and delivered. It appears that Cole attempted to finish canvases for his patrons more or less in the same order that the commissions came in.

In retrospect it is interesting to see that the greatest demand for Cole's work in 1826-1827 came from Gilmor in Baltimore and Wadsworth in Hartford. Since neither wealthy collector lived in New York nor visited there often, a lengthy correspondence developed between artist and patron in each case, albeit with decidedly different tones. Since the letters between Cole and Gilmor have long been available, a great deal has been written about their semi-argumentive relationship.[34] Gilmor characteristically could not resist playing the role of the older and wiser connoisseur, who always managed to mention the superiority of his own art collection, to identify Cole's works with Salvator Rosa's style, and to insist on ways in which Cole might improve by paying closer attention to the details of nature. Gilmor had a house full of European pictures of imaginary scenes; what he did not possess were stirring scenes of the American wilderness. No wonder he was constantly trying to push Cole in that particular direction. However, before jumping to the conclusion that Gilmor's letters are proof that American patrons wanted only Cole's American scenes, and not his more poetic imaginative pictures, one should take into account a much later communication that Gilmor sent to Benjamin Chew Howard, a member of the U.S. House of Representatives from Maryland. The subject was the appropriateness of Robert W. Weir as a congressional choice for one of the remaining national pictures for the Rotunda of the Capitol in Washington. At the end of this long letter, filled with detailed advice, Gilmor added a wonderful postscript, recommending Thomas Cole in the warmest terms: "P.S. I wish Cole would have got a picture — He is the Salvator Rosa of our artists & the best landscape painter we have. His figures are good. His conception is great & his imagination of the best kind."[35]

The recent discovery and publication of nineteen original letters from Cole to Daniel Wadsworth (Watkinson Library, Trinity College, Hartford) adds immeasurably to our understanding of this phase of the artist's career. For example, when he wrote to his patron in Hartford on November 20, 1826, Cole announced that he had just completed a picture of *Kaaterskill Falls* (Wadsworth Atheneum), but he feared that Wadsworth might be disappointed with this quasi-replica of Colonel Trumbull's painting: "I have laboured twice as much upon this picture as I did on the one you saw: but not with the same feeling. I cannot paint a view twice and do justice to it."[36]

Because of the grand scale of the natural amphitheater behind the upper portion of Kaaterskill Falls, many other artists chose the same vantage point. But, as John K. Howat has suggested in his discussion of William Guy Wall's *Cauterskill Falls* (Plate 128), which was very well received at the National Academy of Design exhibition the following spring, Cole's four images of the falls from three different points of view (above, behind, and below) remain more impressive to modern eyes because they are so dark and tempestuous — "the work of an artist in awe of his subject" — while Wall's rendering, the work of an accomplished topograpical draftsman, seems "spritely and specific providing an attractive record of an inspiring place of resort."[37]

Certainly, Wadsworth was impressed with the picture he had ordered. In fact, his letters to Cole show that he took a far more encouraging and avuncular interest in the artist, praising both the American landscapes and the more imaginary scenes which he also avidly bought in 1827. Gilmor was supportive, too, when the first canvas he had ordered, *Sunrise in the Catskills* (private collection), reached Baltimore in December

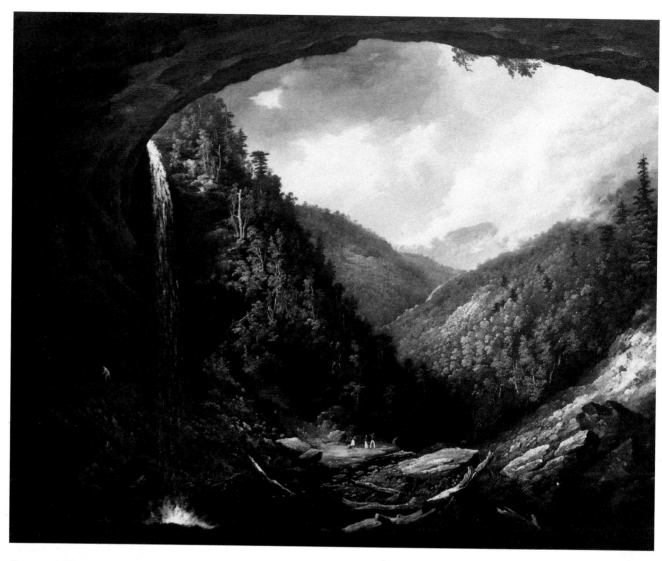

PLATE 128. WILLIAM GUY WALL, *Cauterskill Falls on the Catskill Mountains, Taken from under the Cavern*, 1826–1827.

1826. But he could not resist suggesting that the painter ought to have introduced "a figure or two on the rock in the foreground, particularly Indians," to intensify the wilderness effect.

The response of Cole's patrons who lived in New York City is less easy to document because they did not need to write letters, but their enthusiasm for his style is just as obvious. After purchasing two small panels from Cole in 1826 — a *View on Lake George* (private collection), often misidentified as *Approaching Storm in the Catskills*, and a *View in the Clove* (private collection and replica with variations, Joslyn Art Museum, Omaha) — Henry Ward proceeded to order two more panels of a similar size in 1827 — *In the Catskills* (Arnot Art Museum, Elmira) and *Sunny Morning on the Hudson River* (Museum of Fine Arts, Boston).

Akin to the issue of patronage is the question of increasing sizes and prices at this time in Cole's career. He seemed to like painting on panels approximately 19 × 24 inches with one pair for Wadsworth in 1828 at 20 × 26 inches. Such pictures naturally cost less than canvases 25 × 35 inches, such as *The Clove, Catskills* (Plate 129), whose first owner in New York has not been determined. During the winter of 1826-1827, Cole did produce two 27-×-43-inch landscapes on panel for the new low-pressure steamboat *Albany* (for an undisclosed amount paid by the Messrs. Stevens of Hoboken), and he was also inspired to attempt an even larger work, *Landscape, Scene from "The Last of the Mohicans"* (Van Pelt Library, University of Pennsylvania), measuring

3 × 4 feet. In terms of exhibition strategy, Cole continued to repay his debt to Colonel Trumbull by sending eight representative landscapes to the American Academy in the spring of 1827 , but he saved his first attempt to illustrate a dramatic scene from Cooper's novel for the National Academy. And to the same exhibit held in a skylighted 25-×-50-foot room above Tylee's Arcade Baths, Cole also sent four American scenes plus another imaginative picture, *Saint John in the Wilderness* (Plate 130), which was enthusiastically received.

In reviews of the 1827 National Academy show, writers for the newspapers and periodicals again singled out Cole's works for extended commentary after finding certain faults with the whole exhibit. In the *New-York Mirror* an unnamed reviewer (possibly George Pope Morris) complained: "with the exception of nine or ten landscapes, it is a mere gallery of portraits, of little interest to any but the parties immediately concerned, and throwing an air of intolerable sameness over the room." The writer wanted to know if it was bad taste or sheer egotism which led so many Americans to prefer "the daily contemplation of their own physiognomy, to the sublime and beautiful scenery of their native country, fresh from the true and vivid pencils of Doughty and Cole." After finding a number of defects in Morse's *House of Representa-*

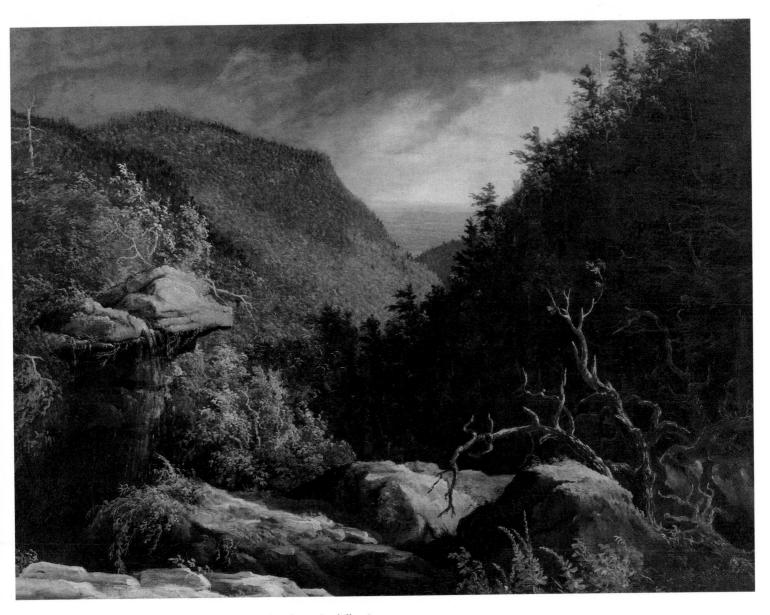

PLATE 129. THOMAS COLE, *The Clove, Catskills*, 1827.

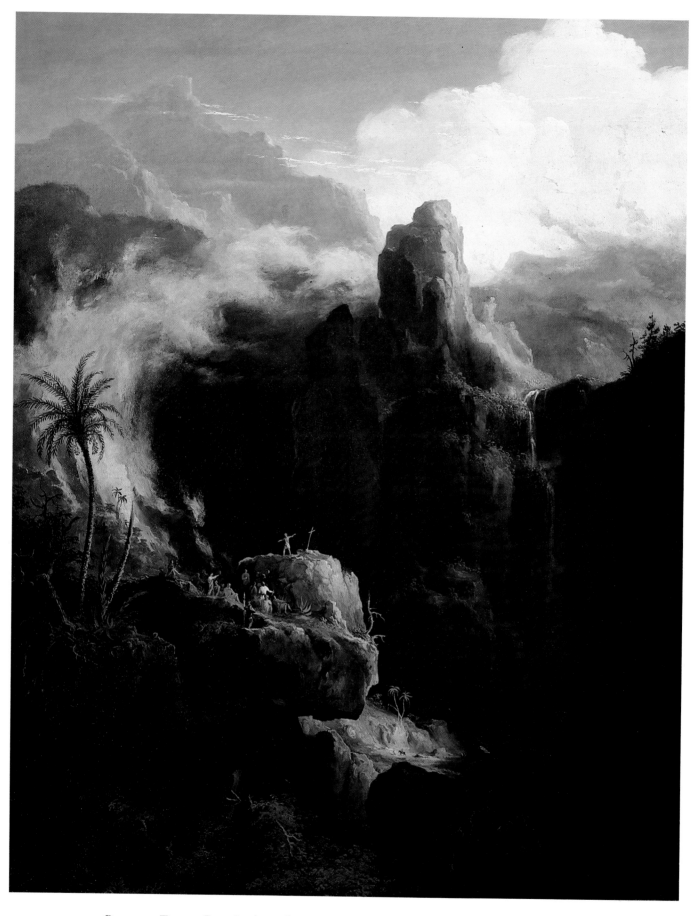

PLATE 130. THOMAS COLE, *Landscape Composition, Saint John in the Wilderness*, 1827.

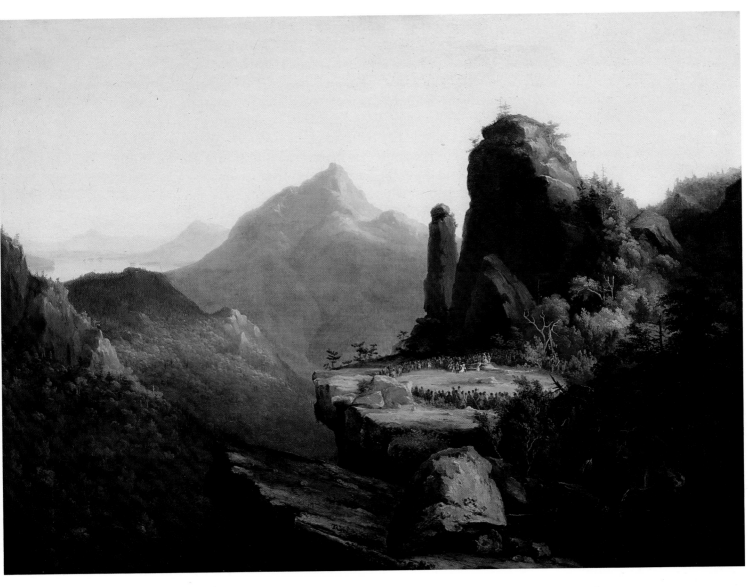

PLATE 132. THOMAS COLE, *Scene from "The Last of the Mohicans" Cora Kneeling at the Feet of Tamenund*, 1827.

tives, Henry Inman's *Portrait of Macready as William Tell*, Asher B. Durand's *Samson Shorn of His Locks*, and even Cole's *Scene from "The Last of the Mohicans"* (a "noble landscape" deformed by "a few small and insignificant figures in the foreground"), the same reviewer turned to Thomas Doughty's *Delaware Water Gap* (Plate 131), which seemed quite refreshing after so many square yards of canvas covered with "the human face divine." But it was the sublimity of Thomas Cole's landscapes that the reviewer seemed to be using as a standard for judgment:

> *Of the artist [Doughty] we know nothing, and our only wish is, that he may be a young man, because, if so, he is one from which much – very much – may be expected, though his style, and choice of subjects, rather make against the probablity of such being the case. Enthusiastic youth delights in the wild and wonderful – the bold, striking, and majestic. The "cloud-capt tower" – the lofty peak – the jutting rock – the foaming cataract, or the fierce storm, are the scenes which, for the most part, take hold of youthful imaginations, and employ youthful pencils. Mr. D's subjects are of a very different character – the calm, clear morning – the silent river, with the broad shadows flung half across – the still foliage, and unclouded summer sky, seem congenial to his mind. But young, or old, he is a devoted worshipper of Nature, and the offerings he has already made at her shrine, fine as they are, only convince us that he will "yet do greater things."*[38]

Dr. David Hosack of New York purchased Cole's large *Scene from "The Last of the Mohicans"* during the run of the exhibition, and sometime during that late spring or early summer, Daniel Wadsworth must also have made the trip to see the National Academy show from which he purchased the *Saint John in the Wilderness* for seventy-five dollars. Arrangements were no doubt made beforehand so that, once the show closed in mid-July, Cole took the *Saint John* with him by steamboat to Hartford, where he enjoyed his patron's hospitality for a week or possibly two, even visiting Wadsworth's Gothic Revival summer house perched on the west side of Talcott Mountain at Avon, Connecticut, overlooking the Farmington River valley.

Unable to accompany Cole on a trip to the White Mountains at the end of July, Wadsworth drew up a complete itinerary which the artist seems to have followed to the letter. Clearly the patron's love of the mountains and major lakes of New Hampshire suddenly became Cole's new passion, overwhelming his earlier fondness for the Catskills and Lake George. By mid-August the painter was back in New York, feverishly working at his easel despite the great contrast between "the voiceless stillness of the mountain wilderness [and] the deafening turmoil of this great city."[39] By the end of 1827, in a burst of intense activity, Cole had produced some of his finest pictures, including several views in the White Mountains plus two versions of a different scene from *The Last of the Mohicans,* namely *Cora Kneeling at the Feet of Tamenund* — one commissioned by Wadsworth (Plate 132) and a variant painted slightly later for Gilmor (New York State Historical Association, Cooperstown). The contrast between these patrons was evident once again in their letters of response in December. As usual, Gilmor found things to complain about, starting with the rise in Cole's prices to one hundred dollars for a narrative landscape, and ending with a criticism of the foreground rocks in his painting, which looked too artificial to his appraising eye. On the other hand, Wadsworth was overjoyed to receive a crate containing three paintings and a frame in early December, especially since the crate had been rescued from a steamboat that ran aground off Guilford, Connecticut. Once the pictures had arrived, he wrote immediately to the artist assuring him that they were safe. Enclosing payment, and saying that he could hardly express his admiration for those features of the "Last of the Mohegans" which impressed him most: "the Grand & Magnificent Scenery," "the deep Gulfs, into which you look from real precipices," "the heavenly serenity of the firmament, contrasted with the savage grandure," the "wild Dark Masses of the Lower World," and "the calm & lovely lake, which seems to lead the eye to regions far, far off — till it is lost among the pale blue mountains."[40]

1828–1829: Growing Ambition

Three notable changes in Cole's thinking mark the winter of 1827–1828 as a turning point in his early career. First of all, Mount Chocorua (also known as Corway, Corroway, or Carroway Peak) came to dominate his production of single views. It forms the centerpiece, for example, not only of a work painted for James A. Hillhouse of New Haven (IBM Corporation, Armonk, N.Y.), but also of an even larger canvas, now called *Autumn Landscape* (Fig. 53), which cleverly plays off the silhouette of the pyramidal mountain against the diagonal of the dead tree and the melancholy figure of a youthful traveler resting next to the stream in the right foreground. What is more, when Gilmor lent his latest acquisitions by Cole to the 1828 exhibition at the Pennsylvania Academy of the Fine Arts in Philadelphia, one was listed as *Landscape — View of Corroway Peak in New Hampshire — Sun Setting* (unlocated), while the other was described as follows: "A composition of real scenes — The mountain is Corroway Peak, and the lake is Winipisioge Lake [Winnipesaukee] with Rattlesnake Island, in N.

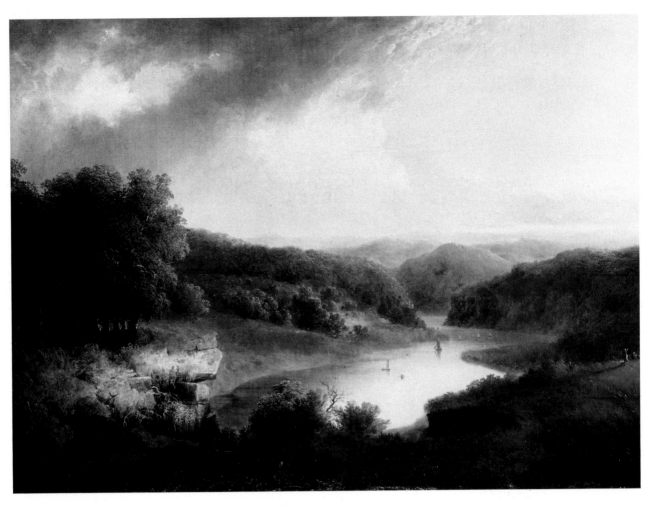

PLATE 131. THOMAS DOUGHTY, *Landscape: Delaware Water Gap*, 1826.

Hampshire — The figures respresent a scene from Cooper's novel, 'The Last of the Mohicans' — Cora kneeling at the feet of Tamenund — Vol. II Chap. 12."[41]

The very fact that Cole asked Gilmor to send these two paintings to the Philadelphia show in the spring of 1828 may be taken as proof of a more aggressive exhibition policy. Convenience might have been a factor in asking his Baltimore patron to lend two works to the Pennsylvania Academy, but one could read the same facts as evidence of Cole's growing confidence and willingness to be measured against Thomas Birch and Thomas Doughty on their home ground. Simultaneously, without worrying too much about proximity, Cole had also asked Daniel Wadsworth to send his *Saint John in the Wilderness* to the second exhibition at the Athenaeum Gallery, Boston, in addition to lending his topographical *View of the White Mountains* (Plate 133) and *Cora at the Feet of Tamenund* to the National Academy of Design in New York. His desire to make a major showing in all three urban centers is self-evident.

At the same time, it looks as if Cole may have contributed in a small degree to the obvious decline of the American Academy of Fine Arts by withholding his larger and more ambitious pictures. In sending only two lesser landscapes he probably contributed to the impression that the collection on public view was "not so numerous as on former occasions" and, on the whole, reflecting "but little credit on the Academy."[42] By contrast, at the National Academy Cole was magnificently represented by eight different canvases, the most impressive being the *Garden of Eden*, now unlocated but known from an engraving (Fig. 54), and the *Expulsion from the Garden of Eden* (Museum of Fine Arts, Boston). The artist wrote to Gilmor that these companion paintings were intended to attain "a higher style of landscape than I have hitherto tried."[43]

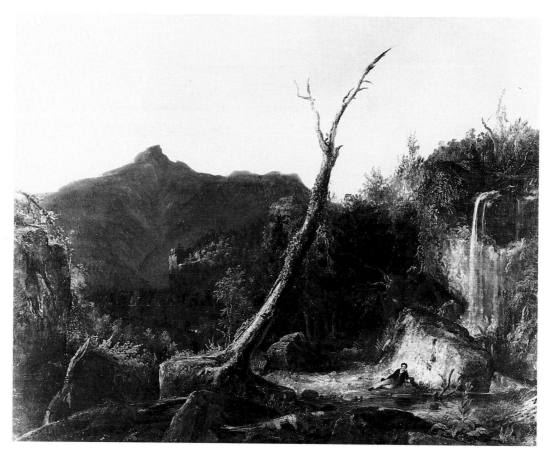

FIG. 53. THOMAS COLE, *Autumn Landscape with Melancholy Figure*, c. 1827–1828. Oil on canvas. Private collection; on loan to the University of Arizona Museum of Art. Photo by Timothy W. Fuller.

As imaginary compositions aspiring to the level of history painting, they became the focus of critical attention, most but not quite all of it full of praise and admiration.

It has recently come to light that the sculptor John Browere, who was a member of the American Academy, found a way to attack Thomas Cole's integrity in print while appearing to be a sympathetic supporter. Under the heading, "MIDDLE-TINT, on the Works of LIVING ARTISTS, at the National Academy of Design, No. 5," this arch-opponent of the new institution published the following accusations in the *New-York Morning Courier* June 21, 1828:

> *Hints, nay, positive assertions have been repeatedly made to us, by his most intimate friends, and members of the National Academy, that the Garden of Eden was copied "Lines per lines" from the engraved piece called the Paphian Bower: And that, with the exception of the beast of prey, and one or two little items, the whole of the expulsion is a literal copy of the celebrated Martin's picture.* [44]

For Cole, who had worked so hard on the multiple beauties of the *Garden of Eden* (even to the point of including a Chocorua-like peak in the background) and then, at the last minute, created its sublime companion just in time for the opening, it must have been worse than galling to be accused of plagiarizing two different mezzotints by John Martin. In a response sent to the *American*, but reprinted in the *Morning Courier* on the following June 24, the artist not only denied the charges but invited the public to see for itself, since a print of Martin's *Paphian Bower* was now hanging beside his *Garden of Eden* —and Martin's *Expulsion* would have been placed next to his version of the same scene if only an impression had been available in the city.

Another irritant for Cole that spring was the fact that he had turned down a cash offer for the *Garden of Eden*, because the purchaser, S. G. Goodrich, wanted it for the

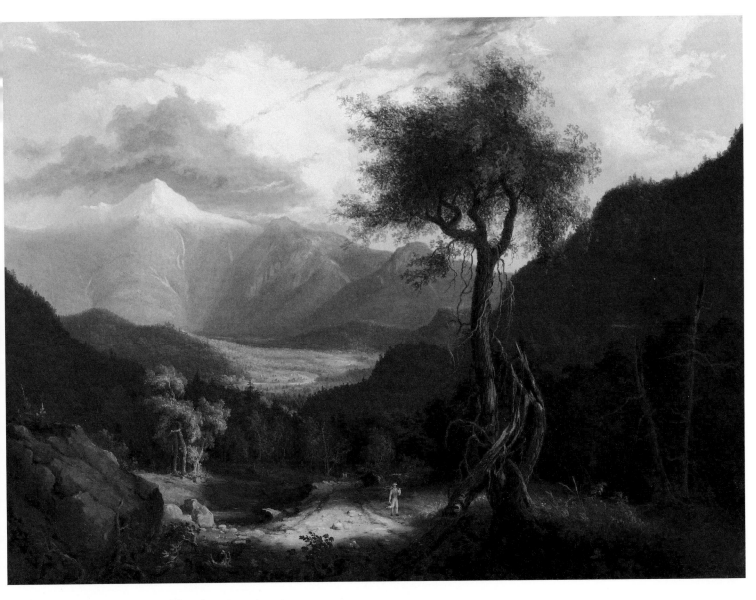

PLATE 133. THOMAS COLE, *View of the White Mountains*, 1827.

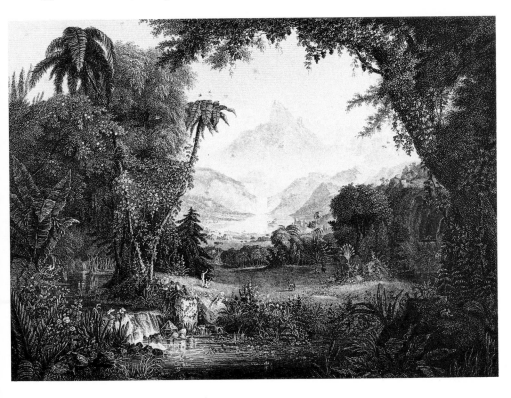

FIG. 54. After Thomas Cole, *The Garden of Eden*. Engraving by James D. Smillie, "From the original picture in the possession of C. Wilkes, Esq., N.Y." Frontispiece for *The Holy Bible*, Vol. I, Boston, 1831. General Research Division, The New York Public Library, Lenox, Astor, and Tilden Foundations.

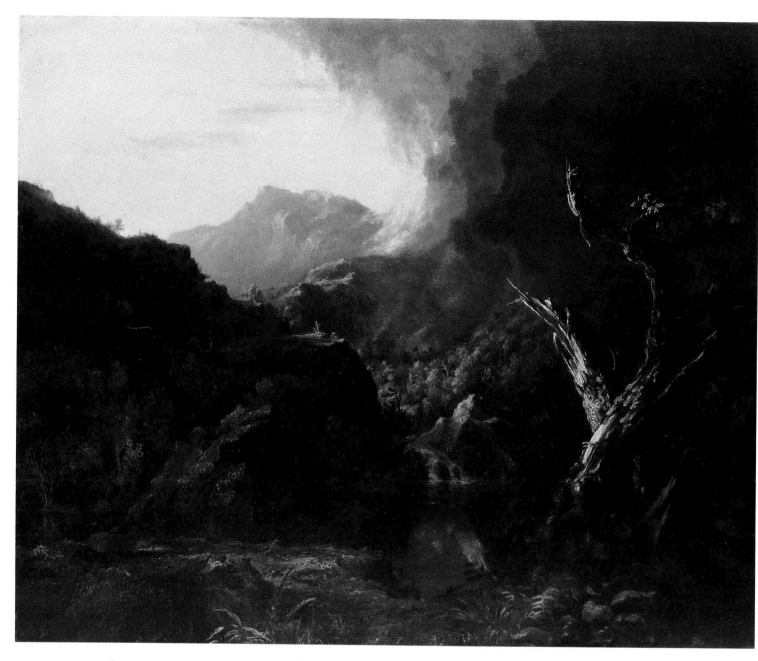

PLATE 134. THOMAS COLE, *Landscape with Tree Trunks*, 1828.

Boston Athenaeum exhibit, whereas the painter had promised it to the National Academy, where he had been led to believe it would surely sell. To make the best of the situation, with two large biblical landscape compositions on his hands, Cole decided to take the pair to Boston for the summer, where he arranged to show them at the old Athenaeum in Common Street. Unfortunately, this small one-man exhibit did not bring in enough receipts at the door to cover expenses, but Cole did announce in a letter to Daniel Wadsworth that he had received two commissions in Boston — one of these, no doubt, from Colonel Thomas Handasyd Perkins for the image *Vermont Autumnal Scenery* (lent to the Boston Athenaeum in 1829), which may not be the same as the picture now known as *Landscape with Tree Trunks* (Plate 134), signed and dated "T. Cole / 1828 / Boston."

Even though his "Paradise speculations" came to nought, another positive result of Cole's extended sojourn in Boston was a new friendship with Henry Cheever Pratt, with whom he made a quick trip to the White Mountains in early October. Pratt, it

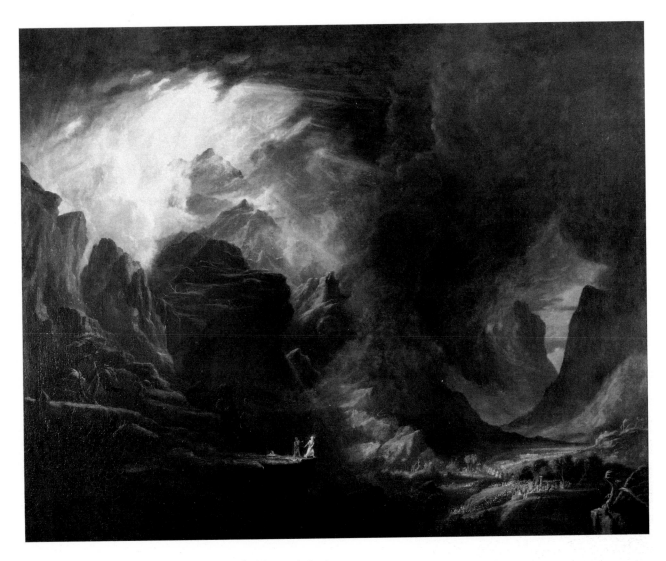

PLATE 135. HENRY CHEEVER PRATT, *Moses on the Mount*, 1828–1829.

turns out, was working on very Martin-like composition of his own at this time, *Moses on the Mount* (Plate 135), a canvas often attributed to Cole in the past. When he wrote to Cole in December 1828, explaining that S. G. Goodrich had already shipped the *Garden of Eden* and the *Expulsion* back to New York, Pratt could not resist mentioning the fact that he was making real progress on his *Moses*, altering the design and coloring it much more strongly than when Cole had seen it last.[45]

As if undaunted by charges of plagiarism and by the failure to sell his large biblical compositions, Cole next produced the major canvas *Subsiding of the Waters of the Deluge* (Fig. 55), inspired by the exhibition of Martin's 1828 mezzotint *The Deluge* at William Colman's Literary Emporium in New York in January 1829. This time, instead of attempting to paint a variant of the same theme of rising waters, Cole illustrated the happy return of sunshine over a bleak and desolate world of barren and even jagged rocks just emerging from the Flood. This ambitious work, sent to the spring exhibition at the National Academy, was listed for sale, whereas his other six landscapes on view already had owners. The Honorable Stephen Van Rensselaer, for example, was named as the owner of *View near Catskills* (Plate 136), an immensely pleasing topographical view, on a standard sized panel, of one of the artist's favorite prospects — the escarpment of the Catskills with Kaaterskill Clove separating Catskill High Peak and Round Top from South Mountain and the Mountain House on its rocky ledge, as seen from the low hills bordering Catskill Creek.

Obviously, for Cole, attractive views of real scenery kept the pot boiling by bringing in the money he needed to live on, to help his family, and to make it possible to make an artistic pilgrimage to Europe, which he had been dreaming of for some time. On the other hand, he poured the greatest amount of effort into his much larger historical landscapes, and for these images, either singly or in companion pairs, he felt compelled to ask much higher prices. It seems that ambition kept calling him like a siren to try more dramatic and emotional subjects than any other landscape artist would tackle. Even during the spring of 1829, with the Eden pictures still on his hands and the *Subsiding of the Waters* in progress, Cole felt compelled to finish another large work, *Hagar in the Wilderness* (destroyed), to take with him on his planned trip abroad. And this work was itself placed on public view in mid-April at Colman's Emporium, where it received very favorable reviews.[46]

Finally, while Cole was out of town in early May 1829, making a quick visit to Niagara Falls for a "'last lingering look' at our wild scenery," his friends arranged for Elam Bliss to exhibit the *Garden of Eden* and the *Expulsion* in his bookstore.[47] Charles

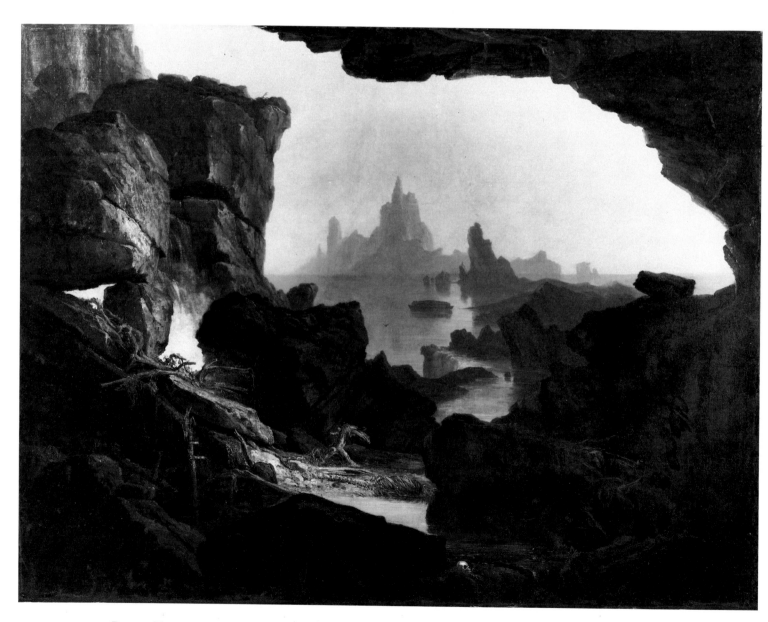

FIG. 55. THOMAS COLE, *The Subsiding of the Waters of the Deluge,* 1829. Oil on canvas. National Museum of American Art, Smithsonian Institution, gift of Mrs. Katie Dean in memory of Minnibel S. and James Wallace Dean and museum purchase through the Major Acquisitions Fund, Smithsonian Institution.

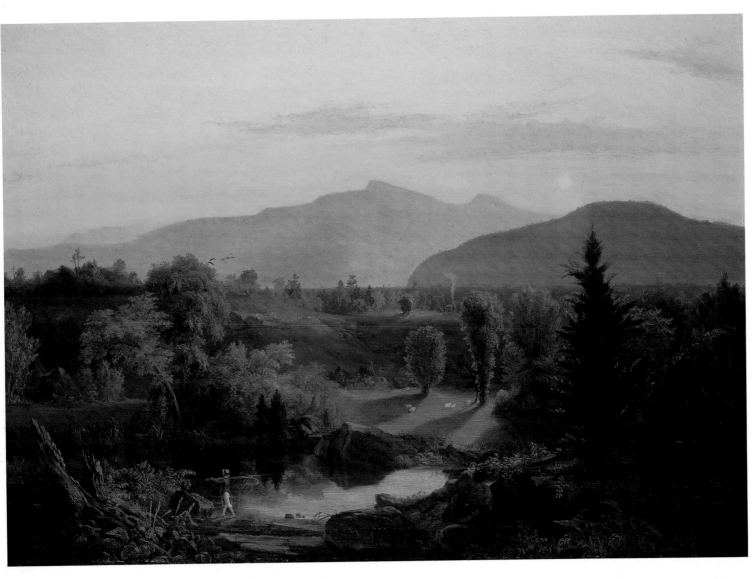

PLATE 136. THOMAS COLE, *View near Catskills,* 1828–1829.

Wilkes bought the *Garden* scene there, purportedly for four hundred dollars. Then a few days after his return from Niagara, Cole encountered Dr. David Hosack in the street, who then and there arranged to buy both the *Expulsion* and the *Subsiding of the Waters* for a sum the artist kept secret, since it was well below his original asking price.

In any event, all of his pictures (except the *Hagar*) were sold at last, and eleven years after his arrival in the United States Cole was ready to return to Europe to further his education as an artist. The High Romantic part of his career, dominated primarily by American scenery, was clearly over—notwithstanding the fact that William Cullen Bryant's famous sonnet "To Cole, The Painter, Departing for Europe," first published in *The Talisman* later in 1829, exhorted the artist to "keep that earlier, wilder image bright." Thus, with several hundred dollars in his pocket, with several full sketchbooks and one finished canvas, the *Hagar,* among his luggage, and with the knowledge from patrons and friends that he, at the age of twenty-eight, was the most admired and talked-about landscapist in America, Cole left New York aboard the packet ship *Columbia* on June 1, 1829, bound for England and a new international stage in his development.

NOTES

1. New-York Historical Society (*Collections*, Vol. LXIV), *Diary of William Dunlap (1766-1839); The Memoirs of a Dramatist, Theatrical Manager, Painter, Critic, Novelist, and Historian* (New York: New-York Historical Society, 1930), Vol. III, p. 807.

2. Letter from William Dunlap to Thomas Cole, New York, August 28, 1834, Cole Papers, New York State Library, Albany.

3. From the copy of Dunlap's *History of the Rise and Progress of the Arts of Design in the United States* (New York, 1834), Vol. II, pp. 353-360, now in the collection of David A. McCabe. I am deeply indebted to Professor J. Bard McNulty of the English Department at Trinity College, Hartford, for sharing a typescript he prepared of these marginal notations by Cole.

4. *Ibid.*, Vol. II, pp. 351-352.

5. Louis Legrande Noble, *The Life and Works of Thomas Cole*, ed. Elliot S. Vesell (Cambridge, Mass.: Harvard University Press, 1964), p. 6.

6. Betty J. Blum deserves all credit for locating this document in the National Archives, Washington, D.C.

7. Noble, *Life and Works*, p. 6.

8. *Ibid.*, p. 7. A copy of this book, published by McCarty and Davis (Philadelphia, 1818), can be found in the library of Yale University Divinity School.

9. For a reprint of this story, published May 14, 1825, see Marshall Tymn, ed., *Thomas Cole: The Collected Essays and Prose Sketches* (St. Paul: John Colet Press, 1980), pp. 77-90.

10. Noble, *Life and Works*, p. 9.

11. For earlier citations of this material from *The Western Herald and Steubenville Gazette*, see E. Parker Lesley, "Thomas Cole and the Romantic Sensibility," *Art Quarterly* 5 (Summer 1942): 198-221.

12. Dunlap, *History*, Vol. II, p. 352.

13. In addition to Parker Lesley's 1942 article, one can find a slightly more focused account in Ralph Fanning, "Thomas Cole in Ohio," *Bulletin of the Columbus Gallery of Fine Arts* 19 (Winter 1948): 10-16.

14. William H. Gerdts kindly called to my attention the existence of John Stein in a letter of June 19, 1980. Since that time Mary Katherine Donaldson has generously sent me a copy of her 1971 doctoral dissertation from the University of Pittsburgh, "Composition in Early Landscapes of the Ohio River Valley: Backgrounds and Components." She identifies John Stein as Cole's probable tutor on pp. 94-95; her discussion of Cole's early works is on pp. 100-110.

15. Dunlap, *History*, Vol. II, p. 353.

16. *Ibid.*, pp. 355-357. Also see Noble, *Life and Works*, pp. 15-20.

17. *Ruth and Boaz* might have been based on an engraving of the Passion in the Louvre. These works are briefly discussed in my article "Thomas Cole and the Problem of Figure Painting," *American Art Journal* 4 (Spring 1972): 67-68. *Belshazzar's Feast* was perhaps inspired by talk of John Martin's successful version of the theme at the British Institution in 1821 or by reports of Washington Allston's large unfinished canvas brought back to Boston in 1818.

18. Mary Katherine Donaldson in her dissertation has shown that this ad ran three times in the *Pittsburgh*

Gazette (on April 18 and 25 and May 2, 1823) and then presumably was withdrawn.

19. According to Dunlap, *History*, Vol. II, p. 358, Cole did a mezzotint of a head of Jackson, but in his personal copy of the book the artist placed an X in the margin and wrote, "Not so / I copied a portrait."

20. *Ibid.*, pp. 358-359, and Noble, *Life and Works*, pp. 26-27.

21. Dunlap, *History*, Vol. II, p. 359.

22. For more on the reattribution of the *Mercury Deceiving Argus* and its impact on Cole, see Richard W. Wallace, *Salvator Rosa in America* (Wellesley, Mass.: Wellesley College Museum, 1979), pp. 35 and 113-121.

23. Dunlap, *History*, Vol. II, p. 359, and Noble, *Life and Works*, pp. 28-29.

24. See my article in *American Art Journal* 4 (Spring 1972): 69, n. 11.

25. See Cole's Writing Book No. 1 in the Detroit Institute of Arts (39.558.A), pp. 1-2.

26. Dunlap, *History*, Vol. II, pp. 359-360, and Noble, *Life and Works*, pp. 32-35.

27. See *New-York Evening Post* (November 22, 1825): 2nd page.

28. *New-York Literary Gazette* (December 10, 1825): 219-220. I am grateful to Gerald L. Carr for bringing this passage to my attention.

29. Letter from John Trumbull to Robert Gilmor, Jr., dated New York, November 14, 1825. Dreer Collection, Historical Society of Pennsylvania, Philadelphia.

30. I am deeply indebted to Abigail Booth Gerdts for her guidance in going through both the rough draft and the finished copy of the minutes of the National Academy of Design from which these details have been extracted.

31. Letter from Thomas Cole to John Trumbull, dated Duanesburg, February 24, 1826, Joseph Downs Manuscript Collection, Henry Francis du Pont Winterthur Museum.

32. *New-York Review and Atheneum Magazine* 2 (March 1826): 285.

33. *Ibid.* (April 1826): 371.

34. See, e.g., the article by Barbara Novak, "Thomas Cole and Robert Gilmor," *Art Quarterly* 25 (Spring 1962): 41-53. The entire correspondence is reprinted by Howard S. Merritt in Appendix I to *The Baltimore Museum of Art Annual II: Studies on Thomas Cole, An American Romanticist* (Baltimore: Baltimore Museum of Art, 1967), pp. 41-81.

35. Letter from Robert Gilmor to Benjamin Howard, dated Baltimore, February 16, 1837, Howard Family Papers, MS. 469, Maryland Historical Society, Baltimore.

36. See Letter No. 2 in J. Bard McNulty, ed., *The Correspondence of Thomas Cole and Daniel Wadsworth* (Hartford: Connecticut Historical Society, 1983), p. 4.

37. John K. Howat, "A Picturesque Site in the Catskills: The Kaaterskill Falls as Painted by William Guy Wall," *Honolulu Academy of Arts Journal* 1 (1974): 16-29.

38. *New-York Mirror* (June 2, 1827): 354.

39. NcNulty, ed., *Correspondence of Cole and Wadsworth*, pp. 7-13.

40. *Ibid.*, Letter No. 10, pp. 22-23.

41. This full entry is not given in Anna Wells Rutledge, ed., *Cumulative Record of the Exhibition Catalogues of the Pennsylvania Academy of the Fine Arts, 1807-1870* (Philadelphia: American Philosophical Society, 1955), p. 50. It is necessary to turn to the original *Exhibition Catalogue* (Philadelphia, 1828), p. 4, No. 53.

42. *New-York Mirror* (May 31, 1828): 374-375.

43. Letter from Cole to Gilmor, dated Philadelphia, May 21, 1828. See *Baltimore Museum Annual II*, Appendix I, p. 58.

44. Christopher Wilson generously brought Browere's review and Cole's subsequent reply to my attention in the form of photostats and transcriptions. The identification of "Middle-Tint" as Mr. Browere appears in T. S. Cummings, *Historic Annals of the National Academy of Design* (Philadelphia, 1865; reprint, New York: Kennedy Galleries and Da Capo Press, 1969), pp. 80-81 (where Browere's attack on Henry Inman is quoted at length). Christopher Wilson's report on his findings appears in the New Discoveries section of the *American Art Journal* 18 (Winter 1986): 73-74.

45. For more details concerning Cole's stay in Boston, the two landscapes he painted there, and the reattribution of *Moses on the Mount*, see my article "When a Cole Is Not a Cole," *American Art Journal* 16 (Winter 1984): 34-45.

46. See Graham Hood, "Thomas Cole's Lost Hagar," *American Art Journal* 1 (Fall 1969): 41-52.

47. In addition to Cole's correspondence with Gilmor, other details about the last-minute arrangements in New York can be found in the *New-York Evening Post* (May 15 and 21, 1829): 2.

BRUCE ROBERTSON

The Picturesque Traveler in America

B Y THE EARLY NINETEENTH CENTURY, the United States was being traversed by tourists both foreign and American.[1] Many of them kept verbal and visual records and published popular accounts of their tours. A primary concern of such travelers was the scenery they encountered; indeed, landscape description was the affective part of a travel guide and might be accorded as much space as a meeting with George Washington or observations on farming. "Picturesque travelers" — that is, tourists in pursuit of picturesque scenery — were so common and their accounts so varied that they were often satirized. One American commentator noted British visitors who "sketch the scenes they pass when half-asleep. / Some best describe indeed what pass'd by night, / 'Tis done by all, who travel but to write."[2]

The Picturesque Tour

Tourism as it developed in England in the eighteenth century has a complex history. However, wide public acceptance of the picturesque tour followed the publication of the Reverend William Gilpin's travels, beginning with his *Observations on the River Wye* in 1782, which records a trip taken down that river in the west of England. Gilpin's theories on the subject were organized in *An Essay on Picturesque Travel*, published in London in 1792. The book was soon in libraries and bookstores in America and was reprinted in its entirety in the *New York Magazine or Literary Repository* in December 1793.

The object of picturesque travel, according to Gilpin, was the discovery of a particular beauty in "the scenery of nature" which could be achieved by following two basic principles.[3] First, "the ingredients of landscape — trees — rocks — broken-grounds — woods — rivers — lakes — plains — vallies — mountains — and distances" should be contrasted: light and dark, high and low, rocky and wooded, cultivated and wild. For the picturesque traveler, this could mean the contrast of green hemlock against orange maple trees in the fall, or smoke against the dark hills.[4] Second, these scenes should be viewed as if in a frame. The eye must be led from the foreground in an orderly fashion into the distance, as into a light-filled bowl of space. These basic principles organize the landscape along lines developed by painters such as Claude Lorrain in the seventeenth century.

Gilpin also recommended that the traveler should sketch and describe what was found in nature as a way of ordering it. As one of his followers explained: "Words will

naturally fail to impress on the imagination a clear idea of the scenery of a country or its several beauties; neither can a proper idea of them be formed, unless we can present a 'perfect whole' at once to the view. The pencil may supply what words are unable to express; but still that does not equal nature."[5]

Viewing a landscape was not a passive reaction but an active mental process, requiring judgment and comparison with models and standards. For European travelers on the continent, the range of landscapes and sensations evoked by them were comfortably familiar: they happily browsed along well-trodden paths, rich in associations (even the terror of the Alps was passed in the company of Hannibal). In America there were no such paths: the New World was unpredictable, untamed, unknown. European travelers in America were always trying to match what they saw with what they knew, which was sometimes an uncomfortable process. Americans were aware of their European inheritance and the ways in which the American landscape might be measured against that tradition, but at the same time their reactions were invariably colored by nationalistic fervor. The difficulty with which many travelers perceived America and the variety of responses they recorded underscore the degree to which landscapes are mental constructions.[6] Description was a powerful tool for creating order out of the flux of the natural world: once pictured, the landscape had a meaning.

The picturesque tourist was the partner of the landscape painter in America.[7] The verbal pictures he produced were governed by the same conventions as visual ones, and had the same range of meanings. Not surprisingly the landscapes most often painted were the ones that had been first identified by tourists. Many artists traveled with guidebooks which described the pictures they should be painting.[8] But in the very act of traveling, a certain reality intrudes. As one traveler wrote:

> . . . *our feelings, our judgement, and even our vision, are unconsciously affected by the degree of personal comfort we enjoy, and the mode of conveyance to which we are subjected . . . upon this principle we may ascribe the diversities and contradictions which often characterize the accounts that different persons give of the same country, to the mode in which they have traveled, and the difficulties they have encountered in the course of their journeys.*[9]

My following discussion analyzes both the realities of picturesque tourism and the "feelings, judgement, and vision" of the travelers.

Tourist Realities

There were few who traveled for pleasure in America until the early 1790s, when the uncertain political climate in Europe and the new taste for the picturesque contributed to the influx of British visitors. The Napoleonic wars again reduced the flow of tourists; but after 1818, with the cessation of hostilities on both sides of the Atlantic, tourism picked up considerably. At the same time, there was a marked increase in the number of Americans traveling about their country. A tourist industry was well established by 1830, with popular hotels and spas, scenic attractions, and passable roads and routes. Travel aids included geographies and gazetteers such as Jedediah Morse's *American Geography* (1789) and road guides and directories like John Melish's *Traveller's Directory* (1815) and Joshua Shaw's *U.S. Directory* (1822). In the early 1820s specialized guides to particular sites became available.[10] Guidebooks also began to consider the actual mechanics of travel as less-experienced travelers required advice and information on transportation, attractions, and hotels.

The quality of roads and lodgings could well decide the success or failure of a trip. One practical author recommended that the tourist "consult comfort in traveling, for

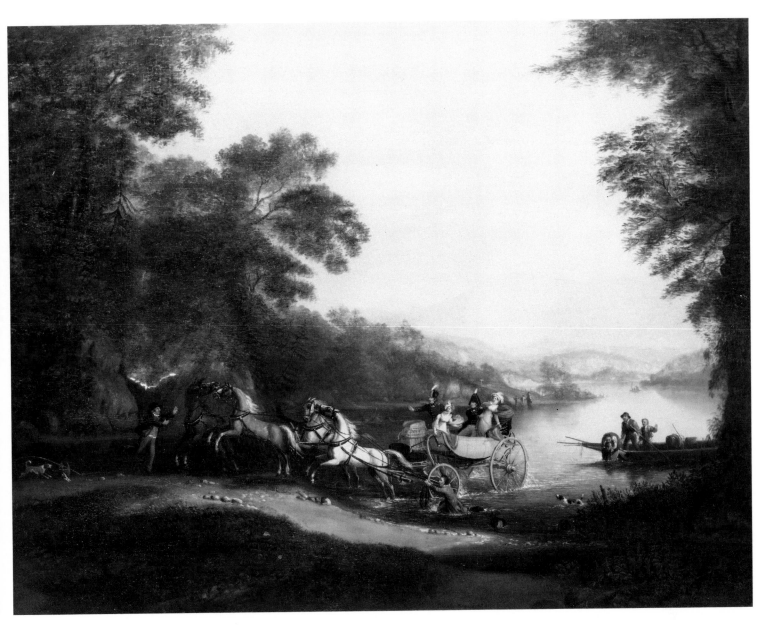

PLATE 137. ALVAN FISHER, *Mishap at the Ford,* 1818.

without this there is no pleasure; he must be particular about the time, — the mode of conveyance, — the ultimate pursuit, — and of all things, the companions with whom the route is intended to be made."[11] The reality of travel in America could be comfortless. Accommodation along major routes was haphazard; between Boston and Washington, inns were small and standards erratic. While one traveler was charmed in Middletown, Connecticut, at an inn where the daughter played the piano for guests, at most places service, cleanliness, and food were wretched.[12] Not until the 1820s were there commodious and efficiently run hotels outside the major cities, such as the Catskill Mountain House and hotels at Ballston Spa and Saratoga Springs which could accommodate hundreds of visitors. Even the village of Caldwell, because of its position at the head of Lake George, a day's ride from the Springs, could boast of Mr. Doney's Lake George Coffee-House, capable of putting up "100 visitants."[13]

Inns and carriages provided material for comedies of American manners, flavoring the social realities lying behind views of these spots. Many Europeans were unprepared for egalitarian American habits. Even at the best hotels, everyone sat down together at regular, and specified, intervals. It is difficult to know which astounded

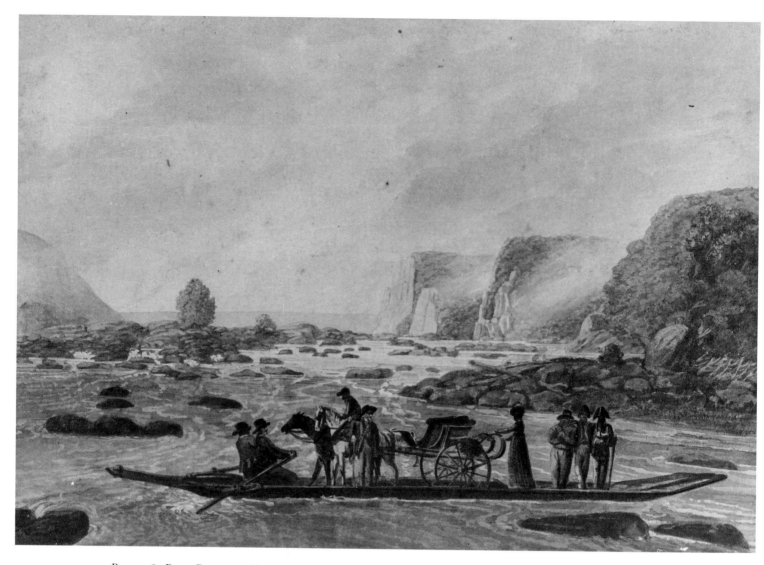

PLATE 138. PAVEL PETROVICH SVININ, *A Ferry Scene on the Susquehanna River at Wright's Ferry just above Havre de Grace*, early nineteenth century.

them most: eating with one's social inferiors, not being able to command a meal when it was wanted, or being forced to eat quickly. Americans were notorious for gobbling their meals.

Carriages were often open to the weather and without padding or suspension. A traveler was crowded next to strangers who asked personal questions. The discomfort of the carriages, which in fact were not much worse than most European ones, was nothing compared to the roads, which were rutted in dry weather and swampy in wet (Plate 137). But both carriages and roads had improved so much by 1819 that one English visitor could even praise them.[14]

At its best, traveling was an endurance test. The trip from Boston to New York in the 1790s took between three and four days. They were long days, beginning before four in the morning. The first stop came some three hours and twenty miles later for breakfast, and the day did not end until early evening. The time was cut in half by 1830, but the days were just as long. The routes between Boston and Washington—the most traveled then as now—were standardized very early. From Boston one took the stage through Worcester to Springfield the first day; from Springfield to Hartford the second; then boated or drove down to New Haven; and finally boated or drove along the coast to New York City. Going south from New York, one ferried over to Hoboken;

went by stage to Trenton, Newark, and the Delaware River; then sailed down the river to Philadelphia. In 1802 the trip took one and a half days and cost five dollars (a price which might be translated into a hundred dollars today). By 1818, with the advent of the steamboat, the trip could be made in twelve hours for two dollars. After a boat trip from Philadelphia to Wilmington, a stage carried the traveler to Havre de Grace (Plate 138) and Baltimore and finally to Washington. Boat transportation was generally no more pleasant than stage, with the risk of storms or of being becalmed.

With the introduction of the first commerical steamboat runs up the Hudson in 1807, all that changed. From then on, trips by "the magic power of steam" were the preferable ones: "I would say to all testy and irritable travelers, that the best way of keeping out of the *hot water* into which every cross accident plunges them, is to keep under the influence of steam."[15] For both practical and picturesque reasons, the Hudson became the major tourist route in America in the 1820s.

Beauty Spots

There were alternatives for the lover of picturesque nature who did not want to hurl himself incessantly through the landscape. As early as 1759 a group of Philadelphia ladies and gentlemen (thirty-two to be exact) had erected a small summer house on the Schuylkill River. "There are several pretty walks about it, and some wild and rugged rocks, which, together with the water and fine groves that adorn the banks, form a most beautiful and picturesque scene"[16]. All later writers concur on the beauty of the banks of the Schuylkill (Plate 139). At an early date, several cities developed suburbs appropriate for villas, which were documented by William Birch in his book of engravings of country seats.

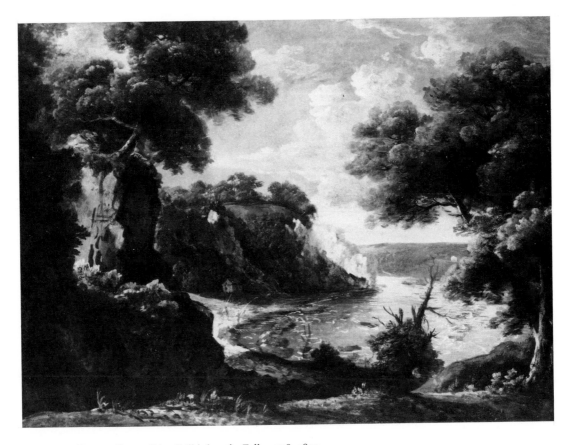

PLATE 139. GEORGE BECK, *Schuylkill below the Falls*, 1798–1804.

PLATE 140. BASIL HALL, *View from Mount Holyoke in Massachusetts*, 1829.

In some natural settings permanent shelter for the visitor was provided. In 1782 Sir Frederick Haldemand built a "Small Rotundo" over the falls of Montmorency in Quebec from which to enjoy the spectacle in comfort. Tea Island on Lake George had a summer house for tea parties as early as 1813. Mount Holyoke was crowned with a shelter in 1821, and by 1824 six to eight thousand tourists had climbed the summit.[17] It was from this shelter that Basil Hall sketched the Oxbow, the famous knotted bend in the Connecticut River, and described a thunderstorm engulfing the valley[18] (Plate 140), a viewpoint and scene which Thomas Cole repeated in 1836. The Catskill Mountain House turned an already popular site into the *ne plus ultra* of comfort in 1825.

Along even the most traveled business routes there were scenic features designated with enthusiastic comment in directories. The route between Boston and New York had a few waterfalls and some fine panoramas—Norwich Falls and the prospect from Mount Holyoke were the primary ones. In general the scenery of New England garnered the most praise for its similarity to England.[19] From New York to Philadelphia the landscape was less varied, but English tourists found the cultivated land picturesque and familiar. Sites for fine country seats were often pointed out. The major attraction immediately outside New York City was the Great Falls of the Passaic in New Jersey, (Plate 141) which attracted more comment and more visitors than any other American natural spectacle in the eighteenth century. As early as 1789 Jedidiah Morse recommended it as the suitable object of a pleasure trip.[20] For the architect Benjamin Latrobe, Passaic Falls,

> . . . *considering them in a picturesque point of view,* . . . *are to those of Niagara and Montmorency what a cabinet painting of the first merit, is to a painting of Raphael in the Vatican.* . . . *Everything indeed is upon a small scale, but nothing is wanting. A school of Landscape, established at Patterson would have within a mile*

around, all the Examples upon which to form, artists of the highest rank in their profession. . . .[21]

New York had a magnificent harbor and the Palisades, a line of high cliffs along the Hudson (Plates 142, 143). Philadelphia, while less spectacular, was graced with the more picturesque Schuylkill River.

Between Philadelphia and Baltimore (Plate 144) the scenic highlight was Havre de Grace and the reaches of the Delaware River. Baltimore, despite its wealth and degree of cultivation, seems never to have excited much comment, perhaps because tourists were eager to push on to Washington. Here the great possibilities of America were made explicit, beginning with the contrast between the wild present and the limitless future (Plates 145, 146). Unsympathetic tourists found the present laughable — a few houses and public buildings lost in the mud and trees. Washington's ambitions were mocked: "What was Goose Creek once is Tiber now."[22] But others found these imperial ambitions exhilarating. The scenery could even be savage: the rapids on the Potomac were dangerous, and farther upstream was Harpers Ferry, where the confluence of the Shenandoah and the Potomac (Plate 147), in Jefferson's famous description in *Notes on the State of Virginia*, gave evidence of one of nature's great cataclysms.

The Potomac was promoted by those who founded the city of Washington as the river which led to the heart of the continent, the key to the settlement and cultivation of the West (although the opening of the Erie Canal would shortly beat out all competition). After 1800, when the seat of government had been transferred, guides were reoriented so that all roads led to "Rome" — Washington — despite the fact that most roads actually led to New York or Philadelphia.[23] The city of Washington was also associated with the universally admired hero of the Revolution and the first president of the United States. While he still lived, Mount Vernon was a great attraction for Europeans (Plate 148). Later his tomb became a site of pilgrimage.

After 1820 routes for tourists were developed. The White Mountains, for example, praised in 1822 by Timothy Dwight, president of Yale College, were a major

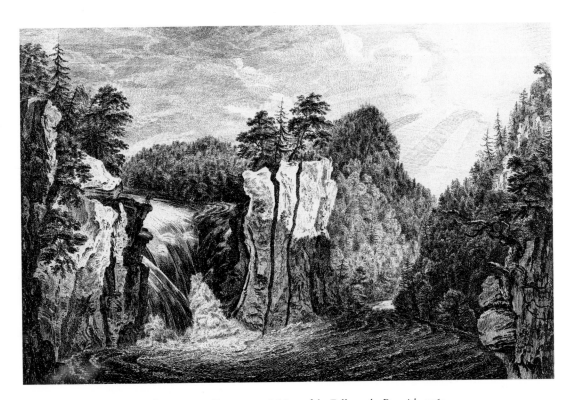

PLATE 141. PAUL SANDBY after THOMAS POWNALL, *A View of the Falls on the Passaick*, 1761.

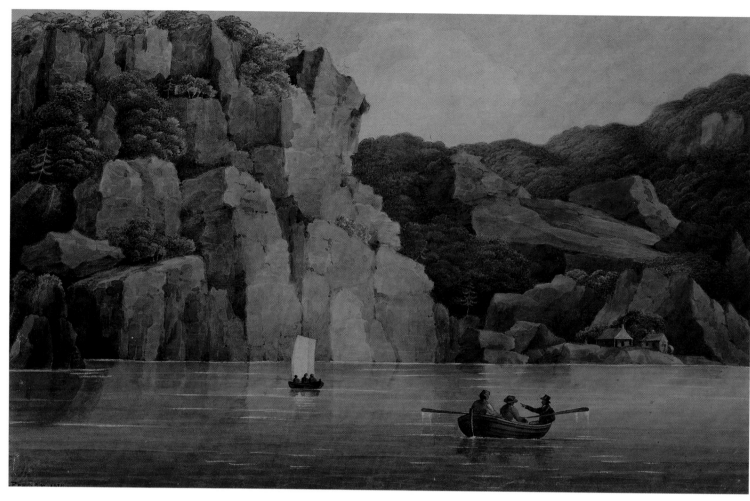

PLATE 142. CHARLES FRASER, *View of the Palisades*, 1818.

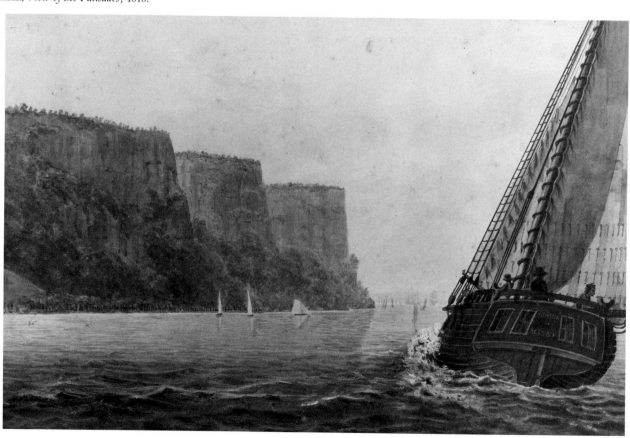

PLATE 143. PAVEL PETROVICH SVININ, *The Sailing Packet Mohawk of Albany Passing the Palisades of the Hudson River,* early nineteenth century.

PLATE 144. FRANCIS GUY, *View of the Bay from Mr. Gilmor's*, 1804.

PLATE 145. JOHN RUBENS SMITH, *View of Washington*, c. 1828.

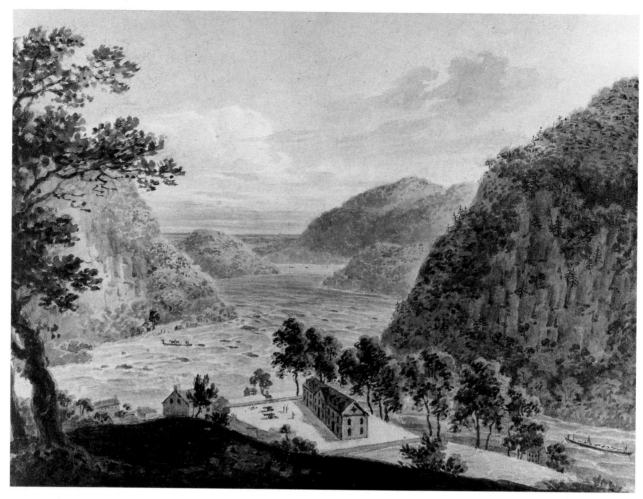

PLATE 147. WILLIAM ROBERTS, *Junction of the Potomac and Shenendoah, Virginia,* 1808.

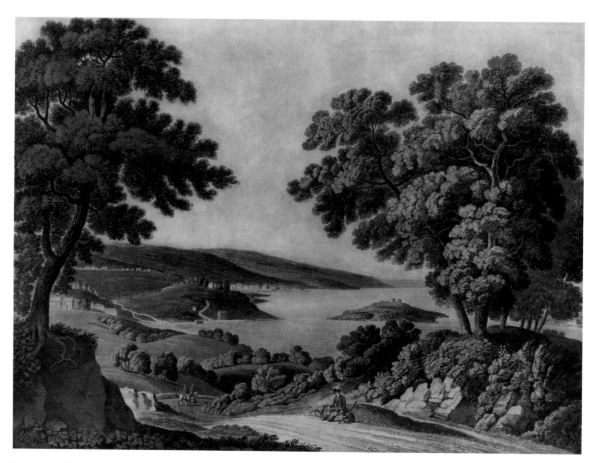

PLATE 146. GEORGE BECK, *Georgetown and Federal City, or City of Washington,* 1801.

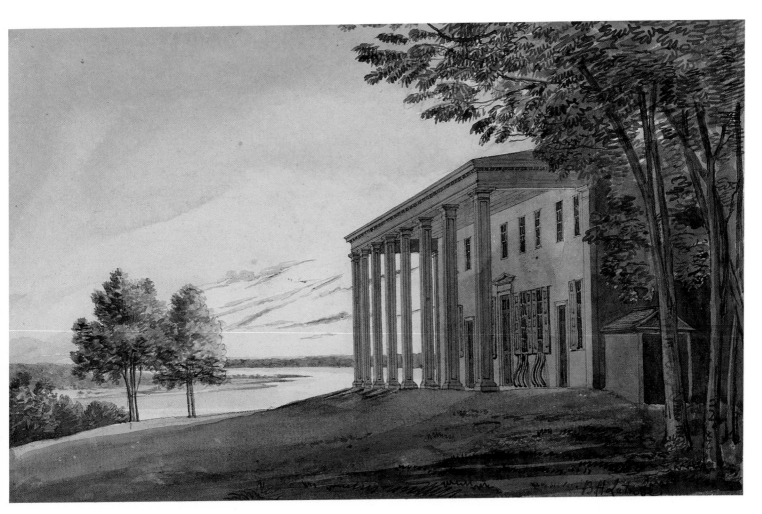

PLATE 148. Benjamin Henry Latrobe, *View of Mount Vernon Looking toward South West*, 1796.

attraction by 1827. In 1830 "the whole number of ladies who have ascended [Mount Washington] is said to be thirteen — enough to vindicate the claim of the sex to enterprise, liberal curiosity, and a taste for sublime scenery."[24] There were also places not on the major tourist routes yet still of interest such as the Ohio River and Natural Bridge in Virginia (Plate 149).

The Beauties of the Hudson River

The most important route was the Hudson River from New York City to Albany and the roads leading from Albany to Ballston Spa and Saratoga Springs, to Niagara, and to Canada through Lake George. These routes skillfully combined scenic and social attractions. By 1824 steamboats ran several times a day between New York and Albany. Averaging four dollars, the trip lasted twelve hours. From Albany, traveling along the Erie Canal, one managed about thirty miles a day, at four cents a mile. Stages for Saratoga left several times a day, while those for Montreal and Boston left three times a week; the cost to the Springs was about two dollars.

Scenically, the Hudson was unparalleled among American rivers. Proceeding along the Palisades, the traveler arrived at "the vast expanse of Tappan Bay, whose wide extended shores present a variety of delectable scenery." Here, surrounded by "the sober grandeur of nature," "the vast bosom of the Hudson was like an unruffled mirror, reflecting the golden splendour of the heavens." Then came the Highlands, a scene of "unrivalled beauty and magnificence," with West Point at its center, and beyond lay

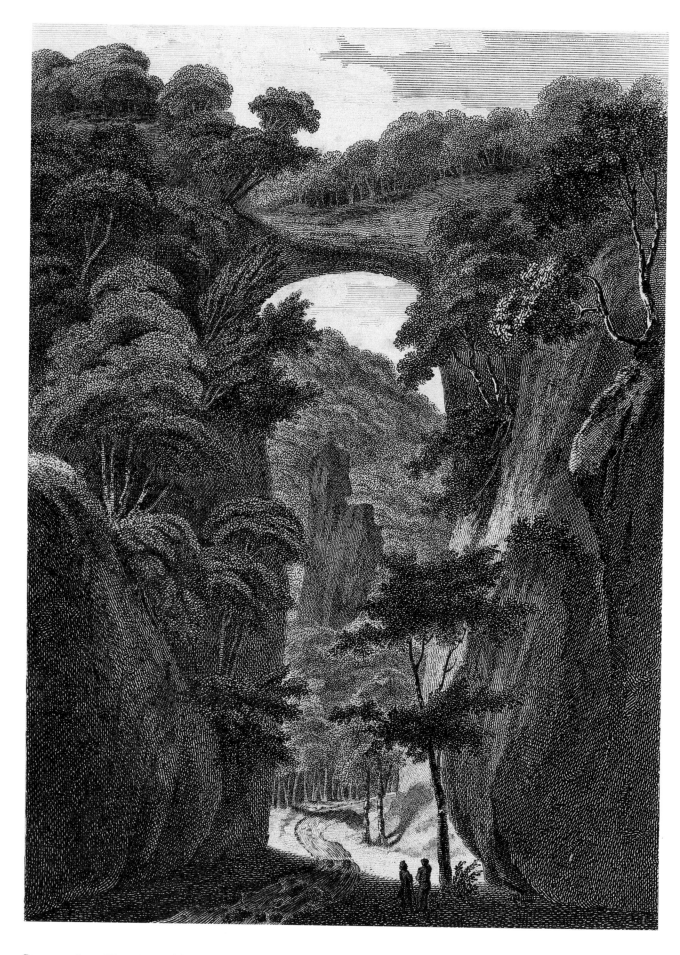

PLATE 149. ISAAC WELD, *View of the Rock Bridge,* from *Travels through the States of North America,* 1798.

the Catskills.[25] The landscape was rich in historical and literary associations from West Point to Sleepy Hollow. One tourist emoted as his steamboat passed under the shadow of the Highlands:

> *This was the land of romance to the early settlers: Indian tradition had named the highlands the prison within which Manetho confined the spirits rebellious to his power, until the mighty Hudson, rolling through the stupendous defiles of West Point, burst asunder their prison house; but they long lingered near the place of their captivity, and as the blasts howled through the valley, echo repeated their groans to the startled ear of the solitary hunter, who watched by his pine-tree fire for the approach of morning.[26]*

In the center of the Highlands was the Catskill Mountain House at Pine Orchard, where one could dine well and admire the view, making short excursions to Kaaterskill Falls and other scenes (see Plates 127, 128). But for the sybaritic tourist, the ultimate destination was the Springs. Many other areas had their spas, but these were pre-eminent, especially for southerners escaping their summers. Saratoga and Ballston Springs — some six miles apart — became the Bath of nineteenth-century America, where one might take the mineral waters for one's health and enjoy the invigorating company of a large crowd of socially acceptable people. The Springs were first discovered and built up in the late eighteenth century; by 1825 there were more than five hotels, several of them capable of holding two hundred guests each. Despite the fame of the spas, they were not particularly attractive. As the satirist James Kirke Paulding noted, "The first view of Ballston generally has the same effect upon visitors that matrimony is said to have upon young lovers."[27] English tourists complained of the commercial development of the site, which had entailed the hasty felling of the surrounding woods.

Nonetheless, there was plenty of scenic beauty within a day or two's ride, for those who desired it. Cohoes Falls and the Mohawk River were not far. And while the men might hunt and fish, "the ladies, too, will not find their time wasted by a visit to Lake George, about twenty-eight miles distant, where their pencil may be profitably employed in sketching the beautiful scenery that presents itself on every side, and the pen in description. On the road toward the lake are the Glen's Falls, which arrest the attention of the traveler in search of the picturesque."[28]

Traveling to Lake George and then to Montreal and Quebec, the tourist passed through the romantic scenery around Fort Ticonderoga. Not only had major engagements taken place here during the Revolution, this was also the site of the massacre of Jane McCrea by British-paid Indians as she went to meet her fiancé. Lake George itself was the one place in America that Basil Hall, a particularly supercilious English tourist, found more spectacular than the hyperbolic descriptions of it.[29] The islands of Lake George, especially those where fine quartz crystals might be found, were already "the resort of parties of pleasure" by 1813.[30]

Tourists might choose to visit Niagara instead of the Springs, particularly after the Erie Canal opened in the early 1820s. Niagara, long before it became generally accessible, was celebrated (Plates 150, 151). By 1820 it was already difficult to see the falls except through the screen of literature. John Howison's response is typical. After reeling under the majestic horror and apocalyptic thunder of the falls in his first close encounter, he examined Goat Island and found it a "terrestrial paradise." His references to the prismatic color of the falls deliberately recalled a passage from Lord Byron's *Childe Harold's Pilgrimage* quoted in the guide books.[31]

No successful tourist spot was without its exploitation and that of Niagara is particularly well documented. Francis Hall commented in 1816, "for Niagara I forsee in a few years travellers will find a finger post, 'To the fall's Tea Gardens,' with cakes and

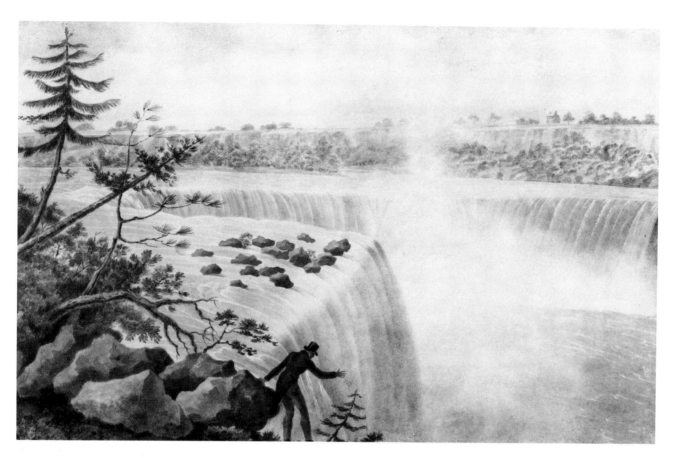

PLATE 150. CHARLES FRASER, *View of Niagara with Figure Leaning over Edge*, c. 1820.

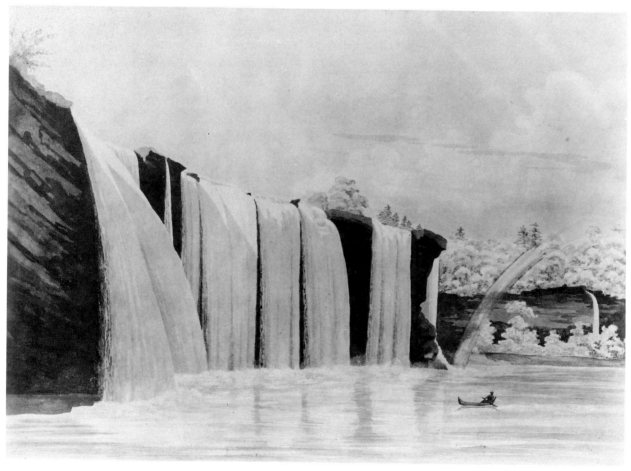

PLATE 152. WILLIAM CONSTABLE, *The Great Falls of the Genesee*, 1806.

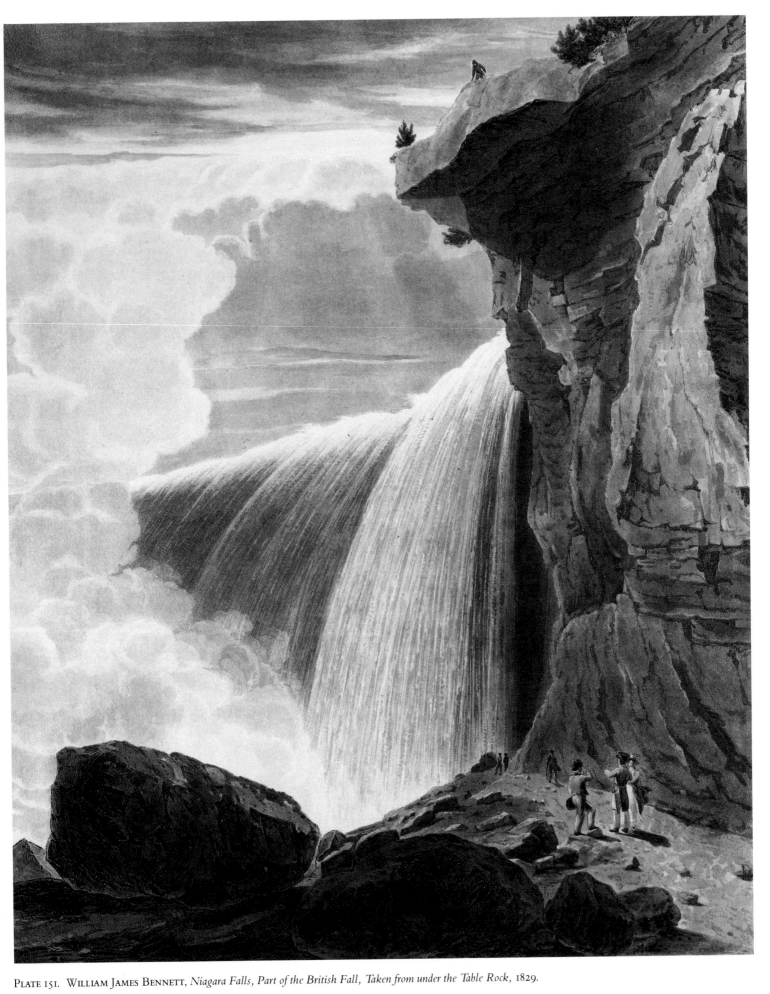

PLATE 151. WILLIAM JAMES BENNETT, *Niagara Falls, Part of the British Fall, Taken from under the Table Rock,* 1829.

refreshments, set out on the Table [Rock],"[32] a prophecy flawed in only one regard: a chunk of Table Rock slid into the river in 1819. Another traveler found a few years later that "the Genius of Poetry seems to have paid a visit" to Niagara Falls, with such names as Iris and Goat islands. This was the vulgar effect of the poetic utterances inspired by Niagara, Passaic, and other falls, which were often inscribed in guest books at the site.

The sensations which the waterfalls were supposed to evoke were sublimity and horror. To add to the frisson of terror, legends of unhappy victims of the mighty Niagara circulated — tales of noble Indians and inebriated sailors going over Niagara at regular intervals, and of similar occurrences at Cohoes and Passaic. Passaic was distinguised from the others by the demise of a clergyman's wife, a tragedy where the refined feelings of both victim and survivor might be exquisitely imagined. When imagination no longer sufficed, boats filled with animals were sent over the falls at Niagara in 1827 and 1829, a spectacle watched by thousands. A natural catastrophe — the avalanche at Crawford Notch in the White Mountains — appealed to the same tastes: "The number of visitors at the White Mountains has of late been considerably increased, on account of the interest excited by the tremendous slides or avalanches on the 20th of August 1826."[33]

The exploitation of these natural resources had its effects. Paulding sarcastically suggested that the falls near Catskill Mountain House could be turned on and off, with the right payment.[34] As the waterfalls were harnessed for power their picturesque qualities were destroyed. By 1791 Passaic Falls had become the site of manufacturing. Howison's complaint about the mills and iron foundries at Genesee Falls (Plate 152) is typical: they "neither harmonize well with the wildness of uncultivated nature, nor give any additional interest to a scene where they are so manifestly out of place."[35] The majority of these waterfalls — Genesee, Cohoes, and Passaic — have by now been either destroyed completely or, like Niagara, exist in an artificial state, turned on and off, as Paulding predicted, as desired.

Ravaging the Land

The disrespect for the land which could be seen at the Springs (Plate 153) and the waterfalls seemed endemic in America, as foreigners often complained. An unspoiled area elicited comment. Francis Hall, for example, remarked about Chaudière Falls in Quebec: "the stately woods have never bowed before the ravage of improvement, nor has the stream been tortured, and diverted from its channel, for the supply of grist and saw mills. The freshness of nature is in every sight and sound, and cold must be the heart that feels not a momentary glow, while thus standing in the presence of her wildest loveliness."[36]

Hall's experience was a dilemma shared by every picturesque traveler. On one hand, cultivation was an essential element of contrast in a picturesque landscape; on the other, the process by which the wilderness was brought under control in America was ugly and destructive. Timothy Dwight, president of Yale College, went so far in his travel accounts as to leave out "all these imperfections" and was instead "transported in imagination" to a future when the right balance would be achieved.[37] What struck foreigners forcefully was the wastefully maintained farm land and the wanton destruction of trees, "the unpicturesque appearance of the angular fences, and of the stiff wooden houses. . . . The stumps of the trees also, on land newly cleared, are most disagreeable objects, wherewith the eye is continually assailed."[38]

Perhaps it was the fecundity of the land that caused North Americans either to ignore trees or to hate them. Riding through wild scenery, Isaac Weld remarks smugly:

PLATE 153. WILLIAM STRICKLAND, *Ballston Springs, New York*, c. 1794.

"The generality of Americans stare with astonishment at a person who can feel any delight at passing through such a country as this. . . . They have an unconquerable aversion to trees . . . the fact of the matter is, that from the face of the country being entirely overspread with trees, the eyes of the people become satiated with the sight of them. . . . they are looked upon as a nuisance."[39] But, as Howison writes:

> *There is no difficulty in explaining the cause of the aversion with which the Canadians regard trees. Their earliest labour is that of chopping them down; they present on every side an obstacle to the improvement of their farms . . . What would be the conceptions of an uninformed Canadian, were he told, that the Agricultural Society in England give a reward, annually, to the person who plants the greatest number of trees?*[40]

It was "the sublimity of real forest" which moved the foreign tourist most, those "mountains clothed with lofty trees [which] form a striking feature in American scenery, in comparison to the bleak and naked hills of Scotland."[41]

But some found little appeal in wilderness. From the top of Mount Holyoke, Basil Hall wrote; "As many of the hills and dales in this pleasing prospect had long been cleared of woods, the eye was not offended by that ragged appearance, so comfortless and hopeless-looking in most newly settled countries."[42] Hall's taste is clearly for the art of the well-tended English park. Others, never experiencing wild forest, commented unfavorably on the second-growth trees they saw: "Although the *masses* of wood are large and grand, yet the *trees* fell much short of my expectations . . . they certainly appear slender and feeble to an Englishman, who has visited the park and forest scenery of his own country."[43]

205

The aesthetic discomfort felt by British writers such as Hall was also a political one, an uneasiness brought about by the sight of so much unclaimed land. One American reviewer's comments underline this connection. Criticizing Hall's prejudice and fault-finding, he wonders how, "amidst all these scenes" of natural magnificence, "the only reflection which escapes from Captain Hall is a denunciation of the 'blighting tempest of democracy,' for having done away with *Primogeniture* and *Entails*." Then he juxtaposes Hall's hysterical attack on "*Improvement*": "An American settler can hardly conceive the horror with which a foreigner beholds such numbers of magnificent trees standing around him, with their throats cut, the very Banquos of the murdered forest."[44] The improvements of English parks — stands of oaks patiently tended over generations before they reach maturity — are predicated on and protected by entail. Hall's horror was prompted by a prodigality of nature which did not need to be managed through inheritance.

Because of the basic rootlessness of Americans, even cultivation did not denote settlement and a sense of identification with the land. After a long description of a farm, one Englishman concluded: "Comfortable as it is, McAllister, like almost all the Americans whom I have seen or heard of, having improved the land he occupies, is not so attached to the spot as to be unwilling to remove to the wilderness of the back country, to see a new creation of the same kind form around him, the produce of his own exertions."[45]

Not just the abundance, but the vastness of the land and its newness stunned the imagination. Henry Wansey wrote: "This was the sentiment that generally struck me most forcibly, as I traveled through the states — the appearance everywhere of a vast outline with much to fill up."[46] How could Americans love something that had no names, no associations? As one traveler complained of the Hudson:

> It is unfortunate for the description of this river, that so few of the mountains and particular headlands have distinct and appropriate names, by which we could designate them. Where a fine promontory presents itself, you apply in vain the sailor for its name: all he can tell you is, that it is some head, point or hook, an old Dutch name for a cape; and it is thus impossible to point out exactly to another traveler the objects that have attracted our notice.[47]

John Duncan writes gratefully that the associations of the regicides with East Rock and West Rock in New Haven "impart to them that traditional charm which is so often wanting in American scenery."[48] But others found the newness refreshing: "What other land is there, which tells only of improvement, or points not the imagination back to better days."[49]

A Tour to Lake George

The task of the picturesque tourist was to fill out this "vast outline" that was America. One of the most complete accounts of a picturesque tour by an American is that of Benjamin Silliman, the professor of chemistry and natural history at Yale. Building on a description of the geology of the landscape, which he sees as the permanent foundation of scenery and the character of peoples, Silliman ranges from historical comment to picturesque rhapsody. Enunciating a truth felt by most Americans, Silliman writes: "National character often receives its peculiar cast from natural scenery. . . . Thus, natural scenery is intimately connected with taste, moral feeling, utility and instruction."[50] The effective start of the tour is an ecstatic description (with engraved views), of Daniel Wadsworth's country estate Monte Video (Fig. 56). Here, where the landscape is turned into an artistic creation, it is possible to view both the actual landscape,

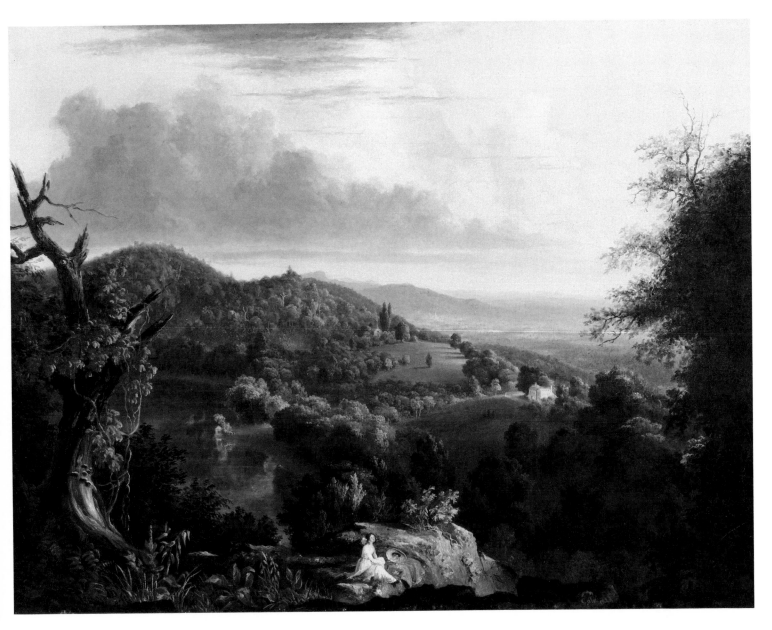

Fig. 56. Thomas Cole, *View of Monte Video, the Seat of Daniel Wadsworth, Esq.*, 1828. Oil on panel. Wadsworth Atheneum, Hartford; bequest of Daniel Wadsworth.

"the whole of this magnificent picture," and a mental landscape of cultivated America, one constructed in Silliman's mind.

The natural rocks he encounters he turns into ruins: "Most of the ridges are parallel, and it is when travelling at their feet, that one is most forcibly struck with their castellated appearance . . . often singularly picturesque and wild, with their lofty impending cliffs, and with their fallen ruins." He complains of New Lebanon: "Had this remarkable place been situated in Europe, tourists would have pronounced its panegyric, and poets would have made it famous, as Windsor or Richmond Hill, or as the little Isle in Loch Katrin."[51]

Silliman's geological knowledge combined with his sense of history can produce fresh expressions of the picturesque mode. Perhaps the best is his description of Lake George, at the head of the "classical ground" surrounding Fort Ticonderoga. Standing on the balcony of the inn, he is able to see the lake on the first clear morning of the tour.

The morning came on with rapid progress; but the woody sides of the high mountains, that form the eastern barrier, were still obscured, by the lingering shadows

of night, although, on their tops, the dawn was now fully disclosed, and their outline,
by contrast with their dark sides, was rendered beautifully distinct; while, their
reversed images, perfectly reflected from the most exquisite of all mirrors, presented
mountains pendent in the deep, . . . the vapour on the lake . . . began to form itself
into winrows, and clouds and castles, and to recede from the water. . . . Opposite to us,
in the direction towards the rising sun, was a . . . notch, lower than the general ridge
of the mountains, . . . Precisely through this place, were poured upon us the first rays,
which darted down, as if in lines of burnished gold, diverging and distinct, as in a
diagram; the ridge of the eastern mountains, was fringed with fire, for many a mile;
the numerous islands, so elegantly sprinkled through the lake, and which recently
appeared and disappeared, through the rolling clouds of mist, now received the direct
rays of the sun, and formed so many gilded gardens; at last came the sun, "rejoicing in
his strength," . . . it seemed, when the full orb was disclosed, as if he looked down
with complacency, into one of the most beautiful spots in this lower world. [52]

Silliman's description constructs this Edenic vision so that his readers may see it
as a painting. But he has also built the scene on substantial underpinnings: a full
description of the geology of Lake George, an account of the heroic events of the
Revolution, and a discussion of the amenities of the neighborhood. As the author of a
gazetteer of New York State put it, after a similarly picturesque description of Cohoes
Falls: "All combine to fix attention, while fancy and imagination instinctively take a
wild flight."[53]

A Free Country

For Americans the wild flight of the imagination was not merely poetic fiction but
characteristic of the fundamental fact of American life — freedom. The land itself was
the objectification of this freedom — limitless, fertile, new — and to travel in it was to
assimilate liberty into oneself. Travel accounts are full of this awareness. The very
ownership of the land conditioned the experience of travel. The tourist could leave the
beaten track and strike out across the country whenever he wished, for even "im-
proved" farmland was not private:

A person taking a walk in the country, who may feel inclined to eat an apple, makes
little scruple of going over a fence, and helping himself, but there are few who carry
this point of equality to a very great length; at least, it is considered rather ill-bred to go
into a man's orchard near to his own house. You may look long enough around you
before you espy a board warning you that man-traps and spring-guns are set or
threatening you with a prosecution for trespassing. [54]

Travel in America was a liberating act, a political expression of freedom of movement;
in Europe travel generally confirmed the old order, or if natural scenery were sought,
heightened the contrast between natural impulse and manmade regulation.[55]

Even the aesthetic appreciation by the British of the American landscape in pic-
turesque terms might be held equivalent to a political domination of the landscape —
the picturesque landscape is, after all, peculiarly English.[56] The matching of English to
American landscape could serve several related purposes. Henry Wansey, like many
other Englishmen, is straightforward in his prejudices. He felt that "of all the states
through which I have travelled, I prefer, as an Englishman, Connecticut," the very state
he found most picturesque and the one which reminded him most of home.[57] But
when Strickland compares the Mohawk River near Cohoes Falls to the Thames be-
tween Henley and Marlow, he seems to be trying to balance the claims of America
against English prejudices:

Certainly the similarity of the two countries is strikingly great, though the features of this are on a larger scale, the want of the numerous gentleman's houses which ornament the former, take off the beauty of the scene, but as several neatly constructed and well situated farms are scattered about, the want of the more magnificent houses are less perceptible in the effect of the general scenery. Were the latter here, the resemblance would be perfect. [58]

Others use the comparison with England in a critical way. Weld, after disputing the accuracy of Jefferson's description of Harpers Ferry, adds: "To find numberless scenes more stupendous, it would be needless to go farther than Wales."[59]

Conclusion: A Summer Tour

Picturesque description, then, while it may have been conventional, was not limited. Picturesque taste provided not only a motive for travel in the late eighteenth and early nineteenth centuries but also a context in which to see the American landscape and a language with which to read it. The range of associations felt and the objects observed was a broad one. The reactions of picturesque travelers both parallel and prefigure much that occurred in American landscape painting. The picturesque tour conditioned both artists and audiences, creating the landscapes which were to be enjoyed for over a century.

The anonymous author of *A Summer Month; or, Recollections of a Visit to the Falls of Niagara, and the Lakes,* published in Philadelphia in 1823, sums up the meaning of the picturesque tour most completely. The author gives his reasons for traveling, no better or worse than any others: "Having a leisure month before me, and growing impatient of the confinement of a large and populous city, I thought I had a *moment to seize*; for the improvement of health; the enjoyment of a survey of the beauties and sublimities of nature, and the diversities of character which present themselves to a traveller." Setting off from New York with two friends, he left "on the 30th of July, 1822, at 4 P.M. in the steam-boat, for Albany." After surveying Niagara, he traveled up to Montreal and then, as autumn gathered in, prepared to return home. "Few excursions, during the summer season, are productive of more benefit or rational amusement, than the one which has been the subject of the within descriptions," he concludes. "All the varieties of travelling, peculiar to our western country, are experienced in a great degree;—internal improvements of every description are going on;—and an interesting diversity of scenery is presented to view among the lesser lakes."[60] On his return to Philadelphia, his mind and spirit are enlarged:

Consider this place, when Penn first planted his infant colony on the shores of the Delaware: and what it now is. Compare the beauteous scenery and deep verdure, which now line those shores, once covered by an unbroken range of wilderness, which plow nor axe had ever pierced. Then behold the encroachments of cultivation, the birth of settlements, the growth of towns, together with the unvaried increase of population, throughout our western country: and we are led in wonder to exclaim; this is a land of enchantment, this is my home and my country! [61]

Notes

1. This essay concentrates on British accounts, not only because of their quantity and accessibility to contemporary American artists and authors, but also because the conventions of picturesque description are most highly developed in them. E.g., Andrew Burnaby's *Travels through the Middle Settlements in North America, in the years 1759 and 1760* (London, 1775; reprint, New York: A. Wessels, 1904) is richly picturesque, while J. Milbert's *Voyage pittoresque du fleuve Hudson* (Paris, 1829) is barren in comparison. Two relevant surveys are Jane Mesick, *The English Traveller in America 1785–1835* (New York: Columbia University Press, 1922), and Caroline Robbins, "The Rage for Going to America," *Pennsylvania History* 28 (July 1961): 231–253.

2. "Picturesque travelers" are described in "Travel," *Port Folio* 4 (August 8, 1807): 81–87. The quotation is from *The Drowziad*, by a Dozer (Charleston, 1829), p. 3.

3. These principles are derived from William Gilpin, "On Picturesque Travel," *Three Essays. . .* (2nd ed., London, 1794), p. 42.

4. These examples of contrasts are from William Strickland, *Journal of a Tour in the United States of America 1794–1795*, ed. J. E. Strickland (New York: New-York Historical Society, 1971), p. 98, and Isaac Weld Jr., *Travels through the States of North America, and the Provinces of Upper and Lower Canada, During the Years 1795, 1796, and 1797* (London, 1807; reprint, New York: Johnson Reprint, 1968), Vol II, p. 53.

5. Francis Baily, *Journal of a Tour in Unsettled Parts of North America in 1796 and 1797*, ed. Jack D. L. Holmes (Carbondale: Southern Illinois University Press, 1969), p. 31.

6. See Yi-Fu Tuan, "Thought and Landscape," in *The Interpretation of Ordinary Landscapes*, ed. D. W. Meinig (Oxford: Oxford University Press, 1979); and John Dixon Hunt, "Ut pictura poesis, ut pictura hortus, and the picturesque," *Word and Image* 1 (January–March 1985): 107.

7. To name just a few travelers who both sketched and wrote: Benjamin Latrobe, Charles Fraser, Isaac Weld, George Heriot, Basil Hall, William Strickland, Francis Hall. Robert Gilmor, who patronized Thomas Doughty and Thomas Cole, toured the East Coast in 1797, keeping a journal and sketching the scenery. "Memorandums Made in a Tour to the Eastern States in the Year 1797," *Bulletin of the Boston Public Library* N.S. 3 (April 1892): 72–92.

8. See, e.g., the sketchbook of "H.S." in the New-York Historical Society.

9. John Howison, *Sketches of Upper Canada. Domestic, Local and Characteristic . . .* (2nd ed., Edinburgh, 1822), p. 64.

10. A guidebook to Mount Holyoke was first published around 1825; see Martha Hopper, *Arcadian Vales: Views of the Connecticut River Valley* (Mount Holyoke: George Walter Vincent Smith Art Museum, 1982), p. 94. Other guides: Gideon Miner Davison, *The Fashionable Tour; An Excursion to the Springs, Niagara, Quebec and through the New England States* (Saratoga Springs, 1822); the eighth edition was translated into French in 1840.

11. *A Summer Month; or, Recollections of a Visit to the Falls of Niagara, and the Lakes* (Philadelphia: H.C. Carey and I. Lea, 1823), pp. 240–241.

12. J. P. Brissot, *New Travels in the United States of America* (New York, 1792), p. 80; *Henry Wansey and His American Journal 1794*, ed. David John Jeremy (Philadelphia: American Philosophical Society, 1970), p. 126.

13. Davison, *The Fashionable Tour* (3rd ed., Saratoga Springs, 1828), p. 115.

14. John M. Duncan, *Travels through Part of the United States and Canada in 1818 and 1819* (Glasgow, 1823), Vol. II, p. 314. Howison agreed (*Sketches of Upper Canada*, p. 318).

15. Howison, *Sketches of Upper Canada*, p. 64.

16. Burnaby, *Travels*, p. 97.

17. Hopper, *Arcadian Vales*, pp. 14, 94.

18. Basil Hall, *Travels*, Vol. II, p. 99.

19. In his comparisons with England, Henry Wansey is both specific and prolix: e.g., "We had, near Middleton [Connecticut], a fine view of the Connecticut River, very similar to the view between Bremerton and Wilton, looking towards Lord Pembroke's Park." *Henry Wansey*, p. 69.

20. Jedediah Morse, *The American Geography* (Elizabeth Town, N.J.: Shephard Kollock, 1789), p. 283. Morse also provides an extended description of Norwich Falls (p. 213).

21. Benjamin Latrobe, Sketchbook V 25a, reproduced in *Latrobe's View of America, 1795–1820* (New Haven: Yale University Press, 1985), pp. 167–168.

22. Thomas Moore, "To Thomas Hume, Esq. M.D., from the City of Washington," *The Poetical Works of Thomas Moore* (London, 1853), Vol. II, p. 296. Tiber Creek, which once flowed along Constitution Avenue, was filled in during this century.

23. John Melish, *The Traveller's Directory through the United States* (Philadelphia, 1825). The first edition of 1815 is not oriented on Washington. The 1825 edition also adds lists of picturesque tours (e.g., Albany to Lebanon Springs, "one of the most picturesque and delightful tours in the United States," p. 187).

24. Davison, *The Fashionable Tour*, 3rd ed., p. 235; Timothy Dwight, *Travels in New England and New York* (1821; reprint, ed. Barbara Miller Solomon, Cambridge, Mass: Harvard University Press, 1969), Vol. II, Letter XIV.

25. Washington Irving, quoted by Henry Dilwood Gilpin, *A Northern Tour: Being a Guide to Saratoga, Lake George, Niagara, Canada, Boston, etc.* (Philadelphia: H.C. Carey and I. Lea, 1825), pp. 17–18. See also pp. 23–44.

26. Francis Hall, *Travels in Canada and the U.S. in 1816 and 1817* (2nd ed., London, 1819), p. 24.

27. James Kirke Paulding, *The New Mirror for Travellers and Guide to the Springs* (New York, 1828), p. 218.

28. Joshua Shaw, *U.S. Directory for the Use of Travellers and Merchants, Giving an Account of the Principal Establishments, of Business and Pleasure, throughout the Union* (Philadelphia: J. Maxwell, 1822), pp. 141–142.

29. Basil Hall, *Travels*, Vol. II, p. 3.

30. H. G. Spafford, *A Pocket Guide for the Tourist and Traveller along the Line of the Canals, and the Interior Commerce of the State of New York* (New York: T. and J. Swords, 1824), pp. 16, 146.

31. Howison, *Sketches of Upper Canada*, p. 116-119. Byron is quoted by Theodore Dwight, *The Northern Traveller* (New York: Wilder and Campbell, 1825), p. 148.

32. F. Hall, *Travels in Canada*, p. 183.

33. Davison, *The Fashionable Tour*, p. 284.

34. Paulding, *The New Mirror for Travellers*, p. 143.

35. Howison, *Sketches of Upper Canada*, p. 300. Already by 1760 Burnaby was complaining that the falls on the Pawtucket River had been ruined by mills (*Travels*, p. 131).

36. F. Hall, *Travels in Canada*, p. 121.

37. Timothy Dwight, *Travels in New England*, Vol. II, pp. 94-95, Letter XII. Thomas Cole concludes his "Essay on Landscape Scenery" on the same dilemma.

38. Weld, *Travels*, p. 232. The practice of girdling trees and leaving stumps in the ground, as well as the predominance of wooden fences and the lack of hedgerows is something commented on by nearly all visitors. It was taken both as evidence of the fundamental laziness of American farmers and as an aesthetic issue. See, e.g., Thomas Cooper, *Some Information Respecting America* (2nd ed., London 1795), p. 51, and William Cobbett, *A Year's Residence in the United States of America* (1819; reprint, ed. J. E. Morpurgo, Carbondale: Southern Illinois University Press, 1964), p. 23.

39. Weld, *Travels*, pp. 39-40.

40. Howison, *Sketches of Upper Canada*, p. 29.

41. Peter Neilson, *Recollections of a Six Years Residence in the U.S.A.* (Glasgow, 1830), p. 92, and Howison, *Sketches of Upper Canada*, pp. 27-28. See also Talleyrand, quoted by Seymour Dunbar, *A History of Travel in America* (1915; reprint, New York: Tudor Publishing, 1937), p. 316.

42. B. Hall, *Travels*, Vol. I, p. 95.

43. Cooper, *Some Information*, p. 104. In several of his descriptions, Weld does not realize that what he is seeing is not virgin forest; e.g., *Travels*, p. 280.

44. [Richard Biddle], *Captain Hall in America, by an American* (Philadelphia, 1830), p. 98.

45. Cooper, *Some Information*, p. 135.

46. *Henry Wansey*, p. 137.

47. H. Gilpin, *A Northern Tour*, p. 35.

48. Duncan, *Travels*, Vol. I, pp. 95-96. Henry Gilpin leavens his guidebook with quotations from Washington Irving, "who imparts a classic feeling to every scene he has described," and James Fenimore Cooper (*A Northern Tour*, pp. 17, 41).

49. *A Summer Month*, pp. 242-243.

50. Benjamin Silliman, *Remarks Made on a Short Tour between Hartford and Quebec in the Autumn of 1819* (2nd ed., New Haven: S. Converse, 1824 [1820]), p. 18.

51. *Ibid.*, pp. 23, 26, 51.

52. *Ibid.*, pp. 145-152.

53. H. G. Spafford, *A Gazetteer of the State of New York* (Albany: Southwark, 1813), p. 170.

54. Neilson, *Recollections*, p. 175. Silliman, in an implicit criticism of the English social system, notes that the trees he sees from Richmond Hill, the royal park on the south side of the Thames in London, are all "in the numerous parks and pleasure grounds attached to the palaces." *A Journal of Travels in England, Holland and Scotland* (3rd ed., New Haven, 1820), Vol. II, pp. 86-87.

55. "In vain does the imagination try to roam at large midst [Europe's] cultivated plains." Chateaubriand, quoted by Roderick Nash, *Wilderness and the American Mind* (New Haven: Yale University Press, 1982), p. 49.

56. See I. S. MacLaren, "The Limits of the Picturesque in British North America," *Journal of Garden History* 1, No. 5 (1985): 98.

57. *Henry Wansey*, p. 147.

58. Strickland, *Journal of a Tour*, p. 132.

59. Weld, *Travels*, p. 244.

60. *A Summer Month*, pp. 2, 4, 145.

61. *Ibid.*, pp. 238-239.

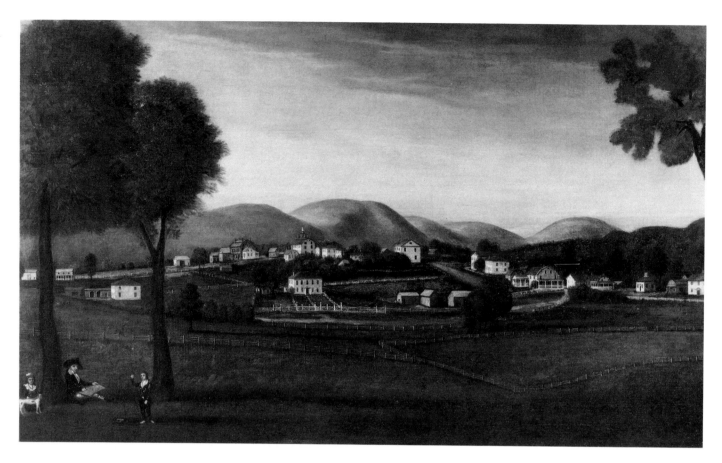

Plate 154. Ralph Earl, *A View of Bennington*, 1798.

JOHN R. STILGOE

Smiling Scenes

NINE YEARS AFTER HIS FIRST VISIT TO LAKE GEORGE, Timothy Dwight returned. The president of Yale College, theologian, and determined observer of landscape found the environs of the lake much improved in 1811, indeed so much so that he did not wait out the stormy weather that prevented his boating about in search of fine views. The most casual glance told him that wilderness magnificence had evolved into moral beauty.

On his earlier trip in 1802 Dwight detailed the spectacular scenery of Lake George, well aware that readers of his projected "Travels in New England and New York" would expect lengthy description of this scenic wonder about which the young republic might justifiably boast. "Lake George is universally considered as being in itself and in its environs the most beautiful object of the same nature in the United States," he wrote; it was so magnificent that even some European visitors who had seen the "celebrated waters of Switzerland, have given it the preference."[1]

By way of preface to several pages of methodical description, he explained: "The scenery of this spot may be advantageously considered under the following heads, the water, the islands, the shore, and the mountains." The water, of "singular salubrity, sweetness, and elegance," frequently rewards the observer with "a gay, luminous azure," forming a sort of ground on which the islands, "fancifully computed at 365," show "unceasing variety, and with the happiest conceivable relations." Some forested with pine, others with beech, maple, and oak, still others merely naked rocks, the islands in their "exquisite and diversified beauty" complement the shore, where beauty originates in juxtapositions of rock and forest and beaches of "light colored sand." Around water, islands, and shore loom the mountains, sometimes "bald, solemn, and forbidding," sometimes "tufted with lofty trees," now and then "naked, wild, and solitary," always rewarding the observer with a prospect of the "magnificent hand of nature." But more than atomistic cataloguing informs his appreciation; Dwight understood not only the necessity of viewing the lake from several vantage points and of observing the environs from a boat sailing about the water, but also the absolute need of scrutinizing the play of light across the scene.

"Unceasing variegations of light and shade" entrance him, for on Lake George they are "not only far more diversified, but are much more obvious, intense, and glowing than in smooth, open countries." Clouds, shadows, "the changes of the day" in short engage the eye "with emotions approximating to rapture." On September 30, Dwight remarks, "a little before the setting of the sun, I saw one of the mountains on

213

the east arrayed in the most brilliant purple which can be imagined. Nothing could surpass the luster which overspread this magnificent object, and which was varied through innumerable tints and softenings of that gorgeous color." Surely Europe offered nothing finer.

Suffusing his lengthy description, although so subtly that his geographical and aesthetic terminology frequently overwhelms it, glows the energy of mated religion and patriotism, the energy that illuminated the early national vision of landscape. As Dwight points out, the Lake George region witnessed stirring events in the War of Independence, including the battle of Ticonderoga: in the glorious scenery there occurred glorious events which presaged a glorious future. Implicit in his paragraphs flows an awareness of Lake George as Edenic stage on which a chosen people will shape a light-enlivened landscape. "The road for the three or four last miles passes through a forest, and conceals the lake from the view of the traveler until he arrives at the eminence on which Fort George was built," he muses. "Here is opened at once a prospect, the splendor of which is rarely exceeded." Out of the darkness, out of the forest of bewilderment and struggle, the republican emerges into the promised land ripe for improvement, a land washed in the light of Protestantism, ordered liberty, and the sun.

Sunlight acquires importance, not only in making mountains purple, but in making possible husbandry, the noble occupation of democracy. Lake George, Dwight insists in his description of 1802, is not finished; its shores lack farms. "To complete the scenery of this lake, the efforts of cultivation are obviously wanting," he concludes. "The hand of the husbandman has already begun to clear these grounds, and will, at no great distance of time, adorn them with all the smiling scenes of agriculture." Only then will the promised land become the landscape of promise, the landscape of Ralph Earl's Bennington or of Jonathan Fisher's Blue Hill (Plates 154, 155).

So quickly did the hand move that even Dwight stood surprised nine years later. Perhaps the change confused him a little; in approaching the lake he missed a turn and

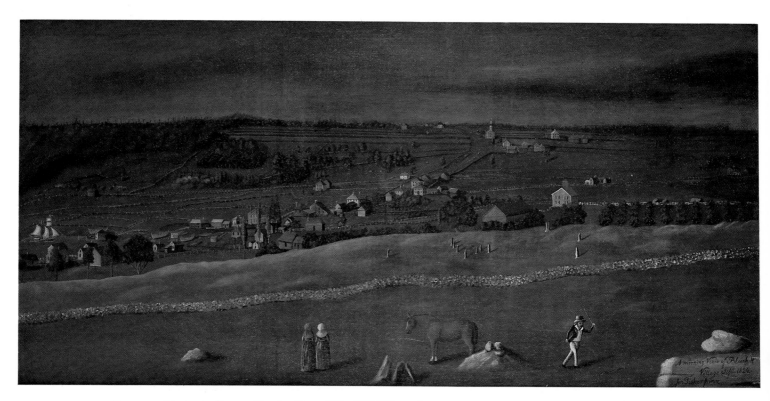

PLATE 155. JONATHAN FISHER, *Morning View of Blue Hill Village,* 1824.

SMILING SCENES

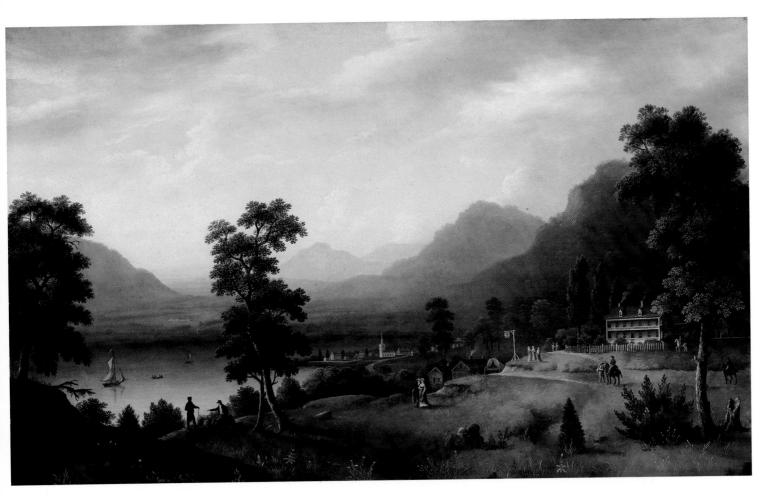

PLATE 156. FRANCIS GUY, *Carter's Tavern at the Head of Lake George*, 1817–1820.

quickly got lost, but not in dense forest. The wrong road ran "bordered for several miles by a succession of good farms, the appearance of which, and of the houses which were upon them, sufficiently indicated the easy, prosperous state of the inhabitants." The road ended at "a beautiful village, exhibiting, with a brilliancy almost singular," the "neat and even handsome houses" and other "elegancies" of art which so improve the "majesty of nature," elegancies remarked — together with topographical contour and light-suffused atmosphere — a few years later by Francis Guy in *Carter's Tavern at the Head of Lake George* (Plate 156). Around the improved lake Dwight discovered what he again termed the "smiling scenes of agriculture," the perfect synthesis of farming, village life, and natural grandeur, all washed in the light of divine liberty.

Inclosure

"The hunter, wherever found, is a savage — the herdsman, in every age, a barbarian; but the planter and the farmer are civilized and social beings," William Plumer assured his audience at an 1821 New Hampshire agricultural society assembly.[2] "Permanent wealth, like that in lands, can neither be obtained, nor enjoyed by any people till the habit of regular industry is formed and established among them; and this habit no-where exists till man begins to cultivate the earth." A decade after Dwight's second visit to Lake George, Plumer told the farm families what they wanted to hear, what they already knew, and what they were just beginning to doubt. Traditional farming lay at the base of all private and public virtue and happiness.

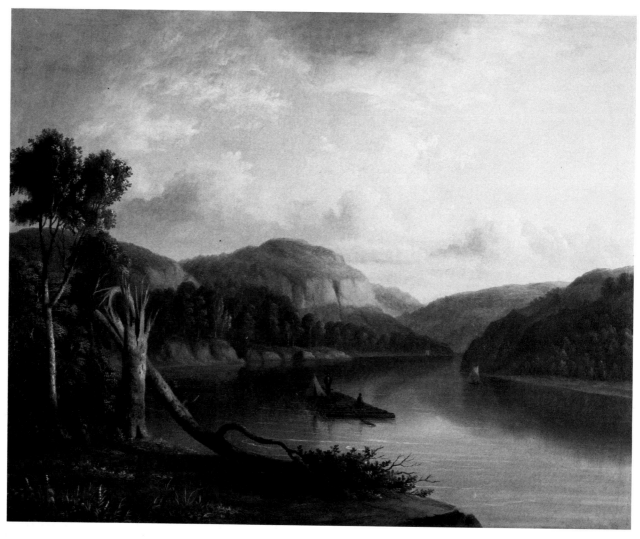

PLATE 157. RALPH E. W. EARL, *Cumberland River*, 1823.

Plumer spent little time on philosophy, however pleasantly his listeners accepted it. Instead he moved immediately to explicating and recommending the latest farming techniques, particularly deep plowing, crop rotation, and, perhaps most important, manuring. Plumer addressed farmers tending long-established farms, and he understood — if they did not — the awesome importance of keeping land "in good heart" by adding to it "the ordinary supplies of the barnyard," along with leaves and other organic material from woodlots and swamps. "Into these neglected nooks, and dark recesses of his farm, the industrious husbandman ought to dig as for mines of gold." The nooks and recesses, "if rightly improved, will furnish him with the means of restoring vigour to his exhausted lands, of preserving those that are still unimpaired, and enable him, by the aid of drains, to convert his useless wastes into fertile fields." A "new era" mandated change; no longer could farmers excuse slovenly agriculture by claiming the exigencies of pioneering.[3]

Everywhere in the eastern portions of the new nation reformers championed the causes of agricultural improvement. "Let us boldly face the fact," announced the Virginian John Taylor. "Our country is nearly ruined. We have certainly drawn out of the earth three-fourths of the vegetable matter it contained, within reach of the plough." In *Arator: Being a Series of Agricultural Essays, Practical and Political*, Taylor fastened on soil exhaustion as a potential, indeed probable, catastrophe for all southern planters. He advocated not only manuring fields but "inclosing" livestock in temporary pens set on impoverished soil and moved to a new location every week or so. Two hundred

cattle and sheep "will in this way manure eighteen acres annually, sufficiently to produce fine crops of Indian corn and wheat, and a good growth of red clover after them," Taylor claimed, implicitly acknowledging that Virginia soil lay exhausted indeed.[4]

Plumer, Taylor, and a host of other early-nineteenth-century reformers followed the mid-eighteenth-century precedent set by Jared Eliot, a New England clergyman whose *Essays upon Field Husbandry* used scriptural authority to buttress common-sense pleas for soil improvement.[5] For roughly a century after 1750 reformers urged upon farmers the gospel of stewardship, of perpetually maintaining tilth and fertility; but in the second decade of the nineteenth century their arguments changed, albeit subtly. Westward migration from the ever more barren fields of New England, New Jersey, and the Tidewater South unnerved farmers still committed to eastern soil. The "boundless extent of our unsettled territory," warned Plumer, "tempts the husbandman to cultivate many acres badly, instead of a few well."[6] Revolution brought more than republican government; it and the Louisiana Purchase opened the way to the Ohio Valley, to Kentucky, across the Cumberland River painted by Ralph E. W. Earl (Plate 157) and a thousand unpainted streams to virgin land far more fertile than that two centuries plowed. As young men abandoned farms to aging parents, as aging parents died, as Thomas Birch and others remarked the great Conestoga wagons moving west (Plate 158), slovenliness stole across the eastern landscape, mocking Eliot's gospel of stewardship.

"There is something so pleasing in the appearance of neatness and cleanliness about a dwelling house, that even a stranger, transiently passing by, cannot help being prepossessed with a favorable opinion of those within," argued the editor of *New England Farmer* in 1823 in one of his first issues. "How different the sensation felt on viewing a contrary scene; — a house dismal and dirty, the doors and walls surrounded and bespattered with filth of all denominations, and fragments of broken dishes and dirty dairy utensils scattered in all directions impress on his mind the idea of misery and mismanagement." The newspaper founded to promulgate scientific agricultural practices like those extolled by Plumer and Taylor very quickly focused on praising traditional carefulness only slightly enhanced by modern techniques. "Prosperity and happiness," in the words of its editor, seemed as likely to grow in consistently well-tended soil as in newly manured fields.[7]

In these years agricultural societies began "noticing" efficient farms and awarding prizes or "premiums" for the most productive cows, the plumpest sheep, the swamp most effectively drained, cleared, and planted to wheat. By the mid-1820s, in shows and fairs like that painted by John Woodside in Pennsylvania (Plate 159), reformers displayed the finest specimens of the finest breeds, championing innovative bloodlines and novel experiments. What pleased the societies most, however, was simply the well-managed "thrifty" farm kept by "fore-handed" people conscious of traditional wisdom and contemporary invention, the bountiful, pacific place Washington Irving detailed in his "Legend of Sleepy Hollow" in 1819. Everything about such a thrifty farm bespoke attention to detail, to order; but perhaps the fields spoke most clearly to approaching observers.

Carefully bred horses, cattle, and other livestock standing in pastures of timothy grass, red clover, or other high-quality grass — pastures reflecting in their rich green tint not only a precise monoculture but the perfect evenness of fertility dependent on inclosing and conscientious manuring — caught the eye of Dwight and society judges. Deciduous trees scattered among the pastures and meadows, their lower branches reaching down to the "browse line" of horses and cattle straining upward for leaves, provided shade for the stock and for the haymakers resting momentarily. "I found the upper part of Richmond valley more beautiful than I had thought it before," mused Dwight of upstate New York in 1811. "The fields in their size, figure, surface, and

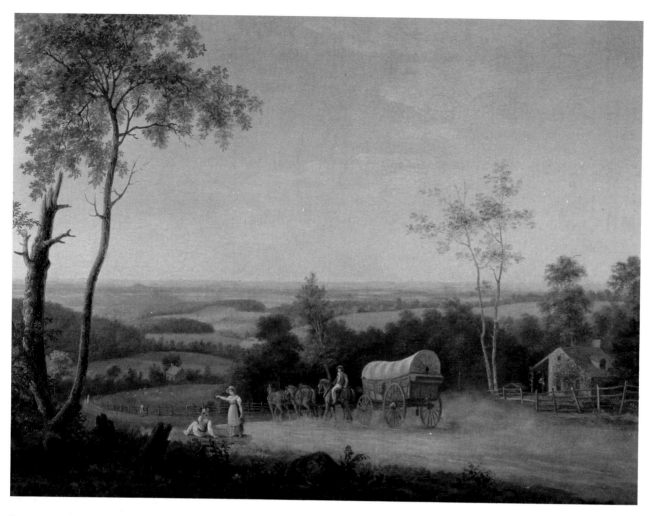

PLATE 158. THOMAS BIRCH, *Conestoga Wagon on the Pennsylvania Turnpike*, 1816.

PLATE 159. JOHN WOODSIDE, *A Pennsylvania Country Fair*, 1824.

PLATE 160. CHARLES WILLSON PEALE, *Belfield Farm, 1815–1820.*

fertility are remarkably fine, and are ornamented with beautiful trees, standing alternately single, in small clumps, and in handsome groves. The cultivation is plainly of a superior cast."[8] Like islands in Lake George, the scattered trees accentuate the smooth green of the fields by introducing vertical shapes into levelness. Elsewhere trees grew in rows along fences and other boundaries, serving as windbreaks and as a regular source of fencing timber and firewood. Interrupting the openness of fields, often on hillsides, farm woodlots further diversified views. Away from Maine and the swamps of the South, the East of 1815 delighted travelers with long stretches of vanquished wilderness, regions where sheep grazed atop treeless hills, where well-tended fences surrounded fields in which no stumps remained to recall the pioneer era.

Next to fields graced with fine livestock and orchards blooming in geometric rigidity, fences advertised the thrifty farm. In all their regional variations from the stone walls of New England and Pennsylvania to the post-and-rail fences of New York to the zigzag snake fences of the Carolinas, fencing separated different sorts of livestock from each other and from corn, wheat, tobacco, and other crops. No structure better advertised a farmer's commitment to order, to what Plumer called "system and economy"; for fences not only made possible the complex internal activity of the thrifty farm but also the larger, even more complicated farm operation of a neighborhood. In the second decade of the new century Charles Willson Peale grasped the significance of fencing; his *Belfield Farm* (Plate 160) extolls nearly perfect post-and-rail fences even as it slights almost all other structures.

At their outermost fence, however, even the most virtuous farmers restrained their efforts. Travelers and agricultural-society judges endured wretched roads bordered with fences good and bad, not only because farmers rarely ventured far from their own land, but because American agriculturists feared good roads as the highways along which tyrannical armies might march. European travelers admired Lake George and its environs, but none enjoyed the rutted, gully-like roads on which Dwight lost his way, which crossed brooks and streams lacking well-marked fords, ferries, and bridges.[9] Well-traveled roads often became extraordinarily wide, as teamsters guiding immense Conestoga wagons pulled by four or six horses swung from side to side around mudholes, living rock, and axle-snapping ruts. Back roads, often roads bordering impeccably fenced farms, wore ever deeper; their three ruts indicated the willingness of wayfarers to follow the route of predecessors over rockslides and through mud. "A loose sand below, sufficiently encumbered with stones," the sort of road Dwight followed to Lake George, struck travelers as "middling" good; while not smooth and well-drained gravel, it still offered no threatening boulders or mudholes and provided some opportunity for landscape observation and botanizing.[10] Everywhere along the roadsides grew the wildflowers increasingly absent from thrifty fields, flowers grazed by escaped livestock and collected by lovers enroute to lovers, flowers that recalled the indigenous vegetation of the settlement era.

Wildflowers within the fences, wildflowers breaking the evenness of meadow grass or field crops reminded early-nineteenth-century farm families of the rising threats to their thrifty existence, the forces likely to break through the defenses of system, care, and post-and-rail fences, the forces evidenced in the slovenliness of so many farms. Taylor begins *Arator* with a series of essays investigating the pernicious impact on farmers of tariffs and manufacturing, concluding that a conspiracy leads "agriculture by a bridle made of her virtue and ignorance, towards the worship of an idol, compounded of folly and wickedness."[11] Plumer warns that the "new era" is produced "by the increase of our population, the diminution of foreign commerce, and the sudden growth of manufactures amongst us."[12] Between 1800 and 1830 the champions of the endangered farm sharpened their arguments, until reformers like Samuel C. Allen, who addressed one assembly of Massachusetts farmers in 1830, knew a complete picture of adverse "political economy." Allen understood that his "subject is too dry for entertainment, and too abstruse to be understood without some effort," but since the principles he chose to explicate "contribute more than government, more than morals, more than religion, to make society what it is in every country," he led his hearers through a complex interpretation of the change overwhelming American farmers, especially those farmers living in long-settled parts of the nation.

"Before manufactures and trade had given rise to much of what is now called capital," Allen argued, "the land with the buildings and improvements upon it, and its annual produce constituted almost all the existing wealth." No longer, however, do farmers control most wealth; instead, they stand ensnared in issues of currency, credit, and "the interest of money," facing "the funds of corporations" and "joint stock companies." Point by point, Allen detailed the changes, until finally he scrutinized "the extent in which real estates among us are passing under mortgages," something "which is bringing the yeomanry of the country into a state of dependence and peril."[13] Along with so many speakers at agricultural exhibitions, Allen understood the immediate, critical need for farmers to improve what they already have, to stay free of the seductions of credit, to manure their fields. Like the icy blasts of winter, the forces of large-scale monopoly and capitalism might strike down the unprepared farmer.

Manured fields became something like the windbreaks that prudent farmers set north of their farmyards and fields. The stands of trees, sometimes evergreen, some-

times deciduous, often served as woodlots too; but chiefly they sheltered house and outbuildings from winter storms. Often nearly embracing one or more sides of the farmstead, the windbreaks epitomized a new concern for firewood conservation and a dawning appreciation of "embellishing" the site of a comfortable, "happy" farmhouse with the trees and shrubs prosperous agriculturists began to equate with beauty. "These rural decorations add more than one would imagine, who had not tried them, to the innocent pleasures of a family," remarked one anonymous essayist in an 1820 issue of *Rural Magazine and Literary Evening Fireside*. "They have no small influence in forming the taste of children; they form a favourite retreat for the birds; and they fling over the whole country an air of peace, and contentment, and innocent enjoyment."[14] Against marked social and economic change the thrifty farm "inclosed" itself, nursing its resources and even essaying a little aesthetic refinement, exemplifying in the eye of its owner — and in that of the traveler — the *traditional* virtue and economy on which rested republican stability.

Village

In villages, in villages growing into towns, and in towns growing into cities pulsed the forces just beginning to unnerve early-nineteenth-century eastern farm families. Southern and northern agriculturists, not yet sundered by the spectres of slavery extension and disunion, saw villages as very slightly suspect. But before the great mill-village experiments of the early 1840s, farmers and aesthetes joined with craftsmen, "mechanicks," and manufacturers in hoping that agriculture might coexist with manufacturing, that villages might remain the essentially agrarian creatures of the surrounding smiling countryside.

Surely Dwight thought so, and expressed his conviction in a book-length poem of 1794: *Greenfield Hill*. This avowedly nationalistic paen to post-Independence rural life juxtaposes the poverty-stricken English community Oliver Goldsmith described in his 1770 "Deserted Village" with a happy, wholly prosperous place:

> *Sweet smiling village! loveliest of the hills!*
> *How green thy groves! How pure thy glassy rills!*
> *With what new joy, I walk thy verdant streets!*
> *How often pause, to breathe thy gale of sweets;*
> *To mark thy well-built walls! thy budding fields!* [15]

Of course, Greenfield Hill is an almost wholly agricultural place, a community utterly dependent on the owners of the budding fields around it, a place of distinctly rural crafts like blacksmithing and milling. Like Penniman's Meetinghouse Hill in Massachusetts (Plate 161) and Fisher's Blue Hill Village in Maine (see Plate 155), Greenfield Hill brushes upon Eden, uniting agricultural and domestic economy with the disciplined worship of the Almighty.

Twenty years changed the eastern village almost beyond recognition. Machinery invaded rural space. "Mechanicks" not only worked a wide range of water-driven machinery, they began building new sorts of machines in a thousand villages blessed with waterfalls.[16] Everywhere in the eastern states north of slavery small manufactories attracted farmers into making shoes or cloth or nails or clocks during the slow winter months, and eventually year round. No one noticed the triumph of shop-scale manufacturing more carefully than the publishers of gazetteers. In his *Gazetteer of the State of New York*, a massive 1824 volume presenting villages in the minutest detail, Horatio Gates Spafford described Yankee Street, a village within the township of Florida, near the Erie Canal. Home to 108 mechanics and their families working five grist

mills, five saw mills, two fulling mills, two carding machines, and one ashery, Yankee Street is still a fledgling village in 1824, for it depends chiefly on the farmers living around it. Twelve years later Thomas F. Gordon presented his New York gazetteer to a public thirsty for news, and chronicled the maturation of places like Yankee Street. Villages no longer only ground grain and shod horses; in 1836 they manufactured hoes, twine, chemicals, India rubber, carpets, rifle cartridges, flint glass, varnish, needles, lime, files, and a thousand other items in the small wooden structures designated "manufactories" or "shops."[18] No longer did the meetinghouse alone exemplify verticality; as Francis Alexander's *Globe Village* (Plate 162) and William Guy Wall's *Hudson* (Plate 163) make clear, the new mills announced the elevation, spatial and otherwise, of mechanism.

In the early nineteenth century John Warner Barber, who specialized in describing villages, published a number of illustrated volumes outlining the "history and antiquities" of every town and village in most of the northeastern states, along with up-to-date geographical and statistical information. Barber understood the extraordinary importance of manufacturing villages in the transformation of national culture, and he distinguished among several types. In Connecticut he discovered Colinsville, established in 1826 as a "company village' within the town of Canton. The houses of the workmen, he observes, "which are built precisely of the same form, are compactly set together on the side of a hill" and "are painted white, and when contrasted with the deep green foliage in the immediate vicinity, present a novel and beautiful appearance."[19] The five hundred inhabitants of Colinsville make axes and reside in a new sort of community space — the village of identical houses owned by a corporation. Further south, in New Jersey, Barber found Clinton, one of hundreds of fast-growing villages that comprised another type, one that was ordered about several unrelated industries. Until 1838, when the federal government located a post office there, Clinton existed as a hamlet of three houses and a mill; in 1844 it contained "3 mercantile stores, 2 large merchant-mills, with one of which an oil-mill is connected; 3 public houses, about 15 mechanic shops of various kinds, a brick-yard, a valuable limestone quarry, 3 churches, 62 dwellings, and 520 inhabitants" along with two schools.[20] Colinsville and Clinton represented the future to Barber. Conway, in the Massachusetts hill country, exemplified the third sort of village, that already stranded in the past. While still reasonably prosperous, its "thirty dwelling-houses and other buildings" included no shops worthy of note, but it did have two churches, although one lacked a spire.[21] Conway announced the quiet agrarian prosperity that Plumer and Taylor honored. On the other hand, Colinsville advertised the power of the joint-stock corporation, and Clinton boasted of the prosperity bred of tariffs levied on imported manufactured goods — power and prosperity that Plumer, Taylor, and Allen feared.

Manufacturing villages flaunted the emerging economic order touching every American, even the farmer purchasing a new plow. Company villages sometimes demonstrated in their perfect, often symmetrical arrangements of mills, shops, and houses a military-like understanding of spatial arrangement, but every manufacturing village announced changes from the traditional agricultural order. By 1815 "mill" no longer designated only the low, unpainted, water-driven gristmill or sawmill to which farmers resorted in winter, when snow-covered roads made sledging grain and timber practical. It meant a multistory structure towering over mill-dam and adjacent houses, often painted a distinctive color other than the traditional white. And even the houses, termed "cottages" by occupants and travelers alike, announced in their sameness and their tiny lots a divorce from the agricultural past. The cottages, the two-family "double houses," the houses straggling into connected shops or stores, all boasted of new powers reaching out into agricultural space, as in Elijah Smith's depiction of the Boston Manufacturing Company's operation (Fig. 57). Infant industries promised

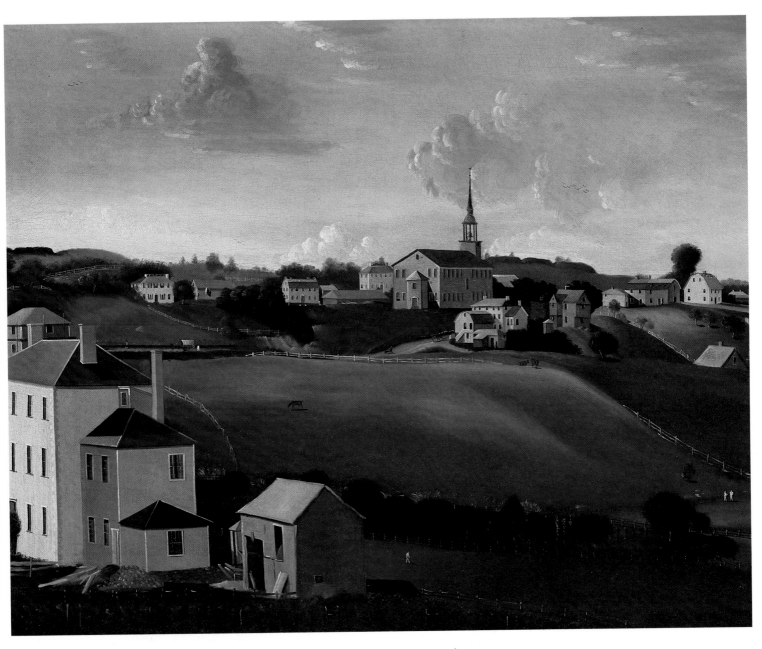

PLATE 161. JOHN RITTO PENNIMAN, *Meetinghouse Hill, Roxbury Massachusetts, 1799.*

economic independence from Britain, certainly, and many Americans delighted in viewing the manufacturing villages. Like the country's immense new bridges, ever-larger sailing ships flying the new flag, and vast "internal improvements" such as the Erie Canal watering Colinsville, the mills and mechanic shops demonstrated the potential of bearding Britain once again.[22]

Even during the embargo years astute observers like Joshua Rowley Watson watched the slow growth of Boston, Philadelphia (see Plate 100), Baltimore, and other coastal cities, remarking the way that mechanics attracted mechanics and shipwrights attracted shipwrights, that the transshipment of farm produce and manufactured goods raised land values and caused property owners to build taller buildings, longer docks, and houses jammed ever more tightly together. Urban growth worried many adherents of the older agrarian philosophy; but for every farmer who worried, another delighted in the ever-increasing range of goods available for sale, in the better newspapers, in the chance to invest in turnpike and toll-bridge companies dependent on urban growth, and best of all, in the new markets cities offered for farm produce. "The streets of New York have unhappily followed, in many instances, its original designa-

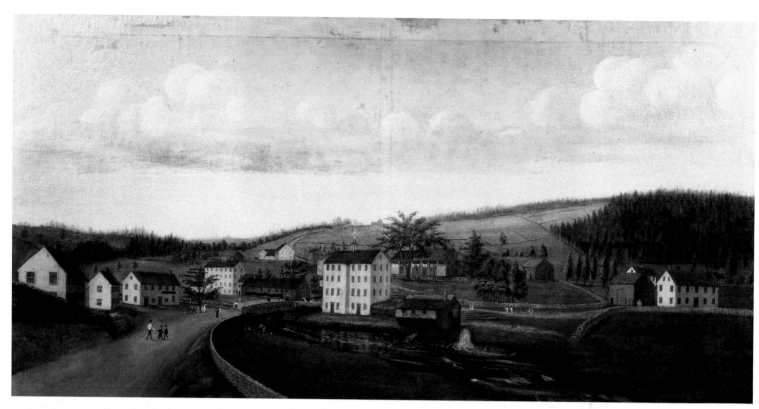

PLATE 162. FRANCIS ALEXANDER, *Globe Village*, 1822.

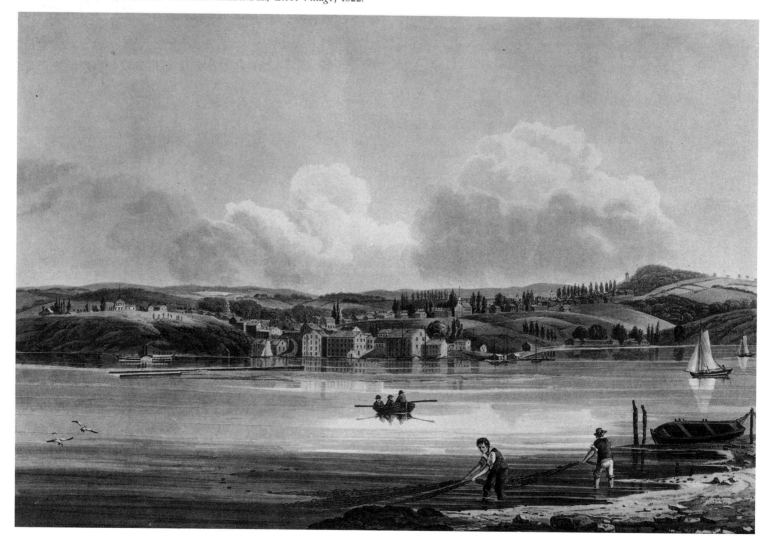

PLATE 163. WILLIAM GUY WALL, *Hudson*, from *Hudson River Portfolio*, 1828 edition.

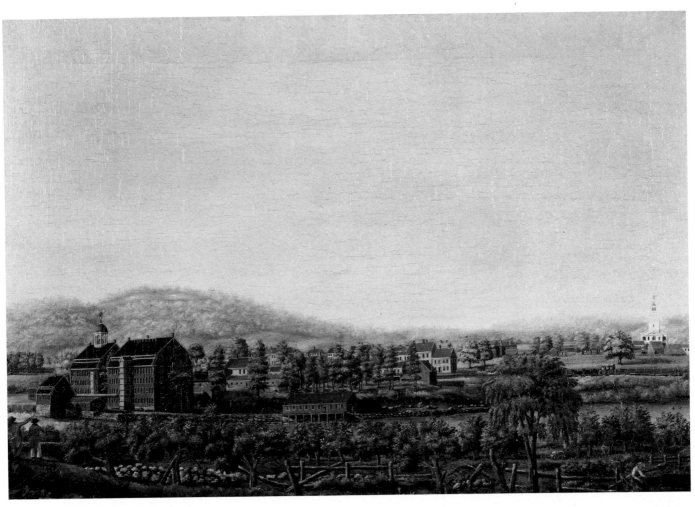

FIG. 57. ELIJAH B. SMITH, *Boston Manufacturing Company at Waltham*, c. 1825. Oil on canvas. Lowell Historical Society.

tion of a fishing and trading village," Dwight decided in 1811. "The streets are generally wider and less crooked than those of Boston, but a great proportion of them are narrow and winding."[23] If New York and Boston grew from villages, what did the future hold for Clinton, or for any village but the stagnating sort like Conway, if not the chance to grow into cityhood?

To stand back, to stand on a hilltop surrounded by fields and woodlots and see far off the manufacturing village or the budding city provided at least the chance to integrate the agrarian vision with the manufacturing, urban one, to see the village and even the city within the broader, reassuring landscape of agriculture, to hope for an equilibrium sometime in the near present. However Taylor and Allen worried, the mechanic shop and the close-packed city represented forces of the future, forces of national economic independence, forces that no right-thinking, patriotic American wholly dismissed in the years before the 1840s tariff and states' rights debates.

Backdrop

Always beyond the most distant fields and woodlots, in the bluish mists inland from coastal cities and above so many valley-bottom villages, the wilderness remained—the unshaped capital beckoning foresters, farmers, and eventually also finely educated observers who were learning something new of scenic beauty. "Up these precipices from the water's edge to their summits, rose a most elegant succession of forest trees,

chiefly maple, beech, and evergreens," remarked Dwight in 1799 of the mountainous region near Williamstown in Vermont. "The deciduous foliage had already been changed by the frost to just such a degree as to present every tincture from the deepest verdure of the spring through all its successive shades to the willow green, and thence through a straw color, orange, and crimson to a reddish brown." Even Dwight, scrutinizing and recording the appearance of farms and villages along the Williamstown road, admired the change from "smiling scenery" to "rudeness and grandeur" to "beauty and majesty."[24]

In 1799 Dwight saw grandeur and beauty where other well-educated observers had seen nothing but wildness a decade earlier. In 1789 even the falls of the Niagara River struck Jedidiah Morse as only "curious." His *American Geography* focuses chiefly on the practical uses of wilderness areas and on the delights of productive rural landscape. After briefly noting the "astonishing grandeur" of the drop itself, the noise, and the vapor sometimes illuminated into rainbows, Morse introduces Lake Ontario, a body of water more useful than the falls or Lake Erie. Upstream from Niagara Falls lurks a lake difficult to navigate, dotted with rattlesnake-infested islands and smothered with pond lilies, on the leaves of which in summer basks the "hissing snake," whose "subtile wind," if "drawn in with the breath of the unwary traveler, will infallibly bring on a decline, that in a few months must prove mortal."[25] Morse tried to appreciate the wildnesses of the Blue Ridge and other mountainous places, but *American Geography* reveals how powerfully he felt the love of shaped land.

Appreciation of utter wilderness came slowly, fueled by European aesthetic theory and literary precedent. The agelessness of American wilderness intermittently perplexed Morse and other writers, who missed the reassuring presence of the ruins enlivening European forest and mountain scenery. "At least," argued Dwight in the preface to his *Travels*, the wondrous transformation of forest into farms and villages "may compensate the want of ancient castles, ruined abbeys, and fine pictures."[26] Only the rarest early-nineteenth-century observers of North American wilderness discovered traces of long-abandoned human effort.

Washington Irving succeeded, albeit in a modest way. Near Manhattan Island, for example, he found Hell Gate, the "narrow strait, where the current is violently compressed between shouldering promontories, and horribly irritated and perplexed by rocks and shoals." It was not only a place to study the wild "paroxysms" of nature; near a group of rocks there lay the wreck of a sailing vessel. "There was some wild story about this being the wreck of a pirate, and of some bloody murder, connected with it, which I cannot now recollect," says Irving's narrator in *Tales of a Traveller*, an 1824 collection. "Indeed, the desolate look of this forlorn hulk, and the fearful place where it lay rotting, were sufficient to awaken strange notions concerning it."[27] Much of the book is ordered by strange notions of times past, but the hunting of buried pirate treasure informs the last portion of the *Tales*, along with the "conspicuous part" played by the Devil in most searches. In the first decades of the nineteenth century the seacoast — that wilderness first touched and often first abandoned by the earliest colonists — provided ruins and folktale enough for Irving, Poe, Hawthorne, and other writers grappling with the nearly overwhelming force of trans-Atlantic Gothic and Romantic art,[28] and for painters like Charles Codman vexed by ruinless forest, swamp, and mountain never visited by seventeenth- and early-eighteenth-century pirates.

Sport attracted many visitors to wilderness, although their steps were lightened by the dawning awareness of scenic beauty. "The approach to Sebago Pond is through a rugged hilly land, which opens a communication between the solitude of the waters and busy world around them," remarked an anonymous essayist in an 1829 issue of *Atlantic Monthly Magazine*. A country walk alone pleases him, sparking thoughts concerning prosperous farms and "the manufactories and machinery of a thickly set-

tled country" downstream; but the "clear depths of this beauteous lake" delight him more. Indeed he concludes patriotically that Izaak Walton himself would have abandoned English water for Sebago Pond, so magnificent is its setting and so soothing its "deep hush." Rocked ever so lightly in his rowboat, the fisherman gazes about, discerning here and there the same pioneer fields of grain Dwight noticed around Lake George, and remarking "an immense ridge of gray rocks, standing in bold contrast with the softness of the surrounding waters and landscape like the habitation of the *genius loci*." Confronting the coming of the smiling rural countryside and the towering "grotesque" rocks, the essayist discovers a few clearings "filled with the charred stumps of the pines, whose blackened surfaces and desolate cheerlessness, were fit emblems of the ancient nobleness, withered and blasted as it now is, of the *rightful* lords of the soil, the American aborigines." From his boatmen he learns something of the "romance" of the environs, a "tradition" involving an Indian love affair ensnared in tribal warfare. On Sebago Pond the essayist finds good fishing and romantic wilderness, and even a ruin — the figures painted by the Indian lovers to commemorate their escape.[29]

No longer is Satan the *genius loci* of the forest wilderness; slowly, tentatively, the vanquished Indian replaces him, then the shades of Revolutionary War heroes. As the decades advanced, the love of wilderness grew stronger among educated Americans,[30] but it grew slowly, especially away from places uncharmed by colonial ruins and traditions, or even by the Revolutionary War events so quickly receding into the romance embroidered by Cooper and Simms.[31] As his mid-nineteenth-century *Maine Woods* and *Cape Cod* make clear, even Thoreau distrusted virgin forest and barrier beach.[32]

Balance

> It is questionable whether mankind have ever seen so large a tract changed so suddenly from a wilderness into a well-inhabited and well-cultivated country. A great number of beautiful villages have risen up as by the power of enchantment; and the road for one hundred and twenty miles is in a sense lined by a succession of houses, almost universally neat, and frequently handsome. Throughout most of this extent an excellent soil, covered deep with vegetable mold, rewards every effort of the farmer with a luxuriant produce.[33]

Poised everywhere midway, upstate New York in 1811 pleased Dwight almost beyond measure. Graced by beautiful natural scenery touched by military exploits, improved by precise, inclosed husbandry totally removed from slovenliness, dignified by villages not yet wholly devoted to manufacturing but completely committed to national economic independence, the region epitomized the glories of republican government, of new institutions blooming in a land bathed in divine and celestial light. How long could it want pictures?

1. Timothy Dwight, *Travels in New England and New York 1769–1815* (1822; reprint, ed. Barbara Miller Solomon, Cambridge, Mass.: Harvard University Press, 1969), Vol. III, p. 244. The descriptions of the scenery of Lake George that follow are found on pp. 244–252 and 287–289; on the military history of the environs, see pp. 252–272.

2. William Plumer, *Address before the Rockingham Agricultural Society* (Exeter, N.H.: Williams, 1821), p. 1.

3. *Ibid.*, p. 20.

4. John Taylor, *Arator: Being a Series of Agricultural Essays, Practical and Political* (1813; reprint, Petersburg, Va.: Whitworth and Young, 1818), pp. 53, 70.

5. Jared Eliot, *Essays upon Field Husbandry* (1748–1762; reprint, ed. Harry J. Carman and Rexford G. Tugwell, New York: Columbia University Press, 1934), pp. 11–26 and *passim*.

6. *Ibid.*, p. 19.

7. "On Farms, Farm Houses. . . ," *New England Farmer* 1 (June 7, 1823): 1.

8. Dwight, *Travels*, Vol. III, p. 287.

9. On fences, roads, and farmers' distrust of road networks, see John R. Stilgoe, *Common Landscape of America, 1580 to 1845* (New Haven: Yale University Press, 1982), pp. 188–191, 21–23, 111–115, 128–133.

10. Dwight, *Travels*, Vol. III, p. 288; see also Vol. II, p. 139.

11. Taylor, *Arator*, p. 17.

12. Plumer, *Address*, p. 20.

13. Samuel C. Allen, *Address Delivered at Northampton* (Northampton, Mass.: Shepard, 1830), pp. 5, 18–19, 22, 24, 27, 29, and *passim*.

14. "The Village Teacher," *Rural Magazine and Literary Evening Fireside* 1 (September 1820): 324.

15. Timothy Dwight, *Greenfield Hill* (New York: Childs and Swain, 1794), p. 33.

16. "The Mechanick," *Rural Repository* 6 (June 20, 1829): 15.

17. Horatio Gates Spafford, *Gazetteer of the State of New York* (Albany: Packard, 1824), p. 176.

18. Thomas F. Gordon, *Gazetteer of the State of New York* (Philadelphia: Gordon, 1836), pp. 632, 714.

19. John Warner Barber, *Connecticut Historical Collections* (New Haven: Durrie, 1836), pp. 70–71.

20. John Warner Barber, *Historical Collections of New Jersey* (New York: Tuttle, 1846), pp. 244–245.

21. John Warner Barber, *Historical Collections of Massachusetts* (Worcester: Lazell, 1844), pp. 244–245.

22. See Stilgoe, *Common Landscape*, pp. 300–334.

23. Dwight, *Travels*, Vol. III, p. 315.

24. *Ibid.*, pp. 166–167.

25. Jedidiah Morse, *American Geography* (Elizabethtown, N.J.: Shepard Kollock, 1789), pp. 39–40 and *passim*.

26. Dwight, *Travels*, Vol. I, p. 8.

27. Washington Irving, "Hell Gate," *Tales of a Traveller* (1824; reprint, New York: Bedford, 1891), pp. 206–209.

28. See, e.g., Edgar Allan Poe, "The Gold Bug" [1843], *Best Known Works*, ed. Hervey Allen (New York: Blue Ribbon, 1927), pp. 53–77, and Nathaniel Hawthorne, "Footprints on the Seashore," *Twice-Told Tales* (1851; reprint, Cambridge, Mass.: Houghton Mifflin, 1882), pp. 504–516.

29. "Sebago Pond," *Atlantic Monthly Magazine* 1 (October 1829): 448–452.

30. On the growing love of wilderness, see Cecelia Tichi, *New World, New Earth: Environmental Reform in American Literature from the Puritans through Whitman* (New Haven: Yale University Press, 1979).

31. See, e.g., James Fenimore Cooper, *The Spy: A Tale of the Neutral Ground* (New York: Wiley and Halsted, 1822), and William Gilmore Simms, *The Partisan: A Tale of the Revolution* (New York: Harper, 1835).

32. On Thoreau and life-threatening wilderness, see John R. Stilgoe, "A New England Coastal Wilderness," *Geographical Review* 71 (January 1981): 33–50.

33. Dwight, *Travels*, Vol. III, p. 373.

Catalogue of the Exhibition

GUIDE TO THE CATALOGUE

The catalogue is arranged alphabetically by artist's name. The objects by which the artist is represented in the exhibit are listed immediately following his name, ordered by date of execution. In cases in which there are both a painter and an engraver for a given work, complete information for that work is listed under the painter's name, with a cross reference under the engraver's name. Illustrations of those objects exhibited have been designated Plates and are placed throughout the essays and catalogue section in numerical order, 1 to 203. The essays are further illustrated by fifty-seven works not included in the exhibit. These have been designated Figures.

Height precedes width in the measurements. In dimensions of prints, the size of the plate is given unless otherwise noted.

In the selected bibliography at the end of each artist's biography, most standard dictionaries of artists and general histories of American art are not listed. These include William Dunlap's *History of the Rise and Progress of the Arts of Design in the United States*, Matthew Baigell's *Dictionary of American Art*, George C. Groce and David H. Wallace's *The New-York Historical Society's Dictionary of Artists in America 1565–1869*, and E. Bénézit's *Dictionnaire critique et documentaire des peintures, sculpteurs, dessinateurs et graveurs*.

FRANCIS ALEXANDER

1800–1880

Globe Village, Southbridge, Massachusetts

Oil on canvas, 1822

32½ x 65½ in. (82.6 x 166.4 cm)

Private collection

PLATE 162

Born on February 3, 1800, in rural Killingly, Connecticut, Alexander at the age of twenty took lessons with landscapist Alexander Robertson at the American Academy of Fine Arts in New York. Upon his return home after only a few months of study,[1] he achieved local prominence painting portraits of Killingly townspeople. His success as a portraitist continued in Providence, Rhode Island, where he remained two years in constant employ.

Although perhaps best known for his portraits, Alexander early in his career executed *Globe Village*, an industrial landscape scene of 1822. Here industry is depicted positively, with a textile mill set comfortably within an agricultural landscape. Industrialization changed the configuration of New England towns, and landscape paintings such as Alexander's recorded this development. The village oriented toward the mill complex illustrates an interdependence between industrial and agricultural pursuits and a prosperity based on labors either on the farm or in the factory. A comparable elucidation of man's industry occurs in Alexander's *Ralph Wheelock's Farm*,[2] of about 1822, although there the emphasis is exclusively agricultural.

On a visit to Italy during 1831–1833 Alexander lived for a time with Thomas Cole, and together they traveled the Italian countryside painting landscapes. An exhibition of Alexander's European work was held in Boston shortly after his return. The years 1833–1845 were Alexander's most successful as a portraitist; thereafter he exhibited little.[3] In 1853 he and his family sailed to Italy, where they remained the rest of their lives except for a fourteen-month visit to America beginning in 1868. By this time Alexander no longer painted, and the remainder of his days were passed teaching his daughter to draw and paint, collecting primitive paintings, and retouching European works.[4] He died in Italy on March 27, 1880.

CMD

1. Because of financial difficulties, Alexander was forced to return within weeks of his arrival to New York on two separate occasions. William Dunlap, *History of the Rise and Progress of the Arts of Design in the United States*, 3 vols. (1834; reprint, New York: Benjamin Blom, 1965), Vol. III, pp. 235–236.
2. Garbisch Collection, National Gallery of Art, Washington, D.C. Wheelock's farm and Globe Village were located within sixteen miles of Alexander's home.
3. Catherine Pierce, "Francis Alexander," *Old-Time New England* 44 (October–December 1953): 37, notes a deterioration in Alexander's art after his European trip and suggests that the wealth of his wife may have adversely affected his motivation to paint.
4. *Ibid.*, p. 42.

BIBLIOGRAPHY

Jay E. Cantor. "The New England Landscape of Change." *Art in America* 64 (January 1976): 52.
Catherine W. Pierce, "Francis Alexander." *Old-Time New England* 44 (October–December 1953): 29–46.

WASHINGTON ALLSTON

1779–1843

Romantic Landscape

Oil on canvas mounted on masonite, c. 1803

28¾ x 39 in. (73 x 99.1 cm)

Concord Free Public Library

PLATE 78

Landscape with a Lake

Oil on canvas, 1804

38 x 51¼ in. (96.5 x 130.2 cm)

Museum of Fine Arts, Boston; gift of Mrs. Maxim Karolik

PLATE 164

Italian Landscape

Oil on canvas, 1814

44 x 72 in. (111.8 x 182.9 cm)

Toledo Museum of Art; gift of Florence Scott Libbey

PLATE 2

Landscape, Evening (Classical Landscape)

Oil on canvas, 1821

25½ x 34 in. (64.8 x 86.5 cm)

IBM Corporation, Armonk, New York

PLATE 77

Considered one of America's major landscape painters of the early nineteenth century, Washington Allston did not depict his country's wilderness or rural communities. His views are creations of the mind instead of representations of particular locales.[1] The historical, moral tone which pervades his early landscapes evolves in his later works into a subtle, mysterious, romantic mood.

Born November 5, 1779, in the District of Georgetown, South Carolina, and educated at Harvard, Allston studied painting at the Royal Academy in London, becoming one among several young Americans befriended by Benjamin West. Allston's exposure to paintings by Titian, Tintoretto, and Veronese during his 1803 visit to the Louvre in Paris had a tremendous effect upon his manner of painting. Recalling this episode thirty years later, he wrote to William Dunlap, "they took away all sense of subject. . . . I thought of nothing but of the *gorgeous concert of colors*. . . . It was the poetry of color which I felt."[2] What he learned from them is

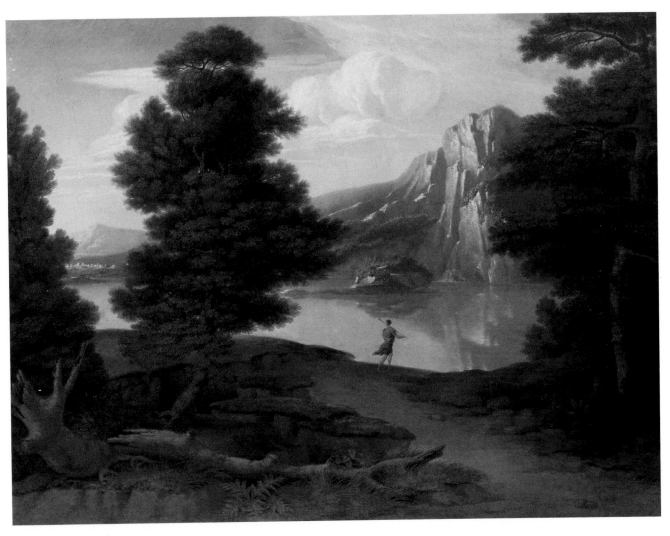

PLATE 164. WASHINGTON ALLSTON, *Landscape with a Lake*, 1804.

evident in the glazes of his landscapes and in his compositional quotations from the Old Masters.

Romantic Landscape, painted around 1803, with its rich tonalities and dramatic setting reveals familiarity with the work of Rubens and Salvator Rosa. In 1804 Allston traveled through Switzerland to Rome, where he stayed until 1808. He was struck by the beauty of the landscape he saw along the way, and scenery suggestive of these European locales recurs throughout his oeuvre. *Landscape with a Lake* is the earliest to show the impact of this trip, not only in its mountainous scenery, but also in its clarity of color and classical composition.[3]

After a stay in Boston, Allston returned to London in 1811, accompanied by his young wife and a student, Samuel F. B. Morse. Allston enjoyed critical favor there as a history painter, and in 1818 was elected an associate of the Royal Academy. It was in the winter of 1817–1818 that he painted a biblical landscape, *Elijah in the Desert* (Museum of Fine Arts, Boston). Here the artist is indebted to Titian in the warm, resonant color and to Rosa in the harsh irregularity of the landscape.

Italian Landscape of 1814 and a number of scenes such as *Moonlit Landscape* (Museum of Fine Arts, Boston) and *Landscape, Evening,* painted shortly after his return to America in 1818, are essentially reminiscences of Italy. In contrast to earlier landscapes, the Italianate towns, bridges,

and classical ruins are pushed farther into the distance while the formerly distinct figures are increasingly obscured, merging with the setting to evoke an imaginary, dreamlike world. Soft light, remindful of that in Claude Lorrain's landscapes, bathes these quiet, contemplative scenes, heightening their nostalgic, romantic mood. Allston wrote to Dunlap concerning his gradual transformation of style:

> . . . the time must come to every man who lives beyond the middle age, when "there is nothing new under the sun."
> His novels are then the refacimenti of his former life.
> The gentler emotions are then as early friends who revisit him in dreams, and who, recalling the past, give a grace and beauty . . . to what in the hey-day of his youth had seemed to him spiritless and flat.

Despite his stylistic transition from large dramatic views illustrating lofty ideals to smaller evocative images of calm reverie, Allston never wavered in his primary purpose of communicating emotion through his landscape.

GLH

1. For Allston's aesthetics, see Richard Henry Dana, ed., *Lectures on Art and Poems by Washington Allston* (New York: Baker and Scribner, 1850).
2. William Dunlap, *History of the Rise and Progress of the Arts of Design in the United States,* (1834; reprint, New York: Dover, 1969), Vol. II, p. 163.
3. For a discussion of the impact of Italy on Allston's landscape see William H. Gerdts, "The Paintings of Washington Allston," "A Man of

Genius": The Art of Washington Allston (1779–1843) (Boston: Museum of Fine Arts, 1979), p. 39 and esp. pp. 43–49. Also see Bryan J. Wolf, *Romantic Re-Vision: Culture and Consciousness in Nineteenth-Century American Painting and Literature* (Chicago: University of Chicago Press, 1982).

BIBLIOGRAPHY

Richard Henry Dana, ed. *Lectures on Art and Poems by Washington Allston.* New York: Baker and Scribner, 1850.

Jared B. Flagg. *The Life and Letters of Washington Allston.* New York: Benjamin Blom, 1969.

William H. Gerdts and Theodore E. Stebbins, Jr. *"A Man of Genius": The Art of Washington Allston (1779–1843).* Boston: Museum of Fine Arts, 1979.

Elizabeth Johns. "Washington Allston: Method, Imagination, and Reality." *Winterthur Portfolio* 12 (1977): 1–18.

Carter Ratcliff. "Allston and the Historical Landscape." *Art in America* 68 (1980): 96–104.

E. P. Richardson. *Washington Allston: A Study of the Romantic Artist in America.* Chicago: University of Chicago Press, 1948.

Robert L. White. "Washington Allston: Banditti in Arcadia." *Art Quarterly* 13 (1961): 387–410.

Bryan Jay Wolf. *Romantic Re-Vision: Culture and Consciousness in Nineteenth-Century American Painting and Literature.* Chicago: University of Chicago Press, 1982.

GEORGE BACK

1796–1878

Upper Part of the McKenzie River, Woods on Fire

Watercolor on wove paper, 1825

5⅜ x 7⅜ in. (13.6 x 18.9 cm)

National Gallery of Canada, Ottawa

PLATE 6

A-wak-au-e-paw-etek or Slave Falls

Watercolor on wove paper, 1825

5⁵⁄₁₆ x 7½ in. (13.5 x 19.0 cm)

National Gallery of Canada, Ottawa

PLATE 96

Back was born in Stockport, Cheshire, and entered the Royal Navy as a midshipman in 1808. He was captured by the French the next year and remained a prisoner for five years. During that time he studied drawing, but his surviving watercolors are entirely English in style. In 1814 he was stationed in Halifax, and from there volunteered for Sir John Franklin's first Arctic expedition in 1819, sketching the new territories with Robert Hood. His watercolor technique and his compositions are more straightforward than Hood's. Surviving the trip (and saving the group from starvation), he returned to the Arctic with Franklin in 1825. Franklin used Back's drawings to illustrate accounts of both expeditions. *McKenzie River, Woods on Fire* and *Slave Falls* are from a sketchbook from the latter. His account of Slave Falls sounds like a tourist description of Niagara or Passaic: an heroic Indian dashed to death in his canoe, a watchful eagle, steep cliffs.[1]

In 1833 Back led a party in search of another Arctic explorer, John Ross, and received a hero's welcome on his return to England. He was promoted to captain, elected to the Royal Geographical Society, and published and illustrated his own account of the expedition. In 1836 he ventured into the Arctic one last time, a disastrous expedition during which he and his men were trapped on their ship in the ice for months, which left him seriously weakened for years. He received several medals from the Royal Geographical Society and a knighthood for his achievements in 1839, and he maintained an active interest in Arctic exploration until his death on June 23, 1878.

BR

1. George Back, "Journal: June 3, 1825," quoted in Bruce G. Wilson and Douglas E. Schoenherr, *With Franklin to the Top of the World 1825–1826. Arctic Journal and Sketches by George Back* (Ottawa: Public Archives Canada, 1979).

BIBLIOGRAPHY

Archives Canada Microfiches. *George Back.* (Microfiches 11, 12.) Ottawa: Public Archives Canada, 1980.

George Back. *Narrative of the Arctic Land Expedition to the Mouth of the Great Fish River, and along the Shores of the Arctic Ocean, in the Years 1833, 1834, and 1835.* London: J. Murray, 1836.

———. *Narrative of an Expedition in H.M.S. Terror, Undertaken with a View to Geographical Discoveries on the Arctic Shore, in the Years 1836-7.* London: J. Murray, 1838.

John Franklin. *Narrative of a Journey to the Shores of the Polar Sea, in 1819, 1821 and 1822.* London: J. Murray, 1823.

———. *Narrative of a Second Expedition to the Shores of the Polar Sea in 1825, 1826, and 1827.* London: J. Murray, 1828.

JOHN JAMES BARRALET

c. 1747–1815

View of Philadelphia from the Great Elm Tree in Kensington

Watercolor and sepia ink on paper, 1796

16¹⁄₁₆ x 24 ⁷⁄₁₆ in. (40.8 x 62 cm)

Private collection

(Corcoran only)

PLATE 106

Bridge over Schuylkill (Market Street Bridge)

Oil on canvas, c. 1810

36 x 48 in. (91.4 x 121.9 cm)

The Historical Society of Pennsylvania, Philadelphia; gift of heirs of George Cathbert

PLATE 1

Born in Dublin around 1747, Barralet entered the Dublin Society's school, where he studied under James Mannin, the French master of landscape and flower painting. Becoming a highly skilled draftsman, Barralet produced town and country views of a topographical nature. He created several illustrations for

Thomas Milton's *Seats and Demesnes of the Nobility and Gentry of Ireland* (1773), a study that generated interest in Ireland's scenery.[1]

Barralet enjoyed a favorable reputation as a teacher of drawing and painting from the time he opened his Dublin studio in 1764 to his departure for London about 1770. During the next ten years he exhibited forty-seven landscapes and historical drawings at the Royal Academy, the Free Society of Artists, and the Society of Artists, which made him a member in 1772.[2] Despite the success of the drawing school he established in 1771, he returned to Dublin in 1779 hopeful of obtaining the position in the Society's school vacated by his former teacher. Disappointed with a temporary post, he decided to seek new opportunities in the United States.

In 1795 Barralet settled in Philadelphia, where he found temporary employment as an engraver with Alexander Lawson.[3] America's natural and manmade environment provided suitable subjects for his topographical style. Executed in small and even brush strokes, *Bridge over Schuylkill* was painted in exchange for his rent in 1810.[4] Portrayed is the first permanent bridge (1800–1805) built across the Schuylkill River; the Powelton farm is neatly depicted on the left.[5] It is not surprising that such American compositions of Barralet's bear a close resemblance to those he produced in Britain, particularly in the animation of the setting with well-dressed strollers and workmen.

In the sensitive watercolor *View of Philadephia from the Great Elm Tree in Kensington,* one of the earliest representations of this site, Barralet linked a symbol of America's past with the young country's present. The elm where William Penn signed the famous treaty with the Indians injects a note of history and continuity in this seemingly straightforward rendering of a prosaic scene. The popularity of this particular subject is evident from numerous similar works, including one by Thomas Birch.[6]

Barralet, who became well known for his book illustrations, spent the rest of his life in Philadelphia. He died on January 16, 1815.

KK

1. Walter G. Strickland, *A Dictionary of Irish Artists* (London: Maunsel and Co., 1913), Vol. I, p. 26.
2. *Philadelphia: Three Centuries of American Art* (Philadelphia: Philadelphia Museum of Art, 1976), p. 235.
3. Alexander Lawson, who emigrated from Scotland to Philadelphia in 1794, achieved recognition for his engravings in Alexander Wilson's *American Ornithology* (1808–1814). See George C. Groce and David H. Wallace, *The New-York Historical Society's Dictionary of Artists in America* (New Haven: Yale University Press, 1957), p. 30.
4. Nicholas B. Wainwright, *Paintings and Miniatures at the Historical Society of Pennsylvania* (Philadelphia: Winchell Company, 1974), p. 291.
5. *Philadelphia*, p. 257.
6. An engraved treatment of the subject by Birch is in this exhibition (Plate 107); Birch's painting is in the collection of the Historical Society of Pennsylvania. See also George Beck's *Philadelphia from the Great Tree at Kensington*, Plate 168.

BIBLIOGRAPHY

Anne Crookshank and the Knight of Glin. *The Painters of Ireland: 1660–1920.* London: Barrie and Jenkins, 1979.
Philadelphia: Three Centuries of American Art. Philadelphia: Philadelphia Museum of Art, 1976.
Walter G. Strickland. *A Dictionary of Irish Artists.* London: Maunsel and Co., 1913.

WILLIAM BARTRAM

1739–1823

The Great Alachua-Savanna in East Florida

Ink on paper, c. 1774
12½ x 15¹³/₁₆ in. (31.7 x 40.1 cm)
American Philosophical Society Library, Philadelphia

PLATE 111

On April 20, 1739, Bartram was born outside Philadelphia, in Kingsessing. There he grew up amidst the botanical gardens his father, John Bartram, had established in 1730. As a youth, he frequently accompanied his father on collecting expeditions. While at Old College in Philadelphia, he also devoted time to sketching flora and fauna. In 1754 John Bartram began sending his son's illustrations to Peter Collinson, a London merchant and amateur botanist, who circulated them among European naturalists. Fearing that William would not be able to support himself as an artist-naturalist, John Bartram apprenticed him to a Philadelphia merchant in 1756,[1] but he was not a success as a businessman.

In 1765 Collinson helped secure John Bartram's appointment as Botanist of the North American Continent to George III. The Bartrams immediately set out on a collection expedition to the Florida Territory, recently acquired by England. John Bartram returned to Kingsessing in 1766, but William remained alone in Florida where he attempted, without success, to establish a plantation. Within a year he too returned to Pennsylvania.

Shortly before his death in 1768, Collinson had found patrons willing to provide Bartram with modest payments for his illustrations. One of them was Dr. John Fothergill, the founder of Britain's largest botanical gardens. Alarmed by reports that Bartram was not doing well financially,[2] Fothergill furnished him with a stipend to explore Florida and the southeastern colonies. In return, Bartram supplied his patron with seeds, specimens, and illustrations.

For four years beginning in 1773, he traveled through the Southeast, going as far west as the Mississippi. Bartram identified many species of flora and fauna and made important ethnological observations on American Indians. He also provided posterity with a remarkable set of illustrations and a literary masterpiece, *Travels through North and South Carolina, Georgia, East and West Florida, the Cherokee Country, the Extensive Territories of the Muscogulges, or the Creek Confederacy, and the Country of the Chactaws* (1791), based on a journal which he had kept for Fothergill. Many of his drawings were sent to his patron; others, including the map of the Alachua Savanna, remained in the artist's hands. With its multiple viewpoints and strange dislocations of scale, the drawing is hardly a map in the conventional sense. Rather, it is an environment in which all living organisms are given more or less equal weight.[3]

Many of Bartram's illustrations have a bizarre quality.[4] Depicted with scientific exactness, animals and plants are placed in schematic landscapes in which rational space and scale are distorted. Sometimes organisms that do not actu-

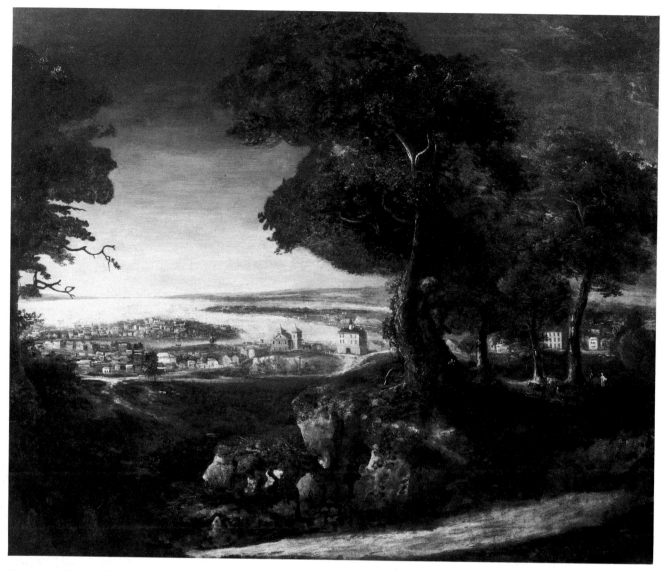

PLATE 165. GEORGE BECK, *View of Baltimore from Howard's Park,* c. 1796.

ally coexist in nature are juxtaposed and interrelated both in terms of content and form. A network of flowing lines unites all forms into a tight, intricately woven composition. Bartram's literary style is analogous. His descriptions of places and things are rich, detailed, and often enhanced by the author's associations. His connections between all elements in creation may reflect his Quaker beliefs;[5] they may also be the result of living alone in nature.

Only a few months before his father's death in 1777, Bartram returned to Kingsessing. Although he lived another forty-six years, there is no evidence he traveled more than a day's distance from Philadelphia.[6] Most of his time was spent managing his father's gardens with his brother, writing, and drawing. He died on July 22, 1823.

When his *Travels* was published in 1791, Americans doubted the truthfulness of many of Bartram's vivid descriptions. Only after his death did scientific evidence confirm the validity of his observations. In Europe, however, the book was an immediate success and had an enormous influence on many writers, including Wordsworth, Coleridge, and Chateaubriand.

KBM

1. John Bartram continued to send his son's drawings to England, and in 1758 engravings of William Bartram's bird illustrations appeared in George Edward's *Gleanings from Natural History.* That year Collinson also published Bartram's drawing of a horned turtle in *Gentleman's Quarterly.* Joseph Ewan, *William Bartram: Botanical and Zoological Drawings 1756–1788* (Philadelphia: American Philosophical Society, 1968), pp. 9, 35.
2. Francis Harper, ed., *The Travels of William Bartram* (New Haven: Yale University Press, 1967), p. xix.
3. See Amy Meyers' essay "Imposing Order on the Wilderness" in this catalogue.
4. See plates in Ewan, *Bartram.*
5. Robert McCracken Peck, Intro. to William Bartram, *Travels* (Salt Lake City: Peregrine Smith, 1980), p. xi.
6. Harper, *Travels,* p. xxviii.

BIBLIOGRAPHY

Bartram Heritage: A Study of the Life of William Bartram. Montgomery, Ala.: The Bartram Trail Conference, 1979.
William Bartram. *Travels,* with an Intro. by Robert McCracken Peck. Salt Lake City: Peregrine Smith, 1980.
————. *The Travels of William Bartram.* Ed. with an Intro. by Francis Harper. New Haven: Yale University Press, 1967.
Edmund Berkeley and Dorothy Smith Berkeley. *The Life and Travels of John Bartram from Lake Ontario to River St. John.* Tallahassee: University Presses of Florida, 1982.
Robert Elmer. *America's Pioneering Naturalists.* Tulsa: Winchester Press, 1982.
Ernest Earnest. *John and William Bartram: Botanists and Explorers.* Philadelphia: University of Pennsylvania Press, 1940.

Joseph Ewan, ed. *William Bartram: Botanical and Zoological Drawings, 1756–1788.* Philadelphia: American Philosophical Society, 1968.

Nathan Bryllion Fagin. *William Bartram. Interpreter of American Landscape.* Baltimore: Johns Hopkins University Press, 1932.

Joseph Kastner. *Species of Eternity.* New York: Alfred A. Knopf, 1977.

GEORGE BECK

1748?–1812

View of Baltimore from Howard's Park

Oil on canvas, c. 1796
37 x 45 ½ in. (94 x 115.6 cm)
Maryland Historical Society; gift of Robert Gilmor
PLATE 165

The Falls of the Potomac

Oil on canvas, 1797–1801
17 x 23 in. (43.2 x 58.4 cm)
Private collection
PLATE 32

McCall's Ferry on the Susquehanna

Gouache and watercolor on paper, 1798–1804
13 ½ x 18 ¾ in. (34.3 x 47.6 cm)
Private collection
(Corcoran only)
PLATE 166

Schuylkill below the Falls

Gouache and watercolor on paper, 1798–1804
13 ½ x 18 ¾ in. (34.3 x 47.6 cm)
Private collection
(Corcoran only)
PLATE 139

View of Baltimore

Ink wash and pencil on paper, c. 1800
16 ⅝ x 22 ⅛ in. (42.2 x 56.2 cm)
Maryland Historical Society; gift of Mrs. Paul S. Anderson
PLATE 167

PLATE 166. GEORGE BECK, *McCall's Ferry on the Susquehanna,* 1798–1804.

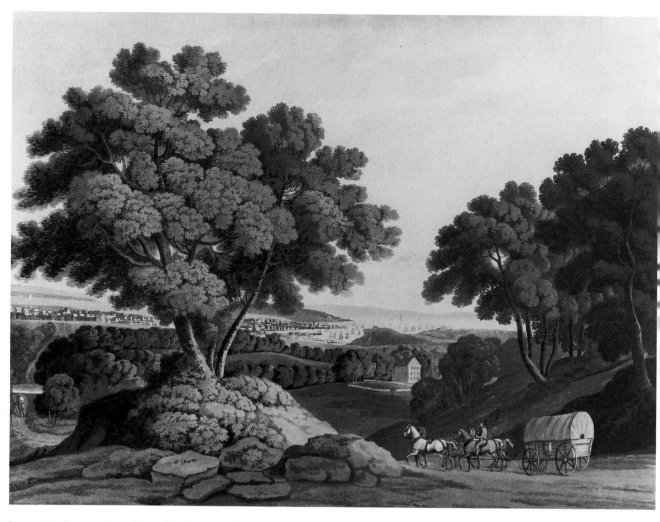

PLATE 167. GEORGE BECK, *View of Baltimore*, c. 1800.

Georgetown and Federal City, or City of Washington

Colored aquatint, 1801
(Thomas Cartwright after Beck)
16⁷/₁₆ x 22¹³/₁₆ in. (41.8 x 57.9 cm) (image size)
Milberg Factors, Inc.

PLATES 20 AND 146

Philadelphia from the Great Tree at Kensington

Colored aquatint, 1801
(Thomas Cartwright after Beck)
16⁷/₁₆ x 22¹⁵/₁₆ in. (41.8 x 58.3 cm) (image size)
Milberg Factors, Inc.

PLATE 168

Beck was born in Ellford, England, around 1748, the youngest son of a Staffordshire farmer. He had a classical education and was skilled in mathematics and science. After illness forced him to give up thoughts of the ministry, he served for thirteen years as a draftsman for the Corps of Engineers in the Tower of London. Resigning his position in 1787 for reasons of health, he taught the daughters of the Marchioness of Townshend. He exhibited his first landscapes at the Royal Academy in 1790; others followed. In addition to country-house views, Beck's English paintings include depictions of rugged scenery, the result of a tour in the early 1790s of western England and Wales. As his biographer wrote in 1812:

> The picturesque and romantic scenery of that country presented a school worthy of his genius. It was there, perhaps, he imbibed the energy and grandeur that distinguished his peculiar style. His bosom flowed with enthusiasm while he contemplated the sublimity of Snowden, of Plinlimmon, and of Cader Idris. . . . The result of this tour gained him many admirers, who suggested that in America he would find a theatre for the exercise of powers that might afterwards enrich his native country. [1]

In 1795 Beck arrived in Norfolk. For the next few years he found encouragement in Baltimore, painting the dramatic view of the city from Howard's Park. In 1797 he sold two large views of the Potomac (now at Mount Vernon) to George Washington, which reveal in their vigorous application of pigment as well as in subject matter Beck's responsiveness to the more sublime aspects of American scenery. From 1798 through 1805, the most creative period of his American career, he was in Philadelphia. The small

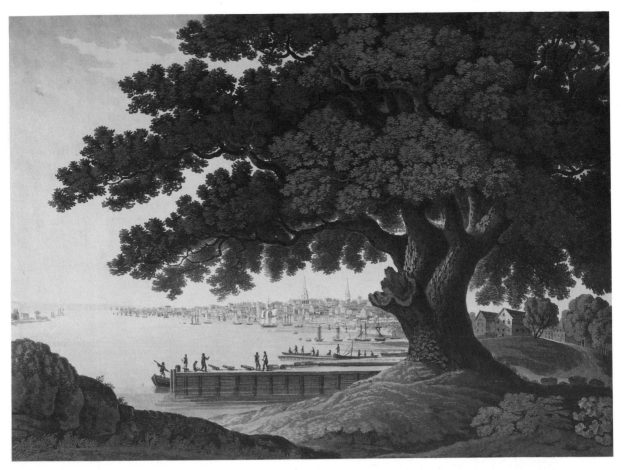

PLATE 168. THOMAS CARTWRIGHT after George Beck, *Philadelphia from the Great Tree at Kensington*, 1801.

painting of the Great Falls of the Potomac probably dates from the same period. *McCall's Ferry on the Susquehanna* and *Schulykill below the Falls* were also undoubtedly created at this time; their compositions as well as the gouache medium relate to the work of Paul Sandby, one of the leading English topographical artists of the day. A series of six aquatints, including views of Washington, Baltimore, and Philadelphia, are perhaps the works for which Beck is best known.

After a tour of the western states in the spring of 1804, Beck and his wife, who was also an artist, moved to Lexington, Kentucky, around 1805. Here both of the Becks ran schools for a time. He died there on December 14, 1812, of tuberculosis, embittered by lack of recognition.

EJN

1. "A Biographical Memoir of the Late George Beck, Esq.," *Port Folio* 2 (August 1813): 119-120.

BIBLIOGRAPHY
"A Biographical Memoir of the Late George Beck, Esq." *Port Folio* 2 (August 1813): 117-122.
J. Hall Pleasants. *Four Late Eighteenth Century Anglo-American Landscape Painters*. 1942. Reprint from *Proceedings of American Antiquarian Society*, Worcester, Mass.: American Antiquarian Society, 1943.
Edna Talbott Whitley. "George Beck, an Eighteenth Century Painter," *Register of the Kentucky Historical Society* 67 (January 1969): 20-36.

PETER BENAZECH

active 1744–1783

See HERVEY SMYTH

A View of Miramichi from *Scenographia Americana*, PLATE 84

WILLIAM JAMES BENNETT

c. 1784–1844

Niagara Falls, Part of the British Fall, Taken from under the Table Rock

Colored aquatint, 1829
(John Hill after Bennett)
$23^3/8$ x $20^5/16$ in. (59.4 x 51.6 cm)
The Charles Rand Penney Collection

PLATE 151

Niagara Falls, Part of the American Fall from the Foot of the Stair Case

Colored aquatint, 1829
(John Hill after Bennett)
$23^3/8$ x $20^5/16$ in. (59.4 x 51.6 cm)
The Charles Rand Penney Collection

PLATE 37

William James Bennett was born in England around 1784. He studied both at the Royal Academy schools in London and with the professional watercolorist Richard Westall. In 1797 Bennett was sent to Egypt and Malta as part of the medical staff of the British army, and later served under General James Craig in the Mediterranean. From 1808 to 1825 he exhibited in London with the Associated Artists in Water-Colours and the Society of Painters in Water-Colours from 1820 to 1825. His work is a careful reflection of the prevalent styles of these societies. Around 1826 Bennett emigrated to New York, exhibiting at the National Academy of Design, to which he was elected in 1828. He "exercised the art of both painting and engraving, happily multiplying by one the products of the other."[1] From 1830 to 1839 Bennett was in charge of the schools of the Academy. He lived in New York until 1843, when he moved to Nyack, perhaps for his health. He died in New York City on May 13, 1844.

BR

1. William Dunlap, *History of the Rise and Progress of the Arts of Design in the United States,* (1834; reprint, New York: Benjamin Blom, 1965), Vol. III, p. 45.

BIBLIOGRAPHY
Ronald A. De Silva. "William James Bennett: Painter and Engraver." M.A. Thesis. University of Delaware, 1970.
Richard J. Koke. *American Landscape and Genre Paintings in the New-York Historical Society.* Boston: New-York Historical Society with G.K. Hall, 1982. Vol. I.

THOMAS BIRCH

1779–1851

The City of Philadelphia in the State of Pennsylvania North America

Colored engraving, 1801
(Samuel Seymour after Birch)
18⅞ x 23¹³⁄₁₆ in. (47.9 x 60.5 cm) (image size)
Milberg Factors, Inc.
PLATE 107

Eaglesfield

Oil on canvas, 1808
26 x 36¼ in. (66 x 92 cm)
Private collection
PLATE 23

View of Sweetbriar

Oil on canvas, 1811
26 x 35½ in. (66 x 90.2 cm)
Judith Hernstadt
PLATE 119

Upper Ferry Bridge at Fairmount

Oil on canvas, 1813
28 x 41 in. (71.1 x 104.2 cm)
The Historical Society of Pennsylvania, Philadelphia
PLATE 169

Conestoga Wagon on the Pennsylvania Turnpike

Oil on canvas, 1816
21¼ x 28½ in. (54 x 72.4 cm)
The Shelburne Museum, Shelburne, Vermont
PLATES 40 AND 158

Point Breeze

Oil on canvas, 1818
39⅞ x 56 in. (101.3 x 142.2 cm)
Private collection
(Corcoran only)
PLATE 120

Fairmount Waterworks

Oil on canvas, 1821
20¼ x 30¼ in. (51.4 x 76.8 cm)
The Pennsylvania Academy of the Fine Arts; bequest of the Charles Graff Estate
PLATE 123

Born in Warwickshire, England, on July 26, 1779, Thomas Birch received his training as a landscape painter from his father, William Birch. He was influenced by the contemporary British landscape school and also by Old Masters through his father's collection of engravings.[1] Later in his life he had the opportunity to see seventeenth- and eighteenth-century European landscape paintings in the collection of his patron Joseph Bonaparte. These may well have influenced Birch's subsequent works, including his portrayal of Bonaparte's estate, Point Breeze, in Bordentown, New Jersey.

Coming to Philadelphia in 1794 with his father, Birch started his career drawing topographical cityscapes. Several of his designs were engraved by his father and published as *The City of Philadelphia in the State of Pennsylvania as it Appeared in 1800,* views which depict a prosperous community. It is this theme of a civilized country which is integral to Birch's art. *Eaglesfield* and *Sweetbriar,* country seats in Fairmount Park, then on the outskirts of Philadelphia, are cases in point. With the houses at the apex of the compositions, an air of cultural confidence pervades these tranquil views of cultivated nature. Well-dressed figures in *Eaglesfield,* occupied in leisurely activities, speak of the gentility of America — its manners, tastefulness, and sophistication — while the more informally attired women and children in *Sweetbriar* suggest a pastoral idyll.

The ingenuity of American industry was recognized and admired by Americans and Europeans alike. The Fair-

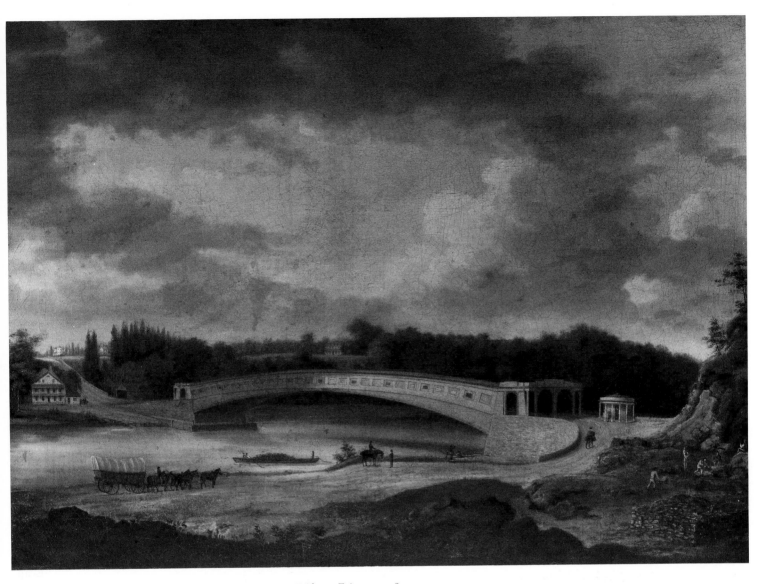

PLATE 169. THOMAS BIRCH, *Upper Ferry Bridge at Fairmount, 1813.*

mount Waterworks, the nation's first municipal water system, housed in a neo-classical structure, is an early example of American ingenuity.[2] A subject frequently depicted in contemporary art (see Fig. 41), the Waterworks were treated by Birch more than once.[3] One of the wonders of America, the dam constructed in 1819–1822 to power the waterwheels serves as the focal point of the composition. The canal, locks, and boat acknowledge the commercial importance of the Schuylkill River. The Waterworks sit on the bank busily supplying the city with water. Concerning the setting, Mrs. Trollope, an English visitor in 1827, wrote:

> At a most beautiful point on the Skuylkill River the water has been forced up into a magnificent reservoir, ample and elevated enough to send it through the whole city. The vast, yet simple machinery by which this is achieved is open to the public, who resort in such numbers to see it. . . . It is, in truth, one of the very prettiest spots the eye can look upon.[4]

The area was landscaped into an informal garden, becoming the first public park in America.[5] Birch captured the essence of a site imbued with great civic pride.

Birch began to concentrate on depicting naval battles after the War of 1812. Although he continued to paint landscapes, he became noted for marine scenes.[6] He died in Philadelphia, January 14, 1851.

KK

1. *Philadelphia: Three Centuries of American Art* (Philadelphia: Philadelphia Museum of Art, 1976), p. 230.
2. Kimberly B. Kroeger, "The Philadelphia Fairmount Water Works, 1811–1911, The Machine in the Garden Revised," honors thesis, University of Pennsylvania, p. 1.
3. Another painting was shown at the Pennsylvania Academy of the Fine Arts in 1824. See Anna Wells Rutledge, *Cumulative Records of Exhibition Catalogues* (Philadelphia: Pennsylvania Academy of the Fine Arts, 1955), p. 27.
4. Frances Trollope, *The Domestic Manners of the Americans* (1832; reprint, New York: Knopf, 1949), p. 261.
5. Kroeger, "The Philadelphia Fairmount Water Works," p. 26.
6. William H. Gerdts, "Thomas Birch: America's First Marine Artist," *Antiques* 89 (April 1966): 528-534.

BIBLIOGRAPHY

Doris J. Creer. "Thomas Birch: A Study of the Condition of Painting and the Artist's Position in Federal America." M.A. Thesis, University of Delaware, 1958.
William H. Gerdts. "Thomas Birch: America's First Marine Artist." *Antiques* 89 (April 1966): 528-534.
Philadelphia: Three Centuries of American Art. Philadelphia: Philadelphia Museum of Art, 1976.

WILLIAM RUSSELL BIRCH

1755–1834

The City of New York in the State of New York, North America

Etching and engraving, third state, 1803
(Samuel Seymour after Birch)
21¾ x 26 in. (55.2 x 66 cm)
The Museum of the City of New York

PLATE 108

Falls of Niagara

Enamel on copper, c. 1808
2½ x 2¼ in. (6.4 x 5.7 cm)
The Pennsylvania Academy of the Fine Arts; bequest of
 Eliza Howard Burd

PLATE 38

Sweetbriar

Watercolor and pencil on paper, c. 1808
6¾ x 9⅞ in. (17.1 x 25.1 cm)
The Corcoran Gallery of Art; museum purchase through a gift
 of Philip Alexius de Laszlo

PLATES 21 AND 109

Sun Reflecting on the Dew, a Garden Scene, Echo

Watercolor on paper, c. 1808
7½ x 9½ in. (19 x 24.1 cm)
The Corcoran Gallery of Art; museum purchase through a gift
 of C. Thomas Claggett, Jr.

PLATE 22

View from Belmont

Oil on canvas, c. 1808
25³/₁₆ x 37¹/₁₆ in. (64 x 94.1 cm)
The Henry Francis du Pont Winterthur Museum, Delaware

PLATE 170

The Country Seats of the United States of North America

Solitude, PLATE 118
Etching, 1808
Library of Congress

William Birch was a highly regarded miniaturist and stipple engraver. Born in Warwickshire, England, on April 19, 1755, he received his training in Bristol and London, where he apprenticed with the goldsmith Thomas Jeffreys. Exhibiting at the Royal Academy and the Society of Artists from 1774 to 1794, he was awarded a medal in 1785 from the Society of Arts for the improvements he made in the enameling process.[1]

According to Birch, he decided to emigrate to America with his son Thomas after the deaths of his patron Lord Mansfield and his friend Sir Joshua Reynolds. Going to Philadelphia, where he had distant relatives, he presented a letter of introduction from Benjamin West to William Bingham, who employed him as a drawing instructor for his daughters.[2] Soon he established himself as a miniaturist. His most renowned work was a miniature after Gilbert Stuart's Lansdowne portrait of George Washington.[3]

Before his departure from England, Birch published a small volume of landscapes after works by Reynolds, West, and others, *Délices de la Grande Bretagne* (1791). In his early years in Philadelphia he undertook two similar projects. *The City of Philadelphia in the State of Pennsylvania as it Appeared in 1800* was the first comprehensive documentation of an American city. About these scenes Birch wrote, "this work stands as a memorial of Philadelphia's progress for the first century."[4] Taken from drawings by his son, the illustrations portray architectural landmarks of Philadelphia embellished with figures that accurately represent the life of what was then not only America's largest city but the country's artistic, political, and cultural center. The authors of the first complete history of Philadelphia noted:

> One of the most important matters connected with these pictures is the delineation of street scenes in the neighborhood of the buildings, which are the principal subjects of the plates. The varieties of the costumes of the men and women are interesting, curious, and amusing, showing the fashions of the day. The occupations of persons who ply their callings in the streets are shown and even amusements of the time, animation and industry, and the social differences between the artisans, laborers, and people of fashion are clearly distinguished.[5]

Birch's other volume, *The Country Seats of the United States of North America*, was published in 1808 from sketches made on a tour through Pennsylvania, Maryland, and Delaware. These were conventional country-house views not unlike those John James Barralet produced in Ireland. Birch included comments about each of the scenes, the gist being that America is a civilized nation equal in beauty to its mother country. In *Sun Reflecting on the Dew, a Garden Scene, Echo,* Birch portrays the American countryside as lush and undisturbed, a kind of Eden. He comments, "the comforts and advantages of a Country Residence, after domestic accommodations are consulted, consist more in the beauty of the situation, than in the massy magnitude of the edifice." Nature in Birch's views has an air of elegance and calm beauty. This is different from the compositions of his compatriot Joshua Shaw, who depicted the wilder aspects of American landscape in *Picturesque Views of American Scenery.*

Birch began a second series of country seats, for which the watercolor *Sweetbriar* may have been intended. This project and another to depict views of New York went uncompleted for lack of subscriptions.[6]

After living in the country near Bristol, Pennsylvania, for fifteen years, Birch returned in 1828 to Philadelphia, where he died six years later.

KK

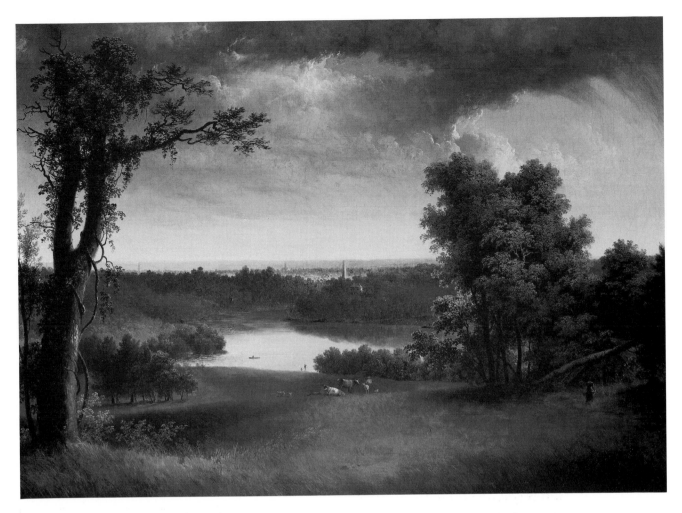

PLATE 170. WILLIAM BIRCH, *View from Belmont*, c. 1808.

1. Jean Lambert Brockway, "William Birch: His American Enamel Portraits," *Antiques* 24 (September 1933): 94.

2. William Birch, "Autobiography," Manuscript Collection, Pennsylvania Historical Society, pp. 33-34.

3. There are two known copies of this miniature. One executed c. 1800 is owned by the R. W. Norton Art Gallery, Shreveport, Louisiana. The other, dated c. 1820, is privately owned.

4. William Birch and Son, *The City of Philadelphia in the State of Pennsylvania as it Appeared in 1800* (Pennsylvania, December 31, 1800), preface.

5. J. Thomas Scharf and Thomas Westcott, *History of Philadelphia* (Philadelphia: L. H. Everts, 1884), p. 1056.

6. *Philadelphia: Three Centuries of American Art* (Philadelphia: Philadelphia Museum of Art, 1976), p. 181.

BIBLIOGRAPHY

William Spohn Baker. *American Engravers*. Philadelphia: Gebbie & Barrie, 1875.

William Russell Birch. "The Life of William Russell Birch Enamel Painter. Written by Himself." Historical Society of Pennsylvania.

———. *The Country Seats of the United States of North America*. Philadelphia, 1808.

——— and Son. *The City of Philadelphia in the State of Pennsylvania as it Appeared in 1800*. Pennsylvania, December 31, 1800.

Philadelphia: Three Centuries of American Art. Philadelphia: Philadelphia Museum of Art, 1976.

Marvin C. Ross. "William Birch: Enamel Miniaturist." *American Collector* 11 (July 1940): 5, 20.

Martin P. Snyder. "William Birch: His Philadelphia Views." *Pennsylvania Magazine of History and Biography* 73 (July 1949): 271-315.

WILLIAM BURGIS

active 1718–1731

A South East View of Ye Great Town of Boston in New England in America

Engraving, c. 1722
(John Harris after Burgis)
23½ x 52¼ in. (59.7 x 132.7 cm)
American Antiquarian Society, Worcester, Massachusetts

PLATE 104

Burgis was a British artist and engraver who came from London to New York around 1718, one of the first professional engravers in the British colonies. He published *A South Prospect of New York* and moved to Boston shortly thereafter. There he published several views of the city and its buildings, including the lighthouse and Harvard College. He married a widow in 1728 and seems to have left Boston in 1731, defaulting on a civil suit and abandoning his wife.

BR

BIBLIOGRAPHY

John D. Morse, ed. *Prints in America to 1850*. Winterthur, Del., and
 Charlottesville, Va.: Henry Francis du Pont Winterthur Museum and
 University Press of Virginia, 1979.
Wendy J. Shadwell. *American Printmaking: The First 150 Years*. New York
 and Washington: Museum of Graphic Art and the Smithsonian Institu-
 tion, 1969.
Walter Muir Whitehall, ed. *Boston Prints and Printmakers 1670-1775*.
 Boston: Colonial Society of Massachusetts, 1973 (distributed by the
 University Press of Virginia).

THOMAS CARTWRIGHT

eighteenth century

See GEORGE BECK

Georgetown and Federal City, or City of Washington, PLATES
20 AND 146

Philadelphia from the Great Tree at Kensington, PLATE 168

WINTHROP CHANDLER

1747–1790

Homestead of Timothy Ruggles

Oil on canvas, late eighteenth century
31½ x 62¾ in. (80 x 159.4 cm)
Collection of Miss Julia T. Green, courtesy of the Worcester
 Art Museum

PLATE 15

Born on Chandler Hill,[1] near Woodstock, Connecti-
cut, on April 6, 1747, Chandler exemplifies the typ-
ical artisan-painter of the second half of the eigh-
teenth century. His output ranged from portraiture and
architectural decoration to carving, gilding, drafting, and
illustration.[2]

Little is known of Chandler's early training; however, in
1770 he executed the likenesses of Reverend and Mrs.
Ebenezer Devotion of Woodstock.[3] Other portraits fol-
lowed, the majority being of his family, friends, and neigh-
bors.

Another kind of portraiture practiced in eighteenth-cen-
tury America and England was the depiction of houses and
landscapes painted or hung on a panel above the fireplace.
Chandler is known to have painted at least eight overman-
tels; all were executed on wooden chimney breasts except
for *Homestead of Timothy Ruggles,* which is painted on can-
vas.[4]

General Ruggles was the father-in-law of Gardiner
Chandler of Worcester, a first cousin of the artist. A promi-
nent man with an impressive military career, Ruggles had
loyalist leanings. He was forced to take refuge with the
British in 1775, and his property in Hardwick, Massachu-
setts, was confiscated. A stone initialed "T.R." dated 1759
was discovered behind the house on the left near the well
depicted in the painting. This house is presumably the
Ruggles' homestead. Today only the cellar hole is visible,
while there are no traces of the house on the right.[5]

One of the distinguishing characteristics of Chandler's
style is his treatment of houses: trimmed in white with
black doors, they reveal a housepainter's knowledge of ar-
chitectural detail.[6] Another is the spongelike foliage.
Chandler occasionally varied his handling of trees, but his
treatment of houses remains constant. An exception is a
work in Petersham, Massachusetts, in which the artist jux-
taposed simple New England frame houses with foreign
towers and domes.[7]

The figures, animals, and birds in the *Homestead of Timo-
thy Ruggles* are typical of Chandler's compositions. In the
left foreground two hounds search for a hare, while in the
middle distance horses trot along the avenue. Such motifs
may have been borrowed from engravings or have been
inspired by imported wallpaper or design books.

Throughout his life Chandler had financial difficulties,
frequently borrowing from relatives. Although he was not
an itinerant artist like some of his contemporaries, he and
his family moved in 1785 to Worcester, Massachusetts,
where he advertised himself as a housepainter and stayed
four years. No paintings can be assigned to this period.
Sick and impoverished, Chandler returned to Thompson
Township, near Woodstock, in early 1790; he died on
July 29.

CMD

1. Still known today as Chandler Hill, this area of land was settled by
Winthrop Chandler's ancestors. Nina Fletcher Little, "Winthrop
Chandler," *Art in America* 35 (April 1947): 77.
2. Nina Fletcher Little, *American Decorative Wall Painting 1700-1850*
(Sturbridge, Mass.: Old Sturbridge Village in cooperation with Studio
Publications, New York City, 1952), p. 53.
3. Despite William Lincoln's remark in *History of Worcester* (1862) that
Chandler studied portrait painting in Boston, no supporting evidence has
been found. Little, "Winthrop Chandler," p. 78. The two portraits hang in
the old Devotion house at 347 Harvard Street, Brookline, Mass.
4. Landscapes comprised a large part of Chandler's artistic output, sug-
gesting that overmantel views may have been popular before the Revolu-
tion. Nina Fletcher Little, "Recently Discovered Paintings by Winthrop
Chandler," *Art in America* 36 (April 1948): 81.
5. Little, "Winthrop Chandler," p. 149.
6. Chandler was by profession a housepainter. James Thomas Flexner,
"An Eighteenth Century Artisan Painter," *Magazine of Art* 40 (November
1947): 275.
7. Reproduced in Little, "Winthrop Chandler," p. 156.

BIBLIOGRAPHY

American Naive Paintings from the National Gallery of Art. Washington,
 D.C.: National Gallery of Art and International Exhibitions Founda-
 tion, 1985.
James Thomas Flexner. "An Eighteenth Century Artisan Painter." *Maga-
 zine of Art* 40 (November 1947): 274-278.
Jean Lipman and Alice Winchester. *Primitive Painters in America:
 1750-1950*. New York: Dodd, Mead, 1950.
Nina Fletcher Little. "Winthrop Chandler." *Art in America* 35 (April
 1957): 77-168.
———. "Recently Discovered Paintings by Winthrop Chandler." *Art in
 America* 36 (April 1948): 81-97.
———. *American Decorative Wall Painting 1700-1850*. Sturbridge, Mass.:
 Old Sturbridge Village in cooperation with Studio Publications, New
 York, 1952.
———. *Land and Seascape as Observed by the Folk Artist*. Williamsburg:
 Abby Aldrich Rockefeller Folk Art Collection, 1969.

James Pattison Cockburn
1779–1847

Montmorency Falls

Watercolor, pen, and ink over pencil on prepared ground, 1827
12¾ x 10½ in. (32.4 x 26.7 cm)
Royal Ontario Museum, Toronto

PLATE 9

The Winter Cone of Montmorency

Watercolor over pencil, scraping, 1827
14⅞ x 22⅛ in. (37.7 x 56.1 cm)
Royal Ontario Museum, Toronto

PLATE 97

General Hospital, Quebec

Watercolor and gum arabic over graphite on Whatman wove
paper, backed by Whatman wove paper, 1830
15 x 21¹³/₁₆ in. (38 x 55.4 cm)
National Gallery of Canada, Ottawa

PLATE 98

Cockburn was born on March 18, 1779, in New York City, the son of a British artillery officer, but was raised in England. He attended the Royal Military Academy at Woolwich from 1793 to 1795, when he was commissioned as a second lieutenant in the Royal Artillery. He was posted to the Cape of Good Hope and the East Indies (1795 to 1803), and then to Denmark (1807). He first went to Canada for eight months in November 1822; he returned in 1826, staying until 1832.

Cockburn was a prolific and ambitious amateur artist, publishing aquatints of Copenhagen in 1807, Woolwich in 1816, Quebec and Niagara Falls in 1833. He wrote and illustrated several travel books of Swiss scenery in the early 1820s and also provided illustrations for other travel books. *Quebec and Its Environs, Being a Picturesque Guide to the Stranger* (Quebec, 1831) is traditionally ascribed to him. His work was well known to his contemporaries in Canada. The governor generals during his postings, Dalhousie and Alymer, both owned watercolors by him, and he is mentioned in the correspondence and journals of several other officers.

Returning to England, Cockburn was appointed director of the Royal Laboratory at the Royal Arsenal, Woolwich, in 1838, and retired as a major-general in 1846. He died on his birthday the following year.

BR

BIBLIOGRAPHY

James Pattison Cockburn. *Swiss Scenery.* London: Rodwell and Martin, 1820.
———. *Views to Illustrate the Route of Mount Cenis.* London: Rodwell and Martin, 1822.
———. *Views to Illustrate the Route of the Simplon.* London: Rodwell and Martin, 1822.
W. Martha E. Cooke. *W. H. Coverdale Collection of Canadiana: Paintings, Water-colours and Drawings (Manoir Richelieu Collection).* Ottawa: Public Archives Canada, 1983.

Charles Codman
1800–1842

Landscape

Oil on canvas on masonite panel, 1828
30¼ x 40 in. (76.8 x 101.6 cm)
Portland Museum of Art; gift of Anna Fessenden

PLATE 171

Footbridge in the Wilderness

Oil on canvas, 1830
25½ x 38½ in. (64.8 x 97.8 cm)
Portland Museum of Art

PLATE 61

The Pirate's Retreat

Oil on panel, 1830
22¾ x 28¾ in. (57.8 x 73 cm)
Courtesy of Mark Umbach, James H. Ricau Collection

PLATE 76

Charles Codman was born in Portland, Maine, in 1800. The Boston directories of 1822 and 1823 list both Charles Codman and William P. Codman as portrait painters, and it is believed that the latter was the father of Charles. If so, then it is likely that Codman received his initial training in portraiture. Known in Portland as a limner in 1823, Charles Codman is recognized today for his romantically expressive landscapes, a number of which are owned by the Portland Museum of Art.

Landscape, Footbridge in the Wilderness, and *Pirate's Retreat* are examples of Codman's painting style. Using a dark palette, he dramatized a scene by stark manipulation of light and shadow, often with the inclusion of cavernous rock formations or gnarled trees. Because of qualities such as these, Codman has been compared to Thomas Cole.[1]

Codman's potential was first recognized in 1828 by the writer and critic John Neal, who was also a native of Maine. After this, Codman began to exhibit regularly at the Boston Athenaeum. His work was also exhibited in 1832 and 1838 at the National Academy of Design, and in 1839 at the Apollo Gallery.

Many of Codman's commissions were for fireboards like those created for the John Deering house near Diamond Cove in Portland. The artist's literal interpretations of the area were so popular that they inspired Sylvester B. Beckett to write that the paintings were "almost as beautiful as the reality."[2]

Known for painting local scenes and shipwreck sites off the coast of Maine such as *Pirate's Retreat,* Codman created paintings that were either picturesque or dramatic. Whether one considers the artist's dark, expressive landscapes or those with a more subtle delicacy, it is clear that Codman was consistently able to incorporate an air of mystery into his pictures through careful control of the ele-

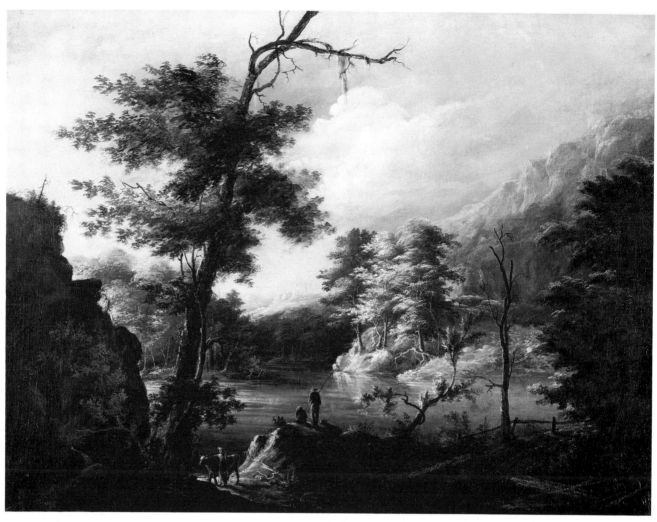

PLATE 171. CHARLES CODMAN, *Landscape*, 1828.

ments of composition. Never traveling far from his native home during his life, the artist died in Portland in 1842.

PAH

1. Matthew Baigell, *Dictionary of American Art* (New York: Harper & Row, 1979), p. 72.
2. The Beckett poem was published in 1836 in the *Portland Sketch Book*. For more details on the popularity of Beckett's poem and Codman's fireboard scenes, see *Sea and Sail: An Exhibition Catalogue* (Portland: Portland Museum of Art, 1975), p. 6.

BIBLIOGRAPHY

Sea and Sail: An Exhibition Catalogue. Portland: Portland Museum of Art, 1975.
Mabel Munson Swan. *The Athenaeum Gallery 1827-1873: The Boston Athenaeum as an Early Patron of Art*. Boston: Merrymount Press, 1940.

THOMAS COLE

1801–1848

Kaaterskill Falls

Oil on canvas, 1826

43 x 36 in. (109.2 x 91.4 cm)

The Warner Collection of Gulf States Paper Corporation, Tuscaloosa, Alabama

PLATES 63 AND 127

The Clove, Catskills

Oil on canvas, 1827

25 x 33 in. (63.5 x 83.8 cm)

The New Britain Museum of Art, Connecticut; Charles F. Smith Fund

PLATE 129

Landscape Composition, Saint John in the Wilderness

Oil on canvas, 1827

36 x 28¹⁵/₁₆ in. (91.4 x 71.9 cm)

Wadsworth Atheneum, Hartford; bequest of Daniel Wadsworth

PLATE 130

Scene from "The Last of the Mohicans," Cora Kneeling at the Feet of Tamenund

Oil on canvas, 1827

25⅜ x 35¹/₁₆ in. (64.5 x 89 cm)

Wadsworth Atheneum, Hartford; bequest of Alfred Smith

PLATE 132

View of the White Mountains

Oil on canvas, 1827

25⅜ x 35³/₁₆ in. (64.5 x 89.4 cm)

Wadsworth Atheneum, Hartford; bequest of Daniel Wadsworth

PLATE 133

Landscape with Tree Trunks

Oil on canvas, 1828

26 x 32¼ in. (66 x 81.9 cm)

Museum of Art, Rhode Island School of Design; Walker H. Kimbell Fund

PLATE 134

View near Catskills

Oil on panel, 1828–1829

24½ x 35 in. (62.2 x 89 cm)

Kennedy Galleries, New York

PLATE 136

Cole was born in Bolton-le-Moors, Lancashire, England, on February 1, 1801. The son of a woolen manufacturer, he was apprenticed to an engraver of calico designs, and by 1817 was working in Liverpool as an engraver's assistant. In July 1818 the family moved to America, where after working briefly as a wood engraver and illustrator in Philadelphia, Thomas joined his family in Ohio, working in his father's Steubenville Paper Hanging Manufactory. It was in Ohio that Cole met an itinerant artist, Stein, who taught him the techniques of portraiture. After moving with his family to Pittsburgh, he began around 1823 to make studies from nature. Cole then decided to return to Philadelphia to further his artistic education. He drew from casts at the Pennsylvania Academy of the Fine Arts, and was impressed with the landscapes of Thomas Doughty and Thomas Birch.[1] Supporting himself on meager commissions, he moved to New York in 1825 to assist his family who had recently moved there.

The summer of 1825 marked Cole's first sketching trip up the Hudson River, the fruit of which included *View of Fort Putnam* and *Kaaterskill Falls* (both unlocated) and *Lake with Dead Trees* (Oberlin College). On sale in a New York shop for twenty-five dollars apiece, the paintings caught the eye of John Trumbull, who purchased *Kaaterskill Falls.* The other two were bought by the artists Asher B. Durand and William Dunlap when Trumbull called their attention to the paintings. These works from 1825 established Cole as a visionary young artist who was among the first to celebrate the wild beauty of America, which even then was beginning to disappear.

Kaaterskill Falls is based on a detailed sketch made during Cole's first trip up the Hudson. Although the painting depicts a specific place, Cole took liberties with the site as he knew it. The observation pavilion and guard rail near the top of the falls are eliminated. In their place he has introduced an Indian, an allusion to primeval America. In *The Clove, Catskills,* bare trees dot the mountainsides rich with autumn colors, while sprigs of bright green foliage fill the foreground. The theme of growth, death, and decay in nature suggests an analogy to human life. On the passing of the storm bright sunlight illuminates the golden foliage, adding a note of optimism. *View of the White Mountains,* with mountains towering over human figures, glorifies American scenery while providing a moral lesson on man's insignificance. A pastoral vision of America is presented in *View near Catskills,* and the dramatic *Landscape with Trees* speaks of the awesome sublimity of nature. *The Last of the Mohicans* is Cole's visualization of a scene in James Fenimore Cooper's novel of that name.[2] The site depicted was by then the location of an increasingly popular tourist resort.

Saint John in the Wilderness is an early example of the artist's interest in historical landscapes in the tradition of Claude Lorrain and Salvator Rosa. Here Cole creates a landscape of the imagination. By reducing the figures to diminutive scale, he emphasizes the majesty of nature and divine power.

In 1829 Cole took his first trip to Europe. William Cullen Bryant wrote a poem of advice to the departing artist in which he cautioned him not to be seduced by Europe's attractions, but to "keep that earlier wilder image bright."[3] Although historical landscapes figure prominently in Cole's work after this trip, he never lost his fervent love for American scenery.[4] In 1836 Cole settled in the Catskills and lived out his life in the area which had been his greatest source of inspiration. He died there on February 11, 1848.

PAH

1. William Dunlap, *History of the Rise and Progress of the Arts of Design in the United States,* 3 vols. (1834; reprint, New York: Benjamin Blom, 1965), Vol. III, p. 148. For further details on the life and career of Cole through 1829 see the essay by Ellwood C. Parry III in this catalogue.

2. Cole's painting depicts a scene from chapter 29: Cora kneels to beg mercy from the tribal chief Tamenund, as Leatherstocking and his imprisoned comrades look on. Another version is in the collection of the New York State Historical Association at Cooperstown.

3. "Sonnet. To Cole the Painter on his Departure for Europe," *The Talisman for 1830* (New York, 1829), p. 336.

4. See Cole's "Essay on American Scenery" (1835) reprinted in John W. McCoubrey, *American Art 1700-1960: Sources and Documents* (Englewood Cliffs, N.J.: Prentice-Hall, 1965), pp. 102-108.

BIBLIOGRAPHY

Matthew Baigell. *Thomas Cole.* New York: Watson-Guptill Publications, 1981.

John W. McCoubrey. *American Art 1700-1960: Sources and Documents.* Englewood Cliffs, N.J.: Prentice-Hall, 1965.

J. Bard McNulty, ed. *The Correspondence of Thomas Cole and Daniel Wadsworth* (Hartford: Connecticut Historical Society, 1983).

Howard S. Merritt. *Thomas Cole (1801-1848).* New York: University of Rochester, 1969.

Louis L. Noble. *The Life and Works of Thomas Cole.* Elliot S. Vesell, ed. Cambridge, Mass.: Harvard University Press, 1964.

Barbara Novak. "Thomas Cole and Robert Gilmor." *Art Quarterly* 25 (September 1962): 41-53.

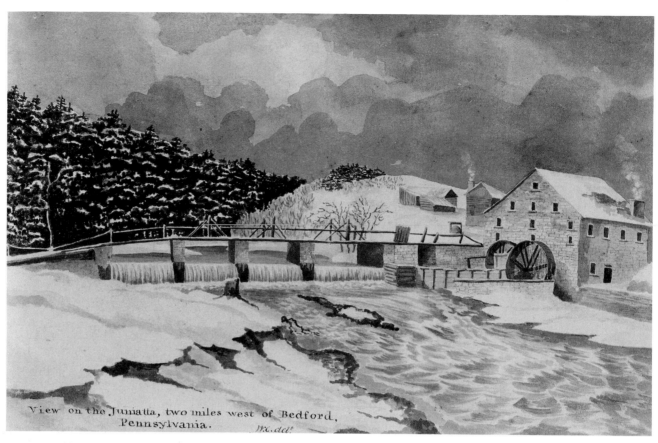

PLATE 172. WILLIAM CONSTABLE, *View on the Juniata*, 1807.

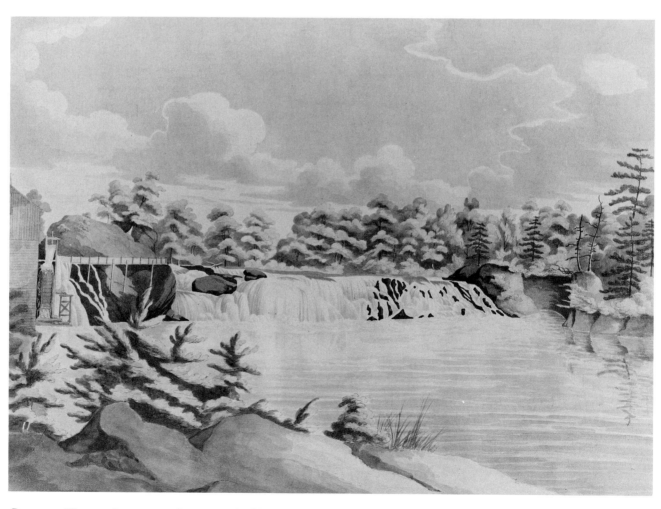

PLATE 173. WILLIAM CONSTABLE, *The Upper Falls of the Kinderhook*, 1808–1820.

WILLIAM CONSTABLE

1783–1861

The Great Falls of the Genesee

Watercolor on paper, 1806
12 x 15½ in. (30.5 x 39.4 cm)
Milberg Factors, Inc.

PLATES 41 AND 152

View of the Juniata

Watercolor on paper, 1807
8 x 12½ in. (20.3 x 31.8 cm)
Hirschl & Adler Galleries, New York

PLATE 172

The Upper Falls of the Kinderhook

Watercolor on paper, 1808–1820
12½ x 17½ in. (31.75 x 44.4 cm)
Collection of Mellon Bank, Pittsburgh

PLATE 173

Little is known of Constable's early life, except that he was born in 1783 and learned to draw as an apprentice in an engineering firm in Lewes, England. At the turn of the century he and his brother Daniel established a drapery business in Brighton, which they sold to finance their trip to the United States in 1806.[1] Shortly after their arrival in July Constable began taking painting lessons.[2] At the end of that month the brothers set out on a sightseeing trip. Traveling on horseback and by river boat, they covered over 13,000 miles before they returned home in 1808.[3] In August and September they visited New Jersey and New York, where the Passaic, Mohawk, Niagara, and Genesee Falls were among sites seen and sketched. Drawings made on the spot were used subsequently for the watercolors Constable produced at home. Such is the case with *The Great Falls of the Genesee,* for which there is a study dated September 6, 1806.

In late 1806 and 1807 the Constables traveled west to Ohio and Indiana and rode flatboats down the Ohio and Mississippi rivers to Louisiana. By June 1807 they were in Virginia viewing the Blue Ridge Mountains and the Shenandoah and Potomac rivers. Moving up the East Coast, they journeyed into New England. During this trip Constable made sketches of Little River Falls at Norwich, Connecticut, and Mount Monadnock in New Hampshire. September found them in Pennsylvania. By December they were in the Allegheny Mountains in the western part of the state. From the summit of Allegheny Ridge Constable sketched a view of the passage of the Connemaugh River through the Laurel Mountains, which served as the basis for *Allegheny Ridge* (Hirschl & Adler Galleries) painted later in England.[4]

With tension increasing between the United States and Britain, the Constable brothers departed for England in 1808. There William converted many of his sketches into finished watercolors and oils. Displaying in their linearity a certain naïveté, Constable's charming sketches and crystalline colors provide an important early record of America's rapidly developing waterways at the same time that they reveal a fresh response to the country's varied landscape.

Constable stopped painting in the 1840s and took up photography, establishing a studio in Brighton.[5] He died in 1861.

JAH

1. Intro., *Early Topographical Views of North America by William Constable (1783–1861)* (New York: Wunderlich & Co., 1984). Documentation on Constable is limited. The itinerary discussed herein is based in large part on a chronology constructed from a catalogue of his works.
2. "William Constable (1783–1861)." *Kennedy Quarterly* 7 (December 1967): 245. Daniel Constable recorded this event in his journal for July 9, 1806, while neglecting to note the teacher.
3. *Early Topographical Views,* Intro.
4. *Ibid.* According to David Grece, a contemporary chronicler of Constable's work, he painted the watercolors and oils from his American sketchbook between 1808 and 1820.
5. Maria Naylor, art historian and consultant to Wunderlich & Co., New York.

BIBLIOGRAPHY

Early Topographical Views of North America by William Constable (1783–1861). New York: Wunderlich & Co., 1984.
"William Constable 1783–1861." *Kennedy Quarterly* 7 (December 1967): 245.

MICHELE FELICE CORNÈ

c. 1752–1845

Ezekiel Hersey Derby Farm, South Salem, Massachusetts

Oil on canvas, c. 1800
40 x 53½ in. (101.6 x 135.9 cm)
Private collection

PLATE 28

The Landing of the Pilgrims

Oil on canvas, 1803
36 x 56 in. (91.4 x 142.2 cm)
Diplomatic Reception Rooms, Department of State, Washington, D.C.

PLATE 174

Classical Landscape

Oil on canvas, 1804
34 x 51 in. (86.4 x 129.5 cm)
Child's Gallery, Boston and New York

PLATE 79

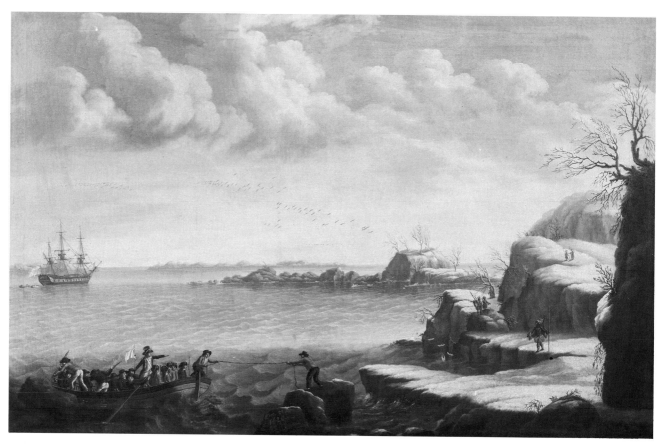

PLATE 174. MICHELE FELICE CORNÈ, *The Landing of the Pilgrims*, 1803.

ittle is known of the early years of the artist, other
than his birth on the Italian island of Elba, probably
in 1752. In 1779 Cornè is known to have been in the
service of the Neapolitan army during a war which resulted
from the French invasion of Naples. Apparently seeking
refuge from this, Cornè was taken aboard the *Mount Vernon*, a merchant ship commanded by Elias Hasket Derby,
Jr., of Salem, Massachusetts. It is believed that during the
eight-month voyage to America Cornè paid for his passage
by painting views of the *Mount Vernon*. Portraits of the
Derby vessel constitute only a small portion of such paintings executed by Cornè for other merchant residents of the
artist's newly adopted home of Salem.

It is likely that Cornè received his initial training as an
ornamental painter before leaving Italy, and with the support of the Derby family he received many commissions
for decorative fireboards, overmantels, and wall murals.
Some of these can still be found in New England homes,
such as the Sullivan Dorr house in Providence.

Today Cornè is perhaps best known for his marine
paintings; however, his charming landscapes also deserve
attention. One imaginative example is his *Classical Landscape*, which shows a community of workers at various
stages of their tasks. A couple in the foreground rests,
while a young boy takes up a hoe and a man drives a team of
oxen. Near the river two women carry laundry on their
heads, as fishermen try their luck from a small boat. A
building in the background and a ship in the harbor introduce themes of commerce as well as agriculture into an
idyllic landscape reminiscent of Italy.

The artist's descriptive style is seen at its best in his
painting of the Derby farm. Purchased in 1800 by Ezekiel
Hersey Derby, son of Elias Hasket Derby, the country estate was faithfully recorded by Cornè. The main house,
barns, and distant summer house are included along with
the Derby family coach.

In the *Landing of the Pilgrims*, Cornè combines elements
of landscape with seascape. American Indians approach in
greeting as a landing party, attired in clothes of Cornè's
day, arrives on the shores of Plymouth where a rock already
bears the 1620 date of their arrival. A source for the Pilgrim
design may have been an engraving by Samuel Hill, which
was reproduced as the upper half of a dinner invitation.[1]

Applying his skill with crisp outline and cool colors,
Cornè contributed a fresh virtuosity to early New England
landscapes. After a long life of ninety-three years, the artist
died on July 10, 1845, at his home in Newport, Rhode Island.

PAH

1. The dinner invitation was issued by the "Sons of Pilgrims," a
Boston group that met on December 22, 1800, to celebrate the 180th anniversary of the Pilgrims' landing. For further information, see Nina
Fletcher Little, Intro. to *Michele Felice Cornè: Versatile Neapolitan Painter
of Salem, Boston, and Newport* (Salem, Mass.: Peabody Museum of Salem,
1972), p. xii.

BIBLIOGRAPHY

Nina Fletcher Little. *Paintings by New England Provincial Artists: 1775–
1800*. Boston: Museum of Fine Arts, 1976.
———. *Michele Felice Cornè, Versatile Neapolitan Painter of Salem,
Boston, and Newport*. Salem, Mass.: Peabody Museum of Salem, 1972.
———. *Sea and Sail: An Exhibition Catalogue*. Portland, Maine: Portland
Museum of Art, 1975.

THOMAS DAVIES

c. 1737–1812

The Falls of Otter Creek, Lake Champlain, with a Saw Mill

Watercolor, black ink margins on paper, 1766
14⁷⁄₁₆ x 20 ³⁄₁₆ in. (36.6 x 51.3 cm)
Royal Ontario Museum, Toronto

PLATE 88

View of the Lines at Lake George

Oil on canvas, c. 1774
25½ x 30¼ in. (64.8 x 77 cm)
Fort Ticonderoga Museum, New York

PLATE 7

Sketchbook

A View of the Attack against Fort Washington and Rebel Redouts near New York on the 16 of Nov. 1776. . ., PLATE 52

A View near Morris House Looking Down Harlem Creek towards New York, PLATE 175

A View of the Hudson River taken near Kings Bridge Looking up towards Tapan Sea, PLATE 176

Watercolor, black wash, pen and ink, and graphite, c. 1773–1797
National Gallery of Canada, Ottawa

View of the Hudson River Looking Down toward New York from Fort Knyphausen

Watercolor on paper, 1779
13⅝ x 20¾ in. (34.6 x 52.7 cm)
Royal Ontario Museum, Toronto

PLATE 177

Chaudière Falls near Quebec, Canada

Watercolor and gouache over pencil on paper, 1792
14⅞ x 20⅝ in. (37.8 x 52.4 cm)
Public Archives Canada, Ottawa

PLATE 178

An officer in the British Colonial Army, Davies captured in his charming watercolors the character of early settlements and the yet untamed nature of North America. Drawing was an essential part of an officer's training, since it was useful in depicting the topography of an area of possible military interest. During Davies'

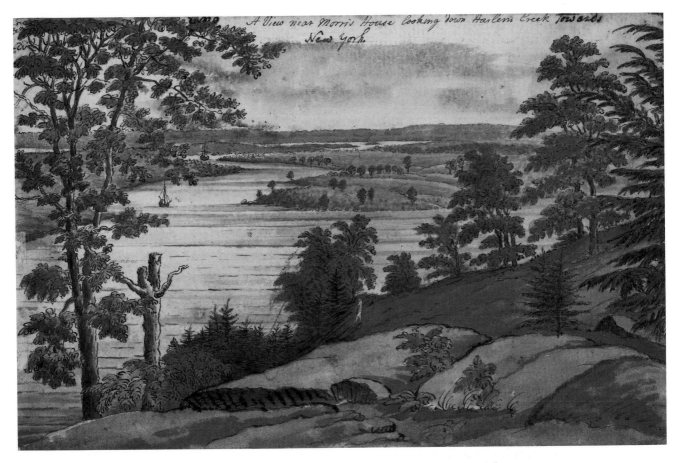

PLATE 175. THOMAS DAVIES, *A View near Morris House Looking down Harlem Creek towards New York* from *Sketchbook*, c. 1773–1797.

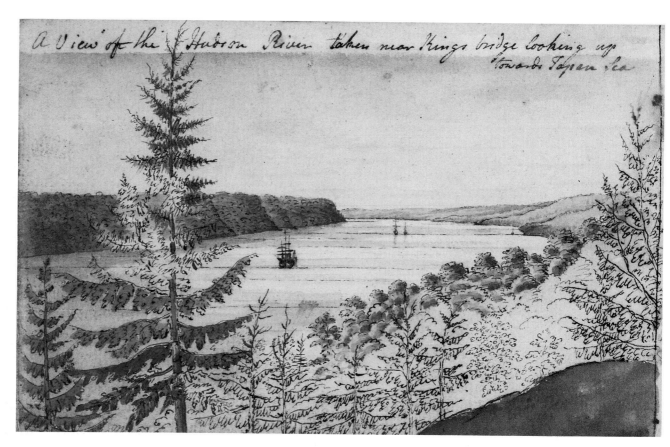

PLATE 176. THOMAS DAVIES, *A View of the Hudson River taken near Kings Bridge Looking up towards Tapan Sea,* from *Sketchbook,* c. 1773–1797.

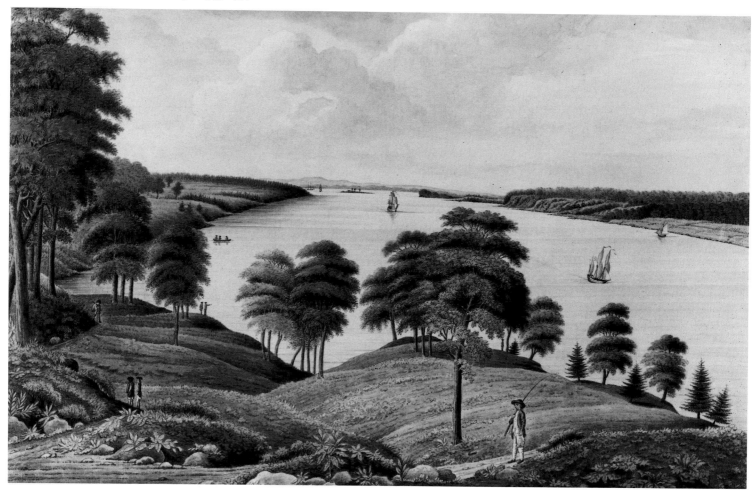

PLATE 177. THOMAS DAVIES, *View of the Hudson River Looking down towards New York from Fort Knyphausen,* 1779.

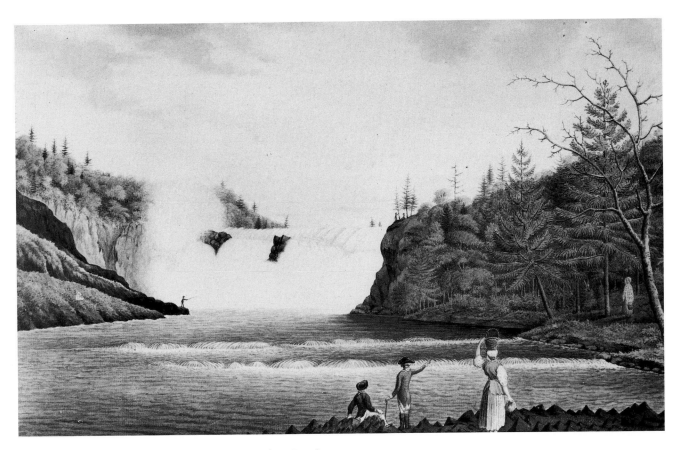

PLATE 178. THOMAS DAVIES, *Chaudière Falls near Quebec, Canada*, 1792.

free time, he also used his skills to record with freshness the unique qualities of the American landscape. He exhibited his compositions periodically at the Royal Academy from 1771 until 1806.

Davies, who began his military career in 1756 as a lieutenant in the Royal Artillery, probably studied in 1755 with Gamaliel Massiot, the drawing master at the Royal Military Academy at Woolwich. He arrived in Canada in 1757, and in the following year he participated in General Sir Jeffrey Amherst's successful expedition against Louisbourg. It was during this tour of duty that he made the sketches which he later developed into the *View of the Lines at Lake George*. He also drew several views of waterfalls which later were engraved and published (in 1768) as a series of six plates dedicated to Amherst. In drawings intended for military use, Davies took few liberties with details: mountains and trees may be reflected in the water; foliage may bracket the scene to create a picturesque composition, but such elements seldom interfere with the topography. With their breadth and clarity, the watercolors reveal a sympathy with nature.

In 1763 Davies returned to England, and the following year saw him in New York. The watercolors of succeeding years such as *The Falls of Otter Creek* mark the beginning of Davies' mature style: the delicate drawing, the fresh colors, the clear light, the crystalline water, are characteristics of this period. Still, Davies' scenes remain topographically faithful, filled with authentic details of places and people.

After a lengthy trip to England Davies embarked on his third tour of duty in North America in 1773. He served as captain of artillery against the rebellious American colonies

and made detailed drawings of several battle scenes. The sketchbook of the Hudson and his view of that river from Fort Knyphausen show the military draftsman's preoccupation with topography, but the style is modified by the aesthetic concerns of the artist.

At the end of the war he again returned to England. Davies' fourth and final tour of Canada and America (1786–1790) was his most productive artistic period. He perfected his mature painting style, executing some spectacular watercolors of waterfalls and of views along the Saint Lawrence River, of which *Chaudière Falls* is an example. With economy of line and sensitivity of color, these works show Davies in full command of the watercolor technique.

In 1781, in recognition of his interests in natural history, particularly ornithology, Davies was elected a fellow of the Royal Society, and membership in the Linnean Society followed. He rose to the rank of lieutenant general. He died in Blackheath, a suburb of London, on March 16, 1812.

MSM

BIBLIOGRAPHY

Mary Allodi. *Canadian Watercolors and Drawings in the Royal Ontario Museum*. Toronto: Royal Ontario Museum, 1974.

W. Martha E. Cooke. *W. H. Coverdale Collection of Canadiana: Paintings, Water-colours and Drawings (Manoir Richelieu Collection)*. Ottawa: Public Archives Canada, 1983.

R. H. Hubbard. *An Anthology of Canadian Art*. Toronto: Oxford University Press, 1960.

———. *Thomas Davies*. Ottawa: National Gallery of Canada, 1972.

Richard J. Koke. *American Landscape and Genre Paintings in the New-York Historical Society*. Boston: New-York Historical Society with G.K. Hall, 1982. Vol. I.

THEODOR DE BRY

1528–1598

See JOHN WHITE
Incolarum Virginiae piscandiratio, PLATE 4

JOSEPH FREDERICK WALSH DESBARRES

1722–1824

A View of the Entrance of Port Hood, from The Atlantic Neptune

Engraving, 1773
20⅞ x 29⅝ in. (53.9 x 76.1 cm)
Library of Congress
PLATE 90

DesBarres was born in either Paris or Switzerland and was educated in mathematics and engineering in Basel. Around 1752 he entered the Royal Military Academy at Woolwich. In 1756 he was commissioned in the Royal American Regiment and, as an aide-de-camp to General James Wolfe, was active in the French and Indian War. From 1763 to 1773 he surveyed the coast of Nova Scotia. During the American Revolution he gathered together his charts and views, and those of several other engineers, to produce for the Royal Navy *The Atlantic Neptune,* published in four volumes from 1777 to 1784. Although the majority of the plates are charts, several topographical views of harbors and other significant features, such as *A View of the Entrance of Port Hood,* were included.

DesBarres' skills were recognized with his appointment as lieutenant governor of Cape Breton from 1784 to 1787. After a stormy tenure, he returned to London to advance his claims for back pay and ownership of *The Atlantic Neptune* and to silence his critics. In 1805 he returned to Canada as lieutenant governor of Prince Edward Island, where he was a successful administrator. Retiring in 1813, DesBarres lived on his estates in Nova Scotia until October of 1824, when he died in Halifax at the age of 102.

BR

BIBLIOGRAPHY

Donald H. Cresswell. *The American Revolution in Drawings and Prints: A Checklist of 1765–1790 Graphics in the Library of Congress.* Washington, D.C.: Library of Congress, 1975.
G. N. D. Evans. *Uncommon Obdurate: The Several Public Careers of J. F. W. DesBarres.* Salem, Mass.: Peabody Museum and University of Toronto Press, 1969.

THOMAS DOUGHTY

1793–1856

View of Baltimore from Beech Hill, the Seat of Robert Gilmor, Jr.

Oil on wood, 1821
12⅞ x 16⅝ in. (32.8 x 42.2 cm)
The Baltimore Museum of Art; gift of Dr. and Mrs. Michael A. Abrams
(Corcoran only)
PLATE 73

Landscape with Pool

Oil on canvas, c. 1823
18¾ x 25½ in. (47.6 x 64.8 cm)
The Pennsylvania Academy of the Fine Arts; Henry C. Carey Collection
PLATE 179a

Landscape: Delaware Water Gap

Oil on canvas, 1826
20 1/10 x 28 in. (51.1 x 71.3 cm)
The Boston Athenaeum
PLATES 3 AND 131

On the Beach

Oil on canvas, 1827–1828
35 x 51½ in. (88.9 x 130.8 cm)
Albany Institute of History and Art; bequest of Rev. Gardner Monks
PLATE 75

Catskill Falls, frontispiece from Theodore Dwight, The Northern Traveller, 3rd ed., 1828

Engraving
(George B. Ellis after Doughty)
The Library Company of Philadelphia
PLATE 64

Girls Crossing the Brook

Oil on canvas, 1829
23¾ x 30 in. (63.6 x 100.6 cm)
Private collection
PLATE 74

Lake Scene

Oil on canvas, c. 1830
25 x 36 in. (63.5 x 91.4 cm)
The Library Company of Philadelphia
PLATE 179b

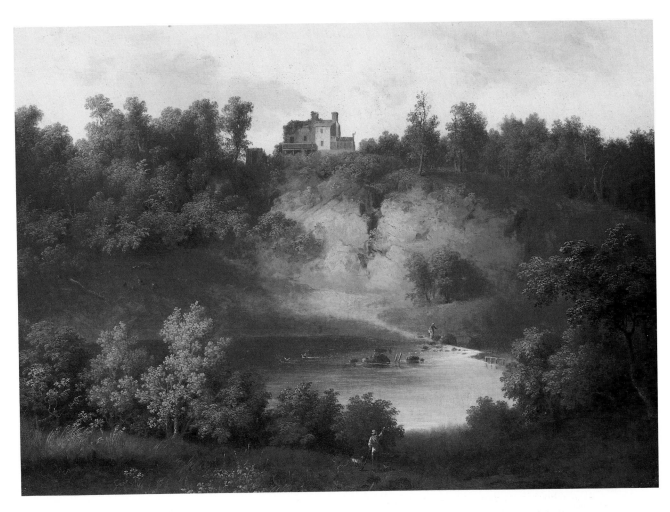

PLATE 179a. THOMAS DOUGHTY, *Landscape with Pool*, c. 1823.

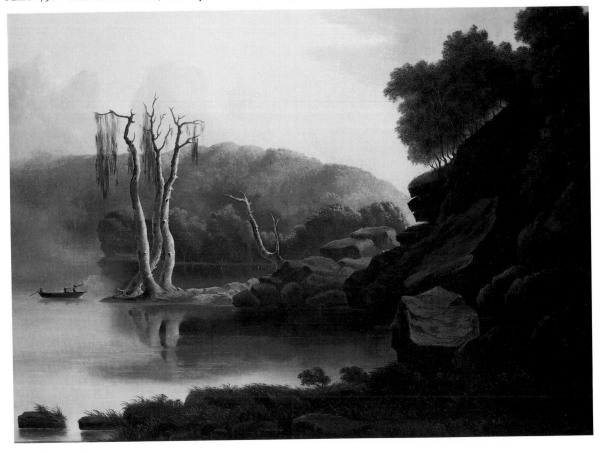

PLATE 179b. THOMAS DOUGHTY, *Lake Scene*, c. 1830.

The tranquil landscapes of Thomas Doughty reflect a change in early-nineteenth-century American art from view painting to painting nature. While still closely observing local scenery, Doughty began to suffuse his works with atmospheric effects. By depicting nature for its own sake rather than just portraying a specific locale, Doughty was a pioneer in the development of a native landscape tradition, which began to celebrate the natural beauties of America.

Doughty was born in Philadelphia on June 19, 1793. In 1820, after giving up his leather business to pursue painting, he was listed in the Philadelphia directory as a "landscape painter," thereby becoming the first native-born American artist to devote himself to that field.[1] Doughty had no formal training beyond a few drawing lessons in school and what he described as "one quarter in night school taking a course in drawing in India Ink."[2] As a youth, he spent much time roaming the region around Philadelphia. An inveterate sketcher, he tried his hand at a few oil works, which he later described as "mere daubs."[3] His style was formed by copying European paintings at the Pennsylvania Academy of the Fine Arts and in the collection of his early patron, Robert Gilmor, Jr., of Baltimore.[4] Doughty also probably referred to popular instruction manuals and learned from other artists.

Doughty's landscapes met with early success. By 1822 he was exhibiting at the Pennsylvania Academy and receiving commissions from Gilmor to paint views of his estate outside Baltimore (Plate 73). In most of these views Doughty included strolling figures and identifiable landmarks, but the landscape, bathed in a warm diffused light, was the primary subject. In another early work, *Landscape with Pool,* Doughty's lyrical interpretation of nature is evident. A house, covered in ivy like a ruin, overlooks a placid pond, encircled by wooded hills. Figures appear along the shore. A painterly concern for light and atmosphere is visible in the soft tonalities and generalized forms.

Elected a member of the Pennsylvania Academy in 1824, Doughty also became an honorary member of the National Academy of Design in New York three years later. In the same year he began exhibiting works at the Boston Athenaeum. One of the paintings probably exhibited there was *Landscape: Delaware Water Gap.* The location is in eastern Pennsylvania, a favorite sketching spot for Doughty in the mid-1820s.[5] This particular view, reminiscent of Claudian landscapes, consists of graceful trees in the foreground, a winding river, mountains in the background, and a light-filled sky. Doughty portrays with accuracy the varied foliage, rough jutting rocks, and scraggly bushes — the unique American qualities of the scene. The figures upon the grassy hill and sailboats upon the calm water are in harmony with the tranquil summer day.

From 1826 to 1832 Doughty worked alternately in Philadelphia and Boston, making journeys to New Hampshire, Maine, and New York. Two paintings from this period, *On the Beach*[6] and *Girls Crossing the Brook,* exhibit the particularly luminous qualities of Doughty's mature style. The former work shows the artist's tendency in this period to portray a sense of the power and majesty of nature. With the cascading water, windswept sky, and hazy distant vista, Doughty suggests nature's sublime qualities. Yet in both paintings he imbues the landscape with a sense of order. The presence of man, the delicate trees, and the soft lighting reveal Doughty's preference for the pastoral vision of America's landscape. In the stunning *Lake Scene* a hunter breaks the eerie stillness of the calm morning by shooting from a small boat upon the silent lake.[7] Yet, with its pervading yellow and gray light, the landscape is all that is quiet and lovely, romantic and beautiful in nature.

Settling in Boston in 1832, Doughty opened a studio to teach drawing and painting. In 1837, at the age of forty-four, he made his first trip to England; a second trip followed in 1847. In 1852 he moved to Oswego, New York, and stopped painting in the next year. Although he enjoyed a considerable reputation during his lifetime, he died in New York City an impoverished man on July 24, 1856.

MSM

1. Howard N. Doughty, "Biographical Sketch of Thomas Doughty," transcript, National Museum of American Art, 1969, p. 15.
2. William Dunlap, *The History of the Rise and Progress of the Arts of Design in the United States,* 3 vols. (1834; reprint, New York: Benjamin Blom, 1965), Vol. III, p. 175.
3. *Ibid.*
4. See Frank Goodyear, *Thomas Doughty* (Philadelphia: Pennsylvania Academy of the Fine Arts, 1973), p. 13.
5. *Ibid.,* p. 21.
6. The exact location of this beach has not been determined, but it may be the Adirondack Mountains (*ibid.,* p. 23).
7. An earlier version, *Carolina Swamp* (1825), is in a private collection. *Ibid.,* p. 22, No. 5.

BIBLIOGRAPHY

Howard N. Doughty. "Biographical Sketch of Thomas Doughty." Transcript. National Museum of American Art, 1969.
Frank Goodyear. *Thomas Doughty.* Philadelphia: Pennsylvania Academy of the Fine Arts, 1973.
Sona K. Johnston. *American Paintings.* Baltimore: Baltimore Museum of Art, 1983.
Richard J. Koke. *American Landscape and Genre Paintings in the New-York Historical Society.* Boston: New-York Historical Society with G.K. Hall, 1982. Vol. I.

THEODORE DWIGHT

1796–1866

See THOMAS DOUGHTY
Catskill Falls, from *The Northern Traveller,* PLATE 64

RALPH EARL

1751–1801

A View of Bennington

Oil on canvas, 1798
35¼ x 59¾ in. (89.5 x 151.8 cm)
The Bennington Museum, Bennington, Vermont

PLATE 154

While best known for his realistic portraits of Americans during the Federal period, Ralph Earl also succeeded in cultivating a taste for regional landscape views, particularly among his patrons in Connecticut, Western Massachusets, and Vermont. A trademark of his portraiture in these regions is the detailed landscape views, frequently including his patrons' newly constructed houses, which appear as window vignettes or as backdrops in his portraits. As a result of the popularity of his portrait style, Earl received several commissions to paint pure landscapes during the latter part of the 1790s.

Earl was born in Worcester County, Massachusetts, to a prominent family of farmers and craftsmen. Little is known of his early artistic training before he established himself as a portrait painter in New Haven between 1774 and 1777. During this period he was exposed to the portraits of John Singleton Copley, whose works had an enduring impact on the artist. As William Dunlap related, Earl painted portraits at this time "in the manner of Copley," including his notable portrait of *Roger Sherman* (Yale University Art Gallery), of about 1776–1777.[1] In addition, Earl produced four sketches of the sites of the Battle of Lexington and Concord, which were engraved in 1776 by his associate Amos Doolittle.

A loyalist, Earl fled his native country for England in 1778. There he received some instruction under Benjamin West and exhibited several portraits at the Royal Academy in 1783 and 1784. It was during his English years that Earl first acquired an interest in landscape painting. The tradition of country house painting and sporting art inspired the landscape vignettes that first appear in his English portraits.

In 1785, after the war, Earl returned to America and settled in New York. Because of a small debt that he was unable to repay, the artist was imprisoned as a debtor from 1786 to 1788. He eventually obtained his freedom by painting portraits of prominent New Yorkers, most of whom belonged to a newly formed benevolent organization called the Society for the Relief of Distressed Debtors.[2] Upon his release from prison, Earl was appointed a guardian, Dr. Mason Fitch Cogswell. When Cogswell moved his medical practice to Hartford in 1789, he assisted Earl in obtaining important portrait commissions in Connecticut.

It was during the 1890s that the artist established the style that has come to be associated with portraiture in Connecticut. His upbringing in nearby Worcester County allowed him to temper the academic style he had learned in England to suit the more modest ambitions of his Connecticut patrons. Although he retained some of the conventions of English portraiture in the grand manner, including the large scale and the use of red curtains to enhance the sitter's importance, for the most part Earl's Connecticut portraits are noteworthy for their departures from such conventions. He tightened his brushwork, painting in a more linear fashion than seen in his English or New York portraits. He did not attempt to idealize his subjects but instead created "true" likenesses of his sitters shown in their own environment.

Earl's skill as a landscape painter was welcomed and encouraged by his later Connecticut patrons, as land ownership was an especially important vehicle for conveying status. In 1796 Earl received three commissions to paint landscapes which included the newly constructed houses of his patrons in Litchfield County.[3] In 1798 while painting in Bennington, Vermont, Earl executed the detailed landscape *A View of Bennington,* which includes a self-portrait of the artist.

During his final years, from 1799 to 1801, Earl settled in Northampton, Massachusetts, where he continued to paint portraits and instructed several students, including his son Ralph Eleazer Whiteside Earl. In 1799 Earl and two business associates, Hezekiah Hutchins and the ornamental painter Jacob Wicker, left Northampton for Niagara Falls. In so doing Earl became the first American artist to travel to Niagara, where he made sketches of the "Stupendous Cataract." The men returned to Northampton, and with Wicker's assistance Earl produced a "Prospectus" of the falls that measured fourteen by twenty-four feet. The panorama was exhibited to the public in the Hall of the Tontine Building in Northampton. From there it was sent on a tour to the major cities in America and was last noted in London.[4] In 1800 Earl painted *Looking East from Denny Hill* (Worcester Art Museum), a landscape commissioned by Colonel Thomas Denny of Leicester, Massachusetts, showing the view from his property of the towns of Worcester and Shrewsbury.

Earl died at the home of Dr. Samuel Cooley in Bolton, Connecticut. The cause of death was recorded by the minister of that town, Reverend George Colton, as "intemperance."

EMK

1. William Dunlap, *History of the Rise and Progress of Design in the United States,* 3 vols. (1834; reprint, New York: Benjamin Blom, 1965), Vol. I, pp. 263–264. Elizabeth Kornhauser, "Ralph Earl, 1751–1801," Ph.D. dissertation, Boston University, Ch. 3 (forthcoming).
2. Elizabeth Kornhauser, "Ralph Earl as an Itinerant Artist: Pattern of Patronage," in Peter Benes, ed., *Itinerancy in New England and New York: Annual Proceedings of the Dublin Seminar for New England Folklife,* No. 9 (Boston: Boston University Press, 1986).
3. The three landscapes include *Ruggles Homestead* (private collection), *View of the Canfield House* (Litchfield Historical Society), and *The Boardman House* (private collection).
4. Kornhauser, "Ralph Earl," Ph.D. dissertation, Ch. 5.

BIBLIOGRAPHY

Laurence B. Goodrich. *Ralph Earl: Recorder of an Era.* Binghampton: State University of New York, 1967.
Elizabeth Mankin Kornhauser. "Ralph Earl as an Itinerant Artist: Pattern of Patronage." *Itinerancy in New England and New York: Annual Proceedings of the Dublin Seminar for New England Folklife,* No. 9. Peter Benes, ed. Boston: Boston University Press, 1984.
_____. "Regional Landscape Views: A Distinctive Element in Connecticut River Valley Portraits, 1790–1810." *Antiques* (November 1985): 1012–1019.
_____. "Ralph Earl, 1751–1801." Ph.D. dissertation, Boston University. Forthcoming.
_____ and Christine Skeeles Schloss. "Painting and Other Pictorial Arts." *The Connecticut River: Art and Society of the Connecticut River Valley.* Hartford: Wadsworth Atheneum, 1985.
William and Susan Sawitsky. "Two Letters from Ralph Earl with Notes on His English Period." *Worcester Art Museum Annual* 8 (1960): 8–41.
Harold Spencer. *The American Earls: Ralph Earl, James Earl and R. E. W. Earl.* Storrs, Conn.: William Benton Museum of Art, 1972.

RALPH ELEAZER WHITESIDE EARL

1785/1788–1838

Cumberland River

Oil on canvas, 1823
31 x 39 in. (78.7 x 99 cm)
Museum of Early Southern Decorative Arts

PLATES 83 AND 157

No record of birth exists for Ralph E. W. Earl, who was the son of Ralph Earl and his second wife, Anne Whiteside Earl, of Norwich, England. It is likely that he was born in 1785, the year of his parents' arrival in America, or in 1788, after his father's release from debtor's prison.[1] R. E. W. Earl received early artistic training from his father and is probably represented as one of the young boys in *A View of Bennington* (Plate 154), painted by his father in 1798. The first known signed portrait by R. E. W. Earl is of *Edward Gere* (private collection), dated 1800. Ralph Earl, Sr., painted portraits of the subject's parents, *Mr. and Mrs. Isaac Gere,* of Northampton, Massachusetts, also dated 1800.[2] After the elder Earl's death in 1801, his son continued to paint portraits in the style of his father in the upper Connecticut River Valley. For instance, Earl's portraits frequently include landscape vignettes that are seen through windows.

In 1809 Earl left for London, where he received encouragement from John Trumbull and Benjamin West. In 1810 he moved to Norwich, where he lived with his mother's father and brother and received patronage from Colonel John Money, who had earlier assisted his father. Earl wrote of his good fortune to Trumbull in February 18, 1810:

I have taken the liberty to inform you and Mrs. Trumbull of my success on coming to Norwich knowing you to have much interest in my welfare – General Money whom you have heard me mention was my father's friend has become my friend, and have just finished a portrait of him to his satisfaction. . . . The General is a particular friend of the Duke of Kent whom he is going to solicit the favour to let me paint his portrait for him. . . .[3]

Four years later the artist traveled to Paris, where he spent nearly a year.

Earl returned to America in 1815, landing in Savannah. Influenced by the history paintings of West and Trumbull, he planned to produce a painting of the Battle of New Orleans. Earl traveled throughout the South, to Alabama, Mississippi, Kentucky, and Tennessee, in order to take likenesses of the heroes of this battle. It was on this trip that he first encountered General Andrew Jackson, initiating a lifelong friendship.

Settling in Nashville in 1817, Earl became the leading portrait painter in Tennessee. There he painted numerous portraits of Jackson, and married his wife Rachel's niece, Jane Caffery. In addition to his work as an artist, Earl announced that with George Tunstall, a junior editor of the *Nashville Whig,* he would open a "museum of Natural and Artificial curiosities," much like the museum founded by Charles Willson Peale in Philadelphia in 1784. Earl produced several of the "portraits of distinguished characters in Tennessee and elsewhere," that went on display in the museum. As a result of his collecting activities for his museum, Earl was eventually appointed custodian of the Tennessee Antiquarian Society. The landscape *Cumberland River* of 1823 is the only known landscape by Earl.

Andrew Jackson was elected president in 1828, and in the same year his wife died. President Jackson wrote from the White House to his good friend Earl on March 16, 1829: "I find myself very lonesome, I wish you were here. . . . In your society I would find some solace to my grief. . . ."[4] In June of that year, Earl moved to the White House as "Court Painter." For the next eight years he painted portraits of Jackson and numerous visitors to the White House. When Jackson left his office to return to The Hermitage, Earl followed, living out his life in Tennessee.

EMK

1. Ralph Earl Prime, great-grandson of Ralph Earl, records 1788 as the birthdate for R. E. W. Earl in Ralph E. Prime to Thomas Gage, March 7, 1914, Thomas Gage Papers, American Antiquarian Society, Worcester, Mass.
2. See Elizabeth Kornhauser, "Ralph Earl, 1751–1801," Ph.D. dissertation, Boston University (forthcoming), for a discussion of the Gere portraits.
3. R. E. W. Earl to John Trumbull, February 18, 1810, Thomas Gage Papers, American Antiquarian Society, Worcester, Mass.
4. Reproduced in Harold Spencer, *The American Earls: Ralph Earl, James Earl, R. E. W. Earl* (Storrs, Conn.: William Benton Museum of Art, 1972), p. 51.

BIBLIOGRAPHY

Elizabeth Mankin Kornhauser and Christine Skeeles Schloss. "Painting and Other Pictorial Arts." *The Connecticut River: Art and Society of the Connecticut River Valley.* Hartford: Wadsworth Atheneum, 1985.
Russell MacBeth. "Portraits by Ralph E. W. Earl." *Antiques* 100 (September 1971): 390–393.
William and Susan Sawitsky. "Two Letters from Ralph Earl with Notes on His English Period." *Worcester Art Museum Annual* 8 (1960): 8–41.
Harold Spencer, *The American Earls: Ralph Earl, James Earl, R. E. W. Earl* (Storrs, Conn.: William Benton Museum of Art, 1972).

GERARD VAN EDEMA

c. 1652–1700?

Fishing Station on Placentia Bay

Oil on canvas, late seventeenth century
32 x 39 in. (81.3 x 99 cm)
Royal Ontario Museum, Toronto

PLATE 10

Probably born in Friesland, Holland, around 1652, van Edema was the pupil of the landscape painter Allart van Everdingen in Amsterdam. Around 1670 he emigrated to England, where he reputedly worked with Willem van de Velde and Jan Wyck for Sir Richard Edgcumbe, and supposedly was patronized by the Fifth Earl of Exeter. Several of his landscapes from the end of his life are in the Royal Collection. It is thought that van Edema died around 1700 in Richmond, outside of London, of intemperance.

Known as the Salvator Rosa of the North, van Edema

delighted in "rocky views, falls of water and scenes of horror."[1] His penchant for wild scenery had undoubtedly been fostered by his mentor, and van Edema traveled to remote areas for subjects. The idea of seeing some of the most primitive landscapes in the world must have played a part in his deciding to undertake the arduous voyage across the Atlantic to America, which resulted in *Fishing Station on Placentia Bay*. The basic composition, with its placement of human activity within a forested area, while undoubtedly true to nature, recalls his Dutch training. The settlement's isolation is reinforced by the surrounding woods and by the absence of a road.

EJN

1. Elizabeth Wheeler Manwaring, *Italian Landscape in Eighteenth Century England* (1925; reprint, New York: Russell & Russell, 1965), p. 7.

BIBLIOGRAPHY
John Harris. *The Artist and the Country House*. London: Sotheby Parke Bernet, 1979.
Horace Walpole. *Anecdotes of Painting In England*. . . . 2nd ed. Strawberry-Hill: T. Kergate 1765–1771.
Ellis Waterhouse. *Painting in Britain 1530 to 1790*. Baltimore: Penguin Books, 1962.

JOHN WILLIAM EDY

active 1780–1820

See GEORGE BULTEEL FISHER

View of St. Anthony's Nose, on the North River Province of New York, PLATE 91

Edy aquatinted the majority of George Bulteel Fisher's drawings. He was a professional English printmaker active from 1780 to 1820, specializing in landscape views.

BR

GEORGE B. ELLIS

active 1821–1838

See THOMAS DOUGHTY

Catskill Falls, from *The Northern Traveller*, PLATE 64

Little is known about Ellis excpet that he studied with Francis Kearny in Philadelphia, exhibited occasionally at the Pennsylvania Academy of the Fine Arts in the 1820s and early 1830s, and engraved illustrations for books and periodicals. Another engraving by him after a work of Doughty appeared in *Atlantic Souvenir* (1828) and he is also known to have engraved a landscape of Alvan Fisher. Ellis was among the artists who sent a memorandum to the Pennsylvania Academy on March 17, 1828, outlining their grievances with that institution.

EJN

BIBLIOGRAPHY
David McN. Stauffer. *American Engravers upon Copper and Steel*. New York: Grolier Club, 1907.
Frank Weitenkampf. "Early American Landscape Prints." *Art Quarterly* 8 (Winter 1945): 40–67.

ALVAN FISHER

1792–1863

Landscape with Cows

Oil on panel, 1815
28 x 40 in. (71.2 x 101.6 cm)
Tom Snyder Collection; courtesy of R. H. Love Galleries, Chicago

PLATE 66

Mishap at the Ford

Oil on panel, 1818
28½ x 35 in. (72.4 x 88.9 cm)
The Corcoran Gallery of Art

PLATE 137

View near Springfield along the Connecticut River

Oil on canvas, 1819
32 x 44 in. (81.3 x 111.8 cm)
The Brooklyn Museum; Dick S. Ramsay Fund

PLATE 67

A Storm in the Valley

Oil on canvas, laid down on board, 1830
19 x 26 in. (48.3 x 66 cm)
Private collection

PLATE 68

Born in Needham, Massachusetts, on August 9, 1792, Fisher grew up in nearby Dedham. Although he spent time in other parts of New England, he eventually settled in Dedham, where he died in February 1863 after a long and productive career. His oeuvre was almost equally divided between portraits and landscapes or related subjects.[1]

Fisher did not decide to become an artist until he was eighteen, when he was placed for two years with the ornamental painter John Penniman. In 1814 he "commenced *being* artist, by painting portraits at a cheap rate." The following year, according to the account he gave William Dunlap, he

> . . . *began painting a species of pictures which had not been practiced much, if any, in this country, viz.: barn-yard scenes and scenes belonging to rural life, winter pieces, portraits of animals, etc. This species of painting being novel in this part of the country, I found it a more lucrative, pleasant and distinguished branch of the art than portrait painting. . . .*[2]

Landscape with Cows dates from this earliest phase. The encircling of figures by lush foliage is typical of Fisher's approach at this period, as is the thematic and compositional debt to Dutch and English art, which the artist probably knew through prints.[3] Focusing on the human activity, these paintings are more subject pictures composed by the artist than landscapes drawn from nature.

Fisher returned to portraiture in 1818, but landscape con-

tinued to occupy his attention. In the late 1810s, his landscape subjects take on a distinctly American flavor. He visits, sketches, and paints familiar sites such as Niagara and depicts specific locales. Such is the case with *View near Springfield,* in which Fisher captures not only a sense of place but presents a pastoral vision of the young country. With their rural settings and crystalline atmospheres these paintings project a simple directness that is peculiarly American.

In 1825 Fisher went to Europe, traveling in England, France, Switzerland, and Italy. In Paris he studied briefly and copied Old Masters at the Louvre. Among them was Claude Lorrain, whose influence is apparent in the work of Fisher's mature period, such as *A Storm in the Valley.* The twilight glow and the movement into a pictorial space dominated by a body of water suggest that Fisher's vision of the American wilderness is now being filtered through the eyes of Claude. However, the passing storm injects a sense of drama in the setting that is more Cole than Claude. The hot reds of the foliage and the searing yellows of the sun, the strong contrasts of lights and darks, electrify the scene. The misty atmosphere is dense with the poetic mystery of America's primeval landscape.

EJN

1. Mabel M. Sawn, "The Unpublished Notebooks of Alvan Fisher," *Antiques* 68 (August 1955): 126.
2. William Dunlap, *History of the Rise and Progress of the Arts of Design in the United States,* 3 vols. (1834; reprint New York: Benjamin Blom, 1965), Vol. III, p. 32.
3. For a discussion of some of the diverse influences on Fisher, see Charlotte Buel Johnson, "The European Tradition and Alvan Fisher," *Art in America* 41 (Spring 1953): 79–87.

BIBLIOGRAPHY

Fred B. Adleson. *Alvan Fisher (1792–1863): Pioneer in American Landscape Painting.* Ph.D. dissertation, Columbia University, 1982. Ann Arbor, Michigan: University Microfilms, 1985.
Charlotte Buel Johnson. "The European Tradition and Alvan Fisher." *Art in America* 41 (Spring 1953): 79–87.
Mabel M. Swan. "The Unpublished Notebooks of Alvan Fisher." *Antiques* 68 (August 1955): 126–129.
Robert C. Vose. Jr. "Alvan Fisher 1792–1863: American Pioneer in Landscape and Genre." *Connecticut Historical Society Bulletin* 27 (October 1962): 97–129.

GEORGE BULTEEL FISHER

1764–1834

View of Saint Anthony's Nose, on the North River Province of New York

Colored aquatint, c. 1790–1795
(John William Edy after Fisher)
16⅜ x 24⁵⁄₁₆ in. (41.60 x 61.70 cm) (image size)
Milberg Factors, Inc.

PLATE 91

Fisher was born in Peterborough, England, in 1764. He entered the Royal Artillery in 1782 and was trained in the Drawing Room of the Tower of London. After becoming a first lieutenant in 1790, he was stationed in Canada from 1791 to 1794, on the staff of the

Duke of Kent. In 1796, on his return to London, Fisher published *Six Views in North America, from Original Drawings made on the Spot, by Lieutenant Fisher,* which were aquatinted by John William Edy. The majority of these depict the Saint Lawrence River, the one exception being *View of Saint Anthony's Nose, on the North River Province of New York.* An aquatint of Niagara was also published at about the same time. The next year Fisher produced a set of views of Gibraltar. He remained active in the army, reaching the rank of major general in 1825. In 1827 he was made commander of Woolwich Garrison.

Fisher came from a family interested in the arts: his older brother John was bishop of Salisbury, John Constable's great patron. Constable, when he first met George Fisher in 1814, called him "an excellent artist."[1] Later, however, having suffered too many lectures from him, Constable described Fisher's work as "heartless atrocious landscapes."[2] Fisher's original watercolors may be found in the Public Archives of Canada, the New-York Historical Society, the Victoria and Albert Museum, and the British Museum.

BR

1. R. B. Beckett, *John Constable's Correspondence,* Vol. II, p. 115 (February 9–11, 1814), Suffolk Records Society (1964).
2. *Ibid.,* Vol. VI, p. 221 (July 1, 1826).

BIBLIOGRAPHY

R. B. Beckett. *John Constable's Correspondence.* Vols. II, VI. Suffolk Records Society. Vols. VI, XII, 1964, 1968.
Martin Hardie. *Water-Colour Painting in Britain.* Vol. III. London: B. T. Batsford, 1966–1968.

JONATHAN FISHER

1768–1847

Morning View of Blue Hill Village

Oil on canvas, 1824
25⅝ x 52¼ in. (6.48 x 132 cm)
William A. Farnsworth Library and Art Museum
 Rockland, Maine

PLATE 155

View of Blue Hill

Oil on canvas, c. 1824
26½ x 46½ in. (67.3 x 118.1 cm)
The Warner Collection of Gulf States Paper Corporation,
 Tuscaloosa, Alabama

PLATE 102

Born on October 7, 1768, in New Braintree, Massachusetts, Fisher was by profession a clergyman who preached at the Congregational Church in Blue Hill, Maine, for forty-one years. His interest in art was cultivated at Harvard, where as a student he depicted the college buildings.[1]

In addition to being a clergyman and artist, Fisher was also an architect, builder, surveyor, linguist, teacher, natu-

ralist, and farmer. To supplement his meager income, he made and sold a variety of useful objects from buttons to picture frames. He invented a form of shorthand (his philosophical alphabet), by which he documented his life in a journal he kept for nearly forty-five years.[2]

Other than a course in mechanical drawing required at Harvard, Fisher received no formal art instruction. The few available art manuals provided training, and Fisher freely copied printed sources. Inventive by nature, he prepared his own materials and crafted his own tools. His body of work is diverse, consisting of landscapes, portraits, still lifes, religious and literary scenes. He also compiled books and notebooks, at times combining his interests in religious training, art, and nature.[3]

Fisher's work projects an individuality and naïveté through its pronounced line and pattern. Direct and literal in his observations, he produced important visual records of his time and place. This is evident in *Morning View of Blue Hill Village* and *View of Blue Hill* of 1824, large panoramic views of a seacoast village in Maine. In the former, a single road leads from the harbor to Fisher's church and beyond to his parish. Houses and farms dot the countryside, as cleared fields separated by winding fences stretch to the distant blue hill on the horizon. Two women in the foreground quietly observe the sprawling landscape, their gaze directed toward the church, whose white steeple is the compositional focal point. To their right, a man about to strike a snake is perhaps an allusion to the devil in this church-dominated landscape.

In these paintings Fisher captures the activity and life of Blue Hill and its surrounding area. An agricultural community, the village nevertheless is dependent on the nearby sea. The three partially built vessels inside the harbor in *Morning View* provide evidence of the local shipbuilding industry. Here, the two essential aspects of this seaside community are harmoniously blended.

Fisher's clerical concerns separate him from his contemporaries, and he conveys in his paintings not only civic pride but a spiritual reverence as well. This is also evident in *View of Dedham, Massachusetts* of 1798 (William A. Farnsworth Library and Art Museum). Like the later *Morning View*, it depicts a distant town in which the church with its silhouetted steeple rising above the horizon is a focal point.

Fisher retired as pastor of the church in Blue Hill in 1837. A universal man in his remote seacoast village, Fisher died there September 22, 1847.

CMD

1. Alice Winchester, *The Art of Jonathan Fisher, 1768–1847* (New York: Pyne Press, 1973), p. 15.
2. Preserved at the William A. Farnsworth Library and Art Museum, Rockland, Maine.
3. Winchester, *Art of Jonathan Fisher,* p. 25.

BIBLIOGRAPHY

Jay E. Cantor. *The Landscape of Change: Views of Rural New England 1790–1865.* Sturbridge, Mass.: Old Sturbridge Village, 1976.

Jean Lipman and Tom Armstrong. *American Folk Painters of Three Centuries.* New York: Hudson Hills Press, 1980.

Alice Winchester. "Rediscovery: Parson Jonathan Fisher." *Art in America* 58 (November 1970): 92–99.

———. *The Art of Jonathan Fisher, 1768–1847.* New York: Pyne Press, 1973.

———. "Versatile Yankee: The Art of Jonathan Fisher 1768–1847." *Antiques* 104 (October 1973): 658–664.

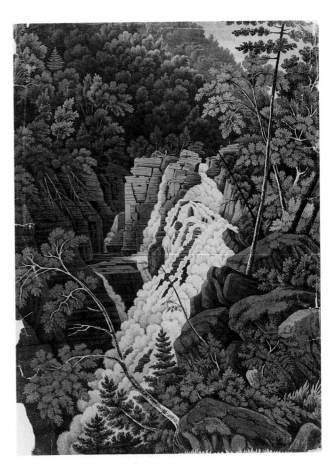

PLATE 180. CHARLES RAMUS FORREST, *Saint Anne Falls,* 1823.

CHARLES RAMUS FORREST

active 1802–1827

Cape Diamond and the Saint Lawrence River from the Seignory of Lauzon

Watercolor over graphite on wove paper, 1822
18¹/₁₀ x 28³/₁₀ in. (46 x 72 cm)
National Gallery of Canada, Ottawa

PLATE 94

Saint Anne Falls

Watercolor over graphite on wove paper, 1823
26³/₅ x 19³/₅ in. (66.8 x 49.8 cm)
National Gallery of Canada, Ottawa

PLATE 180.

Forrest had an erratic military career. Joining the army in 1802 as a lieutenant, he was promoted to captain three years later. From 1808 to 1811 he was attached to the staff of his father-in-law, General William St. Leger, in India. Promotion to brevet lieutenant-colonel followed. He served in several regiments in Ireland, Spain, and New Orleans. In 1817, at the end of the Napoleonic Wars, Forrest went on half-pay until he was appointed to the staff of the Earl of Dalhousie, governor general of Canada, in 1820. Three years later he was dismissed for incompetence but placed on half-pay in 1826.

Forrest came from an artistic family. He is sometimes confused with a relative (perhaps his father), Lieutenant Charles Forrest, who published aquatints of the West Indies between 1783 and 1786. In Canada he drew frequently with James Pattison Cockburn, although his style shows none of Cockburn's influence. Forrest's drawings, such as *Saint Anne Falls,* are highly stylized, with crisp outlines and thin washes of local color defining the forms. On his return to England in 1823, he tried to capitalize on his artistic abilities by publishing prints after his drawings. *A Picturesque Tour along the Rivers Ganges and Jumna, in India,* with twenty-four aquatints, was published in 1824, as well as six small lithographs illustrating the Peninsular War. The next year "A Picturesque Tour through the Provinces of Lower and Upper Canada," with forty-eight colored lithographs, was advertised but apparently never published. Many of Forrest's most finished drawings of Canadian subjects seem to have been intended for this publication, including *Cape Diamond and the Saint Lawrence River from the Seignory of Lauzon* and *Saint Anne Falls.* Forrest died in Bath, England, in March 1827.

BR

BIBLIOGRAPHY

Mary Allodi. *Canadian Watercolours and Drawings in the Royal Ontario Museum.* Toronto: Royal Ontario Museum, 1974.
W. Martha E. Cooke. *W. H. Coverdale Collection of Canadiana: Paintings, Water-colours and Drawings (Manoir Richelieu Collection).* Ottawa: Public Archives Canada, 1983.
Charles Ramus Forrest. *A Picturesque Tour along the Rivers Ganges and Jumna, in India.* London: R. Ackermann, 1824.

PIERRE FOURDRINIER

active 1720–1758

See PETER GORDON

A View of Savannah as it Stood the 29th of March, PLATE 11

Descended from a Huguenot family from Normandy, Fourdrinier was born in Groningen, Holland, and trained by the engraver Bernard Picart in Amsterdam. He arrived in London around 1720 and specialized in architectural perspective, engraving the works of Inigo Jones, William Kent, and William Chambers, among others. He also ran a stationery business until his death in 1758.

BR

BIBLIOGRAPHY

The Quiet Conquest: The Huguenots 1685–1985. London: Museum of London, 1985.
George Vertue. "Vertue Note Books III." *Walpole Society Journal* 22 (1933–1934): 136.

CHARLES FRASER

1782–1860

View on the Hudson River

Watercolor on paper, 1818
11 x 17¾ in. (27.9 x 45.1 cm)
Carolina Art Association / Gibbes Art Gallery, Charleston
PLATE 54

View of the Palisades

Watercolor on paper, 1818
11 x 17¾ in. (28 x 45.1 cm)
Carolina Art Association / Gibbes Art Gallery, Charleston
PLATE 142

View of Niagara with Figure Leaning over Edge

Watercolor on paper, c. 1820
11 x 17½ in. (27.9 x 44.45 cm)
The Arden Collection
PLATE 150

View of Niagara with Spray Rising

Watercolor on paper, 1820
11 x 17½ in. (27.9 x 44.4 cm)
The Arden Collection
PLATE 36

Trenton Falls, West Canada Creek, New York

Oil on canvas, c. 1830
23 x 31 in. (58.4 x 78.7 cm)
Victor D. Spark
PLATE 59

Although painting was Fraser's primary interest, he was also a lawyer, political leader, and historian in his hometown of Charleston, South Carolina. Born August 20, 1782, he remained in Charleston throughout his life, leaving only occasionally for trips to the Northeast. As a ten-year-old student at Reverend Robert Smith's grammar school, he was already interested in painting, becoming a mentor to his younger schoolmate Thomas Sully. In 1775 the talented youth began drawing lessons with Thomas Coram. Since his family discouraged his inclinations toward art, Fraser eventually studied law. It was during his law school years that he met Washington Allston, a fellow South Carolinian, who was visiting Charleston. John Trumbull and Gilbert Stuart became acquaintances during his first trip north in 1806.

Fraser executed several portrait miniatures, undoubtedly under the influence of his friend Edward Malbone, and he

produced a sketchbook of watercolors of country seats and sites around Charleston.[1] Virtual portraits of South Carolina architecture and nature, Fraser's depictions of the environs of Charleston are comparable to views of Philadelphia and country seats published by William Birch in 1800 and 1808.[2]

After admission to the bar of South Carolina in 1807, Fraser practiced law and was involved in civic duties, becoming a lieutenant colonel in the militia by 1810 and a trustee of the College of Charleston in 1817, a position he held until his death in 1860. At the age of thirty-six he abandoned law to take up art as a career. Exhibiting with the South Carolina Academy of Fine Arts, established in 1821, he also served as its director and wrote on art. Widely acknowledged as an important miniature painter, he also sketched scenery on his several trips north.[3] Eight of his views were published between 1816 and 1818 in *Analectic Magazine*.[4]

His great enthusiasm for American scenery was expressed in an article published in the *America Monthly Magazine* in 1835:

> If our country were favored in no other respect, it would be remarkable for the variety of its scenery, exhibiting every feature of grandeur and beauty that taste delights to dwell on. A single view has been pronounced worth a voyage across the Atlantic. . . . In our mountains and cataracts, our forests and lakes, our rivers and bays . . . the simple and beautiful abound. . . . the American landscape painter may be said to imbibe the principles of beauty and sublimity with his earliest perceptions.[5]

His representations of Niagara Falls, Trenton Falls, and the Hudson River are visual verification of his attraction to the grander aspects of American landscape.

While Fraser's subjects were drawn primarily from personal response to native scenery, he was conversant with European art and aesthetics. He owned prints after works by Philip de Loutherbourg, Claude Lorrain, Salvator Rosa, Jacques Callot, and Nicolas Poussin,[6] and he freely copied scenes from William Gilpin's *Observations of Several Parts of England, Particularly the Mountains and Lakes of Cumberland and Westmoreland*.[7] He admired the picturesque and romantic landscapes of Old Masters and contemporary English painters and endeavored to apply their techniques to his own work. While Fraser sometimes painted landscapes with imaginary ruins and English scenery, his views of America are accurate depictions of sites based on observation. Despite generalization of detail and the occasional addition of figures to lend scale and human drama, his watercolors possess a fresh, direct quality indicative of his love for America's environment.

GLH

1. See Alice Huger Smith, ed., *A Charleston Sketchbook 1796–1806* (Charleston: Carolina Arts Association, 1940) for reproductions of sketchbook works with accompanying explanations.
2. The titles of these sketchbooks are *The City of Philadelphia in the State of Pennsylvania as It Appeared in 1800* and *The Country Seats of the United States of North America* (see the entry on William Birch in this catalogue).
3. Carolina Art Association, *Charles Fraser of Charleston: Essays on the Man, His Art, and His Times*, Martha R. Severns and Charles L. Wyrick, Jr., eds. (Charleston: Gibbes Art Gallery, 1983), p. 91.

4. The views published were *Passaic Falls, Westrock near New Haven, Boston, View on the James River, Haddril's Point near Charleston, View on the Hudson River, View on the Shores of Rhode Island, View of Richmond; ibid.*, p. 89.
5. Charles Fraser, "On the Condition and Prospects of the Art of Painting in the United States," *America Monthly Magazine* (November-December 1835), reprinted in *Art in the Lives of South Carolinians*, Vol. II, ed. David Moltke-Hansen (Charleston, 1979), p. CF13.
6. The influence of these artists' works on Fraser is mentioned in Carolina Art Association, *Charles Fraser*, pp. 27–31 and Chapter V.
7. *Ibid.*, p. 78.

BIBLIOGRAPHY

Carolina Art Association. *Charles Fraser of Charleston: Essays on the Man, His Art, and His Times*. Martha R. Severns and Charles L. Wyrick, Jr., eds. Charleston: Gibbes Art Gallery, 1983.

Charles Fraser. "On the Condition and Prospects of the Art of Painting in the United States." *America Monthly Magazine* (November-December 1835); reprinted in *Art in the Lives of South Carolinians*, Vol. II. David Moltke-Hansen, ed. Charleston, 1979.

————. *Reminiscences of Charleston*. Charleston: Garnier, 1969.

Alexander Moore. "A Charleston Artist and a National Art." *Art in the Lives of South Carolinians*, Vol. II. David Moltke-Hansen, ed. Charleston, 1979.

Alice R. Huger Smith, ed. *A Charleston Sketchbook 1796–1806*. Charleston: Carolina Art Association, 1940.

———— and D. E. Huger Smith. *Charles Fraser*. New York: Frederic Fairchild Sherman, 1924.

JOHN GIBBS

active 1703–d. 1725

Attributed

Panel from the Clark-Frankland House

Oil on wood panel, c. 1712

60 x 23 in. (152.4 x 58.4 cm)

Society for the Preservation of New England Antiquities, Boston

PLATE 12

Described as a "painter stayner" in contemporary records, Gibbs was active in the Boston area from 1703 until his death on January 22, 1725. Little is known about his early life and training. Perhaps from Somerset, he may have been apprenticed to Leonard Cotes, a London craftsman. Gibbs probably came to Massachusetts around the turn of the century.[1]

Two landscape panels from the Clark-Frankland House in Boston, both in the collection of the Society for the Preservation of New England Antiquities, are the only works that can be assigned to Gibbs with any degree of certainty.[2] They are the earliest surviving New England examples of architectural landscape painting. The castellated structure on the promontory and the exotic figure in the foreground of the piece exhibited suggest the subject is imaginary or taken from a print. Both the composition and treatment indicate that the artist was a skilled craftsman. Gibbs' work is reminiscent of late-seventeenth-century English decoration.[3]

Although little is known about Gibbs, the house is another matter. Built in 1712 for William Clark, a wealthy merchant and member of the Governor's Council, it stood at the corner of Garden Court and Prince streets until it was torn down in 1833. This panel was one of eleven embel-

lished with landscapes that graced the lavishly decorated north parlor. The panels were divided by gilded Corinthian pilasters and were placed above a dado of painted arabesques. The room also contained a carved Italian marble fireplace, an intricately patterned floor, and other gilded architectural details.[4] The overmantel, with a portrait of the house probably by another and later hand, is preserved at the Bostonian Society. The location of two other panels that survived into the twentieth century is not known.

The description of the house and the remnants of its decoration attest to the social standing of its owner. They also offer an insight into the sophistication of Boston as it entered its second century.

EJN

1. Documentation information on Gibbs appears in Abbot Lowell Cummings, "Decorative Painting in Seventeenth-Century New England," *American Painting to 1776: A Reappraisal,* Ian Quimby, ed. (Charlottesville: University Press of Virginia for the Henry Francis du Pont Wintherthur Museum, 1971), pp. 103–109, 123.
2. A bill dated July 18, 1714, shows that Gibbs painted a landscape on a panel for another patron; *ibid.,* p. 104.
3. Nina Fletcher Little, *American Decorative Wall Painting* (New York: Studio Publications, 1952), pp. 32–35.
4. For additional information on the house and its decoration, see Jean A. Follett, "The Clark-Frankland House Landscape Panels: A Report on their Significance. . . ," in the files of the Society for the Preservation of New England Antiquities.

BIBLIOGRAPHY

Abbot Lowell Cummings. "Decorative Painting in Seventeenth-Century New England." *American Painting to 1776: A Reappraisal.* Ian Quimby, ed. Charlottesville: University Press of Virginia for the Henry Francis du Pont Wintherthur Museum, 1971. Pp. 71–125.
Jean A. Follett. "The Clark-Frankland House Landscape Panels: A Report on their Significance." Files, the Society for the Preservation of New England Antiquities.
Nina Fletcher Little. *American Decorative Wall Painting.* New York: Studio Publications, 1952.
Penny J. Sander. "Collections of the Society." *Antiques* 129 (March 1986).

PETER GORDON

active 1732–1735

A View of Savannah as it Stood the 29th of March, 1734

Engraving
18¼ x 23 in. (46.4 x 58.4 cm)
(Pierre Fourdrinier after Gordon)
Library of Congress
PLATE II

Peter Gordon was the first bailiff of the Georgia Colony, founded in 1732. Early in 1734 he returned to London to report to the trustees. The engraving is a record of the view presented to them, a proud statement of the colony's progress.

BR

BIBLIOGRAPHY

E. Merton Coulter, ed. *The Journal of Peter Gordon, 1732–1735.* Athens: University of Georgia Press, 1963.

WILLIAM GROOMBRIDGE

1748–1811

View of a Manor House on Harlem River

Oil on canvas, 1793
39¾ x 49¼ in. (100 x 125 cm)
Daniel J. Terra Collection, Terra Museum of American Art, Chicago
PLATE 181

Fairmount on the Schuylkill River

Oil on canvas, 1800
25 x 36 in. (63.5 x 91.4 cm)
The Historical Society of Pennsylvania, Philadelphia
PLATE 24

Gray's Ferry Bridge on the Schuylkill

Attributed
Oil on canvas, c. 1800
23½ x 30¾ in. (56.7 x 78.1 cm)
The Dietrich American Foundation
PLATE 122

Autumn Landscape

Oil on canvas, 1802
25¼ x 36 in. (64.1 x 91.4 cm)
Hirschl & Adler Galleries, Inc., New York
PLATE 34

English Landscape

Oil on canvas, 1811
36½ x 49½ in. (92.7 x 125.7 cm)
Maryland Historical Society; gift of Dr. Michael A. Abrams
PLATE 182

Born in Tunbridge, Kent, in 1748, Groombridge may have studied under James Lambert of Lewes[1] and perhaps at the Royal Academy in London.[2] Between 1773 and 1790 he exhibited at the Royal Academy, the Society of Artists of Great Britain, and the Society of Free Artists.[3]

Groombridge came to America in the early 1790s. William Dunlap, who knew him, recalled that Groombridge "painted in New York about this time . . . a view of the Harlem River,"[4] perhaps referring to *View of a Manor House on the Harlem River* of 1793. That year he also executed the Philadelphia subject *The Woodlands, the Seat of William Hamilton, Esq.* (Santa Barbara Museum of Art). Although one of the founders in 1795 of the Columbianum, a short-lived artists' organization in Philadelphia, Groombridge does not appear in that city's directory until 1800, the year he painted *Fairmount on the Schuylkill River.*

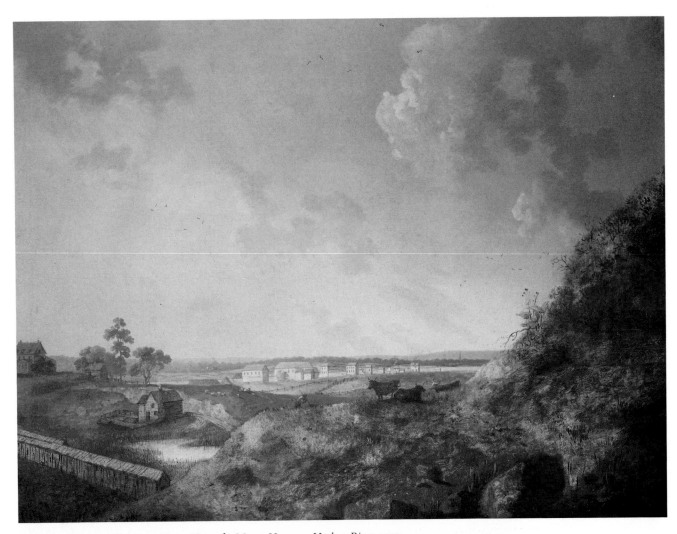

PLATE 181. WILLIAM GROOMBRIDGE, *View of a Manor House on Harlem River*, 1793.

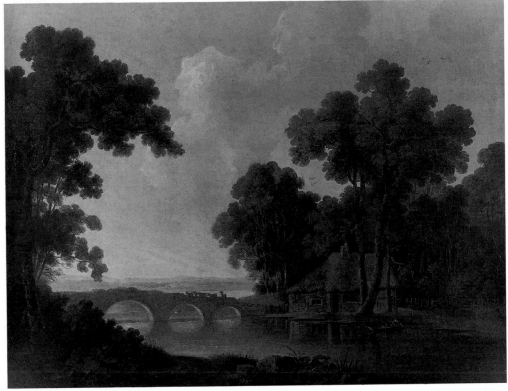

PLATE 182. WILLIAM GROOMBRIDGE, *English Landscape*, 1811.

His last listing in Philadelphia was as a miniature painter, in 1804, the year that he and his wife, headmistress of a ladies' academy, moved to Baltimore.[5]

In June 1807 Groombridge and Francis Guy held a joint exhibition in Baltimore. The public patronized Guy, a self-taught artist, and shunned Groombridge. Eliza Godefroy, editor of *The Observer,* was enraged by the neglect of Groombridge. On June 20 she called Baltimore the "Siberia of the Arts." Critical of public support for untrained Guy, she praised Groombridge's training and technique. Groombridge avoided the controversy, but Guy, angered by Godefroy's insults, replied. Praising Groombridge as an excellent painter and an honest man, he remarked that "if he is really neglected by the public he may ascribe it to *The Observer....* The Connoisseurs of Baltimore will not be dictated to by insolence and abuse."[6]

How this controversy affected Groombridge's career is uncertain. He continued to paint and exhibit in Baltimore until his death, on May 24, 1811. Shortly before then, he executed *English Landscape.* Perhaps based on sketches brought with him from England, this work with its idyllic treatment of sky and countryside suggests that he may have been longing for his native land.

Considered one of the first professional landscape artists in America, Groombridge occasionally was criticized for his use of vivid colors. Dunlap, for example, remarked that "he endeavoured without success to introduce the brilliant tints that nature displays in our autumnal scenery."[7] On the other hand, John H. B. Latrobe praised him for capturing the true American coloring which most foreign artists in their imitations of nature could not understand, or considered "monstrous."[8]

JAH

1. William Dunlap, *A History of the Rise and Progress of the Arts of Design in the United States* (1834; reprint. Rita Weiss, ed., New York: Dover, 1969), Vol. II, Pt. 1, p. 47. According to Dunlap, Robert Gilmor of Baltimore said that Groombridge was a pupil of Lambert. J. H. Pleasants, in *Four Late Eighteenth Century Anglo-American Landscape Painters* (1942; reprint, Worcester, Mass.: American Antiquarian Society, 1943), pp. 31–32, suggests that he must have been referring to James Lambert of Lewes.
2. In an advertisement which appeared in *The Baltimore American,* December 3, 1813, Francis Guy wrote that Groombridge was taught in the academies of London, Rome, and Paris. However, Groombridge's name does not appear in the student registry of the Royal Academy.
3. Algernon Graves, *Royal Academy of Arts, Exhibitors 1769–1904* (1905–1906; reprint, New York: Franklin, 1972), Vol. III, p. 331. Twenty-eight landscapes are listed between 1777 and 1790. Algernon Graves, *The Society of Artists of Great Britain, 1760–1790 and the Free Society of Artists 1761–1783* (1907; reprint, Bath: Kingsmead Reprints, 1969), p. 108. Between 1773 and 1775 at the Free Society of Artists he exhibited two portraits, four portrait miniatures, and five landscapes. His listings at the Society of Artists of Great Britain in 1776 include one portrait, four miniature portraits, and three landscapes.
4. Dunlap, *History,* Vol. II, p. 47.
5. Pleasants, *Four. . .Painters,* p. 33.
6. Stiles Tuttle Colwill, *Francis Guy (1760–1820)* (Baltimore: Maryland Historical Society, 1981), pp. 26–27, 29.
7. Dunlap, *History,* Vol. II, p. 47.
8. Pleasants, *Four. . .Painters,* p. 43.

BIBLIOGRAPHY

Stiles Tuttle Colwill. *Francis Guy (1760–1820).* Baltimore: Maryland Historical Society, 1981.
J. Hall Pleasants. *Four Late Eighteenth Century Anglo-American Landscape Painters.* 1942. Reprint from *Proceedings of American Antiquarian Society,* Worcester, Mass.: American Antiquarian Society, 1943.

FRANCIS GUY

1760–1820

View of the Bay from near Mr. Gilmor's

Oil on canvas, 1804
30½ x 48½ in. (77.5 x 123.2 cm)
Maryland Historical Society; gift of Anthony Kimmell

PLATE 144

View of the Presbyterian Church and All of the Buildings as They Appear from the Meadow

Oil on canvas, 1804
25¹/₁₆ x 39⁹/₁₆ in. (63.6 x 100.6 cm)
Maryland Historical Society, through exchange by the Anne, Ethel, and May Hough Fund and Maria I. Eaton and Mrs. Charles R. Weld Fund

PLATE 183

Prospect

Oil on canvas, 1805
28¾ x 52⅛ in. (73 x 132.4 cm)
Maryland Historical Society

PLATE 25

Carter's Tavern, at the Head of Lake George

Oil on canvas, 1817–1820
39¾ x 66¼ in. (100.9 x 168.3 cm)
The Detroit Institute of Arts; Founders Society Purchase, Robert H. Tannahill Fund, Gibbs-Williams Fund, and the Merrill Fund

PLATE 156

Born in 1760 in the English Lake District, in either Burton-in-Kendall or Lorton, Guy became interested in art at an early age; his father, however, apprenticed him to a tailor in Burton. Cruelly treated, he ran away and eventually settled in London, where he established a silk-dyeing and calendering business. A threat on his life forced him to leave London,[1] and in 1795 Guy came to New York, where he was unable to establish a silk-dyeing business because of lack of funds. He moved to Philadelphia in 1797, the date of his first known work, *The Tontine Coffee House of New York* (New-York Historical Society). The following year saw him in Baltimore, where he succeeded in setting up a dyeing business, only to have it destroyed by fire in June 1799. After that he devoted himself to painting.[2] According to Rembrandt Peale, Guy "boldly undertook to become an artist though he did not know how to draw."[3] Peale described how Guy learned to draw by stretching over the window of a tent a thin black gauze upon which he traced an actual scene in chalk before transferring it to canvas.

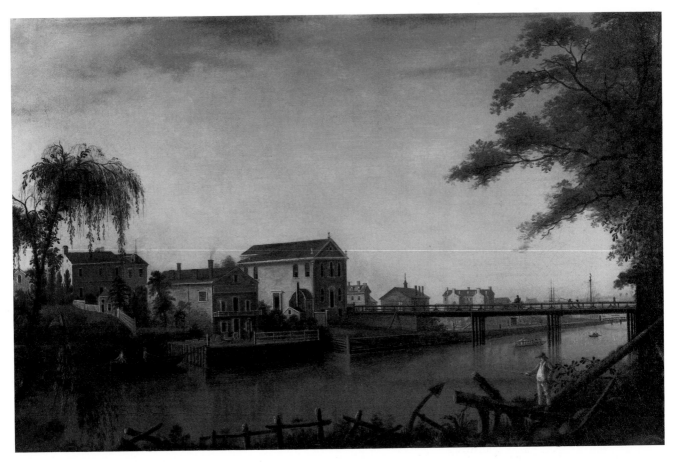

PLATE 183. FRANCIS GUY, *View of the Presbyterian Church and All of the Buildings as They Appear from the Meadow*, 1804.

Guy announced his first public work, the frescoes in James Bryden's Coffee House, in an advertisement in *The Baltimore American* on June 26, 1800. In July 1803 he held his first exhibition there. Among the six landscapes shown was *A Large View of Baltimore from Chapel Hill* (Brooklyn Museum). In this scene numerous important landmarks can be identified, including Saint Paul's Episcopal Church, the Old Court House, and the First Presbyterian Church.[4]

The following spring Guy exhibited fourteen works at Bryden's including two landscapes, *View of the Presbyterian Church*, and *View of the Bay from near Mr. Gilmor's*. The former depicts Jones Falls (now routed underground) and the Baltimore or Market Street Bridge, then located five blocks from the harbor in an area now known as "The Block."[5] The latter work, typical of Guy's style with its paired figures in the foreground, was critical in identifying and attributing other unsigned pieces.[6] A number of his paintings of Baltimore estates (1804–1807) share this compositional device.

Despite carping reviews by Eliza Godefroy, a local Baltimore critic, Guy became a successful artist.[7] In 1811 he exhibited twenty-three landscapes in Philadelphia at the first exhibition of the Society of Artists.[8] In 1812 he was commissisoned by Archbishop John Carroll to depict a view of the Roman Catholic Cathedral in Baltimore designed by architect Benjamin Henry Latrobe.

Guy returned to Brooklyn in 1817, about the time that he painted *Carter's Tavern, at the Head of Lake George*. This picturesque view depicts the public house and the blacksmith shop in the village of Caldwell on Lake George.[9] Guy spent his remaining years painting scenes of Brooklyn and writing his autobiography, now lost. He died of an alcoholic seizure in May 1820.

JAH

1. Henry Stiles, *The History of the City of Brooklyn*, 2 vols. (New York: City of Brooklyn, 1869), Vol. II, pp. 101–102.
2. Stiles Tuttle Colwill, *Francis Guy (1760–1820)* (Baltimore: Maryland Historical Society, 1981), p. 19. This is the best and most recent study of the artist.
3. Rembrandt Peale, "Reminiscences—Desultory," *The Crayon* 3 (January 1856): 5.
4. Colwill, *Francis Guy*, pp. 20, 22.
5. *Ibid.*, p. 53.
6. J. Hall Pleasants, *Four Late Eighteenth Century Anglo-American Landscape Painters* (1942; reprint, Worcester, Mass.: American Antiquarian Society, 1943), pp. 85–86.
7. Colwill, *Francis Guy*, pp. 26–27. For more details, see Groombridge's biography in this catalogue.
8. Pleasants, *Four . . . Painters*, pp. 66–67.
9. Graham Hood, "American Paintings Acquired During the Last Decade," *Bulletin of the Detroit Institute of Arts* 55 (1977): 76–78.

BIBLIOGRAPHY

Stiles Tuttle Colwill. *Francis Guy (1760–1820)*. Baltimore: Maryland Historical Society, 1981.
Graham Hood. "American Paintings Acquired During the Last Decade." *Bulletin of the Detroit Institute of Arts* 55 (1977): 76–78.
Richard J. Koke. *American Landscape and Genre Paintings in the New-York Historical Society*. Boston: New-York Historical Society with G. K. Hall, 1982. Vol. II.
J. Hall Pleasants. *Four Late Eighteenth Century Anglo-American Landscape Painters*. 1942. Reprint from *Proceedings of American Antiquarian Society*, Worcester, Mass.: American Antiquarian Society, 1943.
———. "Francis Guy — Painter of Gentlemen's Estates." *Antiques* 65 (April 1954): 288–290.
Henry Stiles. *The History of the City of Brooklyn*. 2 vols. New York: City of Brooklyn, 1869.

BASIL HALL

1788–1844

Forty Etchings, from Sketches Made with the Camera Lucida in North America, in 1827 and 1828

Wooding Station on the Mississippi, PLATE 101

View from Mount Holyoke in Massachusetts, PLATE 140

Etchings, 1829
The Library Company of Philadephia

Although his family was slightly more prominent than George Heriot's, Basil Hall came from the same area of Scotland as Heriot and was also educated in Edinburgh. He entered the Royal Navy in 1802, becoming a lieutenant in 1808 and captain a few years later. He traveled extensively during his naval career, from China and India to Mexico and Chile. These experiences became the basis for a series of popular travel books. The first, *Account of a Voyage of Discovery to the West Coast of Corea and the Great Loo-Choo Islands,* was published in 1818; many more followed. While in China he was elected to the Royal Society; his geographical interests began to supercede his naval career, and he resigned his commission in 1823. In 1829 he published *Travels in North America in the Years 1827 and 1828,* and *Forty Etchings from Sketches Made with the Camera Lucida in North America, in 1827 and 1828.* Hall's criticisms of American society caused a furor on this side of the Atlantic and much satisfaction among Tory circles in Britain. In 1842 he became insane and was committed to an asylum, where he died two years later.

BR

BIBLIOGRAPHY

Basil Hall. *Account of a Voyage of Discovery to the West Coast of Corea and the Great Loo-Choo Islands.* London: J. Murray, 1818.

———. *Extracts from a Journal, Written on the Coasts of Chili, Peru, and Mexico, in the Years 1820, 1821, 1822.* Edinburgh: A. Constable, 1824.

———. *Forty Etchings, from Sketches Made with the Camera Lucida in North America.* Edinburgh: R. Cadell, 1829.

———. *Fragments of Voyages and Travels, Chiefly for the Use of Young Persons.* Edinburgh: R. Cadell, 1831–1833.

———. *Schloss Hainfield; or A Winter in Lower Styria.* Edinburgh: R. Cadell, 1836.

———. *Travels in North America in the Years 1827 and 1828.* Edinburgh: R. Cadell, 1829.

THOMAS HARRIOT

1560–1621

See JOHN WHITE

Incolarum Virginiae piscandiratio, from Thomas Harriot's *Admiranda narratio fida tamen,* PLATE 4

JOHN HARRIS

early eighteenth century

See WILLIAM BURGIS

A South East View of Ye Great Town of Boston in New England in America, PLATE 104

GEORGE HERIOT

1759–1839

Lake Saint Charles near Quebec

Watercolor over graphite on laid paper, c. 1800
$10^7/_{10}$ x $17\frac{1}{2}$ in. (27.1 x 44.4 cm)
National Gallery of Canada, Ottawa

PLATE 8

Quebec Seen from Outside the Walls near Saint Louis Gate

Watercolor over graphite on paper, c. 1800
$9\frac{3}{4}$ x $14\frac{1}{4}$ in. (24.7 x 36.2 cm)
Royal Ontario Museum, Toronto

PLATE 93

L'Assomption

Watercolor over pencil on paper, 1810
$7\frac{3}{4}$ x $11\frac{1}{8}$ in. (19.6 x 28.2 cm)
Royal Ontario Museum, Toronto

PLATE 184

Quebec, frontispiece from *Travels through the Canadas,* 1807

Aquatint
Library of Congress

PLATE 92

Heriot was born in Haddington, Scotland, the son of well-established local gentry. He was educated at the Royal High School in Edinburgh, where he received solid training in the classics. In 1777 he went to London to become an artist. Initially discouraged, he traveled to the West Indies and probably worked as a civil servant for the military. After his return to England in 1781, he published *A Descriptive Poem, Written in the West Indies.* He then entered the Royal Military Academy for a short time and subsequently worked for the Ordnance at Woolwich.

In 1792 Heriot apparently decided to try his luck in colonial administration, for by September he was working for the Ordnance Office in Quebec. He quickly established himself as an artist, publishing topographical views in the *Quebec Magazine.* During a leave in England from 1796 to

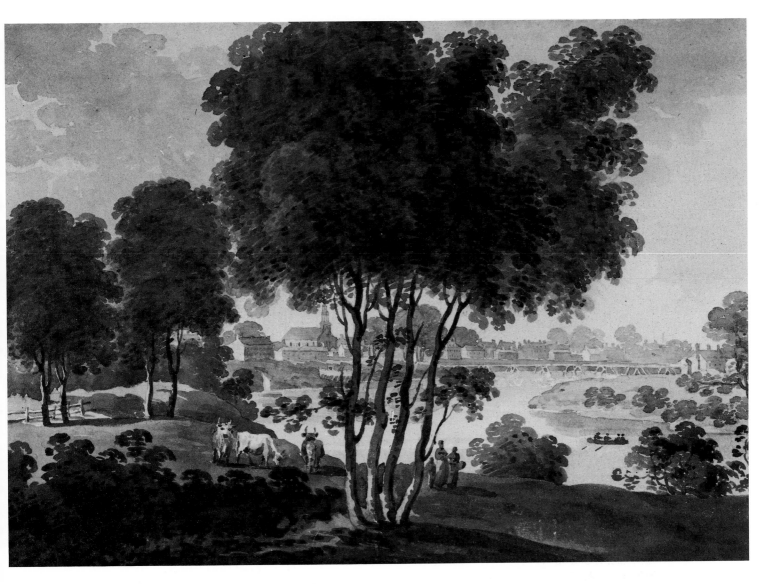

PLATE 184. GEORGE HERIOT, *L'Assomption*, 1810.

1797, he aquainted himself with the most recent artistic developments, including the aquatints of Canadian subjects by G. B. Fisher. He toured Wales and in 1797 exhibited both Canadian and Welsh subjects at the Royal Academy.

Returning to Quebec, Heriot maintained his artistic interests, sketching abundantly in a manner which closely resembled William Gilpin's. Some of his finished work, such as *Lake Saint Charles,* is more monumentally classical in construction. During this period he also began to include Indians in his drawings, as in *Indian Lorette* (National Gallery of Canada). In 1800 he became the head of the Canadian Post Office, a position which permitted him to travel frequently and to record the scenery of lower and upper Canada, as well as the eastern United States. He published a *History of Canada from Its First Discovery* in 1804 and a picturesque travel guide, *Travels through the Canadas,* illustrated with a map and twenty-seven aquatints, in 1807.

Heriot's character was marked by a certain patrician pride and independence, which led to endless battles with both local authorities and the Post Office in London. In 1816 he resigned and returned to England to justify his actions in a long series of petty jurisdictional battles. Once back, he settled into the comfortable life of the gentleman amateur, traveling extensively in both England and Europe. In 1824 he published *A Picturesque Tour Made in the Years 1817 and 1820 through the Pyrenean Mountains, Auvergne, the Department of the High and Low Alps and Part of Spain.* For the rest of his life he resided with his brother's family in London, dying on July 22, 1839.

BR

BIBLIOGRAPHY

Mary Allodi. *Canadian Watercolours and Drawings in the Royal Ontario Museum.* Toronto: Royal Ontario Muscum, 1974.

W. Martha E. Cooke. *W. H. Coverdale Collection of Canadiana: Paintings, Water-colours and Drawings (Manoir Richelieu Collection).* Ottawa: Public Archives Canada, 1983.

Gerald Finley. *George Heriot: Painter of the Canadas.* Kingston, Ontario: Agnes Etherington Art Centre, 1978.

_____. *George Heriot Postmaster-Painter of the Canadas.* Toronto: University of Toronto Press, 1983.

George Heriot. *The History of Canada from Its First Discovery.* London: Longman and Rees, 1804.

_____. *A Picturesque Tour Made in the Years 1817 and 1820, through the Pyrenean Mountains, Auvergne, the Departments of the High and Low Alps and in Part of Spain.* London: R. Ackermann, 1824.

_____. *Travels through the Canadas, Containing a Description of the Picturesque Scenery on Some of the Rivers and Lakes. . . .* London: Richard Phillips, 1807.

EDWARD HICKS

1780–1849

Peaceable Kingdom of the Branch

Oil on canvas, c. 1825

23½ x 30¾ in. (59.7 x 78.1 cm)

Reynolda House, Museum of American Art, Winston-Salem, North Carolina

PLATE 60

Hicks was born in Bucks County, Pennsylvania, on April 4, 1780, into a prominent Tory family that lost its fortune in the Revolutionary War. After the death of his mother in 1783, Hicks was raised by a family friend, Elizabeth Twining, whose Quaker beliefs the young Hicks eventually embraced. When he was thirteen, he was apprenticed to a Philadelphia carriage maker. After a period of riotous living, he had a religious awakening, and in 1803 he joined the Society of Friends and settled down to married life in Milford. By this time he had taken up sign and carriage painting. In 1812 he was recognized as a Quaker minister. Most of his life was spent in Bucks County; he died in Newton on August 23, 1849.

Although Hicks painted a variety of subjects, he is best known for his numerous Peaceable Kingdoms, produced from 1820 onward. They have been divided into three stylistic periods. This work belongs to the first, known as the Peaceable Kingdom of the Branch, because the central motif of the child amidst wild animals is taken from an illustration of the Book of Isaiah by the English artist Richard Westall.[1] The Peaceable Kingdoms with a view of Natural Bridge in Virginia, of which there are only four,[2] are among the earliest treatments of the theme. In the distance under the bridge on the right is a vignette of William Penn's treaty with the Indians, derived from Benjamin West's painting of the subject. The bridge itself is adapted from the cartouche of a contemporary map of North America by Henry S. Tanner which also included a view of Niagara that Hicks used elsewhere.[3] Many of Hicks' compositions contain borders with couplets based on the Isaiah passage. Here, because of the way the canvas is tacked, only the second line is visible.

Marked by a sincerity of sentiment and a charming naïveté, Hicks' Peaceable Kingdoms reflect his strong religious convictions. The idea that the millennium will be realized in America seems implicit in these compositions. The child of Isaiah is juxtaposed with Penn's treaty in a landscape dominated by one of the great natural wonders of America. The artist visually connects through this demonstration of divine power in nature the promise of the American past symbolized in the distant Penn to the promise of the American future embodied in the innocent youth.

EJN

1. This source was first identified by Alice Ford, *Edward Hicks: Painter of the Peaceable Kingdom* (Philadelphia: University of Pennsylvania Press, 1952), pp. xii, 42, 138. Ford established the three periods. This division was further amplified in Eleanore Price Mather and Dorothy C. Miller, *Edward Hicks: His Peaceable Kingdoms and Other Paintings* (Newark: University of Delaware Press, 1983). Mather and Miller also provide a catalogue of Hicks' work.

2. The other three are at Yale University Art Gallery, New Haven; Abby Aldrich Rockefeller Folk Art Center, Williamsburg; Mead Art Gallery, Amherst College, Amherst, Massachusetts.
3. Mather and Miller, *Hicks*, p. 22.

BIBLIOGRAPHY

Alice Ford. *Edward Hicks: Painter of the Peaceable Kindgom*. Philadelphia: University of Pennsylvania Press, 1952.
———. *Edward Hicks: His Life and Art*. New York: Abbeville Press, 1985.
Julius Held. "Edward Hicks and the Tradition." *Art Quarterly* 14 (Summer 1951): 121–136.
Eleanore Price Mather and Dorothy C. Miller. *Edward Hicks: His Peaceable Kingdoms and Other Paintings*. Newark: University of Delaware Press, 1983.

JOHN HILL

1770–1850

See WILLIAM JAMES BENNETT

Niagara Falls, Part of the British Fall, Taken from under the Table Rock, PLATE 151

Niagara Falls, Part of the American Fall, from the Foot of the Stair Case, PLATE 37

See FIELDING LUCAS, JR.

Lucas' Progressive Drawing Book, PLATE 44

See JOSHUA SHAW

Picturesque Views of American Scenery, PLATES 46, 51, 194

See WILLIAM GUY WALL

Hudson River Portfolio, PLATES 56, 57, 58, 126, AND 163

Born in London on September 9, 1770, Hill was apprenticed to a publisher of illustrated books. Subsequently he acquired skill in aquatinting, a form of etching originated in France and developed in England by Paul Sandby. Hill achieved considerable success in England as a printmaker, translating the works of J. M. W. Turner, Philip de Loutherbourg, William Henry Pyne, Thomas Rowlandson, and others into plates.[1] He also worked for the great London publisher Rudolph Ackermann. Despite his success, he became concerned about his ability to support his family in a highly competitive market with a decreasing demand for aquatints. In England he was just one of many skilled craftsmen; in America, he would have no peers. Therefore, in 1816 he emigrated to America, settling in Philadelphia, then a very active publishing center. Three years later he sent for his family.

In 1819 Hill started work on Joshua Shaw's *Picturesque Views,* one of the two major publications for which Hill is best known. Although the publication did not attain its projected size of thirty-six plates (when finally issued it had only twenty including the title page), it was the first major series of views to be printed in America. Earlier efforts had

been sent to England for engraving, since there was no one in America until Hill capable of producing aquatints of high quality.

Hill was still finishing up the Shaw project when he embarked on his collaboration with William Guy Wall. The *Hudson River Portfolio* is a monument in the history of fine art printing and of landscape in America. This project, which resulted in Hill's moving in 1822 to New York, involved him well into the 1830s as new editions were issued or new pulls from plates made. Hill aquatinted the series and supervised the coloring of the plates. Thousands of copies of the various prints were sold.[2]

Among his individual and serial prints were views of New York by Wall and of Niagara by William James Bennett, a fellow Englishman and a master aquatinter. The pair of Niagara views are among the most effective early views of that sublimest of American scenes.[3] Hill also designed and executed two artists' manuals, one of which was on landscape, and contributed to Fielding Lucas' *Progressive Drawing Book*.

In 1837 Hill bought property in Clarksville, Rockland County, New York. He moved there with his wife a few years later, and it was there that he died on November 6, 1850.

EJN

1. The standard study of Hill is Richard J. Koke, "John Hill, Master of Aquatint," *New-York Historical Society Quarterly* 43 (January 1959): 51–117. Hill's English account book is preserved at the Metropolitan Museum of Art; his American records are in the collection of the New-York Historical Society.
2. Koke, "John Hill," p. 99.
3. To place the Bennett-Hill views of Niagara in context, see Jeremy Elwell Adamson, "Nature's Grandest Scene in Art," *Niagara: Two Centuries of Changing Attitudes, 1697–1901* (Washington, D.C.: Corcoran Gallery of Art, 1985).

BIBLIOGRAPHY

Richard J. Koke. "John Hill, Master of Aquatint." *New-York Historical Society Quarterly* 43 (January 1959): 51–117.
_____. *A Checklist of the American Engravings of John Hill (1770–1850).* New York: New-York Historical Society, 1961.
_____. *American Landscape and Genre Painting in the New-York Historical Society.* Boston: New-York Historical Society with G. K. Hall, 1982. Vol. II.
Dale Roylande and Nancy Finlay. *Pride of Place: Early American Views from the Collection of Leonard L. Milberg '53.* Princeton: Princeton University Library, 1983.
Frank Weitenkampf. "Early American Landscape Prints." *Art Quarterly* 8 (Winter 1945): 40–67.
_____. "John Hill and American Landscapes in Aquatint." *American Collector* 17 (July 1948): 6–8.

ROBERT HOOD

1795/1796–1821

Trout Fall and Portage on the Trout River, Northwest Territories

Watercolor on paper, 1819
10 x 15½ in. (25.4 x 38.6 cm)
Public Archives Canada, Ottawa

PLATE 95

A Canoe on the Northern Land Expedition Chasing Reindeer in Little Marten Lake, Northwest Territories

Watercolor over graphite on paper, 1820
10 x 15 in. (25.4 x 38.1 cm)
Public Archives Canada, Ottawa

PLATE 5

Hood was born in Portarlington, Ireland, the son of a minister. He entered the Royal Navy in 1809, becoming a midshipman in 1811. Although there is no record of his training, he was active as an artist from the beginning of his naval career. Hood's style is a sophisticated one; clearly he was in touch with the latest developments in London. The first engraving after his work dates from his first ship, the *Melpomene,* in 1809; four more engravings date from 1811 and 1812. He joined John Franklin's Arctic expedition in 1819 but did not survive it: he was murdered on October 20, 1821. As several of the group lay starving, Michel, an Indian member of the party decided to cannibalize them. He killed three men, including Hood, before he was shot. Hood's watercolors, including both *Trout Fall and Portage on the Trout River, Northwest Territories* and *A Canoe on the Northern Land Expedition Chasing Reindeer in Little Marten Lake,* were used by Franklin to illustrate his *Narrative of a Journey to the Shores of the Polar Sea,* 1823.

BR

BIBLIOGRAPHY

W. Martha E. Cooke. *W. H. Coverdale Collection of Canadiana: Paintings, Water-colours and Drawings (Manoir Richelieu Collection).* Ottawa: Public Archives Canada, 1983.
John Franklin. *Narrative of a Journey to the Shores of the Polar Sea in the Years 1819, 20, 21, and 22.* London: John Murray, 1823.
Charles Stuart Houston. *To the Arctic by Canoe 1819–21: The Journal and Paintings of Robert Hood, Midshipman with Franklin.* Montreal: Arctic Institute of North America and McGill-Queen's University Press, 1974.

FRANCIS JUKES

1747–1812

See ALEXANDER ROBERTSON

Hudson River from Chamber's Creek, PLATE 19

Mount Vernon in Virginia, PLATE 193

Francis Jukes was one of the earliest aquatint engravers in England and seems to have been a student or close associate of Paul Sandby. He exhibited two aquatints after drawings by Chatelain at the Society of Artists in London in 1775, closely modelled on Paul Sandby's prints and predating them in publication. Jukes was a prolific publisher of drawing books and landscape aquatints.

BR

BIBLIOGRAPHY

Bruce Robertson. *The Art of Paul Sandby.* New Haven: Yale Center for British Art, 1985. Pp. 68–70.

PLATE 185. BENJAMIN HENRY LATROBE, *View of Richmond from Washington's Island*, 1796.

BENJAMIN HENRY LATROBE

1764–1820

"An Essay on Landscape," 1798–1799

Taste Anno 1620, PLATE 115a

Studies of Trees, PLATE 115b

Watercolor and ink on paper
Manuscript
Archives Branch, Virginia State Library
(Corcoran only)

View of Mount Vernon Looking toward the South West

Pencil, pen and ink, watercolor on paper, 1796
6¹⁵/₁₆ x 10¹⁵/₁₆ in. (17.7 x 27.8 cm)
The Maryland Historical Society
PLATE 148

View of Richmond from Washington's Island

Watercolor on paper, 1796
6¹⁵/₁₆ x 10⁵/₁₆ in. (17.7 x 26.2 cm)
The Maryland Historical Society
PLATE 185

Born in Fulneck, Yorkshire, on May 1, 1764, Latrobe was raised and educated by the Moravian Church in England and Germany. After leaving the seminary of Barby in Saxony in 1783 because of religious doubts, Latrobe joined his parents in London. Shortly thereafter he began studying engineering and architecture. In 1790 he married, but his wife died three years later. Latrobe then decided to emigrate to America. He settled first in Virginia, where he made the acquaintance of Thomas Jefferson and George Washington. While in Virginia he designed the penitentiary at Richmond. In 1798 he moved to Philadelphia. A second marriage followed in 1800. Latrobe remained in America the rest of his life, dying in New Orleans of yellow fever on September 3, 1820, while engaged in work on the city's waterworks.

Latrobe was one of the best neoclassical architects of the young republic. His training and practice in England had put him in touch with the leading members of his profession. Among his major American buildings are the Bank of Pennsylvania. the Philadelphia Waterworks, and the Roman Catholic Cathedral in Baltimore. In 1803 President Jefferson appointed him Surveyor of Public Buildings in Washington. In his capacity as Architect of the Capitol he oversaw the construction of that building according to the plans of Dr. William Thornton and contributed significantly to its final form, particularly in the design of the interior space and architectural details. He served in Washington from 1803 to 1811, and again from 1815 to 1817.

As an amateur painter, Latrobe was particularly responsive to landscape. In "An Essay on Landscape," an instruction manual in drawing and artistic theory written in 1798–1799 for his student Susan Catherine Spotswood, Latrobe remarked: "I find nothing so instructive as the contemplation of nature."[1] His sensitivity to nature is demonstrated in the many watercolors he produced of American scenery, especially in his handling of light and atmospheric effects.[2]

The text of Labrobe's "Essay" and the landscapes he painted reveal his grasp of the picturesque. His balanced compositions, with a house or distant prospect framed by a tree as in *View of Mount Vernon* and *View of Richmond,* conform to the Claudian model associated with that aesthetic. But he also emphasized a fidelity to nature which is particularly apparent in his renderings of rugged and rural scenery. Latrobe argued for an exact imitation of nature, but his views in keeping with current artistic practice were not necessarily accurate records of a given place, nor were the watercolors executed on the spot.[3] If, in practice, he at times produced works which are formulaic and generalized, Latrobe was nevertheless keenly aware of the need to define the particularities of a landscape.

<div align="right">EJN</div>

1. Edward C. Carter II, et al., *The Virginia Journals of Benjamin Henry Latrobe 1795–1798,* 2 vols. (New Haven and London: Yale University Press for the Maryland Historical Society, 1977), Vol. II, pp. 467–531, reproduces the "Essay," p. 468.
2. Edward C. Carter II, John C. Van Horne, and Charles E. Brownell, eds., *Latrobe's View of America, 1795–1820* (New Haven and London: Yale University Press for the Maryland Historical Society, 1985), reproduces a large selection.

3. See Charles Brownell, "An Introduction to the Art of Labrobe's Drawings," *ibid.,* pp. 17–18, 25.

BIBLIOGRAPHY

Edward C. Carter II, et al. *The Virginia Journals of Benjamin Henry Latrobe 1795–1798.* 2 vols. New Haven and London: Yale University Press for the Maryland Historical Society, 1977.
———, John C. Van Horne, and Charles E. Brownell, eds. *Latrobe's View of America, 1795–1820.* New Haven and London: Yale University Press for the Maryland Historical Society, 1985.
Talbot Hamlin. *Benjamin Henry Latrobe.* New York: Oxford University Press, 1955.

JOHN H. B. LATROBE
1803–1891

FIELDING LUCAS, JR.
1781–1854

Lucas' Progressive Drawing Book, 1827–1828

Falls of the Susquehanna above Columbia, PLATE 186

View of the Susquehanna, PLATE 44

Colored aquatints, c. 1825
(John Hill after Latrobe)
Library of Congress

PLATE 186. JOHN HILL after Latrobe, *Falls of the Susquehanna above Columbia,* from *Lucas' Progressive Drawing Book,* c. 1825.

The artist of the colored illustrations in *Lucas' Progressive Drawing Book* was the elder son of Benjamin Henry Latrobe. Born in Philadelphia on May 4, 1803, he was educated at Georgetown College in Washington and Saint Mary's College in Baltimore. A lawyer by profession, Latrobe was an amateur artist throughout his life. These illustrations were done when he was a young man just embarking on a career, a fact which may in part explain his use of the nom de plume "E. van Blon," a play on his middle name, Bloneval. Public servant and philanthropist, Latrobe was founder and president of the Maryland Historical Society; he also served as regent for the University of Maryland. Some of the designs in this book were based on works by his father.[1] Latrobe died in Baltimore on September 11, 1891.

Lucas was a major publisher of fine art books in the early part of the nineteenth century and a key figure in the cultural life of Baltimore. This particular volume is important for several reasons. With its beautifully crafted aquatints by John Hill after works by Latrobe, *Lucas' Progressive Drawing Book* was the most ambitious and sumptuous drawing manual yet published in America. Moreover, it was the first American book on landscape art to be illustrated with native scenery. Earlier works, including one published by Lucas, had been decorated almost exclusively with English scenes and architecture. Appropriately, Lucas' publication was dedicated to Robert Gilmor, a leading art patron in Baltimore who then was acquiring works by American landscapists such as Thomas Cole and Thomas Doughty.

The text borrows heavily from the works of John Varley, one of the leading English watercolorists and drawing masters of the day. Lucas had published Varley's treatise on perspective a few years earlier. From the sophistication of the material and the elaborate production, the book clearly was aimed at an informed and limited audience, not at the uninitiated amateur, as were so many of the other instruction manuals published at the time.

EJN

1. Edward C. Carter II, John C. Van Horne, and Charles E. Brownell, eds., *Latrobe's View of America, 1795–1820* (New Haven and London: Yale University Press for the Maryland Historical Society, 1985), pp. 39, 224.

BIBLIOGRAPHY

Edward C. Carter II, John C. Van Horne, and Charles E. Brownell, eds. *Latrobe's View of America, 1795–1820.* New Haven and London: Yale University Press for the Maryland Historical Society, 1985.
James W. Foster. "Fielding Lucas, Jr., Early 19th Century Publisher of Fine Books and Maps." *Proceedings of the American Antiquarian Society* 65 (October 1955): 161–212.
Peter C. Marzio. *The Art Crusade: An Analysis of American Drawing Manuals, 1820–1860.* Washington, D.C.: The Smithsonian Institution Press, 1976.
John E. Semmes. *John H. B. Latrobe and His Times, 1803–1891.* Baltimore: Norman, Remington Co., 1917.

CHARLES B. LAWRENCE
c. 1790–1864

Point Breeze

Oil on canvas, 1817–1820
26⅞ x 36¼ in. (68.3 x 92.1 cm)
The New Jersey State Museum Collection, Trenton; gift of Mr. and Mrs. Harry L. Jones

PLATE 187

Point Breeze

Oil on canvas, c. 1817–1820
26 x 35½ in. (66 x 90.2 cm)
The New Jersey State Museum Collection, Trenton; gift of Mr. and Mrs. Harry L. Jones

PLATE 43

In 1812 the critic of *The Port Folio*, a magazine devoted to literature and culture, praised Lawrence's landscapes for their "strong resemblances of the places he has meant to represent." The writer also remarked,

> *There is a charm in nature, a fascination of which he who arduously tries to imitate it, must seize some portion; and it is, I believe, as certain, that the spectator will himself feel an irrestible sensation of pleasure when he looks on the imitation. Such at least are the sensations that we feel at looking on the pictures of young Lawrence. . . .*[1]

In his view the young artist, who was at times compared to Thomas Birch, had great promise as a landscape painter. Despite this early recognition, Lawrence seems not to have produced a large body of landscapes and has become a rather shadowy figure in the history of American art.

Born near Bordentown, New Jersey, probably in the 1790s, Lawrence is believed to have studied with Rembrandt Peale and Gilbert Stuart.[2] A portrait and landscape painter whose artistic career centered on Philadelphia, he exhibited regularly at the Pennsylvania Academy of the Fine Arts from 1811 to 1832. Seven views of the area around Bordentown and the Delaware River were shown there between 1811 and 1813. Lawrence moved to Philadelphia in 1813, where he is known to have painted portraits. Among his sitters are Abbé Correa de Serra, Professor of Botany and Portuguese Minister to the United States; Pierre de Poletica, Minister from Russia; and Countess Charlotte de Survilliers, daughter of Joseph Bonaparte, Napoleon's brother who had come to America in 1815.[3] Joseph Bonaparte built a mansion near Bordentown — Point Breeze — which became something of an artistic center.[4] Lawrence executed two landscapes for Poletica[5] and one for Bonaparte. Listed in the Bonaparte sale of works of Point Breeze is a "landscape by Lawrence: A View of the Old Mansion, the Park and the Delaware River, beautifully painted for the prince."[6] However, it is not possible to identify the two works exhibited here with any of these documented pieces.

Lawrence painted mostly portraits in his later years. In 1825 he was on the Committee of Arrangement of the

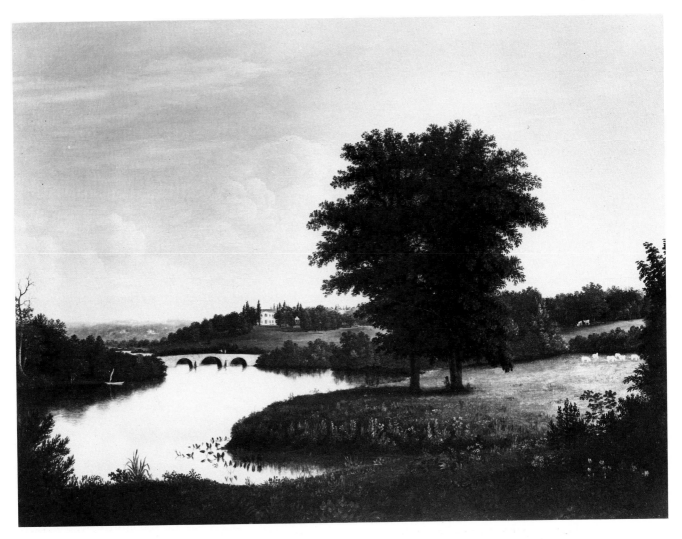

PLATE 187. CHARLES B. LAWRENCE, *Point Breeze*, c. 1817–1820.

Pennsylvania Academy along with Thomas Doughty and John Neagle. Around 1837 he stopped painting. After that he reportedly worked as a clerk in a bank and as a plumber in Philadelphia.[7] He died in 1864.

LEM

1. "The Fine Arts — For the Port Folio: Review of the second Annual Exhibition — Picture Gallery." *Port Folio* 8 (July 1812): 28.

2. William Dunlap, *History of the Rise and Progress of the Arts of Design in the United States* (1834; reprint, Rita Weiss, ed., New York: Dover, 1969), Vol. II, p. 254.

3. Joseph Hopkinson papers, Historical Society of Pennsylvania, courtesy of Jill Mesner, curator.

4. William Gerdts, Jr., *Painting and Sculpture in New Jersey* (Princeton: Van Nostrand, 1964), p. 56.

5. Letters from P. Poletica to J. Hopkinson, December 5, 9, and 10, 1821, Joseph Hopkinson Papers, Historical Society of Pennsylvania. The letter dated December 10 discusses Lawrence's landscapes of Point Breeze and Morrisville; these were not exhibited at the Pennsylvania Academy.

6. Evan Morrison Woodward, *Bonaparte's Park and the Murat* (Trenton, N.J., 1879), p. 64. Several versions of this subject exist and have been attributed to Lawrence; they are in the Historical Society of Pennsylvania, New Jersey Historical Society, Bank of Mid-Jersey in Bordentown, and a private collection.

7. George C. Groce and David H. Wallace, eds. *New-York Historical Society Dictionary of Artists in America* (New Haven: Yale University Press, 1957), p. 387.

BIBLIOGRAPHY

Bordentown 1682–1976. Bordentown, N.J.: Bordentown Historical Society, 1977.

William Gerdts, Jr. *Painting and Sculpture in New Jersey.* Princeton, N.J.: Van Nostrand, 1964.

Letters from P. Poletica to J. Hopkinson, December 5, 9, and 10, 1821. Joseph Hopkinson Papers, Historical Society of Pennsylvania.

J. Thomas Scharf and Thompson Westcott, eds. *History of Philadelphia.* Philadelphia: L. H. Everts and Co., 1884. Vol. II.

Evan Morrison Woodward. *Bonaparte's Park and the Murat.* Trenton, N.J., 1879.

GEORGE MURRAY

?–1822

Buttermilk Falls Creek, Luzerne County, Pennsylvania

Engraving from *The Port Folio,* February 1809
Library Company of Philadelphia

PLATE 42

Little is known about the early life of Murray except that he was born in Scotland and went to London as a young man. There he received instruction in engraving from Anker Smith. Murray served his master for five years from the time he was eighteen.[1] Democratic political views apparently caused him to leave England for America.

273

After a few years in the South, where he married and unsuccessfully engaged in business, he moved to Philadelphia around 1800. Here he took up his old profession. In 1810 or 1811, he along with John Draper and Gideon Fairman established a company which specialized in engraving banknotes. The firm was very successful; however, Murray lost his fortune in real estate speculation. He died impoverished on July 2, 1822.

Although Murray exhibited his work, he is more important as an artistic force in Philadelphia than as a creative artist. He was in the forefront of those who agitated to get representation of artists in the affairs of the businessmen-dominated Pennsylvania Academy of the Fine Arts. And he was one of the founding fellows of the Society of Artists of the United States in 1810, set up in opposition to Academy policies. Other members included John James Barralet, Thomas Birch, Benjamin Henry Latrobe, and James Peale. For several years the Society played a vital role in the artistic life of Philadelphia, providing classes and holding exhibitions.[2] However, its differences with the Academy resulted in tension in the small cultural community, and Murray's pronouncements antagonized many, including Thomas Sully, who resigned from the Society because he found its demands to the Academy unreasonable.

Murray was also an articulate spokesman for American landscape. In his address to the new Society in August of 1810, in which he encouraged drawing from nature and minimized the academic practice of beginning with casts, he waxed eloquent on the "sublime and picturesque scenery" of America.[3] His illustration of *Buttermilk Falls* initiated the series of landscapes that appeared periodically in *The Port Folio* as a way of promoting American scenery. Murray also contributed reviews of exhibitions to the magazine.

EJN

1. The primary source of information on Murray is William Dunlap, *History of the Rise and Progress of the Arts of Design in the United States* (1834; reprint, New York: Benjamin Blom, 1965), Vol. II, pp. 285–286. See also "Mr. Murray's Correspondence with Mr. Bell. . . ," *Port Folio* 2 (July 1813): 88.
2. For information on the Society of Artists and its relationship with the Academy, see Edward J. Nygren, "Art Instruction in Philadelphia, 1795–1845," M. A. Thesis, University of Delaware, 1969, esp. Ch. 4; also Nygren, "The First Art Schools at the Pennsylvania Academy of the Fine Arts," *Pennsylvania Magazine of History and Biography* 95 (April 1971): 221–238.
3. George Murray, "Progress of the Fine Arts: Address Delivered before the Society of Artists of the United States, on the first of August, 1810," *Port Folio* 4 (September 1810): 260–261.

BIBLIOGRAPHY

"Mr. Murray's Correspondence with Mr. Ball. . . ." *Port Folio* 2 (July 1813): 84–93.
George Murray. "Progress of the Fine Arts: Address Delivered before the Society of Artists of the United States, on the first of August, 1810." *Port Folio* 4 (September 1810): 258–263.
Edward J. Nygren. "Art Instruction in Philadelphia, 1795–1845." M. A. Thesis. University of Delaware, 1969.
———. "The First Arts Schools at the Pennsylvania Academy of the Fine Arts," *Pennsylvania Magazine of History and Biography* 95 (April 1971): 221–238.

JOHN NEAGLE
1796–1865

"Lessons on Landscape Painting"
(Notebook No. 5), c. 1825–1830

From Sully's Imitation of Turner, PLATE 71

From Sully's Copy of Varley, PLATE 188

Manuscript and watercolor on paper
American Philosophical Society Library, Philadelphia
(Corcoran only)

View of Peter's Island on the Schuylkill

Oil on canvas, 1827
24⅞ x 35⅞ in. (63.2 x 91.2 cm)
The Art Institute of Chicago; Friends of American Art
PLATE 72

Best known as a portrait painter, Neagle was born in Boston on November 4, 1796, when his parents were visiting the city from Philadelphia. His father died when he was four, and his mother remarried, to a man "who was no friend to John or to the arts."[1] Neagle had little formal training: a short period in Pietro Ancora's drawing academy and two months of instruction from Bass Otis. Around 1813 he apprenticed himself to Thomas Wilson, a coach and ornamental painter, who encouraged his artistic ambitions.

Completing his apprenticeship in 1818, Neagle set out for Kentucky to see if he could make a living as a portrait painter. Discouraged, he went to New Orleans. Soon he returned to Philadelphia, where he set up a studio in his mother's house. By 1825 Neagle was well established as a portraitist. Around this time he became friendly with Thomas Sully, whose stepdaughter he married in 1826.

During the 1820s Neagle availed himself of the advice of many artists, particularly Sully. His notebooks, preserved at the American Philosophical Society, are important for the insight they provide into artistic interaction during this decade and after. In the notebook containing "Lessons on Landscape Painting," Neagle reproduces Sully's imitation of J. M. W. Turner and copies after John Varley, two of the leading English watercolorists of that period. He also transcribes the quotations from Varley that were in Sully's sketchbook. The notebooks contain references to other artists such as Joshua Shaw, who discussed Philip de Loutherbourg's use of orange orpiment to create certain fiery and sunny effects,[2] a color Neagle apparently employed to the same end in his famous painting of *Pat Lyon* (Museum of Fine Arts, Boston).

These documents reveal Neagle's artistically acquisitive and inquisitive nature. And his receptivity to ideas is apparent in his willingness to experiment with new techniques and forms. *View of Peter's Island on the Schuylkill* is a case in point. Neagle produced very few pure landscapes in

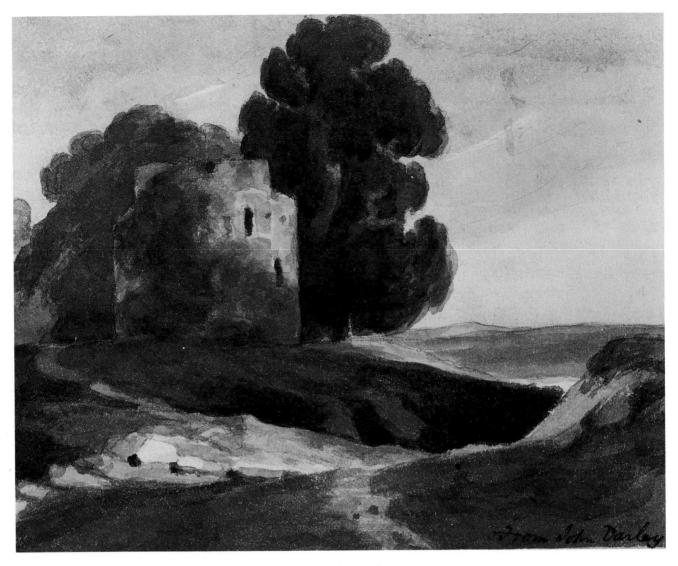

PLATE 188. JOHN NEAGLE, *From Sully's Copy of Varley,* from "Lessons on Landscape Painting," c. 1825–1830.

his life, and those he created were done about this time when he was experimenting with watercolor. In this oil, which according to an old inscription was "painted from nature,"[3] he achieves a freshness that must in part be attributable to his concurrent interest in watercolor. The breadth of execution — fluid brushwork and subtle treatment of atmospheric effects — speaks for Neagle's painterly concerns, while his use of light and dark visually enlivens the drama of the dog and little girl in the foreground. Such techniques display Neagle's unique approach to subject matter.

Throughout much of his life Neagle was active in the artistic affairs of Philadelphia, serving as president of the Artists Fund Society for many years. In the last years of his life he was paralyzed. He died in Philadelphia on September 17, 1865.

TYL

1. William Dunlap, *History of the Rise and Progress of the Arts of Design in the United States* (1834; reprint, New York: Benjamin Blom, 1965), Vol. III, p. 165.
2. John Neagle, "Receipts," Manuscript, American Philosophical Society, [p. 57].
3. Daniel Catton Rich, "A Landscape by John Neagle," *Chicago Art Institute Bulletin* 29 (1935): 78.

BIBLIOGRAPHY

Virgil Barker. "John Neagle." *The Arts* 8 (1925): 7–23.
Marguerite Lynch. "John Neagle's Diary." *Art in America* 37 (April 1949): 79–99.
John Neagle. "Lessons on Landscape Painting. . . ." Manuscript. American Philosophical Society.
———. "Receipts. . . ." Manuscript. American Philosophical Society.
Ranson R. Patrick. *Early Life of John Neagle, Philadelphia Portrait Painter.* Ph.D. dissertation, Princeton University, 1959. Ann Arbor, Mich.: University Microfilms, 1959.
———. "John Neagle, Portrait Painter and Pat Lyon, Blacksmith," *Art Bulletin* 33 (September 1951): 187–192.
Daniel Catton Rich, "A Landscape by John Neagle." *Chicago Art Institute Bulletin* 29 (1935): 78–79.

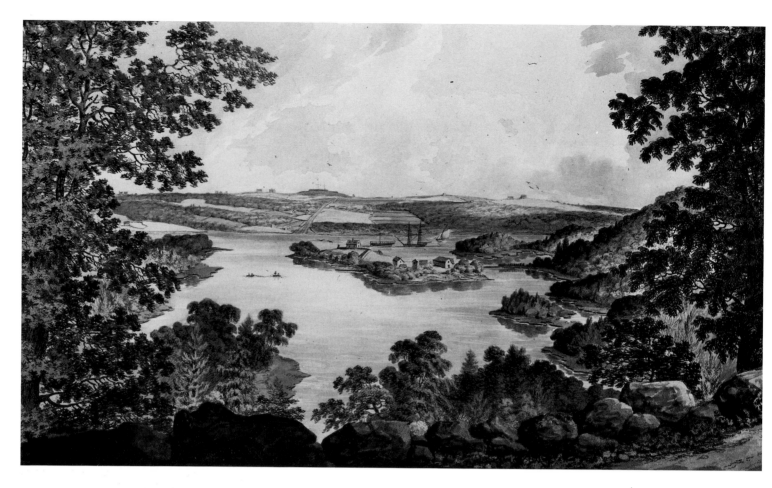

PLATE 189. GEORGE ISHAM PARKYNS, *View from Cowies Hill near Halifax, Nova Scotia*, 1801.

GEORGE ISHAM PARKYNS

1749–1820

Falls of the Schuylkill

Oil on canvas, 1800

28 x 36 in. (71.1 x 91.4 cm)

Private collection

PLATE 110

Washington

Aquatint, c. 1800

13½ x 15⅝ in. (32.6 x 40.7 cm) (sheet size)

Library of Congress

PLATE 124

View from Cowies Hill near Halifax, Nova Scotia

Etching and aquatint with watercolor, 1801

12⁷/₁₀ x 21 in. (32.38 x 53.34 cm) (image size)

Public Archives Canada, Ottawa

PLATE 189

Parkyns, an English engraver and painter, was born in Nottingham, England, in 1749. Little is known of his early life, except that he exhibited a landscape engraving at the Society of Artists in London in 1772.[1] By 1782 he was the commander of a company in the Nottinghamshire militia; in 1792 he published six plans for landscape gardens.[2]

While in the militia Parkyns met Captain Francis Grose, who was well known for his illustrated views of the antiquities of Great Britain. Grose introduced him to James Moore, an amateur draftsman, who persuaded Parkyns to assist him in engraving Moore's drawings of ancient abbeys, religious houses, and castles in England and Wales.[3] The first volume appeared in London in 1792 with great success, but the publication came to a halt in 1794 after a fire at the printers destroyed many of the plates.[4] In the early 1790s Parkyns also engraved the drawings of J. C. Barrow for another publication, *Picturesque Views of Churches and Other Buildings*. Two of the prints were shown in 1791 at the Society of Artists, where the artist exhibited four landscape paintings.[5]

Parkyns came to the United States in 1794 to settle the titles of considerable tracts of land that he had purchased.[6] According to William Birch, Parkyns not only made drawings of some of the country seats near Philadelphia but laid out at least one of them.[7] In Philadelphia in 1794, he was one of eight English artists who joined the short-lived Columbianum, an artist's organization. The following year

Parkyns entered into an agreement with New York publisher James Harrison to produce a series of twenty-four aquatint views of American cities. Although the publication failed for lack of subscriptions, several views were published: *Washington from Georgetown, Mount Vernon, Annapolis, Maryland,* and *Washington from the Shore. Mount Vernon* is the only known view of Washington's estate engraved during the president's lifetime.[8] Parkyns also completed drawings of Passaic Falls and Brandywine Mills in Pennsylvania in 1796.[9] *Falls of the Schuylkill* and the aquatint engravings of Halifax were done at the turn of the century.

Parkyns returned to England in 1801. A few years later he exhibited several American landscapes at the Royal Academy, including *A View on the Brandywine Creek, near Gilpin's Mills,* in 1808, and *The Great Falls of the Passaick River* in 1813.[10] These landscapes and an English battle piece may have been the productions which led to his appointment as Draughtsman to Their Royal Highnesses, the Dukes of York and Kent, in 1813.[11]

His remaining years were spent producing a revision of *Monastic and Baronial Remains,* issued in 1816. His last known work, *The Cathedral and City of Ely Seen from the Cam,* was engraved in 1820, the year of his death.

JAH

1. Algernon Graves, *The Society of Artists of Great Britain 1760–1790 and the Free Society of Artists 1761–1763* (Bath: Kinsmead Reprints, 1969), p. 189.
2. C. F. Bell, "Fresh Light on some Water-Colour Painters of the Old British School Derived from the Collection of Papers of James Moore, F.S.A.," *The Walpole Society,* Vol. VI (London: Oxford University Press, 1915–1917), pp. 60, 61.
3. George I. Parkyns, *Monastic and Baronial Remains* (London: Longman. . . , 1816) Vol. I, p. vi.
4. Bell, "Fresh Light," pp. 48–49; Parkyns, *Monastic and Baronial Remains,* pp. vii–viii.
5. Bell, "Fresh Light," p. 65; Graves, *Society of Artists,* p. 189.
6. Parkyns, *Monastic and Baronial Remains,* p. viii.
7. William Russell Birch, "The Life of William Russell Birch, Enamel Painter, Written by Himself," typescript, New York Public Library, p. 47.
8. Robert L. Harley, "George Washington Lived Here," *Antiques* 47 (February 1945): 104–105.
9. Rita Susswein Gottesman, *The Arts and Crafts in New York 1777–1799* (New York: New-York Historical Society, 1954), pp. 48–49.
10. Algernon Graves, *The Royal Academy of Arts Contributors in 1789–1904* (1905–1906; reprint, New York: Burt Franklin, 1972), Vol. V, p. 60.
11. Bell, "Fresh Light," pp. 65–66.

BIBLIOGRAPHY

C. F. Bell. "Fresh Light on Some Water-Colour Painters of the Old British School Derived from the Collection and Papers of James Moore, F.S.A." *The Walpole Society.* Vol. VI. London: Oxford University Press, 1915–1917.
"George Isham Parkyns (1749/50 ca.–1820)." *Kennedy Quarterly* 7 (December 1967): 241.
George I. Parkyns. *Monastic and Baronial Remains.* 2 vols. London: Longman, . . . , 1816.
I. N. Stokes and Daniel C. Hasdell. *American Historical Prints – Early Views of American Cities . . .* New York: New York Public Library, 1933.

JAMES PEACHEY

active 1773–1797

A View of the Falls of Montmorency

Etching with watercolor, 1783
12 x 17⁹/10 in. (30.5 x 45.5 cm)
Public Archives Canada, Ottawa

PLATE 89

A Winter View of the Falls of Montmorency

Watercolor and pen and ink on paper, 1781
15¹/5 x 22²/5 in. (38.5 x 56.8 cm)
Public Archives Canada, Ottawa

PLATE 190

Peachey first appears as a draftsman for the Board of Trade surveys of Canada in the early 1770s. It is probable that he received some training in the Drawing Room of the Board of Ordnance in the Tower of London. During the American Revolution he remained in London, rendering the surveys into maps and views, some of which were incorporated into *The Atlantic Neptune.* From 1780 to 1784 he was again in Canada as a surveyor, and because of his job he traveled widely. Returning to London, he produced etched outlines and aquatints of these views, such as *A View of the Falls of Montmorency,* in emulation of DesBarres and Sandby, and exhibited Canadian subjects at the Royal Academy in 1786 and 1787. In Canada in 1788, this time with an army commission, he continued his surveying. Working his way up the ranks to captain, he transferred to several different regiments, probably leaving Canada for Martinique not long before his death there on November 23, 1797.

BR

BIBLIOGRAPHY

Mary Allodi. *Canadian Watercolours and Drawings in the Royal Ontario Museum.* Toronto: Royal Ontario Museum, 1974.
W. Martha E. Cooke. *W. H. Coverdale Collection of Canadiana: Paintings, Water-Colours and Drawings (Manoir Richelieu Collection).* Ottawa: Public Archives Canada, 1983.
James Peachey (active/connu 1773–1797). Archives Canada Microfiche 2. Ottawa: Public Archives Canada, 1976.

JAMES PEAKE

active 1743–1782

See THOMAS POWNALL

A Design to Represent the Beginning and Completion of an American Settlement or Farm, PLATE 87

A professional English engraver, Peake exhibited regularly at the Society of Artists in London from 1761 to 1771.

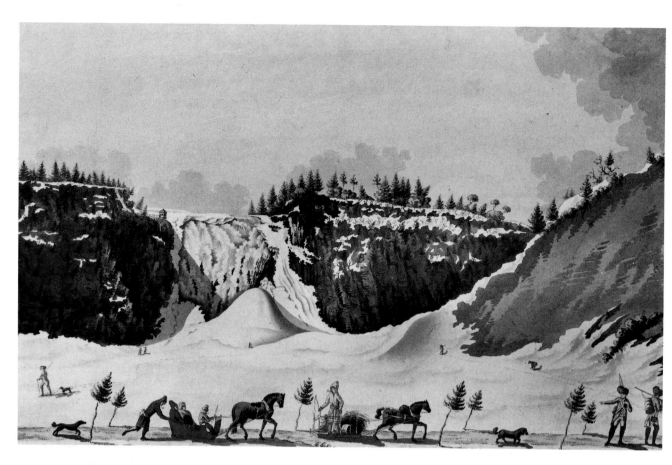

PLATE 190. JAMES PEACHEY, *A Winter View of the Falls of Montmorency*, 1781.

CHARLES WILLSON PEALE

1741–1827

Sketchbook of the Hudson, 1801

American Philosophical Society Library, Philadelphia
(Corcoran only)

PLATE 53

Belfield Farm

Oil on canvas, 1815–1820
10¾ x 15⅝ in. (27.31 x 39.69 cm)
The Detroit Institute of Arts; gift of Dr. and Mrs. Irving Levitt

PLATE 160

Germantown Mill Scene

Oil on canvas, 1815–1820
11⅛ x 15⅞ in. (28.3 x 40.3 cm)
Private collection

PLATE 191

Meadow and Road in Germantown (Country Lane)

Oil on canvas, 1815–1820
11¹⁄₁₆ x 15⅞ in. (28.1 x 40.3 cm)
Private collection

PLATE 30

Landscape Looking towards Seller's Hall from Mill Bank

Oil on canvas, c. 1818
15 x 21 in. (38.1 x 53.3 cm)
Private collection

PLATE 113

Born on April 15, 1741, on the Maryland Eastern Shore, Peale was nine when his father died and the family moved to Annapolis. There he was apprenticed to a saddler. In 1762, he took up portrait painting. With artists in short supply in the Tidewater region, Peale discovered portraiture was a more lucrative occupation than saddlemaking.[1] Five years later, the generosity of several benefactors enabled Peale to travel to London, where he worked under Benjamin West. Upon Peale's return to the colonies in 1769, he became the pre-eminent portraitist in Maryland, Virginia, and later Philadelphia, where he relo-

cated in 1775. Following the British model, Peale frequently depicted a sitter against a landscape background associated with the subject. Such motifs also lent a poetic charm to the image.

Peale's pure landscapes are few and tend to be concentrated in the early nineteenth century, by which time painting had become less an occupation than a pastime. There is evidence that early in his career independent landscapes posed problems for the artist. In 1769 Peale received his first landscape commission — presumably imaginary views in the European tradition. He failed to execute the commission and expressed relief when his patron finally ordered paintings from London.[2] Possibly his earliest independent landscapes are the topographical views of Philadelphia and its environs, which he sketched in 1787 for James Trenchard's *Columbian Magazine*.[3] In order to accurately record the perspective lines and impose an overall order on the separate elements within the landscape, Peale relied on an earlier invention, his "painter's quadrant," a type of camera obscura.[4]

The 1780s saw the establishment of the Peale Museum in Philadelphia. Originally consisting of a portrait gallery of Revolutionary War heroes, it later housed a natural science collection as well. In the ensuing years the museum occupied more of Peale's time, and in 1794 he announced that all portrait commissions would be handed over to his two older sons, Raphael and Rembrandt.

Although art demanded less of his attention, Peale still painted and drew, primarily for personal pleasure. On a museum-related trip in 1801, he made a visual record of a voyage up the Hudson. The river scenery, so rugged and dramatic in comparison with the gentler countryside around Philadelphia, stirred his emotions. He wrote, "The grand scenes . . . so enraptured me that I would if I could have made drawings with both hands at the same instant."[5] However, the landscapes in the sketchbook (1801) seem more a straightforward documentation of his journey than a visual expression of his feelings. Quickly sketched in pencil, evidently without the aid of the painter's quadrant, these drawings were later finished in watercolor. Less calculated than the scenes published in the *Columbian*, Peale's sketchbook studies are still strongly topographical.

In 1810 Peale turned over the responsibilities of the museum to his son Rubens and retired to Belfield, a farm in Germantown, just outside Philadelphia. At Belfield, Peale returned to portraiture and created his first landscapes in oil, which in some respects closely resemble the *Columbian* scenes of thirty years before. Again, Peale used a painter's quadrant to impose a fixed order on nature. The distinct landscape components are placed within a clear, rationally organized space and are depicted with scrupulous attention to detail. Although nature is perceived as calm and disciplined, these compositions are by no means static. In *Belfield Farm* and *Meadow and Road in Germantown*, sweep-

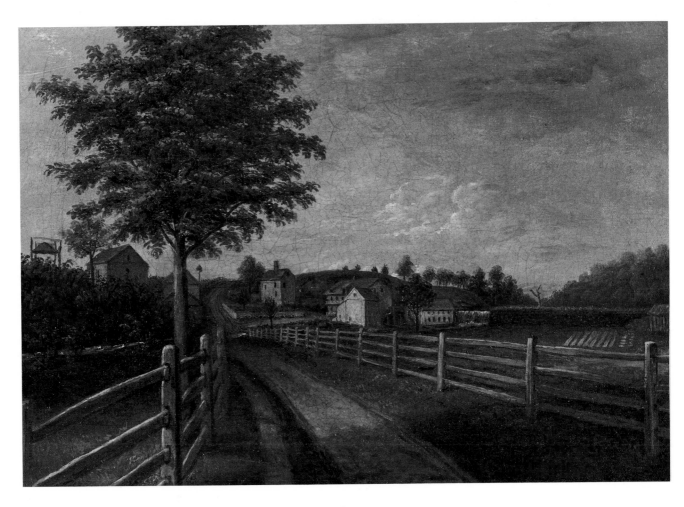

PLATE 191. CHARLES WILSON PEALE, *Germantown Mill Scene*, 1815–1820.

ing curved lines, converging at a distant point slightly off center, not only organize the compositions but add to them a sense of liveliness.[6]

Peale was not, however, entirely satisfied with these landscapes. He implied in a letter to his son Rembrandt that painting nature in broad masses of light and shadow was preferable to recording it in exacting detail, but "too many minute objects" on his Belfield farm prevented him from composing such a view.[7] Evidently Peale's scientific mind would not allow him to exclude any object within his sight. Following the death of his third wife in 1821, Peale returned to Philadelphia and to his museum. In the six remaining years of his life he painted more portraits, but the landscapes created at Belfield were his last.

It is curious that a man who was so deeply affected by nature only infrequently attempted to translate its beauty into art. Perhaps Peale felt less compelled to paint landscapes because the museum enabled him to express his total devotion to nature.[8] In his orderly arrangement of museum specimens set against painted scenes, Peale sought to reveal nature's physical truths and its underlying rational structure. In his landscape art Peale was guided by the very same principles. On February 22, 1827, at the age of eighty-six, Peale died in Philadelphia.

KBM

1. Edgar P. Richardson, "Charles Willson Peale and His World," in *Charles Willson Peale and His World*, by Edgar P. Richardson, Brooke Hindle, Lillian B. Miller (New York: Abrams, 1982), p. 25.
2. *Ibid.*, p. 90.
3. Peale's sketches, later engraved for publication by Trenchard, are discussed in Edgar P. Richardson, "Charles Willson Peale's Engravings in the Year of National Crisis, 1787," *Winterthur Portfolio* 1 (1964): 166–181. They are also reproduced in Richardson et al., *Peale*, Plates 57–62.
4. Richardson et al., *Peale*, p. 90.
5. Quoted in *ibid.*, p. 95.
6. Peale employed a similar compositional format in the *Columbian* drawing *East View of Gray's Ferry*. See *ibid.*, Plate 59.
7. Jessie Poesch, "Germantown Paintings: A Peale Family Amusement," *Antiques* 73 (November 1957): 435.
8. See Amy Meyers' essay "Imposing Order on the Wilderness" in this catalogue.

BIBLIOGRAPHY

Louise Lippincott. "Charles Willson Peale and His Family of Painters." *In This Academy*. Philadelphia: Pennsylvania Academy of the Fine Arts, 1976.
Jessie Poesch. "Germantown Landscapes: A Peale Family Amusement." *Antiques* 73 (November 1957): 434–439.
Edgar P. Richardson. "Charles Willson Peale's Engravings in the Year of National Crisis, 1787." *Winterthur Portfolio* 1 (1964): 166–181.
———, Brooke Hindle, Lillian B. Miller. *Charles Willson Peale and His World*. New York: Abrams, 1982.
Charles Coleman Sellers. *Charles Willson Peale*. New York: Scribner's, 1969.

JAMES PEALE
1749–1831

Pleasure Party by a Mill

Oil on canvas, c. 1790
26 x 40 in. (66 x 101.6 cm)
The Museum of Fine Arts, Houston; Bayou Bend Collection, gift of Miss Ima Hogg
PLATE 81

Landscape near Philadelphia

Oil on canvas, 1830
20 x 26 in. (50.8 x 66 cm)
Private collection
PLATE 82

The lives of James and Charles Willson Peale, his older brother, were as fundamentally different from one another as their art. Charles was a product of the Enlightenment: his public spiritedness and wide interests were not unusual among men of his generation. James was a more private individual who pursued few interests outside of art, even though it provided him with little financial reward.[1]

James Peale was born in Chestertown, Maryland, in 1749 and as a youth worked in his brother's Annapolis saddlery. Following an apprenticeship to a cabinetmaker, he became Charles' framemaker and pupil in the years immediately preceding the Revolution. After serving three years in the Maryland regiment, Peale resigned his commission in 1779 and moved to Philadelphia, where he rejoined his brother's busy studio and concentrated on miniature painting.

There is very little documentation of James Peale's life; however, a surviving sketchbook reveals that by the late 1780s he was interested in landscape as a subject.[2] One sketchbook drawing is of the site depicted in a *Pleasure Party by a Mill*.[3] Like Charles Peale's contemporaneous views in the *Columbian Magazine*, this work fits within the topographic tradition both in its specificity of place (the northern New Jersey milltown of Bloomsbury)[4] and in its detailed linear treatment of the foreground. This painting also shows Peale's familiarity with English artistic conventions. Although suggestive of a conversation piece, the painting is less a portrait than a fancy picture with the elegantly dressed lady and gentleman gracing an idyllic, pastoral setting.[5] With its accumulation of flora, fauna, and figures, Peale's *Pleasure Party* stresses nature's liveliness and diversity. The multiple vanishing points further enliven the landscape; but the pronounced asymmetry may in part be due to the artist's inexperience in landscape. Although his earliest works are often confused with Charles', *Pleasure Party* indicates that by 1790 James Peale had a distinct style of his own. By this time he was also leading a life independent of his brother.

Although landscape plays a predominant role in some of Peale's portraits between 1790 and 1810,[6] the majority of his

pure landscapes were created in the final two decades of his life. Around 1810 failing eyesight prompted him to hand over all work in miniature to his daughter Anna; but he continued to paint and frequently exhibited portraits, landscapes, and still lifes at the Pennsylvania Academy. Sometimes he traveled from Philadelphia to Germantown to do landscapes with his brother.[7] Probably around 1820 James executed the Swarthmore College *Wissahickon*,[8] which forms an interesting transition from his earlier landscapes to those created in the final years of his life. Extraneous details have been omitted; landscape elements are massed together in broad areas of light and shadow and are fluidly integrated into a cohesive composition whose focal point is an oval formed by the arc of a bridge and its reflection in the water. Indeed, it may have been James Peale's landscapes which led Charles to conclude that nature is best described in masses of light and shadow rather than exacting detail.

In *Wissahickon* nature is still perceived as benign, although it dwarfs the small figures and imparts a romantic flavor to his picturesque view. During the final years of his life Peale produced a series of landscapes in which this romantic vision is heightened. Despite its name, *Landscape near Philadelphia* is probably the work of the artist's imagination rather than an accurate description of a specific site. In it we find some familiar iconographic details of early-nineteenth-century romantic landscape painting: the windswept trees, uprooted trunks, and distant mountains. The composition is organized around a vortex of curves and countercurves, most of them converging on the lighted area of the near embankment.

Strong contrasts of light and dark contribute to the overall effect of nature's awesome power. The clarity and peacefulness of Charles Peale's Germantown landscapes suggest a world in which nature was controlled, even shaped by man. In James Peale's late landscapes the opposite view is expressed. Lucidity has been replaced by shadow and mystery; calmness by a threatening storm; and man, present by implication in Charles' paintings, has been banished. Shortly after completing this painting, James Peale died in Philadelphia on May 24, 1831. He was survived by children and grandchildren who carried on his artistic legacy.

KBM

1. Charles Coleman Sellers, "James Peale," in *The Peale Family. Three Generations of American Artists,* Charles H. Elam, ed. (Detroit: Detroit Institute of Art, 1967), p. 26.
2. Charles Coleman Sellers, "James Peale," in *Four Generations of Commissions. The Peale Collection of the Maryland Historical Society* (Baltimore: Maryland Historical Society, 1975), p. 31.
3. Although Sellers (*ibid.*) notes that the figures are dressed in costumes of an earlier period, Shelly Foote of the Smithsonian Division of Costume states that their dress was indeed fashionable around 1790.
4. David B. Warren, *Bayou Bend* (Houston: Museum of Fine Arts, 1975), p. 139.
5. Because the figures are not well integrated in the landscape and seem artificially posed, Linda Simmons, Associate Curator, Corcoran Gallery of Art, suggests the possibility that they derive from a print source. Mrs. Simmons is currently engaged in research on James Peale.
6. An example is *The Artist and his Family* (1795), a small conversation piece in the Pennsylvania Academy of the Fine Arts.
7. Jessie Poesch, "Germantown Landscapes: A Peale Family Amusement," *Antiques* 73 (November 1957): 439.
8. *Ibid.,* Fig. 8, p. 438.

BIBLIOGRAPHY

William H. Gerdts. *Painters of the Humble Truth. Masterpieces of American Still Life 1801–1939.* Columbia: University of Missouri Press, 1981.
Louise Lippincott. "Charles Willson Peale and His Family of Painters." *In This Academy.* Philadelphia: Pennsylvania Academy of the Fine Arts. 1976.
Jessie Poesch. "Germantown Landscapes: A Peale Family Amusement." *Antiques* 73 (November 1957): 434–439.
Charles Coleman Sellers. "James Peale." *The Peale Family: Three Generations of American Painters.* Charles H. Elam, ed. Detroit: Detroit Institute of Art, 1967.
——. "James Peale." *Four Generations of Commissions. The Peale Family Collection in the Maryland Historical Society.* Baltimore: Maryland Historical Society, 1975.
David B. Warren. *Bayou Bend.* Houston: Museum of Fine Arts, 1975

TITIAN RAMSAY PEALE

1799–1885

Muskrats

Watercolor on paper, c. 1820
6⅞ x 9¼ in. (17.3 x 23.5 cm)
American Philosophical Society Library, Philadelphia

PLATE 112

Sundown on the Missouri

Watercolor on paper, c. 1820
5¼ x 16½ in. (13.3 x 41.9 cm)
American Philosophical Society Library, Philadelphia

PLATE 114

Born in Philadelphia on November 2, 1799, Titian Ramsay Peale II was the next to last child of Charles Willson Peale and his second wife, Elizabeth DePeyster Peale. He was named for his recently deceased half-brother, Titian Ramsay Peale I (1780–1798), a gifted artist-naturalist. Titian II received little formal education. However, from birth until age ten, when his father retired to Belfield, his farm in Germantown, Titian lived in the building which housed the Peale Museum. Here, surrounded by its collections, he met some of the leading naturalists of the day, whom his father often consulted.[1]

At Belfield, Titian spent his leisure hours preserving and drawing butterfly specimens. By 1816 he was back in Philadelphia, where he assisted his half-brother Rubens at the museum and attended anatomy classes at the University of Pennsylvania. In 1817 Titian Peale contributed six drawings to the prospectus of Thomas Say's *American Entomology,* was elected to the Academy of Natural Sciences, and departed on a specimen-collecting expedition to the eastern coast of Florida and Georgia. The following year he was appointed assistant naturalist on an expedition headed by Major Stephen Long to the Rocky Mountains.[2]

Of the more than 120 drawings which Titian Peale executed during this arduous two-year journey, approximately fifty survive. Most of the sketches are specimen

drawings of western flora and fauna; however a few are pure landscapes. In the best of these drawings, many of which were finished in watercolor, Peale paid careful attention to the abstract elements of design. In *Sundown on the Missouri* the emphatic horizontality of the composition is offset by the fanlike diagonal arrangement of colored sun rays.

Design considerations also informed his specimen drawings, in which a landscape representing the species' natural habitat is sometimes made to conform with the general outline of the animal. In *Muskrats* the curved contours of the pair of animals are echoed in the mid-ground embankment which supports the decayed tree and in the faint outlines of the distant hills. Even the cattails springing from the water and land repeat the snakelike form of the muskrat's tail. In addition to Peale's obvious sympathy for the animal, the great appeal of these sketches lies in the artist's classical sense of balance, harmony, precision, and restraint. Peale includes just enough landscape detail to suggest a definite locale, but he never allows the accumulation of separate elements to interfere with pictorial considerations.

In the 1820s and 1830s, while Titian Peale managed the museum, he also contributed to important natural science publications[3] and participated in several more expeditions, culminating in his appointment to the scientific corps of the remarkable four-year global expedition led by Charles Wilkes.[4] Traveling back and forth across the oceans, recording exotic flora and fauna in remote parts of the world, Peale returned to Philadelphia in 1842 only to face a series of bitter disappointments and losses. Within the space of a few years he lost his wife and two of his children. In addition, financial problems forced the closing of the museum. Called to Washington to help organize the Wilkes Expedition collections, Peale also worked on *Mammalia and Ornithology*, which was completed in 1848. Errors in nomenclature drew severe rebuke from Wilkes, who deleted important portions of the manuscript and limited the number of copies printed.

For twenty-five years in Washington, Peale was an examineer in the Patent Office. Inventive like his father, he experimented in the new art of photography. He also executed landscapes in oil,[5] but his gifts as a painter were not equal to his abilities as a draftsman. His densely painted monotonous canvases lack the abstract purity and sense of restraint characteristic of the Long Expedition drawings.

Upon his retirement in 1873, Titian Peale returned to Philadelphia and spent his final years preparing a book on butterflies, the subject of his earliest studies at Belfield and an abiding interest throughout his life. His death on March 13, 1885, occurred before the book's completion, and it was never published.

KBM

1. Jessie Poesch, *Titian Ramsay Peale, 1799–1885, and His Journals of the Wilkes Expedition* (Philadelphia: American Philosophical Society, 1961), pp. 8–9. Among the famous naturalists were William Bartram and Alexander Wilson. Poesch views Wilson's influence on Titian Peale as being especially strong.

2. For a detailed discusion of the Long Expedition and particularly Peale's contributions, see Amy Meyers' essay "Imposing Order on the Wilderness" in this catalogue; also Martha Sandweiss, "The Long Expedition. Samuel Seymour and Titian Ramsay Peale," in *Pictures from an Expe-*

dition. *Early Views of the American West* (New Haven: Yale Center for American Art and Material Culture and Yale University Art Gallery, 1978).

3. Poesch, *Titian Ramsay Peale*, p. 46. Peale's most notable contribution was to the first and fourth volumes of Charles-Lucien Bonaparte's *American Ornithology*, a continuation of Alexander Wilson's pioneering work.

4. For an account of the Wilkes Expedition, see Poesch, *Titian Ramsay Peale*; also Herman J. Viola, Carolyn Margolis, eds. *Magnificent Voyagers. The U.S. Exploring Expedition, 1838–1842* (Washington, D.C.: Smithsonian Institution, 1985).

5. See color reproductions in *ibid.*, pp. 103–107.

BIBLIOGRAPHY

Dolores M. Gall. "Titian Ramsay Peale, an American Naturalist and Lithographer." *Yale University Art Gallery Bulletin* 38 (Winter 1983): 7–13.

Brooke Hindle. "Charles Willson Peale's Science and Technology." *Charles Willson Peale and His World.* Edgar P. Richardson, Brooke Hindle, Lillian B. Miller, eds. New York: Abrams, 1982.

Jessie Poesch. *Titian Ramsay Peale and His Journals of the Wilkes Expedition.* Philadelphia: American Philosophical Society, 1961.

Martha Sandweiss. *Pictures from an Expedition: Early Views of the American West.* New Haven: Yale Center for American Art and Material Culture and Yale University Art Gallery, 1978.

Herman L. Viola and Carolyn Margolis, eds. *Magnificent Voyagers. The U.S. Exploring Expedition, 1838–1842.* Washington, D.C.: Smithsonian Institution, 1985.

JOHN RITTO PENNIMAN

1782?–1841

Meetinghouse Hill, Roxbury, Massachusetts

Oil on canvas, 1799

29 x 37 in. (73.6 x 94 cm)

The Art Institute of Chicago, Centennial Year Acquisition and the Centennial Fund for Major Acquisition

PLATE 161

Born in Milford, Massachusetts, probably in 1782, Penniman served an apprenticeship in the Meeting House Hill section of Roxbury, perhaps in the shop of clockmakers Simon and Aaron Willard, for his earliest known signed work is a painted clock dial dated 1793.[1] In addition to painting clock faces, Penniman engaged in other types of ornamental painting,[2] an occupation that may account in part for the decorative qualities of his easel work.

In 1799 Penniman painted his earliest known landscape, *Meeting House Hill, Roxbury, Massachusetts*. A sharply delineated typographical rendering of the houses and landscape surrounding the town's fourth meetinghouse, it provides important visual evidence of Roxbury at the turn of the nineteenth century. The gambrel-roofed parsonage at the far right, built in 1751, still stands, as does the Spooner-Lambert-Taber house located immediately to the left of the meetinghouse.[3] Earthworks, erected to protect the town at the time of the Revolution, are visible in the far left distance and to the right of the church steeple. A decorative and charming effect is achieved by the use of clear bright colors, sharp contours, and white accents. Perhaps indicative of a lack of formal instruction is the skewed perspective, a feature which recurs in other paintings by Penniman, notably *Franklin Ruggles' Homestead*, of about 1830.[4]

The life of Roxbury, a suburb of Boston, is delightfully recorded by Penniman: cows grazing on enclosed bare rolling hillsides speak for the cultivation of the land, while lumber strewn in the foreground suggests man's industriousness. This simple, idyllic portrayal of a prosperous village exudes community pride.

Other landscapes by Penniman are characterized by clearly defined areas of color, a glossy hard finish, and heavy pigmentation.[5] Although capable of a painterly style perhaps reflecting the influence of his friend Gilbert Stuart,[6] Penniman remained an ornamental painter throughout his life, being listed as such in the Boston directory from 1805 to 1827. Around 1830 his fortunes declined. At one time lauded by William Dunlap as someone whose talent exceeded that of many artists aspiring to higher branches of art,[7] Penniman was twice committed to a poorhouse in south Boston, and in 1834 to the house of correction for counterfeiting money. He died in Baltimore on October 15, 1841.

CMD

1. Carol Damon Andrews, "John Ritto Penniman (1782–1841) an Ingenious New England Artist," *Antiques* 120 (July 1981): 148, n. 9.
2. Penniman ornamented apothecary furniture, tinware, fire engines and buckets, coaches, chaises, furniture, military standards, signs, chimney pieces and fireboards, and reverse painting on glass for looking glasses and clocks. *Ibid.*, p. 147.
3. Penniman's accurate portrayal of an eighteenth-century American town enabled Carol Damon Andrews to identify almost all the buildings, roads, and lanes. Eleanor H. Gustafson, "Museum Accessions," *Antiques* 120 (July 1981): 90.
4. Collection of Mr. and Mrs. Alan Lewis, illustrated in Jay E. Cantor, *The Landscape of Change: Views of Rural New England, 1790–1865* (Old Sturbridge Village, 1976), Fig. 8.
5. See *Duck Hunter and Dog*, 1805–1811 (Andrews, "Penniman," p. 148) and *View of the Greek Ruins*, 1819–1825 (*ibid.*, p. 152). The same technique is evident in a much later painting, the landscape setting of the *Portrait of Ann Elizabeth Crehore*, 1836 (*ibid.*, p. 164).
6. Stuart was reportedly attracted to Penniman's work soon after he arrived in Boston in 1805 (*ibid.*, p. 153).
7. William Dunlap, *The History of the Rise and Progress of the Arts of Design in the United States* (New York: G. P. Scott and Co., 1834), Vol. III, p. 27.

BIBLIOGRAPHY

Carol Damon Andrews. "John Ritto Penniman (1782–1841) an Ingenious New England Artist." *Antiques* 120 (July 1981): 147–170.
Jay E. Cantor. *The Landscape of Change: Views of Rural New England, 1790–1865.* Old Sturbridge Village, Mass., 1976.
Mabel M. Swan. "John Ritto Penniman." *Antiques* 39 (May 1941): 246–248.

THOMAS POWNALL

1722–1805

A View of the Falls on the Passaick

Engraving, 1761
(Paul Sandby after Pownall)
14 x 20⁷/₁₆ in. (36.4 x 52.8 cm) (sheet size)
Library of Congress
PLATES 85 AND 141

A View in Hudson's River of Pakepsey and the Catts-Kill Mountains

Engraving, 1761
(Paul Sandby after Pownall)
14½ x 20¹/₁₆ in. (36.7 x 53.4 cm) (sheet size)
Library of Congress
PLATE 86

A Design to Represent the Beginning and Completion of an American Settlement or Farm

Engraving, 1761
(James Peake after Pownall and Sandby)
14¹¹/₁₆ x 21¹/₁₆ in. (38.3 x 54.3 cm)
Library of Congress
PLATE 87

Engravings of American subjects were popular in the colonies as well as in England in the mid-eighteenth century.[1] Sketches, often done by colonial administrators or officers, were transformed into prints and published in London for markets on both sides of the Atlantic. A case in point is the set of engravings issued in 1761 after drawings by Thomas Pownall.

A colonial administrator and author, Pownall was born at Lincoln in 1722. He graduated from Trinity College, Cambridge, in 1743. Shortly after, he obtained a place with the Board of Trade. He arrived in America in 1753, becoming lieutenant-governor of New Jersey and then governor of Massachusetts in 1757. Pownall was active throughout the French and Indian War. After the surrender of Canada in 1760, he resigned his posts and returned to England. In 1764 he published *Administration of the Colonies*, which discussed the union of the colonies, and in 1776, *A Topographical Description of the Dominions of the United States of America*. The latter utilized materials he had gathered for a map of the colonies, issued in 1755 by the cartographer Lewis Evans, whom he had met in Philadelphia. From 1767 to 1780, Pownall was a member of Parliament and wrote extensively on economic and political matters. He died on February 25, 1805, in Bath.

Pownall's first venture to capitalize on his colonial experience was *Six Remarkable Views in the Province of New York, New Jersey and Pennsylvania*, a set of engravings published in London in 1761. These were engraved by the leading artists from paintings by Paul Sandby, whom Pownall had engaged to copy his own drawings (now lost). The landscapes are concentrated on the Hudson River and areas of New York City. *A View in Hudson's River of Pakepsey and the Catts-Kill Mountains* captures the sweep of one of America's great rivers and the grandeur of its scenery; *A View of the Falls on the Passaick* is a depiction of one of the then major tourist attractions on the East Coast. Pownall's idealized representation of the progress of an American settlement conveys a sense of the country's potential.

MSM and BR

1. Joan Dolmetsch, "Prints in Colonial America," *Prints in and of America to 1850,* John D. Morse, ed. (Charlottesville: University Press of Virginia for the Henry Francis du Pont Winterthur Museum, 1970), p. 66.

BIBLIOGRAPHY

John A. Schutz. *Thomas Pownall, British Defender of American Liberty: A Study of Anglo-American Relations in the Eighteenth Century.* Glendale, Calif.: A. H. Clark Co., 1951.

HENRY CHEEVER PRATT

1803–1880

Moses on the Mount

Oil on canvas, 1828–1829.
48½ x 60½ in. (123.2 x 153.7 cm)
The Shelburne Museum, Shelburne, Vermont

PLATES 80 AND 135

Born in Oxford, New Hampshire, on June 13, 1803, Pratt at the age of fourteen worked on a Vermont farm, where he reportedly painted scenes on barn doors. In 1817 the promising young artist came to the attention of Samuel F. B. Morse, who was working in the area as a portraitist. The following year Pratt became an apprentice under Morse, traveling from Vermont to Washington in search of commissions. Pratt's teacher encouraged him to use a heavy impasto in his painting, and while this technique is found in his early work, Pratt eventually adopted a smooth surface finish which he used throughout most of his career.

By 1825 Pratt had established his own portrait studio in Boston. In 1827 he exhibited five works in the Boston Athenaeum, most of which were landscapes. On his way to the White Mountains that year, Thomas Cole stopped at the Athenaeum, where one of his paintings was on view; he probably saw Pratt's work on that occasion. The two artists are known to have met the following year when Cole returned to Boston for a longer stay. They discovered they shared a deep appreciation for the American landscape and enjoyed traveling with sketchbook in hand. It was at this time that Cole and Pratt made a sketching trip together to the White Mountains. They took another trip together in 1845, this time to Maine.

Pratt's style was undoubtedly influenced by the drama in Cole's landscapes, a characteristic apparent in *Moses on the Mount.*[1] The subject and composition were probably influenced by the work of John Martin, a contemporary English artist. Engravings after Martin's biblical subjects were popular in America at the time.[2]

Pratt showed annually at the Boston Athenaeum from 1827 until 1860. In 1842 he exhibited several portraits and one landscape at the first exhibition of the Boston Artists Association and sent work there again in 1843 and 1845. Pratt's paintings also were exhibited at the National Academy of Design in New York in 1828, 1829, 1837, 1844, and 1858.

Pratt made his home in Wakefield, Massachusetts, where he died at the age of seventy-seven on November 27, 1880.

PAH

1. There have been conflicting opinions regarding this painting; although originally assigned to Thomas Cole, the painting is now generally attributed to Pratt. See Ellwood C. Parry III, "When a Cole Is Not a Cole: Henry Cheever Pratt's *Moses on the Mount,*" *American Art Journal* 16 (Winter 1984): 34–45.
2. John Martin's *Joshua Commanding the Sun to Stand Still* (1816) is considered a source for *Moses on the Mount.* For more information see "Thomas Cole and the Creation of a Romantic Sublime" in Bryan Jay Wolf, *Romantic Re-Vision* (Chicago: University of Chicago Press, 1982), pp. 177–236 and esp. pp. 188–189 and Fig. 51. Wolf's book assigns the Pratt work to Cole.

BIBLIOGRAPHY

Alice Doan Hodgson. "Henry Cheever Pratt (1803–1880)." *Antiques* 102 (November 1972): 842–847.
Ellwood C. Parry III. "When a Cole Is Not a Cole: Henry Cheever Pratt's *Moses on the Mount.*" *American Art Journal* 16 (Winter 1984): 34–45.
Robert F. Perkins Jr. and William J. Gavin III, eds. *The Boston Athenaeum Art Exhibition Index, 1827–1874.* Boston: Library of the Boston Athenaeum, 1980.
Watercolors and Drawings from the John Russell Bartlett Papers (John Carter Brown Library). Providence, R.I.: Brown University, 1962.
Bryan Jay Wolf. *Romantic Re-Vision.* Chicago: University of Chicago Press, 1982.

HUGH REINAGLE

1790–1834

View of Elgin Garden on Fifth Avenue

Sepia wash on paper, c. 1811
10¾ x 16⅜ in. (27.2 x 41.5 cm)
The New York Public Library

PLATE 125

A theatrical scene painter, architect, and drawing master as well as a landscape, historical, and portrait painter, Reinagle was born in Philadelphia in 1790; he died of cholera in New Orleans on May 23, 1834. Reinagle exhibited landscapes throughout his career at the Pennsylvania Academy of the Fine Arts in Philadelphia and at the National Academy of Design in New York, of which he was one of the original fifteen founding members in 1826. Many of the landscapes were views of the Hudson River or areas nearby, but unfortunately few have survived or can with certainty be assigned to Reinagle.[1] He also exhibited, as advertised in Paxton's *Philadelphia Directory* of 1818, "a great variety of interesting views of various places in the United States" at his drawing academy in Philadelphia.[2]

It is believed that Reinagle learned the art of painting from John Joseph Holland, a British scene painter and watercolorist.[3] Holland was employed by Alexander Reinagle, Hugh's father and co-manager of the Chestnut Street and New Theatres of Philadelphia.[4] Scenery with naturalistic landscapes was a major innovation of the British stage at the end of the eighteenth century.[5] Holland may have taught this type of scene painting to the young Reinagle, who became one of the foremost designers in New York and Philadelphia.[6] Reinagle's sets were praised for their convincingly realistic depictions.[7]

The sepia ink drawing *View of Elgin Garden on Fifth Avenue* was executed by Reinagle before 1811.[8] Although there

is a history of botanical gardens in this country going back to the late seventeenth century, the most active period for collecting, domesticating, and categorizing American and exotic plants was between 1800 and 1860, when the number of public and private gardens greatly increased.[9] Not surprisingly, this growing interest in botany and horticulture coincided with the growing interest in landscape painting.

The Elgin Botanical Gardens were established in 1802 by David Hosack, Professor of Botany at Columbia College, who purchased twenty acres of land from the Corporation of the City of New York for this purpose. The gardens were sold to the state of New York in 1810.[10] Reinagle's drawing shows the main group of greenhouses which were located near the present-day Rockefeller Center.

It is not known whether Reinagle and Hosack knew each other, but the two could have met through William Dunlap. Dunlap and Hosack were friends, and Reinagle and Dunlap were theatrical colleagues.[11] The present composition is important, not only because it is one of the earliest drawings of a botanical garden, but also because it is a rare surviving example of an artist whose work was favored as subjects for lithographers and engravers.[12]

<div align="right">LEM</div>

1. A painting by Reinagle is in a private collection in New Orleans. A drawing attributed to Reinagle is in the New-York Historical Society, and two are in the Eno Collection of New York City Views in the New York Public Library.
2. Alfred Coxe Prime, *The Arts and Crafts in Philadelphia, Maryland and South Carolina, 1786–1808* (1933; reprint, New York: Da Capo Press, 1969), Series 2, p. 32.
3. Richard J. Koke, *American Landscape and Genre Painting in the New-York Historical Society* (Boston: New-York Historical Society with G. K. Hall, 1982), Vol. III, p. 82.
4. William C. Young, *Documents of American Theater History: Famous American Playhouses* (Chicago: American Library Association, 1973), Vol. I, pp. 36, 41.
5. Sybil Rosenfeld, *Georgian Scene Painting and Scene Painters* (Cambridge: Cambridge University Press, 1981), p. 74.
6. Joseph Ireland, *Records of the New York Stage 1750–1860* (New York: Benjamin Blom, 1966), Vol. I, p. 381.
7. George C. D. Odell, *Annals of the New York Stage* (New York: Columbia University Press, 1928), Vol. III, pp. 147, 152, 157.
8. David Hosack's *Hortus Elginensis,* published in 1811, contains an engraving after Reinagle's *Elgin Garden.*
9. Americans owe their first botanical garden to George Fox, founder of the Quakers. Fox traveled in the colonies in 1671–1672. When he died in 1690 he bequeathed to the Quaker Meeting in Philadelphia "sixteen acres. . . . Six for a meetinghouse, schoolhouse . . . and for a Garden to plant with physical plants for Lads and Lasses to know Simples, and to learn to make Oils and Ointments." The first botanical garden worthy of the name was established and maintained by Christopher Witt in Germantown, Pennsylvania, in 1708. Ulysses Prentiss Hedrick, *History of Horticulture in America to 1860* (Oxford and New York: Oxford University Press, 1950), pp. 84–85, 399. For further discussion of botanical gardens see Therese O'Malley's essay in this catalogue, "Landscape Gardening in the Early National Period."
10. Hedrick, *History,* p. 423.
11. William Dunlap, *The History of the Rise and Progress of the Art of Design in the United States* (1834; reprint, Rita Weiss, ed., New York: Dover, 1969), Vol. II, pp. 296, 326.
12. Koke, *American Landscape and Genre Painting,* p. 81.

BIBLIOGRAPHY

David Hosack. *Hortus Elginensis or a Catalogue of Plants Indigenous and Exotic Cultivated in the Elgin Botanic Garden.* New York: T&J Swords, Columbia College, 1911.
Joseph Ireland. *Records of the New York Stage 1750–1860.* New York: Benjamin Blom, 1966. Vol. I.
Richard J. Koke. *American Landscape and Genre Paintings in the New-York Historical Society.* Boston: New-York Historical Society with G. K. Hall, 1982, Vol. III.
George C. D. Odell. *Annals of the New York Stage.* New York: Columbia University, 1928. Vol. III.
Alfred Coxe Prime. *The Arts and Crafts in Philadelphia, Maryland and South Carolina.* 1932; reprint, New York: Da Capo Press, 1969. Series 2.
I. N. Phelps Stokes. *The Iconography of Manhattan Island.* New York: I. N. Phelps Stokes, 1915.
———. *New York, Past and Present, Its History and Landmarks 1524–1939.* New York: Plantin Press, 1939.
William C. Young. *Documents of American Theatre History: Famous American Playhouses.* Chicago: American Library Association, 1973. Vol. I.

WILLIAM ROBERTS

active 1803–1808

Natural Bridge

Colored aquatint, 1808
(Joseph C. Stadler after Roberts)
31¾ x 24³⁄₁₆ in. (80.6 x 61.4 cm)
Museum of Early and Southern Decorative Arts, Winston-Salem, North Carolina

PLATE 33

Junction of the Potomac and Shenandoah, Virginia

Watercolor on paper, 1808
12 x 15½ in. (30.5 x 38.1 cm)
Museum of Early and Southern Decorative Arts, Winston-Salem, North Carolina

PLATE 147

Roberts was a British amateur artist about whom almost nothing is known. During a visit in 1803 with his brother Edward, a merchant in Norfolk, Virginia, Roberts introduced himself to Thomas Jefferson. On a visit about five years later, he sketched Harpers Ferry and Natural Bridge, the two natural wonders which Jefferson had praised in *Notes on the State of Virginia,* and he presented paintings of the scenes to Jefferson. Roberts' views were widely copied after they were aquatinted in 1808 by Joseph Constantine Stadler, a professional landscape engraver in London. Stadler also aquatinted Philip J. de Loutherbourg's *Picturesque Scenery of Great Britain* and Joseph Farington's watercolors for J. E. Smith's *Tour to Hafod,* 1790.

<div align="right">BR</div>

BIBLIOGRAPHY

Barbara C. Batson. "Virginia Landscapes by William Roberts." *Journal of the Museum of Southern Decorative Arts* (1984): 34–48.

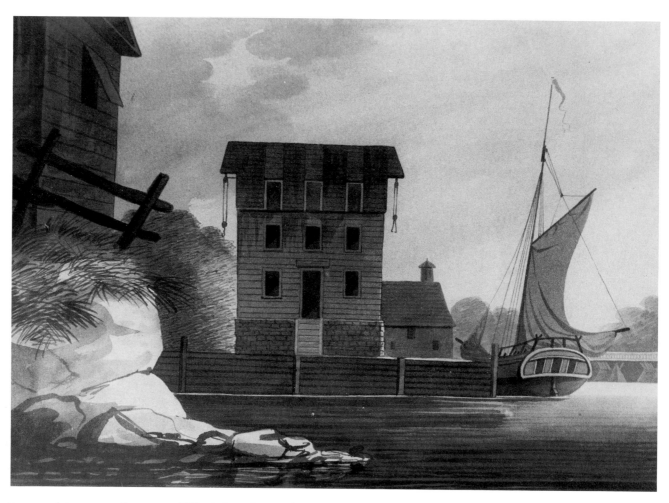

PLATE 192. ARCHIBALD ROBERTSON, *Hillyer's Store, Brunswick, New Jersey*, 1802.

ARCHIBALD ROBERTSON

1765–1835

Collect Pond

Watercolor on paper, 1798
17⅞ x 23⅛ in. (45.3 x 58.7 cm)
Metropolitan Museum of Art; bequest of Edward W. C. Arnold
(Wadsworth Atheneum only)
PLATE 17

"On the Art of Sketching"

Manuscript, c. 1800
Private collection
PLATE 16

Hillyer's Store, Brunswick, New Jersey

Watercolor on paper, 1802
11 x 14¾ in. (27.9 x 37.5 cm)
The New Jersey Historical Society
PLATE 192

Elements of the Graphic Arts

Book, 1802
Private collection
PLATE 18

Hobuck

Watercolor on paper, 1808
16¾ x 21¼ in. (42.5 x 53.0 cm)
The New Jersey Historical Society; bequest of Miss Emily L.
Stevens
PLATE 26

ALEXANDER ROBERTSON

1772–1841

Mount Vernon in Virginia

Colored aquatint, 1800
(Francis Jukes after Robertson)
14⅞ x 18¾ in. (37.8 x 47.6 cm)
The New York Public Library
PLATE 193

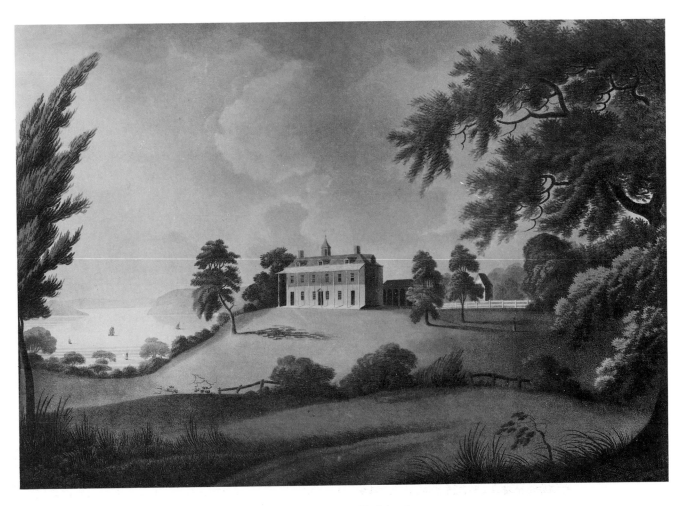

PLATE 193. FRANCIS JUKES after Alexander Robertson, *Mount Vernon in Virginia*, 1800.

Hudsons River from Chambers Creek

Colored aquatint, 1802
(Francis Jukes after Robertson)
10¾ x 16⅜ in. (27.3 x 46.6 cm)
The New York Public Library

PLATE 19

Born at Monymusk, Scotland, May 8, 1765, Archibald Robertson was the eldest son of the architect and draftsman William Robertson. Raised in Aberdeen, he studied at Marshall College there, and in Edinburgh from 1782 to 1785. He also attended the Royal Academy in London in 1786. Returning to Aberdeen, he set up a studio and school. In 1791 he was invited to teach drawing in New York City by a committee of important men. Once settled there, Archibald Robertson sent for his brother Alexander, who was also an artist. Together they opened the Columbian Academy of Painting, one of the first schools of art in the United States. Their school followed established academic practices: the students drew from plaster casts and copied prints before going on to nature studies. The partnership lasted almost thirty years, and many successful artists including Francis Alexander and John Vanderlyn received some training at their academy.

In 1802 Archibald Robertson's *Elements of the Graphic Arts*, one of the earliest art instruction books published in America, was issued in New York.[1] Dedicated to his pupils at the Columbian Academy, the work was aimed at the amateur artist and reflected the writings of the English aesthetician Reverend William Gilpin, who popularized the concept of the picturesque in his illustrated tours to various parts of England, Scotland, and Wales. Gilpin's ideas are also to be found in Archibald's manuscript "On the Art of Sketching."

The Robertsons were active in the American Academy of Fine Arts, established in 1802 and revitalized in 1816. Archibald served on the board of directors starting in 1817, and Alexander served variously as secretary and keeper from 1816 to 1835. Both were frequent exhibitors. The product of extensive travels, their topographical scenes in quill and ink and in watercolor, although stylistically distinctive, were almost indistinguishable. Several designs by Alexander, including *Mount Vernon* and *Hudson River* were reproduced in aquatint by the English engraver Frances Jukes and published in London at the turn of the century.

The Robertsons played a key role in disseminating a conservative taste and mode of expression in America. The characteristics of their landscapes are derived from the style of contemporary artists such as Gilpin and William Payne. The artistic conventions presented in the *Elements of the Graphic Arts* and in the "Art of Sketching" recur in the compositions of the Robertsons' pupils and demonstrate their systematic method of instruction. The student was encouraged to learn a vocabulary of drawing and painting

strokes to produce a landscape quickly and easily: tree foliage in round, looping outlines; volume and shadow in the fore- and mid-ground achieved with a strong zigzag pattern; and the most distant forms indicated with a very light outline. The result, while true to the scene, presented a generalized view of nature in keeping with eighteenth-century sensibilities.

Archibald Robertson's watercolor *Hobuck* of 1808 displays the basic compositional formula: trees frame a middle ground, usually occupied by a house or valley, which gently dissolves into a distant city view or mountain. *Collect Pond* is typical of how contours, light, and shade were reinforced subtly by adding gray washes and then other colors to a sketch. *Hillyer's Store* exemplifies the Robertsons' watercolor method: a variety of brilliant hues were applied in prescribed strokes. Practiced by the Robertsons and their pupils alike, the method produced ostensibly topographical scenes that were elegantly stylized renderings of nature.

In addition to their teaching, the Robertsons remained active in public life. Archibald served as head of fine arts activities for the opening celebration of the Erie Canal in 1825. He spent his later years in retirement, nearly blind, and died on December 6, 1835. Alexander later became one of the original incorporators of the New York Public School System. He died in 1841.

TYL

1. Archibald Robertson also wrote a treatise on miniature painting in 1808, which he sent to his younger brother, Andrew, an artist in Britain; it was later published in *Letters and Papers of Andrew Robertson, A.M. . . . also a Treatise on the Art by his Eldest Brother Archibald Robertson* (London: Eyre and Spottiswoode, 1895).

BIBLIOGRAPHY

Edith Robertson Cleveland. "Archibald Robertson and His Portraits of Washington." *Century Magazine* 11 (1890): 3–13.

Mrs. Warren G. Goddard. "Archibald Robertson, Founder of the First Art School in America." *New York Genealogical and Biographical Record* 51, No. 2 (1920): 130–137.

Kennedy Galleries. "A. and A. Robertson, Limners," *American Drawings, Pastels, and Watercolors*. Catalogue, March 14–April 28, New York, 1967.

Richard J. Koke. *American Landscape and Genre Painting in the New-York Historical Society*. Boston: New-York Historical Society with G. K. Hall, 1982. Vol. III.

Archibald Robertson. *Elements of the Graphic Arts*. New York: David Longworthy, 1802.

Emily Robertson, ed. *Letters and Papers of Andrew Robertson, A.M. . . . also a Treatise on the Art by his Eldest Brother Archibald Robertson*. London: Eyre and Spottiswoode, 1895.

John E. Stillwell. "Archibald Robertson, Miniaturist." *New-York Historical Society Bulletin* 13 (1929): 1–33.

PAUL SANDBY

1725–1809

See THOMAS POWNALL

A View of the Falls on the Passaick, PLATE 85

A View in Hudson's River of Pakepsey and the Catts-Kill Mountains, PLATE 86

A Design to Represent the Beginning and Completion of an American Settlement or Farm, PLATE 87

See HERVEY SMYTH

A View of Miramichi, PLATE 84

Paul Sandby was the most important drawing master and topographical artist in Britain during much of his lifetime. He was born in Nottingham in 1725, but from 1751 onward he worked in London after a brief stint as Chief Draughtsman for the Ordnance Survey of Scotland. He and his brother Thomas were the recipients of much royal patronage, which helps account for his appointment to the post of Chief Drawing Master at the Royal Military Academy at Woolwich in 1768, a post he held until 1797. Sandby was also a founding member of the Royal Academy in 1768, and an active exhibitor throughout his life.

While Sandby is remembered primarily for his watercolors, it is his prints which did most to spread his influence. His first etchings date from 1747, and over the next two decades he published both etchings and engravings, often collaborating with other engravers and artists. In 1775 he published the first commercially successful aquatints in England, a set of views of Wales. These were followed in the next decade by many more, establishing aquatint as an important medium for the reproduction of watercolor landscapes. Sandby also frequently contributed to topographical publications and was often copied by both amateur and professional artists. He died in Paddington on November 7, 1809.

BR and MSM

BIBLIOGRAPHY

Bruce Robertson. *The Art of Paul Sandby*. New Haven: Yale Center for British Art, 1985.

Adolph Paul Oppé. *The Drawings of Paul and Thomas Sandby in the Collection of His Majesty the King at Windsor Castle*. Oxford: Phaidon Press, 1947.

_____. "The Memoirs of Paul Sandby by His Son." *Burlington Magazine* 88 (June 1946): 143–147.

SAMUEL SEYMOUR

active 1796–1823

See THOMAS BIRCH

The City of Philadelphia in the State of Pennsylvania, North America, PLATE 107

See WILLIAM RUSSELL BIRCH

The City of New York in the State of New York, North America, PLATE 108

William Dunlap reports that Seymour was born in England, but where and when is not stated.[1] Nor is the date and place of his death recorded. What is known is that Seymour was a friend of the Birches, who were also English, and was involved with them on several projects. In addition to his work as engraver for the Birches' views of Philadelphia and New York, Seymour also assisted on the preparation of *The City of Philadelphia in the State of Pennsylvania, North America*, consisting of twenty-eight plates when first published in 1801. In his autobiography William Birch remarked about this publica-

tion: "I superintended it, chose the subjects, instructed my son in the Drawings, and our friend Mr. Seymour in the Engravings."[2]

A painter of landscapes in oil and watercolor, Seymour was an associate of the Society of Artists of the United States (Thomas Birch was a fellow) at its formation in 1810. He is perhaps best remembered for his role as artist on the Long Expedition to the West in 1819–1820 and 1823. Titian Ramsay Peale also served as an artist on the first expedition. Seymour's drawings from these trips, a few of which are preserved at the Beinecke Library at Yale University, illustrated the published accounts.

EJN

1. William Dunlap, *History of the Rise and Progress of the Arts of Design in the United States* (1834; reprint, New York: Benjamin Blom, 1965), Vol. II, p. 257.
2. William Birch, "The Life of William Russell Birch, Enamel Painter, Written by Himself," typescript, New York Public Library, p. 48.

BIBLIOGRAPHY

James Edwin, comp. *Account of an Expedition from Pittsburgh to the Rocky Mountains, Performed in the year 1819, '20* . . . Philadelphia: H. C. Carey and I. Lea, 1822–1823.
William H. Keating, comp. *Narrative of an Expedition to the Source of St. Peter's River . . . in the year 1823*, 2 vols. Philadelphia: H. C. Carey, 1824.
John F. McDermott. "Samuel Seymour: Pioneer Artist of the Plains and the Rockies." *Annual Report of the Smithsonian Institution* (1950): 497–509.
Martha Sandweiss. *Pictures from an Expedition: Early Views of the American West*. New Haven: Yale Center for American Art and Material Culture and Yale University Art Gallery, 1978.

JOSHUA SHAW

c. 1777–1860

Landscape with Cattle

Oil on canvas, mounted on masonite, 1818
31 x 41 in. (78.7 x 104 cm)
The Butler Institute of American Art, Youngstown, Ohio
PLATE 47

Stormy Landscape

Oil on canvas, 1818
29½ x 41½ in. (74.9 x 105.4 cm)
Collection of Dr. and Mrs. Henry C. Landon III
PLATE 48

Night Scene (River Scene with Steamboat)

Oil on canvas, c. 1819
20 x 28 in. (50.8 x 71.1 cm)
Private collection
PLATE 49

Picturesque Views of American Scenery

Burning of Savannah, PLATE 46
Jones Falls near Baltimore, PLATE 194

View near the Falls of the Schuylkill, PLATE 51

Colored aquatints, 1820–1821
(John Hill after Shaw)
Library of Congress

View in the Pennsylvania Countryside

Oil on canvas, 1823
25⅝ x 36⅛ in. (65 x 96.8 cm)
High Museum of Art, Atlanta; lent by the West Foundation, Atlanta
PLATE 50

Joshua Shaw was a pivotal figure in the history of American landscape painting. Born in Bellingborough, Lincolnshire, in the northeast of England, he trained as a painter in Bath and London. Shaw's landscape style was mostly formed on that of Richard Wilson, one of the leading British landscape painters at the end of the eighteenth century.

It is not known exactly why Shaw emigrated to America; however, he came to Philadelphia in 1817 with Benjamin West's *Christ Healing the Sick* and letters of introduction from the artist. Soon after his arrival he began work on a series of American landscapes. Touring the East Coast, he made sketches and solicited subscriptions for the proposed work. *Picturesque Views of American Scenery* paved the way for greater interest in landscape as a subject in American art. The project was a collaborative effort. Shaw executed the compositions, which were then engraved in aquatint by John Hill, a fellow Englishman who had come to America in 1816. Born in London in 1770, Hill, a master engraver, had no serious competition in America, a factor which may have contributed to his emigration to this country. It is not known whether Shaw and Hill knew each other in London; however, they may well have been aware of each other's work.

Picturesque Views was designed "to exhibit correct delineations of some of the most prominent beauties of natural scenery in the United States."[1] Thirty-six plates were projected, but only twenty were issued.[2] Although projects of this type were not uncommon in England, nothing like this had been attempted before in this country. As the first publication of a group of large colored scenic prints, it is a milestone in the history of American landscape art and printmaking. In descriptions accompanying the views, Shaw interpreted the American scene in terms of the concepts of the beautiful, the sublime, and the picturesque. These concepts were propagated in the late eighteenth and early nineteenth centuries by a host of British aestheticians including Edmund Burke, William Gilpin, Uvedale Price, and Richard Payne Knight.[3]

Joshua Shaw created over 210 paintings during his life in America.[4] Landscapes executed before 1820, such as *Landscape with Cattle* or *Stormy Landscape*, display an idealized, poetic approach to scenery. Although painted in the United States, they are not American views. *Landscape with Cattle* depicts a view near Bath; and the ruined castle in *Stormy Landscape* suggests a Welsh subject. So, too, works like

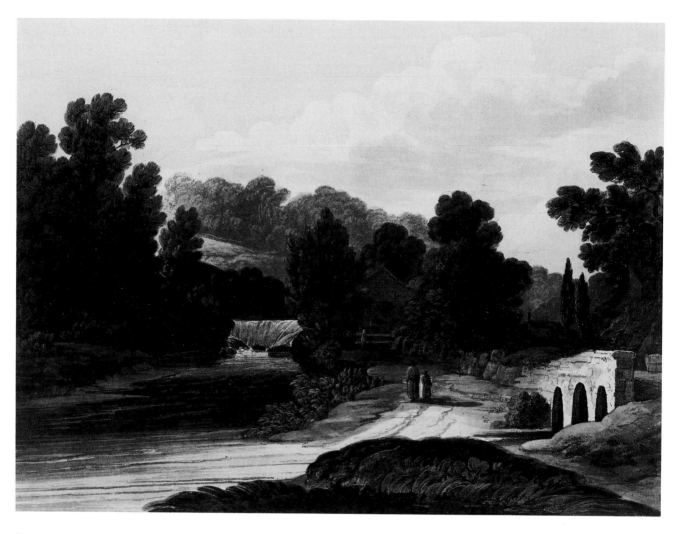

PLATE 194. JOHN HILL after Joshua Shaw, *Jones Falls near Baltimore*, from *Picturesque Views of American Scenery*, 1820–1821.

Night Scene and *View in the Pennsylvania Countryside* are generalized in treatment.

Shaw's American career spanned nearly thirty-five years. He was an inventor as well as an artist. His irascibility sometimes lost him friends, but his contributions to the development of landscape art in America are significant. He died in Burlington, New Jersey, on September 8, 1860.

LEM

1. Joshua Shaw, *Picturesque Views of American Scenery* (Philadelphia: M. Carey and Sons, 1820), p. 1.
2. Richard Koke, "John Hill, Master of Aquatint 1770–1850," *New-York Historical Society Quarterly* 43 (January 1959): 80.
3. For further reading on the concepts of the beautiful, the sublime, and the picturesque see Edmund Burke, *A Philosophical Inquiry into the Origin of Our Ideas of Sublime and Beautiful* (1757; reprint, J. T. Boulton, Intro., Notre Dame: University of Notre Dame Press, 1968); Christopher Hussey, *The Picturesque: Studies in a Point of View* (1927; reprint, London: Frank Cass, 1967).
4. Miriam Carroll Woods, "Joshua Shaw: A Study of the Artist and His Paintings," M.A. Thesis, University of California, Los Angeles, 1971, p. 104.

BIBLIOGRAPHY

William Gerdts, Jr. *Painting and Sculpture in New Jersey.* Princeton, N.J.: University of Princeton Press, 1964.
Richard J. Koke. "John Hill, Master of Aquatint 1770–1850." *New-York Historical Society Quarterly* 43 (January 1959): 51–117.
Joshua Shaw. *Picturesque Views of American Scenery.* Philadelphia: M. Carey and Sons, 1820.
———. *U.S. Directory for the Use of Travellers and Merchants.* Philadelphia: J. Maxwell, 1822.
———. "On the Preparation and Use of Mastic Varnish, Particularly Suitable for Paintings in Oil." *Journal of the Franklin Institute* 4 (August 1827): 131–132.
———. "Practical Observations on the Good and Bad Properties of the Colours Used by Artists." *Journal of the Franklin Institute* (January 1832): 10–12.
Miriam Carroll Woods. "Joshua Shaw: A Study of the Artist and His Paintings." Master's Thesis, University of California, Los Angeles, 1971.

John Smibert

1688–1751

A Vew [sic] of Boston

Oil on canvas, 1738
30 x 50 in. (76.2 x 127 cm)
Child's Gallery, Boston and New York

Plate 105

Born in Edinburgh on March 24, 1688, Smibert studied in Scotland, London, and Italy. During his stay in Italy between 1719 and 1722 he improved his technique by making numerous copies after Old Masters.[1] On his return to London, he established a portrait studio.

In 1729 Smibert came to America as a member of a party headed by Dean George Berkeley. An Anglican minister and a leading British philosopher, Berkeley hoped to establish a college in Bermuda for the education and enlightenment of colonists and native Americans. Smibert, who had met Berkeley in Florence in 1720,[2] was invited to be instructor of drawing, painting, and architecture at the proposed college. Landing first in Virginia, the group established itself in Newport and awaited word concerning funds for the project. Allocations were not forthcoming, and Berkeley, with most of his entourage, returned to England. Smibert, however, decided to remain.

Settling in Boston, Smibert opened a studio where he exhibited copies of Old Masters as well as his own works. He eventually set up a color shop in which he sold prints and supplies. Smibert was the most important portrait painter in America in the 1730s and 1740s. He was an influence on the young John Singleton Copley, and his studio continued to attract artists even after his death.

Although best known for his portraits of American colonists, Smibert executed a number of landscape paintings.[3] In a letter to his London agent Arthur Pond, written April 6, 1749, Smibert recalled that he "hath been diverting myself with somethings in the landskip way."[4] The recently discovered prospect of Boston may be the painting Smibert recorded in his notebook for August 1738.[5] Whether this was painted on commission or for personal enjoyment is unclear, as no payment for it is recorded. According to Richard Saunders, the attribution to Smibert seems secure on stylistic grounds: Smibert had painted a partial view of Boston in a portrait of *Francis Brinely,* and both palette and brushwork in the landscape exhibited resemble the artist's work.[6]

Smibert journeyed to Philadelphia, Burlington, New Jersey, and New York in 1740 for portrait commissions. When he returned to Boston, his health and eyesight began to fail. He received fewer and fewer commissions in his later years and devoted himself mostly to landscapes.[7] Thirteen landscapes were in his studio when he died on April 2, 1751.

LEM

1. John Smibert, *Notebook of John Smibert:* essays by Sir David Evans, John Kerslake, and Andrew Oliver (Boston: Massachusetts Historical Society, 1969), p. 6.
2. Richard Henry Saunders III, "John Smibert (1688–1751): Anglo-American Portrait Painter," Ph.D. Dissertation, Yale University, 1979, p. 32.
3. James Flexner, *First Flowers of our Wilderness* (Boston: Houghton Mifflin, 1947), p. 115.
4. Henry Wilder Foote, *John Smibert, Painter* (Cambridge, Mass.: Harvard University Press, 1950), p. 99.
5. *Notebook of John Smibert,* p. 95.
6. Saunders, "John Smibert," pp. 196–197.
7. Foote, *John Smibert,* p. 99.

BIBLIOGRAPHY

Frederick Coburn. "John Smibert." *Art in America* 17 (June 1929): 175–187.
Paula Deitz. "The First American Landscape." *Connoisseur* 212 (1982): 28 ff.
Henry Wilder Foote. *John Smibert, Painter.* Cambridge: Harvard University Press, 1950.
Richard Henry Saunders III. "John Smibert (1688–1751): Anglo-American Portrait Painter." Ph.D. Dissertation, Yale University, 1979. 2 vols.
John Smibert. *Notebook of John Smibert.* Essays by Sir David Evans, John Kerslake, and Andrew Oliver. Boston: Massachusetts Historical Society, 1969.

John Rubens Smith

1775–1849

Falls on the Sawkill

Watercolor on paper, c. 1820
12¾ x 16³/₁₆ in. (32.4 x 41.2 cm)
The Corcoran Gallery of Art; gift of Ted Cooper

Plate 62

Mills on the Brandywine

Watercolor and gouache on paper, c. 1828
12¾ x 18¾ in. (32.4 x 47.6 cm)
The Philadelphia Print Shop

Plate 195

View of Washington

Watercolor on paper, c. 1828
13¾ x 21¾ in. (34.9 x 55.2 cm)
The Philadelphia Print Shop

Plate 145

Born January 23, 1775, in London, Smith was the son of the renowned mezzotint engraver John Raphael Smith, and grandson of landscapist Thomas Smith of Derby. The young Smith acquired early training in his father's studio and from 1789 to 1799 studied at the Royal Academy. By 1799 he was teaching his own drawing classes. Smith's professional work in London, which was primarily in watercolor, ranged from sea and landscape views to portraiture. From 1796 to 1811 approximately fifty of his works were exhibited at the Academy.

After a preliminary visit to America in 1802, Smith emigrated to Boston in 1806, carrying letters of introduction

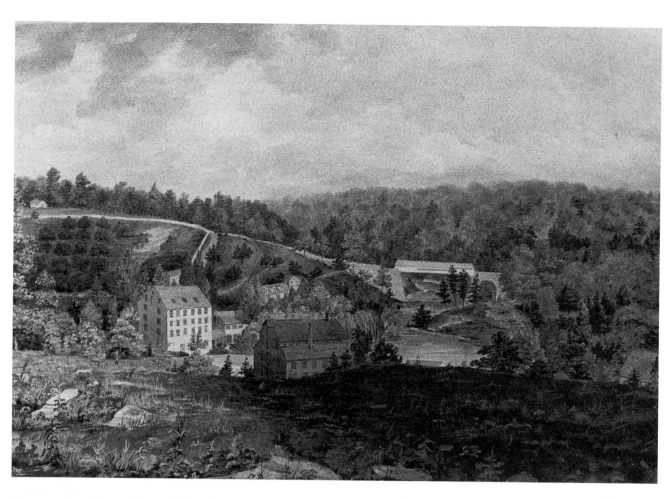

PLATE 195. JOHN RUBENS SMITH, *Mills on the Brandywine*, c. 1828.

written by Academy president Benjamin West to American painters Gilbert Stuart and Washington Allston. Smith's reputation insured the success of his first drawing academy, begun in 1807. He married a pupil, Elizabeth Pepperell Sanger, in the spring of 1809. From this marriage came three children, one of whom, John Rowson Smith, became a panorama and scene painter.

Smith's topographical watercolors are marked by meticulous detail and accuracy. In *Mills on the Brandywine* he employs a conventional treatment of pictorial space: the bottom third of the painting is devoted to foreground vegetation; the next third to the vivid orchards and linear buildings of the middle distance; and the top to sky. Similarly in *Falls on the Sawkill* the human figures at the lower right serve conventionally to give scale to the scene and to provide a visual bridge from the foreground to a background composed of recognizable tree types. Smith's finely crafted city views, such as the one of Washington, serve as an important chronicle of the young United States.

Although Smith produced a large body of topographical scenes, he was also an important drawing master and author of several instructional art manuals. In a handbill dated January 2, 1809, Smith "notified his former pupils . . . that by paying five dollars down and two dollars monthly they might borrow, in the manner of a circulating library, his books, prints, drawings and patterns, to work from at their leisure and have the benefit of his criticism."[1] A year later Smith was unsuccessful in his attempt to establish an in-

stitution in Boston patterned after the Royal Academy.[2] Moving to New York City in 1814, he had by 1816 established a drawing school in the building housing the American Academy of Fine Arts as compensation for his services as keeper. Here he gained a reputation as a fine instructor.

Smith's drawing manuals, which went through several editions, were significant contributions to American art education. The first, *The Juvenile Drawing Book* (1822), presents a basic program of instruction for amateur and professional alike. His second work, *A Compendium of Picturesque Anatomy,* was published in Boston in 1827. In Philadelphia he produced *Key to the Art of Drawing the Human Figure* (1831), *Chromatology* (1839), and *The Elementary Drawing Book* (1841). Endorsements came from John Trumbull, Thomas Sully, John Neagle, Washington Allston, and others. Smith's irascibility alienated many fellow artists. His unpopularity was further increased by the critical reviews he wrote of exhibitions at the American Academy and, after 1826, at the National Academy of Design. He spent the closing years of his life in poverty, dying in New York on August 21, 1849.

TYL

1. From a handbill in the Karolik Collection, cited in Boston Museum of Fine Arts, *M. and M. Karolik Collection of American Water Colors and Drawings: 1800–1875* (Boston: Museum of Fine Arts, 1962), pp. 275–276.
2. E. S. Smith, "John Rubens Smith: An Anglo-American Artist," *Connoisseur* 85 (May 1930): 305.

BIBLIOGRAPHY
Boston Museum of Fine Arts. *M. and M. Karolik Collection of American Water Colors and Drawings: 1800–1875.* Boston: Boston Museum of Fine Arts, 1962. Vol. I.
Marion S. Carson. "The Duncan Phyfe Shops by John Rubens Smith, Artist and Drawing Master." *American Art Journal* 11, No. 4 (1979): 69–78.
Peter C. Marzio. *The Art Crusade.* Washington: Smithsonian Institution Press, 1976.
E. S. Smith. "John Rubens Smith: An Anglo-American Artist." *Connoisseur* 85 (May 1930): 300–307.

HERVEY SMYTH

active 1760

A View of Miramichi, from *Scenographia Americana,* 1768

Engraving
(Paul Sandby and P. Benazech after Smyth)
14¼ x 20¾ in. (37.1 x 53.5 cm)
Library of Congress

PLATE 84

Captain Hervey Smyth (or Smith) was an aide-de-camp to General James Wolfe, the hero of the French and Indian War who was killed in the decisive battle at Quebec. Smyth is known only from the engravings *Six Elegant Views of the Most Remarkable Places in the River and Gulf of St. Lawrence,* published in London in 1760. Francis Swaine, a marine painter, exhibited an oil copy of one of Smyth's views at the Free Society in London in 1763; three of Swaine's copies are now in the Royal Ontario Museum. Paul Sandby etched *A View of Miramichi;* Peter Paul Benazech (active 1744–1783), an engraver trained by François Vivares who worked in both Paris and London, retouched the plate.

BR

BIBLIOGRAPHY
Donald H. Cresswell. *The American Revolution in Drawings and Prints: A Checklist of 1765–1790 Graphics in the Library of Congress.* Washington, D.C.: Library of Congress, 1975.

JOSEPH CONSTANTINE STADLER

active 1780–1812

See WILLIAM ROBERTS
Natural Bridge, PLATE 33

WILLIAM STRICKLAND

1753–1834

Ballston Springs, New York

Watercolor on paper, c. 1794
9 x 13⅜ in. (22.9 x 34 cm)
The New-York Historical Society

PLATE 153

Potomac River, Harpers Ferry, West Virginia

Watercolor on paper, 1795
9 x 13⅜ in. (22.9 x 34 cm)
The New-York Historical Society

PLATE 196

Born on March 12, 1753, in Yorkshire, Strickland was interested in new scientific methods of agriculture and established a farm at Welburn in Yorkshire in 1778. Between 1794 and 1795, he toured the eastern United States, seeking firsthand knowledge of America and its agricultural practices. The diary of his trip contains detailed descriptions of the landscape. He also made sketches on which he noted types of trees, grasses, crops, and soils, as well as references to historical locations.[1] His sketches and diary provide an interesting view of American life during the early years of the young republic.

After landing in New York on September 20, 1794, Strickland traveled through New Jersey and then up the Hudson Valley to Albany. There he explored the new settlements, including Schenectady and Ballston Springs, where he was appalled by the wasteful destruction of the forests. About Ballston, he wrote that it "was cut out of the woods and like every other settlement without taste, judgement or foresight. Nothing is preserved and everything wasted."[2] The watercolor of Ballston Springs — showing trees girdled and destroyed by fire — depicts the senseless and indiscriminate practices of the backwoodsmen in land clearance. He criticized the American government for allowing such practices and called the people of the new settlements "barbarous savages."[3] His attitude undoubtedly was colored in part by his awareness of England's deforestation in the sixteenth and seventeenth centuries.

Strickland left the Albany area in October and traveled to New England, where he was surprised by the similarity in culture and environment to his native England. Impressed by the manners and customs of the New Englanders, he found a rich and diversified countryside farmed by people protective of their woodlands.[4]

Philadelphia served as a base for the remainder of Strickland's visit. There he enjoyed a cordial relationship with George Washington, founded on a mutual interest in agriculture.[5] In the spring of 1795 Strickland made two side trips: one to the Chesapeake region and the other through Maryland, Virginia, and the Carolinas. In the South he discovered a way of life completely new and totally appalling

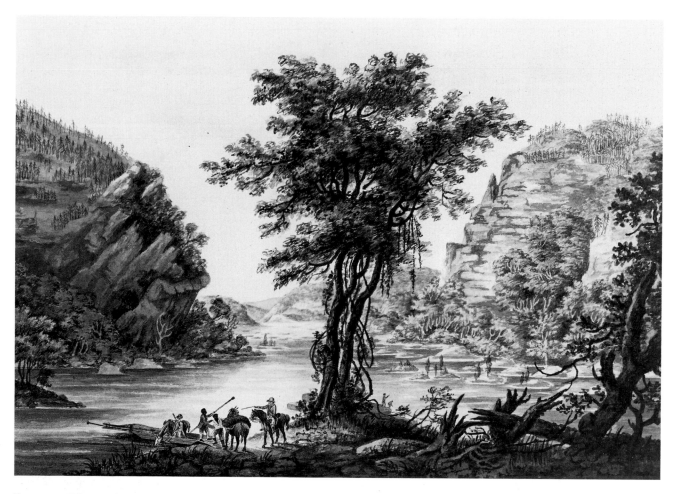

PLATE 196. WILLIAM STRICKLAND, *Potomac River, Harpers Ferry, West Virginia*, 1795.

to him, especially in Virginia, where huge estates were farmed by slave labor.[6] The watercolor of Harpers Ferry was executed on one of these trips.

Strickland returned to England in July 1795. A few years later, in 1801, he published *Observations on Agriculture in America*, critical of American agricultural practice and policy. Despite this criticism, Strickland was enthralled by the beauty of the wilderness and impressed by the cultural similarity between America and England. Strickland succeeded to the Baronetcy of Boynton in 1808. Increased responsibilities may have prevented him from making the return trip to America he had planned, but his interest in the United States never flagged, and he continued to correspond with friends here until his death in 1834.[7]

JAH

1. William Strickland, *Journal of a Tour of the United States (1794–1795)*. J. E. Strickland, ed. (New York: New-York Historical Society, 1971), p. ix. The editor, a great-great-grandson of Strickland, donated to the New-York Historical Society a collection of letters, letter-books, copybooks, drawings, itineraries, and the manuscripts of nineteen volumes of his diary from which the *Journal* was published. Although written as if it were a diary, it is evident that the artist composed the manuscripts from his notes after his travels, because the *Journal* contains references to events about which he could have known nothing at the time of his stay in America. The *Journal* ends abruptly in Boston, in November 1795, thus giving an incomplete account of his trip.
2. *Ibid.*, p. 138.
3. *Ibid.*, p. 146.
4. *Ibid.*, pp. 196–199, 233.
5. *Ibid.*, p. xiii. See App. IV, pp. 241–246, for a letter from George Washington in response to Strickland's *Observations on Agriculture in the United States of America*.
6. Strickland, *Journal*, p. xvii.
7. *Ibid.*, p. xix.

BIBLIOGRAPHY

Richard J. Koke. *American Landscape and Genre Paintings in the New-York Historical Society*. Boston: New-York Historical Society with G. K. Hall, 1982. Vol. III.

William Strickland. *Journal of a Tour of the United States (1794–1795)*. J. E. Strickland, ed. New York: New-York Historical Society, 1971.

THOMAS SULLY

1783–1872

Castle on a Cliff, Sea at Base – Imitation of Turner

Watercolor on paper, 1814
10¾ x 8⁷/₁₆ in. (27.3 x 21.4 cm)
Yale Center for British Art, Paul Mellon Collection

PLATE 69

Fort Putnam from Across the River

Watercolor on paper, 1814
10¼ x 6⅜ in. (26 x 16.2 cm)
Yale Center for British Art, Paul Mellon Collection

PLATE 70

Landscape with Ruined Castle
(after John Varley)

Watercolor on paper, c. 1815–1820
6¹³/₁₆ x 8½ in. (17.3 x 21.6 cm)
Yale Center for British Art, Paul Mellon Collection

PLATE 197

One of the foremost American portrait painters of the first half of the nineteenth century, Sully was born July 19, 1783, in Horncastle, Lincolnshire, England. The youngest son of actors Matthew and Sarah Chester Sully, Thomas moved with his family to Charleston, South Carolina, in 1792. His earliest instruction in the rudiments of art were received from his schoolmate Charles Fraser.

At the age of twelve Sully was apprenticed to an insurance broker by his parents, but his aspirations were elsewhere. After studying briefly with his brother-in-law, the French miniature painter Jean Belzons, Sully in 1799 was invited by his elder brother Lawrence, a miniature and device painter, to join him in Richmond, Virginia. Upon Lawrence's death in 1803, Thomas assumed responsibility for his brother's family; two years later he married his sister-in-law.

In 1806, acting upon the advice of the actor Thomas Abthorpe Cooper, Sully moved his family from Richmond to New York City, where he obtained lessons from John Trumbull by having Mrs. Sully sit for her portrait. After a trip to Boston to meet Gilbert Stuart, he relocated his family in Philadelphia, then the artistic center of the United States. Wishing to improve his art, in 1809 Sully went to England, where he was befriended, as many American painters had been before him, by Benjamin West; he also came under the influence of Thomas Lawrence. The spring of 1810 saw him back in Philadelphia, where he quickly became the city's leading portraitist. In his extremely long and productive career he executed over 2,600 works.[1] He died in Philadelphia on November 5, 1872.

Supportive of the Pennsylvania Academy of the Fine Arts, Sully was also unremitting in sharing his knowledge with others. His ideas are recorded in his notes and manuscripts. Some of these writings, published posthumously in 1873,[2] provide insight into this man as a teacher and an artist.

Although primarily a painter of portraits, Sully did explore other subjects. A portfolio of landscape watercolors

PLATE 197. THOMAS SULLY, *Landscape with Ruined Castle* (after Varley), c. 1815–1820.

295

PLATE 198. PAVEL PETROVICH SVININ, *The Tornado,* early nineteenth century.

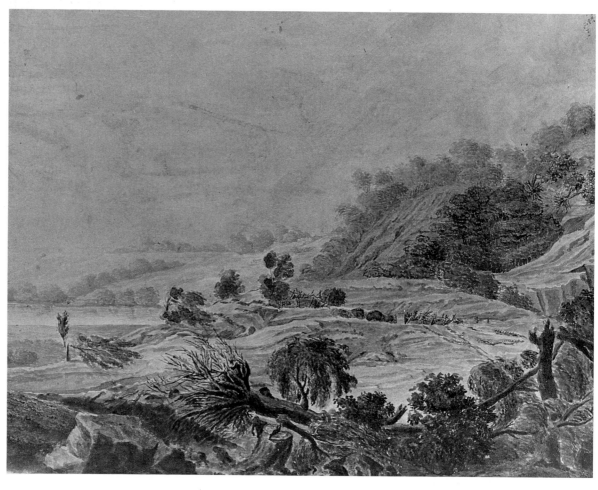

PLATE 199. PAVEL PETROVICH SVININ, *After the Tornado,* early nineteenth century.

begun in August 1814 reveals his familiarity with current English practice.[3] While the copies after John Varley and imitations of J. M. W. Turner document his knowledge of those artists' works, there are others that display a fresh response to the American scene in advance of the stylized drawings of the Robertsons and the conventional compositions of John Rubens Smith. This sketchbook, from which colleagues such as John Neagle copied, attests to Sully's receptiveness to new ideas and willingness to share them with others.

TYL

1. Monroe Fabian, *Mr. Sully, Portrait Painter* (Washington, D.C.: Smithsonian Institution Press, 1983), p. 10.
2. Thomas Sully, *Hints to Young Painters, and the Process of Portrait Painting as Practiced by the Late Thomas Sully* (Philadelphia: J. M. Stoddart, 1873). Manuscript material related to this publication is preserved in the Beinecke Library, Yale University.
3. Collection of the Yale Center for British Art, New Haven.

BIBLIOGRAPHY

Edward Biddle and Mantle Fielding. *The Life and Works of Thomas Sully (1783–1872)*. Philadelphia: Wickersham Press, 1921.
Henry Budd. "Thomas Sully." *Pennsylvania Magazine of History and Biography* 42, No. 2 (1918): 97–126.
Monroe Fabian. *Mr. Sully, Portrait Painter: The Works of Thomas Sully (1783–1872)*. Washington, D.C.: Smithsonian Institution Press, 1983.
Thomas Sully. *Hints to Young Painters, and the Process of Portrait Painting as Practiced by the Late Thomas Sully*. Philadelphia: J. M. Stoddart, 1873.
_____. "Sketchbook: Lessons in Landscape Painting. . . ." Yale Center for British Art, New Haven.

PAVEL PETROVICH SVININ

1787/1788–1839

The Sailing Packet Mohawk of Albany Passing the Palisades of the Hudson River

Watercolor on paper, early nineteenth century
9¹³/₁₆ x 15¹⁵/₁₆ in. (24.9 x 40.5 cm)
Metropolitan Museum of Art; Rogers Fund, 1942
(Wadsworth Atheneum only)

PLATES 55 AND 143

A Ferry Scene on the Susquehanna River at Wright's Ferry just above Havre de Grace

Watercolor on paper, early nineteenth century
8¾ x 13 in. (22.2 x 33 cm)
Metropolitan Museum of Art; Rogers Fund, 1942
(Corcoran only)

PLATE 138

The Tornado

Watercolor on paper, early nineteenth century
9⅞ x 15⅜ in. (25 x 39.1 cm)
Metropolitan Museum of Art; Rogers Fund, 1942
(Corcoran only)

PLATE 198

After the Tornado

Watercolor on paper, early nineteenth century
7½ x 10⅛ in. (19 x 25.7 cm)
Metropolitan Museum of Art; Rogers Fund, 1942
(Wadsworth Atheneum only)

PLATE 199

Svinin was born in Russia on either June 8, 1787, or June 19, 1788, and educated in Moscow. He studied drawing at the Academy of the Fine Arts of St. Petersburg and was later an academician. Entering the service of the foreign office, he arrived in Philadelphia in 1811 as the secretary to the Russian counsul-general. During the two years he spent in the United States he traveled up and down the East Coast, sketching and recording his impressions in series of carefully rendered watercolors. He exhibited several of his watercolors of St. Petersburg at the Pennsylvania Academy of the Fine Arts in 1812, about which the reviewer remarked:

> These views are beautifully executed, and are certainly superior to the general productions of amateurs. From the manner of finish and correctness of outline, he should have been inclined (without particular information) to have attributed them to a professional of great merit.[1]

Of the over fifty watercolors now in the Metropolitan Museum, at least fourteen are copied from Isaac Weld, Henry Gilpin's *The Northern Tour*, Chastellux, and *The Port Folio*. Svinin also mentioned Thomas Birch, William Groombridge, Francis Guy, and Archibald Robertson in his writings, and some views of Moscow were engraved by William Kneass in Philadelphia in 1812. On his return to Russia he published in 1818 *A Picturesque Voyage in North America*, and later several books on the Mediterranean and England. He died in St. Petersburg on April 21, 1839.

BR

1. G. M. [George Murray?], "Review of the Second Annual Exhibition," *Port Folio* 8 (August 1812): 143.

BIBLIOGRAPHY

Fedotoff D. White. "A Russian Sketches Philadelphia, 1811–1812." *Pennsylvania Magazine of History and Biography* 75 (January 1951): 3–24.
Abraham Yarmolinsky, ed. *Picturesque United States of America, 1811, 1812, 1813: being a Memoir on Paul Svinin, Russian Diplomatic Officer, Artist and Author*. New York: W. E. Rudge, 1930.

JOHN TRUMBULL

1756–1843

View on the West Mountain near Hartford

Oil on canvas, c. 1791
19 x 24⅞ in. (48.2 x 63.2 cm)
Yale University Art Gallery; bequest of Miss Marian Cruger Coffin in memory of Mrs. Julian Coffin (Alice Church)

PLATE 27

Norwich Falls

Oil on canvas, 1806
27 x 36 in. (68.5 x 91.5 cm)
Yale University Art Gallery; Mabel Brady Garvan Collection
PLATE 35

Known primarily as a portrait and history painter, particularly of the American Revolution,[1] John Trumbull was born in Lebanon, Connecticut, on June 6, 1756, to the future governor of Connecticut, Jonathan Trumbull. In 1775, two years after graduating from Harvard, Trumbull served in the Revolutionary army, for a time as aide-de-camp to General George Washington. Aggravated over the delayed authorization of his rank, he resigned his commission in 1777.

In 1770, while a student at Nathan Tisdale's school in Lebanon, Trumbull executed his earliest surviving work, *A View of Part of the City of Rome,* an amalgamation of images derived from several print sources.[2] His desire to study art was intensified when, on his way to Harvard in 1771, he visited John Singleton Copley, but it was not until 1777 that Trumbull, after leaving the army, moved to Boston to paint. In 1780, while abroad on an investment venture for his family, he studied briefly in London with Benjamin West; however, he was arrested as a suspected spy, imprisoned for eight months, and subsequently deported. Three years later Trumbull finally returned to England to study painting with grudging parental blessing.

A desire to paint a series of works commemorating the American Revolution brought him back to America in 1789 to sketch portraits and locales for the projected compositions. *View on the West Mountain near Hartford* dates from this period and demonstrates the artist's attraction to American scenery. The property represented became a part of Monte Video, the estate of his nephew-in-law, Daniel Wadsworth.[3] Trumbull emphasizes the pastoral quality of a landscape, inhabited yet unspoiled by man. The rocky and dramatic terrain with its sudden, clifflike drop suggests Trumbull's familiarity with the work of Salvator Rosa, the seventeenth-century Italian painter whose landscapes were widely admired at the time for their sublime effects.

After another stay in England (1794–1804), Trumbull returned to America to settle in New York. Despite a few prolonged absences, he resided in that city until his death in 1843. He quickly became New York's most important artist, and in 1817 he was elected president of the American Academy of Fine Arts, which had been founded there in 1802.

The early years in New York were his most prolific as a landscape painter. In 1806, commissioned to paint a portrait of John Vernet and his family in Norwich, he included one of the local sites, the Falls of Yantic, in the background. The scene so attracted Trumbull that he painted several additional views.[4] In *Norwich Falls* the sublimity of the image is heightened by the spectator's impression of hovering over the glassy water to survey the wilderness. The direct confrontation with uncivilized nature, unusual for this time period, makes this painting a possible precursor of Romantic landscapes of the Hudson River School.[5] The

following year a trip to Niagara resulted in several compositions of the falls there.[6] It is in works such as *Norwich Falls* that his sympathetic treatment of wild nature, while reflective of the concept of the sublime, also suggests his artistic pride in America, a sentiment evident as well in his history paintings.

GLH

1. Trumbull is renowned for his four scenes of the American Revolution in the Rotunda of the United States Capitol Building (1815–1824).
2. Irma B. Jaffe, *John Trumbull: Patriot-Artist of the American Revolution* (Boston: New York Graphic Society, 1975), p. 10.
3. Daniel Wadsworth, a patron of Trumbull, was the founder of the Wadsworth Atheneum at Hartford in 1842.
4. Trumbull is known to have done at least six pencil sketches, a pen and ink drawing, and three oil paintings of the site. Two of the oils are known to survive: *Norwich Falls* (Yale University Art Gallery) and *The Falls of the Yantic at Norwich* (Slater Memorial Museum), both of 1806. *John Trumbull: The Hand and Spirit of a Painter* (New Haven: Yale University Art Gallery, 1982), p. 222
5. Bryan Wolf, "Revolution in the Landscape: John Trumbull and Picturesque Painting," in *John Trumbull: The Hand and Spirit of a Painter,* p. 214.
6. Two fourteen-foot-long panorama studies, *View of the Falls of Niagara from under the Table Rock* (1808) and *Niagara Falls Two Miles Below Chippewa* (1808) are in the New-York Historical Society. *Niagara Falls from an Upper Bank on the British Side* (1807–1808), and *Niagara Falls Below the Great Cascade on the British Side* (1807–1808) are in the Wadsworth Atheneum. For a discussion of these works within the context of artistic treatments of Niagara see Jeremy Adamson, *Niagara* (Washington, D.C.: Corcoran Gallery of Art, 1985), pp. 29–34.

BIBLIOGRAPHY

Irma B. Jaffe. *John Trumbull: Patriot-Artist of the American Revolution.* Boston: New York Graphic Society, 1975.
Theodore Sizer, ed. *The Autobiography of Colonel John Trumbull.* New Haven: Yale University Press, 1953.
———. *The Works of John Trumbull.* rev. ed. New Haven: Yale University Press, 1967.
Helen A. Cooper, et al. *John Trumbull: The Hand and Spirit of a Painter.* New Haven: Yale University Art Gallery, 1982.

WILLIAM GUY WALL

1792 after 1863

The Bay of New York and Governor's Island Taken from Brooklyn Heights

Watercolor with white on paper, 1820–1825
21⅝₁₆ x 30¼ in. (54.1 x 76.8 cm)
The Metropolitan Museum of Art; bequest of Edward W. C. Arnold, 1954
(Corcoran only)
PLATE 200

The Bay of New York Taken from Brooklyn Heights

Watercolor with white on paper, 1820–1825
21⅝₁₆ x 32¾ in. (54.1 x 83.9 cm)
The Metropolitan Museum of Art; bequest of Edward W. C. Arnold, 1954
(Corcoran only)
PLATE 201

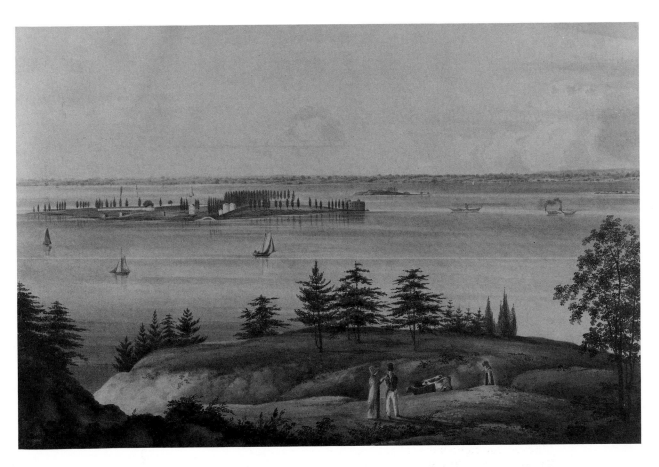

PLATE 200. WILLIAM GUY WALL, *The Bay of New York and Governor's Island Taken from Brooklyn Heights*, 1820–1825.

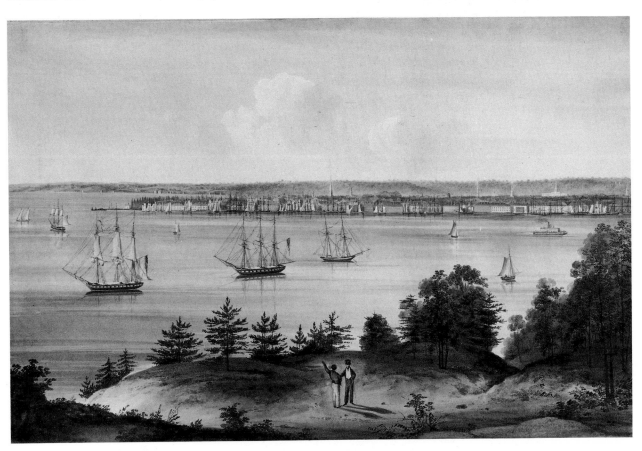

PLATE 201. WILLIAM GUY WALL, *The Bay of New York Taken from Brooklyn Heights*, 1820–1825.

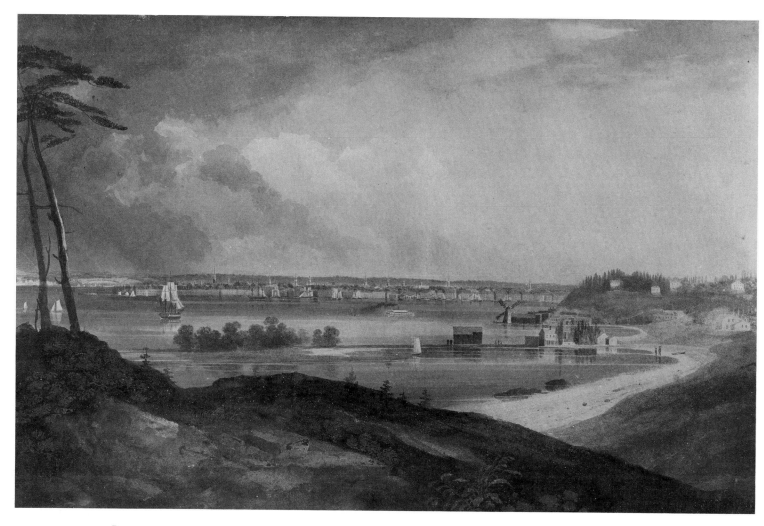

PLATE 202. WILLIAM GUY WALL, *New York from Heights near Brooklyn*, 1823.

New York from Heights near Brooklyn

Watercolor with white on paper, 1823

16⅛ x 25½ in. (41 x 64.7 cm)

The Metropolitan Museum of Art; bequest of Edward W. C.
 Arnold, 1954

(Wadsworth Atheneum only)

PLATE 202

New York (from Weehawk)

Watercolor with white on paper, 1823

16⅛ x 25½ in. (41 x 64.7 cm)

The Metropolitan Museum of Art; bequest of Edward W. C.
 Arnold, 1954

(Wadsworth Atheneum only)

PLATE 203

Cauterskill Falls on the Catskill Mountains, Taken from under the Cavern

Oil on canvas, 1826–1827

37 x 47 in. (94 x 119.4 cm)

Honolulu Academy of Arts; gift of the Mared Foundation, 1969

COVER AND PLATES 65 AND 128

Hudson River Portfolio, 1828 edition

Hadley's Falls (John Rubens Smith and John Hill after
 Wall), PLATE 56

View near Hudson (John Hill after Wall), PLATES 57 AND
 126

Hudson (John Hill after Wall), PLATE 163

View of Fishkill Looking to West Point (John Hill after
 Wall), PLATE 58

Colored aquatints

18 x 24½ in. (45.7 x 62.2 cm)

Private collection

In his history of the arts in America published in 1834, Dunlap remarked about Wall: "This gentleman has been indefatigable in studying American landscape, and his reputation stands deservedly high."[1] Wall began his career in America in 1818. Born in Dublin in 1792, he arrived in New York on September 1, 1818, presumably a fully trained artist, although John Rubens Smith subsequently claimed to have taught him proper watercolor technique.[2] In New York, Wall immediately began exhibiting his drawings, probably Irish subjects since one of them was of ruins, at the American Academy of Fine Arts.

PLATE 203. WILLIAM GUY WALL, *New York (from Weehawk)*, 1823.

In the summer of 1820, Wall went on a tour of the Hudson. The works he produced as a result of that trip were the basis for the *Hudson River Portfolio*. The surviving watercolors from the series, faded though they are, show Wall's mastery of a conservative technique.[3] Although in 1834 Dunlap stated that Wall's "practice of late is to color all his drawings from nature on the spot," it is unlikely, given their size and finish, that the Hudson views were painted directly from nature. It is more likely that, like earlier productions, they were composed in the studio from sketches and notes, the normal practice at the time. Issued in five parts of four plates each between 1821 and 1825, the *Portfolio* was the foundation of Wall's reputation. The watercolors were aquatinted primarily by John Hill, who replaced Smith.[4] Wall collaborated with Hill on other projects, including several views of New York.

Wall was an established artist, responding enthusiastically to American landscape when Cole appeared on the New York scene. He remained an active force in the community, exhibiting frequently at the National Academy of Design of which he was, like Cole, a founding member. As John Howat suggested, Wall's awareness of the younger artist's talents and accomplishments may have contributed in part to his depiction of Kaaterskill or Cauterskill Falls, a year after Cole exhibited an almost identical view.[5] Wall's version, shown at the National Academy in 1827, was greatly admired. "This brilliant picture shows that Mr.

Wall has attained the same facility in oil, for which he has long been distinguished in watercolors," one critic observed. Another called it a "splendid specimen of landscape painting"; a third, "one of the best of Mr. Wall's productions. . . ."[6]

Why Wall chose this time to move to Newport is not known. But he was there by 1831 if not earlier. Four years later, he was in New Haven, where, according to Dunlap, he was pursuing his profession with great success. In 1836, Wall was again in the New York area. And then he returned to Dublin, where he lived for two decades. Lack of recognition apparently prompted him to return to the land of his greatest success. For a period of several years between 1857 and 1862 he resided in Newburgh, New York. But time had passed him by. "Advanced in years, afflicted in his family by sickness, and discouraged for want of employment,"[7] Wall returned once again to Dublin in 1862 where he presumably died.

EJN

1. William Dunlap, *History of the Rise and Progress of the Arts of Design in the United States*, 3 vols. (1834; reprint, New York: Benjamin Blom, 1965), Vol. III, p. 103.

2. The following notation appears on the bottom of a watercolor by Wall, *View of New York from Brooklyn* (Philadelphia Print Shop): "Wall's style of painting before he came to me, in a year I got him engaged to Megary — to paint the subjects of the Hudson River Portfolio — in return he gratefully tried to ruin me in Business — Ingratitude JRS." If Smith's remarks are accurate, then the work must be from 1819 rather than 1825 –

1828 as noted on the sheet presumably by Smith. Since Smith was replaced by John Hill as aquatinter of the *Portfolio*, his comments are suspect. See n. 4 below.

3. Donald A. Shelley, "William Guy Wall and His Watercolors for the Historic *Hudson River Portfolio*," *New-York Historical Society Quarterly* 31 (January 1947): 35–38, for a discussion of Wall's technique.

4. Smith started four of the plates, but they were completed by Hill and are so indicated on the prints.

5. John K. Howat, "A Picturesque Site in the Catskills: The Kaaterskill Falls as Painted by William Guy Wall," *Honolulu Academy of Arts Journal* 1 (1974): 28.

6. Quoted in *ibid.*, pp. 26–28.

7. Thomas S. Cummings, *Historic Annals of the National Academy of Design* (1865), quoted in Shelley, "William Guy Wall," p. 33.

BIBLIOGRAPHY

John K. Howat. "A Picturesque Site in the Catskills: The Kaaterskill Falls as Painted by William Guy Wall." *Honolulu Academy of Arts Journal* 1 (1974): 17–29, 63–65.

Richard J. Koke. *American Landscape and Genre Paintings in the New-York Historical Society* (Boston: New-York Historical Society with G. K. Hall, 1982). Vol. III.

———. "John Hill, Master of Aquatint 1770–1850." *New-York Historical Society Quarterly* 43 (January 1959): 51–117.

Donald A. Shelley, "William Guy Wall and His Watercolors for the Historic *Hudson River Portfolio*." *New-York Historical Society Quarterly* 31 (January 1947): 25–45.

JOSHUA ROWLEY WATSON

1772–after 1829

A View of Philadelphia and the Schuylkill River

Watercolor on paper, c. 1827
20⅛ x 31⅜ in. (51.1 x 79.9 cm)
Atwater Kent Museum, Philadelphia

PLATE 100

Watson was commissioned in the Royal Navy in 1798. He was stationed in North America shortly after the War of 1812 and became active as an artist in Philadelphia in the 1820s. His sketchbook from a tour of the eastern United States in 1816, which survives in the New-York Historical Society, demonstrates the great freshness and beauty of his work. Joshua Shaw adapted two of Watson's drawings for *Picturesque Views of American Scenery* (1820-1821). *A View of Philadelphia and the Schuylkill River* was published by Cephas Childs in *Views in Philadelphia and Its Vicinity in 1827–1830*. Watson also exhibited at the Pennsylvania Academy in 1829.

BR

BIBLIOGRAPHY

Richard J. Koke. *American Landscape and Genre Paintings in the New-York Historical Society*. Boston: New-York Historical Society with G. K. Hall, 1982. Vol. III.

ISAAC WELD, JR.

1774–1865

View of the Rock Bridge, frontispiece from Travels through the States of North America. . . , 1799

Aquatint
Library of Congress

PLATE 149

Weld was born on Fleet Street in Dublin on March 15, 1774. He was educated in Norwich, England, but returned in 1793 to Dublin, which remained his home for the rest of his life. In 1795 he traveled to Philadelphia, intent on examining the prospects of America in great detail. After two years he returned to Dublin and in 1799 published *Travels through the States of North America, and the Provinces of Upper and Lower Canada, During the Years 1795, 1796 and 1797*, illustrated with his own views. Weld was disillusioned by the United States, finding the society less than ideal and the scenery not as grand as he had expected. A great success in Europe, the book was translated into French, German, and Dutch; it was criticized by Americans. In 1807 he published another illustrated travel account, *Illustrations of the Scenery of Killarney and the Surrounding Country*. Weld was principally a geographer and contributed several pamphlets to the Royal Dublin Society, of which he was a member and later vice-president (1849). He died at Ravenswell, near Bray, on August 4, 1856.

BR

BIBLIOGRAPHY

Isaac Weld. *Travels through the States of North America, and the Provinces of Upper and Lower Canada, During the Years 1795, 1796 and 1797*. London: J. Stockdale, 1799.

———. *Illustrations of the Scenery of Killarney and the Surrounding Country*. London: Longman, Hurst, Rees and Orme, 1807.

BENJAMIN WEST

1738–1820

Landscape with Cow

Oil on panel, c. 1752–1753
26¾ x 50¼ in. (68 x 127.5 cm)
Pennsylvania Hospital, Philadelphia

PLATE 14

Born in Springfield, Pennsylvania, not far from Philadelphia, on October 10, 1738, West went on to become historical painter to George III and president of the Royal Academy, of which he was a founding member in 1768. With little formal training, the young West had achieved recognition as an artist in Philadelphia before he left for Italy in 1760 with the aid of his patrons. Three years later he was in London, where he remained until his death on March 10, 1820.

West was a critical figure in the development of American art. As an enormously successful artist and later as president of the Royal Academy, he was a model for and inspiration to two generations of aspiring American painters. His studio and house were open to all who came to London. He was teacher and friend of many, including Washington Allston, Ralph Earl, Charles Willson Peale, and John Trumbull. English artists befriended by him before they left for the United States included Joshua Shaw and William Birch.

Primarily known as a history painter, West throughout his life executed landscapes. In his portraits and history pieces landscape elements figure prominently, but he also produced pure landscapes, particularly of the scenery around Windsor. *Landscape with Cow* — done when he was around fifteen, many years before his departure for Europe — is one of the earliest works that can with certainty be ascribed to the painter.[1] Its unsophisticated handling of perspective identifies it as the product of a neophyte. By this time, however, West probably had met William Williams, the English artist who introduced him to art theory and landscape.

Landscape with Cow was painted along with *Storm at Sea,* also in the collection of the Pennsylvania Hospital, as an overmantel for a house in Philadelphia, where the young West was boarding. The landscape is clearly imaginary. The diverse elements and multiple perspectives argue against its being copied from any one print; however, it could be a composite image designed from various sources. Offering little evidence of West's future greatness, the painting is, nevertheless, charming in its naïveté while its elaborate composition speaks for the young painter's artistic ambitions.

<div align="right">EJN</div>

1. The date of this and its companion piece, *Storm at Sea,* is open to question; see Helmut von Erffa and Allen Staley, *The Paintings of Benjamin West* (New Haven and London: Yale University Press, 1986), p. 435.

BIBLIOGRAPHY

Dorinda Evans. *Benjamin West and His American Students.* Washington, D.C.: National Portrait Gallery, 1980.
Grose Evans. *Benjamin West and the Taste of His Times.* Carbondale, Ill.: Southern Illinois University Press, 1959.
William Sawitzky. "The American Work of Benjamin West." *Pennsylvania Magazine of History and Biography* 62 (October 1938): 433–462.
_____. "William Williams, First Instructor of Benjamin West." *Antiques* 31 (May 1937): 240–242.
Helmut von Erffa and Allen Staley. *The Paintings of Benjamin West.* New Haven and London: Yale University Press, 1986.

JOHN WHITE

active 1585–1593

Incolarum Virginiae piscandiratio, from Thomas Harriot's *Admiranda narratio fida tamen,* 1590

Engraving
(Theodor de Bry after White)
The Library Company of Philadelphia

PLATE 4

Nothing conclusive is known of White until 1585, when he was on Roanoke Island, recording Sir Walter Raleigh's first colonizing venture. There is evidence, however, that he participated in earlier expeditions.[1] The 1585 Roanoke settlement lasted a year, during which time White worked closely with the astronomer-mathematician Thomas Harriot, surveying the area from Roanoke north to the mouth of the Chesapeake. White also executed hundreds of watercolors of the flora, fauna, and native inhabitants. Although many of these works were lost at sea, the remainder comprise the most extensive visual description of the New World to survive from the sixteenth century in original form.[2] His depictions of the Carolina Algonquins, distinguished by a wealth of factual information, have been described as the best portrait of the American Indian before Catlin.[3] In June 1586 White and Harriot returned to England. With the intention of attracting investors and settlers to Virginia, Harriot wrote *A Briefe and True Report of the New Found Land of Virginia,* published in 1588 without illustrations.

Appointed "Governor of the Cittie of Raleigh in Virginia," White, along with eighty-six colonists, departed for the New World in April 1587 to again establish a colony on Roanoke Island. Almost immediately, serious problems arose with the Indians, and food shortages threatened the colony's survival. White had to return to England for supplies a short time after his daughter gave birth to Virginia Dare, the first child of English descent born in the New World. His efforts to return to the colony were frustrated for almost three years. When White did return to Roanoke in 1590 there was no sign of the colonists. Their fate has never been learned. As for White, nothing more is known of him except that in 1593 he was living in Ireland, perhaps on one of Raleigh's estates.

On a trip to London in 1588 Theodor de Bry, a Flemish engraver working in Frankfurt, purchased from White a set of copies of his original watercolors. Two years later, de Bry published engravings after them in Part I of his projected multivolume series "America." The text of this volume consisted of a reprint of Harriot's treatise on Virginia augmented by his comments on the illustrations. These additions changed Harriot's text from a description of the land to an ethnological study.[4] De Bry's engravings follow the originals closely but not exactly. For example, in White's watercolor of Indians fishing, there is only a vague landscape in the distance; in de Bry's version it is more specific. The engraving also contains more marine life, canoes, figures, and fishtraps. Yet, the additional details and slight variations neither crowd the scene nor alter its basic tone. Clarity and order characterize the de Bry illustrations as much as the originals.

<div align="right">KBM</div>

1. Paul Hulton, *America 1585: The Complete Drawings of John White* (Chapel Hill and London: University of North Carolina Press and British Museum, 1984), pp. 8, 29, 194. For further discussion about John White, see Amy Meyers' essay in this catalogue, "Imposing Order on the Wilderness."
2. *Ibid.,* p. 84.
3. Samuel Eliot Morison, *The European Discovery of America,* Vol. I: *The Northern Voyages* (New York: Oxford University Press, 1971), p. 652.
4. Paul Hulton, Intro. to Thomas Harriot, *A Briefe and True Report of the New Found Land of Virginia* (New York: Dover, 1972), p. viii.

BIBLIOGRAPHY

Paul Hulton. Intro. to Thomas Harriot. *A Briefe and True Report of the New Found Land of Virginia.* New York: Dover, 1972.

_____. *America 1585: The Complete Drawings of John White.* Chapel Hill and London: University of North Carolina Press and British Museum, 1984.

Samuel Eliot Morison. *The European Discovery of America.* Vol. I: *The Northern Voyages.* New York: Oxford University Press, 1971.

David B. Quinn, ed. *New American World.* Vol. III: *English Plans for North America. The Roanoke Voyages. New England Ventures.* New York: Arno Press and Hector Bye, 1979.

GEORGE BRANDER WILLIS

active 1809–1866

Niagara

Oil on canvas, 1816
24 x 36 in. (70 x 91.4 cm)
Royal Ontario Museum, Toronto

PLATE 39

Willis joined the Royal Artillery in 1809 and served in the Peninsular Wars. From 1815 to 1817 he was stationed as a lieutenant in Canada, where his sketches of the local scenery were copied by other amateurs. His views of Niagara Falls, including the painting and drawing now at the Royal Ontario Museum, show him to be a well-trained artist with a taste for the dramatic. His familiarity with the aesthetic of the sublime is evident here in the stormy sky and wind-swept panorama that make the human figures appear insignificant before the forces of nature. There is a theatricality about this composition that recalls treatments of Shakespearean subjects by his contemporaries such as Benjamin West and Francesco Zuccarelli, and ultimately the seventeenth-century paintings of Salvator Rosa. Willis retired on half-pay to his estate at Sopley Park, Hampshire. As late as 1866, he was still listed on the rolls of the Royal Artillery.

BR

BIBLIOGRAPHY

Mary Allodi. *Canadian Watercolours and Drawings in the Royal Ontario Museum.* Toronto: Royal Ontario Museum, 1974.

J. Russell Harper. *Early Painters and Engravers in Canada.* Toronto: University of Toronto Press, 1970.

WILLIAM WINSTANLEY

active 1793–1806

Falls of the Genesee

Oil on canvas, 1793–1794
39 x 49 in. (99.1 x 124.5 cm)
National Museum of American History, Smithsonian Institution, Washington, D.C.

PLATE 31

According to William Dunlap, Winstanley was a young man from a good English family who came to America in the early 1790s on some business for the Episcopal Church.[1] Nothing is recorded about his birth or training, and it is not known when or where he died. However, Winstanley was back in England in 1806, when he exhibited several works, including three Virginia landscapes, at the recently established British Institution.

Winstanley is remembered today for two very different artistic connections. First, Gilbert Stuart, in his comments to Dunlap, portrayed the young artist as an unscrupulous copier of his full-length portrait of George Washington. The veracity of Stuart's remarks, at least in certain details, has been questioned.[2] Second, Winstanley was patronized by the first president, who called him "a celebrated Landskip painter."[3] Washington purchased four major canvases from the artist. Two views on the Hudson, *Morning* and *Evening* (Figs. 7 and 8), were acquired in 1793 when Washington was president and living in Philadelphia. They are now on display at Mount Vernon. Of the two purchased in 1794, only *Falls of the Genesee* has been located. A fourth canvas of about the same size, *Meeting of the Waters* (1795), is in the collection of the Munson-Williams-Proctor Institute in Utica, New York.

Morning and *Evening* as well as *Meeting of the Waters* recall the work of the great English landscape artist of the late eighteenth century Richard Wilson and of his French contemporary Claude-Joseph Vernet. Their soft atmospheric effects, gradual recession into space, and pastoral vision ultimately are derived from the seventeenth-century master Claude Lorrain. Projecting an air of peace and tranquility, these compositions are embodiments of the aesthetic concept of the beautiful with which Claude's paintings were closely associated at the time. *Falls of the Genesee* is another matter. While the handling of light and atmosphere softens the scene, the dramatic subject represents an essay in the pictorial sublime.

In 1795 Winstanley was in New York, where he exhibited a panorama of London, the first work of its kind to be shown in America. Five years later he was in Washington, where he became an intimate of Dr. William Thornton, architect of the Capitol. Shortly thereafter, in November of 1801, Winstanley was in Boston advertising a projected series of prints after his landscapes.[4] There is no evidence that the project materialized. Last mention of him occurs in 1806 when he exhibited six works at the British Institution.

EJN

1. William Dunlap, *History of the Rise and Progress of the Arts of Design in the United States,* 3 vols. (1834; reprint, New York: Benjamin Blom, 1965), Vol. II, p. 77.
2. *Ibid.,* Vol. I, p. 235. J. Hall Pleasants, *Four Late Eighteenth Century Anglo-American Landscape Painters* (1942; reprint, Worcester: American Antiquarian Society, 1943), pp. 129, 131.
3. Letter from George Washington to the Commissioners of the District of Columbia, September 5, 1793, quoted in Pleasants, *Four . . . Painters,* p. 119.
4. See *ibid.,* pp. 132–133, for a reproduction of the prospectus.

BIBLIOGRAPHY

James Thomas Flexner. "George Washington as an Art Collector" *American Art Journal* 4 (September 1972): 24–35.

William Barrow Floyd. "The Portraits and Paintings at Mount Vernon from 1754 to 1799, II." *Antiques* 100 (December 1971): 894–899.

J. Hall Pleasants. *Four Late Eighteenth Century Anglo-American Landscape Painters*. 1942. Reprint from *Proceedings of American Antiquarian Society*, Worcester, Mass.: American Antiquarian Society, 1943.

JOHN ARCHIBALD WOODSIDE

1781–1852

Lemon Hill

Oil on canvas, 1807

20⅜ x 26⅝ in. (51.8 x 67.6 cm)

The Historical Society of Pennsylvania

PLATE 121

A Pennsylvania Country Fair

Oil on canvas, 1824

20⅛ x 26⅛ in. (51.1 x 66.3 cm)

Private collection

(Corcoran only)

PLATES 29 AND 159

William Dunlap wrote in his early history of American artists: "Woodside paints signs with talent beyond many who paint with higher branches."[1] Although Woodside also created and exhibited paintings of animals and still lifes, it was his signs which gained him recognition.

Little is known of Woodside's training. Born in Philadelphia in 1781, he is thought to have studied with Matthew Pratt, a fashionable portraitist and sign painter.[2] In June, 1802, he reputedly started working for William Berrett, a coach and sign painter. A few years later he opened his own shop, advertising himself as a "sign and ornamental painter."[3] Woodside exhibited at the Pennsylvania Academy of the Fine Arts between 1817 and 1836. Among the landscapes he produced was a view of Lemon Hill, the country seat in Fairmount Park of Henry Pratt, his supposed teacher's son. *A Pennsylvania Country Fair* is probably also a portrait of a particular farm. Certainly the specificity of the architecture and the setting suggests this. The focal point of the painting is the large stone Switzer-type barn found in southeastern Pennsylvania.[4] The scene, whether a depiction of a specific place or not, is a visualization of America's wealth and productivity brought about by the richness of her land. As such, it is an enormously appealing image brimming with optimism.

A Pennsylvania Country Fair typifies Woodside's style with sharply drawn bold masses and strong colors. When compared with *Lemon Hill* and other examples of his work, it is an unusually sophisticated and well-designed painting. The friezelike treatment of the animals creates a strong unified composition. However, the unsophisticated handling of space reflects the limitations of the self-taught artist and sign painter. The composition forces the viewer to consider the scene from a distance like a sign board. Still, the paint-

ing displays the attention to detail that brought Woodside well-deserved fame during his lifetime. He taught his two sons the trade and continued to paint and operate his shop in Philadelphia until his death on February 26, 1852.

KK

1. William Dunlap, *History of the Rise and Progress of the Arts of Design in the United States* (1834; reprint, Rita Weiss, ed., New York: Dover, 1969), Vol. III, p. 471.
2. Pratt (1734–1805) studied in London with Benjamin West from 1764 to 1766. He is best known for his painting *The American School*, 1765 (Metropolitan Museum of Art), a tribute to his teacher.
3. For a discussion of his activities as a sign painter, see Joseph Jackson, "John A. Woodside: Philadelphia's Glorified Sign-Painter," *Pennsylvania Magazine of History and Biography* 57 (January 1933): 61.
4. Clearly made of stone by virtue of its structural design, such a barn could only have been built in southeastern Pennsylvania. See Eric Ross Arthur and Dudley Witney, *The Barn: A Vanishing Landmark in North America* (Greenwich, Conn.: New York Graphic Society, 1972).

BIBLIOGRAPHY

Virgil Barker. *The American Painting: History and Interpretation*. New York: Bonanza Books, 1951.
Georgia S. Chamberlain. "A Woodside Still Life." *Antiques* 67 (February 1955): 149.
Thomas J. Flexner. *Light of Distant Skys*. New York: Dover, 1969.
Joseph Jackson. "John A. Woodside: Philadelphia's Glorified Sign-Painter." *Pennsylvania Magazine of History and Biography* 57 (January 1933): 58–65.
Philadelphia: Three Centuries of American Art. Philadelphia: Philadelphia Museum of Art, 1976.
John A. Woodside. "Day Book." Historical Society of Pennsylvania.

JOHN ELLIOT WOOLFORD

1778–1866

Head of a River, Runs into Lake Nipissing

Watercolor over graphite on laid paper, 1821

13³⁄₁₀ x 18 in. (33.9 x 45.8 cm)

National Gallery of Canada, Ottawa

PLATE 99

Woolford, in the Royal Engineers, arrived in Halifax from England in 1818. He quickly established himself as an artist, publishing four etchings of the city, dedicated to Governor-General Dalhousie, in 1819. He was stationed in Quebec and Saint John, New Brunswick, from 1820 to 1823, during which time he seems to have accompanied Dalhousie on at least one inspection tour of Upper Canada in 1821. Most of his drawings, including *Head of a River, Runs into Lake Nipissing*, seem to date from this trip. His work was copied by Charles Ramus Forrest, although Woolford's drawings are much softer and less stylized. In 1824 he was transferred to Frederickton. Remaining there for the rest of his life, he was active as an architect, designing both the Government House in 1826 and King's College in 1827. He also illustrated Abraham Gesner's *New Brunswick with Notes for Emigrants* (London, 1847).

BR

BIBLIOGRAPHY

Mary Allodi. *Canadian Watercolours and Drawings in the Royal Ontario Museum*. Toronto: Royal Ontario Museum, 1974.

W. Martha E. Cooke. *W. H. Coverdale Collection of Canadiana: Paintings, Water-Colours and Drawings (Manoir Richelieu Collection)*. Ottawa: Public Archives Canada, 1983.

UNKNOWN ARTISTS

Seat of Colonel George Boyd

Oil on canvas, 1774

17 x 32 in. (43.1 x 81.2 cm)

The Lamont Gallery, Phillips Exeter Academy, Exeter, New Hampshire; gift of Thomas W. Lamont, Class of 1888

PLATES 103 AND 116

Overmantel from the Perez Walker House

Oil on wood panel, last quarter of the eighteenth century

40⅜ x 46 in. (102.6 x 116.8 cm)

Old Sturbridge Village, Massachusetts

PLATE 13

Townscape, Stonington, Connecticut

Watercolor on paper, c. 1800–1825

18 x 22 in. (42.7 x 55.9 cm)

The Shelburne Museum, Shelburne, Vermont

PLATES 45 AND 117

Notes on Contributors

AMY R. W. MEYERS is a research associate at the Center for Advanced Study in the Visual Arts at the National Gallery of Art. In 1985 she received her doctorate from Yale University, having completed a dissertation titled "Sketches from the Wilderness: Changing Conceptions of Nature in American Natural History Illustrations, 1680–1880."

EDWARD J. NYGREN is Curator of Collections at the Corcoran Gallery of Art. His concentration on British and American art of the seventeenth to nineteenth centuries has been the basis for exhibitions in the United States and abroad dealing with the Anglo-American tradition.

THERESE O'MALLEY is a research associate at the Center for Advanced Study in the Visual Arts at the National Gallery of Art. As a candidate for the doctoral degree at the University of Pennsylvania, she is currently completing her dissertation on "The National Mall in Washington, D.C.: Art and Science in American Landscape Architecture, 1791–1852."

ELLWOOD C. PARRY III teaches art history at the University of Arizona in Tucson. Among his many publications are *The Image of the Indian and the Black Man in American Art, 1590–1900* (1974) and a forthcoming book on the art of Thomas Cole.

BRUCE ROBERTSON, an instructor in the Art Department at Oberlin College, is a Ph.D. candidate in the history of art at Yale University. He has published widely on British and American art from the early eighteenth to the early twentieth century.

JOHN R. STILGOE is Professor of Visual and Environmental Studies at Harvard University. Author of *Common Landscape of America, 1580 to 1845* and *Metropolitan Corridor: Railroads and the American Scene,* he is presently completing a book on American outer suburbs, 1750 to 1940.

Commentaries on the artists exhibited have been written by the following:

CMD	Christine M. Doremus
GLH	Grayson Lauck Harris
PAH	Pamela A. Henne
JAH	Judith Ann Hughes
EMK	Elizabeth Mankin Kornhauser
KK	Kimberly Kroeger
TYL	Trudi Y. Ludwig
LEM	Lorette E. McCarthy
KBM	Kathleen B. Miller
MSM	Margaret S. Moore
EJN	Edward J. Nygren
BR	Bruce Robertson

Edward Nygren and Bruce Robertson are identified above as authors of essays, Elizabeth Kornhauser is a research curator at the Wadsworth Atheneum, Kathleen Miller is an education consultant to the Corcoran Gallery, and the remaining authors were members of Dr. Nygren's class "Anglo-American Landscape Art," given in the fall of 1984 in the Department of Art, George Washington University, Washington, D.C.

Lenders to the Exhibition

ALBANY INSTITUTE OF HISTORY AND ART, New York

AMERICAN ANTIQUARIAN SOCIETY, Worcester, Massachusetts

AMERICAN PHILOSOPHICAL SOCIETY LIBRARY, Philadelphia

THE ARDEN COLLECTION, New York

THE ART INSTITUTE OF CHICAGO

ATWATER KENT MUSEUM, Philadelphia

THE BALTIMORE MUSEUM OF ART

THE BENNINGTON MUSEUM, Vermont

LIBRARY OF THE BOSTON ATHENAEUM

THE BROOKLYN MUSEUM, New York

THE BUTLER INSTITUTE OF AMERICAN ART, Youngstown, Ohio

CHILDS GALLERY, Boston and New York

CONCORD FREE PUBLIC LIBRARY, Massachusetts

THE CORCORAN GALLERY OF ART, Washington, D.C.

THE DETROIT INSTITUTE OF ARTS, Michigan

THE DIETRICH AMERICAN FOUNDATION, Chester Springs, Pennsylvania

WILLIAM A. FARNSWORTH LIBRARY AND ART MUSEUM, Rockland, Maine

FORT TICONDEROGA, New York

GIBBES ART GALLERY, Carolina Art Association, Charleston, South Carolina

THE WARNER COLLECTION OF GULF STATES PAPER CORPORATION, Tuscaloosa, Alabama

JUDITH HERNSTADT

THE HIGH MUSEUM OF ART, West Foundation, Atlanta, Georgia

HIRSCHL & ADLER GALLERIES, INC., New York

HISTORICAL SOCIETY OF PENNSYLVANIA, Philadelphia

HONOLULU ACADEMY OF ARTS

IBM CORPORATION, Armonk, New York

KENNEDY GALLERIES, New York

THE LAMONT GALLERY, Phillips Exeter Academy, Exeter, New Hampshire

COLLECTION OF DR. AND MRS. HENRY C. LANDON III

THE LIBRARY COMPANY OF PHILADELPHIA

LIBRARY OF CONGRESS, Washington, D.C.

COLLECTION OF BERTRAM K. AND NINA FLETCHER LITTLE

TOM SNYDER COLLECTION; Courtesy R. H. Love Galleries, Chicago

THE MARYLAND HISTORICAL SOCIETY COLLECTION, Baltimore

COLLECTION OF MELLON BANK, Pittsburgh

THE METROPOLITAN MUSEUM OF ART; New York

MILBERG FACTORS, INC.

MUSEUM OF EARLY SOUTHERN DECORATIVE ARTS, Winston-Salem, North Carolina

MUSEUM OF FINE ARTS, Boston

THE MUSEUM OF FINE ARTS, Houston

MUSEUM OF THE CITY OF NEW YORK

NATIONAL GALLERY OF CANADA, Ottawa

NATIONAL MUSEUM OF AMERICAN HISTORY, Smithsonian Institution, Washington, D.C.

THE NEW BRITAIN MUSEUM OF AMERICAN ART, Connecticut

THE NEW JERSEY HISTORICAL SOCIETY, Newark

NEW JERSEY STATE MUSEUM, Trenton

THE NEW-YORK HISTORICAL SOCIETY

THE NEW YORK PUBLIC LIBRARY, Astor, Lenox, and Tilden Foundations

OLD STURBRIDGE VILLAGE, Sturbridge, Massachusetts

THE CHARLES RAND PENNEY COLLECTION

PENNSYLVANIA ACADEMY OF THE FINE ARTS, Philadelphia

PENNSYLVANIA HOSPITAL, Philadelphia

PHILADELPHIA MUSEUM OF ART

THE PHILADELPHIA PRINT SHOP

PORTLAND MUSEUM OF ART, Maine

PUBLIC ARCHIVES CANADA, Ottawa

REYNOLDA HOUSE MUSEUM OF AMERICAN ART, Winston-Salem, North Carolina

COURTESY OF MARK UMBACH, THE JAMES H. RICAU COLLECTION, New York

ROYAL ONTARIO MUSEUM, Toronto

SHELBURNE MUSEUM, Shelburne, Vermont

VICTOR D. SPARK

THE SOCIETY FOR THE PRESERVATION OF NEW ENGLAND ANTIQUITIES, Boston

TERRA MUSEUM OF AMERICAN ART, Chicago, Illinois

THE TOLEDO MUSEUM OF ART, Ohio

DIPLOMATIC RECEPTION ROOMS, United States Department of State, Washington, D.C.

VIRGINIA STATE LIBRARY, Richmond

WADSWORTH ATHENEUM, Hartford, Connecticut

THE HENRY FRANCIS DU PONT WINTERTHUR MUSEUM, Delaware

WORCESTER ART MUSEUM, Massachusetts

YALE CENTER FOR BRITISH ART, New Haven, Connecticut

YALE UNIVERSITY ART GALLERY, New Haven, Connecticut

Index *

Index of People

*Numbers in italics indicate illustration; **numbers in bold** indicate bibliographical entries.

Index of Places